The Ailsa Mellon Bruce Studies
in American Art

*Abstract Expressionist Painting
in America*

Abstract Expressionist Painting in America

William C. Seitz

Published for the
National Gallery of Art, Washington
by Harvard University Press
Cambridge, Massachusetts, and London, England
1983

Library of Congress Cataloging in Publication Data
Seitz, William Chapin.
 Abstract expressionist painting in America.

 (The Ailsa Mellon Bruce studies in American art)
 Includes bibliographical references and index.
 1. Abstract expressionism—United States.
2. Painting, Abstract—United States. 3. Painting,
Modern—20th century—United States. I. Title.
II. Series.
ND212.5.A25S4 1983 759.13 82-18734
ISBN 0-674-00215-6

Contents

Illustrations

Hans Hofmann

Robert Motherwell

Foreword

The supreme temptation for the philosopher of art, said Paul Valéry, is to discover the laws that will make it possible to know with absolute certainty *(and it was he who underlined the words) which paintings and sculptures will be admired in a hundred years time. To which Picasso replied that art philosophers had the souls of picture dealers. In a civilization that regards posterity as hazardous, Valéry's "absolute certainty," the fight against chance, becomes as absurd and as invincible as the desire to escape from death.*

Which of us does not dream of catching posterity red-handed?

—ANDRÉ MALRAUX, *Anti-critique* (1976)

Until now William Seitz's book has existed for some twenty-eight years only in a few, poorly microfilmed copies of the typewritten original, a dissertation submitted in 1955 to the art history faculty of Princeton University for a doctorate of philosophy. As one of the book's protagonists, and as one of the originators (in various ways) of that "movement" in painting that is Seitz's central subject—Abstract Expressionism—I reread now his volume with mixed and intense emotions, with a strange sensation that is more than that of an old artist reading about the deeds and attitudes and colleagues of his youth. Is it a Proustian sensation? No, not at all. Proust was remembering the past. Here is not the past recaptured, but the *past as present*. And in all its problematic immediacy . . . *something that can never happen again!* For though present and future art critics may be "Prousts" in scholarly reconstruction of this earlier period, they will undoubtedly transform it, as Proust himself did with reflection.

Artists, while this book was being written during the early 1950s, were themselves asking what voyage we had been embarked on for the past ten years, one that had become known as Abstract Expressionism, an adventure that was, as Alfred H. Barr, Jr., told me several times, the movement most hated and feared by other artists and by the art public in American art history, even though its works were beginning to be respected and becoming influential among artists abroad. But self-consciousness, that enemy of creation, and epigones were already appearing by 1955—indeed, at this moment it seemed that half the jokes at the old Cedar Bar were in a pseudo-Dutch accent, homage to the growing de Kooning personality cult, as well as a reflection of the withdrawal to the East Hampton countryside of the deeply depressed Jackson Pollock, shortly to die in his automobile in 1956. (If Pollock had been accessible to Seitz, he would have been, I presume, one of this book's key figures—perhaps in place of Mark Tobey, who alone of the six was not a member of the new New York scene.) With hindsight of course anyone can question the choice of Seitz's particular six "key figures." But it is easy to forget that it was only after 1950 or so that the mature Kline, the Newman, the abstract Guston so familiar to us now, made their appearance, as did a whole second wave of artists. I presume that Seitz was sticking to artists with a longer Abstract Expressionist history, going back to the very early 1940s. Or perhaps certain artists, say, Clyfford Still or Adolph Gottlieb, refused to see him. Who knows? Or perhaps Seitz had a six-pointed schema of extremes, which each of his chosen artists fitted characteristically. Part of his fairness was not to violate each artist's individuality, despite the general phrase, "Abstract Expressionism." Or perhaps these six *were* indeed his choice, with the unfortunate exception of Pollock. In my own case Seitz was hesitant about a brief "nude" series of 1953, and just before he finished this thesis, I abandoned it, destroyed most of the paintings, and began—all in 1955—the "Je t'aime" series, the note on which, if either of us had known, my representation here should have ended.

Subsequent art history makes most original artists seem more sure than they were at the time. In

the early fifties a certain initial confusion, compounded by the growing number of followers at second hand, yielded the verbal confusions which were then becoming ubiquitous. This situation partly motivated Seitz's desire to go directly to the paintings. Thus, his study became a stunning effort to clarify the actual nature of Abstract Expressionism, a thorough but broad critical analysis of not only what we artists were saying, but more importantly, were *painting*, the central issue. In this respect Seitz's book remains unsurpassed. For he was not only a skilled scholar inspired by such superb predecessors at Princeton University as George Rowley and Alfred H. Barr, Jr.; Seitz was a talented, practicing painter. This extraordinary circumstance cannot be emphasized enough. It is the sine qua non of the several other elements that, taken together, make his book a classic—not only in the literature of Abstract Expressionism, but also sui generis in the scholarship of Modernism.

It should not be forgotten that often the main emphases in graduate departments of Art History are on iconography, cultural symbols, attribution, and historical artistic borrowings and influences, all highly relevant to the art of the past, but less so in the case of twentieth-century artists; a century that has seen, generally speaking, iconographic subjects assume less and less importance with the rise of abstraction in regard to its leading artists, a century which does not employ a tribal iconography for the most part (being an art of individuals, whose principal conquest, perhaps, has been the realm of subjective feeling), showing on a stage where the principal influences on any contemporary artist are more or less obvious, and where nearly every work can be authenticated. One might argue that traditional art history training in certain respects gets in the way of scholars of modern art, that the method implies as natural taking-off places ones that are not only inadequate, but even misleading.

I remember, ten years or so ago, speaking at the request of the advanced students at the famous New York Institute of Fine Arts, a citadel of impeccable art historical methodology, one block from New York City's Madison Avenue with all its art galleries, and discovering to my astonishment that no one could remember when, or even if, another artist had spoken within those academic premises. Here were scores of art scholars who had never heard an artist talk, let alone had frequented an artist's studio. Yet I would suspect that the structural methods and tools of most painters and their studio routines have changed less during the past five centuries than those of any of the arts. I do not mean here to malign art scholarship, I mean only to emphasize that his intimate studio knowledge as a practicing painter equipped William Seitz uniquely to deal with a contemporary art movement whose very character resisted and, in the end, *could not yield its essential nature*—or natures, the more individualized the matter was treated—to traditional art scholarship, a method better suited to more peripheral discoveries, for example, the reason for a given title.

The core of Seitz's book, Chapters 2 through 6, is a detailed examination of what happens in each of his painters' work in those painterly means that painters themselves think in, consciously or not. By painterly means I mean something more than sheer technique (on which Seitz is masterly), but in no way divorced from it. I open Seitz's manuscript at random, encountering: "the spirit in which the extreme Abstract Expressionist painting is begun can be summarized thus: shapes, colors, and lines are placed on the canvas with the least possible premeditation, their initial form and juxtaposition dictated by various levels of the sub-, un-, or semi-consciousness; by unplanned 'inspirations,' by sheer fortuity, or by the inherent nature of the medium. Here is a disorganized but vital complex of raw for-

mal data—an uncoordinated 'unknown,' a Heraclitan flux which the painter, during subsequent phases of the process, relates, alters, and organizes on the basis of mediating set of attitudes and principles which run through all his works, and even through all of his life. In direct contrast with the purist point of view, predetermination of goal is regarded, not as an essential discipline, but as a danger. 'The question of what will emerge is left open. One functions in an attitude of expectancy.' Motherwell and Harold Rosenberg quote Juan Gris's statement: 'You are lost the instant you know what the result will be.' " This passage jerks back from time the freshness, the anxiety, the devotion, and the risks each artist in those days carried in his own way and also implies memories of the very look of each artist's studio then, scattered with the debris, like autumn leaves, of work in progress, of human nature working on a "disorganized but vital complex of raw formal data—an uncoordinated 'unknown.' "

With *known* criteria, the work of the artist is difficult enough; with no known criteria, with criteria instead in the process of becoming, the creative situation generates an anxiety close to madness; but also a strangely exhilarating and sane sense too, one of being free—free from dogma, from history, from the terrible load of the past; and above all a sense of nowness, of each moment focused and real, outside the reach of the past and the future, an immersion in nowness that I think noncreative persons most commonly parallel in making passionate love under certain circumstances—or perhaps in their dreams, where one knows there are meanings, but meanings so charged and so ambiguous, so transformed and cryptic that one is astounded by one's own imaginativeness and richness of connections, and frightened too.

On a more limited, technical level, note the precision with which Seitz uses the scientist Katz's 1911 treatise on color to arrive at an accurate description of each artist's individual attitudes toward color. From the concrete directness of some of the artist's color to the *mysteriousness* of Rothko's color effects, all is made plain: I know of no "poetic" or "religious" evocation of Rothko's "film" color so accurate empirically and, at the same time, so eloquently evocative of the actual appearance of Rothko's unique masterworks in color. Or the lucidity of Seitz's discussion of "Area, Shape, and Plane" where, beginning quite matter-of-factly with a discussion about what can happen on a picture plane, by the third, short paragraph he has arrived at this summary: "If the case is equivocal . . . is unstable and one cannot clearly separate image and ground—the effect gains the *ambiguity* so important to the modern aesthetic." Only someone used to *making painting* can move so clearly and fluidly from practical possibilities to ultimate aesthetic "effects" (in Poe's and Mallarmé's sense) and the moral vision implied, a vision in the case of Abstract Expressionists that is perhaps an ambivalent humanism, strongly against entrenched dogmas, aesthetic, moral, religious or political, but strongly for *presences* and possibilities—possibilities of truth to experience that a real man, a whole man might feel less ambivalent about than our sickenly rich inheritance of clichés, politics (right or left), God or not, art or anti-art, and all the rest.

Seitz does have difficulty in finding an essential Abstract Expressionist manifesto, but the very nature of a manifesto is to affirm forcefully and unambiguously, and not to express the existential doubt and the anxiety that we all felt. Certain kinds of paintings are easier to describe and to evoke (and perhaps to make) than others: van Gogh more easily than Cézanne, Picasso more easily than Matisse, Surrealism more easily than Abstract Expressionism (one that is certainly very difficult). For more than thirty years contemporary art

criticism has been strewn with failures to interpret Abstract Expressionism adequately and accurately not only because of faulty methodology, but often deliberately (in New York City) because of personalities and art politics.

But very early on William Seitz succeeded. He modestly noted at the beginning of his preface that "whatever unique qualities this book may have . . . arise in part from the fact that it combines the viewpoint of a painter with that of an art historian. If such a blend can constitute a method, it lies in an attempt to reconcile empathy with fact." He did just that, with the factuality of a fine scholar and the generosity of spirit of a creative mind, whose true satisfaction comes not from recognition of self but of the work. To have accomplished this so soon, without historical distance from his subject, is creatively nothing short of the category of the marvelous. But then we are confronting a man whom Leonardo himself would have understood across the centuries when Seitz

wrote to his own art dealer, Marian Willard, also the dealer of Tobey and David Smith, during the period he was writing this book and no doubt thinking of himself: "the fact that the artist paints in what seems to be an automatic manner does not in the least imply that his theories, his ethics, his ideals, and his cynicisms, are not involved. The more he can both broaden and intensify his knowledge, empathy, and cognizance of the world and himself, the richer is the raw material which gives meaning to his paintings. I cannot believe that the humanist scholar and the artist must, by definition, be separate. The barrier which has arisen between their twin approaches toward the truths of existence is one of the sad phenomena of modern life. Intellect, emotion, and sense need not be separated."

With his completeness of view, perhaps Seitz has indeed caught posterity red-handed.

Robert Motherwell

Introduction

William Seitz's writings on art derive strength from his remarkable ability to hold fast to the ideals formed in his youth. Although he left little unquestioned and repeatedly challenged his own assumptions, there remained an unswerving faith in the value of an artist. Seitz accepted the grand tradition, rooted in the Renaissance, that held that an artist is an intellectual and that painting is a form of knowledge. He saw no reason, he wrote to his dealer, to separate the humanist scholar from the artist. Everywhere in his various writings—whether he was commenting on an artist of his own epoch or an artist from ancient China—the reader can sense his deep respect for the mysterious power of the individual talent. A work of art in which he discerned value was promptly subject to intense scrutiny from many points of view, but always Seitz conserved a healthy respect for the inner timelessness of any exceptional work of art. Paintings, he thought, could be apprehended as knowledge: "In the eyes of the world, they never cease to change. But once objectified, they have a timelessness; they become independent stimuli in a new relationship to the history of ideas." For him it was a matter of faith, even if a carefully criticized faith, that there is something inviolably true incarnated in a work of art: "Pictorial images manifest a meeting of matter and spirit, and the invisible forces contained within them are so essential, yet so diverse and untouchable, that they cannot be outlined or systematized without impairing truth."

Such views are all the more impressive when set against the period in which Seitz was writing, a period dominated by an analytic critical approach that rarely conceded to the traditional terms of discourse in which a notion such as "matter and spirit" could survive scientific assault. In Seitz's view the possibility of "spirit" could not be negated. His sense of himself, both as an accomplished painter and as a critical scholar, was as a spirit alien to the materialistic values of his time.

He speaks for himself as well as the six individuals studied in this text when he writes: "Like the scholar or the philosopher, the artist lives in a world of ideas vastly different from that of the businessman, the merchant, or the worker; but he is more acutely conscious of his isolation than is the intellectual. Society connotes to him not a social organism of which he is a part, but a huge middle-class world of property, manufacturing, buying and selling—a society to which he is alien."

As a humanist scholar, Seitz understood the vagaries of history. He never underestimated the longevity of ideas, or ideals. He set himself to study and participate in the present without prejudice, but he also felt the presences of many singular figures in history who had contributed to the formation of a present. It was this exceptional quality of plasticity in intellectual formation that enabled him to undertake the delicate task this book represents. When he began working on his thesis Seitz was in his middle thirties—a seasoned painter and observer of contemporary art, and a disciplined scholar. His range of interests was unusually broad for someone sheltering in academe. I remember visiting him in Princeton and listening with awe as he conversed with his friend and mentor George Rowley, a distinguished professor of Oriental art. These conversations probed deeply and provided Seitz with the background necessary to weigh the influence of Oriental art in the burgeoning New York School. His frequent sorties to New York brought him into many milieux and stimulated his inquiring nature. But he was no journalist. His notes and verbal comments indicate that he struggled to site his actual experiences within some larger context, both historically and aesthetically.

Not surprisingly, Seitz's proposed thesis subject met with considerable resistance in 1950. Art historians have understandable reservations concerning texts that have not been distanced in history. It seems to have taken the special pleading of Alfred

H. Barr, Jr., then Director of The Museum of Modern Art, to convince the Princeton dons that Seitz's subject was worthy of a thesis. As Barr remarked in his initial letter to Professor E. Baldwin Smith, Chairman of Princeton's Department of Art and Archaeology: "I have often wondered why art historians in our universities should feel that the learned study of contemporary art is somehow out of bounds for the graduate student when, in other departments, the study of the present is accepted as a matter of course. I suppose the graduate student in economics, anthropology and the other social sciences, in political or military history, not to mention the natural sciences, rarely has to think twice before embarking on the present or the recent past as a valid field of study, providing he is well equipped with a background of history and theory." Barr pointed out in the same letter that Abstract Expressionism was the "overwhelmingly predominant *movement*" of the period, and that it had already accumulated documents of importance. Most important, however, was the observation based on his own experience that he added in a postscript: "Reading over this letter, I am reminded . . . of my own difficulties this summer trying to make some sense of the chronology of Matisse's work and that of his colleagues of forty years ago. If only someone like Seitz with Princeton training had done his thesis on the Fauve movement working, say, in 1910, what a help it would have been!"

Barr understood in advance the nature of the biases Seitz would encounter. In response to his letter, Professor Smith spoke of the department's misgivings about the subject, and delivered himself of a judgment all too common among art historians: "We all know that artists themselves are never very clear about their purposes and methods when it comes to stating them in words."* This judg-

ment, still heard frequently, ran directly counter to Seitz's experience both as a working artist and as a cultural historian. What distinguishes his written work, beginning with this book, is the evidence of his ability to listen with the special attention often required to make sense of artists' statements. A painter himself, Seitz understood the difficulties of translation, but he also understood that no one can be certain of anything in art, and that if the artist is "not very clear" about his purposes and methods, there is no reason to believe that the art historian will be any more so.

Never forgetting humility before the work of art, Seitz writes at one point in his book: "What a delicate operation it is to determine what is demonstrably 'there' in a work of art." It was just such an operation he undertook in his book. Taking as his subject a deliberately amorphous configuration (the Abstract Expressionist movement, after all, jealously guarded its right to be protean), Seitz was able to find much *there* there, to paraphrase Gertrude Stein. Now, nearly thirty years later, Seitz's perceptions not only remain accurate, but have been echoed in numerous subsequent studies. The New York School, or the Abstract Expressionist movement, is perceived today much as Seitz presciently described it—as an authentic movement of international consequence. But already barnacles are obscuring its basic outlines, for it has acquired a scholarly history crammed with secondary footnotes to which, I think, Seitz's book will be a fitting antidote. It does make a difference that there was a brilliant mind and eye at work at the beginning, when everything is always fresh, and that such a mind, impatient with trivial detail, discerned the most telling characteristics among the six points of view he examined.

I say beginning, and I mean it quite literally, for Seitz had the advantage of having been a very young employee on the WPA when the sense of community that led to a movement was gestating. All of the participants in the New York School

* Garnett McCoy, ed., "A Continued Story: Alfred H. Barr, Jr., Princeton University, and William C. Seitz," *Archives of American Art Journal*, 21 (1981), 8–13.

have at one time or another discussed (whether negatively or positively) the great significance of the government art projects in the formation of an authentic artistic culture. Seitz was able to use his own experience of radical change in the cultural climate during the Depression years to gauge the social and aesthetic consequences of the Abstract Expressionist movement. Later, he was an alert chronicler of the animated exchanges that occurred not only informally at the Cedar Bar but also in the gatherings at The Club, a relatively stable, anti-institutional institution that flourished during the early 1950s. Nearly every Friday night a large group of artists and other intellectuals foregathered in a loft to hear each other's statements and make their often heated ripostes. The Club, as Seitz recognized at the time (unlike many others, who, seeing the disarray of the loft environment and the often boisterous behavior of the artists, dismissed it), was an authentic cultural phenomenon. Not only did artists invite artists to speak on widely varied issues, but they also invited luminaries in other fields, among them e. e. cummings, Hannah Arendt, John Cage, and Lionel Abel. The nature of discourse at The Club was often spontaneous, and it took a sharp ear such as Seitz's to catch the truly significant topics and locutions, many of which are cited in this book. The Club was a significant force in the making of a movement. It was a focal point and an agora. As Seitz recognized, "the story of Abstract Expressionism from 1947 to 1954 is one of dissemination from a source."

One of the most valuable aspects of Seitz's inquiry is his light-handed way of evoking an authentic zeitgeist. Without belaboring the point, he manages to suggest that the individuals he discusses were sensitive to the significant currents of thought of the period, and were aware of philosophic, literary, and scientific events. He demonstrates in fact how much these artists drew upon the insights of others and how intelligently. His use of contemporary sources is at all times precise. For instance, in

the chapter on the creative process, he identifies the historical sources of the Abstract Expressionists' notion of their own creative processes: they synthesized germinative ideas drawn from the French Romantic movement of the nineteenth century with such later sources as Bergson, Whitehead, Dewey, the Surrealists, and Sartre. It is important to note that Seitz did not merely point to the ways of thought these thinkers introduced, but caught his subjects in the act of using them. Because he himself was a creative witness to the period, he was well aware of the way such books as Paul Klee's notebooks, published in the late 1940s, or Arthur Waley's and Suzuki's books on Oriental philosophy, published in the early 1950s, or William Empson's book on types of ambiguity, published in the late 1940s, entered the inner discourse of his subjects. Whereas in subsequent years the influence of John Dewey waned and later scholars tended to overlook him as a source, Seitz was working at a time when Dewey's *Art as Experience* could be found in many studios. In selecting a passage to present his artists in relation to Dewey's thought he retrieved an important element. His quotation of Dewey is to the point: "If the artist does not perfect a new vision in his process of doing, he acts mechanically and repeats some old model fixed like a blueprint in his mind . . . the real work of an artist is to build up an experience that is coherent in perception while moving with constant change in its development." These lines, published in 1934, forecast the views developed by Harold Rosenberg in the 1950s in his vivid accounts of Abstract Expressionist attitudes.

Seitz also caught the essence of Whitehead, whom many painters had read, when Whitehead said that philosophy "builds cathedrals before the workmen have moved a stone, and . . . destroys them before the elements have worn down their arches. It is the architect of the buildings of the spirit, and it is also their solvent:—and the spiritual precedes the material." This idea—that the

spiritual precedes the material—was implicit in the attitudes of many painters Seitz mentions.

The philosophic attitudes that were most congenial to the Abstract Expressionists were those of the French Existentialists who were widely discussed soon after the Second World War when translations of their writings appeared in the United States. Seitz was well aware that painters were not professional philosophers and he did not overstress the role of Existentialist thought in the pictorial image. But he knew there were identifiable affinities and remarked "in an existentialist aesthetic no part of the process is merely technical; it is a symbolic act, inseparable from the biography of the artist." Accordingly, Seitz was able to focus on and evaluate fragments of conversation or written statements by his artists that indicate how much they had assimilated the Existentialist rhetoric. For example, he quotes de Kooning as saying that "the texture of experience is prior to everything else," including the "distant space of the physicist." And Seitz, in one of his own rare observations (he was perhaps overly reticent with his own views), uses Existentialist terminology to define the nature of expression as "that art stemming directly from the predicament of a single human being."

One of the principal virtues of Seitz's approach to his daunting task was his own Existentialist conviction that essences are grasped through process. Throughout his book it is apparent that his own unspoken discipline demanded that he look first to the work, then to the artist himself, and then to the outside envelope of culture. He built his thesis in accordance with his conviction that art is a form of knowledge. He did not forget, though, that painters are curious fusions of impulses and abilities; that they are men of techne as well as men of spirit, and that in some cases, as when Gorky discovered the sign-painter's liner brush, the material means determines the spiritual essence. Seitz developed a method of inquiry that had the advantage of being

classical and therefore coherent (as for instance when he knowingly uses the traditional philosophical doublets such as matter/spirit, chaos/cosmos) and that was at the same time open to the consideration of the loose ends that inevitably challenge a preconceived system. He used an objective analytic method—almost Aristotelian in its categorical divisions—but with a strong sense of paradox. This enabled him to perceive the attraction that tradition held for his adventurous painters. Unlike so many other commentators, intent on showing only how the Abstract Expressionists effected what critics vulgarly called a "breakthrough," Seitz saw that all of his subjects—even Rothko, whose departure from tradition seemed, on the surface, most radical—were intent on absorbing and redefining tradition rather than rejecting it. He noticed that the nature of pictorial space changed in the work of the later 1940s, and that certain artists, such as Tobey and de Kooning, achieved a rhythmic unity (which Seitz aptly called "consonance") that seemed to challenge all previous idioms in painting. But he insisted that the best painters never abandoned the idea of a work of art "as a limited constellation." He felt in each case that "they remain conscious, as did Cézanne, of limitation; and of a midpoint, either unknown or demarked, which ties them to both tradition and perceptual experience."

Perhaps it was Seitz's use of traditional categories that enabled him to bring into relief the radical transformation of art culture initiated by the Abstract Expressionists and their genuine ties to tradition. He was very skillful in balancing the discussion of tradition and innovation, always maintaining the tone of a respectful witness, always assuming that the individual artist could never be totally encompassed in analytic terms. For example, his numerous allusions to Gorky allowed for the role of temperament (he more often used the word "personality"). Gorky, he said, recognized the values he had discovered in Surrealism, but also

those of his own personality. Many commentators have failed to remain as consistently sensitive to individuals as Seitz. For all their discussions of individual genius and "autographic" works, most critics approaching Seitz's subject have managed to congeal it. Seitz was exceedingly careful to preserve intact the idiosyncratic developments in the lives of each of his subjects—developments that often seemed dependent on elements of tradition. When, for instance, he is examining the larger question of the coloristic and sculpturesque tendencies in Western painting (a cunning shift from Wölfflin's "linear" and "painterly" terminology), he enlarges his point with a reference to Gorky's unique use of both traditions. It was no historical accident that: "intrinsically, an ideal of three-dimensional bulk, whether achieved by contour or chiaroscuro, opposes colorism. Gorky is fascinating because he has refused to renounce either ideal."

Seitz also indicates Gorky's manifold sources when he discusses the role of movement in his compositions. Both Kandinsky and Klee had written about the dynamic possibilities that line presents, and Gorky had surely fused his knowledge of the discourse of modern art's progenitors with his own experiences as a man working with a brush. Seitz quotes him from an unpublished letter stating that: "movement is the translation of life, and if art depicts life, movement should come into art, since we are only aware of living because it moves." Gorky's friend de Kooning was no less aware of the organic tradition in painting, and it was Seitz's obligation to point to the failure of his own categories—line, brush, and plane—to define de Kooning as de Kooning progressed into the 1950s.

Seitz considered the organic tradition central. In an abstract of his thesis he wrote: "In spirit, organic process was the keynote, involving an intense identification, varying from artist to artist, with 'man' and 'nature,' a love of freedom, and a corresponding rejection of mechanism, determinism, or

any subjection of art to absolute rules, political dogma, or utilitarianism." Yet he also recognized an urge to centrality: "an impulse toward an intuited core of truth and reality; an absolute, but one which stops short of a static focus."

In grappling with the ambiguities of the problem of the absolute in Abstract Expressionism, Seitz wrote some of his finest pages. He was struck by the fact that these artists, so robust and fearless, so much given to hyperbole, quite often had recourse to the values usually described as "transcendental." With their devotion to the painterly act, and to the importance of matter itself, their preoccupation with transcendence was paradoxical. Seitz cautiously defines the way the artists he is discussing used the word transcendental to "indicate values which, though subjective, are not merely personal. They are ideal or spiritual, but still immanent in sensory and psychic experience." The contradictions inherent in such a definition could be resolved only in the paintings themselves, and it is largely through Seitz's discussion of individual paintings that he illuminates this still perplexing question. Always before him was the fact that almost all the painters in the group insisted that they remained close to mundane experience. De Kooning particularly. De Kooning has been guarding himself from abstruse spiritual interpretations all his painting life, and Seitz was able to catch the vitalistic approach in his conversations with the artist. He tells us, for instance, that the element of shape is cardinal with de Kooning, and gives us a picture of de Kooning leafing through a tabloid and pointing to a mystifying detail in a news photograph to illustrate the importance of shape. Such a man would hardly fit an abstract or absolute description of a transcendental visionary. Yet Seitz could make distinctions that brought de Kooning near to values "immanent in sensory and psychic experience." In his discussion of the impact of the outside world on these artists, for instance, he says that the pure for-

malist painters had always separated art from life, whereas "the Abstract Expressionist insists on the *inevitability* of broader involvement." This broader involvement stretches so wide that it can and did incorporate the notion of transcendental values and the absolute. Seitz dared to invoke the name of God in his examination of the deeper values that group shared, saying that: "God, in the traditional sense in which He was imaged on the Sistine ceiling, is seldom represented today. Yet the personal quest for a transcendental reality, and for an absolute, has in no sense abated."

This was an important insight, and one which made many artists uneasy at the time. Since Seitz's statement, there have been countless cultural phenomena that corroborated his insights, among them the turning to Buddhism, Taoism, and other religions. At the time he was writing, however, the artists he mentioned, with the exception of Tobey, were wary indeed of absolutes, including God. All the more impressive, then, is Seitz's diligent exploration of their conversations, writings, and paintings, in which he found irrefutable evidence of a secret hunger for transcendental reality, or, as he puts it, the "reality of realities."

The ideal of an absolute, he maintained, had been worn away in the modern era, as Malraux had observed in his important essays published in English around that time. Since traditional absolutes have dissolved, the modern "outcast" artist was haunted by visions of his *own* absolute, and could only assume it would emerge somehow in his work. "The absolute of modern art," writes Seitz, "lies at a focus known only through intuition. It involves unity, structure, and gestalt." Relying on intuition as well as analytic knowledge, Seitz arrived at wonderfully felicitous descriptions, such as the statement that a picture is "a spiritual tuning fork." The pictures of Rothko served him well, and his discussion of them is heightened by literary vibrations that reflect the paintings. In Rothko he of

course saw the intense drive toward an absolute, much as Rothko disavowed it on occasion. He discerned in Rothko's work one of the central motifs of his argument: "In the drive toward a core, a oneness, varied types of feeling merge. It is the characteristic of artists in general, and of the six painters we are dealing with in particular, to be motivated by such a *centripetal* drive." This centripetal drive toward oneness, which is in fact a transcendental value, is differentiated by Seitz from all that had gone before in modern art. In one of his superb insights, he points out that the nineteenth-century Romantics and their heirs, the Surrealists, shared a centrifugal orientation: theirs was "a flight away from reality rather than an impulsion toward it." The Abstract Expressionists, on the other hand, with romantic disdain for established categories of experience, moved inward with the paradoxical intention of transcending the personal. The realities they sought to invoke included realities of the spirit that, with ineffable incalcitrance, would only be incarnated in matter. In seeking what was "demonstrably *there*" in a painting, Seitz did not shy away from the intangibles that were also undeniably there. And when he modestly gave way to others' arguments, he did so with total appositeness, as, for instance, when he quotes Sartre, who had only recently been made available in English, disentangling definitions and proffering ambiguity as a positive value: "Tintoretto did not choose that yellow rift in the sky above Golgotha to *signify* anguish or to *provoke* it. It is anguish and yellow sky at the same time. Not sky of anguish or anguished sky; it is an anguish become thing, an anguish which has turned into yellow rift of sky, and which thereby is submerged and impasted by the proper qualities of things, by their impermeability . . . and that infinity of relations which they maintain with other things." Seitz remarks that "Rothko, too, describes his areas as 'things' and, like Sartre, emphasizes the 'imman-

ence' of their meaning. Meaning is immanent in the form or, in Sartre's phrase, 'trembles about it like a heat mist; it *is* color or sound.' "

To lend authority to his argument, Seitz used the historian's technique of finding precedents. He sought to enlarge the discussion of the less accessible aspects of Abstract Expressionism by invoking the statements and works of artists of the past who prefigured Abstract Expressionist attitudes. He noted, for instance, that there had been a recurrent and crucial problem in the entire history of modern art: "How can the physical and emotional realities of human existence be reconciled with abstract means?" The problem was not resolved, but rather incorporated as subject matter in the works of the Abstract Expressionists, who were aware of its historical genesis from Delacroix to themselves. Where evidence was useful, Seitz summoned quotations from the past, as when he has Motherwell quoting from Redon that his works: "*inspire* and are not meant to be defined. They determine nothing. They place us, as does music, in the ambiguous realm of the undetermined. They are a kind of metaphor."

The ambiguous realm of which Redon spoke was precisely the realm in which much of the drama of Abstract Expressionism unfolded. In seeking to make "a kind of metaphor" for their perception of creative existence, they took on, as Seitz says, "the most challenging problem . . . the reconciliation of human and natural themes with abstract means." This presupposed an aesthetic of incompleteness in which "the work completes itself only in the experience of the spectator." It also demanded a negative attitude to "manifesto thinking" and a revolt against "authoritarian control and mechanical rationalism." Because the manifesto characterized the various artistic phenomena dominating the nineteenth and twentieth centuries and was eminently usable by the art historian, the stubborn refusal of the Abstract Expressionists to make a public, collective credo made Seitz's task all the

more formidable. All the same, he managed to give, in several wonderful passages, precise characteristic descriptions, as when he noted the Abstract Expressionists' affinities with older romantic movements and stated: "They value . . . expression over perfection, vitality over finish, fluctuation over repose, feeling over formulation, the unknown over the known, the veiled over the clear, the individual over society, and the inner over the outer."

Although his task of locating "what is demonstrably 'there' in a work of art" commanded most of Seitz's attention, with all the anguishing choices and deletions that required, he did not lose sight of the fact that his group of artists *were* consciously participating in a movement, and that it was, in the last analysis, an American movement. Throughout the text Seitz suggests that the modern tradition, with its European locus, was boldly assimilated by these artists who, all the same, harbored ambivalent feelings. All through the Depression years they had argued against regionalism and pronounced themselves in favor of a cosmopolitan, internationalist outlook. Yet they had yearned to distinguish themselves from the Europeans. Seitz shared in the ambivalence. He was reluctant to sound the nationalist note, and reluctant, also, to overlook certain characteristics endemic to the American situation. It is with a touch of nostalgia that he invokes Bonnard and Vuillard and asks: "Would it be farfetched to suggest that the scale of the Intimists, and the greater Renoir, is denied us as contemporary Americans, that we are so conditioned that we cannot paint the scale of intimacy, softness, tenderness, and domestic warmth? We turn away from the quiet sensuousness and beauty of the everyday world, craving for conflict, tragic ritual, intensified essences, and colossalism." Concluding that there is little peace in Abstract Expressionism, Seitz sees its restlessness as a reflection of an American spirit which, he says, at its worst can be malevolent, self-satisfied, and overbearing. But at its best, "these

qualities become practicality, confidence, determination, inventiveness, and a hardheaded refusal to accept cultish preciosity."

Seitz was well aware of the cultural forces that enter any discussion of a national art movement and took care to strike a credible balance between the individual initiatives of the grouped artists and the cause-and-effect forces that played upon them. I suspect that he believed more in the individual's power to resist than in his adaptability to outer circumstances. He quotes Barnett Newman, "the thing that binds us together is that we consider painting to be a profession in an 'ideal society,'" understanding the paradox and yet believing that it was possible for a painter to take such a position.

So many years have passed since Seitz commenced his research for this book, years in which he wrote extensively and helped, by the force of his clear mind and examined feelings, to shape the history of modern art. Yet, with the exception of his Monet book and his essay "The Art of Assemblage," both singularly imaginative, his most important work remains this long-underground book, so rich in fact and prophecy. Now, when four of the six protagonists are long dead, and when numerous journals, letters, and varied documents have revealed many details of the Abstract Expressionist movement not available to Seitz, we can judge his breathtaking achievement in having known, all the same, the true lineaments of the movement.

Dore Ashton

*Abstract Expressionist Painting
in America*

1 The Spread of Abstract Expressionism

The years between 1944 and 1954 mark a fundamental transformation in American painting. Regional Realism, which still bristled defensively in the face of European Postimpressionism during the thirties, lost ground in the forties. It gradually became apparent, not only in the studios and galleries of Manhattan but in regional exhibitions and art schools dotted from one coast of the United States to the other, that an art in the international tradition had either radically altered or supplanted localized genre. The aesthetic isolationism championed by Thomas Craven during the thirties was dealt a severe blow by the international upheavals which culminated in the Second World War. It may well have been final, for by 1950 a majority of the most influential painters on both sides of the Atlantic were producing works either abstract, expressionistic, or in some way combining both viewpoints. And in New York militantly abstract painters had become less doctrinaire, expressionists and realists more abstract, and Surrealists more concerned with formal structure. Of the several labels that were advanced to summarize the new tendency—among them the New York School, Action Painting, and Informalism—only one, "Abstract Expressionism," stuck.[1]

This softening of stylistic barriers was without question international in scope. Yet the American environment, within which all of the European styles were able to affect each other with a new freedom, was an ideal germinating ground. The conditions that it offered, though perhaps not essential to the international phenomenon, nevertheless accelerated it, and in so doing marked its spirit. At the same time, the internationalism of the American artists, unlike the aggressively nationalistic program of the Midwestern realists, was philosophical rather than propagandistic. As Robert Motherwell wrote in 1946: "One is to know that art is not national, that to be merely an American or a French artist is to be nothing; to fail to overcome one's initial environment is never to reach the human . . . Thus when we say that one of the ideals of modern art has been internationalism, it is not meant in the sense of a slogan, of a super-chauvinism, but as a natural consequence of dealing with reality on a certain level."[2]

One important effect (and also cause) of the change from localism to what Motherwell calls "supranationalism" has been the establishment of a closer bond with the great European art of the immediate past. "Every intelligent painter," he wrote in 1951 for an exhibition of the School of New York, "carries the whole culture of modern painting in his head. It is his real subject, of which anything he paints is both a homage and a *critique*, and everything he says a gloss." A similar idea of tradition is implicit in the graphic words of another New York painter, Willem de Kooning: "There is a train track in the history of art that goes way back to Mesopotamia . . . Duchamp is on it. Cézanne is on it. Picasso and the Cubists are on it; Giacometti, Mondrian and so many, many more—whole civilizations."[3]

As well as demonstrating the traditional aspect of modern art, such remarks show the affinity which American painters feel between their ideas and works and those of Europe. Looking toward the future, they suggest that, for the first time, our painters are beginning to repay spiritual debts. A living relationship to tradition is regenerative: the greatness of the past, whether as pattern or challenge, forms an inevitable part of the raw material from which the present creates the future.

One of the outcomes of this study has been the realization that during the postwar decade American painting joined the mainstream of Western art, not as in the past as one of its tributaries, but as one of its component sources as well. The Atlantic no longer separates the cosmopolitan painter from the provincial. As a consequence of many interrelated cultural developments, the American is now

in a position to survey the world's art on his own, free from nationalistic barriers. He can appropriate or reinterpret what suits his aims and reject what does not.

Objectives and Methods

Developing in waves, the assimilation of "the culture of modern painting" by Americans began with expatriates like West, Whistler, and Macdonald-Wright. But these early internationalists were closer to Europe than America. It was not until Stieglitz, Duchamp, Marin, and the Armory Show that an American city became the scene of art events of international scope. The process of assimilation, as far as painting was concerned, was slowed down by the First World War. But it was vastly accelerated by the immigration of refugees from European chaos and totalitarianism which followed during the thirties, and by the Second World War. By 1950 the schism that separated European from American painting had almost closed.

A painstaking documentation of this development—of the roles played by teachers like Hans Hofmann, of The Museum of Modern Art, of dealers like Peggy Guggenheim, of the broad dissemination of reproductions, of art magazines, of new opportunities for travel, of publications like those of Wittenborn, of partisan critics like Clement, Greenberg, and finally of the many contacts between European and American artists made in New York City during the late thirties and forties—has yet to be written. It will be a work essential to an understanding of our art during the next half-century.

Such is not the aim of this book, which will, instead, try to search out the fundamental premises—technical, aesthetic, philosophical, or ethical—through which Abstract Expressionism developed. Its method will proceed from the specific and particular to the general: from the works and com-ments of individual painters toward group principles, concepts, and values. In attempting to separate constituent from transitory data, such an intention implies a tacit belief in zeitgeist—in a constellation of ideas which seem to be in the atmosphere.[4] It assumes that a specific group or locality during a particular time-span can constitute a definable cultural personality. One remembers the Athens of Pericles, the Rome of Augustus, the Florence of the Medici.

How clearly can an artistic milieu, a whole community of ideas, attitudes, and forms, be defined without falsification? Thinking of the intellectual hierarchy at midcentury, R. P. Blackmur offers an image (which had occurred to him, he remarked later, in placing random dots on a sheet of paper) of "a set of shifting positions about an unknown center."[5] A perceptual structure, it suggests the possibility of valid generalization from concrete data, but at the same time acts as a warning recognition of the intangibility of zeitgeist—a reminder that pat formulations can be as false as they are precise.

With this in mind, it is my intention to plot certain of the "shifting positions" of painting during the postwar decade, and to ascertain something of the "unknown center" postulated by their arrangement. But what constitutes a position? It must be a specific datum, however concrete or intangible: each passage of colored surface, each acceptance or rejection of a traditional technical procedure or subject matter, each unprecedented form, method, or idea, and every strongly felt aesthetic, metaphysical, or ethical conviction provides an element through which the changing whole can be seen. Together they fill in our understanding of the individual artist and his work and, in turn, the nature of the milieu.

Any painter of sensibility is partially conditioned by his social and cultural environment. By the same token, any artist of stature expresses intense and individual convictions which, if they become known,

affect his contemporaries. In narrowing a distressingly broad subject to manageable essentials, and ultimately to a core of material drawn from the activity of six painters, this question of an artist's impact on his professional world has been a primary consideration. For the men who have most imprinted their concepts on the milieu thereby gain an importance almost independent of the aesthetic worth of their individual works.

In order to determine the significance of a particular cultural phenomenon, to evaluate it, or to mark its connections with the world, one must understand its content and the medium in which it is expressed. It must first be studied in detail and on its own terms. So, before one can separate what is American from what is European in modern painting of the forties and fifties, understand its connection with its antecedents, or speculate on its potentialities for the future, individual works must be known at first hand, along with the ideas of which they are products. To this end, however, one does not study middle-of-the-road works which spice familiar forms with a dash of Picasso, Klee, or Matisse, but those which are new, either in their complete break with precedent or in the audaciousness of their synthesis.

In selecting such a group of key artists, one is inevitably caught in the dilemma of separating a criterion of cultural leadership from absolute evaluation of individual works of art. Must the historian or museum curator choose contemporary works without critical commitment? Are painters or groups elevated, willy-nilly, if they can serve as evidence of trends? Or is it possible for historical primacy to be merged with aesthetic value in a more significant judgment?

Looking back on what appear to be the errors of our grandfathers, we know that we are neither historically nor critically infallible, and that any selection, either of six or sixty artists, may exclude those whom the future will consider the most noteworthy. Willem de Kooning, Arshile Gorky, Hans Hofmann, Robert Motherwell, Mark Rothko, and Mark Tobey are nevertheless presented both as artists of distinction and as pioneers. They have been leaders not only in their works, but as teachers, theorists, authors, and, in one case, an editor. They are prime figures in a world that is necessarily small, for painters do not occupy a high position in the American hierarchy.

The primary data will be drawn from the activity of these six painters—from their paintings and drawings, published and unpublished writings, participation in semipublic discussions, and conversations with the writer. When it has seemed advisable, this core has been freely augmented, not only by reference to the works and thoughts of other artists but by the relevant observations of poets, critics, philosophers, or simply friends of painters.

This is not a history of the Abstract Expressionist development. Yet, regarded in another light, it is only as history that such a study can gain its fullest meaning: history, not as a sequence of events in everyday life, but as the metamorphosis of forms and concepts. Since their origins in the nineteenth century, spirit-history and style-history have challenged scholars, artists, and critics. They have been drawn toward the central reality which Arshile Gorky sensed, for his own period, in the "invisible relations and phenomena of this modern time."[6]

Not everyone will agree as to the validity of characterizing a period or a locality by what may seem to be an arbitrary selection of controversial painters. It is common to consider contemporary American art a diversity of tendencies of more or less equal validity. Regarded from this point of view, the Abstract Expressionists appear as one group among several, and a study of their work should recognize this limitation. It is true that in comprehensive exhibitions works similarly dated show great differences in spirit and manner—but

let us look for community rather than divergence. The various works embody cultural stimuli which, though dated the same year, reflect the years of their origin, and each succeeding phase in a nation's art can be best characterized by a limited group of forms and ideas.

The development of nineteenth-century French painting is exemplary: the thirties can be epitomized in the struggle between the styles of Delacroix and Ingres; Courbet and Manet dominate the midcentury; Manet and the Impressionists, the sixties and seventies; and Cézanne, van Gogh, Toulouse-Lautrec, Gauguin, and Neo-Impressionism the late years. Regarded in terms of the flux of ideas, confusing differences form a meaningful temporal pattern.

American diversity is more complex than French, for in addition to the retention of tradition in the styles of the present, the dualism of native realism and European modernism has shown itself in innumerable relationships that run the gamut from defensive nationalism to thorough internationalization.

With these qualifications, the reasons for seeing the Abstract Expressionists as the focus of a more general development become clearer. In the state of least adulteration, theirs is the hue by which the decade has tinted the art of realists—"magic" or social—resolutely geometric abstractionists, and expressionists. The six painters are selected as representatives of the School of New York, but the region designated by that label is more ideological than geographical. Just as the painters of the School of Paris could spend their time in Le Havre, Argenteuil, or the Midi, Mark Tobey, who is regarded as the chief painter of the Northwest School, can also be very much a New York artist.

The speed and completeness of the lines of ideological communication have been constantly accelerating since the twenties. Not only do the new tendencies of Europe and New York move rapidly

toward the West despite resistance, but the "Oriental" ideas of the West Coast return in the opposite direction. Little international enclaves, like those of scholars and scientists, can spring up anywhere. But so far, New York City has remained the nerve center.

Among those who will dispute the citation of the Abstract Expressionist group as the most characteristic nucleus of recent American style inevitably are resentful conservatives and painters whose work, sometimes against their will, has been influenced. Their opinions are not considered, but defensive. Another objection cannot so easily be put aside: Can Abstract Expressionism be accurately sampled by a study focused on only six painters? This question can be best met by considering the qualifications of each man individually.

The Artists

Hans Hofmann is the oldest artist of the group, and his entire career demonstrates a willingness to synthesize freely from diverse tendencies of modern art, though he has never become an advocate of any one movement. His formative period was spent in the Cubist Paris of 1904–1914 rather than in the Germany of Die Brücke and Der Blaue Reiter, which may explain why he has never been, in any sense, a German Expressionist. Yet he was painting as a pointillist in 1902, before he left Germany. Suddenly forced to return home because of the war, he had already learned the lessons of Cézanne, Cubism, and Matisse at first hand.

Hofmann was more than a painter: he had nurtured an inherently speculative mind through the study of science, and his concern for the first principles of nature was almost pantheistic. It may have been the analytical strain in his personality which led him, when forced to face a compromise between the life of art and the hard economic facts of wartime Munich, to open a school expressly de-

voted to modern art. Through his work in Germany and in summer classes at European resorts Hofmann, along with Ozenfant and Lhote, became one of the three leading teachers of advanced style. He conducted his pioneer sessions in America at the University of California during the summer of 1930. Since then his own schools, begun in 1934 and 1935 in New York City and Provincetown, Massachusetts, have gradually come to be regarded as primary centers for the study of modern painting by its exponents and detractors alike. Hofmann's writing has grown out of the challenge that all teachers face: that of simplifying and formulating ideas and processes that are neither simple nor susceptible to analysis.

For years he had little time for his own work; no Hofmann exhibitions were held between 1910 and 1931, and he was not represented by a New York dealer until 1944. Since then, known as painter as well as teacher, he has been active in both capacities. The foremost figure in the education of modern artists in the United States, Hofmann has followed a path almost identical with that described by the ideas of modern art as they have developed here since the thirties. His expressionism has been the projection of his own passionate personality as it responded to the dynamism of American life.

Mark Tobey, born in Centerville, Wisconsin, in 1890, is ten years Hofmann's junior. Neither the personalities nor the distinctive painting styles of these senior artists are similar, yet in fundamental ways—in their internationalist view of the world, in certain governing principles of their art, and in their mystical dedication to painting as a symbol of man and nature—they are in harmony.

These and other correspondences go far to demonstrate the unity that underlies the diversity of modern art. At the same time they emphasize the importance of the American environment, especially that of New York, for the cross-fertilization that resulted in the maturity of these two painters. More than any other contemporary, Tobey has stressed the idea of unity, not alone in art but in every phase of life. "The oneness of mankind" is a basic precept of the Bahai World Faith to which Tobey has adhered for many years, and in interrelation with which his aesthetic has been formed.

In 1922, after a stay in New York City that left a lasting impression on him, Tobey started for San Francisco, but wound up in Seattle. Since then, between teaching posts in England and Alaska and trips to Europe, the Near East, and the Orient, he has remained a resident of the American Northwest. His wide travels must be seen in the light of the one-world idea and his interest in Oriental art forms as an aspect of a total world view. Tobey is the first painter who has fully realized the median geographical position that the American continent occupies between Europe and the Far East, and the mediating role that the United States could play in a synthesis of what is best in both cultures. No other painter so well symbolizes the influence that Oriental art and philosophy have had on American artists. Tobey's Abstract Expressionism, a union of Eastern and Western ideas, began in 1935, the outcome of a development totally different from that of Hofmann.

Arshile Gorky has been elevated, since his tragic death in 1948, to the position of an old master of the New York School. Born Vosdanik Manoog Adoian, in a village of Turkish Armenia, he arrived in America in 1920, lived in Boston and Providence, and studied for a time at the Rhode Island School of Design and Brown University. As a painter, however, Gorky is associated with New York, in or near which he worked continuously from his twenty-first year until his death at the probable age of forty-four.

During the period of the Federal Art Project (though he was not a member of the American Abstract Artists Group) Gorky was an eloquent defender of modern style against the attacks of Marx-

ist aesthetic theory, hitting back ironically at Social Realism as "poor art for poor people."[7] But unlike many abstract painters, he admired the art of the Renaissance and haunted the museums, where his great frame, sad eyes, and drooping mustache (which seemed truly to relate him to the illustrious surname he had chosen) made him a familiar figure even to those of us who knew him only by sight. Earlier, in Boston, he had looked carefully at Copley; and a full-sized photostat of *Ingres as a Young Man,* which he admired at The Metropolitan Museum of Art, hung in his Union Square studio.

Gorky's late period, which began with studies of landscape in 1942, is a prime example of the synthesis of diverse viewpoints so characteristic of Abstract Expressionism. It was Gorky's historical contribution, following the example of Joan Miró, to implement successfully his personal subject matter and love of nature by fusing the structuralism of the abstract tradition with Surrealist imagery of the subconscious.

Willem de Kooning was one of Gorky's closest friends, and he has often been regarded, quite incorrectly, as a follower. Except for the wide-eyed frontal head type that both painters employed in their figure paintings of the twenties and thirties—it could also be found in the murals of the Federal Art Project—their kinship does not go far beyond that which relates the other four artists. Of European artists Gorky was closest to Cézanne, Miró, Kandinsky, and Picasso, whose influence, in both the Cubist and Classical phases, can be found in de Kooning as well. By native background, personality, and influences de Kooning differs completely from his friend. His early training as an apprentice decorator and window-display painter during the day, together with attendance at the Rotterdam Academy at night, more closely resembles the education of a medieval journeyman of the guild than an American art student. But in Holland, as

Thomas Hess has noted, "the disastrous cleavage between the Academy and experimental art had not taken place."[8] De Kooning learned the precepts of his academic instructors, the know-how of the trade, and the new forms of Jugendstil and de Stijl together. "When you say Poland you say Chopin; when you say Holland you say Mondrian," he remarked.[9] One moves a long way toward understanding de Kooning's spiritual parentage in realizing that he, like van Gogh and Mondrian, is a Dutchman. It is toward these two, of all painters, that his conversation is most apt to turn. The contrast of their styles suggests the extremes between which his development has oscillated.

The difficult journey to America was made because he "just got the notion to go to the New World." Maintaining himself after his arrival in 1926 as a house painter in Hoboken, New Jersey, he was able to paint full-time only through the WPA; except for an underground reputation among New York artists, he remained unknown until his first success in 1948. Even in 1951 he haltingly confessed himself to a reporter as "still working out of doubt."[10]

The consciousness of opposites and their resolution, in Abstract Expressionism, covers many dualisms: of tradition and modernism, of cerebration and feeling, of geometry and automatism, of Romanticism and Classicism, or, in Nietzsche's words, the "Apollonian and Dionysian." To have any value as a true stylistic characterization, the terms "abstract" and "expressionist" must be interpreted in their broadest, most connotative, sense. But for de Kooning and the painters close to him, expressionism has a more specific implication akin to that of van Gogh and Soutine. It conceives the canvas surface as a field for dramatic action in paint, and its content involves what the anti-expressionists of the New York group have characterized as "anguish."

Along with Milton Resnick, Jack Tworkov, and

a group of younger painters who are approaching figuration through the free manipulation of pigment, de Kooning at one pole of his personality is a part of the European-American tradition that begins with van Gogh and Munch. It shares with certain of the German Expressionists a style infusing ruggedly brushed pigment with brooding emotional content, and it prefers marks of struggle to the professional métier of the French. Set up as a criterion of value, it views Gorky's "Gallic" elegance as a bit suspect; for painting, thus regarded, is a more existential than craftsmanly activity.

Not only is Robert Motherwell completely disinterested in "German" expressionism, but, thinking of the painters mentioned in the preceding paragraph, he regards himself as an anti-expressionist. Yet he and they have a great deal in common. Perhaps his most evident divergence from de Kooning lies in his conviction that an artist's relation to the outside world should be one of responsive feeling rather than projection of the self; but even this ideal is paralleled in de Kooning's reticence. Motherwell is close to the Dutch-American painter, furthermore, in having built an art on a realization of his own conflicts. Born in 1915 in Aberdeen, Washington, the son of a well-to-do family, he has never thrown off the mannerisms and the love of gracious living that mark the affluent middle class. He has, nevertheless, been ruthless in his criticism of bourgeois values and is a champion of the artist, whom he has regarded as an underground man in a materialist society. Strongly affected by the Surrealists during the late thirties and early forties, his thinking, like theirs, was marked by the paradoxical combination of Marxist analysis and anti-materialist idealism. His attitudes were drenched in the literary Romanticism of Baudelaire and Rimbaud and the introversion of Kierkegaard. A defiant advocate of sexuality as a content of art, he is nevertheless, as James Fitzsimmons notes, something of a puritan.[11] Gregarious, friendly, and subject to moods of

loneliness, his air can be cursory and condescending even in public lectures—an attitude hardly calculated to please a lay audience.

Motherwell is the youngest of the six painters, not only in age but in the conditions of his development. He was first attracted to the theory of art as a student of philosophy at Stanford and Harvard universities, then to John Dewey's concept of "art as experience," and to Delacroix and Romanticism. Beginning as a philosopher, he was ultimately drawn to painting as a profession, one of the first of the generation who came to modern style directly, rather than through a sequential change from literalism. "When I first saw the work of Matisse," he remarked, "I knew that was for me."[12]

Whatever gaps an academic rather than a craftsman's background may leave in a painter's training, it helps him to organize and articulate ideas coherently. It has enabled Motherwell to become the best-known spokesman for the New York group. As a result, he has been the bête noire of the adversary of modern art, defending and counterattacking on just those issues most likely to inflame the layman, and he has continued to produce painting of a concentrated directness which can infuriate an unsympathetic eye. Always partisan, Motherwell's concern with modern art has expanded to include, besides painting and teaching, its psychology, philosophy, sociology, and history. As editor of Wittenborn and Schultz's Documents of Modern Art series, he has led in familiarizing American artists and students with many of the first papers of contemporary art.

For the past hundred years a barrier of misunderstanding has separated the modern artist from the lay public and the conservative art world. Artists' values have differed from those of society, and, though they have cultivated indifference to the hostility that has so often greeted their work, a reaction was inevitable. Hence, in retaliation, hostility has become a content of art as well as a condition

of the artist's existence. Along with de Kooning and Hofmann, Motherwell and Mark Rothko were among the twenty-eight painters and sculptors who banded together against the director and the exhibition policies of The Metropolitan Museum of Art in 1950.[13] Both have expressed their feelings openly, but, unlike Motherwell, Rothko has consistently refused to temper his attitudes or to collaborate, even with sympathetic curators, critics, and scholars.

Publicly Rothko has covered his career with protective veils not unlike those which fill his latest paintings. Born in Dvinsk, Latvia, in 1903, he immigrated to Portland, Oregon, in 1913, spent the years from 1921 to 1923 at Yale, was connected with a theatrical company back in Oregon in 1924, and painted in New York after 1925. During the thirties he was known as an expressionist. He is reluctant to show work of that period, however, because his viewpoint was reformed, about 1939, through a study of the dramatic themes of ancient myth—a crystallization, perhaps, of interest in the theater and an early reading of Nietzsche's *The Birth of Tragedy.*

Rothko's paintings and comments form an essential part of this study, because he is set off from the other five painters in significant ways. His pictorial means are unquestionably the most unprecedented, and, unlike the others, he refuses to acknowledge any debt to the past. It is the artist's right—in certain situations it may be his responsibility—to "will against": to disassociate himself from the past, from those aspects of his period which he rejects, and even from his colleagues. Rothko's inclusion also serves to represent the viewpoint of those

painters who, intentionally or unintentionally, find a part of their content in their own hostility. Clyfford Still, for one, expressed his resentment in print, and far less genially than his friend Rothko.

Hostility and social frustration are implicit, too, in the violent impastos which led to Jackson Pollock's abandonment of the brush. One can see in such responses a motive force behind the lack of finish, the ruthlessness, the austerity, and the anguish which marks some of the best painting and literature of the twentieth century.

In introducing what might be thought of as a panel of painters, the field of this study, in its inclusiveness and in its limitations, has been marked off. From the critical viewpoint which categorizes modern painting, often quite properly, in terms of divergent "isms," its area of concentration is "between the cracks," focused on a period during which the barriers separating realistic portrayal of man and nature, the quest for abstract purity, and expressionism of the self have softened. It is an area clearly cut off from literalistic painting, which offers few problems of interpretation; but its limits are also established within the field of "advanced" art—on the one hand, by geometric abstraction and the aesthetic of internal relations as the sole goal of art, and on the other by the abandonment of the brush for a purely automatic technique. At either the geometric or the fluid pole a direct response of pigment to the hand of the artist is minimized or obliterated. By definition, Abstract Expressionist painting can touch either extreme, but it does not exclusively adopt either. Is not the presence of the human touch the sine qua non of expressionism?

2 Pictorial Elements

The adjective modern, applied to a painter's style, usually indicates that he has either renounced or radically departed from the pictorial means traditionally employed during the three hundred years from the sixteenth to the nineteenth centuries: a change which has paralleled a gradual abandonment of the idea that art should mirror the physical world.

It is not difficult to summarize the means that modern artists have repudiated. Renaissance linear and aerial perspective were abandoned, and with them the sculptural bulks inherited from Antiquity. With mass went the emptiness by which it was surrounded, the enclosed volume of the stage box. It is significant that bulk and perspective were rejected together, for it was by this rationalization of sight that exact size and precise location in space could be decided by rule. In correlation, the theoretical or photographic modeling of light and shade and the dominance of imitative local color were also put aside.

This is not to say that no vestiges of traditional form remain or that a modern painter must join a campaign to exterminate the past. Fundamental changes are never immediate and are seldom complete. In endeavoring to express viewpoints absent from the painting of the past an artist faces a problem: Can he use old forms by altering them and changing their principles of relationship, or must a new means be evolved which organically embodies the new viewpoint? There are indeed times when new wine can be put into old bottles whose contours reshape according to the new contents—a stylistic situation which, with no intent to depreciate, can be characterized as mannerism. Art is of the past as well as the present and future, and there are periods when mannerism is modern.

Eventually the temporary bond breaks. It is as difficult to imagine the sculpture of the Ancient Greeks without plasticity as it is to envision the art of the Byzantine Greeks without its hieratic two-dimensionality. In the same sense, linear perspective was essential to the Italian Renaissance and microscopic detail to Jan van Eyck. Inevitably certain means became anathema to modern style. Nevertheless, it is no contradiction of the term modern to recognize the continued use by hundreds of good contemporary painters of rejected forms.

Contemporary means, by the very fact of their existence, effectuated the dissolution of essential elements of traditional style. One must be wary, however, of wrapping up for discard a package labeled "traditional pictorial means." More or less rapidly art is always in a state of flux, so that wholesale rejections must be viewed as a sort of negative idealism. The same treatment is not meted out to all galleries of the *musée imaginaire*. Tobey, in discussing the discovery of Coptic, Peruvian, South Sea, Northwest Indian, and Byzantine art, remarks that they were "taboo" when he was young, because the Renaissance was then the exclusive influence: "It was closest to the Greek, we thought."[1]

Historically the revolt was directed almost exclusively against the hegemony of the Classical Greek/Renaissance tradition. Yet this indication is also misleading. As often as not, contemporary painters are excited and stimulated not only by Renaissance masters, but by the great academicians as well: Gorky loved the work of both Uccello and Ingres. Although it is true that the rejected means reflect the Classical tradition, they represent it only in a petrified state, fused with attitudes imposed upon the artist in his immediate environment by an unconscious alliance of conservatism, provincialism, and ignorance. In this situation he regurgitates what does not fit his orientation. But as the dissemination of art objects and photographs has expanded, the authority of academic Classicism has declined, not only because of its intrinsic hostility to change, but because its standards have been challenged by the resultant cultural relativity.

Repudiation of past forms can also be viewed as

a rejection of the standards of a materialist society. Form cannot be separated from ideological, ethical, and social matters. But whatever one's interpretation, there must be periods in the history of art when the weight of the past, in the form of the reactionary prejudice of the present, must be thrown off before tradition can continue to grow. Destruction itself can be a symptom of growth, and even the most negative manifestations of Dadaism and Futurism, seen in retrospect, reveal constructive values. Also, conditions in Europe and America have not been the same. European artists were in revolt against the full stream of the past, whereas Americans have been faced with a much more naive and provincial conservatism: a Yankee pragmatism which still instinctively distrusts the expressive arts.

Aside from, if not independent of, social causes is a process that works, as Focillon has remarked, "within the styles themselves."[2] It has been too often assumed that any given subject matter can find an appropriate form in any pictorial means, and that its execution can employ virtually any technique. On the contrary, each shift in cultural or personal orientation implies a parallel form change.

Depending on one's viewpoint, repudiation of traditional means by modern artists can be regarded as a necessary clearing of the decks, a natural consequence of twentieth-century forms, a rejection of the values of a materialist society, or, more positively, as the inevitable effect of a changing attitude toward artistic reality.

The Medium

Remember that a painting—before being a warhorse, a nude woman, or some sort of anecdote—is essentially a flat surface covered with colors assembled in a certain order.

Maurice Denis' words, written in 1890, summed up the revolution taking place around him.[3] By its token, art was no longer imitation; "stripped bare by her bachelors," like Marcel Duchamp's "Bride," illusionistic and literary veils were torn aside, openly exposing the physical facts of the painters' medium. The actual surface became a fundamental reality: the material door through which immaterial realities could be approached.

Nonobjective painting, like that of the primitive, is built directly of lines, strokes, and areas. For the painter's model and the objects of the external world were substituted, as Motherwell says, "arbitrary esthetic elements of the simplest kind." Elements which, though they "constitute a part of the external world . . . *in no wise image it.*" "An empty canvas is more to the point, in being itself, an 'object,' and not merely an awkward image of 'real objects' . . . The problem is more nearly how not to lessen the original virginal loveliness of the canvas."[4] "What an inspiration the medium is!" he continues elsewhere, "colors on the palette or mixed in jars on the floor, assorted papers, or a canvas of a certain concrete space—no matter what, the painting mind is put into motion, probing, finding, completing."[5]

The medium must not be separated from the content it embraces. "Reality," Tobey states, "must be expressed by a physical symbol."[6] In an analogous statement Hofmann insists that an idea cannot be communicated until it is "converted into material terms." The ideas of the painter, like those of the choreographer, the composer, or the writer, are modified by his medium: "a plastic art cannot be created through a superimposed literary meaning. The artist who attempts to do so produces nothing more than a show-booth. He contents himself with visual storytelling. He subjects himself to a mechanistic kind of thinking which disintegrates into fragments."[7]

The stripped aesthetic prophetically announced

by Denis gave priority to the canvas over all else. Of the present group of painters, his words point most specifically to Motherwell, who sees wall-embellishment as the ideal social function of a painter, and who has a predisposition for mural qualities which draws him toward the fresco painters of pre-Hellenic Antiquity. He recalls Alfred Barr's remark: "You think like an Egyptian."[8] Such an intense feeling for flatness is personal; nevertheless, it spotlights one of the essential premises of modern style.

Both de Kooning and Tobey base their organization on a respect for surface, but concentrate more on execution in their comments, emphasizing the process by which the canvas is covered. Already implicit in the paintings and the *Journal* of Delacroix, the concept of art as gesture is central to Abstract Expressionist thought. This idea constitutes one of its chief points of divergence from the purist viewpoint. Active use of the medium offers expressionistic potentialities denied the purist painter.[9] However, in discussing their nature one must constantly guard against overemphasis on the "brute" aspects of expressionism. Pictorial means, like human thought and feeling, are varied. To the disturbed impasto of van Gogh and Soutine or the early canvases of Jackson Pollock must be opposed not only the subtle philosophical brushwork of Tobey and the flowing line of Gorky but all of those indefinable personal variations which Roger Fry (in comparing his own coldly mechanical tracing of a Paul Klee drawing with its animate model) fittingly called "Sensibility."[10]

Meditation on the application of pigment gives rise to a triple consideration: the psychological process by which the paint is marked; the formal elements created by the movements of the brush; and the "certain order" in which they are arranged—the question of relationships. Expressionist brushwork, furthermore, can be regarded as a historical counterpart of the abstract artist's regard for surface. Tobey "writes" his pictures, and on at least

one occasion (*New York Tablet*, Fig. 261) the panel is specifically designated as a writing surface.

On the skeleton to which Denis' words reduced painting, contemporary artists have erected a new edifice. In correlation with related conceptions of space and structure, the simple postulates of flatness, color, arrangement, and execution have given rise to two fundamental principles: the expressive use of the medium, or gesture; and picture plane. Through the former, the means is permeated with an existential or transcendental overtone; through the latter, the a priori of panel-flatness is transformed into relational unity.

Each sentence in the subsequent discussion of pictorial means must take cognizance of these powerful conditioning factors, and of the identification of medium with each artist's unique content. Collage fits Motherwell's orientation, whereas line and calligraphic brush, completely abandoned by Rothko for area in his latest work, are the necessary conditions for Tobey's transcendental humanism.[11] The color plane is Hofmann's essential element, and for Gorky it finally became the contour line, which Hofmann never uses. De Kooning, by contrast, translates his particular experience into paint largely by lapping brushstroke over brushstroke, in a broad webbing.

Line and Brush

One of the clichés of art criticism asserts that a line, being an abstract convention, has no analogue in nature. A glance at Tobey's "delicate threadlike structures" of blades of grass or wheat stalks, not to mention such artifacts as rope or wire, will determine its falseness. Stanley William Hayter, the pioneer printmaker, defines a line as "a long narrow volume of a color or value differing from that of the surface on which it is traced," thus ruling out the junction edges of masses, planes, and toned areas as implied in the no-lines-in-nature theory,

but which, in its expressive function, line can represent.[12] Hayter, an etcher and engraver, conceives of line as the trace of a rigid point; but, considering flexible painting tools, one can regard any stroke which remains relatively uniform throughout its length also as line—a means quite distinct from brush, which varies noticeably in width, tone value, and quality. Conversely, the stroke of a flexible pen can partake at a small scale of the variations of brush. And inasmuch as no line is utterly uniform —in thickness, tone value, or quality of edging —line and brush, like other means, can fuse. It should be emphasized, nevertheless, how clearly certain twentieth-century painters have defined their pictorial methods. Even in many of the works of Miró and Klee, for example, lines are indisputably lines and areas are areas. Such distinctions are often far less clear in the works of the Abstract Expressionists.

Intrinsically line refers to nothing but itself. Yet even a single trace can serve to represent a wirelike object or a movement through space. In combination with each other simple lines, as Hayter explains, are capable of a great variety of expression —describing relationships in one plane (which almost invariably generate spatial qualities); defining three-dimensional volumes, masses, and movements; or representing natural or man-made forms.

By changes in quality line multiplies its meanings. Ruler-drawn, it bears the mark of mechanical tools; but its precision, if not perceptually altered by the relational situation of which it is a part, drastically curtails its rhythmic possibilities, for the variations which embody human feeling are eliminated. Nonetheless, in terms of perceptual relationships, as abstract painters have demonstrated, precision lines and areas are capable of great expressiveness. Augmented by variations in edging, tone value, speed, and attack, infinite possibilities are opened up. Edges can be rough, smooth, clear, or blurred; the tone of the line against its field can vary from black against white to a barely perceptible difference between tones or between hues of the same value. Through the use of a dry brush a line can gradually lighten or darken; open breaks can interrupt its path; and thickness can vary—though only up to the point at which the uniformity characteristic of delineation is lost.

It is difficult to generalize concerning the possibilities of linear means. Each line has its unique mood and history. One has its future precisely decided before hand is laid to surface; another discovers itself almost free of conditioning by the artist and is only later incorporated in a scheme. As lines are multiplied on a surface they generate "multimeanings."[13] Automatically, like the thread of a spider or the crystallization of a mineral, lines can form cellular structures, labyrinths, webbings, nets, and membranes, thus losing their autonomous separateness. They can describe the contours or the axes of bulks and volumes and the edges or intersections of planes. If hatched more and more closely, they ultimately lose their identity completely, merging into passages of tone, illumination, or chiaroscuro.

The many meanings that line can be given— what Hayter calls its "expressive ambiguity"— have made it a major means not only to the draftsman or printmaker but to the painter as well.[14] But when a stroke is too varied in tone, width, edging, and rhythm, its linear character is lost. The calligraphic brushstroke (so-called because of its parallel to Chinese and Japanese brush-writing) usually bears little resemblance to any natural object and almost never resembles a mechanical artifact.[15] Even in the representational painting of Monet the individual stroke, rather than an element of the subject matter, tends to form the irreducible pictorial unit. In this sense the calligraphic stroke is more abstract than line. Unless it is specifically controlled to conform to the shape of a leaf or some other natural form, as in Oriental painting, it repre-

sents nothing beyond itself. It asserts its own existence and, beyond that, a symbolic reference that involves not only its shape, but the spirit—lyrical, violent, or tentative—in which it was executed. Gradually, since the exploitation of flexibility which began with the Venetians and was continued by the "Rubenists," the Romantics, and the Impressionists, the strokes themselves, rather than the representational units they compose, have tended to become the irreducible pictorial elements.

The willingness of painting tools and materials to adapt to the direct expression of human consciousness and the qualities of nature has contributed, since the Impressionist period, to a new direction in Western painting. During the twentieth century a free use of the brush has paralleled the change in viewpoint that militated against the traditional representation of bulk, chiaroscuro, and empty space and has asserted the physical existence of the medium as a primary reality.

It would be methodologically rigid to limit the idea of brush exclusively to a technique of separated strokes. Except for isolated works, neither Motherwell nor Hofmann nor Rothko could be characterized as calligraphic painters, yet all three use media and tools with expressive sensibility. The weighted surfaces of Gorky's early period, the varied impasto of Hofmann, and the fluctuating areas of Rothko are as much involved in the question of brush as are Tobey's calligraphy or de Kooning's expressionism.

The reaction of the Abstract Expressionist milieu against technical as well as ideological determinism tends to reject the procedure that makes the brush subservient to the T-square as well as that which ties it to modeling bulk. Any active use of the medium, whether facilitated by brush, knife, finger, flow, dripping, or whatever, has become a sufficient cause to rechristen a precision-geometric painter or even a traditional realist. When an artist either abandons geometric forms or softens and reinter-

prets his realistic images he becomes, from a superficial technical point of view at least, as much an expressionist as anybody else.

It would be arbitrary, therefore, to insist on tight categories isolating expressive line from calligraphic brush and the many modulations and enrichments implied by the word "sensibility." Rather, their analytical separation should serve as a conceptual device to sharpen one's feeling for each artist's unique synthesis of means.

Line has been instrumental in the formation of the styles of Tobey and Gorky, so it is appropriate to introduce the discussion of linear and painterly elements with a consideration of their work. Hofmann, in criticism of line as a primary means, remarks that "we can lose ourselves in a multitude of lines."[16] Yet Tobey has exploited precisely this attribute of linear structure. A considerable part of the attraction of his work is its power to make us, as active participants in the visual life of the painting, lose ourselves.

Line cannot be clearly separated from brush in Tobey's paintings. If his works were arranged in a sequence from the most linear toward those most broadly rendered, the individual steps from picture to picture would overlap. But from the sequence a group can be selected that show clearly separated steps. First, unequivocally linear in means, come those in which the strokes show a minimum variation in width, tone, value, and quality. *Space Architecture* (Fig. 249), or *Gothic* (Fig. 248), both of 1943, could begin the progression. The subjects are architectural; and each line, no matter what part of the building it represents, remains uniform throughout its path. The equivocal depth-surface, empty-full effect of *Gothic* does not result from the individual character of each line but from an arrangement of lines similar to each other. In conversation Tobey calls attention to the fact that the picture is constructed entirely of lines, and in fact their uniformity has a peculiar fitness for the

subject: each vertical suggests a shaft, a window, or a rib; and each curve a vault, a groin, or some other member—a sort of poetic architectural draftsmanship.

Greatly abstracted, and employing subject matter closer to our time, Tobey's New York pictures of 1944–1946 utilize line in every sense. The ascetic limitation of *New York* (Fig. 256) is too great for most painters. Each section of straight line, however much it might differ from its neighbors in thickness or tone value, maintains a sufficient unity through its length. It is as if the picture were constructed (considering it for the moment as an actual three-dimensional entity) of numberless girderlike members of varying lengths and thicknesses.

A few years earlier, in 1942, Tobey's line is different, but even more uniform. The curving "white lines in movement" of *Threading Light* (Fig. 244) flow in and out from compartment to compartment, mingling with (and often themselves forming) the figures and objects which their movements combine into complexes. Their effect—they "symbolize light"—is that of an illuminated movement path. *Drift of Summer* (Fig. 245) also has a representational reference, not in this case to architecture or moving light but to waving grasses. The blades form bows, loops, ellipses, and other curves rather than rectangles, but they retain a linear identity that relates to their subject matter.

A stroke's function is determined as much by its context as by its intrinsic nature. To mention one interesting instance: *Multiple Margins of Space* (Fig. 264) appears as a series of separated patches suspended before a dark void; only a careful study of the original reveals that the dark "background" is in fact a series of rough-edged brush lines painted *over* the "real" background. It is the contradiction of physical fact by visual effect which gives the work its peculiar appeal. Ultimately, the narrowness that keeps a stroke linear is a question of scale. The uniformly wide bands of *Ancestral*

Island (Fig. 262) are not lines; their representational overtones are to bars or poles, but if they were lengthened many times, thus changing their scale, they would again appear linear.

The similarity between Tobey's lines and Eastern calligraphy is slight, but like the Ch'an and Zen Buddhists, he regards the brushstroke as "the symbol of the spirit," and the more broadly brushed works present a closer parallel.[17] *Agate World* (Fig. 259), though in certain ways close to the New York pictures, uses means that are quite different. Before a field of broad, loosely articulated planes dance vibrating wisps. They cannot be read as architecture, light paths, grasses, or any other realistic forms. The strokes vary from wide to thin, homogeneous to split or broken, disciplined to loose, or bold to tentative. Without the remotest reference to the natural or artifactual world, they nevertheless retain their power to express feeling directly. Variation within each stroke and from one stroke to another becomes extreme in *Pacific Transition* (Fig. 251) or *Tundra* (Fig. 255). The forms truly seem "Oriental fragments" which "twist and turn."[18] Individual brush gestures assert themselves against each other as if the artist were seeking a maximum variety within a circumscribed range.

In considering the Oriental influence on Tobey's brush it is fascinating to couple it with his early admiration for what he calls the "handling bug"—the pyrotechnics of Harrison Fisher, Howard Chandler Christy, J. C. Leyendecker (who "for sheer technique took the cake"), and the other commercial illustrators—and his taste for fine-art virtuosi like Sargent and Sorolla.[19] Where is the line to be drawn between mere brilliance of handling and truly expressive brushmanship?

One of the earliest of the New York pictures, the 1935 *Broadway* (Fig. 239), separates itself from both earlier and later works by its impressionism. Applied to an evident linear-perspective scheme, the lines, scumbles, hatchings, and swirls merge into a

combined representation of closely packed figures and buildings flooded with electric illumination. It took several years for Tobey to evolve the direct, rather than representational, relationship between brush and ideas so characteristic of his style.

It is important to realize how intimately tied one particular brush quality can be to the movement, structure, and subject matter of a particular picture. A rhythmically flowing line can indicate a movement path, and uniform straight lines can suggest architecture. In the 1950 *Written Over the Plains* (Fig. 274) a new stroke is introduced, and with it a new movement and space. The rapid vibration of the nervous little wiggles suggests the scientific concept of energy as a basic reality, and the architectural grid is gone. There is neither up nor down in the format, but an endless spatial movement around a focal center. *Universal City* (Fig. 278) fragments the brushstroke. As if in conformance with some natural principle of division, the stroke has become a tiny touch. Supplanting calligraphy, the artist has used an activated pointillism, one that aims not at representing light but at the formation of a world with autonomous optical laws.

By 1926 Gorky's brushwork began to free itself from the traditional obligation to sculptural mass and chiaroscuro. The strong contours of *The Antique Cast* (Fig. 45) disassociate themselves from the bulk of the torso and stand out as independent strokes. The dissolution of bulk is carried further in *Composition: Horse and Figures* (Fig. 46), but perhaps through the influence of Cubism, Gorky's natural feeling for painterly opulence develops slowly. The incipient Surrealism in the drawings of the early thirties softens Cubist planes and leads to a new more expressionistic means of evolving form with a heavily charged moving brush.

The spirit that led Gorky to reject the rectangles of the abstract tradition also kept him from emulating its neat, thin paint surfaces. At the opposite pole, the thickness of his impasto—and especially the astounding weight of his pictures—gave rise to an exaggerated legend. Gorky's interest was not just in thick paint, but in molded richness of surface. Often it was the natural result of repeated repaintings in different colors, yet even in drawings he strove for nurtured textural qualities. Those of 1932–1933 (Figs. 52–54) were rendered in india ink, and, as Ethel Schwabacher tells us, he "washed off or erased surfaces before building them up again," amalgamating the ink with the paper to "form a different substance."[20]

He loved fine paints, and his studio, even during periods of poverty, was stacked with "hundreds of tubes of the most expensive colors, dozens of palettes covered with huge piles of paint, forests of fine brushes, bolts of linen for paint rags, and carboys of oil and turpentine."[21] "Great mounds" of paint, squeezed direct from the tubes or scraped off the canvas immediately after it had been put on, lay piled in dishes or on palettes. "You know how fussy and particular I am in painting," Gorky wrote, "I am ever removing the paint and repainting the spot until I am completely exhausted."[22] Elaine de Kooning recalls that during the thirties, "he would work on . . . paintings for years, scraping them with a razor blade at the end of each day's work, not in order to remove the paint, but to smooth it down for the stony surfaces that were an obsession with him at the time. Changing the colors of more or less fixed shapes, he would lay on coat after coat of pigment until the edges rolled up like rugs next to the shimmering black bands that physically divided them, like valleys" (compare Figs. 57–63).[23]

In 1940, abandoning his heavy impasto, Gorky thinned his paint and "released" his shapes, "letting them fly freely over the surface of the canvas."[24] As an outcome, he found a new means of evolving form by active brushwork. After establishing a temporary image in the first layer of paint

and letting it dry, it was partially repainted, retaining certain areas and obliterating others. The remaining shapes were thus radically altered, and the unsuspected arrangements that emerged became parts of a new scheme. The process is fully applied in The Museum of Modern Art's *Garden in Sochi* (Fig. 64): the main "foreground" images are actually passages reserved from the underpainting and reshaped by the olive-green background painted over them.

One might expect that, having hit on such an audacious means for creating form and equivocal space-flatness, Gorky would have based future work on it, and he does use the principle in certain passages of his later painting. But after 1942 his impasto becomes increasingly thinner and more transparent, so that the "reveal," surrounded by an opaque color, is seldom used. His late forms are established in line and derive, as we shall presently see, from drawings.

The old master of the New York School, Gorky is remembered by his dazzling modulation of color, automatic form, and fluid application of pigment. As a matter of fact he distrusted colorism and admired the linearism of Ingres; certain early portrait drawings even copy the academic master's style. If it were not for Gorky's opulent painterliness, one would say that he was dominated by an essentially linear-sculptural concept with roots in the Neo-Classical tradition. The importance of line for the late style was prefigured in the work done during 1929 and 1932 when, abandoning painting for lack of materials, he drew in pen and ink (Figs. 52–54). Unlike the later drawings, however, line is hatched and scribbled to provide textured planes and quasi-sculptural form.

But there can be no question concerning certain essential phases in the development of Gorky's later paintings. The process by which they evolve has its origin in the series of pencil and crayon drawings begun in 1943 and done from nature: the most

publicized has been that which served as a preparatory sketch for *The Liver is the Cock's Comb* (Fig. 69). Representation in these studies is vacillating and metaphoric, but the delineation of forms is anything but vague. Their contours show a ruthless precision like that of a surgeon performing an appendectomy. In sharp contrast to many of his American colleagues, Gorky was in the fullest sense a contour draftsman. In these probing nature studies (Figs. 67, 68, 83) delineation performs most of its possible functions. Meaning is not in abstraction, but in a painstaking morphology of the visual and tactile world, depicted in a draftsmanship which draws hairline distinctions between fleshy masses, hard bony protuberances, ephemeral clusters of overlapping petals, or the fragile bodies of insects.

Contour is a traditional means. It was used by the Greek vase painters, by Botticelli and Dürer. Yet the result for Gorky is new, for behind his searching eye and skillful hand lay a distinctively modern personality. He was simple, yet incalculably sophisticated. He had learned structure and the importance of optical movement from Cézanne and the Cubists; nevertheless, he loved the equivocal, the miraculous, and the ambiguous—values that he had discovered in Surrealism as well as in his own personality. Moved now by one and now by another stimulus, Gorky's lines have multiple meanings. An identical trace can serve to establish the contour of an anatomical detail, to suggest the limitation of a structural plane or an area of color, and to initiate a movement. Only rarely does a group of strokes coagulate into a hatching reminiscent of the pen-renderings of 1932; modeling is accomplished by contour alone.

In 1945 and 1946 (Figs. 74, 77) line has a simpler clarity. It often appears in its primary meaning, as a thin tendril or an abstract projection through space, but suddenly cognizant of the picture plane, it comes forward and streaks across the

flat surface. Occasionally Gorky chooses to forget line draftsmanship for a volatile automatism (Fig. 73), but such canvases are few. Almost all of the major late works proceed from line studies and develop by a systematic process that can be demonstrated by the studies and the three final versions of *The Plow and the Song* (1947). The central image that dominates each of the three paintings is a painstaking monumentalization of a small study (Fig. 83). The full-sized sketch (Fig. 84) was enlarged by the traditional grid method, and freely transferred to each of the three canvases (Figs. 85–87).

Once fixed on the surface, the central image was augmented by an architectural subdivision that partitioned those areas which remain blank in the studies, setting the stage, as it were, for the dominant theme. Linear structure established, Gorky painted on the three canvases alternately. Cued for his color-spotting by the wax-crayon passages in the studies, he painted (and often scraped out and repainted) between the lines. Amazingly, Gorky was able to avoid any debilitating effect from what is essentially a filling-in process, and to give the casual spectator the impression that his forms were the result of an unplanned freedom of improvisation.

Everything but the initial layout of elements in line—hue, value, surface quality, and tonal modulation—was subject to extreme alteration. By scraping and repainting, color surfaces were enriched; following the method of the *Garden in Sochi* with thinner paint, parts of the undercoat were allowed to remain either in reserved passages or as partially revealed tones which permeated the entire new color. Through successive scrapings and recoatings Gorky gained not only his unique vitality of color, but the porcelainlike surface so characteristic of his most finished work.

No painter before or since Gorky has equaled the easy uniformity of brush line, at once relaxed and controlled, so typical of his late style. As a moment's comparison of drawings to paintings will show, it is a direct translation from pencil. Such a line, which never takes on the thickening and thinning of calligraphic brushwork, was impossible with traditional painters' tools. It was only in 1945, when Gorky was introduced to sign-painters' brushes by his friend Willem de Kooning, that he learned to trim them down to a few hairs and thus to duplicate the pencil trace of the studies. Once he had established his draftsmanly procedure for producing a picture, Gorky never completely abandoned it.[25]

Line plays quite a different role in de Kooning's work. He scarcely used it before 1940. The early figure paintings (Figs. 1, 3, 4) are organized on the basis of flattened chiaroscuro, and the nonobjective canvases are constructed of color planes. In *The Wave* (Fig. 9), in *Untitled* (Fig. 10), and in other works of the early forties, a thin, uniform brushstroke serves to trace strange, bulging movement-shapes and define rectangles, bars, or palettelike ovals. Still subservient to the color planes, it nevertheless has a directness, a movement, and an élan characteristic of de Kooning.

By 1946, however, in a design for a modern dancer's theatrical backdrop, he draws in charcoal directly on the paint surface (Fig. 15). The dark line operates in a reciprocating alliance with planes of pink, green, burnt orange, and yellow, heightening the effect of recession, intensifying shapes barely suggested in paint, or creating planes independently. Its function is the same in the 1944 *Pink Lady* (Fig. 14), either freely following formative clues or originating new developments.

The difference between the roles played by line in the canvases of de Kooning and Gorky reflects basic differences in personality and procedure. By comparison with the stage-by-stage development of Gorky's mature period, de Kooning's process seems

indecisive—a fluctuating succession of rejections, revisions, changes of mind, hesitancy, contradiction, and fire-brigade improvisation. The separate phases which for Gorky punctuate the growth from the sketch to the canvas are confused and conflated. Whereas the first tiny sketches in oil or pastel often have the monumentality of finished pictures, revision of large canvases (sometimes using full-sized charcoal-on-paper details taped tentatively over abandoned passages) can continue for months.[26] The final stage of the picture remains intentionally unfinished in appearance; from first sketch to final hanging, everything remains subject to change.

Consequently, line does not greatly condition the final image. It is one means among many, to be used at any phase of the wavering or stormy growth of a painting; if it fails to turn the passage properly, it is obliterated—sometimes only partially, to remain as a phantom image. By 1947 (Figs. 17–19) for de Kooning drawing is completely freed from the secondary job of outlining and plays an autonomous part in the orchestration of the picture. A wiry reinforcing skeleton is thrown up to support the fleshiness of the wide interwoven brushstrokes, asserting a necessary vertical at one point, reinforcing a plane outline at another, acting as a foil for a passage that would otherwise be dull, or originating its own motifs, such as the double-crossed "T" that holds an "O" at the upper center of Figure 18. Against a background of established forms, the lines have a life of their own; they are never slack or without character. Tense and alert, they adapt decisively to the formal terms of the environment, reinforcing, paralleling, or violating its terrain in a vital interplay.

As de Kooning's means develop they become increasingly intertwined, so that an analytical categorization into line, brush, and plane becomes more and more arbitrary. The 1948 *Painting* (Fig. 21) in enamel employs a receding group of black

shapes defined by brushstrokes of more or less uniform width. They tend to read as heavy outlines, but often, especially near the fringes of the design, they melt into white area patterns. A few strokes, more markedly linear, define shadowy black paths with an almost dry brush whose trace is evocatively taut. Several verticals dispersed over the surface are of a still different quality—the black resulting from a scratch through an area overpainted in white, and the white from the paint which the tool drags over the dry black undercoat. Finally, the immediacy of the mood is heightened by three or four threads of enamel whipped Pollock-wise across the surface.

Inextricably woven with his other means, line, either as a brushstroke which retains uniformity for some part of its length or as a charcoal enrichment of painted forms, continues to be a part of de Kooning's formal equipment. But he is a painter first of all, who as tradesman and professional has been involved with brushes and pigment on every level and has based his methods on the tools and the know-how of the trade. It is his broad housepainter's strokes which have enabled him to build the elastically webbed surfaces so inimitably his own.

Like Gorky's, de Kooning's line and brush were not freed without a flattening or opening-out of the traditional three-dimensional means of the early figure paintings and a softening of abstract shapes. Although it is not among the works that the artist values most highly, an early abstract study (ca. 1938; Fig. 2) demonstrates the manner in which area, depth, and brushwork are used in the complex later work. Shapes are not defined in the customary way, but by the sign-painters' technique of cutting-in the background area while reserving the foreground image. In this instance, forms result from both positive and negative methods. Especially prophetic is the trapezoidal "window" at the lower right. Through it a chosen passage of the under layer of paint is revealed: a broad horizontal

brushstroke with a line crossing it diagonally. Rejected parts of the image were masked, after they had dried, by the fill-in strokes of the final coat, leaving an aperture through the opaque paint film. Space is induced by overlapping and enhanced by the dark diagonal line (freely ruled in the manner of a sign painter) which, moving from the upper-left corner toward the bottom and right of the canvas, begins as a background line but ends as a part of the foreground. Over it another crosses, completely in the forward plane until it is cut off at the right by a final stroke. Such an over-and-under process evolves shape, area, and color relations naturally, and heightens the foreground-background tension.

By 1947, in the black-and-ivory *Orestes* (Fig. 19), form development by interlocking layers of positive and negative cutting has become an established method. The large letters that build the composition—"O," "R," "A," "P," "E," "I," and "T"—tend to appear as positive images, but it is evident that their shapes are as much a result of overpainted white as they are of directly painted black. Black will not remain in the foreground, for the stony textures of the surrounding whites advance, and strong brushstrokes of white break away, dividing the black areas and establishing their own positive patterns. Such also is the method of The Museum of Modern Art's black and white *Painting* of 1948 (Fig. 21). The shuffling dark shapes, defined by white brushstrokes painted over a black ground, are touched only here and there with positive blacks.

The conceptual implications of a procedure that may at first seem but a technical expedient are significant. Because of an unorthodox use of the brush, new formal relationships are suggested which in turn imply alterations in structure and meaning. Ultimately such a development can revise fundamental tenets of an artist's viewpoint.

Gradually de Kooning's ideas become enmeshed in a widening periphery of technical and expressive devices which are announced in the sketch for a backdrop (Fig. 15). They expand in terms of reciprocal statements in a broad brush and a free charcoal line. It is a method exploited throughout all the later work, especially in the recent figure canvases. Singly or in groups, aggressive strokes describe shapes resembling hands, breasts, or other profiles of the human body. They function as planes, refusing to remain on the surface, and perform a space-dividing role. The charcoal line, drawn on the dry—or even *into* the *wet*—paint, not only serves to outline and emphasize brush planes previously established, but takes off in statements of its own invention. By alternately painting in and painting around, many layers of depth are indicated, each superimposed brushstroke or line creating a new receding plane, successively enriching the picture space as the overlaps multiply.

As the means of 1949 and 1950 become more aware of their potentialities, ambiguity and complexity increase. Occasional works, however, use a simpler method. In *Night Square* (Fig. 32) a delicately moving brush is the only device. Scumbled swaths of light fade into the dark and are cut by the finest threads of enamel to form a white network that stands, fragile and filmy, before a pure black ground. Against soft dry strokes, traces of line stand out with sharp whipped clarity or wriggle as the hand has slowed. At salient points the paint thickens and clots. The pictorial structure is that of suspension, and the mood, although delicate, is under tension. Every stroke is calculated so that it falls with both freedom and control, while avoiding superficial virtuosity. Because of the expanse of black, space is deep, though the picture plane is reasserted by the openwork of white.

But most of de Kooning's works of this period involve many more technical problems. Space is shallow, with the brush's path into depth rigorously restrained by opaque whites, pinks, oranges,

and greens. Yet, within a limited range of recession, every inch of *Attic* (Fig. 23), *Ashville* (Fig. 26), and the 1950 *Collage* (Fig. 31) is vitalized by intense brushing. Hardly a stroke, however, retains its separate identity as line, area, or calligraph. Continually the brush paths transform themselves. The sharp cut of the sign-painters' liner holds the artist's gesture, but the fluid paint runs, and both his movement and the clarity of the thrust are lost in the gravitational flow. Another stroke begins full and clean; but hit from the side with a knife, it is spread to become a smear, modeling into a dark pocket. Or, one edge ragged and the other sharp as a razor, it is like a tattered flag on a pole. As paint is exhausted from the brush, the stroke becomes as spare as raveled hemp, fading into the whole. Too intricate to isolate in the late paintings, de Kooning's direct methods are clear in numerous enamel-on-paper sketches (Figs. 27–29). Not drawings in the traditional sense, they are instead rehearsals in paint.

The 1952–1953 canvases (Figs. 41–43), all female figures, are not equally successful, but they contain the most turgidly complex brushwork of his career. Without sacrificing the spatial, expressive, and metaphoric meaning of abstract works like *Excavation* (Fig. 30), the artist incorporates into them his obsessive concept of the female. The close-knit homogeneity of the nonfigurative canvases is sacrificed for a pounding power which insists on its rudeness. The pigmentation, as emotionally charged as that of Soutine, is nevertheless quite different: it is imbued, not with suffering, but with an orgiastic gaiety. The atmosphere of disorder is intentional—a response perhaps to the untidiness of life—but behind it is a purist's respect for structure.

From reinforcing vertical, to human gesture, to assertion of space, to description of image—such a sequence is often the meaning-path of one stroke of the brush. In one movement an arm is drawn,

fleshy bulk is modeled, and a pocket of recession is formed. If a structural weakness is sensed, as the brush moves its path must change in order to reassert geometrical form and tie image to format. And as the painter's sensibility shifts from intellect to feeling or from intensity to delicacy, the brush follows, solidifying changing meanings in changing form.

Hofmann, his theory in sharp contrast to the ideas of Tobey, does not regard line as a primary means: "A work based only on a line concept is scarcely more than illustration; it fails to achieve pictorial structure. Pictorial structure is based on a plane concept. The line originates in the meeting of two planes . . . Only in a mathematical sense is a line, in itself, thinkable. In a creative sense, the line is to be considered as the carrier of a multiple meaning, since it results from the merging of planes . . . We can lose ourselves in a multitude of lines, if through them we lose our sense for the planes."[27] Beside revealing his disposition toward a particular means, Hofmann's theoretical rejection of line as a primary element is interesting in showing the difference between his conception and that defined by Hayter, whose predisposition is fundamentally linear. Yet both men discuss the potentialities of related lines: Hofmann, "multiple meaning"; Hayter, "expressive ambiguity."

It must be stressed that though he uses lines, Hofmann's practice remains true to the spirit of his theory; he is not dominated by linear or calligraphic form. Drawings and loosening-up studies in watercolor or gouache tend to be more linear than his oils, in which plane, movement, or sheer impact of pigmentation and color take precedence. Though paintings are often begun in line, they are usually conceived in plane: the lines indicate shape-limitations and plane-intersections, as in *Fruit Bowl* (Fig. 129). *Aggressive* (Fig. 114), more truly linear,

is keyed by a gyrating linear motion-image tracing one explosive gesture, though the original movement lines are overpowered by color, changed to planes by filling-in, or otherwise made subsidiary. *Submerged* (Fig. 122) is based on a rapid trace that scallops over the surface; but it subsequently serves to establish color areas.

The heavily loaded works of the later period are painted with brushes, knives, and even pigment squeezed directly from the tube. Where line schemes existed in the underpainting they have usually been covered with impasto. When painting *alla prima* with heavy pigment, a thin trace is virtually impossible: it bogs down. But laid over the rugged surface after drying, linear detail serves to enliven a key area, relieve a tedious passage, fill in a hole, or, as in *Interpenetration* (Fig. 142), heighten emotion by an acid zig-zag or a dynamic spiral. Such final linear embellishments are painted with a small brush or even, when the tone contrast between ground and pigment coat is marked, scratched into the wet surface with the handle of a brush or a sharp instrument. When the coat is smooth and dark, with light canvas underneath it (as in *Composition*, Fig. 149), a scratched line stands out with the taut delicacy of wood engraving.

To Hofmann, line is only one of a variety of means. Frequently it is excluded entirely, either for a scheme of geometric planes in which nothing thinner than a colored bar appears or for an encrusted field of molded pigment and color pattern. His primary means are color, plane, and brush. The unprepared spectator is shocked by the neo-Fauvist violence of his color and brushwork, which imparts an expressionist spirit to his most geometric compositions despite the fact that the plane, and not the brushstroke, is the irreducible element. Other works eschew even the plane for pure color and pigmentation. Change is the rule, and, unlike Tobey, Hofmann never constructs systematically

with a variation on a particular stroke-type. Painting is for him a process of working up a surface into a charged unity of active material that can run the gamut from the uncovered canvas to a reckless loading which forms a veritable cliff of pigment.

Nonetheless, impasto is only one road toward the bursting life at which Hofmann aims. He may, as he remarks, use "a hundred tubes" of paint for one picture, though "one tube" can serve for "a hundred pictures; lots of medium or none at all."[28] There are even a few, like the 1952 *Das Lied der Liebe* (Fig. 145), which employ quick washes and lines on an otherwise untouched white ground.

"Brush" is a limited term to characterize Hofmann's empathetic involvement with materials. He smudges his paint with gauze, squeezes it directly from the tube, draws in the heavy layers as one might in wet sand, and even scratches in it with his fingernails! Anything at hand can serve as a tool, and almost any liquid can be used as a painting medium. Even in the still-life and interior subjects of the thirties paint is assertive. The perimeter of the pink table in the 1936 still life of that name (Fig. 100) is established with one great oval brush gesture, and the legs of the stool offer an excuse for an early example of the slashingly straight strokes characteristic of the fifties.

Increasing intensity during the forties runs parallel to a virtual abandonment of still-life subject matter. Inner experience is immediately translated into color, pigment, and space, pictorial means themselves substituting for a material motif. By contrast with the ebullience of these works, many of those of the early fifties are starkly geometric. Planes are as rigid as heavy-gauge aluminum, and edges are ruler sharp. Nevertheless, these plane arrangements are never quite allowed to freeze in a glass case of void, for heavy passages of impasto pull rearward passages back to the surface of the canvas, and the space in which they stand is churned into tangibility by color and pigmentation.

The edges, moreover, retain a record of the motion of the artist's hand. Sometimes, it is true, a line is ruled by masking-tape; more typically, the gap between the geometric purist and the expressionist is bridged in a sort of passionate geometry which has led to Hofmann's astonishing ability to lay down freehand brush lines which, in their unswerving suddenness, are like pistol shots.

Motherwell's art, reflecting his personality, is built on a series of highly simplified contradictions. More than any of the American painter-theorists, he has emphasized the validity of automatism and the belief, as he phrases it, that the "unconscious makes sense."[29] Judging from certain of his early drawings, *Automatic Drawing No. 1* (Fig. 150), *The Room* (Fig. 158), and especially the blood-spattered *Three Figures Shot* (Fig. 157), Motherwell was at that time an automatist. Line, although drawn (not dripped) on the surface, spatters, runs, and flows. It merges with the background planes in some passages, and spreads from line to area. But if the line alone were separated from *Three Figures Shot*, its structure would be reminiscent of Picasso's constructivist drawings, suggesting structural rods or plane edges. It is easy to imagine the creator of these works evolving a style as fluid as Pollock's, but Motherwell's civilized restraint, intellectuality, and keen sense of tangible materiality—all perhaps more automatic to him than abandon—never let him give fluidity and fortuity full play.

Whether working in cut and torn paper or in paint, he thinks in terms of flat shapes and their juxtaposition—a surface-adjustment procedure natural to collage. A line is a clean-cut element. When, at some phase in the process of revision and re-alignment, a line is drawn on the objective picture surface, it has an identity as clear as that of a horsehair floating in a saucer of milk. Such a line, pinned between an egg shape and a protruding

point of area, already appears in the *Mallarmé's Swan* of 1944–1947 (Fig. 153). The few lines (distinct from the bars) in the *Spanish Prison (Window)* (Fig. 161) have the same autonomy, but add another function: they appear as joints and, like the cracks between the planks of a barn door, they insist on the actuality of the surface.

The panel's reality established in the process, Motherwell's lines are drawn on its surface as directly as are a child's chalk markings on the pavement; the shallow space which they form seems to exist as an actual part of the physical environment, like the space in Picasso's objects or the *Merz* constructions of Kurt Schwitters. The dark lines of *Personage* (Fig. 151) imply (if one may be permitted to three-dimensionalize their reference) a reinforcement of metal bars, whereas the thinner light lines at the left come forward in a relationship almost independent of the curves which they force to the rear.

Later, both in paintings and in collages, line remains objective, dividing surfaces like the mullions of a grill or forming circles, trapezoids, ovals, or more complex geometric shapes. Its role is as clearly defined as it is essential: scrupulously dividing, circumscribing, and spatializing. Despite the feeling and thought with which lines are placed, they retain a material directness of function as intrinsic as that of the twine with which the butcher secures a roast. As a result of increasing elimination and abstraction, many lines are ultimately excluded. Motherwell's first responsibility is to his working surface and the relational life of juxtaposed areas. Yet it is not a lack of respect for its qualities that makes line rare in the later works. A sparing use, on the contrary, implies a deepening realization of its nature and spotlights its inherent qualities. In certain canvases of the Spanish Elegies group (Figs. 178–180) an isolated black line, its thinness dramatized, is clamped between two chamfered ovals; it can be seen as a dividing joint, as in

the earlier *Spanish Prison;* abstractly, as the essence of a line; or emotionally—a black-dipped broom-straw imprisoned by two lumps of coal.

The Millburn synagogue mural (Fig. 186) also advances the possibilities of delineation. Here line is used symbolically. Exploiting a device used earlier in *The Red Skirt* (Fig. 170), that of straight lines crossing over a circumscribed field, Mother-well evolves a symbol for the Diaspora. Twelve dots, indivisible entities, symbolize the twelve tribes; and the lines, performing a function typical of Motherwell's linear motifs, divide the tribes from each other. In this fortunate instance an irre-ducibly simple cohesion between means and idea is achieved; an ancient meaning finds form in a mod-ern pictorial device.

Motherwell exploits both the personal and meta-physical expressiveness of the brush. But a puritani-cal strain forbids him the anguish of de Kooning; he is too civilized for Pollock's total act; and for him Tobey's spiritual brushwork is too lacking in flesh. A solely linear or calligraphic means would unravel, dissolve, fragment, or otherwise destroy the touchable reality of the picture-object. In this concern Motherwell is closer to the Cubist than he is to the Expressionist or Surrealist position. How-ever, no purist, he regards himself as a romantic and is emphatically committed to the associational aura of feeling which surrounds a work of art. Painting is identified with the most private aspects of life. Unrestrained, such a concern for feeling might be expected to release abandoned brush-work, and indeed, in occasional small paintings and in those works which he characterizes as "Capric-cios," he does allow himself this release.[30] Draw-ings, too, are often calligraphic. The motifs of the Millburn mural were later transformed by an ab-breviated brush and ink technique more Oriental than Tobey's "white writing."

Sensibility in the employment of media, though always present, is seldom given full rein; it is disci-plined by a concern for the picture-object. Whereas, in sharp disagreement with the purist viewpoint, Motherwell insists on sensual richness of brush-manship, impasto, and edging, he is sparing and disciplined in their use, imbuing them thereby with a concentrated intensity. The spattered paper used in the collage-paintings from 1943 to 1946 exploits the chance distribution of paint later monumental-ized by Pollock, but the quality is limited, as in *Pancho Villa, Dead and Alive* (Fig. 155) and *La Résistance* (Fig. 165), to the enhancement of con-tained geometric units.

It is difficult to isolate any "typical" use of the brush, manner of cutting or tearing papers, or treatment of surface in Motherwell's work. The character of any passage—whether an edge is sharp and straight, or jerky, torn, and ragged; whether paint is unctuously worked or spare and dry; whether separations are clear or fused, and so on—is determined specifically by its position in the developing series of oppositions and consonances which constitute the picture. The results, neverthe-less, are completely individual. An important prin-ciple which unifies his style is not tied to any one means, but concerns the degree to which each is al-lowed to assert itself. The ocher surface of *The Homely Protestant* (Fig. 175), for example, varies little in hue or value, yet it has a controlled acci-dentalism in its spatters, runs, and scratches which, like the weathering of an old wall, stresses actual-ity. It is just this thoroughly intentional emphasis upon worn surfaces that so often exasperates the layman.

When unmixed black and white, as in the Span-ish Elegies (Figs. 177–180), has been substituted for color, and when shapes have become few and elemental, the overtones of the slightest variation are heightened. The hesitant, wavering edge of a black bar can stand for unsureness, groping, or fear. Quite the opposite, the brush of the sketches for *La Danse II* (Fig. 194) has a bravado that is al-

most arrogant; and the soft, creamy impasto and
edging of the Pregnant Nude group (Fig. 193) trem-
bles with a moist, quivering sensuousness. It may
be argued that such associations between feeling
and "brush" are subjective and farfetched, and one
must agree that two spectators will seldom respond
identically to the same pictorial qualities. But is
it not a proper function of poetic, musical, and
painterly form to elicit diverse responses? The ex-
pressive ambiguity of poetry and music has been
taken for granted; but the eyes of the West, habit-
uated for so long to interpret painting largely in
terms of representational and narrative subject mat-
ter, find it difficult to perceive degrees of meaning-
ful variation which, as the pioneer Kandinsky real-
ized, are commonly accepted in music. An art of
pure sounds has existed, after all, since the Ren-
aissance—but painting which is "music without
words" is the creation of our own century.

Neither line nor calligraphic brush has a place in
the late canvases of Rothko. His disposition toward
flat shapes is already clear in the thirties. Autono-
mous linear brushstrokes are used only to accent,
as in a painting of a group of subway straphangers
in which the brush executes a sort of Jugendstil ar-
abesque based on a folded newspaper (Fig. 196).

By contrast with these early urban scenes, the
mythological subjects of the years from 1938 until
1943 are brushed with a freedom akin to that of
the automatist wing of the Surrealist movement.
Over grounds washed with muted colors, swirling
strokes form ritual images of figures, human faces,
or parts of birds, animals, and plants. By means of
a great variety of lateral rhythmic movements, the
semitransparent paint serves to delineate outline,
establish bulk-defining shadows, build contrasting
surface textures, and record gesture.

In 1944, with a shift away from representational
symbols, Rothko's brush becomes even more mark-
edly linear. One canvas (now destroyed), influenced
by Miró, generated form by a fast-moving, looping
trace. And between 1945 and 1947 charcoal as
well as brush lines operates independently against
flat shapes. But Rothko's line (unlike that of Gorky
during the same period) never defines three-dimen-
sional contour and bulk and never suggests strong
recession; because deep space is never sought, the
sense of lateral activity is intensified. The lines
of *Birth of Cephalopods* (Fig. 200) move in
tracks like those of an ice skater or sprout like
plant growths to the right or left. Also characteris-
tic is the multiplicity of stroke types in one compo-
sition: they take the forms of lines, spots, and tex-
tured shapes or of some indefinable protean
morphology; some stand independently, whereas
others tend to merge; some are strong, others are
halting, and some wiggle and squirm with the mo-
tion of microscopic organisms. In *Archaic Idol* (Fig.
202) lines, points, blots, spirals, and staccato spurts
combine to define ritual symbols which suggest
shields, arrows, and figures.

Important as are line and calligraphic brush to
Rothko's style before 1947, they are conspicuously
absent afterward. Beginning with these canvases,
the last to retain a vestige of the old calligraphy,
colored area is the sole means. It might seem to one
who has not seen Rothko's painting that this strin-
gent limitation would result in a formalism which
would assign to the brush only the mechanical job
of filling in prescribed tones. Such is not the case.
From 1948 until the present (Figs. 218–231) for-
mats increase in size; some are twenty feet wide. At
this scale small differences appear greater; areas are
larger, allowing room for considerable variety of
surface, despite a narrowly prescribed range. The
paint, although it seldom runs, is thin, glowing
with a peculiar translucence which only occasion-
ally appears transparent or solidly opaque. Color
tones often seem to be applied one over the other,
although in order to achieve that effect several
methods are employed. Sometimes a tone is

scumbled or lightly brushed over the ground color or an intermediate layer; in other instances independent mixtures simulate an effect of overlaid translucency.

At a quick glance, Rothko's areas are uniform in tone, but as sensory experience of them becomes more acute they show variations, as if the painter, intending to apply an even coat, had used a mixture that was a bit too thin or not well enough mixed. However, during the moments when this thought passes through the mind, a manner of internal modeling begins to emerge: the slightest changes in color and tone act to create a changing form and space. A soft creamy-gray expanse edged like gauze becomes a fluted curtain, or a muddy blue covering virtually the entire upper section of a canvas eight feet wide separates into deep recessions and intermediate planes. Another area goes through a triple change: first it is simply painted surface, next it becomes receding atmosphere, and then a representation of an impenetrable rectangular bulk. Again, a dark tone concentrates near the edge of a shape, bending its plane toward (or away from) the spectator.

But we are concentrating on the use of the brush: here its function is to establish plays between equivocally presented form meanings, some premeditated by the artist and others perhaps the product of the spectator's response. Besides the inner articulation of area, it is the role of the brush to adjust the junctures, so crucially important to Rothko's effects, at which areas meet. Quality of edging, determined in the main by brush manipulation, has tremendous influence on his ambiguous space-flatness. Overlap and shape separation are kept at the hairline at which they are controlled by changing fixations of the observer's eyes. Some edges fade into each other with no clear point of termination; brilliant, light, or warm overlaying dull, dark, or cool. In other cases the color tones of two adjacent areas are fused in a median band, and

again lightly brushed strokes at right angles to the edge finish each of the adjoining areas, reserving a valley (or in effect a superimposed "stripe") of ground color between them. Occasionally a patch has a "torn" edge. But never do outlines sharpen sufficiently to dissipate a shifting atmospheric imprecision, so that, like color and motion seen through a haze, the image never becomes frozen.

The terms "line" and "brush" have been used broadly in the foregoing discussion in order to indicate as fully as possible the range of means they connote. Common to all of these is their direct response to human touch and gesture. Keeping the bond between content and material in mind, it may be of value to consider the tendency toward abandonment of the close contact that painters have always maintained between the hand and the painting surface. Is the unprecedented method of Jackson Pollock—whose effectiveness, for himself at least, he has proved—the isolated solution of one painter? Or does it portend a general change in technique?

Until 1946 Pollock's paint surfaces were passionately molded with brush and knife in what Thomas Hess characterized as a "heavy, dark Expressionist idiom."[31] The irreducible unit of his style, despite rectilinear structure, was the individual stroke, though its identity was apt to be lost in the total textural maelstrom and the optical pulsation effected by variegated color. It can be said in fact that it was Pollock who purified the brushwork and impasto of the figurative Expressionists into a self-sufficient means. Much as Malevich and Mondrian pursued conclusions drawn from the Cubist movement to a categorical extreme, so Pollock's identification of passion with nonobjective brush tracks gradually disintegrated his planar structure, pushing values inherent in van Gogh and Soutine to an ultimate conclusion which was Abstract Expressionism in the most specific sense. But after 1947 and until

1952, when he began to return to a more traditional manner, tools seldom touched the painting surface. Limiting our nucleus to a denotation of that union of paint and feeling effected at the meeting point of the hand, the tool, and the surface, we can say that the flow or drip of enamel from brush, stick, or can is neither "expressionism" nor "brush."

Pollock is not the first American to create forms from a distance. Knud Merrild toyed with his flux method of poured paint as early as 1909, and "light painting" has a long history.[32] One could argue that the forms of Merrild and Pollock, like those of moving light, differ in both content and method from expressionism.

The philosophical problem must be set up in terms of the degree and nature of the control that the artist intentionally or unconsciously exerts over his medium. The idea of accident is deeply entrenched in modern tradition and, it is interesting to note, highly regarded in the legends of Chinese and Japanese painting. Yet control of the brush is all-important to Oriental artists. The character of each stroke, often the exact area which it is to cover, conforms to plan. Pollock's control is looser, but by no means nonexistent. He has demonstrated that direction can be given to even so fluid and willful a medium as poured enamel. Control here applies not to the exact track and shape of each brushstroke to be sure, but to the types of relationship inherent in his process. Individual passages (in common, oddly enough, with the mechanically painted squares of the purists) at no point evidence the direct touch of the painter. Rather, it is his entire bodily activity that from a distance influences, but by no means determines, his configuration. Accident, gravity, and the fluid response of the paint combine with human gesture to form a structure that is the result of their interaction.

By comparison with the highly humanized brush of the painters on which our discussion is focused,

Pollock's means, like the web of the spider, is naturalistic. Rhythmic irregularity of touch, systematically exorcised by de Stijl, is literally dissolved by Pollock. Merrild seems to recognize the issue involved, going so far as to consider the possibility that his chosen form is not art at all. Pollock's means, nevertheless, like Mondrian's, have arrived at forms that have significance for us. He has offered new and stimulating experiences to both the eye and the mind: an unprecedented structure dependent on a new type of line, striking color effects derived from an absence of transitional tones, and a host of related perceptual and emotional experiences. Aside from color, line predominates. Paralleling nature in operation, it finds an equivalent in dense thickets of tangled winter underbrush—thin branches bent into tense loops with wads of leafy matter trapped in the cages of their intersections. One can find a human reference, too, in the spatial movements: the whirling whites of *Number 1, 1949* (Fig. 292) are as alive as the curve of a cowboy's lariat.

Regarded on another level, the linear maze elicits the ancient associations which men have felt for the labyrinth. It is easy to see three-dimensional structure in Pollock's pictures; and as one's consciousness moves, in exploring his endless space of cellular division, time is involved as well. Finally, following the perceptual jolt by which one's impression of a visual field shifts, hollow space becomes flat surface. What was open structure is seen as a network of lines that weave above and below each other across the canvas, and the spectator is excluded. The picture, still vital, becomes a wall decoration.

Peter Blake's use of Pollock's canvases as partitions in a proposed open architectural scheme suggests a new approach to the ornament of modern buildings.[33] Many have noted the failure of contemporary architecture to develop a relevant ornament. But serious painters today seldom aim at decorative

art forms. Is an ornamental style necessarily super-ficial? Henri Focillon has written inspired para-graphs on the great ornamental art of the past. One such passage, describing Celtic illumination, might have been written in response to a Pollock canvas. Focillon speaks of

an undulating continuity where the relationship of parts ceases to be evident, where both beginning and end are carefully hidden . . . [It] eventually becomes "the system of the labyrinth," which, by means of mobile syntheses, stretches itself out in a realm of glittering movement and color. As the eye moves across the labyrinth in confusion, misled by a linear caprice that is perpetually sliding away to a secret objective of its own, a new dimension sud-denly emerges, which is a dimension neither of motion nor of depth, but which still gives us the illusion of being so . . . the ornament, which is constantly overlaying it-self and melting into itself, . . . appears to be shifting among different planes at different speeds.[34]

Pollock and Focillon are contemporaries. Can it be possible that the modern critic's remarks apply to the modern painter, whose work he never saw, even more aptly than to the manuscripts that ac-tually inspired his imagination?

Area, Shape, and Plane

An idiom of two-dimensional shape seems so ele-mentary! After centuries of linear and aerial per-spective, illusionistic color and light, chiaroscuro, bulk, and all of the other laboriously cultivated de-vices of representational art, it seems iconoclastic for painters to have limited their modus operandi so drastically. But, as we have seen, new horizons opened up as old means were abandoned.

The purist painters sought the most controllable simplicity. They achieved an austere security by limiting freedom with rules: the edge must be clean, the shape purely rectilinear, and the color primary and uniform in tone. These tenets abandoned, secu-rity begins to be undermined. What possibilities and dangers are opened by a progressive relaxation of rules?

It is possible to deal with area simply as linear division and subdivision of a surface. Chosen units can then be filled in, as in certain canvases of Mon-drian, with color. Or, as in Malevich's Suprematist compositions, autonomous toned squares can be grouped within a format. But as soon as one enclo-sure or independent shape detaches itself from its surroundings, the painting tends to divide into a positive figure and its ground. If the case is equivo-cal—if the gestalt is unstable and one cannot clearly separate image and ground—the effect gains the ambiguity so important to the modern aes-thetic. Optical movement results, and the "elemen-tary" means of shape begins to complicate.

As the number of squares grows, relations of color, position, and size bring about differences in apparent depth. Optically the ground is opened, and unless the tendency is deliberately counter-acted, separated elements recede or advance in rela-tion to each other and their format. Shapes laid down in a frank two-dimensional scheme become floating parallel planes, and the hard surface of the canvas begins to lose its tangibility. Material sur-face becomes picture plane: a shifting mean be-tween the apparent depth positions of the parallel elements.

If the restriction banning diagonals is lifted, par-allelograms and even trapezoids can be added to the shape vocabulary. Immediately—at least to our perspective-trained eyes—the diagonals are read as recessional; space deepens, and it becomes impossi-ble to insist on the receding planes as simple surface divisions. Taking another step, if our hypo-thetical painter augments his vocabulary again to include sharp-edged biomorphic, naturalistic, or ac-cidental shapes, and the control of mechanical tools is eschewed, the security of "pure" forms is lost. To abandon the rule of primary colors and uni-

formity of tone within an area, even for a regular pattern or texture, is to move again toward the indeterminate. By successive steps, as color and tone take on free modulation, as optical texture is allowed to vary freely, and as the surface is permitted to rise or depress in apparent or actual relief, possibilities are multiplied infinitely. Form becomes less and less determinable.

Even accepting all of these expansions of means —as Gorky's heavy canvases of the late thirties show—shape can remain clear. It is by softening and varying their silhouettes that shapes are fundamentally threatened. Widened and modulated junctures between areas, no matter how they are produced, tend to become gradations. Ultimately they merge in a coloristic amorphousness, or hump and hollow the surface into a homogeneous relief.

Hypothetically we have traced the metamorphosis of area as it expands from limitation toward freedom. However, open possibility is by no means precluded by restriction to purely geometrical units. The use of such units simply places unpredictability within bounds by reducing the number of variables. At the other remove, a state is approached in which all is flux and chaos, where there is no demarcation and no structure: the Heraclitean unknown which the painter James Brooks takes as his point of departure.[35]

It has been emphasized that any group of juxtaposed areas have a tendency to be seen as differing, not only in their actual lateral arrangement, but also in depth—a phenomenon which is one of the fundamental experiences of modern painting. If the principle is applied effectively, what is in actuality a divided flat surface becomes a series of planes which, being disposed in depth, create space. Difference in this apparent position establishes the overlapping distinction made between plane and area. As the existence of a group of painters dedicated, by avoiding overlaps, and so on, to going beyond Mondrian toward a complete neutralization

of visual space testifies, it is virtually impossible to make varied shapes remain utterly flat.[36] The would-be dispeller of vagueness, wishing to separate fact from fancy, has an almost impossible job. As the Ames and Princeton demonstrations have shown, vision is subjective and conditioned; the human eye is a poor reporter of material facts.[37]

It is nevertheless true that, by abandoning traditional perspective and chiaroscuro devices (which are capable of operating in abstraction as well as representation), modern painting has committed itself to an ambiguous, variable, and hence active area and plane relationship. Each picture must achieve its own flatness-depth, area-plane synthesis.

After a period of loosely improvised watercolors Motherwell was attracted by the medium of collage and was especially concerned with maintaining the tangibility of his surfaces. Excepting overtones, depth for him is as pointedly shallow as that of classical Cubism: an expansion of the real in-front-or-behind of papiers collés. These qualities point to mural flatness; a direction evident in *Wall Painting with Stripes* (Figs. 163, 164). During the painting process, elements were altered or replaced and certain of them were removed. In the final arrangement the medium-dark crescent at the left comes from behind one light band but overlaps the next. Between the bands a dark barbed bar retreats to the deepest point in the composition. At the right a dark oval is laterally clamped into position by the other two light bands which appear to bend under the strain, giving the oval a suggestion of bulk. Pervaded with an increasingly emotional significance, emphasis on tension between areas, especially between the oval and the rectangle, is climaxed in the Spanish Elegies.

Motherwell is too involved in sensibility to be a formalist, yet he insists on the identity of each shape unit. He articulates the geometrical uniqueness of each, playing trapezoids, diamonds, ovals,

circles, and rectangles against each other. The clarity that comes from shapes which are few in number and well defined is characteristic of Motherwell's work—except in the instances when he chooses to disguise or bury it, as in the 1949 *Collage in Yellow and White with Torn Elements* (Fig. 176) or the 1952 *Dover Beach* (Fig. 192), by superimposing irregularly shaped papers of analogous color tones. These works exist, unlike those with more striking shape patterns, in terms of their weathered panel surface. Individual areas, with randomly torn edges, reveal themselves only gradually.

From 1949 to 1952 both simplicity and clarity are intensified. The Wall Paintings (Figs. 182–185), similar, in some respects, to the late collage-paintings of Matisse, juxtapose a limited vocabulary of shapes: bars, rectangles, roughly delineated ovals, and a recurrent pattern which, in various versions, approaches the form of a philodendron leaf, a shamrock, or a fleur-de-lis. These designs are abstract: the artist seeks "simply the character of a wall painted with style."[38] What raises them to expression is the evident sensibility and emotional identification with pictorial means and relationships. The ocher, black, mottled purple, and white shapes—color schemes are similar—are not smoothed or made neat, but retain marks of struggle. Verticals and horizontals bend and waver, and edges are often choppy, as if they had been hacked out with a hatchet.

The Spanish Elegies (Figs. 177–180) renounce color, and even grisaille tonality, for pure black and white. In their extreme simplification the tension of obsessively studied variations in edging, from sharp and clean to scrawny and wobbly or to wet-in-wet softness, is great. The empathetic involvement with shape is intensified by ambiguously bending, either actually or apparently, the straight edges of black bars, by inserting concave sections into convex outlines or by flattening the sides of ovals until they suggest trapezoids. Qualities of the Elegies and Wall Paintings are masterfully fused in *Wall Painting IV* (Fig. 195).

In a joint letter to the *New York Times*, written in 1943, Mark Rothko and Adolph Gottlieb listed among their aesthetic convictions the "simple expression of the complex thought." "We are for the large shape," they continued, "because it has the impact of the unequivocal. We wish to reassert the picture plane. We are for flat forms because they destroy illusion and reveal truth."[39]

Like Motherwell, Rothko has a predisposition for area, but because the two artists' ideas and personalities differ greatly, their approaches to area and shape reveal little similarity. In Rothko's representational canvases of the thirties the human figure is either lengthened and attenuated almost to nonexistence or its bulk is compressed toward flatness. In the early forties his ritual symbols are always treated in their broadest, more readable aspect, thus reducing bulk to silhouette—a convention reminiscent of Egyptian, Babylonian, or early Greek art.

Further flattened after 1944, his shapes function more directly as areas before a vertical ground. It was during this period that Rothko wrote of shapes:

They are unique elements in a unique situation.
They are organisms with volition and a passion for self-assertion.
They move with internal freedom, and without need to conform with or to violate what is probable in the familiar world.
They have no direct association with any particular visible experience, but in them one recognizes the principle and passion of organisms.

In the same essay he explains that he thinks of his pictures as dramas in which shapes are the performers, who "have been created from the need for a group of actors who are able to move dramati-

cally without embarrassment and execute gestures without shame."[40]

As Rothko's art develops it moves continually in the direction of a more pictorial language, endeavoring to make painterly means rather than symbolic representation the bearer of content. Yet the shapes of this period (Figs. 200–215) are not without associational reference. They lie just at the periphery of recognition, imitating plant, animal, or human form; shields, arrows, and other objects associated with primitive rites; or fantastic costumes of fur and feathers. None of them can be specifically named, and all are subject to varied interpretations. During these years area is augmented, and in the *Birth of Cephalopods* (Fig. 200) virtually supplanted, by skeins of looping line in brush and charcoal. But always, behind the dramatic encounter of lines and shapes, stands the impenetrable flatness of the panel.

To regard the successive phases of Rothko's development as a sequence of retreats from representation toward a nonobjective art of purely formal relations would not only be negative but false. He has sought to make area, tone, and color the direct vessels of content. The shapes of the forties play primary rather than supporting roles, creating an environment of contrasting qualities. Soft polyp forms seem about to be wounded by staccato accents; organic growth collides with artifact; line contrasts with area. The encounters are disciplined by carefully placed verticals and by the recurrent horizontals of the backgrounds. Through the geometry of architectural lines undulating shapes, often more visceral than those of Miró, are kept in a sufficient suspension.

Rothko's employment of area can be best understood by concentrating on the large works painted after 1948 (Figs. 218–231). They break sharply with the earlier oils and watercolors. Gone is the distinction between solid background plane and active foreground forms; stage and players fuse. Cot-ton-edged, like flat clouds, color areas intercept each other, forming a world which in the 1948 canvases appears at first glance random, but which gradually discloses a controlled structural geometry —like viewing architecture through layers of moving fog.

Areas in the works after midcentury are more geometrically shaped, larger, and fewer in number. Variety is lessened and conformity to the horizontal and vertical is greater; but geometricity is a hint rather than a statement. The format is not divided, as are the panels of Mondrian, but is occupied. Each colored sheet is an autonomous thing. After several hours spent among a group of Rothko's huge canvases, it is with difficulty that one remembers that, reduced to pictorial elements, their impact arises solely from the edging, juxtaposition, and surfacing of colored areas upon a flat surface. One recalls his earlier aim: "the simple expression of the complex thought"—no longer in the slightest degree literary or archaistic, but embodied in a purely pictorial language.

Gorky's art is many-faceted; consequently, it can be regarded rewardingly from many points of view. The art criticism of the late forties associated him with Miró and the early landscapes of Kandinsky as an apostle of fluid automatism. Yet close as Gorky's art was to the progressive wing of the Surrealist movement, his style was in great part draftsmanlike. A dialectic between the linear and painterly was essential to his development. Nor is this the only paradox to be found in Gorky: he appropriated the visceral shape vocabulary characteristic of Arp and Miró and synthesized it with the feeling for surface, plane, and structure which earlier had led him to Cubism, Cézanne, and Uccello.

The foremost influence in Gorky's early abstract style was Picasso's Cubism of 1915–1928 (Figs. 47, 49, 50). Except for the richness of the pigment surfaces, these compositions are derivative, con-

structed in flat planes which parallel each other or tip slightly into depth.

In the 1932 drawings (Figs. 51–54) Gorky breaks away from the traditional still-life theme and abandons Cubist vocabulary; the last of these already uses the shapes so characteristic of his later painting. Through the use of several images in one format it resembles an exhibition of modern sculpture viewed from above: three reclining "figures" combine flesh, organ, and bone shapes; the environment, by contrast, is austere and geometrical. Nor is the effect solely one of shape; bulk and recession are created by the modeling of the warped organic patterns and the trapezoidal background planes. Throughout the thirties and until 1941 Gorky's painting develops through a rapport between his brush and a host of shape ideas which grow increasingly personal. The multiple-unit composition is abandoned, but the distinction between a central complex of humanoid forms and an architectural setting is retained, with qualifications, throughout the later work. The two versions of *Image in Xhorkom* (Figs. 59, 60), for example, can be seen as human figures in a room, birds in an aviary, animals in an arena, and so on. The churning effect of the swelling and interlocking shapes proceeds directly from the employment of freebrush movement, but the shape units, despite immensely thick layers of pigment, are clear. They could be cut apart like the pieces of a jigsaw puzzle.

Standing at the radical turning point in Gorky's career, *Garden in Sochi* (Fig. 64) climaxes not only the period of heavy repainting and broad brushwork but that of preoccupation with surface relations. The change, which by the 1943 *Waterfall* (Fig. 67) has been accomplished, inaugurates a new "spotting" of thinly painted color passages over the surface of the canvas. It does not, needless to say, abandon area, but encompasses in addition many more considerations. Shape is so elusively allied

with bulk suggestion, multiple image, planar recession, linear movement, color and textural modulation, and variety of edging that it appears almost like the work of another painter. The expressionist ruggedness of *Garden in Sochi* is supplanted by a French elegance.

Beginning with *Anatomical Blackboard* (Fig. 68), *The Liver is the Cock's Comb* (Fig. 69), and the other studies that derive in part from landscape, the shapes as well as the linear schemes are established in pencil line and wax crayons. In certain instances crayon sets the shape independently—conspicuously so in the tall ovoid columns of color which Ethel Schwabacher has aptly termed "plumes." Toward the edges of the shapes, color is applied less and less densely, or hues successively lighter in value are substituted for the central tone, so that no clear line of demarcation is left to delimit the area. Thus, because of its modeled edge, the tone may appear as a tubular shaft of colored matter tapering at its ends, or, conversely, as an opening curving inward from the canvas surface. Structurally the plumes operate as architectural verticals, controlling the action of other forms.

In other passages of these drawings, line and tone combine to define an area or plane. Such is the case with the socklike shape at the left of *Anatomical Blackboard*. Removal of the tone would dissolve the unity of the linear shape—one could then read the lines in an entirely different configuration—but the edge of the area is stated by line and not by the indefinite tonal edge. More often than not (the study for *The Liver* is a perfect illustration) such distinctions between area, plane, and bulk cannot be drawn, for the bulks that derive from a combination of contour drawing and tone also often function in the flat; voids between bulks operate as parallels to the picture plane, or areas waver between flatness and bulk.

The double imagery of the Surrealist movement stimulated the morphological sense which was one

of Gorky's strangest gifts. It paid not the slightest heed to established categories. Generic differences were ignored for form metaphors, so that a given shape could simultaneously partake of the qualities of some part of a flower, a fruit, or an insect, describe a complex of foliage or an atmospheric effect, and suggest a detail of the inner or outer anatomy of the human body. Shapes were selected with an uncanny ability to discover those with the greatest possible multiplicity of reference, to suggest an inner core of universal morphology uniting, as André Breton noted, the theoretically separated species and types of scientific classification.

Art as well as nature provided Gorky with a mine of shapes. A chance passage in the work of a student or a fellow artist would provide the key to entirely new form-ideas. Elaine de Kooning demonstrates such a connection between the *Diary of a Seducer* (1945; Fig. 75) and Jacques Louis David's *Mars Disarmed by Venus* (Fig. 283). An empty space—the negative area between Mars's right arm and his torso—is changed from unoccupied volume to positive form in Gorky's picture, and from dark to light. Mars's helmet becomes a shadow, and the sole of Venus' foot, "an obscure little glow on a pale grey surface."[41] This painting in grisaille, moreover, is evidence of how closely Gorky's pictorial design is allied to his sense of area, shape, and surface spotting. It is as if the surface were a glass against which forms of the natural and organic world, still soft and living, were pressed, presenting a two-dimensional equivalent of their rounded existence in space.

In many works between 1945 and 1948 recessional planes play a greater part than they do in *The Liver* or the *Diary,* occasionally, as in *Untitled* (Fig. 77), forming the nuclei of isometric, or even diminishing, linear perspectives. Many of the later canvases use receding architectural planes in combination with biomorphic and landscape form, playing a counterpoint between canvas surface, suggestions of bulk, and empty volume and establishing platforms upon which arrangements of hybrids are grouped between vertical screens.

Resembling nothing else in the previous history of American art, Gorky's final paintings are far from those of the thirties, but he never abandoned any of his discoveries. As he grew, the past phases somehow remained at the edge of his consciousness and reappeared in new forms.

During the time when de Kooning was still virtually unknown, in numbers of canvases and small panels now destroyed or widely dispersed among old friends he was continually probing new possibilities of shape. The tiny untitled abstraction of 1938 (Fig. 2) is identified by its owner as "The Hairbrushes" because of two shapes, midway between the biomorphic and the geometrical, which dominate the softly modulated background. Carefully delineated and edged with the taut touch of the professional brushman, their reciprocal tension forces the panel to open inward. This sketch also demonstrates the negative cutting of shapes—a device drawn from the sign-painters' trade and the improvisation of Gorky. Yet the two artists used it very differently: de Kooning's work of the thirties, though more delicate and tentative than his friend's, is nevertheless freer in its metamorphosis. Gorky changed colors and endlessly built up impasto; but, once established, his basic shapes were not so likely to change. De Kooning's, like oil on water, remain in flux as long as a work is in progress.

By means of flat shape alone, an amazingly three-dimensional quality is achieved in a study of 1938 (Fig. 5). A grayed-vermilion bubble seems to rise against a background that modulates between light tones of robin's-egg blue, green, and violet. Flat, the orb nevertheless seems inflated in a buoyant bulk. Harmonizing with other rounded forms— two at the left and one at the right—it opposes the

rectangles below it. The diagonal stripe at the center does not recede, but close to the canvas surface it weaves from behind the background to lap the central rectangle and stops short when its sharp end meets the red globe. Nonobjective though this composition may be, an intent identification with means gives it an emotional overtone. There is not a relationship, a color, or an edge which is slack, coldly formalistic, or patternistic.

At the other extreme is the single human figure. Before 1943 (Figs. 3, 4, 6, 7) the unseeing eyes stare directly forward with a Byzantine fixity; solidity and chiaroscuro are progressively flattened, so that bulk tends more and more to become shape. A dualism of figurative and abstract painting, de Kooning's career during the thirties brings up a recurrent and crucial problem of modern art: How can the physical and emotional realities of human existence be reconciled with abstract means? For de Kooning, the solution always involves shape. Leafing through a tabloid, he will call attention to a mystifying passage of drapery in a news photograph. When parts are isolated, he points out, one cannot imagine what they represent.

By a somewhat similar process of isolation, de Kooning reworks the forms of his model—which at that time could be a dummy draped with old clothes. Tracing an ear, a fold in a sleeve, or a finger (compare Fig. 4), the brush detaches it from the subject. Once separated, the detail becomes independent, and as shape, brushstroke, and plane it is placed into the new context of the painting. Two figure paintings, one male (Fig. 7) and one female (Fig. 8), in their "unfinish" approach a median point between subject matter and means. The back wall of the male portrait advances to meet the body, so that the head is a part of it, and the ear seems incised in low relief. In both compositions the drapery and hair become pure shape, and the muscles of the boy's arm are flattened into planes. The girl's head breaks, dislocating the planes of her

cheeks. Even more abstracted, the passage at the upper left, beside the boy's head, is a vital, but completely nonrepresentational, interlude, though parts of the exotic shapes, as careful study will reveal, are in fact isolated sections of realistic drapery from the undercoat.

Between 1940 and 1945 pure and representational shapes are combined and synthesized. The design of *The Wave* (Fig. 9) evolves by means of a scalloping brush line that outlines shapes resembling fingers. The window that fills the upper right-hand corner of an earlier study (Fig. 3) reappears here, but as a pure rectangle; and at the upper center the brush, incompletely covering an underpainting, reserves textured areas shaped like ovals or water drops. *Summer Couch* (Fig. 11) might represent a nude on a settee: the reclining "figure" combines several characteristic torso contours into a new form, opposing it to a "chair-back" and to purely geometrical shapes.

Two other works—the abstract sketch for a theatrical drop (Fig. 15) and the early *Pink Lady* (Fig. 14)—are strikingly similar in their treatment of shape. The female figure sits with raised knees, but the anatomical forms, though generally identifiable, become areas: the breasts, oval shapes, and the knees, the flat hill-forms of *The Wave*. At the top of the canvas the window-rectangle appears again. In the same sense that the woman is abstract, the landscape can be seen as representing four figures, one in each corner of the composition. Each unit combines characteristic profiles of torso, breast, arm, shoulder, finger, and buttock forms. Compellingly human, they stand before a field successively opened and interrupted by overlapping horizontal and vertical planes.

But by the time de Kooning's art is publicly known, in 1948, he is really an expressionist: area exists as a spot or smear of pigment, and plane is identical with brushstroke; shape is defined gesture. Later the use of wide plane-strokes gives rise to an-

other new means: by temporarily covering a por-tion of the canvas surface with a clean-edged sheet of paper and bridging a wide brushstroke from mask to canvas, or by cutting over dried strokes, a brush-plane is established with one edge as neatly severed as if the canvas had been cut with a razor (the head, for example, in Fig. 42). Through this means the plane is lifted from its context by the same pictorial surgery that separated muscle shapes from the early figures, leaving an "impossible" ter-mination of the stroke. A wildly expressionistic stroke is given a mechanical ending. Thus, in the search for new shape complexes, meaning and tech-nic interact, deriving form from the means, from gesture, from natural appearances, or from geomet-rical figures. Three 1947 canvases (Figs. 17, 18, 19) even use letters and whole words as a springboard.

Except for its circular central area, one of these works, *Noon* (which incorporates the word ART), is indivisible into separate areas or planes. Flatness, shape, space, and bulk suggestion combine into a synthesized form. Paradoxically, the importance of shape is not lost as the means become more and more closely amalgamated. The use of trick edging cuts the picture surface itself into areas, so that it appears to be assembled like a contradictory jigsaw puzzle. On occasion in fact, as in the 1950 *Collage,* unsuccessful paintings on paper are actually cut in pieces along the lines of their dominant shapes, and chosen sections are then reassembled, lapping over and under each other, into new compositions.

Whether actual cutting takes place or not, the technique of collage for de Kooning is more than a technical expedient. As Thomas Hess's discussion of the development of one of the 1952 Women points out, revision by the temporary insertion of charcoal-on-paper details is a regular procedure.[42] For the preparatory studies, grinning mouths are cut from toothpaste or Coca-Cola advertisements to insert in the compositions. By successively dis-

secting and rearranging passages, either in fact or in effect, initial relationships are intentionally dislo-cated. Not only do the wide strokes (as in *Excava-tion,* Fig. 30) themselves form planes, but, by tricks of collage, masking, and the resultant alterations of scale, continuities are broken, heightening the sense of plane, overlap, recession, and ambiguity. Figura-tively, too, de Kooning's art can be regarded as a sort of collage—a montage of ideas and experi-ences. Geometric shapes are cut, as it were, from a sense of order and the abstract-structural tradition. In addition to personal emotion, sharp eye and mouth shapes reflect details from Picasso's late pe-riod, and soft-outlined forms sensuously refer to the human body. These shapes and others, a multi-plicity of reminders of life and art, are juxtaposed on the assembly table of the canvas to reveal their most evocative profiles in tension with each other.

The plane to Hofmann, who rejects a linear ap-proach, is the key formal means. He sees Cubism as a "revolution in that the artist broke with tradi-tion by changing from a line to a plane concept." A plane is a basic unit: "a fragment in the architec-ture of space. When a number of planes are op-posed one to another, a spatial effect results."[43]

Hofmann's concept of plane structure, the out-come of a strongly three-dimensional idea of space, is rooted in an analytical study of Cézanne and Cubism. His teaching theory and that group of paintings which most closely reflect it proceed from a union between a direct experience of nature and a conceptual plane-space interpretation. The resul-tant means, to make only one comparison, is quite different from that of Motherwell, whose space de-rives from the apparent detachment of his areas from the actual surface of the panel. By contrast, Hofmann's planes are representational: images of a prior three-dimensional visualization of straight-surfaced and ruled-edged planes. A detail for a pro-

posed mural (Fig. 139A) dominated by the intersection of a triangle and a slotted rectangle could represent sheets of plywood or metal with textured surfaces. Even such a soft and clouded work as *Retained Mood* (Fig. 126) is based on a geometrical plane relationship. Vitality is maintained, and the picture plane reasserted, by keeping depths incommensurable, by relating plane shapes to the frame, and by a number of painterly devices of color, texture, and relationship.

The plane theory of Hofmann is also the distillation of years of painting from nature, so that in the main works dating before 1945 tend to show less formulation. In the still-life compositions of the thirties, freely painted color strokes are laid into a shallow depth where verticals, horizontals, and parallels are powerfully emphasized. The diagonally receding plane, so common after 1949, is seldom used in these canvases; and even in the rich Provincetown landscapes recession is played down for a combination of realistic calligraphy superimposed upon abstract arrangements of color areas. Seen with the early work in mind, the hard trapezoids and triangles of the later style seem to draw as much from thought as from direct sensory response to nature and to enforce a more rationalized and representational space.

One reason for the geometricity of 1950 and 1951 perhaps is the extreme automatism and improvisation of the forties. Deriving more from paint, brush, and gesture than from nature, space seems to be a secondary consideration. To a greater degree than either the later or the earlier works, those of the forties (when Pollock was asserting his aggressive new style) generate flat area by dynamic line or, as in *Palimpsest* (Fig. 123) and *The King* (Fig. 112), they accept the premise of an accidentally spattered panel.

As a philosopher of art, Hofmann believes that painting should be governed by fundamental laws.[44]

It is these derived laws that his teaching has tried to verbalize. While painting, however, he endeavors to forget, even to violate, his own theory, so that few of his canvases stand (one is tempted to add fortunately) in a deductive relationship to his plane concept. Nevertheless, the theoretical core retains a sort of alter-ego connection with the improvised exuberance of brush, color, and impasto, strongly conditioning the canvases of the early fifties.

As a physical fact, an area is a two-dimensional unit and cannot leave the panel. Such a condition is only approached in modern painting, but Hofmann's planes, quite unlike those of Rothko and Motherwell, often plunge depthward. That in the center of *Visione Nobilissima* (Fig. 143) allows of only one spatial reading: it is a hard, rectangular sheet in linear perspective. Only by texture, color, and impasto is the picture plane asserted. Other works are shallower and more rectangulated. In the still lifes, *Fruit Bowl* (Fig. 129) and *Magenta and Blue* (Fig. 134), the perspective effect of the geometric shapes is closely controlled by the horizontals and verticals, so fewer painterly means are required to stress the surface.

How unfair and one-sided it is to discuss Hofmann's plane structure without proper consideration of his singing color! All of his planes are conceived as color planes, so often in just those instances when color best fills its function the camera is most false. Even the inadequate color notes that accompany some of the plates demonstrate the failure of black-and-white photography. In *The Circus* (Fig. 121), for example, the area pattern of blue, red, and yellow, all but nonexistent in the photograph, gives the picture its structure.

Tobey writes his pictures. Unlike Motherwell or Rothko, he is not primarily concerned with the precise adjustment, shaping, and edging of areas; nor

does he project partitions into space in the manner of Hofmann, or freely improvise shapes, like de Kooning. Nevertheless, neither area, assertion of the picture plane, nor the creation of depth by planes is eliminated.

Familiarity with Tobey's work leads to a deepening consciousness of its endless depth. To an observer unfamiliar with it the numberless strokes usually appear as chance markings on a flat surface, like overlaid scribbles of chalk on a flat pavement. It is evident, especially in the *New York Tablet* (Fig. 261) and the other urban paintings of 1944–1947, that Tobey thinks of both depth and surface plane. The tracery is "written" on not one but three surfaces, which are nonetheless a single unit, refractions of the same image. In the rear, a few inches from the foremost plane, stands what appears to be a tablet of stone surrounded by darkness. The frontal plane is not parallel to the tablet but tips into a shallow depth. Of this surface a significant phenomenon must be emphasized: it is not warped, and although its diagonal recession is evident one cannot determine whether the right or the left edge is that which recedes, for the relationships are exactly calculated to effect just this ambiguity. The third plane lies between the forward plane and the tablet in the rear, more transparent and less clearly defined.

The multiplicity of lines which make up Tobey's paintings, like the details in the panels of Jan van Eyck, demand microscopic study. As one is impelled to gaze deeper into the forward surface of the tablet, its tactile hardness opens, allowing entrance into quite another world, structured by a set of continually shifting facets of implied surface among which the eye can wander. The plane is thus a natural outcome of linear means. Viewing the uniform strokes of the brush metaphorically as architectural steelwork, one sees transparent walls and floors, which follow as inevitably as those of the builder succeed his steel skeleton.

How can individual planes in a panel like *New York* (Fig. 256) be isolated? It is as if one were looking through a million glass panes, fading from sight within a city-space divided by them into an infinitude of tiny compartments. And for each observer, during each moment he spends with the painting, relationships will change, units will regroup, directions of projection will vary, and behind and before will reverse themselves.

In his use of planes Tobey, like most modern painters, acknowledges a debt to Cubism. The space of *Broadway* (Fig. 239) is pre-Cubist, within a traditional perspective framework. *Rummage* (Fig. 243) multiplies minuscule representations of realistic objects and three-dimensional figures by enclosing them within walled compartments, and *Threading Light* (Fig. 244) moves toward the later open form, overlaying a planar underpainting with a network of lines. It is not necessary to examine Tobey's statements for an acknowledgment of Cubist influence: it is apparent in *Still Life with White Plane* (Fig. 241), and directly stated in *Cubist Vertical* (Fig. 247). The latter, a frankly nonobjective construction, emphasizes the visualization of plane structure which, lying in the artist's mind, stands behind his clouds of individual strokes, forming them into the shadowy partitions which compart the picture space.

Separable areas, however, are rare; Tobey either keeps the panel intact to write upon it or dissolves it into movement-filled volume. It is only when bulk is flattened into pattern, as in the figures of *E Pluribus Unum* (Fig. 250) or the totem poles of *Drums, Indians and the Word of God* (Fig. 253), that laterally related shapes are fundamental. Typically the diagonal and curving movements of the brushstrokes create what Hofmann calls "push and pull"; but being small units, they form fragmented areas.

Shape is more characteristic of Tobey's means, but it is relative and implied rather than directly

stated. Distinctive movements have their unique shape qualities—of grasses, light, or molecular fragments—and each canvas has its peculiar shape-unit—some particular rectangle, triangle, or free-brush path. Yet, as in natural cellular structures, the identity of individual shapes, however clearly they may be articulated, begins to be drowned in infinitely detailed multiplicity.

3 Pictorial Relationships

In studying a work of art the problem of relationships is all-important. Ideally one pictorial unit, such as a single line or area, has no internal relations. The quality of art inheres not in a mosaic of parts but in the whole which results from their reciprocal effect on each other. Such an aesthetic is completely valid for pure geometrical paintings: colored squares are absolutely separable units, and the final work derives wholly—with allowance for slight, but often crucial, variations in the handling of pigment—from their juxtaposition within the format. Abstract Expressionist means, however, cannot be so neatly laid out; as a result, any methodical separation of a work into its elements runs the danger of becoming arbitrary.

In contrast with artists of other periods, the modern artist gives more thought to relationships within the picture than he does to the nature of its component parts. This is the position advanced by Hofmann: "Metaphysically," he writes, "a thing in itself never expresses anything. It is the *relation between things* that gives meaning to them." A "thing" in Hofmann's terminology indicates either an object of the physical world or a thought. A formal element is a plastic thought.

Let us explain our philosophical perceptions with the help of a practical example: take a sheet of paper and make a line on it. Who can say whether this line is long or short? Who can say what its direction is? But when, on this same sheet of paper, you make a shorter line, you can see immediately that the first line is the longer one . . .

Was it necessary to enlarge the first line to make it the longer one? We did not have to touch that line or make any change. We gave it meaning through its relation to the new line; and in so doing, we gave simultaneous meaning also to this new line, meaning which it could not have had otherwise.[1]

Hofmann expands his illustration, discussing the directional movement resulting from the position of the lines in relation to each other, and the relationship which they mutually establish with the initial four lines which bound the sheet of paper.

During the Studio 35 Discussions in 1950, Hofmann reaffirms his position: "I believe that in an art every expression is relative . . . Anything can be changed . . . One shape in relation to other shapes makes the 'expression'; not one shape or another." Motherwell, moderating the discussion, calls attention to this point: "Would you say that a fair statement of your position is that the 'meaning' of a work of art consists of the relations among the elements, and *not the elements themselves?*" Hofmann: "Yes, that I would definitely say . . . *It is all relationship.*"[2] Elsewhere, Motherwell asserts that painting has become a "lyricism" in which the "internal relations" of the painting itself are the primary elements.[3] One would expect him, as a collagist, to be especially cognizant of relativity within a work of art: Is not collage the relational medium par excellence?

Hofmann's fundamental thesis once established, the nature of plastic relationships can be further defined: one unit of pictorial means is an inert thought, or a physical fact. Two such facts in relation, however, constitute a completely new phenomenon: "a third fact of a higher order." In this distinction Hofmann's theory pinpoints a crucial philosophical principle of modern art. The new relational fact differs not only in degree, but in kind, from its constituent elements. Not a thought but an idea of a higher order because it is nonphysical, it is a living unit because its existence cannot be separated from the sensory response, the personality, and the experience of the artist or the spectator. The idea always "overshadows the material qualities . . . of the basic factors from which it has sprung."

Proceeding from a physical starting point, Hofmann postulates an anagogical movement from the material to the immaterial. This transcendent quality, so difficult to isolate, leads him to conclude

that "in a sense it is magic"—a "spiritual quality" which "dominates the material." This relational value constitutes the essential meaning of a work of art. As it grows, groups of ideas or meanings are again related, giving rise to multimeanings, and from them, ultimately, the total unity develops, its quality synonymous with that of its interrelationships. During the process the work becomes increasingly "surreal": "The physical carrier is overshadowed by a relation. The relation creates an overtone. The physical carrier is absorbed by this overtone. The overtone spontaneously transforms the means of creation into a spiritual reality. The mystery of creation is then revealed."[4]

Tobey reminisces how, as a child in a Saturday morning painting class, he got his "first lesson in relativity": "We had a still-life set-up to paint. Suddenly I saw that the pitcher was *so* big [his hands outline the shape of a pitcher, then close in] and the glass was *so* big. From that time on everything was all right."[5] So began an integral aspect of Tobey's world view. Besides light, his "white lines in movement symbolize a unifying idea which flows through the compartmented units of life bringing the consciousness of a larger relativity."[6]

It is typical of Tobey to expand the problems of his medium to those of outside life. For Hofmann, too, this connection exists. When asked by the painter Ad Reinhardt (who, in innumerable arguments has espoused the purist view that a work of art has nothing whatever to do with the world outside it) whether he considered "the inter-relationship of the elements in a work of art to be self-contained," he answers quickly: "It is related to all of this world." Earlier, in support of Hofmann, the sculptor Herbert Ferber agrees: "The means are important, but what we were concerned with is an expression of a relationship to the world. Truth and validity cannot be determined by the shape of the elements of the picture." The issue involved here is a significant one. The pure formalist separates art

from life, asserting that the external world is not, cannot be, and should not be the concern of the painter. The contrary view of the Abstract Expressionist, the abstract naturalist, or the abstract transcendentalist insists not only on the desirability but on the inevitability of a broader involvement. "It would be very difficult," Motherwell argues, "to formulate a position in which there were no external relations. I cannot imagine any structure being defined as though it only has internal meaning."[7]

Space and the Picture Plane

Through one pictorial device or another the greatest percentage of the world's painting has dealt with the representation of space. Spatial concepts are therefore revealing keys to the world views of various localities and epochs. Both stylistic and philosophical art history have been concerned with their metamorphosis, and attempts have been made to discover parallels between the space of the artist, the scientist, and the philosopher.

In our century popular space-consciousness has sprung primarily from new modes of transportation and scientific conceptions of the universe. Advanced as an explanation of the space of art, scientific parallels unfortunately have often led to a determinist interpretation whereby painting and sculpture were deducible, as a sort of by-product, from physics and the theory of relativity. Surely, as in other periods of history, artists have been keenly influenced by their impression, right or wrong, of the reigning conception of the physical microcosm and macrocosm; but this does not excuse a redundant and superficial deification of physics as the sole determinant of painters' space and movement concepts. Nevertheless, in justice to the science-art parallel—which within bounds is perfectly valid—it should be noted that influential artists, among them Hayter and Matta, have been stimulated by astrophysics.

Physical science is only one, and perhaps not the most important, source for the artist's "space of the imagination." A false science-fiction aura has been woven around modern art which the painter often finds acutely annoying. The space with which he deals, unlike that of the physicist or mathematician, is directly experienced—either from nature or by an imaginative projection of the visual, tactile, and kinetic senses. "That space of science," de Kooning writes, "the space of the physicists—I am truly bored with by now. Their lenses are so thick that seen through them, the space gets more and more melancholy. There seems to be no end to the misery of the scientists' space. All that it contains is billions and billions of hunks of matter, hot or cold, floating around in darkness according to a great design of aimlessness."[8]

Besides becoming a cliché, overemphasis on physics has obscured the significant parallel between artists' space and that suggested by psychology and psychoanalysis on the one hand—"the space within which the creative mind functions. The water where the artist swims, the chills and fevers which stimulate the imagination"[9]—and, on the other, the more specific coincidence between modern pictorial means and the experimental conclusions of gestalt psychologists. As the universe has expanded outward, psychoanalytical psychology has expanded inward, and the study of vision has focused on the point at which, for the painter, the inner and outer worlds meet.

Material for the spatial imagination can come from anywhere—from nature, from physical science, from psychology, from ancient myth, or from any other source that will stimulate and reflect the painter's imagination. Whatever its source, the space which ultimately appears on canvas is conditioned, perhaps first of all, by the medium of painting and by its internal tradition. Since Cézanne it has been a tradition which insisted that space be reconciled with the physical reality of the painted surface. Once the canvas has been visually broken by depth-inducing means, its existence must be reasserted on a new material basis. Of all the structural criteria which provide a bond between the individualism of modern painters, the creation of this "translucent" relational surface, the picture plane, is the most important. So fundamental is it, so taken for granted, that it usually remains on the periphery of discussion. Bradley Walker Tomlin, discussing common pictorial criteria, begins by "assuming that painters in this group hold similar views in relation to the picture plane."[10] De Kooning covers the unused edges of his unstretched canvas with aluminum paint while working, so that they do not "make a plane."[11] Rothko and Gottlieb, it has been noted, wished to "reassert the picture plane." Motherwell is uniquely interested in preserving the reality of his surface. And Gorky, in 1931, saw Stuart Davis as "one of but few, who realizes his canvas as a . . . two-dimensional surface plane."[12]

For a painter to ignore the plane is to dissociate himself from tradition in formation; it is as if an artist living in the second decade of the quattrocento had chosen to abandon linear perspective or the analytical depiction of muscles. After the broad influence of Matta Echaurren's fluid and linear paintings, his later Renaissance style was rejected because of its overt use of manneristic perspective recession that destroyed the picture surface. At the same time, the uncontrolled depths of the "abstract" Surrealists Yves Tanguy and Kay Sage were rejected for the panel-consciousness of Miró, Mondrian, and Cubism. The desire to assert the picture plane has been one of the foremost formal determinants leading to the dissolution of traditional three-dimensional bulk and the materialization of empty volume. To preserve the picture plane is to flatten, dissolve, or fragment solid bodies, and to fill void.

In Germany, France, and the United States, Hofmann has literally lived through all of the fundamental changes that have taken place in pictorial form during the twentieth century. We turn to him, therefore, for a general philosophy of space and the picture plane. "Painting," he insists,

possesses fundamental laws . . . dictated by fundamental perceptions. One of these perceptions is: the essence of the picture is the picture plane. The essence of the picture plane is its two-dimensionality. The first law is then derived: the picture plane must be preserved in its two-dimensionality throughout the whole process of creation until it reaches its final transformation in the completed picture. And this leads to the second law: the picture must achieve a three-dimensional effect, distinct from illusion [that is, traditional representation], by means of the creative process. These two laws apply both to color and to form.[13]

Assertion of the picture plane does not result in patternistic flatness but is inseparable from depth; "translucent" or "transparent," the plane is implied rather than stated. Its existence and its position in space (for details often extend from it) are established by all of the contributing elements of the composition. Optically the plane is always in a state of active tension, subject to forces which Hofmann likens to the opposed pressures inside and outside an inflated balloon. Not a material wall, the plane is established "in a spiritual sense." Much more than a technical or formal criterion, it is at the crux of the problem of translating three-dimensional nature or formless human feeling into a two-dimensional medium. The plane is a metaphysical as well as a formal principle, and a content as well as a means of painting: "The mystery of plastic creation is based upon the dualism of the two dimensional and the three dimensional."[14]

The interrelated theories of space and the picture plane are inductively derived from Cézanne, Cubism, Hofmann's own work, and that of his contemporaries. As one glances over his development one can see that the creation of "*push and pull* on a flat surface" is his first pictorial aim. It is already evident in student drawings of 1898 (Figs. 96A–96C), and in the 1914 design for a ceiling (Fig. 95).

During the twenties, as the editors of Hofmann's *Search for the Real* note, "form and color and the two-dimensional flatness of the picture surface begin to be more important pictorially than the representation of objects." His development, in this feature as in others, is a valuable indication of the direction of contemporary style. Tables are tilted from horizontal to vertical (Fig. 100); curves are rectangulated (Fig. 97); opposed planes are partially merged in the ambiguous transition known by the French term *passage* (Figs. 101–103); and rearward planes are represented in advancing colors or textures.

Deeply as the tradition which flows through Cubism has affected Hofmann, he has never arrived at a neo-Cubist art. The Cézannesque immediacy of connection between real three-dimensional nature and the picture remains. Even today many of Hofmann's canvases are based on still life although, as in the *Magenta and Blue* (Fig. 134), abstraction goes further than it did in the early canvases. And after 1941 (Figs. 111, 113, 119, and so on) his unified post-Cézanne development splits, temporarily breaking with still life or nature for automatic improvisation. In *Fantasia* (Fig. 118), both flatness and depth derive from suggestions generated by an emotional use of pure means. The ruggedly painted background asserts its surface through pigmentation, and the arabesque, moving laterally, states surface first and space second. Colors go where they are going to go, with the looseness that only a spontaneous process can produce. In *Palimpsest* (Fig. 123) he "accepted the 'visual premise' of an already paint-spattered surface." Hofmann's editors remark on his Leonardesque attitude toward the

spattered and weathered wall. But *Palimpsest* is more than an accident. In accepting an accidentally established picture plane as a point of departure, structuring it, and adding to its "natural hillocks and ravines,"[15] space is created while flatness is underlined.

The geometric canvases, despite their robustness, are related to the nonobjective movement. Reaching into depth, their edges sometimes ruled with masking tape, they battle against the surface fact of mountainous impasto. In those canvases that really succeed, the whole ensemble floats wonderfully: color, pigment, and the insistent geometry declaring themselves to the point where the surface is blasted even as it stresses the fact of its own physical existence.

Modern space cannot be discussed independent of picture plane. Their separation can be justified here, however, not only as an expedient leading to a more complete understanding of their interdependence, but on another basis: conceptually, it is possible for any of the pictorial elements or relations, though interrelated on the canvas, to lead separate lives. An unqualified "space of the imagination" may precede problems of medium in the mind of the painter or sculptor—as it may exist for the poet, the philosopher, or the scientist.

Hofmann's conceptual space is architectural: "When a number of planes are opposed one to another, a spatial effect results. A plane functions in the same manner as the walls of a building. A number of such walls in a given relation creates architectural space in accordance with the idea of the architect who is the creator of this space. Planes organized within a picture create the pictorial space of its composition."[16]

The opposition, now common, of positive to negative space stems from Hofmann's teaching. If presented in carefully unambiguous terms, it fits the physical world (or traditional painting) better than it does modern means: "Space discloses itself to us

through volumes. 'Objects' are positive space. Negative space [which] results from the relation of objects . . . is as concrete to the artist as is objective-positive space." Thinking of modern means, the "object" should be imaged as a complex of lines, brushstrokes, areas, or planes—or even as a single pictorial element—rather than as a bulk or a realistic representation. Through the existence of such "objects," "space . . . becomes tripartite. We differentiate between the space in front of an object, the space within an object, and the space in back of an object. Space within an object is limited. Space in front of and behind an object suggests infinity."

The line of exposition, up to this point, is unilateral and thus clear, presenting a completely three-dimensional concept. Hofmann is quick to qualify it, however. Negative and positive space "supplement each other, both resolve into a unity of space" which is a "*two-dimensional* expression" involving "the coexistence of positive and negative space . . . Form [which here implies the positive occupying elements] exists because of space and space exists because of form; thus space and form exist together in a three dimensional unity which is plastically represented by the two dimensional unity of the picture plane."[17]

It is difficult for Hofmann's reciprocal formulation to reveal that both fullness and emptiness are relative, subject to great variation of quality, means, and degree; and that, as the negative and positive approach each other, ambiguity is heightened and the frequency of depth-surface oscillation becomes more rapid. The 1952 *Eclat* represents a huge orb, like the earth or sun; but the globe-object is flattened, rendered in thin paint with few modulations. The remaining area, the void, on the other hand, is encrusted with a mosaic of thick knifeloads of variegated pigment, its roughness and color vibration imparting to the negative space a tangibility and objective body greater than that of the sphere.

Before the thirties Hofmann's format is shallow, and as early as the 1914 mural sketch (Fig. 95) he had worked out a vibrating relieflike depth not unlike that of the present New York painters. Later, when he was painting from nature, depth is strongly conditioned by the physical environment. *Apples* (Fig. 98), related to Cézanne even in motif, follows the master's tendency to rotate objects in order to assert the unity of the picture plane. All planes are virtually parallel to it, and empty negative spaces are consequently flattened and filled. Yet, in contrast to the Cubism of Picasso and Braque, the airy atmosphere of Impressionism is retained.

Space deepened during the thirties. Still lifes expand to become interiors reaching to a depth of twelve feet or more, but the color pattern—in, for example, *Still Life, Pink Table* (Fig. 100)—keeps the upper, hence rearward, section of the canvas from overrecession. After 1943, during the surge toward automatism which followed in the wake of the Surrealist movement, Hofmann revels in improvisation. Space would be nonexistent, if such a thing were possible for an artist who had felt it so deeply. It is present only in the most spontaneous works, as a by-product of splashing color-washes, gesticulating lines, and varied surfaces.

Conceptual discipline returns in the fifties. Architectural planes divide space like constructivist sculpture, conforming more closely to theory. Planes intersect schematically, grouping themselves like constellations of enameled drawing instruments. With all their resounding vitality, certain of these constructions appear theoretical; yet one of them, *Composition* (Fig. 149), though geometric and thinly painted, distills a nostalgic effect of very deep space-within-flatness by its odd shape and color tensions, its mood strangely akin to one of de Chirico's lonely city squares of 1913. The looser canvases of the fifties (Figs. 145–148), on the other hand, owe little to contrivance. Brilliantly white,

the canvas stands frankly as a painting board for color-charged brushes and knives. Juicy elements shoulder each other into a complex of positions in depth, operating on the eyes by devices—hue, value, size, edging, impasto, unpainted surface—that are simple enough in essence, but which, as a changing gestalt, are too interwoven to be analyzed fruitfully.

It would be a gross oversimplification to attribute Tobey's unprecedented style of painting solely to his "white writing." The form complex of which line is a part also encompasses its own articulation of space. Volume and bulk organization in *Landscape in the Snow* (Fig. 237) is traditional, but two years earlier the objects in the *Cirque d'Hiver* (Fig. 235) are enclosed in black lines, and the 1934 *Shanghai* (Fig. 236) uses specifically Oriental characters. Multiple space, however, is inaugurated in the little *Broadway Norm* of 1935 (Fig. 238), though it was "discovered," according to one interviewer, by 1925.[18] The study began, Tobey says, as a still life of a crystal dish.[19] By means of its retracing line, an effect of numberless compartments of volume, containing very small bulks, was evolved: a structure in which he felt an analogy to the sociology and architecture of New York City. The progressive expansion of concept which Tobey derived from this metaphoric image is one of the most interesting instances that contemporary art offers of close rapport between means and content.

After *Broadway Norm* it was several years before the potentialities of multiple space were developed. The change can be seen by a comparison of the 1935 *Broadway* (Fig. 239) with *Broadway Boogie*, painted in 1942 (Fig. 246), the same year that Mondrian's *Broadway Boogie Woogie* was begun. The 1935 canvas, it is true, also employs an open brush; but for an effect essentially impressionistic: a reference to the bright illumination of the street. The picture space, moreover, is controlled by a lin-

ear-perspective scheme and literalistic scale. A simi-
lar Times Square scene shows like a ghost through
Broadway Boogie. The crowd occupies a triangle at
the base of the format, and the buildings stand on
either side of the "negative" volume above the
street. In the interim between the painting of the
two panels, philosophical content has been enriched
in coordination with linear-calligraphic means. Per-
spective recession and naturalistic relationships are
no longer in control; scale is readjusted in accord-
ance with pictorial rather than photographic con-
siderations. The entire upper portion of the picture
surface is alive with a tremolo of ambiguous sur-
face-depth. Realistic symbols, the lettering of elec-
tric signs, and abstract calligraphic forms, human
and mechanical, fill the air as if with structuralized
ticker tape.

To bring forward the rearward sections of the
subject Tobey uses a solution similar to that noted
in Hofmann's landscapes, adding psychological
weight and interesting detail to the (descriptively)
receding upper section. In the interest of the picture
plane, it is only at lower center that a pictorial re-
cession can be permitted, so the canyon of Broad-
way, in terms of pictorial space, becomes a sort of
tunnel—the only opening in a curtain of tangibly
vibrating atmosphere which has been lowered over
the upper two-thirds of the scene. At the apex of
the lower triangle which contains the crowding fig-
ures, two focal images are placed: the crowned
head of a Negro and a light-toned dancing figure.
At just this point, to follow Tobey's description of
his picture, is its "closed center," from which "em-
anates [*Broadway Boogie* is also titled *Emanations*]
and flows the life which corresponds to that which
they have built in the sky above them."[20]

During the period between 1942 and 1945
Tobey painted several street scenes, all employing a
similar archlike forward movement that asserts the
picture plane and compensates for photographic re-
cession. *Cubist Vertical* (Fig. 247), as we have seen,

shows the plane-thinking through which realistic
subjects are structured. But each year, although he
intentionally strives to contain the past, Tobey's
style moves toward essence and becomes increas-
ingly abstract. *Threading Light* (Fig. 244) demon-
strates one phase in the transition. Its weaving line
pushes planes like those of *Rummage* (Fig. 243)
rearward, so that the light structure opens onto a
back wall of cubicles like a catacomb: "compart-
mentalized units of life," containing figures, sym-
bolic birds and animals, and humanized still life.

After 1944, as pure means increasingly take over
the functions of realistic symbols, pictorial experi-
ence is more ascetic. It is forecast in the 1942 *Drift
of Summer* (Fig. 245) in which grasses, "delicate
thread-like structures," "among and floating free
above matter . . . rise and float, wind-blown as
the summer passes."[21] Flatness-depth ambiguity
also increases in the urban pictures, distilling sub-
ject matter initiated as early as 1921 in realistic
studies of Harlem nightspots. There is no realistic
detail whatsoever in *City Radiance* (Fig. 254) or
New York (Fig. 256), and the eye can move by
crystal clear facets into endless depth. Then, in a
second, space closes and all is surface. What was
the city becomes a web of graffiti on a stone tablet.

The bustle of the street becomes fainter as
Tobey's concept rises; at the same time the concept
changes scale, to a broader, but less personal, hu-
manism and a new space-consciousness. Now, in
Tobey's thinking, ideas already are transformed
into pictorial form, as is seen in "Reminiscence and
Reverie":

On the third floor of Manning's Coffee Shop in the
Farmers' Market in Seattle confronting the Sound, the
windows are opaque with fog. Sitting here in the long de-
serted room, I feel suspended—enveloped by a white si-
lence.

Two floors below, the farmers are bending over their
long rows of fruit and vegetables; washing and arranging
their produce under intense lights shaded by circular

green shades. Above, where I sit, the world seems obliter-
ated from all save memory; abstracted without the feeling
of being divorced from one's roots.

My eye keeps focusing upon the opaque windows [an
equivalent of the picture plane]. Suddenly the vision is
disturbed by the shape of a gull floating silently across
the width of the window [a line of movement drawn
across the picture surface]. Then space again.

Note how, ambiguously, what was first "opaque"
becomes "space."

At this point in his reverie, Tobey makes a leap
to a geographical space concept:

In opposing lines to the gull's flight, the Sound moves
northward through the Inland Passage . . . It is true that
trains run daily out of Seattle to points East and South,
but my mind takes but little cognizance of this fact. To
me Seattle seems pocketed. There is only one way out:
ALASKA, towards the North! Swerving to the left, there
is the Orient, although in San Francisco I feel the Orient
rolling in with the tides. *My imagination, it would seem,
has its own geography.*[22]

In 1944 Tobey painted *The World Egg* (Fig.
252), and by the late forties space expands from
the grid of New York to become global, taking on
the new technical problem of reconciling spherical
organization with flat pictorial structure. Beginning
with *Geography of Fantasy* (Fig. 266), panels
which at first glance appear as an allover pattern of
calligraphy reveal a spherical (or, better, ovoid)
space which magnetically arranges itself around a
focal point usually placed just right of center, as in
Written Over the Plains (Fig. 274).

Widely as the new space concept expands, only
rarely (*Above the Earth,* Fig. 280) does it become
interstellar. The emphasis is on man, even though
the influence of astrophysics cannot be resisted: "I
am accused often of too much experimentation, but
what else should I do when all other factors of man
are in the same condition. I thrust forward into

space as science and the rest do."[23] There is per-
haps a valid parallel to modern science in the spurt-
ing brush-movements of these spherical configura-
tions. *Written Over the Plains* could be either a
cosmos or a microcosm, and *Universal Field* (Fig.
268) flattens the sphere again but fragments every-
thing into particles whose matter and energy are
identical. But most characteristically, when Tobey's
ideas figuratively rise from the surface of the earth,
his gaze is downward. The moving brush of *Canal
of Cultures* (Fig. 275), *Distillation of Myth* (Fig.
277), and other watercolors of the early fifties
crowd swarming strokes that symbolize humanity
viewed from a metaphysician's height, which,
above time as well as space, sees life as a panorama
spreading from the future to the past and from the
West to the East.

Interplay between two essential roots forms the
core of de Kooning's painting: immediate personal
experience as a man, and professional know-how
as a painter. But in elevating emotional life and
technical mechanics to art, the pictorial tradition of
the modern movement has provided a reservoir of
formal solutions. Space, like everything else in de
Kooning's art, has arisen from this matrix. The tex-
ture of existence prior to everything else, the ab-
stract and distant "space of the physicist," does not
interest him.

Two kinds of space are necessary for him as a
painter: The first, circumscribed when "I stretch my
arms next to the rest of myself and wonder where
my fingers are," is the actual space of workshop-
living quarters.[24] The second is the perceptual ad-
vance and recession of the medium. In the early fig-
ure paintings the human form exists within its own
compartment—one of the cubic units which consti-
tute Tobey's urban multiplicity. Sequestered behind
walls and opaque windows, these de Kooning can-
vases concern themselves with the room, the figure

enshrined within it, emotion, and the physical fact of paint and canvas. Only the earliest of which a photograph exists (Fig. 1) is set outdoors—but within an architectural enclosure. In sharp contrast, the 1938 abstraction (Fig. 2) relates flat, nonobjective color shapes; and tricks of brush and "impossible" edging present the eye with a contradiction of behind and before.

The split between the styles was not unbridgeable. The room in the figure paintings of the late thirties is shallower than nature would have it. The gaze of the eyes is frontal, and the necessary recession of the upper legs of the seated figures is slight, with diagonals minimized. The 1940 painting of a boy (Fig. 7) achieves a similar solution by more complex means. The far wall unites with the figure in a sort of relief, and the exotic shapes of the upper left originate their own nonrepresentational expression. Technical tricks further heighten the suggestion that the far wall is indeed the surface of the painting panel. It breaks at the top, peeling away like old wallpaper, and at the boy's right upper arm a parallelogram recedes from the overlapped "background" forcing it into a forward position.

De Kooning's 1940s room-space becomes even shallower, strongly rectangulated, and more cognizant of the picture plane. In such a format bulk must be flattened, with the result that the solids of the human body and the surrounding empty volume begin to approach each other. The abstract paintings, on the other hand, achieve active space-flatness by area, shape, texture, and color relationship. As Thomas Hess has noted, "each unit of the picture insistently refuses to surrender either its action through imagined space, or its emphatic adherence to the plane of the surface."[25] Brushwork as well as shape and color contribute to the effect, so that we are again reminded that both the expressionist and structural poles of the modern movement imply the objective existence of surface. More

and more de Kooning's treatment of flatness and recession becomes a combined function of expressive brush and architectural plane.

Space changes again in 1945. It is no longer based exclusively on the volume of the studio or limited in scale to the panel. Expanding, it exploits brush freedom and unorthodox technical devices, forming a naturalistic landscape-space from the pictorial means themselves. The pivotal sketch for a theatrical drop (Fig. 15) combines geometric and biomorphic planes, charcoal lines, and free brush in an image resembling a cliff face. It opens by a succession of planar barriers and shorings that entice the eye into the exploration of an extremely shallow but richly divided depth. From 1945 until the *Excavation* in 1950 this allover "flat landscape," with its caves, ledges, and paths, characterizes the nonfigurative canvases.[26]

Louis Finkelstein in a perceptive essay has noted striking similarities between the work of de Kooning and that of John Marin. After calling attention to the inadequacy of a patternistic interpretation of modern flatness, he reasserts the inevitable connection of space with modern means, pointing out at the same time the interaction between the painting-object and the subjective response of the observer: "If we see space in a picture, it is there . . . thus, while we are always aware of the picture plane, we are aware also of the recession and spatial movements synthesized from and related to it, and the two elements, constructed and imaged space and actual flatness, can be appreciated simultaneously."[27] Along with the two artists' love of active brush-gestures, their treatment of related flatness and depth gives the key to their kinship. Both are involved with an oscillating surface, and both combine the abstract with the naturalistic. But there is a fundamental difference: Marin's landscapes were painted before nature, whereas *Attic* (Fig. 23), *The Mailbox* (Fig. 22), the 1950 *Collage* (Fig. 31), and *Excavation* (Fig. 30) proceed

from memory, means, and imagination. Also, de Kooning's depth is shallower, more Cubist than that of Marin, but with the synthesized unity of cloth floating on water, receding into folding caves and crevices—"breaking the canvas," a reporter noted in 1951, "into arcs, tunnels, humps and skies of space."[28] The huge *Excavation* climaxes the abstract canvases. Its surface is a webbing of overlapping brush-planes about two to four inches wide, through which "reveals" of color are glimpsed. Nonfigurative though the work is, the strokes, weaving over and under the picture plane, have the somatic bulk of the figure canvases. It is like a flat wall of living musculature: a fusion of the post-Cubist structural tradition, the naturalistic overtones of the "flat landscape" of the mind, and the human subject matter of Expressionism.

The 1949 *Figure* (Fig. 24), on the other hand, occupies a volume more traditional and illusionistic than that of four years earlier. From the bottom edge of the format, floorboard lines recede in a garbled linear perspective, almost as if the intention were to continue the actual studio floor into the picture box itself, within which, whether as reality or hallucination, sits the figure. Among forms of ambiguous meaning the requisite parts of the body can be easily identified, although the irreducible unit is not an eye or finger, but a brushline, brushstroke, or brush-plane—strokes that stretch like elastic bands through the interior space. Play between image and abstraction tends to assert surface, but the canvas is traditional in that, even more than Picasso's early Cubist images of 1909, the figure stands as a pyramidal solid within a box.

In the almost contemporary *Woman* (Fig. 33), paralleling Cubist speculation, flesh is not only exploded into a contradiction more void than solid, but the "background" has moved forward of the figure. And between the frame and the center of the canvas, the treatment of shape and brush changes. Rectilinear and architectural near the edges, like the

gold frame of a trecento madonna, the brushing transforms itself by degrees toward a central whirlpool of anguished—or ecstatic—strokes, smears, anatomical shapes, and receding interstices that form a throbbing heart within the architecture of the composition. The first canvas tells us something about the actual spatial state of things, whereas the second contradicts photographic space utterly, establishing a pictorial tension between subject, mood, and flat canvas. A more unified composition results, one charged with a more vital ambiguity. Even color conforms to the new scheme. The second figure is painted in a variety of blacks against pastel pinks and violets; its background is built of much more assertive yellow oranges, including, at the upper left, a passage of intense vermilion. The image is woven tightly into the warp and woof of the surface. Both sides of the face, for example, are rotated, Picasso-wise, into the plane, so that the two mouths seem to bite each other. There is a recession where they meet—but into the "flesh" of the picture rather than that of the figure.

One suspects that the formal development outlined is involved in de Kooning's discussion of space in 1950: "I am always in the picture somewhere. The amount of space I use I am always in, I seem to move around in it." At life-size or larger, the great figure, like a female counterpart, stands opposite the painter. Pictorial space (and in *Woman* the *figure* itself is opened) provides a volume which can be vicariously occupied. Then, "there seems to be a time when I lose sight of what I wanted to do." Like a sculptor filling an actual niche, the painter retreats: "I paint myself out of the picture, and when I have done that, I either throw it away or keep it." By such a standard, *Woman* is one of the most succcessful. Bulk is aerated and volume is packed just to that point where each achieves vital flatness by being charged with the opposite. It is perhaps this, for de Kooning, that gives a picture its "countenance." [29]

Almost all of the canvases from 1951 to 1953 represent the female, but each finds its own resolution of space with flatness and brush. Most of them move toward a monumentalization of a dominating goddess—a form alien to the space of the "flat landscape." But sketches combining several detailed views of the body (Figs. 35, 36), or studies in which the number of figures is multiplied (Figs. 35–38) bring the two elements much closer to each other.

Gorky's *The Antique Cast* (Fig. 45), painted in 1926, begins to alter a traditional space treatment by flattening bulk, freeing brush, and controlling depth. During the next decade his space develops in keeping with a reconciliation of flatness with a shallow structure of tilting planes, a direction for which he found stimulation in Cézanne, Picasso's Cubism, and Uccello. Never, even in the representational portrait of *The Artist and His Mother* (Fig. 48), is the rear wall of his space far distant. However varied, the experiments of the thirties are carried on within this flat stage. After the sharply outlined color patterns of 1929 and 1930, the 1932 drawings model form and introduce biomorphic shapes. The paintings of the middle thirties often get their images from these drawings: *Nighttime, Enigma, and Nostalgia* (Fig. 56) uses the upper-left-hand motif from *Drawing* (Fig. 54). Abandoning the multiple-image composition, Gorky places one of the motifs within a relatively deep room space, its floor indicated by a recessional diagonal as well as by a change in color tone. *Image in Xhorkom* (Fig. 59) employs a similar depth device at the right, but the heavy pigment and rough brushing keep forms closer to the surface. The effect of being in space is heightened by the pearly tans, soft creams, warm grays, milky greens, and pinks that suffuse individual parts with the whole and induce an atmospheric permeation. This is also true of *Garden in Sochi* (Fig. 64), but because of an in-

creased use of overlapping brushstrokes, and especially negative cutting, the olive background pushes forward and the flat surface is more insistent.

After 1941 neither space nor flatness is a problem to be wholly solved indoors. Cubism has been allowed to slip back into the unconscious, permitting the mature work of the forties to unfold with a structural control more truly automatic than are its multiplied images. On leaving the studio, with its interior and still-life space and studied regard for shape and surface, Gorky carried the lessons learned there to nature. The depth of the flat stage remains as a phantom architecture of bounding planes which solidifies all of the later work. Linear drawing, automatic double imagery, empirical study of nature, and colorism unfold with a disciplined abandon only possible to a painter who has already mastered the formal fundamentals of his art so completely as to be almost innocent of their existence.

The shifting, volatile *Waterfall* (Fig. 67) not only moves subject matter from the studio into the open air and initiates a new use of the medium, as we saw in Chapter 2, but it begins a new type of space as well. Planes are intimated rather than defined, and elegantly modulated color plays a much greater role in hollowing, filling, and indicating advance and recession. The subject is a flat landscape, for the forward surface of the waterfall, broken by brush-movement and changes in hue, provides a shimmering natural analogy to the picture plane, the short recessional table of its top surface forming a platform of just the proper depth. Around it vernal shapes and colors can move forward or back with an ambiguity of pure painterly means, but with an out-of-doors atmosphere.

The pencil, ink, and crayon study for *The Liver is the Cock's Comb* (Fig. 69) has qualities of both indoor and outdoor space. It is as if the gesturing form elements had obligingly suspended themselves, a living relief, in space. One thinks of the aerial

ballet featured in circus performances: a troupe of chorus girls suspended in a vertical plane. But the openings between the forms of the drawing are not holes, as they would be in actual space, but are stopped by passages of brilliant color, or the flatness of the paper itself is emphasized. Unlike a three-dimensional situation, the drawing intentionally confounds space with the facts of the medium. Depth is only partially described, so that the modeled bulks, overlaps of leafy planes, and hollow volumes are contradicted in a play with unspatialized qualities.

The translation of *The Liver* from study to canvas (Fig. 70) is less precise, detail for detail, than that of many subsequent works, but it is like them in treatment of space. In the drawing the empty paper above and below the image is untouched, but at the top and bottom of the painting freely architecturalized screens of overlapping color are erected. Typical, especially of the horizontal compositions, is a judiciously placed horizon, or floor line; and rectangular volumes are often subtly inferred at corners of the format. What happens in the enlargement of the sketch is that a geometric room—or, perhaps better, a stage (reflecting the interior space of the thirties)—is built around the pulsating forms, disciplining and grouping them, partially partitioning units off from each other by segregating certain areas and volumes. Never, however, are these compartments absolutely defined. If a spatial definition is introduced by a complex of lines, a change in color planes, or other devices, it is dropped just short of completeness, encouraging a duality, or more often a multiplicity, of interpretations.

A brilliant passage of shapes, lines, and color at the upper left of *The Betrothal II* (Fig. 82), which in the first version of the subject (Fig. 81) hangs somewhat slackly, is neatly pinned within a volume simply by a change in brush rhythm. It allows the dark undercolor to assert itself through the ocher background. The new strokes go around, rather than behind the structure, adroitly establishing another space division and a new volume unit. So artfully is this partitioning accomplished that one cannot tell whether the plane (or cubed volume?) is in front or behind the more opaque ocher below it. Nevertheless, it achieves the proper degree of containment and disciplines the entire side of the composition.

The distinction which has been made between architectural interior and natural outdoor space is important in Gorky's work, for it oscillates from one to the other. The addition of structural setting in *The Liver* partially interiorizes what began essentially as a landscape. *Landscape Table* (Fig. 74) and the other linear canvases of 1945 and 1946 introduce other combinations. Line and color-tone pocket the flatness of bare canvas into a mountain landscape with its own natural geometry. Again, the 1946 *Charred Beloved II* (Fig. 78) is neither inside nor out; its volume suggests a deep psychological world, a cloudy place where insistent shapes tie one to unconscious memories. *The Orators* (Fig. 90) is another interior, perhaps, as one interpretation suggests, a scene at the death of Gorky's father; whereas the three versions of *The Plow and the Song* (Figs. 85–87) are lyrically set in the sun, among flowers and insects.[30] Their structure is more akin to that of Cézanne's Postimpressionism than it is to that of Cubism.

Quite differently from Gorky, who synthesized representations of nature and free association with structure, or Hofmann, who binds together opposed concepts of deep space and flatness, Motherwell creates depth and picture plane that proceed from optical advance or recession of the surface materials themselves. He has not, like many modern painters, developed from a more or less realistic attitude toward an abstract form, but has been a "modern" painter from the beginning.

The Room (Fig. 158), in its use of deep space, is not typical of Motherwell; many of the pieces that hung in Art of This Century, his first show at Peggy Guggenheim's gallery, combined painting with collage. In the works of the early forties—*Pancho Villa, Dead and Alive* (Fig. 155), *Jeune Fille* (Fig. 162), or *La Résistance* (Fig. 165)—brightly mottled papers are contrasted with dull areas, and powerful brushstrokes emphasize cleanly cut or torn edges. Adjustments are often made with both wit and feeling, the final design resulting from many successive rearrangements: "One cuts and chooses and shifts and pastes, and sometimes tears off and begins again."[31] In 1944 Motherwell speaks of collage as the greatest "discovery" of twentieth-century painting.[32]

The effects of advance and recession in his work, like those in the work of Rothko, are by-products. Motherwell's first concern is with the meaning and sensibility with which execution in two dimensions can be imbued; with silhouettes, edging, color and value intervals, and textures. He seldom employs the recessional diagonal, and does not represent but constructs. Overlap, the inevitable method of the collagist, develops his depth effect. Whether paper or paint, or both, are used, space results from the laying of surface over surface. Recession, although it far exceeds the actual physical separation of the materials, remains immediate and objective in its shallowness. In *The Flute* (Fig. 152) the right-hand rectangular plane (which gives the picture its name) pushes forward. The "music stand" next to it, constructed of lines extending below a plane, recedes. Even though depth-effect is contradicted by surface planes at the top of the format, the picture is plainly spatial. More specific in its effect is *Personage* (Fig. 151); ambiguities of depth are essential to its structure. The complex of curvilinear and straight lines at the left advances, like a construction of wires, forward of what appears to be the actual surface; while below, the light rectangle

pushes the entire passage backward. The busy center panel, although it also tends to extend forward, appears like the open upper section of a divided door. Within this area forms are projected out into the air by quasi-shadows that flatten, and at the same time objectify, the ground on which they fall. Sinking still more deeply into depth, the bar of dark at the far right, although it operates as a surface division, reads as a void.

It is interesting to notice the depth effects of the group of works in various stages of completion that appear in the photograph of Motherwell in his studio (Fig. 163). The shapes of collages and paintings (especially the 1944 collage, Fig. 160) seem to project themselves out into the room like actual physical entities, implying a constructivist's relationship of material elements.

Conveniently for the present discussion, black-and-white photography, by no means accurate in its tone intervals, emphasizes the advance and recession of Motherwell's planes. Usually the effect is partially neutralized by a reverse operation of color tones and tactile qualities. Their selection, in order to maintain the picture plane, can be dictated by just such a requirement. By relating all of these various solutions, by controlling the character and size of shapes, by overlaying them with lines, and by using colors (like the deep orange and dulled turquoise in *The Poet*, Fig. 172) which equal each other in their tendency to advance or recede Motherwell is able to achieve flatness-and-depth shifts of great subtlety.

As a direct product of material elements, his space does not reflect an a priori deep-space concept. A picture with a landscape title, like *View from a Tower* (Fig. 159), states a metaphoric parallel between a collage pattern of papers and a terrain viewed from above—a connection emphasized, in this instance, by the inclusion of a fragment from a contour map. Suggestions of deeper space are rare. In *Spanish Prison (Window)* (Fig. 161) the

largest areas are hard and flat, but the barred central rectangle really implies a prison, and passages of color push in and out. *Granada* (Fig. 177) and *At Five in the Afternoon* (Fig. 179) are typical of the later Elegies. The relation of the black shapes to the white grounds, and the intentionally ragged edges, are managed to provide a figure-ground impasse: Which shall be regarded as the positive image, the black or the white? Which stands in front and which in back? Later, in the 1952 versions of the theme, the bars bow to the right and the left as if by a lateral pressure from the center of the format, so that an ovoid volume is left between. In the Elegies, too, the constructed character of space is less evident. These and the Wall Paintings play down overlap for a greater separateness of elements; in the synagogue project it is avoided in the interest of the heraldic autonomy of individual motifs (Fig. 186). A scrupulous control is maintained over the degree to which units are laid over or under each other. This sometimes results, strangely enough, in an overtone of much deeper and more atmospheric recession than in the canvases of the forties. The horizontal band atop the widest division of certain of the Elegies seems like an architectural enframement placed at some distance behind the picture surface, and the related *Black Still Life* (Fig. 181) is really deep.

True to the Old Testament and Talmudic texts that emphasize the enshrining curtain walls of the temple, the Millburn synagogue design maintains austere mural qualities, and a clear division exists between the positive key shapes and their backgrounds. Nevertheless, with area as a primary means, background and foreground are often interchangeable. While painting, Motherwell has remarked, he is not always sure which position the passage on which he is working should take.[33]

Not all of his paintings of course are subject to the same limitations. In occasional small interiors painted with a rich *alla-prima* impasto, he works in a room-space reminiscent of Bonnard or Vuillard, seeking qualities less monumental and intellectual, but revealing a more mellow tendency to a sort of connubial warmth. This spirit is evident in *Pregnant Woman Holding Child* (Fig. 193). Composed of patterns of orange and white, its space suggestion is deep, and in upper sections a cluster of fleshy and bony shapes, like stages in a foetal sequence, move inward and outward.

Pressed on the question of space, Rothko insists that, like color or flatness, it is not essential to his conception. He emphasizes the material facts: that his variously shaped color areas are simply "things" placed on a surface. From this viewpoint, spatial and atmospheric phenomena are subjective responses of the spectator, and not necessarily part of the artist's intention. The painter's remarks notwithstanding, the spatial impact of his works cannot be ignored. Looking backward at Rothko's development, however, the quality of "spacelessness" does have a peculiar connection with his art. We have seen extension parallel to the picture plane as a unifying element which runs through every phase of Rothko's changing style. His shallow recession has never implied a prior deep-space concept like Hofmann's, so that the picture plane is never established (as it is, for example, in John Marin's watercolors) as a mean between elements widely separated in depth. Even the wraithlike genre figures of the thirties are contained in a shallow format within which movement has to be lateral. In a sense their picture-space is indeed volumetric, but, in the process of compression, the rear wall pushes forward toward the surface of the panel. The figures, thus flattened and attenuated, seem of less importance than the walls behind them, and as the atmosphere becomes dense, freedom of movement is restricted. "Real life" figures are gone in the early forties, replaced by atavistic symbols and fragments of human and natural form.

Bulk has been spread flat in relief, giving embossed shapes which, as elemental motifs in a new shallow world, are less constrained.

Later, when the iconography distills to an essence of purely emotive shapes with little specific representational reference (Figs. 200–216), shapes are finally free to "move with internal freedom, and without need to conform with or to violate . . . the familiar world."[34] In short, as realistic images are successively supplanted by symbols and then by purely pictorial forms, the format becomes shallower, lateral movement is increased, and flatness is emphasized. Behind the scenes of action the horizontally divided backgrounds are flat, vertical, and impenetrable, so that lines, strokes, and shapes must execute their movements toward the right, the left, the top, or the bottom of the format, silhouetting themselves against the rear wall of the shallow stage and presenting their broadest aspects to the spectator.

Until 1948 Rothko shares with Motherwell that quality of the pictorial artifact which derives from a material tangibility—reminiscent of Harnett's "bulletin-board" still lifes—of surface. After that date the positive forms no longer appear before a wall. Like an ice-pond in spring, the matter-of-factness of the surface begins to dissolve. In its place are vaporous translucent barriers, which, background no longer, themselves become the subject. At the same time, the performer-areas structuralize themselves; geometric background fuses with the natural and biomorphic foreground. Softened edges and suffused colors, in suggesting the light and atmosphere of nature, abandon a morphology heavy with anthropological archaism. The panel is open at the rear so that, for the first time, recession into depth is not blocked off. The result of relinquishing as an overt aim both flatness and considerable depth is a new quality of space in which color areas are free to move toward depth unimpeded, or even to leave the surface and advance.

Atmospherically edged and charged with shadow, liquid with depth or permeated and luminous, the multiple unity comprised of color-area relationships, edging, and brush qualities presents a surface which, though it maintains its flatness and directly reveals itself as paint, constantly changes. The patterns differ from left to right in the 1948 and 1949 canvases (Figs. 218–221) in such a way that the eye can move recessionally from plane to plane into depth, exploring an architecturalized landscape, a world of softly geometricized light planes which seem continually to readjust their relative positions from right to left, top to bottom, or front to rear. Quite differently, the opposing halves of the works after 1950 tend to reflect each other. Division is either exclusively horizontal, or each shape that appears in one section is complemented by its equivalent in the other. Yet the symmetry is far from absolute, intentionally upset by critical variations in shape, tone, and brushmanship. The shapes are not the results of division and subdivision; they are more independent, and their field is separated from the edge of the format by a contrasting periphery. Thus, the picture plane cannot be seen as a simple equivalent of the canvas surface, though intermittently one or more of the areas appear strikingly dense and impenetrable as a mass of concrete; but as the eye moves upward or downward—the only directions that the balanced format will permit—the spatial and the physical effects shift, and what was mass becomes mist.

How can one, aspiring to separate objective fact from subjective response in this confrontation of space with flatness, movement with stasis, and mass with emptiness, draw a line between physical truth and the private experience of the spectator? If one observer sees the brilliant vermilion in the upper panel of *Number 21, 1951* (Fig. 224) first as a burning "sky" in recession and then, from another visual focus, as a frontal plane, on what basis can his experience be denied by a neighbor who does

not share it? Can the two onlookers together or can a dozen experimental psychologists reduce the picture to what is "actually" there? Not just a picture-object, the work of art is an emotionally and perceptually charged object capable of exciting diverse responses: an effectual object. The upper area of *White and Black on Red* (Fig. 225) can be interpreted as a black void seen through a red periphery or as a suspended forward plane. Then, suddenly, the lower third of the black area bulges forward in a huge rectangular mass, an effect neither accidental nor dictated by the spectator: it has been determined by the right and left borders of the shape which hint at recessional diagonals and quietly suggest the top and bottom planes of a block. Yet the definition is so tentative, the edges that appear as recessions are so close to amorphous curvature, that what is at one moment mass can appear at another to be hollow.

It is precisely such a partially controlled, partially indeterminate multiplicity of response that as content, in analogy with the mystery of man and the world, the modern painter seeks. But because of his refusal to resolve ambiguity, he exasperates the critic whose aim it is to simplify or explain the art object by reducing its qualities to a simple formula.

Structure and Unity

"For the goal which lies beyond the strictly aesthetic," Motherwell writes, "the French artists say the 'unknown' or the 'new,' after Baudelaire and Rimbaud; Mondrian used to say 'true reality.' 'Structure' or 'gestalt' may be more accurate." Moving, as it does, toward a center, the metaphysics of modern art reaches an area within which terminology overlaps. But the correspondence of the "unknown" or the "new" with "structure" and gestalt is by no means inevitable; it obtains only for those who, like Mondrian, centripetally seek a reality behind appearances.

The artist, according to Motherwell, is "constantly placing and displacing, relating and rupturing relations: his task is to find a complex of qualities whose feeling is just right—veering toward the unknown and chaos, yet ordered and related in order to be apprehended." The resulting objects, "which are, more strictly speaking, relational structures," express this felt, new, or true reality.[35] The unity, or wholeness, of the object is its essential nonmaterial characteristic; but it is a wholeness of a particular kind: neither a monad, undifferentiated and without parts, nor a mosaic which is but their sum, it is a relational whole "dependent on the universal interaction of literally all its parts,"[36] hence a gestalt.

"Structure" is a word of many interrelated meanings. There is no branch of higher thinking to which it is not relevant. One of its most apparent references is architectural: that building is most structural which least resembles the pierced block. Monolithic mass has not only been rejected by modern painters and architects but by many sculptors as well. The openwork structures of Picasso, the Constructivists, Pablo Gargallo, and Julio Gonzales, and more recently of the Americans Smith, Ferber, Roszak, Lassaw, Hare, Lippold, and Lipton, are skeletal rather than fleshy in form. Structures in the most mechanical sense, they stand in sharp contrast to the closed form which has been the traditional sculptural criterion. The new forms created during our century have moved on the one hand toward pictorial flatness, and on the other to openwork. Sculpture, as classically defined, has been hollowed, fragmented, compressed, or, reducing bulk to its essence, simplified to the egg of Brancusi.

It should not be surprising, therefore, that structure, rather than composition or design, is the term that best characterizes modern pictorial organization, for in addition to an architectural emphasis it has intrinsic advantages for the expression of

higher unifying concepts. Metaphysical as well as material in connotation, it points to a whole universe of relationships which tie painting to nature, to inner human consciousness, and to the historicity and universality of ideas. It points to the common meeting ground of the artist and the philosopher. It is philosophy, Alfred North Whitehead has written, which "builds cathedrals before the workmen have moved a stone, and . . . destroys them before the elements have worn down their arches. It is the architect of the buildings of the spirit, and it is also their solvent:—and the spiritual precedes the material."[37] One can assume that these lines are written with the religious architecture of the High Middle Ages in mind, though the direction of thought is close to that of the modern artist. In the language of paint the same metaphor is stated by the Cubist paintings of 1910–1912. The figure, still-life, and landscape subjects of Picasso and Braque are opened out into planes which are then built into a narrow pyramidal form not unlike that of a Gothic cathedral, but resembling more closely the narrow pyramid of the Eiffel Tower. The connection is documented by Delaunay's use of the Tower as a Cubist subject. But the artist, recognizing perhaps that the weight and autonomy of architecture does not ideally fit the medium of painting, tends to reverse the image, so that the central motif becomes negative, a receding hollow, and the surrounding space, the solid canvas surface. Mondrian carries the dissociation of painting from physical weight and gravity even further: his canvases of 1914 reverse the architectural principle which requires buildings to taper upward. His structure becomes heavier and more active at the top, and flattens at the bottom. The lower quarter, rather than the upper, is thereby neutralized. Finally Mondrian and the de Stijl movement eliminated all reference to weight, mass, and even space.

Following in this path, the American purists tended to limit their structure exclusively to rela-

tionships of the horizontal and vertical ruled line or the rectangular area, sometimes expanding this limitation (at least in the case of Mondrian's follower, Fritz Glarner) to include the diagonal. Deviations from rectangularity come about only through the spectator's sensory adjustment of the visual field, and even these "errors" in perception must on occasion be corrected. Burgoyne Diller, who begins work with a T-square and ruler, finds "there are situations when you have to come off the vertical or the horizontal slightly to retain the sense of them."[38] To Mondrian, mechanically drawn rectangles were distinctively human, the more so because they do not resemble the appearance of nature. This is not untrue: but they represent only one, the conceptual, aspect of human activity which, wrongly or rightly, we label "rational," or "objective." Ironically it is mechanical form, man's purest creation, which most directly contradicts the forms of his own organism.

For this reason we associate the grid with the mechanical artifact. Yet for Mondrian, who after 1910 bridged the gap between representation of landscape and abstract art without employing still life as a transitional motif, precise geometry was an expression of nature in essence: "vertical and horizontal lines are the expression of two opposing forces; these exist everywhere and dominate everything; their reciprocal action constitutes 'life.' I recognized that the equilibrium of any particular aspect of nature rests on the equivalence of its opposites."[39]

As a counterforce to the Surrealist-Expressionist-Automatist wave of the late thirties and early forties, the view epitomized by Mondrian exerted a powerful influence, even though most painters found its many renunciations impoverishing or shackling. The experience of John Ferren is characteristic. Working in Paris during the thirties, he was in close contact with the avant garde. There were only two groups, he notes, the abstractionists and

the Surrealists. "I knew all the people, talked all the talk, and reacted against it . . . They [the purists] were at fault in limiting the idea of structure . . . [to] an architectural analogy . . . a horizontal-vertical bias." With a thoughtful hesitancy, Ferren defines a "purist" as a man who believes "structure alone can communicate," adding that to the Abstract Expressionist "emotion comes before structure." He concludes that "all artists work both ways." Automatic as well as geometric painting can be structural: "Jackson Pollock has evolved a *new type* of structure."[40]

The structuralism of modern painting begins with Cézanne. As his perception of the world found a basis in Poussin, he in turn has conditioned contemporary seeing. To purists the Postimpressionist abstract tradition was sufficient; their style was formed by a progressive distillation from it. But the Abstract Expressionist aim is more embracing. Flux, direct emotion, and vagueness—the dross of purism and the gold of Expressionism—must be reconciled with order.

Even the drive toward structure can lead to chaos. "If we see structure in the past," George McNeil argues, "we should be anti-structural." The job of the artist is to strive toward "what is possible—what is unknown." As soon as a certain structure is established, "it is the job of the artist to disestablish it . . . Since Mondrian and Cézanne said the last word on structure, structure becomes a bore. There is no contribution in another statement in hushed tones. You can peel off your flesh and come to a new level of sensitivity. All abstract art until 1940 has to do with the virtue of the organized picture. Now [February 1952] I feel that virtue lies in disorganization."

Extreme as McNeil's dialectic may appear on paper, it is by no means nihilism, but springs from an unwillingness to spawn weak reflections of the great art of the past. It suggests a Hegelian antithesis: "The process of being anti-formalistic depends on some kind of an irrational rationality. Something which *will ultimately appear rational and valued* . . . Nothing to do with the painting of Cézanne, but related to the painting of van Gogh." Implicit in these remarks is a recognition of the historical character of the structure-chaos problem. Jack Tworkov notes that only now is Cézanne's painting regarded as ordered and structural.[41] De Kooning calls attention to the debilitating effect which installation in the home of a wealthy patron has on a canvas of van Gogh.[42]

Artists realize that a painting conceived in heightened sensibility often appears chaotic or even repugnant at the time of its creation. They are aware of the psychological and historical truth that the rapport of a painting with an audience is a developing transaction. The perception of order and structure in a work of art often requires an educative lag which has three phases: first, the image appears without organization, chaotic or amorphous; later, its structure is apprehended by an interested minority; finally, in some instances, the work becomes an accepted object of public value. But as its organization becomes more apparent, its intensity tends to weaken. By this process the flowers and fields of van Gogh, outpourings from a life of pain, frustration, and insanity, are now reproduced on the covers of candy boxes and ladies' magazines and on scarves. Works regarded during the first Expressionist's lifetime as distortions even by fellow painters serve today as pretty ornaments for suburban walls, structure and expressive content both emasculated in domesticity.

Although the painter cannot, and surely should not, always realize it, his structural concept is continually in tension with time and change. The "prehension" (to use Whitehead's word) of ideas from the world by the individual can be conceived as if on a cinema screen: the evolving image of a group-mind moving through history. It is a concept related to the vitalism of Bergson, Whitehead's pro-

cess, or the "life of the forms" which Focillon describes with such eloquence. Its mobile face is never visible to more than a few. Now conditioned by material forces and again aloof from them, its shapes and relationships reform in response to new situations, intuitions, revolts, rejections, and identifications—changes in the orientation of art to the world.

Significant alterations can originate within the inherent dynamism of forms themselves. Unexpectedly doors open at the ends of blind alleys, opening to new ideological truths. Repetitions at less intense levels, academicism, and loss of tone are pitfalls to be avoided, but to proceed toward a dead end is no error. The artist's answers do not necessarily lie in the ultimate possibilities of his direction, but in its physical embodiments. The best pictures cut themselves off from the stream, and even then they do not remain static. In the eyes of the world they never cease to change. But once objectified, they have a timelessness; they become independent stimuli in a new relation to the history of ideas.

In shifting attention back again from the spiritual and historical implications of structure to pictorial organization, it may be helpful to indicate a significant distinction between the picture as a structural object and the pictorial representation of structural motifs. With the spirit of Picasso's *Harlequin* (*Project for a Monument*) of 1935 (Fig. 290), Gorky's *Portrait* (Fig. 62) seems to have taken an imagined three-dimensional construction as a model. It implies a mental process in which a work of art conceived in one medium is represented, like a natural object, in another. The mark of represented structures which, whether drawn from architecture, nature, art, or metaphysical imagery, repeat the Cubist solution is their separability from the format. Frame can be separated from image, so that the picture depicts, but does not necessarily itself become the object. The frames of Tobey's biographically important but tentative *Broadway*

Norm (Fig. 238) or Rothko's *Processional* (Fig. 199) contain their structural images like packing boxes, so that the periphery reads as a dead surrounding void. Even in their best work at least three of the painters we are studying proceed on the basis of just such a three-dimensional a priori, but the transition from format to image is managed so adroitly that the pictorial object remains intact. By the criteria which modern style has set up, however, a noticeable separation of structural image from format is usually an aesthetic flaw, so that better instances of it can sometimes be found in painters less knowledgeable than these, or in the work of realistic painters who have been only recently seduced by advanced forms.

In painting which is both representational and abstract in aim the synthesis of picture and subject is a technical and philosophical problem. Hofmann's *Fruit Bowl* (Fig. 129) finds a precise solution: realistic motif is pictorialized and space is flattened with great finesse; the image is complete—just complete and no more—within its frame. But many of Hofmann's canvases are perilously close to becoming representations of architecture or open sculpture, so that the identity of subject and surface must be maintained by other means. In confronting such problems understanding and mastery can be separated from mediocrity. Gorky's conception, too, was powerfully three-dimensional. He was very much concerned with representation of the natural world, and his late canvases can be seen as limited spaces containing constructions of organic and tectonic forms. But by the many devices which have been discussed, his conceptual structures were brilliantly integrated with picture surface and format.

Those artists who use modern means but desire at the same time to represent the human figure face a double problem. The bulk of the figure must be reconciled with both active flatness and space. Several possible methods, in combination with each

other, can facilitate the necessary transformation: (1) three-dimensional bulk can be flattened and modified; (2) the complexity of human form can be simplified in the direction of organic abstraction; (3) the body can be fragmented into its anatomical parts; (4) the size of the figures can be radically reduced and their number multiplied; (5) the closed form which the body naturally suggests can be opened; or (6) the figure can be rendered with such volcanic impasto, with so active a brush, or with so fluid a medium that pictorial unity and consonance of rhythm dissolve the autonomy of the masses, uniting them with their background.

Rothko's early figures are flattened, and before he ceases to use figure motifs the body is separated into significant details arranged in low relief. The early figures of Gorky and de Kooning are also flattened into the format, but in the forties their methods diverge. Except for the Women, de Kooning abstracts, fragments, and flattens, fitting organic shapes into his picture structure. Following the ideas of Surrealism, Gorky adjusts the small bulks of human organs (and those of nature) into a structural scheme.

Tobey, trying to fit modern style to his humanistic and religious beliefs, has tried everything. Like de Kooning's, his form development reveals an anxiety over the conflict of structuralism with the representation of the figure: "Every artist's problem today is 'What will we do with the human?'"[43] In discussing a portrait (traditional in its bulk save for a superimposed layer of linear wiggles) that was not completely successful, the painter tacitly confesses his difficulty: "The Cubists used the figure, but they broke it up."[44] Through lines, intersecting planes, and overpainting in opaques, this was Tobey's answer in *Beach Space* (Fig. 273) or *Mockers Number 2* (Fig. 257). His most characteristic solution, however, has been to reduce figures to small or even microscopic scale, so that their tiny bulks are almost lost in the interstices of the maze.

The bulk-structure problem is most acute in those compositions involving one or two large figures. Gorky creates several such compositions in the thirties, including his magnificent double portrait (Fig. 48), but abandons this form by the forties. As for Motherwell, the priority of media and structure in his work before 1952 obviates the problem. "Figures" are structural ideographs. Each of the Pregnant Nudes of that year, however, is dominated by one palpitating female shape. The idea of bulk, intrinsic to the subject matter, is accomplished without chiaroscuro, by silhouette and paint quality. The figure is softened and flattened, but not fragmented. Tobey's large figures, on the other hand, keep a quasi-chiaroscuro, but are broken up, interrupted, or overlaid.

In the series of Women, de Kooning meets the crisis head-on. He aims at a monumental female image and a primordial vitality. In the middle 1940s the solution was to flatten, abstract, and superimpose it with linear structure. Organic divisions were maintained: he insisted, that is, on the proper number of arms, legs, eyes, and so on. Later, flatness is ignored for an emphasis on bulk and surrounding volume. But the huge torsos nevertheless open out into structures, and in a 1949 version (Fig. 33) surrounding space becomes tangible picture surface and solid flesh is hollow central volume! One battle in the historical war between figuration and structure is fought to a draw. Subsequent solutions are less evidently structural. *Woman I* of 1950–1952 (Fig. 41) depends for unity, like the most turgid works of Soutine, mainly on brushstrokes, consonance, color, and pigmentation.

In the foregoing discussion structure has been considered a far more encompassing question than pictorial arrangement, inseparable from content and representation. But whether a painter begins with an intuition of a structural reality, from a three-dimensional concept, or from a real-world

motif, he must translate his idea into the painters' medium. If, on the other hand, his form springs directly from the qualities of the medium itself, he temporarily cuts himself off from the outer world or holds his attitudes toward it in abeyance. In this situation structure, whatever its overtones, is most internal. Beginning with the choice that must be made between simplicity and multiplicity or complexity, let us examine some key criteria of internal structure.

In addition to favoring the simple expression of the complex thought, Rothko writes that the "progression of a painter's work, as it travels in time from point to point, will be toward clarity."[45] Clarity and simplicity are far from identical, yet they are associated in the employment of large units which are few in number and clearly separated. Rothko and Motherwell have moved toward fewer and larger shapes, toward a simplicity that would impoverish many painters, although they have refused to recognize in any sense the ideological limitations of the purists. In Motherwell's Wall Paintings the individual shape always retains its identity and autonomy in the composition, overlaps are few, and intervals of hue and tone are kept clear. With formal elements so few and so evident, the slightest deviation, rhythmic irregularity, or ambiguity gains intensified importance. Expressive qualities (or weaknesses) which could be muffled by multiplicity or complication are starkly apparent.

Of all the works on which this discussion is based the Spanish Elegies are the purest examples of the simple expression and the large shape. Absolute black and white constitute their color and tone. The number and diversity of elements are rigorously limited to three rough triangular bars, three ambiguously formed oval-trapezoids, a line, and, in some versions, a horizontal bar with an outline that suggests a window. The salient gain through such austerity is an impact. It is important to its effect, in these works or in those of Franz Kline, that the

black areas do not unequivocally establish depth positions in relation to the whites. Neither image must irrevocably defeat the other. By a precise adjustment of the character and size of the contending areas toward an equivalence between figure and ground, four essentials—picture plane, depth, perceptual vitality, and synthesis of image with format—are never lost. Everything is staked on the most limited means; and if the work falls short of success, its failure can be dismal.

Nothing so annoys and shocks the unsympathetic layman or the realistic painter confronting the late canvases of Rothko as their apparent simplicity. Few American painters have devoted so much square footage of canvas to so few pictorial elements. But, as perception deepens, the huge rectangles of color, "like impalpable translucent blinds drawn, one upon another, down over a magic window," contradict, multiply, and expand, transcending their primary divisions.[46] Variations within adjoining areas combine to form subsidiary units, and new relationships continue to unfold.

After an initial recognition of the dominance of large elements, their fewness and clear interval, the experience of such paintings consists of both an intensified response to a concentrated simplicity and a growing realization of variations and complexities which can be observed only gradually, in the way one becomes accustomed to darkness after a bright light is suddenly extinguished. A black and white canvas of Motherwell or Franz Kline, though it may carry on a pictorial argument within itself or imply a structural world beyond the frame, will not easily yield the autonomy of its shape units. Quite the opposite, Rothko's blocks of soft-edged color become impalpable, liquid, and open; shape identities shift and multiply.

For Rothko the result also is increased complexity, though to multiply is not necessarily to complicate. Much of Tobey's painting, in its total effect if not in its details, is at the opposite remove, not

only from fewness but from both diversity and complexity as well. On the basis of a module of line or brush, he multiplies rhythmically similar units again and again in a process like natural cellular growth. In the hypnotic *New York* (Fig. 256) distinctions between large and small units, solid and void, dark and light, or before and behind lose themselves in endless multiplications. As the closed unity of the surface opens, the space structure it reveals implies expansion of a principle of growth to infinity. Composed of free-brush units, Tobey's uniformity is not at all mechanical; yet, the size and variation of elements, like the leaves of a tree, are circumscribed.

Although it is often minute, the detail of a Tobey is invariably clear; unending diversity of form is there for the eye willing to probe deep enough. Enlarged, the many nuclei could provide—and in terms of Tobey's influence one might say have provided—motifs for hundreds of "simple" paintings. Among other characteristic qualities, the richness of play between variety and "uniform" multiplicity distinguishes Tobey's work from that of the many painters who, during the forties and fifties, have covered surfaces with patterns of similar strokes.

A particular kind of rhythmic homogeneity best described as consonance results from such repetition. It is present not only in Tobey's work but in de Kooning's abstract canvases as well, and (with a different "module" in each case) in the painting of Pollock, Bradley Walker Tomlin, James Brooks, and many others. It is just this tendency, reduced to a "school" characteristic of calligraphic patternism, that was attacked by the anti-abstract paper *Reality* as "mere textural novelty," and by the sympathetic critic Harold Rosenberg as "apocalyptic wallpaper."[47] The same objection, moreover, is inherent in Hofmann's distaste for the fragmentation of a surface that destroys *intervalle*.

Modern painting has often been attacked as paternistic; it was even said that the impeccably organized compositions of Matisse resemble "dress goods." Such criticism actually begins to be valid when nuclear pictorial structure threatens to fragment into undifferentiated pulsation, like that which appears on a television screen between channels, which could be extended infinitely in all directions. The danger, which Hofmann calls that of the "impressionistic method," was approaching in the canvases of Cézanne and Monet in 1906; but, like most of art's dead ends, it was bypassed, in this instance by the Fauves and Cubists.[48]

With the exception of Pollock, who produced a few scroll-like "runners," the best painters among the Abstract Expressionists have never abandoned the idea of a work of art as a limited constellation. They remain conscious, as did Cézanne, of limitation; and of a midpoint, either unknown or demarked, which ties them to tradition and perceptual experience. The focus of the cone of sight, as Alberti realized, was within the observer; this was the center around which, in tension with surface and depth, Cézanne's world was organized. Look at de Kooning's "flat landscapes." From the 1946 study (Fig. 15) until their culmination in the *Excavation* (Fig. 30) they are centrally focused—in the case of these two compositions, in fact, by diagonals drawn from corner to corner to form a precise center.

Tobey has skirted the homogeneous, overall pattern dangerously, but his fields, like those of de Kooning, are always focused. In *Universal City* (Fig. 278), for example, the individuality of the particles, both in color and in form, and their magnetic relationship to a dot indicating the exact center of the panel separate it completely from allover repetition. We cannot accept a surface which can be cut off anywhere as a work of art (though in 1950 Pollock's paintings were described as being without beginning or end).[49] To abandon limitation is to ignore containedness, which the Greeks achieved by confronted figures and the closed trian-

gle, the early Renaissance artists by the focus of one-point perspective, and Cézanne by establishing a point around which his picture was built. A work of art is a unity of reciprocal elements, and it is understandable that Alexander Dorner, in championing "the transformation of the concepts 'art' and 'artist' into practical energies of autonomous change," was forced by the determinism of his thoughts to scrap both gestalten and the term Art.[50]

In summarizing the opposition of fewness to manyness, it can be said that the tendency toward extreme simplification and that toward what Martin James called a "homogeneous over-all character without nuclear areas" can be found within the Abstract Expressionist group. The painter Kurt Seligman points out the first, citing Robert Motherwell and William Baziotes as "concentric, nuclear artists."[51]

Multiplicity, although opposed to fewness, is not necessarily diverse. Infinite in its potential extension, a honeycomb is nevertheless a simpler structure than the most elementary arrangement of diverse shapes. It is multiple diversity which directly opposes one-celled simplicity. In relinquishing illusionistic representation for frank arrangement of elements upon a flat surface, modern painting raised in a new context the eternal problem of "the one and the many." To allay the confusion which is a primordial response to a reality too complex to understand or control, to relate the part to the whole, to limit multiplicity, to order diversity— these have been fundamental aims of Western thought. The answers of the East have often been different.

Modern life is faced with a greater complexity than any previous period, characterized by an expanded apprehension of structural relations of various kinds—and of their absence. This situation, with its attendant indistinctness and ambiguity, both frightens and stimulates. We seek unity, yet, at least in the democratic West, we abhor that

which is imposed and look for that which is reciprocally dependent upon its parts. In concentrating so much feeling and intellect on pure means, Abstract Expressionist painting makes a subject matter of this direct structural response of the personality. Rothko's and Gottlieb's espousal of the "simple expression of the complex thought" points out the simultaneity with which both poles of response are operative. In perceptual structures Tobey wrestles with his concern for the multiplicity and unity of peoples; James Brooks begins with complete flux; Rothko introduces us to a new state of apparent quietude which is at the same time in conflict. Hofmann, the teacher of structural clarity, intentionally pushes his own painting beyond the threshold of structure and toward confusion.

Although the early paintings of de Kooning separate into two groups, abstract and figurative, his forms were uniformly both few and large. Unlike Rothko and Motherwell, he did not abandon traditional elements, but re-formed them in combination with the new. "Banning nothing," the two approaches reciprocate in his development, constantly enriched and complicated by the meeting of new concepts with old processes.[52] The direction of de Kooning's growth, therefore, is toward increasing complexity. In the abstract pictures complication is necessarily limited. Representation is never more than overtone, and the space of the "flat landscape" is shallow. The shifting format of black strokes, spots, and smears, and the intervening shapes of off-white, apple green, vermilion red, and golden yellow can never move far from the picture surface. Given these restraints, sheer diversity of form, movement, and attack is the keynote. A wild pitch of means is held, in which the eye is perpetually forced off base, kept roving, denied the security of separable and defined shapes.

As his remarks concerning Mondrian demonstrate, clarity is to de Kooning a static point outside of art. So, in analogy with existence, his paint-

ing is a battle between chaos and organization.[53] Psychologists tell us that an observing subject seeks to adjust irregularity and ambiguity to its clearest possible state. De Kooning's intense activism and complication frustrate this desire. When figurative subject matter and deep space join the battle, diversity and tension become extreme. Nevertheless, the result is never confusion alone. One feels that if, somehow, the imbroglio would cease, a clear order would emerge. The experience is quite the opposite of that of the simple picture. One participates by glimpsing simplicity and order, as in the landscapes of Soutine, behind a world that is reeling.

Gorky's complexity is different. Passing through a sequence of styles that always aimed at an interpretation of emotion and structure, he was finally able to incorporate an incisive study of natural forms within an elegant synthesis. In his ability to solve a multiplicity of contradictory problems simultaneously and to combine divergent details into an organic whole, he is like an accomplished orchestral conductor, delicately threading his way through a difficult score; in the final solution each part finds an appointed place. When, as in The Plow and the Song series, a lightly brushed passage trembles between foreground and background or between autonomy and inclusion in a larger unit, its ambiguity is precisely adjusted, refusing to give ground to contradictory pulls. But this work is always structurally clear. One's enjoyment is in a beautifully complex artistic synthesis, fashioned with the skill of the master craftsman and the nature of the poet.

At its most intellectual Hofmann's art and theory emphasize the lucidity of large, defined planes and shapes and separated color tones stepped in chords. Consequently, he rejects the form which evolves from purely linear or calligraphic means and, as will be demonstrated, the fragmentation caused by a multiplicity of similar motifs. The Dionysian spirit of his painting aspires to explosive violence.

The result again is a theme of structure in tension with anti-structure. But Hofmann seldom allows his elements to be ground to bits. *Burst Into Life* and *Jubilant* (Figs. 147, 148) show little obvious architectonics, yet the principle of large diverse motifs, existing autonomously, is maintained. The immense strokes, ovoid rectangles, and a focal motif of a small "O" crossed by a large "X" are pointedly separated.

In Rothko's symmetrically arranged canvases the triple or quadruple horizontal divisions excite such a variety of perceptual experience that their seeming simplicity is a mask. In emerging as subforms, shape and color variations offer a multitude of reciprocal part-to-part and part-to-whole relationships. Surely the thought is extremely complex, even though the primary units are at first glance starkly elemental.

The opposition of the simple to the multiple, the diverse, and the complex raises other key questions. Given sufficient interest to implicate them, the human senses, mind, and emotions first grasp at the readily comprehensible; but boredom results from situations which appear to be elementary. As units become progressively smaller, multiplied in number, and more diversified, even with definition crystal clear, the eye and the mind (subject to a host of special conditions) reach a point at which the power to separate is lost. This process is intrinsic to the history of style. It can be observed, for example, in the evolution of Chinese bronze vessels or in late Gothic architecture. But in these cases the merging of numberless parts into unity is the result of a perceptual or intellectual inability to comprehend entities whose definition, if regarded in isolation, is clear. Lack of readability is raised on quite another basis when separations are actually softened—a situation which could be described as the melting of structure. It is an analogue to the shifting states of consciousness so admirably described by William James. In certain works of Pollock or

James Brooks, or in the quasi-representational canvases of Balcomb Greene, sharpness begins to dissolve, fading into the vague, the soft, and the amorphous. Dissolution becomes a subject.

Structure will continue to be challenged. It is atomized by overall pattern, melted by softness, violated by lateral movement—as it was in Duchamp's famous descending nude—or attacked in a new way by certain canvases of McNeil, Still, Brooks, or Kline. In these paintings the image implies outer limits which are not stated within the format.

When the painter appears to attack structure and unity, the very bases of his art, it is because he is impelled toward unknown structures, unities, and realities. It was by this process that Monet altered the Renaissance concept, which was rooted in the rationalized system of absolute location of objects by linear perspective, and that Cézanne conceived a new unity of reciprocal relationships. Any challenge to the gestalt, to the active structural whole, whether by autonomous change, unqualified accidentalism, disorganization, or static formulation, is directed against the art of painting as it exists today. Yet such creative attacks will and should be made, so that "ever expanding their energies toward a larger relativity," artists can discover new, and possibly more relevant, unities.[54]

Movement

It is no longer necessary to point out the concern for movement—kinetic, evolutionary, or optical—that has characterized the art of the twentieth century. But, the many impassioned disquisitions on the subject notwithstanding, it has been more publicized than studied. Eulogy of the "dynamic" has become an annoying cliché, and the label "static" has been affixed only to ideas which have been completely rejected. Yet we must recognize that the vitalistic urge is paramount. This fact granted, the

question of the particular movement concept held by each individual artist or group is raised.

In posing this question, a possibility far beyond the confines of these pages is suggested: that of a movement history of modern (or of all) art, intertwined with its space history and structure history. My more modest aim is to indicate the critical importance of various movement ideas and forms to the Abstract Expressionists. No phase of their technical, emotional, or philosophical viewpoints can be fully grasped without reference to some movement concept. The picture is viewed as a material object rather than as a peep show; at the same time, the process of its formation is often given an importance second only to that of the final work. Dominated by a vision of an evolving organism, and a Bergsonian concern for an *élan vital*, this organicism is evident in the emphasis on active application of pigment and the establishment of optically dynamic relationships. By contrast, one should be mindful of the essentially static techniques of apostles of movement such as Herbert Bayer and László Moholy-Nagy who, although fired by a highly intellectualized movement conception, represent ideas of motion and flux with more or less inert or diagrammatic forms.

The writings of Hofmann, more than of any other of the six painters, formulate a theory of movement. He states flatly that "the phenomenon of plastic movement determines whether or not a work belongs in the category of the fine arts or in the category of the applied arts." It should be realized, however, that there is no similarity between the mechanistic kineticism of the Futurists and Hofmann's movement ideas, which stem directly from his theory of space and assertion of the picture plane and have their historical roots in the painting of Cézanne.

"The aim of art," Hofmann writes, "is to vitalize form. This vitality arises as the result of organic relationships between the formal elements, which in

turn arise through . . . qualities inherent in the medium." He states that "the picture plane reacts automatically in the opposite direction to the stimulus received; thus action continues as long as it receives stimulus in the creative process." This composite phenomenon he describes as "push and pull." Every one of the various pictorial means must be treated according to this principle: lines must express active mutual forces, which make of them a "living unit"; motion is produced by the "shifting of planes"; "swinging and pulsating form and its counterpart, resonating space, originate in color intervals"; "the act of creation agitates the picture plane."[55]

In one instance, Hofmann refers to lines as "shooting stars which move with speed through the universe." His idea of movement, however, in contrast with Hayter's, is seldom that of orbital continuity, but of "movement and counter-movement," which results in a simultaneous "expansion and contraction" of space. Space is "dynamic, . . . imbued with movement expressed by forces and counterforces; space vibrates and resounds with color, light and form in the rhythm of life."

The outcome of the dynamic relationship of all of the devices available to painting is an equilibrium of forces: a state of ordered tension. Finally tension becomes multiple: "the living effect of coordinated, though opposing, forces" which constitute a "many-faceted, yet unified, life." Conversely, no degree of unity could compensate for a lack of vitality, for "a plastic presentation which is not dominated by movement and rhythm is a dead form and, therefore, inexpressive."

Movement provides a link between form and subject matter, but in a different manner than it does in representational art. "The creative process lies not in imitating, but in paralleling nature—translating the impulse received from nature into the medium of expression, thus vitalizing this me-

dium." It parallels the tension of the artist's existence and, in fact, all life, for "life does not exist without movement and movement does not exist without life."[56]

Gorky, in a letter which is one of the few documentations of his philosophy of art, advances an idea of life rhythm which, except for its reference to representation, is identical to that of Hofmann: "movement is the translation of life, and if art depicts life, movement should come into art, since we are only aware of living because it moves."[57] Even before she had discovered these words, Ethel Schwabacher wrote that Gorky "had come on the scientific truth stated in botanical textbooks: 'All the parts of the plant above ground are actually in constant motion, so that the branches, leaves and flowers execute a veritable dance.'"[58] It was precisely because of his "traditional" desire to represent organic movement that Gorky achieved his final style. He also realized that the multiple imagery of the Surrealists was a subjectively rhythmic device, and he united it with more structural methods.

Few modern artists would reject the idea of the painting as a symbolically living object: James Brooks stops when the work is still "alive and moving"; the sculptor Ibram Lassaw wants his work to have a "life of its own"; and to the painter Hedda Sterne "the thing takes life and fights back."[59] The origins of optical vibration can be traced through Impressionism to the luministic touch of Constable and the expressionistic brush of Delacroix, and back still further to the Venetians. Moving forward from Impressionism, it stems from Monet, Cézanne, and van Gogh: a principle common to the perceptual, the structural, and the expressionistic tendencies of our period. After that time, however, the active expression of brush and paint was associated with subjective or naturalistic representational painting, whereas the abstract-

structural tradition evolved mainly through techniques in which active manipulation of pigment was minimized.

Writing in 1952, Harold Rosenberg, a poet closely associated with the New York artists, saw the aesthetic of dramatic gesture as their common bond, dubbing them "The American Action Painters." Painting, by this token, becomes an act, or drama, which breaks the barrier between art and life.[60] De Kooning is more strongly identified with the idea of painting as personal biography than anyone else, and gesture is at the heart of his style. It can be seen in his defense of Renaissance painting, in which "everything was gesture. Everything in these paintings 'behaved.' The people were doing something; they looked, they talked to one another, they listened to one another, they buried someone, crucified someone else." Here the artist is referring to the representation of dramatic activity; but unlike the historical painting he defends, his own work interprets human movement almost completely in terms of the medium. In the next sentence de Kooning's attention shifts in this direction: "The more painting developed, in that time, the more it started shaking with excitement. And very soon they saw that they needed thousands and thousands of brushstrokes for that—as you can see for yourself in Venetian painting." And, he continues, putting his words into the mouth of a hypothetical Renaissance artist, "How do we know that everything is really not still, and only starts moving when we begin to look at it?"[61] Reversing this observation in discussing Mondrian, he insists that "what is called Mondrian's optical illusion is not an optical illusion. A Mondrian keeps changing in front of us."[62] In conversation de Kooning directs one's eye to the molding of the window, noting the impossibility of keeping the edges from bending and twisting when fixed in concentrated gaze.

De Kooning's triple concept of movement raises

a point which will be dealt with in Chapter 6. He sees Renaissance dramatic content as "painting itself," and "subject matter" as a later (and static) development. It was only when no crucial human acts were involved, when "posing in painting began," that "subject matter" became separate from painting: "For really, when you think of all the life and death problems in the art of the Renaissance, who cares if a Chevalier is laughing or that a young girl has a red blouse on."[63]

Perhaps the ultimate step in the aesthetic of gesture was Pollock's abandonment of the brush in 1948. The location of his lines and spots premeditated in only the most general way, the enamel flowed from his moving hand to the horizontal canvas surface like a syrupy secretion. The painting approached its final configuration as a direct consequence of bodily movement, in the gyrations of a privately performed ritual dance. As the viscous fluid whipped through the air, partially controlled by the combined forces of bodily movement and gravitation, its linear pattern in time was not unlike those photographic time exposures in which the path of a moving light affixed to the body of a dancer was recorded by the open camera lens.

Hofmann's movement has been compared to that of a football player plunging through center; Tobey's to the dematerializing rhythm of a mystical experience; and de Kooning's to a biographical drama. Motherwell's work throws a contrasting light, for, notwithstanding the startling animation of his tensely related shapes (Figs. 194, 195), a special concern for the picture-object gives his canvases and collages a unique solidity. He was introduced in Chapter 1 as an anti-expressionist: as a painter he sees a world constituted of objects, and a work of art as one of them. Movement, like extreme emotion, is a destroyer of that tangible form which, whether he finds it in a piece of Tarascan sculpture, the resistance of a wall, or the physical

reality of a collage, is the cornerstone of his aesthetic. Building on this materialist foundation, Motherwell is led to reject the dematerialization which Tobey's use of the brush cannot avoid. This predisposition may have qualified a characterization of Alexander Calder's mobiles, written in 1944: "There is something splendid about the form of motion, or, more exactly, motion *formed*."[64] It is the power of motion to objectify itself, to create what has been called "virtual volume" that Motherwell especially admired.

As a commentator he is keenly cognizant of the activism of the more expressionistic New York painters: of their opposition to "finish"; of the drips, smears, and "accidents" which mark their style of painting as an "act of revenge"; of the "barbaric" qualities the French see in Abstract Expressionism; and of the notion of the canvas as a field on which to fight personal battles. Motherwell recognizes loneliness, hostility, and self-dramatization as his emotions as well, but prefers to keep them at a distance from painting itself. His approach to a picture is close to that of the more expressionistic New York painters, but—and here he is anti-expressionistic and anti-dramatic—he does not wish to project emotions upon the canvas. Responding almost passively to the "felt reality" of the world, his intent is to produce a picture which is a thing in itself, not a desperate gesture or a mystical experience. However challenging the struggle of the painting may be during its growth, Motherwell aims, by consonance of shape, by common tonality, or by other unifying means, to solidify the work. It must not fragment or dissolve: "I cover the battleground, so no evidence of the battle remains. For the other Abstract Expressionists it must show strongly."[65]

Tobey's art, like that of Mondrian or Marin, reveals a search for a vital principle. The fundamental difference among the three is the direction each artist's search has led. Mondrian found his reality in a dynamic relationship of equivalent rectangles; Marin discovered a natural rhythm in landscapes of the coast of Maine; Tobey's equally vitalistic reality has been sought in his conviction of the brotherhood of man. Yet the three share one formative experience, to which we must return: the dynamic intensity of life in Manhattan. Extended over four decades, the lusty pulsation of New York has been a condition of each man's orientation.

Marin prophetically had linked the means of Cézanne and Cubism with the American tempo before 1915; twenty years later Tobey had to find his own synthesis. He had been a commercial artist, and his admiration for the slick-brush illustrators and Sargent (his teacher, a Mr. Reynolds, warned him that he had "the American handling bug")[66] provided the means, and the period when he studied painting in China the catalyst, to unite content and form. This unity fused Tobey's love of movement and mysticism, his brushmanship, and the religious humanism that had drawn him to the Bahai movement. "I have just had my first lesson in Chinese brush from my friend and artist Teng Kwei. The tree is *no more a solid in the earth, breaking into lesser solids bathed in chiaroscuro*. There is *pressure and release*. Each movement, like tracks in the snow, is recorded and often loved for itself. The Great Dragon is breathing sky, thunder and shadow; wisdom and spirit vitalized"; "All is in motion now . . . One step backward into the past and the tree in front of my studio in Seattle is all rhythm, lifting, springing upward!"[67] Apart from the importance of Tobey's soliloquy for his own painting, its cultural coincidence has meaning for the history of style: it records the meeting of Western and Oriental concepts of motion and shows how both interpretations militate against traditional bulk and chiaroscuro. And as movement breaks through barriers to dissolve mass, so spiritual rhythm can unite individual men: "We all feel a separateness; we wish that a drop of water would

soften our ego; the world needs a common con-
science: *agreement* . . . we must concentrate out-
side ourselves."[68]

Expanded from a personal to a terrestrial scale,
Tobey's "Oriental" fragments of brush "twist and
turn drifting into Western zones forever speaking of
the unity of man's spirit."[69] Thus, "England col-
lapses, turns Chinese with English and American
thoughts. Thousands of Chinese characters are
turning and twisting; every door is a shop. The
rickshaws jostle the vendors, their backs hung with
incredible loads. The narrow streets are alive in a
way that Broadway isn't alive. Here all is human,
even the beasts of burden. The human energy spills
itself in multiple forms, writhes, sweats and strains
every muscle towards the day's bowl of rice. The
din is terrific."[70]

Rothko associates movement with spiritual free-
dom. Writing in 1948, his interpretation of paint-
ings that represent the inactive posed figure is not
unlike that of de Kooning: "For me the great
achievements of the centuries in which the artist ac-
cepted the probable and familiar as his subjects
were the pictures of the single human figure—
alone in a moment of utter immobility." However,
"the solitary figure could not raise its limbs in a
single gesture." The critical choice, Rothko insists,
is not between representation and abstraction but
between, on the one hand, loneliness and immobil-
ity and, on the other, movement, freedom, and dra-
matic interrelatedness. Shapes are "organisms with
a volition and a passion for self-assertion," which,
free of constraint, move with "internal freedom"
and are able to "execute gestures without shame."[71]
Rothko recognizes his responses to the indifference
and hostility of society as a motive force and con-
tent of painting; his position is expressionist in that
it is the opposite of Motherwell's passive response.
But the canvas, especially in late works, is never the
scene of anguished brush-projection. Motion and
movement are countered by rectangles, contained-

ness, and softness in a pictorial means enabling
confronted tendencies to be held in a high-keyed
but controlled tension whose effect paradoxically
approaches tranquillity.

Color

No matter how long one works with color, its un-
predictability, relativity, and variability continue to
be a source of amazement. These mysterious attri-
butes, more than any others, excite the modern
painter. "The concern of the artist," according to
the colorist-painter Joseph Albers, "is with the dis-
crepancy between physical fact and psychological
effect."[72] His distinction is far more difficult to ver-
ify for color than for the other means. The actual
size of a shape can usually be ascertained with a
ruler, whereas precision measurements of a color
under one set of conditions may be so far wrong
when the conditions are changed as to be worse
than a direct visual estimate.[73]

Experts are fully aware of "the tremendous influ-
ence exerted upon the appearance of any color
when such factors are introduced as surrounding
hues, fatigue of the retina, variance in sensibility of
certain parts of the retina, after-images, different il-
luminants—their intensity and spectral character—
texture of surface of the sample, and the particular
qualities possessed by certain coloring materials
that alter their appearance under differing condi-
tions, etc."[74]

For these reasons a tone which is in physical fact
gray can appear as a muted green, red, blue, or vio-
let depending on its surroundings. To a painter this
psychological effect is a far more significant reality
than any objective comparison of color-tones with
a group of coded swatches. One must realize,
moreover, that the total color effect of the painting
—though the essential character of its relationships
can be said to endure—is also in flux. It, too,
changes in response to different conditions of illu-

mination. Recalled in memory, or by color slides or prints, it is again altered.

The color expert, predisposed to controlled experiments and mathematical analysis, usually feels that painters are too unsystematic in their methods. But ignoring such advice, painters are guided by feeling rather than system. One might expect also that artists would be constantly swapping color-and-pigment shoptalk; as a matter of fact, color is seldom discussed. Rothko disclaims interest in it, at least as an end in itself. Gorky distrusted colorism. Tobey has built his style on tonally related brush-strokes of subtly varied grays, within which a purer hue occurs mainly as an accent. De Kooning, who does not consider himself primarily a colorist, admits that he cannot predict where he wants to put a blue or a rose.[75] He, Gorky, and Motherwell have shown an unprecedented degree of interest in black-and-white.

The only artist in our present group who has advanced anything that could be described as a color theory is Hans Hofmann. It is developed in several of his writings, and summarized in *Space Pictorially realized through the intrinsic Faculty of the Colors to Express Volume*.[76] Without assuming general acceptance of Hofmann's theories, it can be said that they have more than personal relevance. At the very least, his formulation serves as a basis for comparison. A clear knowledge of the principles that govern his ideas of plane relationship makes it almost possible to deduce his color theory. Just as the former emphasizes tensions between clearly defined planar units, the latter insists on the *intervalle* between "unbroken pure colors." These units are not necessarily spectral hues: "pure" is not used, as in the technical vocabularies of colorimetry, to signify full chromatic intensity. "A pure color can be any mixture of color [including, presumably, black, white, and earth tones] as long as such a mixture is handled flat and unbroken." Color-tone and color-shape are identified: any modeling, modulation, or

fragmentation which destroys the former also obliterates the edges which delimit the latter. As between the notes of a chord, smears cannot be condoned. The fundamental unit of painting, it follows, is the color-shape or color-plane. In explaining the interrelated functions of these elements, Hofmann's language is like that of a gestalt psychologist: "When mutually related, everything makes its mark on another thing. So do colors. They influence each other considerably in a psychological sense, as shapes do. A different color shade gives the same shape another psychological meaning."

The tendency of different color-tones to appear at different planes of depth, and thus to enclose volume, is a commonly recognized (but often erroneously formulated) phenomenon which has been given considerable experimental study. Though he is careful not to single out any arbitrarily advancing or receding hues, this attribute of color is essential to Hofmann's theory. Each mixture suggests "depth penetration and with it volume of varied degree." Thus, color is inseparably bound to the other means, and to pictorial structure; specifically: *"any color shade must be in the volume that it suggested, the exact plastic equivalent of its formal placement within the composition."* Except as didactic emphasis, this language seems a bit overprecise. The relationship of color to volume is established by painterly sensibility—which varies from individual to individual—and is not scientifically exact. But as in other aspects of Hofmann's aesthetics, categorical statements are subject to qualification. The picture plane must be preserved. Consequently, color must also "counteract its formal placement in the necessary compositoric attempt to re-establish two-dimensionality." There is a parallel to this in Joseph Albers' statement: "I want color and form to have contradictory functions."[77] *Seated Woman* (Fig. 116) can be cited as an obvious example of the principle. The area behind the figure is

a pure sunflower yellow, and thus the most brilliant and advancing area in the composition. In black-and-white, therefore, the tension between space and flatness is destroyed completely.

The total relational effect of the tones in a painting stems "*mainly from the psychological rapport capacity of the colors,*" something transcending mere color arrangement, "a phenomenon of a more mysterious order."[78] Of all levels of structural unity, color organization is among the least susceptible to definition. Hofmann's explanation uses the word "translucence," which, it is important to note, he holds as "synonymous with the transparency of the picture plane." Through it, color unity takes on the interrelated permeation he sees as "mystic." The painting must "light up from the inside through the intrinsic qualities which color relations offer."

Though Hofmann's practice in color does not follow his precepts to the letter, theory continues to act as a conceptual governor for extremes of painterly exuberance. Theoretically, any color mixture is considered "pure" if it is properly placed. Yet, to a greater degree than almost any painter except those in the de Stijl tradition, Hofmann leans toward the pure chromas of the color circle: the brightest lemons and golden yellows, unmixed scarlet, magenta, and turquoise or ultramarine blues. Combined or tinted with white, these primaries provide another range of brilliant secondary tones, like lilac, shrimp pink, and lettuce green. Usually these assertive colors are played against various whites, deep shades, and an unlimited number of dulled tertiaries—muddy grays, olives, and violets —which result, either intentionally or without plan, from continued mixture on the palette or canvas. But, as a comparison of the black-and-white reproduction of *The Circus* (Fig. 121) with the color-plate that accompanies it shows, the *intervalle* between color-shapes is maintained not by tonal (black, white, and gray) differences, but by con-

trasting hues. Consequently, the photograph, in which vermilion and spectral blue are almost identical and which loses its yellow in white, cannot record the essential plane structure of the design. Without the intervals between color areas virtually nothing can be photographically conveyed of a painting like *Color Poem* (Fig. 133) except its incrustation of pigment.

It should not be regarded as a weakness, in view of his theory, that Hofmann's canvases often photograph poorly. Painting, conceived as "forming with color," is a medium distinct from "graphic art," which achieves its structure tonally. Color must never be modeled from light to dark or impressionistically broken. A mixture remains pure only

as long as the area that is given to the color or the shape in which the color exists is not shaded down in a multitude of different light values as the Impressionists did. (This dissolves the areas or shapes.) . . . The impressionistic method leads into a complete splitting and dissolution of all areas involved in the composition, and color is used to create an overall effect of light. The color is, through such a shading down from the highest light in [sic] the deepest shadows, sacrificed and degraded to a [black-and-white] function. This leads to the destruction of the color as color.[79]

A rejection of all color and modeling methods from Raphael to Monet is inherent in Hofmann's axioms. Because of the need of High Renaissance painters to render chiaroscuro, the local colors of objects, and suggestions of atmosphere, autonomy of color-shapes was impossible before Manet. It came about, as Hofmann realizes, through the Impressionists' attempt to represent the "overall effect of light" rather than bulk. But color only becomes a plastic means for him in the painting of Cézanne. Hofmann quotes the master's remark that "all lies in the contrast," regarding it as a defense of *intervalle* between color-planes. Looking backward for

historical examples of contrasted color, he bridges the period from Raphael to Monet—cites "the Icons," Cimabue, Giotto, Fra Angelico—and then adds Matisse and Miró.

As a combined consequence of the historical movement from representation to abstraction and relational structure, Hofmann's theory is typically contemporary. Yet it would be a mistake to generalize too broadly from his precepts, especially in their exclusion of broken color and modeling. They strongly suggest that painting which uses color tonally, like that which uses a broken or calligraphic technique, is somehow inferior. It is an arbitrary criterion which would label Tobey's entire production, as well as much of the work of Gorky, Rothko, and de Kooning, as graphic art rather than painting. The sharp contrast between the means of Hofmann and Tobey has already been pointed out, but their differences are underlined where color is concerned. Light, to Tobey, is a content. In a Neoplatonic sense he identifies it with Christ and the Logos; his white lines "symbolize light as a unifying idea."[80] He has considered Turner greater than the Impressionists because he "dissolved everything into light."[81] Thus, in Tobey's paintings light not only takes the form of a graphic style, to which Hofmann objects, but of precisely the "overall effect" which he finds so destructive to color interval.

For Tobey's painting is both tonal and impressionistic. *Tundra* (Fig. 255) has the effect of variegated wisps of a muted earth red; *New York* (Fig. 256) only deviates from a middle tone in being warmer or cooler, lighter or darker; *The Dormition of the Virgin* (Fig. 258) is brown, separating into violet grays and ocher yellows. A few panels are more coloristic. *Space Intangibles* (Fig. 271) opposes a modulated surface-void of blue, lavender, and greenish tones to red, brown, gray black, and yellow; but everything is mellowed and soft, like a faded fresco. The totem-pole patterns of *Drums, Indians and the Word of God* (Fig. 253), especially

assertive in color for Tobey, are dulled, and the units are small, so that the ultimate effect is the permeation of a predominating light tone. Light combines all spectral colors; hence it is none of them individually. From Tobey's early *Broadway* (Fig. 239), which takes its cue from the dissolving brightness of Times Square, it is the visual effect of minuteness fused into unity which constitutes, even in grisaille, his quality of light. As in Monet's Rouen Cathedral facades, broken technique brings about a fluctuating flatness of surface as well.

In another—though related—sense Hofmann, too, is acutely concerned with light, but it "must not be conceived as illumination." The light at which he aims is identical with relational color unity and the two-dimensionality of the picture. Unlike that of the Impressionists, his light is a product of the reciprocal action of discrete units of distinctly differentiated color-tone: "Since light is best expressed through differences in color quality, color should not be handled as a tonal gradation, to produce the effect of light."[82] Taking cognizance both of paintings and of precepts, Hofmann's color ideas can be reduced in essence to four related rules which tie color inseparably to structural principles: pictorial elements should be sufficiently unlike each other in hue and so on; separated from each other as areas or planes; few in number; and large in size.

Hofmann's theory notwithstanding, it cannot be said that Tobey's art is inferior or less modern because his means do not conform to it. A clear idea of the nature of their divergence, however, is of great value in understanding both painters and in elucidating our subject in general. Color, like other means, is part and parcel of an artist's total concept. Hofmann's objection to the "overall effect that destroys the *intervalle* and contrast-faculty" of colors must be understood with this in mind.[83]

Though, unlike Hofmann, Tobey has not formulated his theoretical principles, the association be-

tween his form and thought is, if anything, closer. His universalizing ideas have found their appropriate embodiment in just those formal solutions Hofmann discards—in a facade of grays and ambient light.[84] Tobey's tempera backgrounds vary in tone rather than hue, displaying grays with the softness of old stone, or smoke; modulating within a narrow range between warm grays suggesting violet or brown, and cools moving toward blue or green. Occasional touches of brighter color appear in the calligraphy. They too are muted, but, like the tonal contrasts of the light or dark brushstrokes, they can produce a kind of brilliance impossible with pure primaries.

Motherwell's color is austerely intellectual in its simplification; although hue is important to his area contrasts, their effect is often tonal. Thus, his relationships, like those of Tobey, photograph well. Yet considering Hofmann's designation of "any mixture" as pure, providing it is handled "flat and unbroken" with "only one light-meaning," Motherwell's simpler use of color serves almost better to illustrate the elder painter's theory than does Hofmann's own.

The Poet (Fig. 172) provides an illustration. It is a pasted surface assembled of overlapping strips of a deep tangerine orange and opposed by smaller areas of sky blue. Measured separately against chromatically pure samples, the colors are not brilliant: orange drops to brown, and sky blue almost to gray. The effect of brightness is relational, a psychological effect of complementaries similar in tone and saturation. The orange and blue, hues of median value in their pure state, are carefully bracketed between lighter and darker areas. On the lower end of the scale there is the focal point of crossed dark lines as well as the worked area at the lower left, and on the upper end the white ground for the noticeably brushed brown-blacks. As reproduced in black and white, the blue areas appear lighter than the orange, but in color their equiva-

lence in value and degree of purity is the condition of the picture's flat vitality. The effect of brightness is heightened, too, by the transparent brown-gray which parallels the right-hand blue vertical; a spot of brighter orange would have dulled the whole scheme.

It should be evident as we consider *The Poet* that although it is helpful to examine color as a hypothetically separate means, it is in no sense independent. A color's position in depth is directly conditioned by the method of its application, its textural working, the size and character of its shape, and its edging. The deepest recess (except for a suggestion of infinity in the upper-left area of blue) is the dark passage, hatched with lines, at the left. It goes back, not because of hue but because of its dark tone and the drawing of the ragged opening—like a hole in the elbow of a worn sleeve. The swinging oval pendulum shapes stay forward, moreover, not because of brightness (they are duller than their surroundings) but because, in drawing, they overlap adjacent elements.

The keynote of Motherwell's color in his later work is simplification. In *The Poet,* aside from the dark umber and a wash of similar tone, there is no hue other than the opposed complements. In the Wall Paintings the choice of tones remains almost identical: many are painted entirely in an ocher yellow which may vary from golden to orange or a sienna earth. Differences result not only from many pigment mixtures, but from changes in the sizes of areas, shapes, and positions. In some versions a cold lemon yellow or varieties of white are added, and, for smaller shapes, a mottled royal purple and a transparent hunter's green.

More than many painters, Motherwell sees color as symbolic and associative: "The 'pure' red of which certain abstractionists speak does not exist, no matter how one shifts its physical contexts. Any red is rooted in blood, glass, wine, hunter's caps, and a thousand other concrete phenomena. Other-

wise we should have no feeling toward red or its relations, and it would be useless as a[n] artistic element."[85] In *Three Figures Shot* (Fig. 157) and *Pancho Villa, Dead and Alive* (Fig. 155) the splotches and spatters of red which cover important areas represent, in an ironically decorative scheme, blood. More somber, *Spanish Prison (Window)* (Fig. 161), first of the Elegies, is painted in white, vermilion red, and black which, especially in consideration of the later paintings in the series, gains a funereal significance.

Black to the modern painter is a color. We must guard against making the "scientific" error of the Neo-Impressionists, remembering that the "color circle" is an attempt to equal with pigments the band of hues that results when light passes through a prism. Hofmann is absolutely right in insisting that any mixture can be, in the painter's sense, "pure." To some, black can be the most important color on the palette, and for Motherwell it seems to have the richest associations. In a catalogue essay for a Black or White exhibition, he writes:

Sometimes I wonder, laying in a great black stripe on a canvas, what animal's bones (or horns) are making the furrows of my picture . . . black grows deeper and deeper, darker and darker before me. It menaces me like a black gullet. I can bear it no longer. It is monstrous. It is unfathomable. "As the thought comes to me to exorcise and transform this black with a white drawing, it has already become a surface. Now I have lost all fear, and begin to draw on the black surface" (Arp). Only love—for painting, in this instance—is able to cover the fearful void.[86]

White, which reflects all of the light black absorbs, is defined in the dictionaries, Motherwell remarks, as the color of snow. He recalls a chapter in *Moby Dick* which evokes its quality. White is light, and a symbol of purity; but, like black, it has associations with death. And, as the untouched canvas, it can also represent either void or surface. Tobey

remembers "two men dressed in white jeans with white caps on their heads . . . climbing over a large sign of white letters. Of course, the words spell something, but that's unimportant. What is important is their white, and the white of the letters."[87]

One of the most interesting of the innovations of the Abstract Expressionists has been their preoccupation with pure black and white as a medium for finished paintings. It has few precedents. Of these, Picasso's masterpiece *Guernica* (Fig. 291), though it employs middle tones, is the most noteworthy. Its flat gray shapes (some textured with marks which imply newsprint) suggest the grisaille photograph or newsreel. Its subject matter is tragic, black and white constituting a symbol of mourning for the catastrophe of the destroyed village. In view of Picasso's national origin, the war subject, and the early development of its motifs in the print medium, association with Goya's *Desastres de la Guerra* is inevitable.

In those instances in which Motherwell limits his palette to black and white, he is of course aware of the tragic associations which Picasso's surrender of color implies. His black-and-white paintings symbolize, at least in part, a "subjective image of modern Spain." They are "funeral pictures, laments, dirges, elegies—barbaric and austere."[88] Spectral color is less important to Motherwell than it is to Hofmann. The essential poles of his aesthetic are humanistic subjectivism and care for the internal relations of a pictorial object. To point out the latter concern in his own words: "If the *amounts* of black or white are right, they will have condensed into quality, into feeling."[89] For either associational or formal ends, spectral color can be an enrichment, but it is never a necessary condition.

Gorky's grisaille *Nighttime, Enigma, and Nostalgia* (Fig. 56) was finished roughly three years before *Guernica*, during the period when the painter worked almost exclusively in pen or pencil because

he was unable to afford paints. It carries into pigment the motifs of the 1932 drawings and is a very close (although freehand) transcription of a black and brown ink drawing (Fig. 55). After that Gorky did several paintings in grisaille; the most notable example is the well-known *Diary of a Seducer* (Fig. 75). Elaine de Kooning has shown that its forms were in part derived from a magazine-cover reproduction of J. L. David's late *Mars Disarmed by Venus* (Fig. 283), the most Ingresque of the master's works. David's central nude, moreover, is very close to Ingres' grisaille *Odalisque* (Fig. 284) which Gorky so admired during his trips to The Metropolitan Museum. It can be assumed that Gorky was unfamiliar with the David original, which is in Brussels, so that, as far as his experience of the picture is concerned, both were in black and white. Both figure compositions had the sensual forms Gorky loved, and they were in all probability connected in his mind.

Color and form were established separately in French Neo-Classical painting. Partially this was a consequence of the polished whiteness of the Roman sculpture and plaster casts from which Neo-Classicism derived and the line engravings by which ancient art was illustrated, but it also reflected the highly rationalized academic procedure. This, as well as the funereal aspect of grisaille, is concentrated in *Guernica*, which in its face types, the adoption of the Minotaur symbol, and its pedimental composition is surely in the Classic tradition. Picasso's French affinity with Ingres is as powerful as his Spanish bond with Goya, and Gorky, attracted both to the neoclassical Picassos of the twenties and to Ingres was himself something of a Neo-Classicist. His art, however, was built on reciprocal opposites, and one of its paradoxes, as we have seen, lies in the fact that, though Gorky is remembered for fluid painting, automatism, and dazzling modulation of hue, he distrusted unbridled colorism. He was not far from agreeing with Ingres

that "drawing includes everything except the hue."

We are already familiar with the priority which contour—that earmark of classical style—had in his late work. Yet, to record the swing of a pendulum to its opposite extreme, Gorky's color and pigment often intensified the fluidity of the first master of automatic abstraction, Wassily Kandinsky, who drew inspiration not from the idealized bulks of the human body but from landscapes and Moscow sunsets. A very few canvases, like *The Leaf of the Artichoke Is an Owl* (Fig. 73) or *How My Mother's Embroidered Apron Unfolds in My Life* (Fig. 71) of the same year, 1944, go far beyond Kandinsky's early works in improvisation; but such canvases are rare.

A battle between coloristic and sculpturesque painting has been carried on throughout the history of modern Western art, with Titian and Tintoretto pitted against Raphael, and Rubens against Poussin. It is intensified after 1825 in the opposition of Delacroix to Ingres. The struggle is no mere historical accident: intrinsically, an ideal of three-dimensional bulk, whether achieved by contour or chiaroscuro, opposes colorism. Gorky is fascinating because he has refused to renounce either ideal, a fact already evident in *The Artist and His Mother* (Fig. 48). Sections of the preliminary black-and-white drawing (especially the folds of the sleeves at the elbows) have an exaggerated rotundity, whereas the head-covering of the mother is almost a flat pattern. In the painting chiaroscuro is played down and broken into individual tones—like those in certain works of Miró—which function as distinct color areas. Picture plane is emphasized, and the whole surface is united by a wonderful suffusion: the tones are pale yellows, muted olive greens, the off-whites of oyster, flesh, pearl, mist, or cream; grayed orange-pinks and soft blue-gray.

Most of Gorky's oils of the late twenties were influenced by Cubism. They moved in the direction of flat plane and away from chiaroscuro, and hence

toward flat areas. In the thirties the impasto raised in thick layers, but color shapes remained intact. We have seen how, "changing the colors of more or less fixed shapes, he would lay on coat after coat of pigment."[90] This method led to the production of canvases almost identical in drawing but different in color, like the versions of the Xhorkom theme, two of which are reproduced (Figs. 59, 60). They have the same permeated light as the mother-and-son portrait, but not its porcelain surface and technical delicacy. The colors of the darker version are described by Thomas Hess as "strange chalky lavenders; light, acid greens; heavy, reddish mud."[91]

The several versions of the Sochi motif, at the beginning of the next decade, are very unlike. That in The Museum of Modern Art (Fig. 64), summing up the heavily painted manner, evolves shape, surface, and color-effect simultaneously, in a resonant organization of opaque white, black, vermilion, cold lemon, and deep blue controlled by the overlapped moss green background which surrounds everything.

Gorky's 1943 *Waterfall* (Fig. 67) is one of two paintings of this nature subject and a step toward the thin style. In the handling of pigment, shape, and color it is a great change from the Sochi. The title gives a key to its treatment: paint is transparent and liquid, and the varied greens, tans, and reds are not separated from each other by sharp edges. Everything melts together in a unity of coalescence. A completely coloristic and automatic style could have begun here, had not Gorky's "Ingresism"— a taste for three-dimensional form and contour— intervened.

The empirical study for *The Liver is the Cock's Comb* (Fig. 69) as we have seen, is linear in conception. Yet the wax-crayon passages (a standard corner-store assortment of reds, yellows, greens, and blues) contradict the bulks and fill the spaces

between them with soft-edged plumes of color. The degree to which the coloration of the large painting (Fig. 70) reflects that of this small drawing is amazing. Where the drawing says blue, yellow, or vermilion, the painting follows, in effects which are plainly monumentalizations of those qualities which happen naturally with crayon. And, important for the final effect, precise delineation is almost completely obliterated by opaque paint; the former areas of empty space at the top and bottom are filled with rich new tertiary tones of copper and bluish gray, against which the primary "crayon" passages stand like neon. As in the making of a tapestry, a line drawing has been transformed into an experience that is essentially coloristic, preserving at the same time chosen elements of bulk and space which act in tension with the color pattern.

In 1945 (see *The Unattainable*, Fig. 76, or *Landscape Table*, Fig. 74) washes of color against bare canvas stand in direct contrast to precise lines, striped in the manner described earlier. In these works the track moves along the surface, so color lies flat more easily, line and hue playing equal roles. Two years later *The Limit* (Fig. 80), though unfinished, was regarded by Gorky as complete, for it is signed in the upper-right-hand corner. He had covered the paper surface (mounted on burlap) with a deep but translucent veil of a muted robin's-egg blue and had begun an upper ground of thin, brush-marked white. Over this a few black lines taken from the preparatory drawing were laid and, in the lower section, indications of "crayon" primaries and blacks. But at this point—a spotting of bright accents against a two-toned ground—he stopped.

During the same period Gorky returned to the probing of nature forms and to a more intense linear style. The three versions of *The Plow and the Song* (Figs. 85–87) demonstrate how, the idea blueprinted and transferred to more than one can-

vas, Gorky could change their aspect utterly one from the other by color. Though they agree in several key accents, which like the line scheme were cued by the first outdoor study, everything else coloristic—hue, value, and purity—was subject to extreme alteration. By varying the hues and values used in similar areas of the three canvases the entire effect changed from version to version. By scraping and repainting, color quality was enriched by a partially revealed tone vibrating through the new coat. In other passages (the upper left, for example, of *The Betrothal II*, Fig. 82) parts of the undercoat were allowed to remain, creating new shapes.

It was perhaps for the very reason that the linear motif *was* fixed beforehand that color could be so free. In Oberlin College's *Plow* (Fig. 87) the turpentine washes were allowed to dissolve whole sections of line. Continuing into more opaque paint in the other versions, color changes paraphrase, augment, and contradict the linear core like musical variations on a central theme.

No single canvas demonstrates Gorky's sense of color more fully than the version of *The Plow and the Song* in the Gordon Collection (Fig. 85). The entire canvas surface surrounding the central image fluctuates with a continually varied tone of golden yellow. By manipulating the brush between opaqueness and translucency of pigment (a device somehow combining methods of Cézanne and Miró) an Impressionist atmosphere is created, space is divided into planes, and flatness is asserted. Against this ground one white, the anatomical diagonal tube at the center, is dominant; the "crayon" primaries provide accents set off by strange leaf greens, a tangerine orange, a grayed violet, black, and pastel blues and pinks. Another striking demonstration of the role color plays in Gorky's late work is given by Ethel Schwabacher, who discovered that the same line plan was used both for a

composition in cool tones (Fig. 88B) and the painfully red *Agony* (Fig. 88A). Difference in color mood had previously prevented recognition of two identical schemes.

The print medium, classicistic grisaille, and funereal austerity, all active in Picasso's *Guernica*, were described earlier in this chapter as cross-references to Abstract Expressionist black and white, but by far its most manifest precedent is the brush and ink of the Oriental artist-scholars. Though color is not uncommon in Chinese art, and as early as the fifth century the Principles of Hseih Ho was regarded as fundamental, color did not necessarily mean the same thing to Chinese theoreticians that it does to us. They often refer, as Osvald Sirén notes, to a coloristic effect gained with brush and ink.[92] Work in a chromatic range was the province of the conservative Northern school. The radical artist-scholars of the Southern school—the painters most interesting to contemporary eyes—usually rendered in pure black. The basis of their work was the structural brushstroke. Ink, as George Rowley explains, "even became a substitute for color because the scholarly painters considered color a lower type of experience; 'If you have ink, you have the five colors.'" It was taken for granted that the proper color for bamboo was black, for the scholars agreed that "the vulgar painter uses color."[93] They regarded the conservatives, with their fuller palette, much as a modern painter does a commercial illustrator.

Chinese and modern aesthetics have some interesting points in common, and Oriental brush writing has influenced expressionism since at least the time of van Gogh. Tobey speaks of Cézanne's painting as "all calligraphic" so that "everything moves, every stroke is alive."[94] With more than a touch of irony, Franz Kline, who paints entirely in broad strokes of either black or white, remarks that now, "instead of making a sign you can read, you

make a sign you can't read."[95] It is historically amusing to find Japanese calligraphers, under the influence of the Western inheritors of the, now nonobjectified, art of brush and "ink," borrowing back their own writing methods in the abstract! But as the section on Line and Brush in Chapter 2 attempted to demonstrate, this adaptation of a language of signs to abstract painting is more than meretricious; it is an almost coincidental meeting of an ancient tradition which the Western painter has only begun to understand with both expressionist and abstract painting. After seeing the black and white works of Kline, Pollock, Motherwell, or de Kooning, one is convinced that, cultural differences notwithstanding, there is a common experience—compounded of dynamic opposition, an effect of brilliance distinct from that of spectral color, and a frugal intensity—which can make a full palette of primaries seem vulgar. Strangely enough, Mark Tobey, the first American painter to call attention to this affinity between modern Western content and Oriental form, avoids pure black and white. His unique qualities are achieved by exploiting the slightest possible tonal differences.

Like Gorky, de Kooning paints in grisaille, but it is even more characteristic of him than it was of his friend. Common also to the development of these two painters is the opposition in their pictorial means of bulk modeling to coloristic relationships. Beyond this the parallel cannot be extended. The split in de Kooning's early work is identical with that between abstract and figurative pictures. The early abstract "Hairbrushes" (Fig. 2), though its clearly shaped areas are united by a common grayness, has a carefully stepped color chord composed of white, a pale cold yellow, a soft pink, sky blue, ultramarine, and gray black. Color per se is of even greater importance in a contemporary abstraction (Fig. 5). Although certain of the light-dark steps of the design could be properly described as tonal, the essential effect lies in hue relationships and is

achieved by opposing two grayed complements of an almost identical value: a background modulated from violet to green tones which generalize into a cloudy sea-blue; and a central globe of soft red-orange. Of all uses of color, the combination of tones equivalent in everything but hue—that is, of the same color value, of the same intensity, and of the same degree of tint or shade—is the most unprecedented and, in one sense, the most coloristic of the contemporary solutions. A painting in complete conformity with this principle, if recorded in an ideally corrected black-and-white photograph, would appear as an unbroken tone of gray. No one, as far as I know, has produced work entirely within such limitations; but the principle was implied by Cézanne, has been investigated by color psychologists, and is operative in a large amount of painting within the range of this study.

At the other extreme from the early abstract canvases, de Kooning's figure paintings were as tonal—or more so—than those of Gorky. This is less true toward 1940, because space and bulk were blending more and more into a common picture plane, thus approaching closer to area, and in those figure pictures early in the next decade, on the borderline of abstraction, the effect of hue contrast with value equivalence is common. In the 1946 backdrop study (Fig. 15) the values are much closer than they appear in reproduction. The advance and recession that the charcoal lines create is readjusted by hue tensions resulting from low intensity greens opposed by burnt orange, with an area at lower left of a more yellowish green, and focal accents of pink and white. Yet, when de Kooning first became known publicly through his 1948 exhibition, it was neither as a spectral colorist, a painter of defined areas, or a figure painter. Clement Greenberg could not find "an identifiable image in any of the ten pictures in his show," and he noted that the predominant tones were "black, grey, tan, and white," explaining that "for de Kooning black becomes a

color—not the indifferent schema of drawing, but a hue with all the resonance, ambiguity, and variability of the prismatic scale."

"Just as the cubists and their more important contemporaries renounced a good part of the spectrum in order to push further the radical renovation of painting that the Fauves had begun (and as Manet had similarly excluded the full color shade in the eighteen-sixties, when he did his most revolutionary work), so De Kooning, along with Gorky, Gottlieb, Pollock, and several other contemporaries, has refined himself down to black." Greenberg further suggests that de Kooning's abandonment of a full palette is parallel with his break with the "closed-form canon" of the "profiled, circumscribed shape—as established by Matisse, Picasso, Mondrian, and Miró." [96]

De Kooning has never gone as far as Kline toward the abandonment of color, but ever since the 1948 exhibition black-and-white has been fundamental to his form. The key in this regard is found in hundreds of studies painted, drawn, and whipped (usually in enamel) on paper (Figs. 27, 28). Between the spurting aggressiveness of the application and the visual crackle of the shining dark against the white surface, black and white in Hofmann's sense become the purest of colors. By the technique which is referred to earlier as the "smear," the deep black strokes become grayed areas with defined, though jagged, edges. But when the spread pigment lightens gradually and the sharp edges are destroyed (as in *The Mailbox*, Fig. 22), a surface relief of modeling results; the picture plane raises and lowers topographically. And in the 1948 abstract canvases, distinctions, especially between drawing and painting or grisaille and color, are hard to establish. De Kooning was one of the first of the American oil-paint calligraphers, and certain of the later works, like *Night Square* (Fig. 32), continue in that vein; but usually the stark contrast of opposites is softened by a substitution of a range of off-whites, creams, and yellows for the pure background of the studies.

The hues of other later canvases, in contrast, are often strident. But however sharp, they are locked within a shallow structure which is a product of the methods of the enamel studies: a sort of Cubist-Expressionist picture-plane chiaroscuro. Hess put it well in discussing *Attic* (Fig. 23), pointing out "De Kooning's ruffled, talc-soft whites, which turn tawny as hooked black lines fold them." [97] The *Excavation* (Fig. 30) is a monumental summation of this period of de Kooning's art. Its effect is that of an elastically taut webbing of a tawny cream yellow, modeled and articulated in black; through its interstices are seen pure hues and tints of red, yellow, and blue, and a bright apple-green. Of the works of 1949 and 1950, *Ashville* (Fig. 26) uses painting techniques derived from collage; and pasting is actually employed in *Collage* (Fig. 31), a reassembly of painted sections cut from rejected work. In both works the sparkle and assertiveness of the color effect depend on adjacent blacks and whites. *Ashville*'s planes of red, green blue, and yellow orange seem to have been fitted into a previously established structure rendered without color; it appears as though they had been slipped through cuts along the lines of the black strokes. Such a method was actually followed in *Collage*, where the red, violet, green, and squash-yellow shapes (intentionally smeared into mud here and there) meet in sharp overlaps which transform random nuances with crisp and contradictory precision.

Looking backward over twentieth-century painting, there are many instances in which black brushstrokes provide a superstructure for color. The German Expressionists found such a precedent in the woodcut, and Rouault in stained glass; it is a factor in the color richness of Utrillo, the barbaric spirit of Picasso's early Cubism, and the decorativeness of Dufy. It has been important in the styles of many

American painters from Hartley to Knaths. For some it has amounted to a decorative cliché, but in de Kooning's case the black strokes are so artfully combined with other means, and so originally employed, that it seems entirely new.

Soutine, too, used the reinforcement of dark strokes; but when his images and impasto begin to pitch and roll they fuse with hue. Something similar happens to de Kooning's Women. We are familiar by now with the merging of means that begins to mark his work at the end of the 1940s. *Woman* (Fig. 33) of this period, however, reads convincingly in a photograph; its broad dark strokes, like the spatial calligraphy of the open sculptors, enclose space. Against the blacks, the flesh-and-blood tones are shrill. Open the black structure further, as in the 1950–1952 *Woman I* (Fig. 41), and it no longer dominates. The surface is closer to that of the earlier webbing, but more coloristic; it is built from a host of bilious body tones. From passages of tinny brilliance, hue is repeatedly stretched to chalkiness or spread into intentionally dirty smudges. Between the meaty swaths of pigment, blacks are again accents only, articulating connections of flesh to picture plane. Everything blends more, and the bizarre off-tones and raw blotches build up a crescendo which, in color as in form, is a disquieting mixture of ugliness and seduction. One might think that the painter hated the opulent richness of his heavily pigmented modulations from cream whites, through a dozen shades from yellow to orange, to pink, to violet, and to steel blue-gray—with a harsh brush, or even with charcoal jabs which pulverize into wet impasto, blacks become intentional "dirt"; anti-color, like cuts of an unclean knife into the "nice, juicy, greasy surface" which de Kooning says he likes.[98]

One intent in opposing the color treatments of these painters is to demonstrate the diversity of color possibilities which have been opened up by modern style, whether it exists unalloyed or in combination with traditional solutions. To encompass such variety, our understanding must be broad enough to include as color almost any combination of tones other than the coldest grisaille, and we must realize that apparently chromatic relationships can be effected by a series of noncoloristic means: the actual or apparent opacity or transparency of the pigment film; impasto and brush rhythm; size, shape, and environment of areas; and, of great importance, edging.

The striking resemblances between the means of modern painting and the experiments and theories of the configurational or gestalt school of psychology have already been remarked. David Katz's study *The World of Colour*, which first appeared in 1911, is another piece of evidence documenting the parallel discoveries of scientific researchers and artists. Katz's methodology aims at an unbiased description of perceptual phenomena and takes natural color experiences as a starting point. It is based on perceptual transactions which, though scientifically controlled, are every bit as direct as those by which we experience a work of art. He has worked out simple distinctions which can be extremely helpful in ordering the complexity of the matters we are now considering.

Katz distinguishes three "modes of appearance" of color. A given tone can resemble either a solid surface, a transparent film, or a volume. His first distinction—between "surface color" and "film color"—is particularly valuable to us. Surface colors are those which are encountered most often on objects of paper, cloth, wood, or metal; they embody the tangibility of everyday artifacts. Their distance from the eye and their position in space can be easily verified, for they lie in the plane of which they are a part. "It might not be out of place," the author states, "to speak of them as 'object colours.'" In the laboratory, surface colors exist as colored papers, but, depending upon the object on which they appear, they can be shiny or

dull, smooth or wrinkled—that is, they can (but need not) have texture. Film colors, on the other hand, have a spongy texture just short of transparency. Intangible, like the blue of the sky, they are seen (by the experimenter through a spectroscope) as colored light. A surface color "presents a barrier beyond which the eye cannot pass," whereas "one feels that one can penetrate more or less deeply *into* the spectral colour." Unlike surface color which "can assume *any orientation whatsoever with reference to the direction of vision,*" a film color "never loses an essentially *frontal-parallel* character."[99]

Katz's method aims to describe surface and spectral colors whose bearing planes are distributed in actual depth. The "space" of painting, on the other hand, is illusory. But though we must recognize this physical difference, it remains evident that this psychologist is forced to use criteria almost identical to ours: measurable against ambiguous space; frontality against diagonal recession; tangible surface opposed to intangible effects of permeation or volume. Further, the effects Katz discusses are by no means exclusively coloristic, but involve (beside space) surface and plane, texture, edging, and many other of the painter's specific concerns. In his concentration on the chromatic aspect of his experiments it seems that Katz himself has not fully realized the degree to which his discrimination between color effects depends on quite other determining factors. He does acknowledge, however, that "all possible intermediate stages are to be found between surface colours and film colours" and that, most important, the surface effect can be reversed by altered conditions. Observation with one eye instead of two, for example, "results in a recession of surface colour. Lack of sharpness in accommodation [blurring of textural detail and edging] can have the same effect. The surface colour-impression normally given by an object can easily be supplanted by the impression of film colour if a screen,

containing a single aperture, is so placed before the object as to conceal it completely, except for the part appearing through the aperture [depriving the sample of shape], and at the same time to prevent the recognition of any surface structure in the object [depriving it of texture]." Katz also notes that surface colors can be seen "on clouds of smoke or steam which stand out in clear relief."[100] One can conclude, therefore, that his distinctions, directly relevant to our subject, are to a great degree determined by conditions by no means wholly coloristic.

Applying these criteria, one can easily see why Motherwell, with his partiality for the tangibility of the art object, would employ surface colors. If his tones remain parallel to the picture plane—if they never lose their "*frontal-parallel* character"—it is not because they are film colors, but because they are applied to frontally drawn shapes. Their existence as object colors is always stressed, as in *Spanish Prison* (*Window*) (Fig. 161) and the Millburn synagogue mural (Fig. 186), either by linear divisions like those of a board fence or by pronounced textural character. In the collages surfaces are emphasized by torn and insecurely pasted edges, which underline their physical reality. Assertion of a color's surface thus becomes a sort of subject matter. Hofmann's planar canvases tie color areas in recessional positions by sharp, almost isometric, drawing, which exerts a push into space quite independent of coloration. The contradictory pull can be achieved by the use of a powerfully advancing red or yellow and by paint impasto which in its relief demonstrates the actuality of the painting's skin.

Which of the six painters makes the most pronounced use of film colors? They are not common in de Kooning's work, prevented by a complex of several opposed qualities: form, especially in the abstract pictures, is established by tonal structure which insists on a very shallow depth; brush-gestures are calligraphic; and in the figure paintings

the fleshiness of paint and subjects gives a corpore-
ality which is a modern substitute for chiaroscuro.
Similar reasons can be adduced for a minimal film
effect in Gorky's art—or, more correctly, in those
works and passages which are modeled, contour-
delineated, or precisely planar in form. But Gorky
was an heir of Kandinsky and Miró as well as of
Ingres, so his definition of bulk and plane is never
unalloyed. In the studies, voids between contoured
bulks are filled with crayon smudges and plumes.
Their edges fade away gradually: even on pure
white paper the reds and blues are volumetric,
hence luminous, and in space. But, when they are
free of the dictation of a linear scheme, one cannot
tell just how deep they lie. These qualities are car-
ried on into the paintings in color passages which
are not empty atmosphere, surface plane, or bio-
morphic bulk, but frontal-parallel films of luminos-
ity totally without an object base: the reds of
Agony (Fig. 88A), the apple green tints of *The
Plow and the Song* (Fig. 85), the semi-determined
areas of *The Orators* (Fig. 90), or the heraldic
color auras of *The Liver is the Cock's Comb* (Fig.
70). Their evocative film effect, though influenced
by chroma, would be impossible without a peculiar
edging midway between dissolution of the area and
the precise definition which, more than anything
else, characterizes a surface color. Quite similar
qualities are achieved in the grisaille *Diary of a
Seducer* (Fig. 75).

It may seem that the difference between film and
surface color is being labored. Remember, however,
that the distinction is not merely technical. We are
dealing with art forms in which human experience
is not represented, but given form equivalents. A
solid, sharply delimited surface plane has its ana-
logue in a self-evident, clearly articulated life expe-
rience. As surely as we speak of being "lost in a
fog" or discover that we are "beginning to see the
light," other less determinate form qualities, in infi-

nite combinations and variations, can also carry
fundamental meanings.

Along with categories of surface color and film
color, Katz distinguishes volume color as a third
and final "mode of appearance." Its primary char-
acteristic, shared with certain film colors, is trans-
parency; it is seen as organized in and filling with
color a "tri-dimensional space." To achieve this ef-
fect it must, to some degree at least, be genuinely
transparent. The example of a slightly cloudy liquid
in a glass vessel is presented: it is truly voluminous
"only where I can discern objects through it." Fog
is another example: "The space which appears as
actually filled with colour is distinguished clearly
from its surroundings in so far as objects can be
seen behind it . . . Under otherwise similar condi-
tions the more one can see objects through a fog
the more the thickness of the fog seems to re-
cede."[101] Volume colors, then, are film colors
which, because objects are perceived behind—or
within—them, have the effect, not of planes, but of
a space-filling medium.

To what extent does this last mode occur in
modern painting? Because the example of fog
which Katz advances is atmospheric, perhaps one
should look for volume colors in that generation of
painters more interested in atmosphere than in the
objects it surrounds or the space which contains it
—the Impressionists. Monet's 1903 *The Houses of
Parliament, Sunset* (Fig. 289) is a capital example.
Linear perspective has been completely abandoned
so that, as in the later work of Rothko, the soft-
edged shapes are frontal-parallel. Thus, one might
consider the overall tones of blue and rose as film
colors. But Monet's areas are composed of hun-
dreds of small, subtly varied, impasto touches. It is
as if the air were palpable—as if the shadowy
buildings, the lone boatman, and even the observer
were enveloped in a cloud of vibrating particles,
visible though transparent, which serves as a dis-

tributive medium for the fogged opalescence of the moonlight. The buildings, the figure, and his boat are not the only visible "objects"; the pellets of paint are almost more concrete (though they cannot be isolated), receding deeply and creating their own coloristic volume. At second glance the building surfaces appear truly frontal and flat, although the eye cannot moor them either on the canvas surface or at any specific point in recession. They hover—as they do in Katz's experimental examples—between transparent film and volume illusion.

To a lesser degree, but without the divisionist technique of later years, Monet achieves a similar effect of color-permeated volume in the famous *Impression: Sunrise* of 1872 (Musée Marmottan, Paris). Three years after it was exhibited in the first Impressionist group show, in 1874, James M. Whistler showed his *Nocturne in Blue and Gold: Old Battersea Bridge* (Fig. 294) at the Grosvenor Gallery in London. Revolutionary in its abstraction and use of frontally disposed transparent color areas as a fundamental means, it is even closer than the *Sunrise* to recent American painting. The *Nocturne*—and to an even greater degree the English and Venetian scenes of the eighties—closely approaches the extreme but emotional simplification of the Abstract Expressionist decade. Yet even with so few pictorial elements the volume effect is great. There is a nocturne of the Southampton Harbor (Fig. 295) in The Art Institute of Chicago, painted in the thinnest of glazes, out of which the moon (somehow both on the surface and at great depth) glows like Monet's *Sunrise*. The tiny lights on the shadowy boats, way off in the distance, are almost suffocated by the volume of the night, as if the whole scene existed under water.

Narrowing consideration again to the Abstract Expressionists, we can see volume color as one of their means. As in the work of Monet and Whistler, its use involves content as well as form. Except

in the pure black of *Night Square* (Fig. 32) it does not exist for de Kooning. His is an art of the close-up, the dynamic gesture, and the flat landscape. Motherwell, in the main, asserts the object—again the close-up; even his black void ultimately becomes surface. But Tobey, while sitting before windows "opaque with fog" felt himself "enveloped by a white silence." "But there was escape, too, even in those days, for there was Whistler living in the gray mists with a faded orange moon. The nocturne transformed itself into dreamy rooms with Chopin's music creating a mood that softened the hard core of self."[102]

I have already asserted that Tobey's means are more tonal than chromatic. Nonetheless, as one moves away from the picture surface, his individual brushstrokes blend in atmosphere and a pervading unity of light which, like the broken color of Monet's late style, fulfills Katz's requirements for volume color: a medium of sufficient transparency appears completely to surround the lines, wisps, touches, or cobwebby filaments. It is interesting to recall Hofmann's objections to "the impressionistic method" which fragments color planes. However, though it is enlightening to contrast Hofmann's theory with Tobey's means, one should recognize that they are not completely tonal, and that occasionally, as in *Space Intangibles* (Fig. 271), relationships are determined primarily by hue differences. Here the panel surface seems solid at first, but soft-edged violets, tans, blues, and greens (almost identical in value) open up to an iridescent fog. The shifting fragments are seen within it, taking their positions through relative size, clarity or vagueness, coolness or warmth.

Consideration of Rothko's color has been intentionally postponed until the general topic was expanded to its fullest inclusiveness. Not only is his treatment the least precedented of the group, but it best evidences the contemporary awareness of sen-

sory phenomena seen in Katz's experiments. From this viewpoint, his changes in style can be seen as a progressive substitution of perceptually effectual color relationships for the traditional means of chiaroscuro and local color.

In painting, as in the everyday phenomena of the world, the modes by which colors are apprehended hinge in part, in some instances entirely, on totally nonchromatic determinants. It has been shown what extreme differences in effect, and consequent expressive potentiality, can result from varying such factors as shape, size, and edging either with or without accompanying changes in hue, value, and intensity. Strolling through the galleries of an imaginary museum, one might notice how naively Signac, trying to be scientific, limited the color question to one of spectral tints; or how Monet and Cézanne in quite different ways discovered new expressive possibilities of color. Unobtrusively, almost every possible relationship of chromatic surface, film, and volume would be found in Klee's watercolors; they could be discovered in aquarelle far earlier, for, even accidentally, watercolor dries in transparent modulations which play fading tones against sharp cuts. The Chinese would be seen as masters in creating effects of color, just as they claimed, through purely nonchromatic means. Kandinsky and Turner would be represented; for both, watercolor was important in determining the form of paintings in oil.

If one were searching for the purest volume colors, they would surely be deepest in the glazed spaces of the old masters and the highly varnished backgrounds of the Academicians. In the hands of Manet, they are subtly, and ambiguously, readjusted on the basis of a new awareness of surface. Whistler's volume colors, too, are actual transparencies. Whether in watercolor or oil, they are thinly glazed over the white surface.

On returning from this vicarious sampling trip, one would notice that the varnished, volumetric

darks of the past almost never exist in modern style; they are too destructive of the picture as an object. Actual transparency, however, is not uncommon. Gorky, Hofmann, and Tobey use it on occasion, and Rothko painted largely in washes from 1943 until 1947. But apparent transparency is by no means identical. By changing related means, effects of transparency or opacity are produced and reversed independently of the nature of the pigment film. Historically—whether or not any influence is involved—Rothko's means might be said to be a continuation of the combination of parallel organization with color films of equivocal depth in Whistler and Monet, though it is a partial, or superficial correspondence, for his aims are quite different. Rothko has endeavored to make frontal-parallel film colors the bearers (as Chapter 6 points out) of a human content which is essentially tragic.

Katz cites experiments demonstrating that in certain situations a given tone can be accepted as film, surface, or volume and, further, that "the purposeful set of the observer [was] in this connection of great significance."[103] How much this discovery tells us—not only about the qualities which make the art object perceptually effectual, but of an emotional transaction as dependent on the observer as it is on the painting! "How often," Rothko writes, must a work be "impaired by the eyes of the unfeeling."[104]

Fundamental to the sensory impact of his later work is its lack of dependence on any one mode of color appearance. Relationships are maintained at just that razor edge which will effect (within a prescribed unity) the proper degree of subjective variation. Thus, in describing *Number 10, 1950* (Fig. 222), Alfred Barr is forced to use a self-contradictory image: "the surface of the canvas seems almost to have disappeared. Instead, mists of color, white, violet blue, golden yellow, pale grey, seem to float over it like impalpable translucent blinds [surfaces] drawn, one upon another, down over a magic win-

dow."[105] Rothko's edging is almost never hard; hence an absolute surface color is impossible. However, inasmuch as the areas are rectangular and complete within the format, they are more tangible than "mists," but at the same time overpainted in such a way as to be "translucent," hovering between surface color and film color. My notes made before this picture indicate an inability to decide whether the lower rectangle (of a penetrable yet flat tone of gray) was transparent or not. It appears as both yellow and gray (or yellow through gray?) simultaneously and subtly modeled in silky vertical flutes, like a translucent filament of gauze. The background on which these color areas appear is of a dulled and cold blue, midway between surface and volume: previous discussion has already emphasized the reciprocal readjustment which results from a prolongation of these initial responses.

Color and the conditions of its appearance are elements of content as well as of form. Hess speaks of Rothko's reds as "angry," and of "purple gashes into green."[106] In some instances—for example, *Number 21, 1951* (Fig. 224)—red shrieks with intensity, and in others, like flame suffocated in dense smoke, it burns dully but ominously. Red, also, is the upper panel of *Red, Dark Green, Green* (Fig. 226), set against a peripheral tone of grayed green. Below it is a median bar of dark viridian which by virtue of three green steps from the perimeter, through paired patches of a more opaque tone to the darker and more emerald center, presses forward. The lower panel is filled by a thick, viscous olive-earth, its consistency that of stagnant water teeming with algae or some microscopic organism: a properly transparent medium becomes opaque, hiding that which it would customarily reveal. This is a volume color; except that a bar of purer hue, following a horizontal division just visible in the photograph, offers an observer a sufficient cue to shift his interpretation and return his experience from volume to surface, from illusion to paint.

Hue, the first characteristic of color, plays an essential part in all of these shifting sensations of space, flatness, degrees of transparency, volume, and permeation. But no rule-of-thumb concerning advancing and receding colors can account for the totality of the phenomena. Emotional associations contribute to the various readings: mottled darks feel dense and stifling; blues, the colors of sky and water, suggest open space. The qualities to which Katz refers as "luminosity and glow"[107] (for which both proper edging and voluminosity are necessary) are associated with flame and light; in hue they can be red orange, yellow, or certain phosphorescent blues, greens, or violets. In their entirety Rothko's means cannot be atomized into hue, value, intensity, associational content, and purely nonchromatic means: the completeness of their unification is the major condition of their unique power. A description of some partial aspect of a painting cannot in the slightest substitute for an experience of the work itself; it can, nevertheless, sharpen one's senses to what *may* be there to observe. With this aim in mind, an attempt to note in memory some responses to *Number 18, 1952* (Fig. 227) concludes this examination of Abstract Expressionist color.

At a cursory glance the big rectangle, $116 \times 91\frac{1}{2}$ inches, baldly asserts its medium: thin, mat-surfaced paint patches distributed on an unframed field of cotton duck. Its blue periphery, either background or an encroaching enframement for the autonomous areas, mingles with the topmost red area, at the upper left and on the edges; the variations within the red give it a coagulated depth which could overpower the panels below, except that between it and the central yellow band lies a thin, gray strip which goes dark and is followed below by a pinker band which quickly modulates into a warm yellow center shot with an underground of orange. At the right and left, like the antas of a Greek temple, stand rectangulated blocks of a dusty

magenta pink. Between them, along the lower ex-
tremity of the yellow center, the band which results
from their connection is a cold gray-green, sup-
ported from below by an overlapping panel of "U"
form and a peculiar salmon-pink tone.

The bottom unit, a deep turgid burgundy like an
unclear wine, holds assertively against the blue pe-
riphery. But by now the experience has richened
and the reading has changed. The canvas, once an
easily encompassed surface, has enlarged. When the
eye fixates again, involuntarily, on the central yel-
low, the rectangular bastions stand on the edge of a
more concentrated vision. They become the frontier
marks of a completely self-contained unity. The red
becomes ugly, threatening to move out like a flood
and inundate the yellow and burgundy below.
Then, suddenly calm and flat, it is a curtain, gently
lowering against a blue void.

Scale

It would be difficult to say much that was worth-
while about the structural relationships, the pro-
cesses, the subject matter, or the philosophy of art
without reference to its scale. In some instances by
intent, and in others, I am sure, unconsciously,
questions of scale have been raised by each of the
various topics which precede and follow this chap-
ter. But to articulate the problem and to maintain a
critical self-consciousness an omnipresent concern
must be concentrated—brought to a summing-up
which belongs, like the squeeze of an hourglass, in
the center and not at the end. Lack of scale has
been singled out as an earmark of Abstract Expres-
sionism, and in fact of modern art as a whole. In
the unfortunate instances where form has been
fragmented into a "homogeneous over-all character
without nuclear areas," the criticism is just, for
scale is indeed nonexistent. Differences, and conse-
quently structural relationships, become too slight

to be of importance. Like the pulsations of the
empty video screen, there is no measure.

Scale does not exist without structure. Yet, if
Tobey could find a common complex in a crystal
dish and a metropolis, structure can exist indepen-
dently of scale variation. Tobey's metaphorical dis-
covery involved a change in size: a shift from a
small structure to a large one. So scale, reduced to
its baldest, is a matter of how big or small things
are. It implies a measure. An entire world view can
be reflected in the choice of a measure: Is it man,
nature, the machine, or an immaterial absolute? To
the Greek and to the Classical tradition man has
been the measure; in Western realistic painting the
size of human figures in relation to their environ-
ment—representational scale—is a valuable indica-
tion of the position man holds in the mind of the
painter and his period. The heroes of Jacques Louis
David stand large, and solid as stone, in their own
cubed space; Watteau's are tiny, and lose them-
selves in the warmth and shadow of an ideal
nature.

The world of utilitarian artifacts is created to fit
man's body; architect or tailor, their maker accepts
the evidence which the tape measure offers him
concerning actual size or physical scale. But to the
degree he is an artist, he is also concerned with size
and proportion as it appears to the eye and mind;
he realizes that the senses often contradict the ruler,
raising the question of apparent size or scale. If the
idea of scale is to be fully useful as a key to the
richest meanings of the arts, it must be further en-
larged: it must encompass more than the material
and the perceptual. As the Gothic cathedral repre-
sents the Gothic world, the work of art is itself a
measure. One must consider its philosophical scale.

Physical scale concerns the actual sizes of things.
Without instruments, using only our tactile and vi-
sual senses, we can only determine them accurately
if they are close to our own size. We measure a

chair when we sit on it; the height of a table, the length of a fork, and the size of a steak when we dine. Though a work of art exists at a psychic distance, our conception of its actual size is determined, more or less accurately, in the same way.

The effect of the use of photographs, color prints, and lantern slides on this fundamental response to works of art has been, to say the very least, disconcerting. Art history, that infant of the humanities, has often been perilously close to operating in a completely unreal relation with its primary material: on the basis, as André Malraux has dramatically demonstrated, either of utterly arbitrary situations unintentionally set up by the photographer and typographer, or, as in the case of Malraux's own books, of deliberate juggling scaled to one commentator's hypotheses. To consider the full implications of the vast and recent expansion of art-historical and archaeological knowledge and its dissemination, in altered form, through the photograph and color print is enough to make one's head spin! This is but one small aspect of the relativism that separates life in the modern world from that of the past.

Paraphrasing de Kooning's views, Thomas Hess writes that "the Renaissance man saw and visualized, let us say, *n* things. Today, fed by still, cinema and television cameras, we experience *n* to the 100th power, and, of course, the *n*s become similar because our brains become numb to their differences. Distinctions weaken." This is what de Kooning means when he says that the modern scene is "no-environment."[108]

The special world in which a spectator lives with a work of art, in contrast with both the outside world and the imaginary museum, is (or should be) coordinated. Even in the real museum, however, this intimate relationship, so essential to meaningful scale, can be distorted or made totally unworkable through a competition between conflicting works as

inimical to aesthetic understanding as it would be to the sacrament of confession. Let us consider physical scale, or size, at its foundation: as an unadulterated transaction between one participating spectator and one painting. Its actual size—omitting mention, for the moment, of the hypothetical chapel within which stand both viewer and object —is a relationship between *you* and *it*. It can either be a good deal bigger than you are, like one of Rothko's recent twenty-foot-wide canvases; much smaller, like one of Tobey's ten-inch temperas of 1954; or "scaled to you." Motherwell's collages are in this category.

It is to be expected that Motherwell, to whom a painting more closely resembles an object than it does to the other painters, would produce physically scaled works. With the special function of eliciting feeling, their physical existence and actual size refuse to dissolve in their aura. Even the murals and Wall Paintings keep their one-to-one relation to the viewer. In the Millburn synagogue mural (Fig. 186), true to its theme, he symbolically represents a group of objects—the Seven-Branched Candelabra, the Ladder of Jacob, the Tablets of the Law—scaled precisely to the audience and the environment. Viewing them at close range requires physical movement from one image to the other.

The size of a canvas not only tells you how big it is, and how big you are, but it can designate how far away from it you should stand and whether you should change position while looking at it (and by what path) or stay in one place. Pollock's *Number 1, 1948*, in The Museum of Modern Art, demands that we approach it closely, attracted by the apertures in the maze; the next response is to move far back in order to take in the whole composition. A large Motherwell, simple and bold, reads from a distance; the only reason to see it at close range is to examine its tactile surface, as one might a ma-

sonry wall. A small Tobey must be studied, as it were, with a magnifying glass; even then, the detail of his finest works goes further than the mind and eye can follow. The robust scale of Hofmann's painterly approach obviates detail like that of Tobey, but the troweled and encrusted surfaces, often countered with washes and bare canvas, demand examination at closer range. There is almost no reason for a close-up study of the spare surface of a late Rothko, nor does the painter want his audience at a great distance. These canvases should be seen at relatively close range or in a room that, judged by the popular idea of the placing of large compositions, is too small and in which the painting might occupy an entire wall. The spectator is not lured into the picture space; he is in fact excluded. Yet he must remain close enough so that the surface of the canvas constitutes his entire visual environment. Rothko values the quality of immanence: of a spirit which is indwelling, unified, and complete. The edges of the canvas are the borders of a finite but expanding environment whose limits lie on the periphery of perception. If one moved back far, the picture would become (what it must not be) a unit of another, larger, configuration. Pinned down laterally by the similarity of right and left, what can one do but stand halfway between, at the center?

Physical bigness has been pointed out as one of the first earmarks of the School of New York. It is Tobey's taste for little pictures and the small-scale medium of tempera which most separates him from this group. From 1940 until 1950 easel painting continually increased its square footage, climaxing in Pollock's immense horizontals, de Kooning's 80-×-100-inch *Excavation* (1950), Clyfford Still's 1952 *Painting,* 9 feet, 11 inches, by 13 feet, and Rothko's 20-foot formats. What are the reasons for this expansion of the easel picture to mural scale? Were such works undertaken, as detractors of the New York group have claimed, simply to attract

attention, as were the enormous salon paintings of nineteenth-century France? Is the entire trend a sort of progressive elephantiasis of style? Aggressiveness and a certain megalomania cannot be eliminated as contributing factors, and an influence of actual mural painting, notably *Guernica,* should be recognized along with Picasso's large easel pictures as well as those of Miró, Kandinsky, Tchelitchew, Lam, and Matta, but there are more intrinsic reasons.

The experience peculiar to Rothko's content is immeasurably heightened by the large visual field presented to the observer. To anyone who has looked at *Excavation* (Fig. 30), one of de Kooning's finest works, sheer bigness, far more dominating than physical dimensions indicate, is an essential part of its impact. Whether one sees it as abstraction, landscape, or musculature, it is a towering "wall of flesh." Still's *Painting* (The Art Institute of Chicago), filled in the main with a huge expanse of palette-knifed black, vibrating between shiny and dull areas, presents an unprecedented painting experience—arrogant, defiant perhaps, or even Dadaistic. But both bigness and effrontery (if such is the case in this instance) can be significant expressive values—characteristically American values, one might add. The tenor of these remarks might obtain for Pollock as well, though the emotional quality of his "poured" works, especially from a distance, is as often one of quiescent beauty as of defiance. But there is no doubt that his best work has been large and that its effect, like that of Mondrian's New York pictures, entails an optical vibration of color that changes as the spectator's focus moves from one point on the surface to another.

The line between easel and mural painting should also be questioned. Motherwell's Wall Paintings, mural in aim, are a case in point. As Peter Blake has noted, the large Pollocks provide an unprecedented solution to the problem of introducing

humanizing ornament into the interiors of austere modern buildings. Formats that can be called exhibitionistic if regarded as easel painting become small when conceived as mural decoration. Does the fault—if one exists—lie in the arrogance of painters or the iconoclasm of architects?

Another, dual, aspect of physical scale also involves bigness: actual size is asserted both by emphasis on the medium and by the human scale of gesture. The insistent reality of Motherwell's cut, torn, or patterned papers and the agitated reliefs, spatterings, or waterfalls of Hofmann's surfaces often prevent the pictorial object from slipping out of objective or human scale to a greater psychic distance; the evident acts of tearing, or emotionally brushing, the material have, in quite another manner, the same effect. Consider the physical scale of gesture. Whatever their apparent or philosophical scale, Tobey's gestures are executed with the forearm or the fingers. Hofmann—and it was he and Pollock, it would seem, who in the Annuals held at the old Whitney Museum began the present trend to huge canvases—remarks: "you can't use your biceps on a small picture."[109] The canvas, in point of fact, is man-sized—directly scaled to the human activity involved. Watching Hofmann paint is like witnessing a boxing match. His gestures, and those of de Kooning, are swings and jabs of the whole upper body. Pollock's movements are even more active; they cover the entire area of a large studio. His gestures are those of the dance. It is "floor" painting, rather than easel or wall painting, scaled by the entire body, graceful and flowing, and, when the horizontal canvas is approached from each of its four sides, unifying.

The objection may be raised that the significant scale of a work of art is independent of its physical size and that true scale, as a measure of a work's value, remains constant. Here can be found, it is true, one of the mysterious powers of great art. But who would deny that the actual conditions of the work were irrelevant to its communicative function? What color prints could suffice for the stained glass of Chartres? The importance of actual size, though recognized for sculpture—the effects of reduction are strikingly evident in small reproductions of large museum pieces like Lehmbruck's *Standing Woman*—and architecture, tends to be ignored, perhaps because of the ubiquitousness of the photograph, slide, and color print, in regard to painting. For this reason, a reactive emphasis seems justified.

The impact of a work of art transcends its physical dimensions. De Kooning passes along a story, brought to mind by the idea of "order," told to him by his friend Jack Tworkov. It concerns a village idiot named Plank, who measured everything: "roads, toads, and his own feet; fences, his nose and windows, trees, saws and caterpillars." But all that he noticed about himself, the tale concludes, "was that his length changed!"[110] Looking at de Kooning's moral—which involves, one suspects, a gentle criticism of what he describes as bookkeeping—from the point of view of scale, we are reminded again of what a delicate operation it is to determine what is demonstrably "there" in a work of art. Because actual physical size remains in a phenomenological relation to the spectator, apparent—one might say aesthetic—scale is quite distinct from absolute size.

In the past the representation of man, nature, and artifact has been inseparable from apparent scale; and they cannot be divorced even in Abstract Expressionist painting. The degree to which nonrepresentational form can allude to the phenomena of the world will be emphasized again in Chapter 6, "Subject Matter and Content." However slight the reference may be, the bigness or smallness of a work, in terms of one's response to it, depends to a greater or lesser degree on whether the representational overtone points toward nature, the figure or

some part of it, still life, an architectural interior or exterior, or to macro- or microscopic extremes. It is a common experience, annoying to a free abstract painter, when an observer points out the unintentional similarity of a passage to a face or some other specific object, for it is next to impossible to return that part of the painting, in one's mind, to its previous appearance. The abstract work which has no representational cue is rare, for even the isolated square refers to mechanical and architectural rather than natural or human form. Even Mondrian can be said to be representing: in *Trafalgar Square*, the city; and in the Boogie Woogie paintings, the urban scene and its music. With metaphoric intent, large and small cues can be combined, as in Tobey's *New York Tablet;* and a title alone can shift the entire representational reference, as Klee has so often proved.

Expressionist brushwork establishes a human scale. Rothko's technique is as vitalistic in another way, but being fluctuating and atmospheric, it veils the act of the artist in a more naturalistic allusion. Motherwell establishes the tie with natural scale in many ways: by the introduction of a detail from a map and the title *View from a Tower* (Fig. 159) a particular scale is arrived at; or a collage is compared to the patterns of a beach; and bright warm colors (at least according to James Fitzsimmons) reflect the light of Southwestern landscapes.[111]

Apparent scale is most evident perhaps in the quality of largeness known as monumentality. Traditionally it has often been tied to the figure, so that, to an eye familiar with primitive or modern art, the most tenuous reference to the human proportions can have an enlarging effect. By this token early Cubism can be seen as an evolution from human to architectural scale, and phases of it as a simultaneity of both: a discovery of the structural link between traditional subject matters.

The scales mentioned above, conflated, can be found in the de Kooning Women. Representation-

ally they begin with room scale, but with the figure oversized, it dominates the space, as the chryselephantine cult statues did the cellas of Greek temples. It confronts the spectator at close range, limb for limb, just enough enlarged over human size to be occupied—for bulk is hollowed. But Thomas Hess says that the "'idolized' *Woman* reminds him [de Kooning] strongly of a landscape—with arms like lanes and a body of hills and fields, all brought up close to the surface, like a panorama squeezed together (or like Cézanne)."[112]

Divorced from connections with the generalized human figure, nature, or architecture, the quality of monumentality, of largeness independent of actual size, becomes even less susceptible to analysis. Here is the crux of the problem of scale in art. After indicating his reasons for employing large surfaces and vigorous technical procedure, Hofmann finds a tiny Ryder "one of the greatest pictures on exhibit," and adds that "an artist should be able to show his capacity for monumental expression in a smaller picture."[113] Elsewhere, following an analysis of relational tensions, he concludes that "it isn't necessary to make things large to make them monumental; a head by Giacometti one inch high would be able to vitalize this whole space"—indicating the room.[114] Again: "The width of a line may present the idea of infinity. An epigram may contain a world. In the same way, a small picture format may be much more living, much more leavening, stirring, awakening than square yards of wall space."

"Monumentality is an affair of relativity. The truly monumental can only come about by means of the most exact and refined relation between parts. Since each thing carries both a meaning of its own and an associated meaning in relation to something else—its essential value is relative. We speak of the mood we experience when looking at a landscape. This mood results from the relation of certain things rather than from their separate

actualities. This is because objects do not in themselves possess the total effect they give when interrelated."[115] In a purely representational work, "the human figure becomes a doll; a landscape, a marionette set."[116] Hofmann recognizes the overtones of representation discussed, suggesting, however, that the true art-nature parallel is between pictorial structure and the characteristic structural relationships of nature, rather than its outward forms.

We say that a whole is greater than the sum of its parts. By the same token, a picture's completeness is expansive. Monumentality can be achieved in a small work by division into many parts. From a distance a little Tobey tempera does not scale large, but the moment one becomes involved at close range in the many detailed distinctions which have passed through the artist's mind and brush, it expands. Concentration on any one compartment enlarges it and postulates great numbers more, seen and unseen. Successively, one responds to physical, representational, apparent or aesthetic, and finally a metaphysical or philosophical scale—it is characteristic of the best works that the various levels are inseparable from each other. But one cannot say that division into parts insures monumentality: at just the point when fragmentation is carried to the extreme of overall pattern, structure, gestalt, and scale die.

It has been asserted that the nave of Amiens Cathedral, almost identical in height with that of St. Peter's in Rome, gives a greater sense of height because of its division into many hierarchically related units. It does not follow that in painting fewness results in smallness. The small and large versions of Motherwell's Elegies (Figs. 179, 180) share a common monumentality, and a small sketch of de Kooning's *Woman* (Fig. 34) comes almost closer to embodying ideally his primordial female idol than do the large versions. In this sort of monumentality de Kooning has one's conscious response to the idea of a cult image on his side. It is

effective also for Motherwell in those works in which the first representational overtone is to three-dimensional construction, objectively human in scale, and the second, buttressed by a title such as *Personage with Yellow Ochre and White* (Fig. 169), to a formalized human image.

Hofmann's monumentality—and there is no doubt that, though physically large, his best canvases scale larger—must operate in the purely abstract examples with little associational reference. What there is is largely architectural, for rigid planes in space suggest three-dimensional structure. But the existence of tension between the elements—the relational situation that attracts some units to each other while forcing others apart—a situation Hofmann likens to pressure inside a balloon, makes of the reciprocally related elements an expanding whole. Toward this end intensity, whether of subject matter, color, or attack, has an analogous effect. Hofmann's gesture and impasto are occasionally so cataclysmically violent that relationships seem to jump from the anthropic scale of his pugilistic application of pigment to symbolize some gigantic natural—or in our age man-created—crisis. An opposite sort of monumentality is created in the best of Franz Kline's black-and-whites (Fig. 285). The huge, precisely spaced strokes and white areas strike like a clap of thunder, as if from outside the canvas; and though the image is artfully structured within its format, the pounding impact cannot be contained, so that the composition must be interpreted as a detail: the focal center of a vast complex of energy, a field simultaneously bombarded by equivalent negative and positive forces.

In these instances we again encounter what might be called the "American" aspect of Abstract Expressionism. In the increasingly large canvases which followed the expansion by Pollock and Hofmann in the mid-1940s, and in the push of the expressionist handling to the nth power during the same period, the American drives for maximum

size, energy, and intensity are amalgamated with ideas whose roots are in Europe and the Orient to form a new product.

It is easy to forget that artists aim at scales other than the monumental. I have identified what might be called "objective" scale with one phase of Motherwell's work; another scale could be called "intimate." It brings to mind Vuillard, especially the warm study in The Museum of Modern Art of his mother and sister, in which the dotted walls push inward. Scanning his own pictures, Motherwell wishes "there were more Bonnards and Vuillards among them."[117] Would it be farfetched to suggest that the scale of the Intimists, and the greater Renoir, is denied us as contemporary Americans, that we are so conditioned that we cannot paint the scale of intimacy, softness, tenderness, and domestic warmth? We turn away from the quiet sensuousness and beauty of the everyday world, craving for conflict, tragic ritual, intensified essences, and colossalism. There is little peace in Abstract Expressionism.

De Kooning's scale is intimate, yet shockingly different from that of Vuillard. He speaks of the still-life objects of the Dutch painter, the things which "were always things in life—a horse, a flower, a milkmaid, the light in a room through a window made of diamond shapes maybe, tables, chairs, and so forth"—objective and human scale. He finds reality in the close-up: "For me, only one point comes into my field of vision. This narrow, biased point gets very clear sometimes. I didn't invent it. It was already here."[118] He searches out the "intimate proportions" of anatomy and attempts to recapture "the feeling of familiarity you have when you look at somebody's big toe when close to it, or at a crease in a hand or a nose or lips or a necktie."[119] By opening the body structurally, de Kooning goes inside it. Picasso abstracted interior anat-

omy; Surrealism and Expressionist Realism represented it. Gorky, beginning with *The Liver is the Cock's Comb* (Fig. 70), synthesized the individual entities of inner body organs with a magnified "look into the grass," fitting them into a scale at once that of interior architecture and landscape.[120]

Only the two extremes of scale remain to be considered: the microscopic, and what might best be called the cosmic. The influence of the microscope on modern art, though it no doubt exists, has been overemphasized by the popularizers. What one sees through its eyepiece is just not human (or even natural) enough to interest our group of painters, although Rothko's forms of the forties bear a resemblance to microscopic organisms, and one work is entitled *Birth of Cephalopods* (Fig. 200)— though they are undersea, not microscopic, creatures. His view is symbolical rather than microscopic, expanding a concentrated content within, behind, or below everyday reality.

Moving outward from this inner world, and back to de Kooning's fixated point—to still life, objective and human scale, that of the architectural interior, the landscape, and the cityscape of Tobey, our vision becomes more encompassing, but people and things grow smaller and smaller. "My imagination," Tobey says, "has its own geography."[121] Occasionally, almost against his will, we have seen that Tobey's scale becomes macrocosmic, as in *Space Intangibles* (Fig. 271), or it oscillates between microcosm and macrocosm, as in *Universal City* (Fig. 278). Here the boundary between the scale of the painter and that of the scientist or metaphysician is almost crossed. It is far from the human and objective reference of Motherwell or de Kooning, speculative and mystical. We are at the point at which the structure of philosophy, "the architect of the buildings of the spirit," begins. Scale becomes philosophical.

The modern artist, although keenly aware that his work is understood and appreciated only by a small minority, does not attempt to make his art more palatable to a mass audience. As far as the process of making a painting is concerned, he endeavors to be unaware of the problem of communication. But he is intensely interested—as is his public—in the process, at once technical, psychological, and spiritual, by which a work of art is formed. Consideration of its various phases raises issues around which essential aesthetic decisions are debated.

The process of making a painting falls quite naturally into four stages: the attitude before starting the work, and the origin of the idea; the actual beginning; the central period of involvement; and the work's completion.

"Is it possible to say why we begin to create a work?" asks the sculptor Richard Lippold.[1] Except for those rare instances in which a modern artist works on commission, he has not the slightest assurance that the piece he is about to begin will find a buyer, or even a casual audience. Why does he choose to make a painting? What emotional and intellectual set precedes the beginning of a work of art? Is it, as Motherwell suggests, an activity which fills the void that the artist feels as a result of his consciousness of separation from society? Is it "to escape from depression," as the sculptress Louise Bourgeois says? Does the artist gain confidence or assurance by objectifying feelings of pain, anxiety, or anguish? Louise Bourgeois answers her own questions: "I try to analyze the reasons why an artist gets up and takes a brush and a knife—why does he do it? I feel it was either because he was suddenly afraid and wanted to fill a void, afraid of being depressed and ran away from it, or that he wanted to record a state of pleasure or confidence, which is contrary to the feeling of void or fear."[2]

To list the possible mental and emotional states which precede creative activity would be to describe the entire range of emotional life. Everyone approaches his or her daily routine with painful, pleasurable, or mixed feelings—questionings, unfulfilled needs, surges of confidence or exhilaration. Such emotions, though they unavoidably affect one's actions, are pushed aside as separate from everyday business. In modern society it is only in the arts that such intimate material can play a legitimate role in professional life. At the same time, artists feel that raw or unrefined emotion must be distilled. But questions of what kinds and degrees of emotion should be allowed to remain, what constitutes rawness or refinement, and to what degree art should be personally referential remain controversial. As a moderator in the 1950 Studio 35 sessions, Alfred Barr notes the interest of the general public in the "specific emotion" of a work of art. He asks: "How did the artist feel when he did the thing? Was it painful? Was it a matter of love or fear, or what not? . . . How important is . . . conscious emotion such as pleasure, grief or fear in making your work?"[3]

By comparison with the frustration and self-pity represented in such paintings as Munch's *Self-Portrait with a Wine Bottle* (Oslo Kommunes Kunstsamlinger, Munch-Museet), which depicts the painter alone in an almost empty café, Abstract Expressionist emotion is never raw. Although the desire to fuse some sort of feeling with paint is a characteristic aim of all expressionism, nonrepresentational form prevents the illustration of emotional situations. Painters as different as William Baziotes and de Kooning have pointed out that there is no one expressionist emotion, but many kinds and shades of feeling. Yet no sensitive and sympathetic observer needs instruction in psychology to respond to the anguished gaiety of a de Kooning, the dream states of a Baziotes, the sensuousness and fluency of a Gorky, the aggressive exhilaration of a Hofmann, the human sympathy of a Tobey, the playfulness and wit of a Motherwell

collage or the funereal tragedy of certain of his black-and-white canvases. These qualities, one can assume, reflect the intimate emotional lives of the artists; though their connections with previous states may not be verifiable by experimental psychology, they are specific enough for art criticism. Almost without exception, the emotional qualities in the works of these painters have been translated into the terms of their medium. In John Dewey's sense, the emotion is aesthetic, rather than raw.

The purist viewpoint opposes the use of the painter's feelings as content. It asserts that, next to a canvas by Mondrian, Fritz Glarner, or Burgoyne Diller, a de Kooning or a Pollock looks "degraded" and "dirty." The Abstract Expressionists are accused of "emptying their guts" in public, of reducing painting to a form of indiscreet catharsis. As a result, they are said to suffer feelings of guilt which make them "apologetic."[4] Except from a special point of view, these remarks cannot be regarded as valid criticism, yet they are valuable in establishing a reference point from which to study the role of personality in Abstract Expressionist painting, to show the coexistence of a sort of puritanism with various shades, degrees, and levels of emotional expression, and to demonstrate the ineffectuality of any single word or phrase to designate adequately the opinions of any group of artists.

Aside from the dichotomy between purists and the painters we are considering, there exists one between anti-expressionists, who veil or neutralize their attitudes, and the more overtly expressionistic painters. The argument concerning personal projection is critical for the creative process. Are emotions nursed as immediate content or do they serve only as a source of energy, to be eliminated in the interest of a nonreferential art, or the higher truth of an alter ego which rejects baser material? The resolution of this problem provides a key to the difference between the mystical goal of a reality

"out there" and what might be called "existential" expressionism.

Common associations with the word "expressionism," influenced by the work of Munch, van Gogh, Nolde, and Soutine, lead us to connect with it only lugubrious and turgid emotions, so that extemporaneous discussion, itself usually characterized by overintensity, tends to oscillate between demands for the obliteration of emotion and a defense of its brute forms. The polarity of discourse oversimplifies an infinite diversity of attitudes which fall between sheer self-projection, responsive feeling, formalism, and various varieties of mysticism. Systematically to label these levels of psychological content as intellectual, emotional, social, or physical would be a hopeless task. "We must remember," Motherwell writes, "that ideas modify feelings. The anti-intellectualism of English and American artists has led them to the error of not perceiving the connection between the feeling of modern forms and modern ideas. By feeling is meant the response of the 'body-and-mind' *as a whole* to the events of reality."[5]

If the evidence of this book again establishes the individual personality as a fundamental subject of modern art, it also demonstrates the rich possibilities of an art of personal expression, objectivized and universalized by its relationship to the social and natural world and by the mediating force of pictorial tradition.

Beginning

Richard Lippold asks: "How do we begin the work; from an idea, an emotional point of view based on experience, or form?"[6] It should be helpful to remember the reorientation that has taken place in this phase of the creative process through the rejection of narrative and realistic subject matter. The Medieval painter of religious themes began

with a commission and specific dogmatic stipulations. Delacroix began with both literary and visual subject matter. Even the modern still-life, landscape, or figure painter starts from his motif if not with a story. Like Cézanne, he may reorder nature in terms of his own sensibility and sense of structure or, like van Gogh, in terms of his existence. Gradually, as he works, his personal view of the world can reveal itself, strengthened by the visual and tactile facts of the subject. Ignoring these traditional points of departure, Lippold's question suggests three possible beginnings: an idea; an emotional point of view based on an experience; or one derived from form. To these a fourth and fifth—the medium, and the creative process itself—could be added.

Only Hofmann of the six painters we are studying has continued to paint directly from a specific landscape, figure, or still-life motif. This is not to say that the others have chosen to ignore the world. No American painter has probed natural form more carefully than Gorky; and Tobey's realistic detail shows his constant observation of men—their customs, their isolated rooms, their artifacts—as well as the face of nature. But their connection with the world differs from that of the realist or the Impressionist. De Kooning's figures were once painted directly from a model or dummy; like those of Motherwell, now they come from images stored in his mind. Naturalistic or abstract, the modern artist makes contact with the world by filtering it through a screen composed of his memories, feelings, ideas, knowledge, and philosophy. As never before, he must draw on himself. Broad as his outer experience may be—and it is surely more diverse than ever before—it is transformed by the experiencing consciousness even before the work is begun.

Lippold's statement of his own method of beginning a piece of sculpture is valuable, both in its differences from, and similarities to, the approaches of the painters:

The early suggestions of form take place for many of us at the stage of sketching or small model making—if you have to make a model—and when that phase comes to an end, I then begin to work on the piece itself . . . I have never made a piece without its springing from the memory of some experience—an emotional experience, generally. I almost always, from the beginning, have a title which labels that experience, because I want it to act as a discipline in eliminating any extraneous ideas which might come into the sculpture. As we all know, the first line or brush stroke can lead to millions of possibilities, and for me to keep clear is to keep a title in mind. It is of value to me at the beginning. When an experience has made itself so persistent in my unconscious or conscious mind—or both—that I feel that I want to make something which reflects that experience, I find my eyes constantly observing all things. While that experience is a memory, suitable forms can be suggested by any number of objects in life: a line on someone's face, or a crack on the floor, or an experience at a newsreel theatre. Then the problem of how to work out the experience which I have had presents itself; I may begin with that idea, and I have to adapt it to my medium. I have to make it clear enough for others to see its relationships. All of this takes place in the sketch stage—in the models I make from drawings. The drawings become more conclusive as I work. Generally when I work on a piece I make very few changes.[7]

Lippold's statement is quoted at length not only because it is clearly stated but because his sculpture and his view of the creative process are in some ways closer to the purist than to the Abstract Expressionist position. Final form is predetermined by the time the piece is begun. One might suppose that his insistence on a blueprinted design is dictated by the intractable medium of sculpture, in support of which Theodore Roszak's planned approach might be cited.[8] David Smith, on the other hand, though he makes many free gouaches or drawings (often

over twenty for one work), drops those which leave nothing to be developed and never uses a preparatory model, stressing the fact that "things happen during the stages of making a sculpture."⁹ More probably, Lippold's process is the result of his particular *kind* of work: "It may be that my work, by nature, almost determines its own conclusion; it is not possible to make many changes once the thing is quite far along."¹⁰

A method which demands complete predetermination contrasts with that described by Motherwell:

I begin a painting with a series of mistakes. The painting comes out of the correction of mistakes by feeling. I begin with shapes and colors which are not related internally nor to the external world; I work without images. Ultimate unifications come about through modulation of the surface by innumerable trials and errors. The final picture is the process arrested at the moment when what I was looking for flashes into view. My pictures have layers of mistakes buried in them—an X-ray would disclose crimes—layers of consciousness, of willing. They are a succession of humiliations resulting from the realization that only in a state of quickened subjectivity—of freedom from conscious notions, and with what I always suppose to be secondary or accidental colors and shapes—do I find the unknown, which nevertheless I recognize when I come upon it, for which I am always searching.¹¹

Lippold's view aspires to that pole which I have called purist: an ideal closer to Neo-Classical than Romantic precedent, it values predetermination, clarity, planning, and discipline over freedom, unbridled emotionalism, complication, variety, movement, and so on. "The only thing I am interested in resolving," he says, "is that intent with which I begin, because I feel in our time there is very little else with which to begin. To grope through a series of accidents is not the function of the artist. The job of the artist is only the job of a craftsman."¹² The sculptor David Hare poses the question specifically: "Do you work from a previously formed conception, or does your work become its own inspiration as it progresses?" Motherwell sums up the two views: "One is a notion that a work in its beginning has its conclusion implied. The conclusion follows the original line of thought and the process is to cut out anything that is irrelevant to that line of thought. The other notion is a notion of improvising—that one begins like a blind swimmer and what one finds en route often alters the original intent."¹³

Whichever pole a given artist's method approaches, both attitudes are involved; but the change in emphasis from one artist to another is significant. The struggle between conceptual determinism and improvisation is a recurrent human experience. Its solution depends in great part on personality: one man seeks discipline to control unpredictability, whereas another, seeking release, courts possibility. It is plain, however, that the disposition of Abstract Expressionism is against predetermination. Finding a go-ahead in Dadaism and Surrealism, its challenge to one-sided intellectualism has taken several forms. "Don't underestimate the influence of the Surrealist state of mind on the young American painters in those days," Motherwell wrote Thomas Hess.¹⁴ Surrealism's emphasis on the unconscious and automatism, coupled with the earlier Dadaist devotion to accident and bulwarked by a filtration of ideas from Dewey, Bergson, Whitehead, and French Romanticism, is a direct historical source of the Abstract Expressionist idea of creative process.

In 1945 Jackson Pollock's dripped style dramatized the implications of automatism. Remarking the importance, in 1944, of the presence of European artists in New York, he was "particularly impressed with their concept of the source of art being the unconscious."¹⁵ Workouts perhaps, but no traditional preparatory sketches preceded the movements that poured paint on the horizontal surface of an unstretched canvas, so that the proce-

dure was as truly automatic as any in the history of modern painting. "When I am *in* my painting," Pollock said, "I'm not aware of what I'm doing."[16] This is indeed unconscious painting—but in the motor sense, like the involvement of a child or a primitive in a ritualistic or playful dance. It is quite a different automatism from the literary or representational improvisation of the Surrealists which affected Gorky. In Pollock's process the image was avoided by fluidity. No symbolic representations, sexual or otherwise, appeared. Again we see the formal aspects of Surrealism retained as its literary-symbolic side was abandoned. Motherwell explains formal automatism in a way which clearly separates it from the psychic catharsis of automatic writing, free association, and the other Surrealist and psychoanalytic techniques: "Plastic automatism . . . as employed by modern masters, like Masson, Miró and Picasso, is actually very little a question of the unconscious. It is much more a plastic weapon with which to invent new forms. As such it is one of the twentieth century's greatest formal inventions."[17]

Pollock's brushless technique, however, tended to short-circuit subjectivity. It parallels the automatic form constructions of the spider, or even of a botanical growth. Like the fluid dripping methods of the painter Knud Merrild, it becomes a form of activational naturalism. Less revolutionary technical processes actually tie the medium more closely to both the conscious and unconscious personality.

"At the time of making a picture," Hofmann says, "I want not to know what I'm doing; a picture should be made with feeling, not with knowing."[18] James Brooks begins with improvisation. He tries "to get as much unknown on the canvas" as he can, "to get a great many unfamiliar things on the surface." He goes as far from predetermination as possible—the opposite of Lippold's aesthetic: "Then I can start digesting or changing." Baziotes points up the contrast: "Whereas certain

people start with a recollection or an experience and paint that experience, to some of us the act of doing it becomes the experience; so that we are not quite clear why we are engaged on a particular work."[19] The element of chance, "the extremest faith in sheer possibility,"[20] is involved in this point of view. The painting of the School of New York, according to Motherwell, is conceived "as an adventure, without preconceived ideas on the part of persons of intelligence, sensibility, and passion. Fidelity to what occurs between oneself and the canvas, no matter how unexpected, becomes central."[21] "The reason we begin in a different way," Baziotes explains, "is that this particular time has gotten to a point where the artist feels like a gambler. He does something on the canvas and takes a chance in the hope that something important will be revealed."[22] George McNeil offers the same analogy: "Painting is like rolling dice, always in the hope that something might turn up—always hoping for something that might be productive."[23]

Unadulterated (as it seldom is), the spirit in which the extreme Abstract Expressionist painting is begun can be summarized thus: shapes, colors, and lines are placed on the canvas with the least possible premeditation, their initial form and juxtaposition dictated by various levels of the sub-, un-, or semi-consciousness—by unplanned inspirations, by sheer fortuity, or by the inherent nature of the medium. Here is a disorganized but vital complex of raw formal data—an uncoordinated "unknown," a Heraclitean flux which the painter during subsequent phases of the process relates, alters, and organizes on the basis of a mediating set of attitudes and principles which runs throughout his works, and even through all of his life. In direct contrast with the purist point of view, predetermination of goal is regarded not as an essential discipline, but as a danger. "The question of what will emerge is left open. One functions in an attitude of expectancy." Motherwell and Harold Rosenberg

quote Juan Gris's statement: "You are lost the instant you know what the result will be."[24] Lippold's concept is rejected by the sculptor Seymour Lipton as an "*a priori* kind of view."[25]

In dialectically presenting two poles of creative process, one must constantly be aware that even in the purest instances the one must partake of the other. The premeditated idea can only rarely be avoided completely; and once an automatic process is repeated, its culmination is to some degree implicit in its beginning—not in exact placings, sizes, and coloring, but in the type of form and structure the process evolves. More often than not the formative process combines, or exists at an intermediate point between, these two poles. When Ad Reinhardt remarks that the paintings of Hedda Sterne "to some extent" appear "generally planned and preconceived," she answers: "Preconceived only partly. Because as I go, the painting begins to function by rules of its own, often preventing me from achieving my original vision."[26] The importance of revising a conception during its growth is stressed by John Dewey: "If the artist does not perfect a new vision in his process of doing, he acts mechanically and repeats some old model fixed like a blueprint in his mind . . . The real work of an artist is to build up an experience that is coherent in perception while moving with constant change in its development."[27] Despite his criticism of the blueprint, Dewey's idea of process is closer to Lippold's than to Miró's or Motherwell's. He would not have condoned automatic beginnings.

As a painter lives a form biography, his concept of a painting changes. Individual works are not isolated jobs, but, as the sculptor Herbert Ferber graphically states: "There is a stream of consciousness out of which [individual works] pop like waves, and fall back." He likens the succession to the turns of a kaleidoscope, where each painting is an image, each "only a moment in the whole process."[28] David Smith sees individual works as parts of a "work life" or "work stream."[29]

Within a broader evolution, separate paintings do not confront the unknown to an equal degree. To meet its challenge is regarded by Motherwell as only one phase of his art: the "mode of discovery and invention," which can but rarely be maintained.[30] Fundamental discoveries are few: in 1935 Tobey, through his own experience and a feeling for the Orient, radically revised his approach to art; Gorky did it through nature in 1943. Such realizations may happen only once—or, to some painters, never. Once a process-form-concept synthesis has been adopted, successive pictures belong to an evolving type, each work constituting a new phase in the growth of a changing idea which, like the prow of a boat propelled from its stern, establishes new positions based on the past.

If an artist, like a sinner in search of salvation, renounces a previously established position, he must sometimes scrap his past utterly. Such crises in a painter's form biography threaten his whole way of life; he may be forced to give up his gallery, his friends, and his source of income. In other cases, when divergences are less extreme, he may have more than one direction. Hofmann produces canvases which he classifies into several types; Motherwell has divided his work into Capriccios, Elegies, and Wall Paintings.[31] Until the fifties, de Kooning painted in separate figurative and abstract directions.

When painting is conceived as a total process in which the artist never abdicates for the technician, a particular relationship of the sketch or model to the finished work results. Many modern painters, and even sculptors, make no models or sketches. Of those who do make sketches, few regard them as preliminary drawings, feeling that the blueprinting concept is inorganic. Among the painters, the relation of the sketch to the finished work is more

closely paralleled in the development of Picasso's *Guernica*. Sketches are made in quantity, each an independent experience. In repeated variations an idea is developed which may dominate the later image. Yet the conception is never finished; it is never frozen to the point where it is reproduced by mere craftsmanship. To a view which parallels art to life, as organic experience and growth, such a procedure is inimical: completion can only come once, in Rothko's final "flash of recognition."[32]

Nevertheless, no absolute connection can be made between an ideal Abstract Expressionist creative process and a specific technical procedure. The most illuminating case in this regard is that of Gorky, whose late paintings appear more fluid, dynamic, and fluctuating than those of many of his successors. But they were produced, as we have seen, by a systematic method in which the central image, the main colors, and the general disposition of the elements were blueprinted and then enlarged by squares (like the murals of Pierre Puvis de Chavannes!) to the final format. Gorky had the unique ability to live an organic creative cycle on a sheet of paper (which itself became a significant work of art) and later to monumentalize it, while retaining both the identity of the original drawing and the vital build-up to a culmination.

Like no past art, the painting of this century has moved in the direction of freedom. In so doing, it has at the same time emphasized the human need for autonomous discipline, for a focus, and for an idea as a center. But the work itself is an end result, not the representation of an a priori conception.

The Central Period

Whatever combination of feeling, philosophical outlook, historical knowledge, or personal tension may provide the artist with a reason for painting, it can only gain meaning as it coalesces with the materials that will become the work itself. Yet it would be a distortion to see the embodiment of content as a simple expression-to-material cause-and-effect relation. For Tobey the brushstroke, in the Oriental sense, is "the symbol of the spirit," but his ideas also rise from his medium; and in Hofmann's aesthetic, spiritual qualities are as much a result of, as an impression upon, the medium. Canvas and pigment are not materials to be stamped with a preordained image, but active participants which condition the work's advance. What was a valid statement when it was laid on the surface can become a mess, and what was an error can become valid. An interacting relation with the medium is set up which, depending on the spirit of the artist, can be regarded as a conversation, a dialectic, a battle, a fencing match, or even a love affair.

We are familiar with the crucial position that Abstract Expressionism assigns to the medium. As it is structured, it "brings feeling into being, just as do responses to the objects of the external world." The intercourse with the medium, whatever its emotional tone may be, "on an ideal plane" is identified with one's intercourse with the world.[33] What might be called "backtalk"—the resistance of the medium—can symbolize the resistance of the world to change.

In an existential aesthetic no part of the process is merely technical; it is a symbolic act, inseparable from the biography of the artist. During his years of teaching, Hofmann has been forced to formulate this organic relationship of process, personality, idea, and material. Once we surmount the hurdle of a special vocabulary, his explanation of it is quite clear. Art, which is "a reflection of the spirit, a result of introspection . . . finds expression in the . . . medium." Every aspect of spiritual, expressional, or philosophical content should be con-

sidered among the "intangible forces inherent in the process of development," which Hofmann regards as "surreal" (using the word without reference to the Surrealist movement). Yet "surreal" content is disembodied and impotent until it is embodied in a "physical carrier." Phrased differently, "an idea is communicable only when the surreal is converted into material terms." The technical problem of the artist, therefore, "is how to transform the material with which he works *back* into the sphere of the spirit."[34]

Hofmann asserts, "the difference between the arts arises because of the difference in the nature of the mediums of expression . . . Each means of expression has its own order of being, its own units."[35] Concern here is with the primary separations between literature, music, sculpture, and painting; but implied is the need for an affinity between the qualities of an idea, the character of the medium, and the manner in which it is used. As for painting, differences between the processes, tools, materials, and surfaces used by the painter imply analogous spiritual differences. A given content not only implies a particular psychological attitude and technical approach, but a selection between the intrinsic qualities of the medium of expression — whether it is dry or flowing, brittle or pliable, shiny or mat, opaque or transparent, or whether it lends itself to thin layers or heavy impasto.

The process of making a work of art, according to Hofmann's belief, requires the active establishment of relationships between the material medium and the spiritual-expressive content contributed by nature and the personality of the artist. By means of relationships between the elements of the work of art, the "surreal" is made manifest. The material "body" of the painting is a "physical carrier" which is overshadowed by a "mystic overtone." The overtone spontaneously transforms the means of creation into a spiritual reality. Herein lies the mystery of creation.

Hofmann's manipulation of oil paint is of unprecedented violence, and the intensity of his "enlivenment of the expression-medium"[36] forms a part of his theory, yet his writing gives only secondary consideration to the physical and psychological aspects of the creative process. Harold Rosenberg speaks of the artist as playing a "role," and of painting as an "act" so deeply involved with the biography of the artist that "every distinction between art and life" is broken down.[37]

Unless he is the kind of artist whose technique, like that of Lippold, requires him to be a craftsman once his concept is fixed, the central phase of the creative process involves the entire range of his personality. And during the event itself, all but fleeting realization of the divisions established by analysis between kinds and levels of consciousness is lost in an experience whose outcome, like that of experience in the world, cannot be predicted.

Each stroke with a brush, knife, rag, or finger leaves a mark on the canvas. If the paint, in its turn, runs, drips, or merges with an adjoining area, human gesture is answered with "natural" gesture. Whatever happens (to the degree that the procedure of any specific painter approaches this hypothetical process) inevitably involves the unexpected. The accident of the medium which uncovers an unprecedented configuration of forms, the unplanned beauty of a wash, a smear, flow, or drip can be pure gold, and even the key to a new content. To a painter who is quick to intuit possibility, however, a chance effect is only accidental once: if it seems effectual, he will incorporate it instantly into his repertoire of intentional procedure.

The idea of creative process outlined — though it must again be stressed that it does not purport to represent the specific procedure of any one painter — lies, in its emphasis on organicism, at the heart of the Abstract Expressionist attitude. "Making a picture is almost a physical struggle," Hofmann remarks.[38] For Tobey it is the necessity for each

brushstroke to be a living, active contribution to a dynamic whole which is basic to his painting method. To de Kooning painting is a "way of living."[39] Though Rothko draws a veil between his pictures and their formation, he assigns to his shapes the gestures which are more apparent in the works of others. It is an aesthetic close to John Dewey's *Art as Experience,* which influenced the Surrealist Matta—the experience of the live creature, of the organism in its struggles and achievement in the world.[40] "Since the painter has become an actor," Rosenberg writes, "the spectator has to think in a vocabulary of action: its inception, duration, direction—psychic state, concentration and relaxation of will, passivity, alert waiting."[41]

Finish

Working with what might be described as an organic, rather than a blueprinted process, the painter allows form to develop spontaneously, and to a degree even automatically and accidentally. As he continues, however, the structure becomes increasingly distinct, the final state begins to emerge. Identification with the work decreases, so that the instant it is completed, "the intimacy between the creation and the creator is ended" and the painter becomes what Rothko calls "an outsider."[42] De Kooning paints himself "out of the picture"; a work is finished for Hofmann "when all parts involved communicate themselves, so that they don't need me." The work becomes an object which, though it retains the imprint of its maker's actions, is now independent of them. At this point, putting aside for the moment the question of whether or not the picture is finished or complete, the creative process is over. "As I work," Hedda Sterne explains, "the thing takes life and fights back. There comes a moment when I can't continue."[43]

The identification of the painting process with that of living has greatly altered the conception of completion. Clear criteria of craftsmanship determine finish in representational work: accuracy of naturalistic values, development of detail to the point implied by a particular technical treatment, and so on. But for a vitalistic aesthetic "what is a 'finished' object is not so certain" (Motherwell). As individual images drawn from a stream of consciousness, "works aren't really complete in themselves . . . The sense of 'finishing' a particular work is [therefore] meaningless" (Ferber). Denial of traditional ideas of completion is so common as to be unanimous: "a sculpture or painting is never finished, but only begun" (Ibram Lassaw). "I consider a painting almost 'finished' when I am half finished with it" (Jimmy Ernst). "I never know when it is 'finished.' I only know there comes a time when I have to stop" (Janice Biala). "The idea of a 'finished' picture is a fiction" (Barnett Newman). "A work is never finished" (David Hare).[44] It is for this reason that Ferber insists that the day of the masterpiece is over, and that Motherwell concludes that an artist must not be judged by one work but by a group which can give a spectator a richer view of what David Smith calls his "work stream."

Nevertheless, certain criteria of completion are apparent. The first is already established: that moment when the work breaks off from the artist and he can do nothing more; though it must be recognized that this is a psychological rather than a formal criterion. Also psychological is Rothko's "flash of recognition," by which the conclusion implicit in the work is reached. For Lippold's predetermined process, it is the point when it "concludes successfully the prophecy of its beginning."[45] For most Abstract Expressionists, however, the work of art is an end result. Its final nature therefore could not have been prophesied, for the artist was only partially conscious of what it might be.

The remaining criteria are more objective in that they relate to the work itself rather than its generation. They reduce to two: unity and vitality. "A

work of art is finished from the point of view of the artist," Hofmann says, "when feeling and perception have resulted in a spiritual synthesis."[46] The sculptor Lassaw considers his work finished when he senses in it a "togetherness": "A participation of all parts as in an organism." Baziotes notes that "the eye seems to be responding to something living." These two characteristics of the finished work of art can be stated as one: the work must have a living and active unity. Regarded from the traditional point of view, which defines the work of art as neat, completed craftsmanship, this insistence on the maintenance of movement, action, and partially unresolved tensions represents, many of the artists say, a refusal to finish the work. James Brooks's thoughtful and tentative statement suggests the character of this unfinished completion: "I think quite often I don't know when a work is 'finished,' because I often carry it a little too far. There is some peculiar balance which it is necessary to preserve all through a painting which keeps it fluid and moving. It can't be brought to a stop. I think you have to abandon it while it is still alive and moving, and so I can't consider a painting 'finished.' . . . But the 'end' is a very difficult thing, something that is determined, not by the form that is 'finished,' but by the fact that I have worked on it."[47]

The emphasis on an equilibrium which is moving, and which by consequence rejects absolute location and static balance, is a concept which runs through all modern painting. Activism, as we have seen, has been intensified in the American environment: a fact which arises in a discussion of contrasting degrees and qualities of finish in French and American paintings. Motherwell calls attention to "the real 'finish'" of French paintings; finished in that "the picture is a real object, a beautifully made object . . . [but] we are involved in process."[48]

From the viewpoint of the spectator the retention of unfinish is especially significant. He can no longer assume the role of passive or judicial observer of a completed event. A painting resulting from these means and processes will not allow the sensory responses of the audience to settle. The colored squares of a Mondrian, despite their neatness, and the multicolored interlaces of a Pollock refuse to resolve themselves into an unchanging configuration. As a result, the painting exerts a functional control over the sensory activity of its audience, and the artistic process continues with their enforced participation. Tensions are never fully resolved unless a specific observer is able to reduce the whole to a stillness within his own consciousness.

Only one qualification remains: activism, dynamism, organicism, and pictorial functionalism inherently posit their opposites. A confrontation of forces is a form of motionlessness which, as tensions slacken like relaxing nerves and muscles, approaches tranquillity. "We recognize the static as the sum total of the dynamic," Hofmann says, "just as we recognize the two dimensional as the sum total of the three dimensional."[49] Will the eventual outcome of four decades of painting, taking movement as a basic premise, be a viable immobility with a suspended tension like revelation or meditation? Modern art is still a quest for an absolute.

The eternal dualistic problem is, in Motherwell's words: "Drama moves us: conflict is an inherent pattern in reality. Harmony moves us too: faced as we are with ever imminent disorder, it is a powerful ideal. Van Gogh's drama and Seurat's silent harmony were born in the same country and epoch; but they do not contradict one another; they refer to different patterns among those which constitute reality." Confronted with a Mesopotamian figurine, de Kooning may get into a "state of anxiety. Art never seems to make me peaceful or pure. I always seem to be wrapped in the melodrama of vulgarity. I do not think . . . of art . . . as a situation of comfort." In 1953 he was still "working out of doubt."[1] From a psychological point of view, de Kooning's painting career could be considered as a monumentalization of indecision.

Dichotomy and Synthesis

Tension was isolated in Chapter 3 as a formal principle of modern art. The inner conflict known as anxiety is also tension. An eminent American psychotherapist, Rollo May, has concluded, after a study of the historical origins of the modern personality, that "our middle of the twentieth century is more anxiety-ridden than any period since the breakdown of the Middle Ages." Along with feelings of "hollowness" and "loneliness," May finds a fundamental cause for our "age of anxiety" in the "splitting up of the personality . . . prepared by Descartes in his famous dichotomy between mind and body": the theory that "the body and mind were to be separated, that the objective world of physical nature and the body (which could be measured and weighed) was radically different from the subjective world of man's mind and 'inner' experience." The true prophets of the mid-twentieth century, the psychiatrist believes, were Sören Kierkegaard, Friedrich Nietzsche, and Franz Kafka.[2]

It is scarcely necessary to point out that with various emphases a similar interpretation has been advanced by many psychologists and by sociologists, theologians, philosophers, critics, poets, and artists. Evidence of the painter's response to the modern "compartmentalization of personality" is offered in every chapter of this book. It is not my purpose to diagnose the ills of society, but to call attention to a key issue raised at every level of our subject, and which I have called The Problem of Opposites. It is not a new issue, for it has colored Western culture since the time of the Ancient Greeks, the thinkers traditionally identified with the triumph of rationalism. However, as E. R. Dodds has shown, they, too, were faced with a dichotomy between mind and emotions, had their Age of Reason, and were confronted, during the Hellenistic period, with its breakdown.[3]

With the development of modern social, economic, and political systems and the intellectualism and scientism which accompanied them, the ancient dualism became ego-centered and was violently intensified in the struggle between Romanticism and Classicism. Returning to ancient origins, Nietzsche's *The Birth of Tragedy* advanced an aesthetic theory based on opposites: "In contrast to all those who are intent on deriving the arts from one exclusive principle, as the necessary vital source of every work of art, I keep my eyes fixed on the two artistic deities of the Greeks, Apollo and Dionysus, and recognise in them the living and conspicuous representatives of *two* worlds of art which differ in their intrinsic essence and in their highest aims."[4] As the nineteenth century moved toward its apogee of scientific optimism, criticism, philosophy, and political theory emphasized either dualistic tension or conflict.

It is significant that, from the thinkers of the nineteenth century, May chose Nietzsche and Kierkegaard as his prophets, for both have a direct connection with the subject of this book. Nietzsche's

conception of the Apollonian and Dionysian, and of dualism as the essence of tragic art, made a deep impression on Rothko, who found his subject matter, during the mid-1940s, in Greek myth and tragedy. Antitheses, Rothko feels, are neither synthesized nor neutralized in his work, but held in a confronted unity which is a momentary stasis.[5] He would no doubt agree with the painter-critic who observed that the tension of color relations in certain of his canvases "has been raised to such a shrill pitch that one begins to feel in them that a fission might happen, and that they also might detonate."[6] In Kierkegaard, Motherwell finds a human being of sensibility and conviction torn by the same conflict between ethical values and feeling which he finds in his own inner life, and which, to him as it did to Kierkegaard's "Johannes the Seducer," has led to doubt of both art and self: "the despair of the aesthetic." Besides the opposition of Romantic to Classic and Apollonian to Dionysian in the nineteenth century, to mention the most obvious instances, there were the Hegelian dialectic of thesis, antithesis, and synthesis; the Marxist theory of class struggle; and, in the twentieth century, the compartmentalization of the personality into the ego, the superego, and the unconscious.

The vast questions raised by such a line of thought are, to say the least, unanswerable here, but it is essential that they be mentioned, if only superficially. Is the dualistic formulation a product of our cultural pattern or is it more deeply embedded in the human personality? Why, in the form criteria of equivocal space and flatness, confrontation of opposing stylistic poles, and emphasis on tension, has duality become so intrinsic a principle of progressive painting?

There are many conditions and solutions of dichotomy and not all of them involve conflict. The Gothic period found a synthesis in faith, which Neo-Thomists like Jacques Maritain offer as a key to modern problems; the Chinese principle of yin-yang poses a solution, quite different from that of the Western tradition, of reciprocal harmony. In each case where the old problem exists one must ask how it is resolved. Do the poles remain as an entirely separated dichotomy? Is their interaction one of hostile conflict? Do they result in an unresolved inner tension or anxiety? Are they harmoniously interlocked in a marriage of opposites? Or do they cease to exist, fused in an undifferentiated unity? Among artists the question of opposites is usually tied up with the words romantic and classic. In a discussion at the Artists' Club, de Kooning opposes the "potatoes of van Gogh" to the "pebbles of Arp": "The potato seems like a Romantic [organic] object . . . you can watch it growing if you don't eat it. It is going to change—grow, rot, disappear. A pebble is like a Classical thing—it changes little if any . . . If it was big you could keep the dead down with it . . . The Classical ideal is not around much anymore."[7]

A few weeks later the critic James Johnson Sweeney offers another metaphor, quoting Wordsworth's image of the stone as "Euclid's element," and the shell as poetic truth: "something of more worth." But the potato of van Gogh is by no means identical to the shell of Wordsworth. The figure becomes triple. A potato is an organism which lives and dies, a symbol of homely existence, whereas the shell, from which issues sounds in an "unknown tongue," speaks of exoticism and faraway places.[8] The potato and the shell provide a new opposition, that of expressionism to romanticism and "the distant in time and space."

It is true, however, as Morse Peckham has observed, that modern artists are closer to historical Romanticism than they are to Classicism. The Abstract Expressionists were deeply influenced by the Surrealists—who, according to Cyril Connolly, "were, perhaps, the last Romantics"—and they value the organism over the static whole, becoming over being, expression over perfection, vitality over

finish, fluctuation over repose, feeling over formulation, the unknown over the known, the veiled over the clear, the individual over society, and the inner over the outer.[9] Tobey speaks of a revelation which is "continuous and not final" and observes that "there have been 32 isms since the advent of cubism, yet after all there are essentially the same two old streams, the Romantic and the Classical. We've just been confused by the storm. Science and psychology have played a great part to say nothing of sex."[10] Motherwell, generalizing, sees the attitude of "poets, painters, and composers during the last century and a half" as "a fundamentally romantic response to modern life—rebellious, individualistic, unconventional, sensitive, irritable," an attitude arising "from a feeling of being ill at ease in the universe, so to speak—the collapse of religion, of the old close-knit community and family."[11]

Whatever the reasons for thinking in terms of oppositional concepts and principles may be, our psychic state is surely revealed by it. Classicism to the modern painter often connotes everything he rejects: academicized hardness of style, static handling which prevents freedom and gesture, cold intellectualism, rejection of emotion, and an absoluteness of space, bulk, and perspective depth which freezes equivalence and ambiguity. He accepts, on the other hand, structural classicism, the path of which has been traced (Raphael-Poussin-Cézanne-Seurat-Cubism) as the "Cubist-Classical Renaissance."[12] Such structural classicism can be said to culminate in the European paintings of Mondrian and in works of pure geometric form by other painters. Not only do Mondrian's works serve as the symbols of what I have called the "purist" position, but, beyond them, his life and ethics are exemplary, as is his belief in a metaphysical reality.

But the purist idea, in the thinking of the New York painters, operates as a nay-saying voice. Like the sermons of a Calvinist preacher it chastens the dramatics, the anguish, the self-involvement, the quasi-representationalism, and the accidentalism of the Abstract Expressionists. It is a sort of conscience, a dead center around which arguments based on the extremes of romanticism and expressionism can arrange themselves radially. The key to the purist viewpoint is its renunciations; it confines itself negatively. It eliminates all representation of the world, emotional expression, structural naturalism, in fact everything referential, to aim at a predetermined, noncontradictory harmony detached from life. It is with this attitude in mind, it would seem, that Motherwell writes that "one might almost legitimately receive the impression that abstract artists don't like anything but the act of painting."[13]

For the purposes of this phase of my discussion, the purist, the formalist, the classicist, the nonobjectivist, and the abstract painter merge into one hypothetical anti-expressionist position, which postulates perfectly planned works, precise in their finish, painted with no other consideration than that of "internal relationships," and, above all, crystalline in their clarity. But the purist goal represents only one pole, or central focus, for Abstract Expressionism, which is inclusive rather than exclusive.

Motherwell defines feeling as a "response of the 'body-and-mind' *as a whole* to the events of reality." In 1944 he wrote that the *Spanish Prison (Window)* (Fig. 161), "like all my works, consists of a dialectic between the conscious (straight lines, designed shapes, weighed color, abstract language) and the unconscious (soft lines, obscured shapes, *automatism*) resolved into a synthesis which differs as a whole from either. The hidden Spanish prisoner must represent the anxieties of modern life, the intense Spanish-Indian color, splendor of any life."[14] Six years later, in 1950, the painter Adolph Gottlieb, writing in the catalogue of the first impor-

tant exhibition held after Gorky's death, concludes:

as for a few others, the vital task was a wedding of ab-
straction and surrealism. Out of these opposites some-
thing new could emerge, and Gorky's work is a part of
the evidence that this is true.

What he felt, I suppose, was a sense of polarity, not of
dichotomy; that opposites could exist simultaneously
within a body, within a painting or within an entire
art . . .

These are the opposite poles in his work. Logic and ir-
rationality; violence and gentleness; happiness and sad-
ness; surrealism and abstraction.

Out of these elements I think Gorky evolved his style.[15]

Abstraction and Representation

Reverberations of the interminable argument be-
tween abstraction and representation are already
more numerous, in these pages, than the attitudes
of Abstract Expressionist painters (who try, more
often than not, to forget it exists) would justify.
For them the question is not one of separate cate-
gories; it is a razor's edge, or a continuum. As a
student of the philosophy of Whitehead, Mother-
well has evinced a special interest in the problem of
abstraction and in that painting which "in no wise"
images the external world. He also calls attention
to the "surprising anger" with which Braque, Miró,
and Picasso have "attacked the idea of a wholly ab-
stract art" and to Mondrian's shift "from an intent
of simple purification to one of expressiveness."
Taking a sociological point of view, he regards
pure abstraction as "an art of negation, a protest
against naturalistic descriptiveness";[16] and, like
Tobey, he suggests that extreme formalism will end
when the separation of the artist from society is
healed through the growth of common values.

Though many of Tobey's paintings are without
representation, it can be said that all of his work is
directed toward human and naturalistic goals, and
he is in sympathy with objections to the "abstract

academy": "We have tried to fit man into abstrac-
tion, but he does not fit."[17] He gets as tired, he
says, of abstract art as he does of sentimental rep-
resentation. Attacks against the "abstract academy"
are often directed toward Hans Hofmann's peda-
gogy, yet Hofmann has never been a nonobjectivist
nor insisted that art should renounce representation
completely. He is in fact the one among the present
group who has least tended to abandon direct
painting from a specific still-life, figure, or land-
scape motif. "The artist who works independently
of the chance appearance of nature," he says, "uses
the accumulation of experience gained from nature
as the source of his inspiration. He faces the same
aesthetic problems in regard to his medium as the
artist who works directly from nature. It makes
no difference whether his work is naturalistic or
abstract."[18]

Nothing so annoys Rothko as the suggestion that
he has become increasingly formalistic. He denies
the slightest interest in abstract art, asserting that
his substitution of ritual symbols for figures and his
later replacement of these by areas have been in the
interest of human content: "I do not believe that
there was ever a question of being abstract or rep-
resentational. It is really a matter of ending this si-
lence and solitude, of breathing and stretching
one's arms again."[19]

When asked the meaning of abstract art to him,
de Kooning answers that he doesn't understand the
question, and that "the word 'abstract' comes from
the light-tower of the philosophers . . . one of
their spotlights that they have particularly focussed
on 'Art.'" Abstraction, he suggests, was something
invented by the theoreticians, a question of "not so
much what you *could* paint but rather what you
could *not* paint. You could *not* paint a house or a
tree or a mountain. It was then that subject matter
came into existence as something you ought *not* to
have."[20]

On the basis of an avalanche of evidence too vo-

luminous to cite, Abstract Expressionism must be regarded as a rejection of programmatic nonobjectivism as well as of literalism, and a move toward a newly conceived connection between art and the world. The forties were years of expansion and synthesis, not limitation. Their tone can be summed up by another statement of de Kooning's: "There *is* no style of painting now. There are as many naturalists among the abstract painters as there are abstract painters in the so-called subject-matter school."[21]

Ambiguity and Clarity

One of the fascinating aspects of dichotomy as a content of art is that, as in life, it often rises out of just the strivings which aim at its resolution. In this way clarity becomes one side of a polarity, or, better, a hub, around which movement, freedom, accident, vagueness, expression, and a multitude of other experiences form a periphery. A poet participating in a panel devoted to painting and poetry speaks thus: "'Ambiguous' is one of my favorite words. Empson wrote a book on *Seven Types of Ambiguity*. I must have a feeling for the ambiguous! I couldn't live without ambiguity."[22] Purple though this declaration may appear, I believe the poet speaks for the painter as well.

The content of modern art centers in the psyche. Individual experiences are its irreducible data. Romanticism emphasized the process of becoming over being. Surrealism and Expressionism have explored dreams, the unconscious, automatism, accident, and revolution. Dadaism approached chaos and nihilism in what now appears, at least in part, as a search for meaning and truth. Rejecting the brightly lighted goal of the established and the known, modern art has sought the unknown. Consequently, an atmosphere of ambiguity and mystery has surrounded its development. So important is the recognition of the ambiguous in the works and

ideas of modern artists that it is impossible to circumscribe it as one of several topics. We are continually concerned, in each section, with forms and ideas whose implications are multiple, and whose meanings are ambiguous in one sense or another—dualistic.

The word "ambiguity" (derived from *ambiguus*, to wander about) can serve to designate all of those states rejected by the purist viewpoint, including dichotomies. In our circular figure it implies a series of radial oppositions to the clarity, precision, and unity identified with the ideas of classicism. Nevertheless, to treat ambiguity and clarity as a simple dualism is false. As dictionary definitions show, and as William Empson has explained in some detail, different ambiguities can be found which are quite distinct from each other, some far clearer than others.

Modern art is ambiguous in one reading simply because of its concentration on the analogy between creative and natural processes. The outcome of a modern painting is never completely planned in advance. Within a more or less prescribed framework, it generates its final form. Even Mondrian, cutting, coloring, replacing, and repainting the squares of colored tape by which his final results were approached, worked with a method which involved uncertainty, change, and accident. Picasso's *Guernica* suffered major alteration just before its completion. Painting is ambiguous in one sense because it is problematical; its outcome is uncertain. It could be said that Pollock's methods of picture-making during the period from 1948 until 1950 exemplify this type of ambiguity. Yet there is something almost mechanically clear and procedural, predestined and inevitable, about the rhythmic physical movements which formed his linear relationships. Real automatism dissolves ambiguity in natural mechanics.

Confusion, indeterminateness, and perplexity are other aspects of ambiguity. "Working out of

doubt," de Kooning has enshrined these very qualities. He remarks how artists' arguments "never get to the point" and, in endeavoring to explain why the painterly art of the Venetian Renaissance "started to tremble," concludes that "the artist was too perplexed to be sure of himself." During the thirties de Kooning's art oscillated between the traditions of expressionism, realism, and post-Cubist abstraction, so that any attempt to categorize it must chop it apart in order to put the pieces into the different pigeonholes. Instinctively, de Kooning opposes analytical categorization, an objection closely related to his feelings of anxiety and perplexity. "Some painters, including myself, do not care what chair [stylistic category] they are sitting on. It does not have to be a comfortable one. They are too nervous to find out where they ought to sit. They do not want to 'sit in style.' "[23]

In the virtually unanimous desire of painters to escape the categories in which critics and historians place their work in an attempt at clarification, they raise another of the conditions of ambiguity: that is ambiguous which can be classified in two or more categories, or equivocal if it cannot be definitely classified. Though an ideal of clarity is rarely absent from his mind, the artist in regarding art as a way of life, a "style of living," refuses to recognize the separateness of professional activity from private life and is resentful or contemptuous of attempts to dispel or evade the ambiguity of experience through formulation. He is committed, at some level and to some degree, to the suggestive, the evocative, and even the chaotic.

Unwillingness to separate abstract from representational painting is another aspect of Abstract Expressionism's ambiguity, though it can be seen as precisely the opposite: a realization of a false, and thus harmful, bifurcation. The path of de Kooning's brush can begin as geometric abstraction, modulate into expression, and finish by modeling a breast or suggesting a detail of landscape. A single work of Hofmann can begin from a provisional still-life motif and translate into a "real" subject matter which involves automaticism or improvisation as well as geometric abstraction. In Gorky's work, the same principle is true of subject matter. Of the American painters, he more than anyone else was instrumental in merging the ambiguities of image and meaning used by the Surrealists with the equivocal formal relationships of the abstract tradition. He structuralized the literary-photographic double and multiple image to produce what André Breton called "hybrid" forms, amalgamating the qualities of representational painting, automatism, pleinairism, and Cubism. But descriptive precision was invariably avoided: "I never put a face on an image."[24]

Rothko's art has been characterized as "veiled." Here is another variety of ambiguity which, as a lack of precise definition or intentional indistinctness, can be seen in the work of Theodoros Stamos, Balcomb Greene, William Baziotes, and others. Baziotes is especially interested in the enigmatic and mysterious: "As for the subject matter in my painting, . . . it is very often an incidental thing in the background, elusive and unclear, that really stirred me."[25] The overtones of his archetypical shapes go in many directions at once, suggesting sea creatures, vegetation, or animals—vague unnameable presences that seem to rise from the unconscious in response to shape and color. Rothko's mythic canvases elicit the memory of cryptic primitive experiences; his late pictures take us to a place of rectangulated definite-indefiniteness. Always the suggestion, the overtone, the veiled revelation—the indefinable area in which the artist's intention and the spectator's imagination meet. Perhaps with something like this in mind, in *The School of New York*, Motherwell quotes Odilon Redon's statement that his works "*inspire* and are not meant to be

defined. They determine nothing. They place us, as does music, in the ambiguous realm of the undetermined. They are a kind of metaphor."[26]

In attempting to understand the relation of ambiguity to an implicit goal of clarity, a distinction must be drawn which, it seems to me, is of crucial significance. The mysterious opalescent compositions of Baziotes recall the vagueness of dream states. They affect one's consciousness like an opiate or a sedative. Never is there the existential reality of de Kooning, the intense concentration of Rothko, or the mystical illumination of Tobey. Unlike the painters we have concentrated on, all of whom drive toward a central or inclusive reality, Baziotes' indistinctness is closer to Surrealism, or perhaps more precisely, to fantasy.

Ambiguity of subject matter cannot be separated from ambiguity of means. Ever since Impressionism, through its concentration on the point at which objective nature, light, and the subjective merge in visual sensation, broke the sculptural contour that separated bulk from empty space, an ambiguity of depth and surface has operated as the most dominant formal principle of the modern movement. Modern space, flatness, and movement are ambiguous in being equivocal, a quality which, although not necessarily either vague or indistinct, "conveys . . . along with a given idea, another quite different one with equal clearness and propriety." Considered from this viewpoint, the entire discussion of modern pictorial relations can be seen as evidence, in one form or another, of modern ambiguity.

Let us look at the question from the other side: What is the Abstract Expressionist idea of *clarity?* In an attempt to "straighten out" terminology, Ad Reinhardt states that "vagueness is a 'romantic' value, and clarity and 'geometricity' are 'classic' values." He considers that "an emphasis on geometry is an emphasis on the 'known,' on order and

knowledge." To Hedda Sterne the question of clarity "has to do with Western thinking. A Chinese thinks very well, but does not use logic. The use of geometrical forms comes from logical thinking."[27]

The interaction of geometric with free form is central to Abstract Expressionist development. Just as a barely perceptible structure has served to architecturalize fluid or expressional painters, the coldness of puristic work has in many instances been dispelled by a partial "melting" of geometry. Bradley Walker Tomlin, who suggests (with de Kooning's agreement), that "automatic structure is in the process of becoming, and that 'geometry' has already been shown and terminated," later states what was unquestionably one of his basic beliefs, that "geometric shapes can be used to achieve a fluid and organic structure."

Since the beginning of history (for example, in the grid-planning of building complexes) geometricity has evidenced the imposition of conceptualized thinking on the variety and irregularity of nature. Hence it is no surprise to find it raised as a symbol of the rational and classic; as "clearer" than loose or variegated form. Yet certain of the Abstract Expressionists are annoyed at the suggestion that their work is less clear than that of the purists. "Why is the rectangle clearer than any other shape?" they argue. Or, in Baziotes' words: "if people stand and look at the moon and one says, 'I think it's just beautiful tonight,' and the other says 'The moon makes me feel awful,' we are both 'clear.' A geometric shape—we know why we like it; and an unreasonable shape, it has a certain mystery that we recognise as real."

De Kooning argues that "there is no such thing as a straight line in painting"; that the idea of "the beauty of the rectangle" is "against art"; that a work completely the product of such a view would be "almost the graph for a possible painting—like a blueprint." He insists that the apparent clarity of

geometrical form is illusory and that all painting is "free": "If a man is influenced on the basis that Mondrian is clear, I would like to ask Mondrian if he was so clear. Obviously, he wasn't clear, because he kept on painting."

These arguments postulate a distinction between types, or degrees, of clarity: one an interaction, and another formulated and static, more intellectual than sensory and emotional. Because he established active relationships by which his geometric elements were perceptually altered, "Mondrian is not geometric, he does not paint straight lines." As in his comments on optical readjustment of the physical environment, here de Kooning reveals an intense preoccupation with vision. In this regard it is interesting to note that he is concerned with the idea of intellectualized geometric clarity as illusory, rather than as the subjective variation of the visual field, thus reversing the customary opposition: "When things are circumspect and physically clear, it is purely an optical phenomenon. It is a form of uncertainty; it is like accounting for something. It is like drawing something that then is bookkeeping. Bookkeeping is the most unclear thing." The line of thought implicit in de Kooning's remarks could be summarized in this way: the active wholeness of experience, whatever its contradiction and ambiguity, is more real, truer, and thereby clearer than the apparent truth and clarity of logic and classification; for in its abstraction from experience, the assurance gained from bookkeeping is both false and dead.

Considerable attention has been devoted to de Kooning's criticism because it points to one of the significant mediating ideas of Abstract Expressionism. It rejects both formulated clarity, as well as any deus ex machina which deterministically reduces reality to only one alternative. Instead of loving confusion for its own sake, it is concerned with that degree and type of clarity consistent with animate experience.

Later, in the consideration of transcendental reality as a content and a goal, clarity will be seen as one aspect of an absolute which Motherwell speaks of as lying "in the background of all my activities of relating"; a focus which, he says, "seems to retreat as I get on its track."[28] As a painter develops, Rothko writes, the progression of his work "will be toward clarity."[29] It is plain that such a focus is approached only with danger. The clarity of modern art must remain equivocal; it must keep an intensity which derives from a tension—an anxiety, if you will—of oppositional forces.

Freedom and Determinism

"Modern art is related to the problem of the modern individual's freedom," Motherwell wrote in 1944. "For this reason the history of modern art tends at certain moments to become the history of modern freedom."

The article in which this statement appears, "The Modern Painter's World," is an invaluable record of the artist's desire to identify himself with meaningful social values. Written at the time when intellectuals were becoming disillusioned with left-wing politics, it is at once an expression and an analysis of their dilemma in striving to reconcile love of individual freedom with the competing ideologies purporting to serve the cause of social freedom: capitalist democracy and Marxian socialism and communism. Motherwell recognized an "irreconcilable conflict" between the Surrealist movement and "working class" political parties. With the benefit of hindsight, one might see it as a dichotomy of individual freedom against both middle-class materialism and Marxist determinism. The social problem of the artist, as Motherwell saw it then, was whether or not to "ignore the middle-class and seek the eternal . . . to support the middle-class by restricting oneself to the decorative . . . or to op-

pose the middle-class," like Courbet, Daumier, and others.[30]

Behind scurrilous documents like the so-called Report of U.S. Representative Dondero in 1949[31] lies the human truth that artists not only have different values from politicians and tycoons, but that, like other men of intelligence and goodwill, they feel a sympathy for their fellow creatures and resent callousness and injustice. During the twenties and thirties social identification drew many painters and sculptors toward left-wing political ideologies intrinsically opposed to their aesthetic aims.

The tragic effect of totalitarian thought on the arts is too broad a subject to be more than mentioned in this book, although the Abstract Expressionists' concept of their position in society will be discussed in Chapter 7. Pertinent to the present topic is a point more psychological than sociological or political. Having once been "used," as it were, during a period of poverty and social disorganization, disillusioned artists were later susceptible to the pendulum's swing toward Neo-Dadaism. Looking back at the thirties, Motherwell singles out hatred of the WPA as a bond uniting the New York group.[32] But more is involved in their attitude than a distasteful memory of the Federal Art Projects: it is a wholesale repudiation of all formulated, systematized, or categorized theories or panaceas, most of all, those which bear the taint of determinism. Hofmann alone, of the six painters, will advance "laws" on which painting should be based—and he insists that they be forgotten while painting.

First among the theories almost universally rejected is the utilitarian functionalism which has been identified with the German Bauhaus, and popularized by The Museum of Modern Art, Moholy-Nagy, and the art schools. This is seen as a tendency to reduce expressive art to a decorative and utilitarian level. All that it produced, from de Kooning's point of view, was "more glass and an hysteria for new materials which you can look through."[33] Though less ironic, Hofmann's analysis is more probing: "It was the tragedy of the Bauhaus, that, at the beginning of its existence, it confused the concepts of the fine and applied arts. As we have noted, the first must serve the deepest in man. It concerns man's relation to the world as a spiritual being. The second serves only a utilitarian purpose."[34]

Flatly rejected are all of those art movements which evolved theories and systems. This viewpoint is eloquently put forth in de Kooning's essay, "What Abstract Art Means to Me": "All of a sudden, in that famous turn of the century, a few people thought they could take the bull by the horns and invent an esthetic beforehand . . . They had hold of it, they thought, once and for all. But this idea made them go backward in spite of the fact that they wanted to go forward. That 'something' which was not measurable, they lost by trying to make it measurable." The programs of Kandinsky, de Stijl, Purism, Surrealism, and functionalism are rejected either because they are too spiritistic or theoretical, but Futurism is singled out for its mechanism:

The sentiment of the Futurists was simpler. No space. Everything ought to keep going! That's probably the reason they went themselves. Either a man was a machine or else a sacrifice to make machines with . . . Personally, I do not need a movement. What was given to me, I take for granted. Of all movements, I like Cubism most. It had that wonderful unsure atmosphere of reflection—a poetic frame where something could be possible, where an artist could practise his intuition. It didn't want to get rid of what went before. Instead it added something to it. The parts that I can appreciate in other movements came out of Cubism. Cubism *became* a movement, it didn't set out to be one. It has force in it, but it was no "force-movement."[35]

The Abstract Expressionist attitude toward manifesto thinking could not be better expressed. In al-

most every instance when a question of the earlier group movements of the twentieth century is raised, artists—Boccioni, Kandinsky, or Mondrian—are revered as individuals; but their programs are scrapped.

Motherwell has described Abstract Expressionism as a "looser 1911 Cubism."[36] This is an extreme generalization, nevertheless it points not only to the broad acceptance of the early work of Picasso and Braque as a source of pictorial means but to the fact that, as de Kooning claims, Cubism was not a formulated program. Painters of the forties and fifties have cut themselves off sharply from unilateral theory also by virtue of a broader view toward tradition, drawing freely from any style and from any period of art, representational or abstract, which would fit a new orientation. For this reason those who believe art must employ only unprecedented forms regard the Abstract Expressionists as archaists in their use of Byzantine images, primitive arts, ancient mythological symbols, Oriental calligraphy, and Hebrew ideographs. Historically the position of Abstract Expressionism must be seen in the light of Malraux's Museum without Walls. Expressed in Tobey's words: "Now it seems to me that we are in a universalizing period . . . If we are to have world peace, we should have an understanding of all the idioms of beauty because the members of humanity who have created these idioms of beauty are going to be a part of us. And I would say that we are in a period when we are discovering and becoming acquainted with these idioms for the first time."[37]

Of the group, Rothko has become the most futuristic, or, perhaps better, "presentistic." He alone, though he recognizes "the great cubist pictures," denies interest in Cubism and abstract painting and has renounced his former use of ancient symbols. Although in the late 1940s he felt that "without monsters and gods, art cannot enact out drama"

and that "an atavistic memory, a prophetic dream, may exist side by side with the casual event of today," he later concludes that "memory, history or geometry . . . are swamps of generalization from which one might pull out parodies of ideas (which are ghosts) but never an idea in itself."[38] Shorn of Rothko's ban on past images, the Abstract Expressionist view of time can also be described as presentistic. Its focus is on present experience rather than on the "distant in time and space" in any direction; and in rejecting manifestos which mechanically project the artist toward a hypothetical future, its movement is from the here and the now toward universal meaning. The sole determinism which the Abstract Expressionist recognizes is the drive which propels him toward the unknown. George McNeil's demand for an anti-structural art skirts closest to temporal mechanism. He is answered, in exasperation, by Jack Tworkov: "Why? Why? Why must one make a disorganized picture? I am against a program before me!"[39]

It would be more truthful to find the focus in the self rather than in the present: "Spiritually," de Kooning writes, "I am wherever my spirit allows me to be, and that is not necessarily in the future. I have no nostalgia, however." And in words which, in this context, no longer appear cryptic, Tobey observes: "You are you whether walking backward or forward."[40]

Rejections of Futurist, nonobjectivist, functionalist, or Marxist theory are not separated decisions. They conform to one pattern of thought: an abhorrence of any predetermining system which would obviate the free operation of the individual personality. With the quasi-regimentation of the Social Realist thirties still in their minds, the New York painters sense a danger in their stylistic community at the same time that it gives them the assurance of solidarity. Such ambivalence can be sensed in de Kooning's observation that "the group instinct

could be a good idea, but there is always some little dictator who wants to make his instinct the group instinct."[41]

In addition to the danger of what has been dubbed "reverse Cravenism," a common style contains the threat of a new academicism. Consequently, with the exception of unimportant publicity stunts, there have been no manifestos of Abstract Expressionism. Even the younger group of painters, weaned by The Museum of Modern Art and Hans Hofmann, who have revolted against their seniors by returning to nature, are chary of programs. One of their spokesmen, the poet Frank O'Hara, writes: "So nature is with us? These new painters have done what they had to do and found what painting seemed to need for them. They have no group, they mail no manifestos and, unlike the Surrealists or Magic Realists or Academicians, they do not favor a given look or an external content; they do not separate themselves from painting."[42]

Perhaps the closest approximation to anything which could be called an Abstract Expressionist Manifesto is the statement signed by Robert Motherwell and Harold Rosenberg inaugurating *Possibilities*, "an occasional review" devoted to the arts, whose first issue appeared in the winter of 1947. Following by only three years Motherwell's analysis of the artist's contradictory social position, it strikingly demonstrates the sharp change of attitude that took place after the end of the war, and concludes with a clear-cut separation of art and politics:

Once the political choice has been made, art and literature ought of course to be given up.

Whoever genuinely believes he knows how to save humanity from catastrophe has a job before him which is certainly not a part-time one.

Political commitment in our time means logically—no art, no literature. A great many people, however, find it possible to hang around in the space between art and political action.

If one is to continue to paint or write as the political trap seems to close upon him he must perhaps have the extremest faith in sheer possibility.[43]

Is this excerpt from a manifesto? If so, it is a manifesto against manifestos—a reaffirmation, at whatever cost, of the free autonomy of art. It is for this reason that de Kooning and Rothko almost welcome the hostility which separates art from a materialist society which could dominate it. Tobey, asked by a follower of Bahai whether he feels that his religion should sponsor its own art, answers: "it is no longer necessary to have a didactic religious art; art will be free in a Bahá'í world."[44] In a similar vein, Hofmann considers modern art the symbol of democracy: "It is the privilege of a democracy like ours that it expects the artist to be, through his art the personification of its fundamental principles in being the highest example of spiritual freedom in his performance of unconditioned, unrestricted creativeness."[45] It is clear why the Abstract Expressionists should be disinterested in Futurism and why Motherwell could write, in the preface of his admirable anthology of Dadaism, that "there is a real dada strain in the minds of the New York School of abstract painters that has emerged in the last decade."[46] Not only was there a powerful current of transcendental idealism in Dada—quite the opposite of the proto-fascism and materialism of Futurism—but it found its ultimate in individual freedom rather than mechanism. It is understandable why the proto-Dada Marcel Duchamp to de Kooning represents a one-man movement: "For me a truly modern movement because it implies that each artist can do what he thinks he ought to—a movement for each person and open for everybody."[47]

A common attitude explains the appeal of Dadaism, the employment of automatic and improvised technical processes, the interest in Surrealism and the unconscious, and the love of contradiction

and ambiguity. From Baudelaire onward, the traditions of Romanticism, Expressionism, Dadaism, and Surrealism have constituted a revolt against authoritarian control and mechanical rationalism. Therefore, it would be wrong to consider the opposition of freedom to determinism as a sympathetic reciprocation like that of ambiguity and clarity, for mechanistic or formulated programs are unequivocally repudiated.

Given the autonomy of the individual artist, an internal dualism does exist: between a controlled, or intellectual freedom on the one hand, and automatism, improvisation, and accident on the other. In extremes these latter are to be avoided; automatism can be itself a mechanism, and pure accident, chaos. On the side of control, the Cubists established criteria of structure and equivocal space; whereas Dadaism attacked authoritarianism and championed freedom. Surrealism offered a new technique of automatism and demonstrated the significance of ambiguity. Remember that Motherwell began (at least in his work of the forties) with mistakes, and that Hofmann sometimes starts with an accidentally spattered surface. Baziotes likens the artist to a gambler who "takes a chance in the hope that something important will be revealed," and McNeil sees painting as "rolling dice . . . in hope something might turn up."[48] Motherwell quotes the charming and perceptive comments of Focillon on Greek and Japanese legends of accidentalism:

Here we are at the antipodes of automatism and mechanism, and no less distant from the cunning way of reason. In the action of the machine, in which everything is repeated and predetermined, accident is an abrupt negation . . . [The] excess of ink flowing capriciously in thin black rivulets, . . . this line deflected by a sudden jar, this drop of water diluting a contour—all these are the sudden invasion of the unexpected in a world where it has a right to its proper place.[49]

Today, because of a revision of our orientation, an unprecedented degree of technical freedom can be philosophically justified. But the twin pitfalls of mechanistic automatism and the disorder of pure accident must be avoided. Abstract Expressionism is not anti-art; there are as many arguments against "mistake, error, and accident becoming the subject" as there are for the unknown potentialities they offer.[50] Reminding ourselves once more of the identity of means and content, we realize that painting problems symbolize living problems. Fear of the responsibility which freedom entails, Erich Fromm has shown, was fundamental to the appeal of totalitarianism. In the same sense, the challenge to the artist's identity posed by the recent astronomical expansion of possible technical means, historical precedents, and subject matters is staggering. Such a diversity of possibilities tends to drown him —a plight signaled, as Motherwell notes, in Kierkegaard's "despair of the aesthetic." Ironically, Motherwell couples his remarks with a recognition of the idea of social determinism—a realization of the lack of choice given to the artist in selecting the historical position in which he finds himself. He regards the belief that the artist can choose whether he should paint as a conservative or a modern as an "academic fallacy."[51]

Where does the middle ground between mechanism and dispersion, the only true area of freedom, lie? This is a challenge that confronts every self-aware citizen of a democracy and which, as a fundamental content, the modern artist faces directly each time he enters his studio.

The 1950 Studio 35 sessions, which I have quoted repeatedly, raised more questions than they answered. At one point during a discussion of abstraction and representation Barnett Newman realized: "We are raising the question of subject matter and what its nature is." And de Kooning asks: "I wonder about the subject matter of the Crucifixion scene—was the Crucifixion the subject matter or not? What is the subject matter? Is an interior subject matter?"[1]

According to Motherwell, more than any other painter the historian of the New York School, Picasso's *Guernica* has an important connection to the group in this regard, for it reversed the historical trend toward substituting the "lesser" genres of still life, landscape, or the arbitrarily isolated figure for the crucial religious, historical, and ethical themes which topped the hierarchy codified by the academies. In a more vital form such content was still of the greatest importance to Goya and Delacroix, and history painting still existed (within the limitations of Courbet's theory) in 1850. In tension with a new formalism its vestiges still remained in the work of Manet. Following the change from Realism to Impressionism, however—at least in the view usually taken by modern criticism—subject matter, in the old sense of a significantly human, usually narrative, theme, became virtually defunct. In the opinion of Lionello Venturi, "modern painters . . . substituted the motif, which is purely pictorial subject-matter, for all other subject-matter which is poetic or oratorical or philosophical."[2]

De Kooning's idea of this development follows a similar pattern, though for him, in an interesting reversal of terminology, "subject matter" is an equivalent of Venturi's "motif." During the Italian Renaissance, he explains,

there was no "subject-matter." What we call subject-matter now, was then painting itself. Subject-matter came later on when parts of those works were taken out arbi-

trarily, when a man for no reason is sitting, standing or lying down. He became a bather; she became a bather; she was reclining; he just stood there looking ahead. That is when the posing in painting began. When a man has no other meaning than that he is sitting, he is a *poseur*. That's what happened when the burghers got hold of art, [de Kooning, remember, is Dutch] and got hold of man, too, for that matter. For really, when you think of all the life and death problems in the art of the Renaissance, who cares if a Chevalier is laughing or that a young girl has a red blouse on.[3]

By the same rationale that causes him to regret the reduction of the figure to a motif, de Kooning can accept Dutch still life only because of its human associations.

Motherwell observes that "it is after the French Revolution and the triumph of the bourgeoisie that the human figure disappears from painting, and the rise of landscape begins. With Cézanne landscape itself comes to an end, and from him to the cubists the emphasis is changed: the subject becomes 'neutral.'"[4] The environmental associations which exist in the iconography of early Cubism notwithstanding, it is evident, as Motherwell implies, that the fundamental distinctions between man, nature, and the artifact were neutralized. The pictorial resemblance of Picasso's *Harlequin and His Family* to Braque's *Houses at L'Estaque*, both 1908, is of consequence; their difference in motifs is almost irrelevant. The paintings and studies of 1910 to 1914 modulate freely from portraits and nudes to bottles, guitars, and newspapers to the borderline of structural nonobjectivism—a subordination of subject matter to form underlined in Picasso's recollection that "Gertrude Stein joyfully announced to me the other day that she had at last understood what my picture of the three musicians was meant to be. It was a still life!"[5]

Most abstract artists of the first and second generations have lived through a personal development analogous to that of early Cubism. Until as late as

1940 the largest group of Hofmann's paintings were derived from still life or the posed figure. He still paints these motifs and his teaching is conducted almost entirely with them, but he believes that "the spiritual and mental content of a painting is found only in its pictorial quality and not in the allegory, or in the symbolic meaning, presented by objects." He adds that "burdening the canvas with propaganda, or history, does not make the painting a better work of art," but often lowers its quality.[6] In arranging a still life he considers an object as a "space-maker." Thus, in *Fruit Bowl* (Fig. 128), "a white bowl, three apples, an ashtray, a small pitcher and a jar of show-card color lose their conventional solidity as the distances between them . . . become more prominent and suggestive than the objects themselves."[7]

It has been said, with an implied comparison with the representational subjects of the past, that the Abstract Expressionists "are involved in a non-subject subject matter"[8]—a meaningful content without overt figuration. With notable exceptions, modern still life is the opposite: a subject matter devoid of broad significance, hence neutral.

Tobey's reminiscence about the children's painting class in which he realized the importance of a difference in size between a pitcher and a glass was a discovery that his true subject involved relationship and scale. From a historical viewpoint, still life (and the objectified use of the figure which parallels it) has provided a neutral motif during a period of transition from one manner of embodying meaning to another. It could be outlined in four stages: a represented subject matter like that of Courbet's *Burial at Ornans* (Musée du Louvre); the Braque and Picasso still-life and figure paintings of 1910–1912; the formalism of de Stijl; and the recent attempt (or that of the early works of Kandinsky) either to communicate human and natural meanings directly through pure means or to fuse them with a significant quasi-representational image.

Gorky's growth, like that of Hofmann, demonstrates these changes. The early *Still Life with Skull* (Fig. 44) and *The Antique Cast* (Fig. 45), both influenced by Cézanne, contain suggestions of the later emotional intensity. The still lifes of the thirties, following Picasso, were the means of mastering the structural methods of Cubism. Already in 1932, however, in the pen drawings, still-life form began to transform into biomorphic abstraction; and until 1941, it was moving toward a more and more expressionistic abstraction. The late works move both backward and forward, simultaneously reemploying figuration—though on another level—and deepening human content.

The hypothesis is suggested that for twentieth-century painters, still life has been in the main a provisional "subject which doesn't matter," a vocabulary of representational units which could be freely manipulated toward other, often only dimly realized, ends. This is the role it plays in modern teaching, in the work of Hofmann, and occasionally in that of Tobey. The cases of de Kooning and Rothko are somewhat different. Once the figure was reduced, for Rothko, to a "*tableau vivant* of human incommunicability," he abandoned it.[9] The oscillation of de Kooning between abstraction and figuration can be seen, especially in the light of his remarks about Dutch still life, explicitly as an attempt to avoid the use of neutral motifs.

As the youngest painter of the group by eleven years, it is interesting to note that Motherwell began painting at the fourth stage indicated above: as a subjective abstractionist. It is at this final phase, which aims at a maximum of meaning within modern means, that a discussion of Abstract Expressionist subject matter is introduced. To schematize the stages in its establishment of course is but a temporary device. Both an advanced and a synthesizing viewpoint, it is the result of acceptances and rejections of diverse contemporary positions, among them the structuralism of post-Cubist

abstraction, figurative expressionism, and the Surrealist emphasis on subject matter.

The world view of a cultural locality is implicit in its choice and treatment (or omission) of subjects. What are each culture's concepts of man and of his natural environment? What is its explanation of the unknown and its God? How does it conceive of the relationship between man, nature, and the absolute? In consideration of the wide spread of time, space, and culture embraced by the attitudes of Abstract Expressionism, these questions offer effective criteria for discussion of its subject matter and content. Nature can indicate for us the entire nonhuman universe, landscape and seascape, the animal life which inhabits it, the microcosmic and macrocosmic worlds, and, as a part of it, man as well. The subject of man, however, divides between an objective outer conception and inner expression. God, in the traditional sense in which He was imaged on the Sistine ceiling, is seldom represented today. Yet the personal quest for a transcendental reality, and for an absolute, has in no sense abated. Recognition must be given to this all-important distinction between more or less objectively stated, often representational, subject matter and an inner existential, or transcendental, content. For the modern period another determinant, the mechanical artifact, must be added. Its symbol is New York City, a totally artificial environment standing in clear-cut opposition to the natural and human worlds. These categories of meaning, needless to say, can be interrelated or even identical; nevertheless, it seemed more pointed to consider them separately, so a section called "The Self and Reality" follows consideration of "Man," "Nature," and "The Artifact."

Man

In a lecture delivered at the Fogg Museum, Harvard University, in April 1951, Motherwell stated his emphatic belief that the practice of art is hu-

manistic by its very nature: "I think that what art is, is a technique for expressing human feelings, and that to express human feelings is to humanize oneself, and to humanize others. I don't think art can do anything but arouse one's sense of humanity. It is this that constitutes its 'purity of heart'; it is moral by nature; it cannot do anything but humanize."[10]

"Spinoza reminds us," he writes elsewhere, "that the thing most important to man is man." He decries the effects of industrialization on human relations, and lauds Goethe, Beethoven, and Goya, "the first to disassociate themselves from class," who were able "to identify themselves with humanity, with all men." It was this identification, "the humanism of the unindustrialized past," which led Motherwell to his sympathy with the Spanish Loyalists. He believes that the unique aesthetic viewpoints of each period are "specific applications of a more general set of human values." As an editor of Dadaist literature, he turns away from Dada's nihilism toward "another, and . . . stronger line in modern art . . . that had its destructive side only in order to recover for art human values that existed in art before and will again, but to which conventional and 'official' art remains insensitive." In 1942 he criticized Mondrian for his "creation of a clinical art in a time when men were ravenous for the *human.*" In 1947 he attributed his own move from collage to oil "to a greater involvement in the human world," noting that "a shift in one's human situation entails a shift in one's technique and subject-matter." Yet abstraction does not necessarily imply to him a disavowal of humanistic concerns: "The strength of Arp, Masson, Miró and Picasso lies in the great humanity of their formalism."[11]

Hofmann's years of teaching attest to his social commitment. The ultimate aim of both teaching and creation, for him, is cultural enrichment. Conversely, "the depth of an artistic creation is a question of human development. The deeper the human

content, the deeper the understanding of the medium." Such views, expressed again and again in his writings, are summed up in a pointedly anthropocentric conclusion: "All our experiences culminate in the perception of the universe as a whole with man as its center."[12]

De Kooning's essay "The Renaissance and Order" is explicitly an affirmation of Western humanism. Coupled with his other views, it is a defense of "human" values against fleshless Orientalism, determinism, Bauhaus functionalism, aesthetic formalism, or science as a basis for painting. In the Renaissance, "art was tied up with effort. Man, and all things around him, and all that could possibly happen to him—either going to heaven or hell—were not there because the artist was interested in designing. On the contrary, he was designing because all those things and himself too were in the world already." "It was because of man, and not in spite of him, that painting was considered an art." The only justification for "all the pots and pans in the paintings of the burghers," is because they "are always in relation to man."[13]

The genial hostility of Rothko and his unqualified impatience with museums, art historians, and formal art education might superficially seem to identify him with some sort of antisocial futurism. Quite the opposite, his resentment of the industrialization of art, like his hatred of "Bauhausism," is based on a conviction of the harm they have done to the human significance of art: "One does not paint for design students or historians but for human beings, and the reaction in human terms is the only thing that is really satisfactory to the artist." Thus, he feels writing on art should never be comparative, historical, or analytical, but should record direct responses in terms of "human need."[14]

To Tobey the idea of "Man"—and in the light of subsequent discussion the word "idea" is used advisedly—takes precedence even over art. He has stated the belief that our century will see the establishment of world peace, to him one of the highest forms of aesthetic unity, analogous to that of a work of art, and quotes the sources of Bahai: "this is the hour of the coming together of men."[15] No living painter has fused his aesthetic theory more closely with a concept of humanity than has Tobey. Yet his Eastern view, almost against his will, is often more spiritual than physical. It separates his humanism from that of Motherwell and de Kooning, who give more emphasis to the tangibility of things.

Among the recurrent dualities that characterize the pattern we are studying one can distinguish the opposition of a transcendental humanism to one which is more existential. Tobey tries to combat dematerialization by a concept of unity that excludes levels. But Motherwell might regard his attempt as unsuccessful for, though in 1951 he stated "Make no mistake, abstract art is a form of mysticism,"[16] he considers mystical experience as inherently antiphysical; hence the opposite of humanism. Nothing, from Motherwell's point of view, is humanistic which denies man's corporeality, his gregarious instincts, or his sexual needs. Nothing is humanist, that is to say, which transcends the fundamental human condition.

Existence, reduced to its starkest reality, is poised between procreation and death. Motherwell's stays in Mexico impressed on him the fact of mortality. Death seemed always imminent in the political tension, the jazz bands blaring the *Saint Louis Blues* in funeral processions, and the prints of Posada. Beginning with *Three Figures Shot* (Fig. 157) and *Pancho Villa, Dead and Alive* (Fig. 155), mortality is one of his recurrent themes. It goes back perhaps to his identification with the struggle of Loyalist Spain, Goya, Picasso's *Guernica*, the symbolism of the bullfight, and the poetry of Lorca.

Aside from his obvious relish of artistry, Gorky's mature work is an expression of sensuous and af-

fective human experiences of love, pain, and union with nature. He was completely immersed in a creative legend based on his subjective view of the world, art, and his own personality. It was because of this love of the organic that, as Ethel Schwabacher tells us, he "hated the very mention of drawing with a ruler."[17]

So pronounced, one must conclude, is the humanist intent of these painters, whatever the differences in their interpretations, that to epitomize their subject matter is to reduce it to human terms —to de Kooning's formalized struggle with the tensions of existence in the modern world; to Gorky's theme of union between man and nature; to Hofmann's worship of creative synthesis; to Motherwell's keen sense of the fundamental "felt realities" of death, sex, and family love; to Rothko's involvement in communicating intense human emotion at once immanent and in conflict; to Tobey's belief in the vital participation of man in the "universal everything."

Yet the growth of a concept of reality based on structure, energy, movement, and process and on a formal and metaphysical imperative demanding relational unity rather than verisimilitude has made the reconciliation of the human image to meaningful pictorial form increasingly difficult, and often impossible. By these determinants even sculpture, heretofore the most corporeal of media, has been deprived of physical mass. We have seen how modern sculpture has dissolved mass—and consequently the form of the human body—by attenuation, transparency, interpenetration, the grid, and the spatial calligraph. For Renaissance criteria, the "open" sculptors have substituted either an expressive architectonics or three-dimensional painting. If the figure is to be represented, rapport must continually be reestablished between new truths, new pictorial means, and the tactile fact of flesh. The challenge posed by Tobey—"What do we do with the human?"—is many-sided.[18] The most viru-

lent attacks on modern painting and sculpture have singled out its "distortion," or its abandonment of the human body as a subject. Is it true, as many artists believe, that the representation of the human image is irreconcilable with the true aims of modern painting? Already in 1951 Alfred Barr wrote that the Abstract Expressionists "did not think of themselves as abstract painters. Far more than their work indicated they were striving for an art in which natural forms, including human figures, would once more *emerge* but without any sacrifice of spontaneity or of the direct impact, purity and reality of the painted surface as the primary instrument of their emotions."[19]

One of the peculiarities of painters' circles, obsessively history-conscious as well as suspiciously antihistorical, is that they are deeply concerned with charting their future development. Such was the context of Barr's summary of the phenomenon labeled—religiously, ironically, or contemptuously, depending on the position of the commentator— "the return to the figure." From 1950 to 1953 viewpoints ranged from those of the programmatic literalist or purist (both outside present consideration) to multiple shades of conviction regarding modes of figural representation; degrees of solidification, fragmentation, or dissolution of the human form; differences in the processes by which it can be integrated with pure means; and the ethical, historical, or philosophic justifications and backgrounds of these various solutions.

The problem for the restive painter who feels a deficiency in his abstract idiom which leads him to a return to—or, if he is of the new generation nurtured on abstract art, to a discovery of—the figure is to advance his art. Is he moving forward or backward? Is his new figuration an enrichment or simply a reappearance of the old bulks in a new context? Is the Neo-Classical nude or studio "poseur" being recalled, in a failure of nerve, into a ticker-tape world of calligraphy, with all the old

problems of anatomy, bulk, and chiaroscuro—but unhappily ill-at-ease and misfit? Has the uncompromising progressive discovered himself, with his fat figures and his loose brush, behind the front lines of his realist enemies, painting like a promising protégé of the late Reginald Marsh?

A rationalized attempt to solve the dilemma of subject, means, and technique, if such it is, theoretically splits into two possible solutions: first, and more conservative, a reciprocal modification of contemporary abstract form and the autonomy of the human body; second, the more daring solution which accepts the challenge of abstraction and seeks to contain and communicate human meaning without representation. It is characteristic of the Abstract Expressionists to find plastic solutions in which contradiction is sustained. In the last analysis, the job of the painter is not to solve verbal problems or to predict future art history, but to create meaningful images.

De Kooning, the painter who has never abandoned either horn of the dilemma, has understandably been the hero of the "Realstractionist."[20] His attachment to "the vulgarity and fleshy part" of the Renaissance, "which seems to make it particularly Western," was too great for him completely to abandon flesh, "the stuff people were made of," and "the reason why oil painting was invented."[21] This predisposition has been fundamental, not only to the Women, but as it has been demonstrated, to the nonobjective canvases as well. We have followed de Kooning's struggle to amalgamate the human image with a Soutine-like expressionism, on the one hand, and geometric structure, on the other. The large *Excavation* (Fig. 30) has been likened to a "wall of living musculature" which organizes fleshy elements according to modern pictorial principles; in the late studies, possible preliminaries to large compositions, figures are ambiguously multiplied, their parts manipulated in size, number, and relationship like those of a landscape. Thomas

Hess's comparison of a de Kooning canvas with the mythical bed of Procrustes is more than literary.[22] Here is something for those who see modern art as anti-human: there is an aura of the abattoir about an alliance of Cubist dissection and reassembly with the fleshiness of expressionism, as if the artist, loving the image and tangible solidity of man, had led himself to his own destruction, impaling his limbs on a rack of abstraction.

De Kooning and Motherwell turn aside from the dematerialization which Westerners see in Oriental art. Tobey, despite the replacement of bulk by energy through "white writing," shares with more physicalistic painters the love of the body. He has felt the influence of Raphael and Michelangelo, and admires Rubens's "unexcelled painting of flesh." Asked why it is difficult for the modern artist to use the figure, he answers that they wish very much to do so, but cannot. Nostalgically, he feels that he "would have made a wonderful portrait painter."[23]

It would be wrong to consider the tension between the figure and modern structure as somehow bad, or to regard works that do not make a clean-cut decision one way or the other as less important because they are transitional. Looked at temporally, all styles are transitional, and historical conflicts are challenges which offer the painter opportunities for creative synthesis. Tobey's *Beach Space* (Fig. 273), following the Cubist solution, breaks the figure into brushstrokes loosely leafed between abstract planes; then the whole is overlaid with structural calligraphy. *Family* (Fig. 272) is quite naturalistic in its proportion, but the figures are dovetailed and fused into the picture plane by an overpainting that appears to have gradually obliterated bulk, which, as a suggestion, still remains. Both of these paintings are successful instances of the practical resolution of a formal problem that only history will finally settle. Loss of vigor, as Tobey realizes, can lie either in the direction of figuration or in the "abstract academy." Recognizing the "Procrustean

bed" of modern form as a social and political phe-
nomenon, he remarks that "we have tried to fit
man into abstraction, but he does not fit."[24]

Let us direct our attention to the other solution.
In regarding the content we call "human" as syn-
onymous with figuration, are we not in tacit agree-
ment with the opponents of modern style? Are we
not committing ourselves to a philosophy of art
which is, to say the least, a bit beefy? John Ferren
suggests in a 1953 symposium that Abstract Ex-
pressionism has given "a new range to the sensibil-
ity involving the whole 'existential' man."[25] Over
forty years before Ferren's gentle defense of his be-
lief in this humanism, which "is implicit not ex-
plicit," the pioneer Wassily Kandinsky militantly
championed his vision of an art of painting which,
like music, could express feeling directly. In those
fluid early canvases, so highly regarded by the Ab-
stract Expressionists, qualities of both man and na-
ture are communicated.

One again asks a question crucial to the history
of modern painting: Is there, as some have insisted,
an intrinsic difference between visual and aurally
perceived form which enables Beethoven or Stra-
vinsky to communicate "human" meaning without
mimesis while preventing Hofmann, Rothko, or
Pollock from doing the same? Rothko's develop-
ment is especially instructive in this regard. His
compositions of the thirties represent human figures
in rooms and subways and streets. Some of the rea-
sons for his change in forms may be reflected in
later observations: "But the solitary figure could
not raise its limbs in a single gesture that might in-
dicate its concern with the fact of mortality and an
insatiable appetite for ubiquitous experience in the
face of this fact. Nor could the solitude be over-
come. It could gather on beaches and streets and in
parks only through coincidence, and, with its com-
panions, for a *tableau vivant* of human incommuni-
cability." Seen in relation to his verbal statements
and conversation, the abandonment of traditional

figuration in Rothko's work appears to have been a
breakthrough from the hampering representation of
everyday situations to meanings hidden behind
compromises which, though they must make up
practical living, mask the inner drives, desires, and
fears which form the core of experience: "The pre-
sentation of this drama in the familiar world was
never possible . . . The familiar identity of things
has to be pulverized in order to destroy the finite
associations with which our society increasingly en-
shrouds every aspect of our environment."[26]

On the basis of such a conviction, wishing to
move closer to a universal center, it is understand-
able, especially in the light of the stimulus of Surre-
alism, that Rothko should have turned to those
themes of the Greek myths which reflect the "col-
lective unconscious," that he should have sought a
world in which everyday acts belonged to a ritual
accepted as referring to a transcendental realm. It is
understandable that an artist committed to human
truths could turn from a representation of surface
phenomena toward a symbolic world of forms in
which "shapes . . . are the performers . . .
created from the need for a group of actors who
are able to move dramatically without embarrass-
ment and execute gestures without shame." Looked
at in this way, Rothko's repeated statements of dis-
interest in the specific pictorial means of design,
color, space, relationships, and so on make sense.
None of them are necessary means: everything is
expendable but content.

In attempting to discriminate between Abstract
Expressionist and realistic humanism a distinction
between an outer representation of figures and a
pictorial objectification of inner experiences is inev-
itable. A dualism of the physical against the tran-
scendental is also indicative, but confusing and,
without explanation, misleading. In one common
usage materialism becomes a label for the worst
features of a spiritually inert and unreceptive so-
ciety. "Physicalism," Tobey's word, is one of its at-

tributes. But when Motherwell and Rothko emphasize their "materialism" the word has another, though not completely unrelated, meaning. They are also concerned with the transcendental, but, like de Kooning, instinctively reject a negative mysticism or pantheism which seems disembodied. Materialism, moreover, calls attention to the physical existence of the picture-object which Hofmann and Motherwell have so often stressed.

The modern painter is a fabricator of objects: charged objects, which serve as carriers of human emotions, feelings, intuitions, and ideas; objects which, in their perceptual life and variability, are capable of stimulating analogous, though not identical, responses, on several levels, in the spectator. Edward Rothschild, in his study of expressionist art written during the thirties, saw Impressionism, Cubism, and Expressionism as scientific, sensuous, and spiritual "dematerialization."[27] What his analysis ignored is the new materiality, the change from an illusion of "the stuff that people are made of" to the tangible material which constitutes the object of art.

The full possibilities for direct communication by painterly means remain to be realized. Whether the nonobjective painter who strives for "realistic" expression of human content is, as one converted abstractionist writes, "trying to be too much with too little,"[28] or whether, without programmatically banning figuration, communication on a new level will be established between the painter and his public is a central problem for the future of world art. It is possible, as John Ferren says, that the human figure "a wonderful medium for pathos, for the political and sublime passions . . . is experienced better plastically and humanly in giant close-ups moving in sequence across a movie or TV screen" or in still photographs, and that painting will find a more appropriate synthesis of form and content.[29]

For the moment, it should be of value to point out again the rich references to existence which

modern artists have already discovered in pure means, in the gesture—hesitating, halting, gay, or heated—by which the paint is applied to the surface; in the opposition of accident to careful control, in the analogy of a shifting gestalt to the equilibrium which is life; in explosive, controlled, or claustrophobic space; or in the opposition of warmth, clarity, and brightness to the fogged tertiaries of shadow and indecision.

Nature

The Western traditions of Judaism, classical antiquity, and Christianity have in common their concentration on man: on the form of his body; on colorful fictions regarding human domination of the universe; and on the material, ethical, and emotional problems of his existence. Were it not for our knowledge that the philosophers of the East often gave priority to other forces, or for the discoveries of modern science, we could easily ignore the vast reduction in our scale which is attendant on a naturalistic, rather than an anthropocentric, view of reality.

Thoroughgoing naturalism abandons man as a measure. He becomes the tiniest part of the cosmos. It is not accidental that the seventeenth-century French academicians who based their rationalistic aesthetics on Poussin's theories and figure paintings chose to ignore his late landscapes. In the broad pattern of European consciousness, pantheistic naturalism is Northern or Gothic rather than Mediterranean. The emergence of landscape as a subject in the work of Patinir, Elsheimer, and Bruegel is largely a northern phenomenon, and the continuation of the tradition with Ruysdael, Hobbema, Friedrich, Constable, and Turner emphasizes the split between classicism and naturalism. Judged in the light of the humanist tradition, the painter or poet who turns away from man to contemplate the

vastness of nature, like the anti-historical scientific investigator, is an apostate.

Considering the background, the views of the Abstract Expressionists toward nature are especially interesting. Humanistic in identification, their convictions must nevertheless be seen in correspondence with a structural naturalism more Oriental in spirit than European.

Motherwell's identification with Baudelaire, Flaubert, Rimbaud, Mallarmé, Kierkegaard, Lautréamont, and Reverdy makes him, in his activity as an editor, essayist, lecturer, teacher, and urbane commentator on the milieu, a spokesman for tradition; and, more than that, for man's search for meaning within himself. The rise of landscape is associated, for him, with the unfortunate disappearance of the human figure from painting. It would perhaps be unfair to say that, intent on human experiences, he is thereby disinterested in the natural world. Yet in the sizable body of his observations, man's ideas, feelings, and artifacts are the recurrent subjects, not nature. Motherwell's views have been colored by Symbolist and Surrealist poetry, a convergence of French romanticism with the psychology of the unconscious. Preoccupation with personality was too great in this tradition to allow for the submergence of the ego which marks a true naturalism. Thus, the Taoist landscape of China is not romantic, and the romantic or neo-romantic finds it hard to stomach a Taoist view of reality.

Without trying to draw a line at the point where Motherwell's romantic psychism ends and de Kooning's expressionist involvement begins, it can be emphasized that neither accepts the precedence of nature. De Kooning's world hinges on immediate perceptions. It is not solipsistic, but concentrated: "For me, only one point comes into my field of vision. This narrow, biased point gets very clear sometimes. I didn't invent it. It was already here." It is this small circle of experience which gives the outside world importance. From his vantage point,

"nature, then, is just nature. I admit that I am very impressed with it."[30] Art, to him, is inseparably tied up with human forms, actions, and perceptions. His rejection of militant abstraction, the theory of Kandinsky—"a kind of Middle-European idea of Buddhism or, anyhow, something too theosophic for me"—rationalism, and scientific art are of a piece. De Kooning is mindful of the narrowness of his concentration, but more as a historical realization than as a personal limitation. He remarked one evening:

What fascinates me about van Gogh is that his sun dries up everything. Maybe he was melodramatic but my point really is . . . if you are a painter you have to face that self-consciousness. You get dirty and pathetic; very miserable. It makes me self-conscious to talk about it. There is something corrupt about art. Nothing to do with any "ism," but a thing in nature loses its innocence and becomes a grotesque thing . . . Maybe this difficulty is personal with me, and maybe it is something that other painters have in common. Perhaps it is also something of today.[31]

Without attempting to imply a rule, it might be inferred that the less fleshy and the more spiritual an artist's view, the closer to the shifting variability of nonbiological nature his art tends to become. A flowing style of Chinese calligraphy is known as "grass writing," and Tobey's art, both in its mysticism and technical method, establishes a naturalistic reference. He is intensely moved by the qualities of nature, as in *Drift of Summer* (Fig. 245): "Among and floating free above matted grasses— delicate thread-like structures rise and float—wind blown as the summer passes." Or, in a reminiscence: "It is Fall. The leaves are being raked under the great elms darkening in the evening light. Slowly they become weighted with darkness. Across the river they are burning the grass on the Minnesota bluffs. Myriads of colored streamers reflect in the river below."[32] In the same essay feeling for na-

ture unites with ideas of the Orient. "A design of flames encircles the quiet Buddha. One step backward into the past and the tree in front of my studio in Seattle is all rhythm, lifting, springing upward!"

One, admittedly negative, virtue in a systematic discussion of modern art is the repeated discovery of its challenge to analytical categorization. In this book "Man," "Nature," and "Pictorial Elements" are considered separately—and the division is not arbitrary. Yet in the actual work of art how completely they are one! What is Tobey's "Nature"? It is not that of the Dutch, the Barbizons, or the Hudson River Painters; it is simultaneously a recreation in memory, a structural analogy, and a portrait of his own consciousness. "Our mind is a night sky," he writes: "My imagination, it would seem, has its own geography."[33]

"The life of forms," Henri Focillon believed, "gives definition to what may be termed 'psychological landscapes.'"[34] Can they be separated from the representation of nature? Each artist and each period responds to landscape in terms of a unique internal topography; the forms of the mind, in turn, have their unique natural parallels. The soft-edged shapes of Rothko's canvases—anything but "representations" of nature—have been likened to clouds and mists; let us think about this most evanescent of landscape elements. Rudolf Arnheim, in a review of a book on John Constable's cloud studies, quotes the Romantic writer C. G. Carus: "Everything that echoes in the human breast, the alternating illumination and darkening, developing and dissolving, the creating and destroying, all this hovers before our sense in the gentle shape of the land of clouds." The lines tempt us, the psychologist and aesthetician remarks, "to think of cloud-painting as the most conspicuous forerunner of modern nonrepresentational art."[35] Jean Paul Sartre, in a painstaking disentanglement of painters'

and writers' means, also uses the cloud image:

Tintoretto did not choose that yellow rift in the sky above Golgotha to *signify* anguish or to *provoke* it. It is anguish and yellow sky at the same time. Not sky of anguish or anguished sky; it is an anguish become thing, an anguish which has turned into yellow rift of sky, and which thereby is submerged and impasted by the proper qualities of things, by their impermeability, their extension, their blind permanence, their externality, and that infinity of relations which they maintain with other things.

For the artist, the color, the bouquet, the tinkling of the spoon on the saucer, are *things*, in the highest degree. He stops at the quality of the sound or the form. He returns to it constantly and is enchanted with it. It is this color-object that he is going to transfer to his canvas.[36]

Rothko, too, describes his areas as "things" and, like Sartre, emphasizes the "immanence" of their meaning. Meaning is immanent in the form or, in Sartre's phrase, "trembles about it like a heat mist; it *is* color or sound."

Means as well as source, "to explore the nature of the medium," in Hofmann's words, "is part of the understanding of nature, as well as part of the process of creation." Some of his finest canvases are the Provincetown landscapes painted from nature during the thirties, and his theory does not by any means exclude that method, but "from the very start of his studies an artist who works from nature faces a double problem. He must learn to see . . . and he must learn to interpret his visual experience as a plastic experience." Only the first step, he must next "interpret the plastic nature of the medium of expression and translate his experience in accordance with it"—translate the three-dimensional phenomena of nature, that is, into pictorial form.[37]

Plainly, Hofmann's concept of nature in art is at the farthest remove from that of Courbet. It is closer to that of China, or even in its intellectuality

to the systematized theory of natural principles which Leon Battista Alberti found in Pythagoras: a conformance to "inherent laws," which are met "behind," or "above" chance appearances. They can find their way into painting independent of any ostensible landscape subject matter. Following Hofmann's contention that pictorial means themselves are a part of nature, a wash of watercolor, save for difference in size, is in fact a flood; and the picture plane, its surface perceptually in tension with recession, is a cliff.

Ruth Field observes that modern painting and modern poetry, beginning with Mallarmé and Cézanne, offer a "flat prospect without illusory depth or perspective." Both media, she infers, have taken on the form of the "flat landscape."[38] Beginning with the medium, abstract painting, often unintentionally, has approached a representation of those aspects of nature which most resemble modern pictorial means. Thus, Motherwell, whom perhaps unfairly I have separated from nature, has been regarded as a painter of landscape, and has been gently censured, by some post-Mondrian militants, for his avowed "atmospheric light" and "chiaroscuro."[39] Even as the realist who sits down to copy nature can end with abstraction, so the abstract painter has made himself and his audience see nature in a new way. Tobey, in the spirit of an Oriental sage, aphorizes: "We look at the mountain to see the painting, then we look at the painting to see the mountain."[40]

In this way, by morphological and rhythmic parallels, Tobey's calligraphy represents grasses; and the layers of brown paper in a Motherwell collage, a beach. Hofmann's heavy pigment becomes a medium filling a cosmic outer space. Pollock's maze is a thicket. We have seen instances in de Kooning's abstract paintings of close analogy between pictorial and natural form; beginning with lines, spots, smears, overlaps, and "reveals" they become land-

scapes. In *The Mailbox* (Fig. 22), for example, rocks, hills, caves, supports, and depressions appear—images changing as the eye successively fuses or separates nuclei from adjacent forms. At the lower center a "highway" turns to the left and disappears behind a "cliff." Behind it, lines form a trestlelike grid which begins to support another curve of the "road"—but here that image breaks down, and the whole section to the left of the "trestle" becomes an hourglass form—a bird or a fish inserted at the left into a slit in the surface. One can read and reread this "landscape of the mind" in numbers of ways, but its association with natural topography continues to be evident. In the large *Excavation* (Fig. 30) a median morphology is established between abstract, human, and natural form, its elements a webbing of brushed musculature, its overall aspect that of an organic cliff revealing glimpses of an open world beyond.

Nature can also be present in its effect on artifacts: a "weathered" painting can resemble a worn wall, the collage of an abandoned billboard, cracked paint, or children's chalk drawing on an asphalt pavement. Representational painters and "abstract" photographers have appropriated the connection between man and nature through artifacts. Aaron Siskind, to mention one such camera artist, wishes his picture, like the painter's canvas, "to be an altogether new object, complete and self-contained, whose basic consideration is order."[41] His naturalism, like that of the painter, demonstrates flow, movement, disintegration, accident. Though he photographs actual cracked and spotted walls, artifacts altered by natural forces, his sources are also in the paintings of Motherwell, Pollock, and others.

A return to nature, somewhat by the path we have just taken, is ideologically as important to many painters as is the return to the figure. But often, just as their figure paintings tend to resemble a

loose-brushed conservatism, so the advance to land-scape or interior scenes can approach a revival of Bonnard, Vuillard, or Monet.

For younger painters who during the early fifties felt impoverished by a lack of naturalistic form, Gorky was especially important. Here was a master, concerned with representation and corporeality in his early work, who abandoned it later for heavily pigmented abstraction, but ultimately returned to human and natural subjects on a new level. The focus of Gorky's reality may have been in himself; but so strong was his urge toward a meeting point of pictorial structure with both biomorphic and naturalistic form that it became a subject matter: the union of man with nature. His synthesis includes a fusion of the earlier bulk and figuration, a free use of structure derived from Cézanne and Cubism, an entirely new empirical draftsmanship, and a vocabulary of soft voluptuous forms partially occasioned by Surrealist precedent. It is already announced in *Garden in Sochi* (Fig. 64) and is evident in his description of the motif:

About a hundred and ninety-four feet away from our house on the road to the spring, my father had a little garden with a few apple trees which had retired from giving fruit. There was a ground constantly in shade where grew incalculable amounts of wild carrots, and porcupines had made their nests. There was a blue rock half buried in the black earth with a few patches of moss placed here and there like fallen clouds. But from where came all the shadows in constant battle like the lancers of Paolo Uccello's painting? This garden was identified as the Garden of Wish Fulfillment and often I had seen my mother and other village women opening their bosoms and taking their soft breasts in their hands to rub them on the rock. Above all this stood an enormous tree all bleached under the sun, the rain, the cold, and deprived of leaves. This was the Holy Tree. I myself don't know why this tree was holy but I had witnessed many people, whoever did pass by, that would tear voluntarily a strip of their clothes and attach this to the tree. Thus through many years of the same act, like a veritable parade of banners under the pressure of wind all these personal inscriptions of signatures, very softly to my innocent ear used to give echo to the sh-h-h-sh-h of silver leaves of the poplars.[42]

We know that Gorky was given to poetic embroidery and even invention in recreating his past, but it is apparent that a real motif existed for his *Garden in Sochi*. The very diversity of the images blended in his memory prevents any one of them from predominating: the road and the spring, the apple trees, the sharp spines evoked in the mention of porcupines; the blue rock in the black earth, the "fallen clouds" of moss, and the connection of shadows with the forms of Uccello; the "Holy Tree" bleached by weather, and the image of the torn *ex votos* fluttering in the wind. In his memory of the fertilizing contact between the yielding obesity of flesh and the hardness of rock, Gorky's blend of form and subject is epitomized. Controlling the literary use of unconscious imagery by his sense of medium, Gorky achieves after 1943 an iconography of morphological differences, building planes of architectonic structure, visceral forms suggestive of virility and fecundity, fluttering petals and leaves, dry bone-shapes, and threatening projections.

It was André Breton who first wrote discerning words concerning Gorky's universal morphology—the power of his eye and hand to reveal the similarities of form between apparently unrelated structures; identities which have been hidden, not only by familiarity, but by scientific classification which, in Breton's words, "somehow forces the lobster and the spider into the same sack." Gorky's visual metaphors, as the Surrealist leader, a medical scientist by training, knew at first hand, cut directly through the "mental prison" of rationally ordered knowledge. Gorky had freed himself, Breton felt, through the "free and unlimited play of *analogies*." The

outcome of visual scrutiny in interplay with promptings of the unconscious resulted in hybrid forms. Breton emphasized that Gorky was, "of all the Surrealist artists, the only one who maintains a direct contact with nature, in sitting down to paint *before her.*" "For the first time" he concluded, "nature is treated . . . in the manner of a cryptogram," which is marked by the imprint of the artist "in the discovery of the very rhythm of life."[43]

In 1942, when Gorky was first sketching in the country, he wrote of his liking for "the heat, the tenderness, the edible, the lusciousness, the song of a single person. I like the wheat fields, the plough, the apricots, the shape of apricots, those flirts of the sun."[44] The nucleus of drawings and paintings of *The Plow and the Song* (Figs. 83–87) fully bears out Breton's interpretation. Yet Americans respond to Gorky's theme of fertility with difficulty. Attitudes toward sex are so overlaid with fear and prudery or so confused by commercialism and pat psychological theory that the audience often lacks the artist's naiveté as well as his sophistication.

In the use of soft forms, as in its draftsmanlike method, Gorky's art is akin to that of Ingres, though it never has the unqualified voluptuousness of *Le Bain Turc* (Musée du Louvre). His "eroticism"—the term is hardly appropriate—is existential, rather than romantic or hedonistic, suggesting a note of tragedy which is more than implicit in his words for *The Liver is the Cock's Comb* (Fig. 70): "the song of a cardinal, liver, mirrors that have not caught reflection, the aggressively heraldic branches, the saliva of the hungry man whose face is painted with white chalk." "In this and in other late paintings," Ethel Schwabacher writes, "Gorky frequently used such primitive symbols as man's body organs, the liver or viscera. These images floating in deep quietness suggest the intimate poetry of helplessness at birth, unconscious wishes, words of a lost and ancient language, remembered only in dreams."[45] The use of Sören Kierkegaard's

title *Diary of a Seducer* (Fig. 75), perhaps with the collaboration of Breton, calls further attention to Gorky's biological themes.

Emphasis on sexual content in the work of one painter raises the question of its importance for the others. Surrealism, besides Cubism perhaps the most important single influence on Abstract Expressionism, was in part a revolt of sexuality against taboos. There has been almost no objective study of this fundamental content that from the representation of the nude—which is far from finished!—to the puritanism of de Stijl, deeply conditions modern art. Critics and historians usually ignore it, and the art-ignorance of psychologists renders their studies of little aesthetic value, whatever may be their clinical worth. Nor do I aspire to advance any theories of hidden sexual motivations—though one could propose divers interpretations of Abstract Expressionist images, pictorial means, and processes. Attention is called to sexual subject matter and content only when it is apparent; and it is not only Gorky, but Motherwell, de Kooning, and Rothko whose works have sexual meanings. If it is an aim of the artist, as Motherwell writes, "to find or invent 'objects' . . . whose felt quality satisfies the passions," then sex can hardly be avoided![46]

A sharp distinction must be made between meretricious eroticism and a preoccupation with human drives, which is, like internationalism or metaphysics, "a natural consequence of dealing with reality on a certain level."[47] Behind the tense oppositions of shapes, lines, and edging in Motherwell's work lies a basic subject matter related to life, love, and death. It has been argued that such universal content cannot be communicated within the stringent limitations of abstract means—one of the most telling criticisms of the aims and achievements of Abstract Expressionism. Whatever the painter's feelings or ideas, the charge can be made that a soft shape is only a soft shape, not a breast; that a black spot on a white ground cannot symbolize

death in the midst of life. But the early *Pancho Villa, Dead and Alive* (Fig. 155), the Spanish Elegies (Figs. 177, 179, 180), and the strutting black forms of *La Danse II* (Fig. 194) go far to defend the Abstract Expressionist position. Motherwell's work has a power deriving from just such content; representationally, moreover, the image of woman is never abandoned. Four drawings are reproduced in a catalogue of 1952. The rear page is filled with a Spanish study, and on the center fold, opposite a sketch of the Seven-Branched Candelabra, is an ideograph reducing the feminine figure to a tiny head above huge breasts and thighs: "Artists like their nudes full blown."[48] There are sketches and paintings which give evidence of Motherwell's "intimism"—far closer than that of Bonnard or Vuillard—a celebration, like the soft pregnant nudes, of married love. "I love painting," Motherwell writes in concluding a statement read at The Museum of Modern Art, "the way one loves the body of woman . . . if painting must have an intellectual and social background, it is only to enhance and make more rich an essentially warm, simple, radiant act, for which everyone has a need."

The reaction of typical American audiences to an artist's honest explanation of his experiences and content is apt to be one of embarrassment, annoyance, or even hostility. But his role is no more to buttress taboos than it is to edify commercialism. It is his right and responsibility to ignore mores when the natural path of his art cuts through them, or, more simply, as Gorky wrote in a letter to his wife, "to see well, in order to render well what he has felt well in seeing well."[49]

De Kooning's seething gestures in thick paint, his overlapping brush-planes, and his interlocking organic shapes are in themselves both voluptuous and intense. Expended upon his fetishistic woman-image, however, this implicit sexuality (which might be discerned also in Hofmann's impassioned attack) becomes explicit. Huge eyes dilated and

teeth set, the full-blown figures struggle against recession, flatness, and structure. The mood, established in small color sketches by the central placement of a lipsticked Coca-Cola mouth clipped from periodical advertising, could not be farther from Motherwell's tenderness. De Kooning's heroine is not wife, mother, or even mistress but, darling of the bar stool and barber-shop magazine, ideal of a million cinema-going males, the indulgent strumpet, a carnal product of wish fulfillment and commercialism, frightening in her orgiastic gaiety. Excoriated with blood reds and ugly slashes of charcoal, her effect is unprecedented. But from the very violence and intentional vulgarity of the image, another woman takes form: a goddess of fertility. Rising from the darkness of the past or the atavistic depths of consciousness, she stands, like the ancient Cybele who drove her lover Attis to madness and castration, a cult image of the eternal female.

Although Gorky, Motherwell, and de Kooning, quite differently, have been concerned with sexual content, their work could not be described as "erotic," like that of Pascin. Pushing toward the wellsprings of experience, the primitivism of de Kooning's women, the visceral pantheism of Gorky, and the connubial content of Motherwell are allied.

Such is true also of Rothko. In his 1943 statement in collaboration with Adolph Gottlieb, it is mentioned that the "subject is crucial and only that subject-matter is valid which is tragic and timeless. That is why we profess spiritual kinship with primitive and archaic art."[50] In the drive toward a core, a oneness, varied types of feeling merge. It is the characteristic of artists in general, and of the six painters we are dealing with in particular, to be motivated by such a centripetal drive. Fundamentally it is this focal motivation which separates their art from that of those nineteenth-century Romantics and twentieth-century Surrealists whose "unknown" was primarily centrifugal—a flight away from reality rather than an impulsion toward it.

The Artifact

Western still-life paintings represent arrangements of natural objects either whole or cut into sections —dead animals, fish, fowl, flowers, fruit, and other plants that have been separated from their natural environments—and artifacts. There are a host of associational, technical, and aesthetic reasons for the interest of painters in this genre. Yet, of all representational themes, still life is most subject to the artist's will. Hence, in the Cubist neutralization of natural motifs, objects played the role of abstract compositional elements. As still life gradually ceased to be the "true" subject, unmasked pictorial units took their place.

The use of still life as a provisional motif does not necessarily indicate the slightest ideological concern for the fabricated object as such. But in dissolving the illusionistic tangibility of realism for an immaterial content, painting appropriated the very materiality which, as a subject, had been eliminated. It is next to impossible, Motherwell wrote in an essay on "Painters' Objects," "to rid oneself of the 'objects' of the external world." "What interests us," he continued, "is the structure of painting, not the appearance of the 'objects' of the external world. An empty canvas is more to the point, in being itself, an 'object,' and not merely an awkward image of 'real objects.'"[51] Historically speaking, the physical priority of the picture was unintentionally brought forward by Impressionism, philosophically implicit in Cézanne, prophesied by Denis, made specific in Cubism, demonstrated by collage, ironically emphasized by the Dadaists, and militantly defended by abstract painters. It is now an established concept.

In 1946 Motherwell expands his theory of painters' objects: "To find or invent 'objects' (which are, more strictly speaking, relational structures) whose felt quality satisfies the passions—*that* for me is the activity of the artist, an activity which does not cease even in sleep."[52] Relieved of its odium, the analogy made by Robsjohn-Gibbings between a modern-art object and a primitive fetish is meaningful. Painters and sculptors, in their concern for concreteness as against illusionism, have repeatedly identified with exactly those art forms, both primitive and historical, in which feeling was objectified rather than illustrated. In the flatness of its picture plane and the narrowness or absence of a frame the Abstract Expressionist picture, like a geometric abstraction, is a "thing." But in its greater involvement in the aura of feeling, it is a special kind of object. The painting emphasizes its existence as a human fabrication, but its perceptual vitality and aura of feeling have made it another kind of artifact. A spiritual tuning fork, it is first an object for sensing and next for emotional and ideological response, symbolically mediating between the spectator and the world.

It is customary to separate subject matter, as the apparent iconography of a work of art, from its less evident content; but with the abandonment of representational subjects and the increasing interrelation of form and content, a clear division has become less and less tenable. This is especially true in considering the artifact as subject matter, motif, and content.

In our epoch as in no other the machine and the totally artificial environment have become basic cultural determinants. In a corrupted way, the ruthless manifestos of the Italian Futurists isolated key principles of contemporary painting: its concern with movement, process, and perception; its dematerialization of represented objects; and its hostility toward academicism. In elevating the kinetic violence of machines above human welfare, however, the Futurists were happily unique, unless one considers Fernand Léger's admiration for war material and mechanization. Movement, process, perception, and dematerialization are all aspects of the modern concept of reality. But the distinction between the

kinds of movement or process, perception, and de-materialization and between the ethical and aesthetic ends they imply is, to put it mildly, crucial. Nor is it surprising that the Abstract Expressionists, like most contemporary painters, should reject the views of the Futurists. More worthy of note is the pattern that repudiates every shade of identification with the machine and its products and expresses distaste for those modern movements which gave them precedence. The worn, beaten, or eroded artifact is preferred to the purity of machine form; and the utilitarian aesthetic symbolized by the German Bauhaus, which attempted to fuse expressive with functional art in "design," is regarded with special opprobrium.

The employment of mechanical abstract forms, Meyer Schapiro observed, relates to the values a social group assigns to the human being.[53] By an opposite token, the responses grouped around the Abstract Expressionists' rejection of machine modernism and determinism are a function of their humanistic view. A regard for significant content also governs the opposition of painters' objects to machine artifacts. Up to a point the distinction is that which exists between the product of the machine, "the ideal instrument of 'Platonic creation,'" for which each fragmentary function of the operator and his machine is only a small unit of the whole, and the craftsman who "makes an object." What characterizes the factory product, as Edward Rothschild has emphasized, is "the negligibility of the human (integrating) factor."[54] But the art work separates itself from both the crafted and machined artifact by its mechanical uselessness, raising the human integrative power to a raison d'être. Going further, the Abstract Expressionist object distinguishes itself from the purely relational object of the purist in its affective connection with non-art experience.

The New York painters have one important link with the Futurists: their love for the modern city as a subject. The island of Manhattan could be called the world's largest artifact. In fact as well as symbol it is a world fabricated by man and machine. "Air-conditioned nightmare" though the possibility may appear, one could pass an entire lifetime in its brightly lit subterranean and aerial maze, with its interconnected bookstores, bakeries, restaurants, office buildings, and hotels, glimpsing no more of the natural world than an occasional patch of sky. Its irreducible form is the right angle, and its fundamental tempo is that of machinery—or, more accurately, some reciprocal mean between the machine and the adaptable human organism.

Since the time of the Ashcan School the appearance and the spirit of New York City as subject matter and conditioning milieu have been instrumental in forming American painting. After returning from France in 1910 John Marin, whose work, more than that of any other American, relates to Cézanne, wrote and painted about a New York which was "a thing alive." The "movements" of the building masses aroused in him feelings which he ascribed to "pull forces." In a catalogue statement (1912) of five packed paragraphs which could have been written in the forties, Marin summarized the effect that the great city was to have on hundreds of other artists, American and European: "And so I try to express graphically what a great city is doing. Within the frames there must be a balance, a controlling of these warring, pushing, pulling forces. This is what I am trying to realize. But we are all human."[55]

Almost thirty years after Marin's return from Europe, in 1940, Piet Mondrian arrived in New York. His change from a direction of progressive purification, already begun in London, was intensified until, in *Broadway Boogie Woogie* (Fig. 288), as Motherwell writes two years later, "the former severe black bands are fractured into segments of color so intense in contrast that they jump, so short in segment that they become a staccato rhythm

against the larger rhythms of the main structure." "For the first time," he adds, "a subject is present, not by virtue of its absence, but actually present, though its appearance is torn away, and only the structure bared. The Modern City! Precise, rectangular, squared, whether seen from above, below, or on the side; bright lights and sterilized life; Broadway, whites and blacks; and boogie-woogie, the underground music of the at once resigned and rebellious . . . Mondrian has left his white paradise, and entered the world."[56]

Tobey arrived in New York in 1911, where he had his first exhibition of drawings in 1917. Although he sketched colorful types in Washington Square, he did not use the tension of city life as a theme until later. But the 1920s were a time of "sirens, dynamic lights, brilliant parades and returning heroes. An age of confusion and stepped-up rhythms." He made realistic drawings of Harlem nightclubs, vaudeville, and burlesque shows. Before New York, Tobey's ideas of art had been influenced by a love of the brush illustrators Sargent and Sorolla—in opposition to his love for the Renaissance tradition. But it was not until the twenties that he could see more in Duchamp's famous *Nude Descending a Staircase* (Philadelphia Museum of Art) than "an explosion in a shingle mill."[57] His discovery of New York City paralleled his discovery of Cubism.

It was in 1935, after the surface "handling bug" had been imbued with new content through the catalyst of the calligraphic art of the Far East, that Tobey was able to focus the elements which were central to his ultimate content and style. In the process of executing a small abstract painting based on a still life, its linear network became a structure revealing little nuclei of forms enclosed within a web. Suddenly Tobey saw his creation as a structural symbol of the modern city. Thus, by means of white lines he had abandoned the provisional still-life motif for a new pictorial means and a pro-

foundly felt subject matter: compartmentalized urban existence. The tiny picture was called *Broadway Norm* (Fig. 238), and soon after the impressionistic *Broadway* (Fig. 239) was painted. If humanity is Tobey's first subject, the tempo of the city has been, from then until now, his second—not alone that of New York, with "its shooting-up towers and space-eating lights," but that of London, Seattle, and the Orient: "Thousands of Chinese characters are turning and twisting . . . The narrow streets are alive in a way that Broadway isn't alive."[58]

It is significant that in 1942 both Mondrian and Tobey were at work on a Broadway boogie-woogie theme. Lacking all stylistic similarity, the two painters were nonetheless akin (and in sympathy with Marin) in fundamental ways: in discovering a form equivalent for their intense responses to New York; in using an analogy between an architectonic structure derived from Cubism and the compartmentalizing steelwork of the city; in seeing movement and equilibrium as crucial; and in seeking a symbolic meeting point between structure—of both subject and pictorial means—and an essentially mystical view of reality. It is in this way that intuitive and devoted men like Marin, Mondrian, and Tobey, though separated in background and temperament, arrive on common ideological ground in response to their age.

In Chapter 3 the boxlike room within which de Kooning's figures pose was seen as one of the infinite numbers of compartmented units of Tobey's New York. Separated from nature, the isolation of the individual is put in relief by urban scale. Self-concentration is intensified rather than softened. De Kooning's two years of work on *Woman I* (Fig. 41) have been compared to a romantic voyage. But the journey "is inevitably around the walls of a studio."[59] And the studio is not that genteel atelier of popular imagination, but a stark, bare, obsolescent manufacturing loft, devoid even of the bric-a-brac

of the Cubists; empty but for the painter, his canvas, and his tools. The "big city dames" are conceived in isolated subjectivity, but incarnated from the atmosphere of the metropolis outside.

Contributing to the tension of New York art is the intensity of its professional environment—a highly charged air of devotion ringed by commercialism and cut with irony and ruthless criticism; a milieu, Motherwell remarks, like the cowboy towns of the Old West: "One has to be quick on the draw."[60] In this setting, the "anguish" of Abstract Expressionism can be seen as a combination of loneliness, personal aggressiveness, frustration, radical humanism, and European bohemianism merged with the tough-guy tradition of American art and letters. It is in contact with the New York spirit that Hofmann develops what is surely the most athletic painting procedure in Western art history, except for Pollock's. It explains the need of long-standing progressives like John Ferren to divide their life between the city and the country—in this instance California—or for others, much as they wish (whether they confess it or not) to remain in touch, to shun the city for isolation in Maine, Long Island, Pennsylvania, or the Northwest. Partially, too, it explains the generalized nature which arises from the qualities of means, and the corollary rejection of the straight line which, as a human concept, has marked both the machine and painting.

Until 1941 Gorky lived and painted from memories recollected within a matrix of bohemian life. Running thin on ideas in his Union Square studio, he would turn for stimulation to the illustrations in a study of Picasso, or to a print of a Uccello, David, or Ingres work.[61] But his art grew to its fullest development when, after periods of neo-Cubist structuralism and expressionist abandonment to medium, he reaffirmed by direct observation his feeling for actual, rather than subjective, nature.

In conclusion, it is not the intent of these paragraphs to defend or criticize a naturalistic, a humanistic, or any other view toward painting, but to emphasize a contention that the expressionist element in the New York painting of the forties and early fifties is the most uniquely American contribution to modern art. It has been influenced little, if at all, by Munch, Nolde, Kirchner, or Beckmann; but like German Expressionism and French Existentialism, it is a response within a particular environment to conditions which are uniquely contemporary. It has given a specific flavor and a new life to principles of modern art which in war-ravaged Europe were becoming stale. For this function its implicit attack on taste and on French métier was a strength. As in the pull which the big city exerts over our imaginations, its vitality cannot be separated from its lack of finesse.

The Self and Reality

In objecting to art's dependence on science, sociology, history, and other disciplines, the Abstract Expressionist painter Jack Tworkov isolates painting, in words like those of a purist, as an autonomous pursuit: "I believe that as one applies oneself painting becomes a true way to reality." Alfred Barr asks a group of painters and sculptors: "Do you want to discuss whether you want to do something practical or go ahead in the search of what we call truth?"[62]

Reality and truth are the terms that best designate the absolute of abstract art. It could be argued that to make a major point of the search for reality and truth—often they become identical concepts—in art is to labor the self-evident. Has not all significant art had such an aim? True. But there is no one approach to reality. Truth is historically, geographically, and individually relative, and a discussion which lays any claim to historicity must proceed in cognizance of this fact. Only then can one clearly perceive the distinctively contemporary character of the reality, or realities, of modern art.

Modern artists, finding truths important to other periods—the painstaking representation of tactile and visual appearances, for example—lacking in significance, have arrived at a metaphysics which can be seen in the work of Mondrian, Kandinsky, and Klee, the philosophy of Whitehead, or the recent Bergsonian platonism of Herbert Read. It is capable of clothing itself in widely varied styles. One of its consequences is the disinterest in beauty as a goal. Beauty becomes secondary, peripheral, even irrelevant: "For the artist himself the problem is not 'beauty,' ever. It is one of accuracy, validity, and life," says Hedda Sterne.[63] At best, beauty is a quality recognized in the completed work of art. Those forms which the contemporaries of Cézanne and van Gogh found ugly, painters realize, only became beautiful to later eyes.

Where does the truth or reality of Abstract Expressionism lie? Though there is no single answer, different positions belong to the same constellation, for they are responses to common problems. They arise from unconscious and egoistic levels of the personality; they have to do with nature; and they converge toward intuitions which can be called mystical. In the instances in which a painter's content lies mainly within his immediate personal life, its emphasis is existential. If, on the other hand, his intuition moves in the direction of a focus felt to be outside the self—surrendering the ego—his content is also subjective, but in quite a different sense. A separation of the existential from the transcendental is helpful, even essential, in structuring this nebulous topic. Nevertheless, it would be false to posit a gap between them. The slightest knowledge of German Expressionism is sufficient to demonstrate the arbitrariness of a clean-cut dividing line between expressional and mystical content in modern painting. Rather, the two focuses should be seen as interrelated tendencies, or varying levels, of inner experience.

Since the Romantic movement, all of the things

we imply in speaking of the self—the individual viewpoint, the emotional coloring, the "qualitative uniqueness" of the personality—have in certain instances become the primary content of art, and are always an important ingredient. Yet the question is simply begged by assigning everything to a huge bin labeled romanticism. Consciousness of self is a basic aspect of modern Western reality; as the concept of truth changes, so must the experience and the concept of the self change. It is equally pointless to accuse the artist of being self-centered. As Motherwell notes, to assume that an honest painter has unqualified liberty in selecting the basic content of his art is a fallacy, however extreme may be his freedom in choosing the form which it will take. But whatever name we invent for it, and whether or not we approve of it, one of the central functions of art today continues to be the expression of inner states of consciousness.

During the 1950 Studio 35 sessions, Bradley Walker Tomlin remarks: "I am sure that there are a number of people who are interested in the matter of self-expression alone and there are others who are not." The phrasing of Tomlin's statement emphasizes the importance of the self in modern art. The reasons for its "subjectivism"—if that is what one chooses to call it—are varied. The social world in which the artist lives cares little, and understands less, about the things which he values most highly. His thoughts continually return to his isolation: "Is the artist his own audience?" (Motherwell); "What is the purpose: to describe our own creative nature?" (Richard Lippold); "An artist is always lonely" (David Hare); "There is a feeling of trying to express the labyrinth of one's mind—its feelings and emotions, and to fulfil one's personality. Each work is trying to complete the expression of that personality . . . an artist is very aware of himself in relation to the rest of the world" (Peter Grippe).[64]

In various discussions of the modern painter's so-

cial situation Motherwell has spoken of a "spiritual underground," in which the artist "tends to be reduced to a single subject, his ego." Abstract painting, it could be said, results from an attempt to escape isolation or dissolution by objectifying the ego in form; though a purely formalistic art, paradoxically, can end in its renunciation. "In rejecting the values of middle-class society, as a historical event, the aesthetic, and other eternal values, like chance, love, and logic, are what remain."[65] The painter of the past, as a functioning unit of society, painted the public myth, ritual, and propaganda of his time, whereas the modern turns to his inner experience; but this is not necessarily because he is so egocentric that no interest remains outside himself, but because private experiences have become the chief, and often the only, ones which he trusts. In more general terms, the individual has become the organ and judge of truth.

Primary to an artist's integrity in this situation is the maintenance of contact between his work and his subjective experience. According to Motherwell, a section cut from a tabletop or a wall in the home or studio of an artist resembles his work.[66] The more "internalized" his work becomes—the more it is the authentic expression of the way he behaves, thinks, moves, and is motivated—the more "true" is the work of art. One function of painting, from the point of view of the self, is to objectify the ego through form. Put another way by Barnett Newmann, "We start from a subjective attitude, which, in the process of our endeavour, becomes related to the world."[67] In Rothko's words, when a picture is completed "the intimacy between the creation and the creator is ended. He is an outsider."[68] Broken off from the self, the picture contains the integrity gained through its source in experience: "It isn't so much the act of being obliged to someone or to society, but rather one of conviction. I think, whatever happens, every man works for himself, and he does it on the basis of convinc-

ing himself. I force my attitude upon this world." De Kooning's words express the opposite of Motherwell's response to a "felt reality." [69]

As a philosophical position, de Kooning's attitude might be regarded as solipsistic. But even aside from the fact that a painter's responsibilities are not those of a philosopher, such a conclusion is dangerous. At no time does he categorically reject the world of either man or nature, and he recognizes that his personal problems "are also part of historical problems—past, present, and future." Besides, he never renounces responsibility to society. The reverence he feels for fellow Dutchmen van Gogh and Mondrian is almost more ethical than painterly in its emphasis; his conception of van Gogh assumes social service as a higher function than art, and he underlines Mondrian's interest in "all of society, not just painting." [70]

De Kooning regards a vital lack of clarity as an essential quality of art. Predetermined clarity is seen as outside it. Oscillations between the self and the world, abstraction and image, geometry and organicism are symbolically, but incompletely, resolved only outside the self, on canvas. To the artist the picture must be the conclusion. When, for instance, de Kooning feels the sort of intuition which sends the researcher or the philosopher to seek for confirming data or formulation, the painter's contact with it breaks before it develops: "I do not think of inside or outside [functionalism, and so on]—or of art in general—as a situation of comfort. I know there is a terrific idea there somewhere, but whenever I want to get into it, I get a feeling of apathy and want to lie down and go to sleep." [71] Unless an artist intentionally assumes the role of critic, historian, or philosopher, his is not the responsibility of formulation. De Kooning's reality finds its proper solution in the dynamic unity of painting. By refusing to resolve his personal contradictions, the richness of experience from which his art is formed is kept alive. Always

cutting off projections beyond the immediacy of existence, he remains, in the most direct sense of the word, a "professional" painter: "If you are an artist, the problem is to make a picture work whether you are happy or not."[72]

Some evil fate willed that Gorky be tragically unable to achieve fulfillment in life; yet in his late style he attained a wonderful creative synthesis, miraculously uniting tensions which de Kooning intentionally leaves unresolved. Attention has already been called to his sense of zeitgeist: of the "invisible relations and phenomena of this modern time." Picasso, Léger, Kandinsky, and Gris gave him evidence of the "supernatural world behind reality where once the great centuries danced."[73] Possessed to the highest degree of a centripetal urge, he began with direct sense experience and the emotional raw material of his biography, but did not stop there. Every scrap of visual or documentary evidence we have of Gorky's views confirms his intense interest in truth: felt or intuited truth, for Gorky was not a scholar but a poet. It was a truth which lay at some central meeting place. It was thus that he was able to conceive hybrid forms which were at once human, animal, vegetable, and architectural, and which at the same time imaged his own biography. Like a mystic or a philosopher, he glimpsed an ideal reality. His unknown center lay both outside and within his personality: "I am an individual—Gorky—and it is my individual feeling which counts for the most. Why? I do not know nor do I wish to know. I accept it as a fact which does not need explanation."[74]

The most recent collection of Hans Hofmann's writing is significantly entitled *Search for the Real*. "Every deep artistic expression," he believes, "is a product of a conscious feeling for reality."[75] His reality combines, and derives from, many levels. The "creative urge" begins in the uniqueness of the self. It means "just one thing . . . To discover myself as well as I can."[76] Spiritual reality is created "emotionally and intellectually by the conscious or subconscious powers of the mind." Personality-centered as this interpretation first appears, and much as Hofmann believes in automatic approaches to painting, "spiritual reality" is also outside the self: "the emotional and intellectual synthesis of relationships perceived in nature, rationally, or intuitively." An artist is characterized by "his intuitive faculty of sensing the inherent qualities of things."[77]

Hofmann's distinction between "two kinds of reality" is significant: "Physical reality, apprehended by the senses," implies the ordinary tactile and visual impressions of the material world. Conventional realistic art represents only these surface phenomena. The spiritual reality of the plastic artist, however, is a distinctly different thing which, although it is an outcome of the painter's manipulation of the medium, relates to outer truth. The translation of the physical carrier into surreality is metaphysical, "for metaphysics is the *search* for the essential nature of reality." Thus, painting is conceived as a plastic metaphysics which transcends the limitations of emotion, the medium, and the physical environment without losing contact with them. In a new form they are still present, and the reality of the artist "concerns both the reality of nature and the reality of the intrinsic life of the medium of expression."[78] The strength of Hofmann's interpretation lies in its synthesis of the spiritual and the physical. The immaterial is never split off in a disembodied idealism, nor is his theory ever purely painterly or technical. Transcendental qualities are achieved directly through the reciprocation of depth and flatness on the picture plane. Consequently, there is no noncreative level of craftsmanship, for technique is inseparable from concept.

The self cannot be separated from the environment. Since content has ceased to be encompassed by established validities of myth, institutional religion, history, or politics, it results from personal responses. In Tobey's words: "An artist must find his

expression closely linked to his individual experience or else follow in the old grooves resulting in lifeless forms."[79] Implying a parallel rejection of institutionalized content, Motherwell in the initial issue of *Possibilities* asserts that "this is a magazine of artists and writers who 'practice' in their work their own experience without seeking to transcend it in academic, group or political formulas."[80] De Kooning has found that "painting—any kind of painting, any style of painting—to be painting at all, in fact—is a way of living today, a style of living, so to speak. That is where the form of it lies." He argues, "Painting is like one's life expectancy; how long you live . . . Life outside the painter passes through his own life."[81]

One of the weaknesses of our concept of expressionism is the tendency to conceive it as only involving the most obvious and violent experiences. But the contemporary artist is involved in finding forms for a view of the world as it is seen from his unique vantage point. His expression will be as obvious or as subtle, as simple or as complex, as narrow or as all-encompassing, as his total personality—mind, world view, emotional make-up, and body—will allow it to be.

The great work of art should be the product of the great life of art. Beyond the individual piece, Hofmann says, "the life work of an artist is 'the work of art.' It includes the whole behavior of the man, his ethical convictions and his awareness of creative responsibilities."[82] An artist should be valued "for his personal interpretive insight and not for his conformity to traditional patterns."[83] His inner responses to the rhythm and structure of life are his only true evidence for the felt nature of things. In this sense a man's art is indeed his biography, the day-to-day experience of one committed to fashioning a continually changing image of the world from one changing position.

Few modern artists would argue against the necessity for this subjectivity of view. Arguments concern the degree to which raw emotions—grief, fear, anxiety, frustration, sexual desire, anguish—should be projected. Yet, despite artists' emphasis on intimate experiences, an art lacking rapport with the world outside is seldom advocated. In Motherwell's words, "To express the felt nature of reality, is the artist's principal concern." Where it was the business of the Renaissance artist to comprehend the appearance of the world of objects and their relationship in a linear-aerial perspective scheme, "we are much more interested in the structure of reality." "Painting is a reality, among realities, which has been felt and formed." But to what degree the artist does or does not transcend his own existence, whatever level his focus may be on, that part of the creative process which involves a bond and a communication with self cannot be avoided, even though the goal be far outside it—an "effort to wed oneself to the universe."[84]

Awareness of the immediacy of personal existence is perhaps more directly expressed in de Kooning's works and remarks than in those of any other American artist. He conceives, and lives, in a painting world inside a circle drawn, as it were, around himself on his studio floor: "If I stretch my arms next to the rest of myself and wonder where my fingers are—that is all the space I need as a painter."[85] It should be no surprise that he is disinterested in the cosmic voids of those whom Jack Levine calls the "space cadets."[86] Consistently he turns away from the scientific, architectural, and impersonal versions of contemporary form and space, always returning to the sensations of the immediate here and now which crowd out impersonal views of the world. He dismisses the spirit as well as the technical means of the architectural-purist schools on the basis of their impersonality: "The point they [Lissitzky, Rodchenko, Tatlin, Gabo, the neo-Plasticists, and so on] all had in common was to be inside and outside at the same time . . . For me, to be inside and outside is to be in an unheated

studio with broken windows in the winter, or taking a nap on somebody's porch in the summer." He is eloquent when he speaks ironically of the conditions for which "pure plastic phenomena" were a substitute: "Man's own form in space—his body—was a private prison; and that it was because of this imprisoning misery—because he was hungry and overworked and went to a horrid place called home late at night in the rain, and his bones ached and his head was heavy."[87]

At the same time painting seems to constitute an evasion, to de Kooning, of the responsibilities of a more important dramatic life—that of the hero, the man who in one act sacrifices himself for society. He sympathizes with van Gogh, but feels that his art was cowardice. After starting out to do something for the world, to be a reformer, preacher, and a savior of his fellow men, he weakened when faced with the dirt and blackness of the coal mine, he got cold feet. It is failure and not success which is important for van Gogh. Painting was a substitute for a heroic existence: "A painter is something of a coward."[88] It is the heroic urge, of which painting is an evasion, that in part gives the artist feelings of guilt. De Kooning's antithetical identification with Mondrian, whose forms are so distant from those of van Gogh, bespeaks in sensory terms the circumscribed subjective immediacy which is his basic reality. When he reasons that geometric shapes are no more clear or pure than are expressionist forms, he speaks from sensate evidence: the optical perceptions of the physical self. The geometrical elements of a Mondrian canvas in their live relationships fall together suddenly in one final adjustment, giving the painting its "countenance."[89]

These materials—the memories, the anguish, the imprisoned heroism, the awareness of the body and its functions, the evidences of perception—all contribute to the character of the work and its philosophical premises. During its growth the picture is a part of the world of self. "I am always in the picture somewhere. The amount of space I use I am always in, I seem to move around in it, and there seems to be a time when I lose sight of what I wanted to do, and then I am out of it. If the picture has a countenance, I keep it. If it hasn't, I throw it away."[90]

The Absolute

Whether the subjective content of painting comes from the unconscious, whether it concentrates on emotion, or whether it consists of an anagogical aspiration, it is an expression of the inner personality. It is intertwined, however, with subject matter derived from social life, philosophical or moral convictions, and sensory experience. The last-named is filtered, as it were, through the first two.

Tobey's personal content is completely one with his social views. His avowed mysticism relates to his personality and to his teleological religious convictions. He is acutely aware of the tension between the everyday world and that of the artist, and that economic conditions, low standards, and "many people, including his friends [and] his relatives" try to destroy what the modern artist is trying to achieve: "his relationship to . . . his inspiration." "So he fights to maintain that; and if he doesn't, he is lost, it seems to me." Nevertheless, he thinks "the artist is concerned with his art, not with himself. He may later have to be concerned with himself . . . when his position is attacked in relation to this thing which is sacred to him."[91]

Tobey sees history as an evolution toward expanded states of humanism. At the present point in the development of society, men are just beginning to evolve beyond the dividing limitations of nationalism, regionalism, and racialism: "We all feel a separateness; we wish that a drop of water would soften our ego; the world needs a common conscience: agreement . . . The era of adolescence is over—we must concentrate outside ourselves;

as we arrive at maturity we must take on new responsibilities."

The focus of Tobey's reality is not in the self; it is spiritual and, like the Bahai religion, strives toward a median point of human aspiration: "We must look to the center to find the truth." His conceptual image resembles an expanding sphere, for while movement is toward a center rather than upward or in levels, the image is also a unity: "There is no break in religion, art, science." [92]

Tobey's idea of the spiritual is not inimical to Hofmann's, but the relation to form has a different emphasis. Hofmann stresses mystical qualities which are generated by an almost unintentional process arising from the medium. Tobey's reality, conversely, is presented as a descent from the spiritual to the material. "Multiple space" and "white lines in movement" symbolize a "unifying idea" or "higher states of consciousness," and the brushstroke, by consequence, "is the symbol of the spirit."

One of the most notable changes which has accompanied the decline of the Surrealist movement since 1945 has been the rejection of fantasy for an expressionistic or naturalistic realism. Of the more prominent Abstract Expressionists, only William Baziotes still clings to the atmosphere of the dream. He resents what he believes is a tendency to impose one quality of emotion—the overtly expressionist—as an arbitrary criterion, and at the other extreme he objects to the pure structuralists who consider his reveries as poetry rather than painting. Each artist is unique: "One hundred artists introduce us to one hundred worlds." [93] Baziotes' subject matter lies at the borderline between the conscious and the unconscious; though no one can deny the appeal of his canvases, their effect comes from mood; they are closer to historical Romanticism than to either mystical realism or expressionism. It is fitting that one painter-reviewer in 1950 considered him as "a hybrid among Ameri-

can painters—half abstractionist, half surrealist . . . one of the last full-blown romantics of a period in which such obsessive and loving personal allegiance to the fanciful and fantastic has almost disappeared." [94] The titles of many of his pictures— *The Mummy, Dragon, Jungle, Solitude, The Dreamer, Sleep, Toy World*—evoke a semi-conscious mood of somnolent reversion. The self drifts wherever the dream wills to lead it. Perhaps the most pointedly subjective painter of the New York group, he "cannot evolve any concrete theory about painting." [95] In attempting to understand the temper of today's art it is important to recognize the difference between submission to diffuse states and a centripetal approach to reality, wakefulness, and clarity.

"The Romantics were prompted," Rothko writes, "to seek exotic subjects and to travel to far off places. They failed to realise that, though the transcendental must involve the strange and unfamiliar, not everything strange or unfamiliar is transcendental." [96] He believes that the need for transcendent experience was understood in primitive societies, but that the materialism of our society rejects it. Hence, a clean break must be made. Separated from stultifying familiarity, transcendental experience, the proper aim of the artist, becomes possible.

In recent years the literature of art has often directed attention toward the contrast between the relativistic contemporary world-view and the absolutes—social, religious, and political—of the past. The last volume of André Malraux's *Psychology of Art,* a book which had considerable influence on painters during the early fifties, is devoted to what he considers *The Twilight of the Absolute.* Fitting Malraux's ideas into his own history of art, Tobey calls attention to the decline in the hegemony of Classical-Renaissance form as an absolute aesthetic standard. No longer is there only one tradition to accept or reject; its influence is combined with that of the Middle Ages, Byzantium, Ancient and Coptic

Egypt, the Far East, the African Negro, and an increasing list of other cultural expressions and art forms: "One naturally looks forward to the time when absolutes will reign no more and all art will be seen as valid."[97] Through the "Museum without Walls" the artist is offered a new freedom, but at the same time he is determined by a new cultural relativism.

As traditional absolutes have dissolved (as Malraux himself has realized), the modern " 'outcast' artist was . . . haunted by visions of his *own* absolute."[98] Overemphasis on the relativism of modern painting ignores a great deal of evidence leading to the conclusion that the idea of an absolute has changed rather than dissipated. Though Tobey calls for an end to the dictation of the humanist tradition, he still hopes for "a Byzantium, some spot to keep alight the cultural values. For what else shall we live?" He even sees its achievement in our day: "Now . . . we are in a universalizing period . . . we should have an understanding of all the idioms of beauty." We are on "the universal marshland wherein lie forms of ancient ideas and cultures, apparently unrelated to us but only waiting for time to reveal them upon the arc of our consciousness."[99] The Romantic period established the self as the only basis for truth in a relativistic world. More and more, however, thought has moved toward a reinterpretation of the idealistic tradition. Herbert Read, once a Freudian and a dialectic materialist, now declares himself as a Bergsonian and a Platonist.[100] The writer Lionel Abel in a talk with painters states his belief "with Plato that the beautiful, good, and true are one, but that society cannot see it . . . We aspire to the plane where they meet." A so-called Dada Manifesto of 1949, written by Richard Huelsenbeck, declares for creativity as a goal. "This last Dada manifesto," it concludes, "is a document of transcendence."[101]

If one looks at the evidence it is impossible to accept the hypothesis advanced by Alexander Dorner

in *The Way beyond "Art"* that the quest for unity and focus has been, or must be, supplanted by a commitment to "autonomous change"—an a priori theory derived from his interpretation of modern science which posits a time-space continuum down which one must, perforce, rush.[102] For this new determinism, represented by the exposition design of Herbert Bayer, universals, unity, and, it is essential to note, the gestalt are scrapped. Along with these, in full acceptance of the implications of his thinking, Dorner also finds the word "art" obsolete.

Valid conclusions concerning the reigning concept of artistic reality—let alone predictions—should not be drawn, it would seem, in disagreement with the pertinent documents: the paintings and ideas of modern artists, and the words of those who reflect or share their views. This evidence discloses that the orientation of the self to reality, as it has changed, has redefined rather than obviated the need for unification and focus. "The absolute which lies in the background of all my activities of relating," Motherwell writes, "seems to retreat as I get on its track; yet the relative cannot exist without some point of support. However, the closer one gets to the absolute, the more mercilessly all the weaknesses of my work are revealed."[103]

The reality of the serious modern artist is new—whatever traditional materials he may employ in its formation. He is not interested in redoing something that has been done before, nor has he the sense of a past golden age on which he must model his art. As the Futurists and Dadaists demonstrated, the desire to discover new truth can lead to extreme and violent renunciations. In order to achieve a purer reality, the artist often tries to cut himself off entirely from the known and the traditional. To Clyfford Still, for example, the past represents "a body of history matured into dogma, authority, tradition. The totalitarian hegemony of this tradition I despise, its presumptions I reject. Its security is an illusion, banal, and without courage. Its substance

is but dust and filing cabinets. The homage paid to it is a celebration of death. We all bear the burden of this tradition on our backs but I cannot hold it a privilege to be a pallbearer of my spirit in its name."[104]

If such a break is seen as desirable, rejection by society can be regarded as a positive value, enabling the artist more easily to throw off the burden of the known. Stripped of security, allegiances, and outside commitments, transcendental experiences are possible. Motherwell divides his approach to art into two "modes," the more rigorous of which is that of "discovery and invention." It encompasses his "deepest painting problem" and his "bitterest struggle." To renounce the tradition of the arts, to "reinvent" the subject matter and the means of painting, is a "voyaging into the night, one knows not where, on an unknown vessel, an absolute struggle with the elements of the real."[105]

In order to arrive at new relationships and truths, the artist often values accidents, mistakes, automatic strokes; the unfamiliar shape, line, color; the completely unprecedented structure—or apparent lack of structure. In accident or error, which may at some level of consciousness be controlled, new truth can be revealed. Contrary to most modern painters, Richard Pousette-Dart regards beauty as an aim, because for him, beauty "is what gives art its significance, it *is* the *unknown*."[106]

Much has been said in literature purporting to simplify modern art for the layman of the spirit of search and its analogy to scientific research. Although the true nature of painting has often been falsified by popularization, the parallel is not totally without validity. "I am accused often of too much experimentation," Tobey writes, "but what else should I do when all other factors of man are in the same condition. I thrust forward into space as science and the rest do." And, "At a time when experimentation expresses itself in all forms of life, search becomes the only valid expression of the spirit."[107] Even Picasso's often quoted devaluation of this interpretation—"To find, is the thing"—postulated its validity, for in science as well as art discoveries are more important than intentions.

Only at the unknown focal point of what might be called "the truth of nature" do the reality of the scientist and the artist meet. Parallels of method and experience, though they undoubtedly exist, lead too easily to a distortion of art and science. To both, nevertheless, truth is in an unknown which may lie in man, in his environment, in materials, or, in the case of the artist if not of the scientist, in himself. The life of the focally directed artist and the committed scientist is a "search for the real." It is with the unqualified romantic, fantasist, or dream-world Surrealist that the analogy breaks down. The absolute of modern art lies at a focus known only through intuition. It involves unity, structure, and gestalt.

The central theme of Motherwell's analysis of "The Modern Painter's World" is the relation of the artist to society. "The popular association with modern art," he notes, "is its *remoteness* from the symbols and values of the majority of men. There is a break in modern times between artists and other men without historical precedent in depth and generality."[1]

Like the scholar or the philosopher, the artist lives in a world of ideas vastly different from that of the businessman, the merchant, or the worker; but he is more acutely conscious of his isolation than is the intellectual. Society connotes to him not a social organism of which he is a part, but a huge middle-class world of property, manufacturing, buying and selling—a society to which he is alien. Today, Motherwell feels, an artist has no communal function; and the real nature of public activity is selling one another something. The artist is not painting to sell something to the public, as was so often true in earlier times. He is, if anything, selling himself and his ethic.[2] Hypersensitive to his social situation, the modern painter is acutely conscious that the values by which he lives are often rejected with condescension, contempt, or hostility. "We have no position in the world," de Kooning says, "absolutely no position except that we just insist upon being around."[3]

As art history since 1850 demonstrates, the lack of sympathy is reciprocal. It was not simply the increasing abstractness of modern painting which caused it to be misunderstood. The break was also occasioned by the artist's "rejection, almost *in toto*, of the values of the bourgeois world."[4] Yet there are advantages to membership in the "spiritual underground." The indifference of society insures freedom of expression. De Kooning notes that twentieth-century artists "were relatively freer than ever before *because* of that indifference."[5] Painters have come to regard isolation almost as a routine of their profession; they find a certain satisfaction

in it. Rothko regards even open enmity as a positive influence: "The unfriendliness of society to his activity is difficult for the artist to accept. Yet this very hostility can act as a lever for true liberation . . . Both the sense of community and of security depend on the familiar. Free of them, transcendental experiences become possible."[6]

A painter's historical consciousness and moral integrity provide him with defenses against society's disapproval. The sculptor David Hare connects his personal problem with his concept of the artist's historical role: "The artist is a man who functions beyond or ahead of his society. In any case seldom within it . . . Some feel badly because they are not accepted by the public. We shouldn't be accepted by the public. As soon as we are accepted, we are no longer artists but decorators. Sometimes we think if we could only explain to the public, they would agree with us. They may agree in the course of years. They won't agree now . . . they should not agree now." Later, Hare adds: "sometimes a young artist becomes too quickly known. He is already a member of the reaction. He can't help it. It is not always such a good thing to find yourself an accepted part of the culture."[7]

Assuming the existence of a barrier between the artist and other men, we can question the issues at stake. What are the values by virtue of which he is cut off and which he in turn repudiates? To Motherwell, "the modern artist's social history is that of a spiritual being in a property-loving world."[8] There is perhaps no point on which progressive painters agree more heartily; they characteristically see themselves as champions of spiritual or expressive truths in a materialistic society. Material values—the acquisition of property, wealth, and power; the adulation of mechanical efficiency and speed; education concentrating exclusively on facts and technical skills; excessive concern for physical comfort—the artist regards as antithetic to the aims of art.

Tobey's denunciation of materialism is particularly eloquent. He draws a parallel between the materialism of the modern period and that of Rome during the time of Christ. When, at a round-table discussion in 1949, it was asked whether anyone in Rome knew the culture was in a decline, Tobey answered: "I presume there were some, but they were called Christians!"[9] Later, in a conversation with me, Tobey recalled the exchange, adding, "I answered that Christ knew it"; the discussion ended. Christ always spoke of the immaterial. His only concession to materialism was "render unto Caesar." To place love of physical comfort before spiritual concerns, he believes, is to overvalue the material. One reason "the artist is not yet an integral part of society," is that in our materialistically oriented world, "people want a couch because they can sit on it, use it; all they can do with a painting is look at it." In most of the statements directed against modern values a defense of humanizing standards against mechanistic dehumanization is implied, if not directly stated. Continuing the discourse begun above, Tobey makes it clear that materialistic and anti-humanistic values are related: "We worship the young. We like *so* much muscle power for *so* much money." We have a strange belief in the "immortality of the body. We're in the age of the denial of everything but physical existence. The thing we've got to fight for now is humanism—it's the highest thing we know; we can't mechanize ourselves out of existence."[10]

Denunciations of "physicalism" also imply conclusions regarding the bond between art, personality, and culture. "A material world which excludes art," Hofmann writes in *Search for the Real*, "will remain a troubled world. The materialist flees from the crying need of his unsatisfied spirit to the drive of the 'daily grind.' Since his physical satisfaction does not necessarily include spiritual satisfaction, the sum total of his living remains unsatisfied. Such a man suffers an inner emptiness, and soon cannot

endure thoughtfulness, nor the products of contemplation."[11] In certain of his statements, the values usually attributed to middle-class society are specifically identified with the United States. When Hofmann first came to this country in 1930, he discussed American culture in this vein: "Artistic efforts have always been more difficult in America than in other countries. The motherland gives but little attention to the artist's heroic pioneering. Interest is directed toward material wealth. Despite the fact that this land is so rich in material it is poor in ideal goods."[12] Though at that time Hofmann regarded the United States as a cultural hinterland, he later realized its world role as a haven for the European artist forced to leave his home: "If I had not been rescued by America," he remarked in 1944, "I would have lost my chance as a painter."[13] Even in 1930 he took an optimistic, if cautious, view of modern art in the United States, though he felt that time would be needed to develop a national style that was something more than a reaction to Europe. In 1948 his tone is much the same: "The problem of civilizing this enormous country is not finished"; but "when America adds a developed culture to its economic richness it will be one of the happiest countries in the world."[14]

Modern art, Motherwell has said, is a development often parallel to the fight for modern freedom. It is understandable, then, that the characteristic of American society most prized by the artist is the freedom of expression which, for whatever reasons, it offers. Naturally it is the immigrant who most appreciates democracy. Hofmann considers modern art and democracy as closely related: "It is the privilege of a democracy like ours that it expects the artist to be, through his art, the personification of its fundamental principles in being the highest example of spiritual freedom in his performance of unconditioned, unrestricted creativeness."[15] In a passing phrase, de Kooning speaks of

his convictions and of forcing his opinions on the world, adding, "I have this right—particularly in this country—and I think it is wonderful." [16] Tobey's specific remarks about America, excepting his general attacks on materialism, are also positive. They deal with its power, its size, and its dynamism—contributions, as we have seen, to the content and form of modern painting.

When one surveys the numbers of socially acceptable goals and standards which the artist rejects, realizing at the same time the traditional criteria of form, subject matter, and content which he has also abandoned, his renunciations seem almost monastic. "One of the most striking aspects of abstract art's appearance," Motherwell writes, "is her nakedness, an art stripped bare. How many rejections on the part of her artists! Whole worlds—the world of objects, the world of power and propaganda, the world of anecdotes, the world of fetishes and ancestor worship. One might almost legitimately receive the impression that abstract artists don't like anything but the act of painting." [17] But to see the austerity of abstract pictorial means only as a residue remaining after successive eliminations is negative; it is false because it ignores the positive additions of modern style. "Cultural phenomena," Rothschild has rightly said, "must be interpreted positively." [18] Nevertheless, there is an element of truth in such an argument. Ad Reinhardt, the most verbal (if ambiguous) defender of the purist view during the early fifties, cites common renunciations as one of the bonds between avant-garde artists: "We have cut out a great deal. We have eliminated the naturalistic, and among other things, the super-realistic and immediately political." [19] He argues later that "Pissarro took a purist view when he attacked commercialism, symbolism, etc.," thus defining the abstract painter as one who rejects anti-art and extra-art material in order to keep his art pure. [20] Defending immanent content rather than form—a view in great divergence from that of

Reinhardt—Rothko nonetheless agrees with the necessity for renunciation: "The familiar identity of things has to be pulverized in order to destroy the finite associations with which our society increasingly enshrouds every aspect of our environment." [21] The diverse connotations and implications of the purist attitude, which Rothko does not share, have been discussed elsewhere. Here the connection to be emphasized is that which exists between rejected social and moral values, on the one hand, and discarded traditional pictorial means and narrative representational subject matter, on the other.

To concentrate on the break between painters and their potential audience may seem negative. Are there no bonds of sympathy between them? In Motherwell's 1944 analysis, after asserting that the artist's first problem was with what to identify himself, he answers that none exist: "The argument of this lecture is that the materialism of the middle-class and the inertness of the working-class leave the modern artist without any vital connection to society save that of the *opposition*." For this reason the artist has had to "replace other social values with the strictly aesthetic." He postulates, as has already been noted, that the artist has a choice of only three possible attitudes toward society: to ignore it and seek eternal values; to support it by restricting himself to the decorative; or to oppose it, like Courbet and Daumier. [22] Since World War II the choice, though on occasion skirting dangerously close to the second alternative, has been the first. Whether the values sought by the "new" style are humanistic, metaphysical, expressionistic, or mystical, they have eschewed the topical, the local, and the particular. They have been articulated in terms of the immediate technical, psychological, and spiritual problems of creative expression.

Regarded as a historical document, Motherwell's essay on "The Modern Painter's World" is extremely enlightening as a partially intentional, partially unconscious explanation of the contradictory

relation between modern art and left-wing political movements. One of the most significant phenomena of the past ten or fifteen years, already mentioned as an aspect of the artist's humanist concern, is the disillusionment of artists and intellectuals with the world socialist movement in general and Soviet Russia in particular. The developments of the postwar years, both in art and in politics, throw new light on the relations the avant-garde has had with Marxism. The paradoxical transcendentalism and dialectical materialism of the Surrealist movement, for example, are only understandable in terms of certain basic attitudes of the modern artist which recent developments demonstrate with self-evident clarity. Artists instinctively resent systems which exploit human beings, ignore their right to self-fulfillment, or treat them as mechanical tools. Politically, by consequence, painters are liberals. At the same time, they have had only a negligible share in the material rewards of modern society, so that, though usually middle-class in their orientation, they have been have-nots economically. Their personal aims and beliefs have been toward a nonmaterialistic interpretation of reality based on intuition or feeling. Because of the resultant break with the mores of our culture, the artist has become on occasion the willing or unwilling associate of those, with the exception of criminals, whose values run counter to the accepted pattern.

In his often contradictory goals of subjective idealism and humanism, the modern artist during the twenties and thirties frequently tried to ignore the avowed materialism of the Marxist dialectic. Or he tried to convince himself, in sharp contradiction to his aesthetic—which, as John Dewey recognized, identifies means with ends—that dictatorial political methods could somehow contribute to the end of a creative social existence. The Surrealist movement, therefore, oscillated precariously between *sur-réalisme* and an anti-idealistic combination of economic determinism and Freudian theory. It is

hard to imagine any other conditions which could have produced the paradoxical personality of Herbert Read. In the light of these truths, as we can see them today, the optimism of a few lines in Motherwell's article gains a pathetic significance: "The socialist is to free the working-class from the domination of property, so that the spiritual can be possessed by all. The function of the artist is to make actual the spiritual, so that it is there to be possessed."[23]

The artist-society schism is not so pronounced as it was in 1944. Really sympathetic ties have formed between the spiritual underground and certain individuals and groups which distinguish themselves from society. These comprise the artist's public. In calling attention to them, it is necessary further to examine the artist's conception of his social status. Unlike that of members of accepted trades and professions, his economic and social position, when he has one, is ambiguous. Ad Reinhardt asks: "Exactly what is our involvement, our relation to the outside world?" In the same vein, Barnett Newman asks: "Are we involved in self-expression or in the world? . . . if you are involved in the world, you cannot be an artist. We are in the process of making the world, to a certain extent, in our own image. This removes us from the craft level." The dilemma of the artist's position is revealed by the undefinitive nature of the 1950 Studio 35 sessions. The ethic and the aesthetic of the painter require that his immediate personal reactions to existence be maintained and respected; it is these which condition his use of materials and tools. Yet, as a member of society who must live, eat, and be housed, he responds to social pressures that tend to classify his activity so that his position, like that of the stonemason or the banker, can be defined. Again, Reinhardt poses the question more specifically: "How many artists here consider themselves craftsmen or professionals? What is our relation to the social world?"[24]

Thus, through a series of questions, the paradox of modern art becomes apparent: the self-imposed responsibility to truth, to moral integrity, to "felt reality" is a motivation parallel to that of the reformer, the prophet, the revolutionary, or the philosopher. Technically, the problem of the painter is to image these convictions in a chosen medium. Although involved with the formation of physical materials, his aim, Hans Hofmann has shown, is by specific definition immaterial. As Motherwell says, "painting and sculpture are not skills, that can be taught in reference to pre-established criteria, . . . but a process whose content is *found*, subtle and deeply felt."[25] To insist, therefore, that the artist's products conform to a trade conception of "good craftsmanship," one which applies to bricklaying or the manufacture of clothing, is to ignore the aim of art in our period. "Technique," Hofmann explains, "is always the consequence of the dominating concept; with the change of concept, technique will change."[26]

The social category "professional" offers similar difficulties, however dignified may be its overtones: except in the most restricted technical sense, a skilled painter cannot be compared to a skilled surgeon, though any full-time artist properly resents the suggestion that he is an amateur. "We ought to have some level as a profession," de Kooning pleads, "some part of painting has to become professional." In continuing the problematical discussion, de Kooning proposes that one's professional status is not decided by oneself, but by society: "You can't call yourself 'professional' unless you have a license, such as an architect has. There are differences, we can make money without a license, but to call ourselves 'professionals,' we can't do that; you must be a 'professional' to someone else —not to yourself."[27]

The word can be regarded in other lights: James Brooks suggests that professionalism conveys the idea of a great deal of time spent on one activity;

to Barnett Newman it means "serious"; to David Smith, it is "just an attitude of mind." Fundamentally it indicates the seriously committed artist and separates him from the dilettante and amateur. In this sense all those dedicated to a formative, rather than profit-making, way of life are professional. "The thing that binds us together," Newman says, "is that we consider painting to be a profession in an 'ideal society.' "[28] Living in a culture whose standards are antithetical to his own, the artist acts according to the values of a social structure which is nonexistent, or which exists, in the most limited and imperfect way, only in the community of the mind that joins him with other modern artists in a defensive union. Since van Gogh, this social idealism has been an aspect of the artist's personality. Like the liberal, the clergyman, and the political radical, the artist has identified himself with those forces that have attempted to effect a change in the world. It is the artists' idealistic reformism which so often during the twentieth century has placed them in socially and politically compromising positions.

The impulsion to change the world, either actually or symbolically, seems a part of the artist's personality. Naturally his reaction to it varies. In the complex and changing present the problem it raises, that of commitment, is of especial significance. The question was discussed in April 1952 by a panel of artists and poets.[29] Agreeing that an artist must be "committed"—involved with his whole being—they centered the discussion on exactly what it was to which the artist is, or should be, committed. Is he, or should he be, committed only to his art? Has he a responsibility to things outside? Even more challenging: What commitment should he have to ideas which take the side of other positive values against his art? In a summary of the problem the poet and critic Lionel Abel draws historical parallels: the proletarianism of Leo Tolstoy, the late conversion of Botticelli, the

rejection of the Antique for the Christian in trecento Italy which led Boccaccio to disown the *Decameron*. Abel notes that in 1928 André Breton and the Surrealists were close to the Communists, cites Breton's magazine *Le Surréalisme au service de la Revolution,* and states that during the twenties the French Surrealists sold *L'Humanité* Sunday mornings on Paris streetcorners.

In the United States the memory of the WPA projects serves as the object lesson against extra-art commitment. The conflict between modern form and proletarian content was at that time so great as to isolate and alienate those artists who resisted the compulsion to Social Realism which, in retaliation, Gorky called "poor art for poor people."[30]

The rejection of modern form by Soviet Russia in 1922 and the consequent anti-formalism of left-wing aesthetic theory acted as a compromising influence on painting. It was the final postwar disillusion with the left which freed the humanist-minded painter from any tendency toward propaganda illustration. For the time being, the liberation of American painting from politics is now virtually complete. It is significant, however, that this is much less true of Europe. Although he was rejected by the Communists, the *engagement* of Jean Paul Sartre bore a certain resemblance to the attitude of the WPA realist. Picasso is willing to accept the contradiction of his artistic and political positions, and the pro-Communist magazine *Arts de France* (which ceased publication in 1951) reproduced paintings startlingly similar to the Social Realism of the American thirties. Abel explains this difference by the immediate state of crisis in European society. Where Europe is unsure of social structure, he argues, America is unsure of art. This, in fact, is the tone on which the discussion ended: the critical issue in America is the existence of art itself.

The broader question of commitment is more than one of political theory. The artist today is not a follower of any political movement. His disillusion with the political left has not only separated him from it, but instilled in him a distinct distaste for any strong political identification. His essential extra-art commitment is to the primary human responses to life. The change which has taken place is not so much in the end as it is in the means. The old slogans of socialism, the romantic martyrdom of the Spanish Civil War volunteers, and the idea of painting as propaganda no longer hold the promise of a brighter future. Though the artist has not lost his belief in man, nor abandoned his interest in progressive society, other methods must be employed. As the poet and critic Edwin Denby remarks, "there are other means than politics of changing the social structure."

The key point of the discussion is summed up thus: "Today, the real commitment is *non-commitment . . .* an active resistance of propaganda by *not* joining." By refusing to identify himself with materialistic and inflated values, by rejecting money-grubbing and the world of gadgets, the artist asserts, in the strongest way he is able, his belief in life, man, and the importance of art. The commitment to art is expressed in the belief that the beautiful, the good, and the true are one, and that art aspires to the point at which they meet. When asked how commitment could achieve this end, Abel answers: "It may not achieve it. But it is from such aspiration that commitment arises."[31]

Ultimately the concept which emerges from these ideas is that it is the creative experience itself which must change society. Hofmann wrote during World War II: "It is through the constructive forces of creative art and human development that a better world will evolve." In the fullest sense, this is a faith; it has no need for dialectic, which it might even find repugnant. Nevertheless, the belief in the formative power of creative activity is related to the historical sense of the artist. "We are connected

with our own age," Hofmann says, "if we recognize ourselves in relation to outside events; and we have grasped its spirit when we influence the future."[32] Tobey would agree, I believe, that art has in it the power of social change, but in a lecture to a Bahai gathering he reverses cause and effect: "When we again have social integration, then we will have art like never before."[33]

In 1952 a somewhat petulant article on modern criticism called attention to the fact that "avant-garde painting has today a large, articulate, and intelligent group of ardent supporters."[34] Questioned by me concerning the present position of the spiritual underground, Motherwell answered, with a touch of irony: "it has become professional." This group, the artist's closest public (save other artists), is composed of critics, historians, reviewers, teachers of art, gallery operators, amateur painters, and those laymen who, for one reason or another, visit contemporary exhibitions, follow the 57th Street shows, and read the critical journals. This last group includes the sincere collector: the patron wealthy enough to express his sympathy and understanding by purchases, but who buys, not simply for prestige or investment, but for love, and as an extension of his acquaintance with the culture and meaning of modern art. Relations between the artist and this inner society are complex, sometimes warm, but often strained or even hostile.

The rapport between an ideal spectator and a work of art is of course not a sociological question; it is psychological and aesthetic. To some extent this observer must himself be an artist. "The difference between the layman who understands art and the man who creates art," according to Hofmann, "is that the layman, or the critic, out of receptive experience, shares passively what the artist, out of productive experience, feels and creates."[35] David Smith takes a more extreme view, insisting that only artists truly understand art, that to follow its

path one must be a visionary. "The philistines," those whose lives are not involved with creative experience, can never know the arts.[36]

When the artist paints, no question of public reaction to his work must enter his mind: on this there is unanimous agreement. For the man who works for a "market," the serious artist has only contempt. While painting, the only responsibility he recognizes is to his concept, his feeling, and his form. Yet, cavalier as the painter's attitude may be toward demands for communication, which Clyfford Still considers "both presumptuous and irrelevant," his need for an audience is obvious.[37] Although "the artist is not concerned with communication while he is in action . . . after he is through," Tobey says, "he likes to feel there is a communication from his work. In other words, he is pleased if someone is moved or gets something from it. How can he not be?"[38] Something of the ambivalence of the artist's position can be seen in another remark of Tobey's quoted by *Time* magazine: "I can't understand doctors and lawyers . . . [so] why the hell should anyone understand me?" Again in an interview: "If I don't wish to speak to society, I divorce myself from society."[39]

It is not the responsibility of the painter to explain his works. His impatience with the demands of puzzled laymen, if not entirely justified, is at least understandable. Even Hofmann, who has spent his life in teaching, feels, as a painter: "No explanations for those who don't understand; some day the philistines will see!"[40] Yet he fully realizes that some training, some contact with the world of art, is essential to a sympathetic understanding, that "unless the observer is trained to a certain degree in the artistic idiom, he is apt to search for things which have little to do with the aesthetic content of a picture."[41] Still, he places the responsibility squarely on the spectator: "If you do not un-

derstand a man who speaks a language you do not speak, is this therefore proof that the man babbles only nonsense? Would anyone seriously state that a Beethoven symphony or a Bach sonata is generally appreciated?"[42]

The painter's real communication, Motherwell believes, is with himself. "Painting is his thought's medium. Others are able to participate in this communion to the degree that they are spiritual. But for the painter to communicate with all, *in their own terms*, is for him to take on their character, not his own."[43] Such is the attitude in the studio. Later, when his works, as it were, separate themselves from him, becoming independent objects, nothing is lost by considering the manner in which they can best find their proper audience. The primary meeting ground of artist and public is the exhibition. Hypothetically this situation is wordless. The communication is direct, in the medium of paint. But fortunately or unfortunately, criticism, discussion, evaluation, and selection do surround the exhibition of pictures. The sculptor Herbert Ferber asserts, during the 1950 discussion, that "the public really is asking all the time 'What does this work mean?' . . . What I am asking is that we should adopt an attitude of either discarding the question or trying to answer it." Later he adds, "The public, the museums and the artists themselves are involved in the question of 'meaning.'"[44] It is understandable that no group of artists could adopt a general attitude toward such questions. Nonetheless, despite expressions of resentment over the need for explanation, the artist continues in one way or another to utilize words as well as paint as a means to find a meeting between his work and the public.

The question of the relation of words to painting, that of verbalization, is a perennial topic of discussion between artists and critics. The problem is not merely a professional one. Consciousness of the weaknesses, the powers, the dangers, and the limitations of words is typical of our period. "This is the age of words," Tobey writes, "and the age of the fear of words."[45] The problem of verbalization concerns the discrepancy between the richness, subjectivity, uniqueness, and ambiguity of experience, and the emasculating and distorting effects of expository formulation. De Kooning recognizes the breadth of the tension when he haltingly remarks: "although it is said that painters cannot express themselves in words . . . cannot express themselves except in their own medium . . . there is a split between the word and . . . everything else is that way too."[46] Asked what he could say of his own art, Tobey replies: "this is the hardest question of all. You cannot describe art by words; you can only approach a description."[47] Richard Pousette-Dart says he can explain nothing about his painting, "just as I can't explain anything about a flower or a child . . . I can't discuss things about my paintings. The true thing I am after goes on and on and I never can completely grasp it."[48] Hofmann touches on the question in talking about his teaching: "I must account for every line, shape and color. One is forced to give an explanation of the inexplicable!"[49] In a discussion with artists James Johnson Sweeney states a similar view from a critic's standpoint: "You cannot help people to understand painting in an easy way. It is necessary to experience it. You cannot approach painting by the book."[50]

Each of these men, I am sure, would agree on the necessity and desirability of verbalization among painters, students, and specialists, even though they would object to explanations directed toward a casual audience. "The first man who began to speak," de Kooning writes, "whoever he was, must have intended it. For surely it is talking that has put 'Art' into painting. Nothing is positive about art except that it is a word . . . We are not yet living in a world where everything is self-evident. It is very interesting to notice that a lot of people

who want to take the talking out of painting, for instance, do nothing else but talk about it. That is no contradiction, however. The art in it is the forever mute part you can talk about forever." On another occasion he agrees on the need for verbalization: "We . . . cannot concern ourselves with painting without the word."[51]

As soon as the artist exhibits his pictures, he must, to some degree, declare himself regarding verbalization. He must either title, or refuse to title, his picture, or resort to numbers as identification. Titling can be a confusing problem; it constituted one of the major questions during the 1950 discussions. Of the approximately twenty participants in that day's session, all but three, who numbered their works, indicated their use of verbal titles. But there was little agreement concerning the relationship which a title should have to a painting. Not only does it vary from artist to artist, but between individual works by the same man. In one case the title may rise as an integral part of an idea, as in the sculpture of Richard Lippold, who from the beginning has "a title which labels that experience." In another view, that of Baziotes, "one can begin a picture and carry it through and stop it and do nothing about the title at all." Here the difficulty is increased, for one is forced to find an exhibition label for a nameless experience. In the former case word and experience are parallel, arise together, and titling is an organic part of the creative process. Of the twenty or so artists polled by Alfred Barr, thirteen answered that they named their works after they were completed.[52]

What should one expect of a name for a painting? Is it possible, as Moderator Barr, the only nonartist taking part in this discussion, asks, "to enrich the painting by words?" There are different answers. Lippold is alone in having a title before he begins. To de Kooning, the matter must not be rigidly formulated. He feels, in fact, that if an artist can always title his pictures, "that means he is not

always very clear" and implies again that this kind of uniformity indicates a lack of real experience: "If you really express the world, those things eventually will turn out more or less good." To James Brooks and Ibram Lassaw a title is merely an identification, like the name of a steamship.[53]

To the majority of the artists the title is a word or a phrase linked to the work of art or its periphery in experience. It may indicate an emotional tone, as in Gorky's sanguine *Agony,* although to specify the type of feeling which conditions a work is more psychologically revealing than many artists wish to be. In Hedda Sterne's words: "It seems too intimate to give them a subjective title." Barr was particularly interested in the title as a revelation of the emotion—grief, joy, or fear—which conditions a work of art. But the emotion that goes into a painting, Brooks remarks, can be a "very ambiguous thing."[54] More objective, the title indicates a source of, or an association with, the emotional tone, as in Motherwell's Spanish Elegies. Beginning with the first of the series, *Spanish Prison (Window),* they bear the names of Spanish cities or phrases associated with ceremonies of death. *At Five in the Afternoon,* for example, occurs as a repeated line in Federico García Lorca's *La Cogida y la Muerte,* a poem about death in the bullring. In these titles, whether or not the spectator can share the artist's association with Spain, aspects of the initial content are indicated, and he is given a valuable clue to the original experience.

Tobey's titles—*Pacific Transition, City Radiance, Canal of Cultures, Gothic*—clearly indicate the directions of his thought. Hofmann's vary. Sometimes they indicate the motif: *Seated Woman, Still Life,* or *Figure Painting;* again they identify associational images: *The Circus* or *Animals in Paradise;* some are named from formal qualities: *Push and Pull* or *Palimpsest;* and some by the feelings which their nonobjective content elicits: *Delight, Aggressive,* or *Cataclysm.* De Kooning's titles are simple—*Collage,*

Figure, Woman (in this case a title for a whole se-
ries)—or they associate pictorial form with a paral-
lel in nature, sometimes chosen with the help of
friends: *The Mailbox* or *Excavation.*

Rothko's attitude toward titling has altered with
his development. During the thirties he used simple
labels: *Entrance to Subway* and *The Party* were ex-
hibited in 1940. During the forties he was one of
the first among the New York painters to make use
of the universalizing overtone of mythological refer-
ences. *The Omen of the Eagle, Processional,* and
Archaic Idol all lead away from the restrictions of
mundane life to universal symbolism. *The Syrian
Bull,* he wrote in the joint letter to the *New York
Times* (1943) already quoted, is "a new interpreta-
tion of an archaic image, involving unprecedented
distortions. Since art is timeless, the significant ren-
dition of a symbol, no matter how archaic, has as
full validity today as the archaic symbol had then."
The statement continues with contempt for "easy
program notes," which cannot explain the paint-
ings: "Their explanation must come out of a con-
summated experience between picture and on-
looker."[55] Rothko no longer titles his work.

Alfred Barr summarizes the problem of titles in
terms of three levels: those which are a mere matter
of convenience; those which act as explanations, or
as a "kind of finger-point"; and the "surrealist
title." Following an unresolved discussion, he says
of the second level: they "do not work particularly
well." A few painters like Clyfford Still sidestep the
question by calling all of the works in an exhibition
simply *Painting;* others avoid it by the use of num-
bers and dates. "If we could agree on numbers it
would be a tremendous thing," Richard Pousette-
Dart says. "In music they don't have this dilemma.
It would force people to just look at the object and
try to find their own experience." Jackson Pollock,
Mark Rothko, Ad Reinhardt, and Bradley Walker
Tomlin have employed this device, but others, with
the sculptor David Hare, feel that the use of num-

bers is a "refusal to accept responsibility." To Her-
bert Ferber, "Numbering the piece is an admission
or a statement or a manifesto that this is pure
painting or sculpture—that it stands by itself with-
out relations to any other discipline. We should not
cut ourselves off from this great rich world."

The Surrealist title, except among its early advo-
cates, has almost become extinct since the decline
of the official movement. It functions with the
work of art by setting up, in Barr's words, "an at-
traction or conflict . . . between the words and
the picture." Gorky's titles, some worked out in
collaboration with André Breton, the leader of the
Surrealist movement, function in this way: *The
Liver is the Cock's Comb; How My Mother's Em-
broidered Apron Unfolds in My Life; Good After-
noon, Mrs. Lincoln;* and *Diary of a Seducer.* They
have an evocative and rich, if not obvious, relation
to Gorky's ideas.

It is to a superficial use of this type that Rein-
hardt alludes when he objects to titles which are
"false and tricky" or add something "that the
painting itself does not have." "If a title does not
mean anything and creates a misunderstanding," he
asks, "why put a title on a painting?" For this rea-
son, and because many paintings do not have a
specific reference or association so that titles "don't
have anything to do with the painting itself," they
are rejected by many modern painters.

The titling problem has a historical, as well as an
aesthetic and personal aspect. "An Assumption or
Crucifixion," Ferber remarks, "needed no title."[56]
With the absence of literary, narrative, and mimetic
subject matter, however, the point of reference
changes, and, in the purest works, vanishes. Yet
even Mondrian found meaningful connections: the
title *Broadway Boogie Woogie* is a real enrichment
of the work.

There is no reason why the titling problem, like
many of the other issues of modern painting,
should be settled one way or the other. The ques-

tion has been given attention here as additional evidence of the serious concern which artists give to the aesthetics, psychology, and ethics of what might seem to be a minor problem. The most telling weakness of verbal titles is their tendency to point, often far too precisely, toward one limited aspect of a work, preventing the spectator from discovering his own personalized interpretations. Unless the meaning is evocative and veiled, as in Gorky's titles, or masterfully denotative, as in those of Paul Klee, words can short-circuit a direct experience of the visual image.

The titling question is but one phase of that of verbalization. The real point of disagreement here lies, not so much in the question of the validity of writing and talking about painting, but in that of just what kinds of discourse are most pertinent and enriching: Does the detailed, objectively accurate research of the scholar, or the individualistic and subjective, but vital, interpretation of the critic-poet most illumine the object? Again the distinction is between feeling and intellect. Nicolas Calas compares Baudelaire's interpretation of Delacroix to the scholar Meyer Schapiro's analysis of van Gogh. He concludes that after reading Schapiro, one understands van Gogh better than one does Delacroix after reading Baudelaire, but that after reading the poet one is excited and inspired to look at pictures, whereas Schapiro leaves one without interest in the paintings. The avant-garde painter, however, often has a keen developmental sense; he is therefore not necessarily unsympathetic to a historical point of view. In general his main objection to the art historian, the critic, or the theorizing of museum directors and professors is their tendency to divide artists, styles, and schools into categories designed to simplify the complexity of modern art. In the process of an artist-critic-historian discussion the moderator, Harold Rosenberg, remarks: "This seems to be the old situation where the critic tries to round up the painters [into categories] and the painter tries to get out."[57] Most painters agree with critic Sweeney who objects to the "pigeonhole approach"; he dislikes tight categories like abstract, classical, and romantic, feeling that they overlap and mix. And often an artist is angry at being labeled, so that one complains that "the titles a painter gives his paintings help to classify him, and this is wrong."[58]

Earlier in the century groups frequently were eager, in the interest of solidarity and the dramatization of their programs, to rally behind a label, but when Barr encourages the Abstract Expressionists to agree on a name "for which we can blame the artists—for once in history!" the response is not enthusiastic. Though one painter feels "we should have a name through the years," David Smith's reaction, that "names are usually given to groups by people who don't understand them or don't like them," is the more accepted view. The transcript of the 1950 sessions at Studio 35 concludes on a note characteristically set by de Kooning: "It is disastrous to name ourselves."[59]

8 The Historical Position of Abstract Expressionism

Measured by the changing form and content of art, time passes with astonishing rapidity. Epochal reorientations have repeatedly been inaugurated and articulated under the very noses of sensitive and accredited observers, and passed with their significance unrecognized. Save for the heightened historical consciousness of the present phase of art criticism and history—which may, on the contrary, overvalue events that are transitory—the years since the last World War could comprise just such a period.

It was with a sense of the importance of what was taking place in American art during the postwar decade that this study of its values was undertaken. Concentration on six painters of the School of New York was not an original intention, but the outcome of a search for constituent forms and ideas. The choice of this group has not been regretted. Augmented where necessary, and bracketed by references to Pollock's automatism and Mondrian's New York style, their works and convictions have served to pinpoint fundamental principles of modern painting in America.

"Abstract Expressionism" is nothing more than a label. No group of painters has officially chosen it as a banner around which to rally—though its combination of terms derived from the two most significant lines of modern form development is at least indicative of the synthesis of styles and viewpoints which has taken place. But, recognizing that Abstract Expressionism is not a "thing," an organized movement, or a local school, but an adjectival characterization of the forties and fifties, one must question the application of any single phrase, whatever it might be, to so wide a range of activity. The six painters we have studied differ widely, not only in their unmistakably personal styles, but in important aspects of their thinking. What do they, and hundreds of other contemporary painters of America and Europe, have in common?

The first, and perhaps foremost, item in what

must be a composite answer lies in what may be called a "monadic" aesthetic: a thorough interrelation and mutual identification of pictorial means, technique, content, subject matter, personal attitude, and ethics. As a designation of the nature of this cohesion, however, the term monadic is misleading, for the union is composed of variable parts reacting on each other in yin-yang relationships. Within this interrelatedness, which has resulted from the combination of a high degree of abstraction with a rejection of both imitation and formalism, only one organic division (also reciprocal) can be made: that between the physical fact of the work of art and its total aura of ideas, intuitions, convictions, beliefs, and feelings, which are nonmaterial. They can best be described as content, or spirit. The perceptual reality of the work of art, at once a quality of the object, the artist, and the spectator, mediates and binds together the material and the spiritual. With these qualifications, the characteristics of form and spirit can be listed.

Form Characteristics

1. *Simultaneity of Abstraction and Subject.* A high value is set on content; consequently, separation of nonobjective from representational art is rejected. The most challenging problem of Abstract Expressionism has therefore been the reconciliation of human and natural themes with abstract means.

2. *Assertion of the Picture Plane.* This basic principle necessitates a series of adjustments and pictorial treatments: flat shapes, limitation of recession, equivalence, and so on. Some works, such as those of Clyfford Still, keep a surface tension or "skin" like that of a body of water, though more common is a flatness-in-depth which varies from Motherwell's objective overlap to Tobey's impressionistic vibration, de Kooning's flat landscape, or Hofmann's (and Marin's) deep push-and-pull.

3. *Activism and Tension.* It can be implemented in many ways: as human gesture embodied in

paint; as a recreation of the process of growth, dissolution, or decay in nature; or as a direct result of the natural qualities of the medium. It is carried to its extreme in automatism, improvisation, and accidentalism. Activism cannot be contained as a form principle, for as space-flatness tension or the perceptual interactivity of color it becomes relational and subjective.

4. *Incompleteness.* A work completes itself only in the experience of the spectator. The late works of Mondrian or the constructions of Richard Lippold, though precisely and geometrically finished, demonstrate this principle: the former presupposes perceptual alteration, and The Museum of Modern Art's *Variation Number 7: Full Moon*, characteristic of the latter, is incomplete without the dissolving effect of light emanating from its center.

5. *Relativity.* The elements of a work of art are not autonomous, although each contributes to the total configuration. Every addition, alteration, or removal of any one element affects others and changes the nature and quality of the unity.

6. *The Painting as Object.* This is the opposite of the painting as a picture-window or stage, opening on an illusion of the actual world. Often unframed, the work can project into the room.

7. *Structure.* A work of art is a "thing" in that it is a structure, with its own internal relations which can stand autonomously, independent of any connection with the outside world.

Spirit Characteristics

1. *Organicism.* The highest possible regard, sometimes amounting to deification, of the creative powers of both man and nature; hence the emphasis on process rather than completion. It is closely related in spirit to Henri Bergson's élan vital, John Dewey's "art as experience," A. N. Whitehead's "process," and Paul Klee's naturalism.

2. *Humanism.* The identification with human desires, needs, emotions, and aspirations—both the inner states of the self, and the universalizing link with "man" which they afford.

3. *Naturalism.* Concern for the structural principles, essential forms, and processes of nature.

4. *Centrality.* The impulsion toward intuitively or subjectively apprehended truths that appear to lie at some universal meeting place.

5. *Inclusiveness.* A need, always in tension with the centripetal urge, to encompass the opposed poles of multiple dualisms within an inclusive unity.

6. *Indeterminism.* Faith in intuition, inspiration, the unconscious, the unknown, and an associated taste for ambiguity, vagueness, and mystery. Unlike that of certain romanticisms, however, the ultimate goal involves focus, clarity, and the conviction of reality—but one which cannot be achieved through formulated or determined systems, which are devitalizing.

7. *Truth.* Though close to reality as a concept, truth can be considered a door through which reality can be reached. It is found by faith in, and attention to, "felt" reality—to the total world of experiences as apprehended by the psyche.

8. *Reality.* Art is a quest for reality and truth as subjectively apprehended and created. It excludes, therefore, indulgence in the mysterious or the unknown for their own sakes, and eliminates beauty (or ugliness) as a goal of art. Differing (but related) realities are those of the picture's physical existence, the truth of immediate perceptual and emotional responses, and the transcendental reality which begins to approach a mystical dissolution of the ego.

9. *The Absolute.* This focus of various realities, the Reality of Realities is the unknown center point which must lie behind a work, but which cannot be approached too closely without petrifying vital reciprocation or voiding the work of art as such.

10. *Commitment.* This is the ethical imperative of devotion to truth, the integrity of art, and its

freedom from commitments to politics, commercialism, social position, material success, utilitarianism, hedonism, and so on.

Origins

However unprecedented they first appear, the forms and ideas of art seldom are without origins in the past. Abstract Expressionism is both radical and traditional. In questioning its sources, the division between spirit and form is essential, because the two do not necessarily follow the same paths. Modern art in America has developed through a cultural interplay between a native realism, either literalistic or romantic, and the innovations of the great European artists by whom the various national or international traditions were formed. Abstraction and expressionism have advanced or receded, it has been said, in waves. The first of these followed the revolution in subject of the group known as The Eight. But the new revolution involved form rather than subject matter, and it had its origins in France rather than the United States. It was given impetus by John Marin, Max Weber, Alfred H. Maurer, and other artists who returned home after studying and working in Europe between 1909 and 1914.[1] This early wave of American modern art was vastly accelerated by the Armory Show, but during the international trend toward conservatism that followed the end of the First World War it gave place to a resurgence of native realism. Weber, Hartley, Bernard Karfiol, Henry L. McFee, Andrew Dasburg, and others who had been modernists either abandoned or qualified their abstract styles—partially, as John I. H. Baur says, because "they discovered that subject was still necessary to them, that the moods of nature, the character of things and men, the sensuous appeal of the human body were still the mainsprings of their art even though they found in modernism fresher and more effective ways to embody their feeling for

these."[2] Andrew C. Ritchie sees two waves of abstract art, Baur three.[3]

The American careers of Hofmann, Gorky, and de Kooning were a part of the wave which continued slowly, underground, in the twenties, survived the realism of the thirties, and reached tidal proportions in the forties. By 1950, for the first time in American history, the realists had become the minority and the avant-garde the majority, at least as far as the professional world of exhibitions, publications, and criticism was concerned.

Scanning this phenomenon with the broadest possible historical perspective, let us note some of the influences which have been increasingly brought to bear on American painters through museums, teaching, publications, travel, and personal contact. They include the entire tradition of Western art. The first, with its roots in Antiquity, the Italian Renaissance, and the academies, could be considered classical. It features Poussin and David, emphasizing sculptural bulks and structural horizontals and verticals. After Neo-Classicism it tends to split into two lines, one sculptural and the other architectural. The latter, reinforced by the early Roman landscapes of Corot, is synthesized with Impressionism in the great painting of Cézanne and provides the substructure of abstract art. Classicism of bulk was fused with Impressionism by Renoir. For reasons which have been examined in some detail, this sculptural inheritance has not fit modern form as well as has the architectural tradition which continues through Seurat and Cubism.

The second tradition—painterly, romantic, and implicitly expressionist—can be found in the Venetian painters, in the arguments of the Rubenists of the French Academy, and in Delacroix and Daumier. It is the tradition of gesture and rough or volatile painting, open form rather than closed. It can be said to include Constable and Turner as well as the French. The third trend is that of realism. Generalized in Millet, physical and nominalis-

tic in Courbet, elegant and ironic in Manet, it provided the bedrock on which the perceptual reality of Impressionism, the synthesis of Cézanne, and ultimately the metaphysical reality of Cubism, Mondrian, and Kandinsky could build.

Tendencies in the art of Rembrandt and Michelangelo notwithstanding, expressionism, that art stemming directly from the predicament of a single human being, cannot be said to have existed before van Gogh. The organicism of his brush was in the direct painterly line of Romanticism and Impressionism, but the content was new.

Structural and sculptural classicism, metaphysical or pictorial realism, romanticism, and expressionism were, in barest outline, the tendencies which formed the art of France at the turn of the century. Paris was a great art center not only because France produced great painters but because it was a milieu within which the richest traditions of the West could merge. Here was the environment, dominated by the genius of Picasso, Matisse, and Braque, within which Hofmann, Alfred H. Maurer, Max Weber, Arthur B. Carles, Charles Demuth, Stanton Macdonald-Wright, Morgan Russell, and John Marin (though he did not absorb it until he returned from Europe) gained firsthand knowledge of modern art. This was the core of the modern tradition which American painters had been following at a distance since the Barbizon School. But as more and more Americans not only studied in Europe but lived there for extended periods, and as mediums of transportation and cultural exchange became faster and better, the lag which separated European innovations and their establishment in America became shorter, and the degree to which they were altered and misunderstood once they arrived was lessened.

The foregoing purports not to be an outline history of modern art but to call attention to the almost exclusively European origins of the form

characteristics listed above. There seems to be no tie whatever to a native tradition. Indeed, an American tradition of art can hardly be said to exist, in the European sense of a succession of stocktakings, revisions, revolutions, and syntheses which progressively establish new premises. The American realist and romantic strains have been kept alive by men like George Bellows, John Sloan, Eugene Speicher, Edward Hopper, Rockwell Kent, Leon Kroll, Peter Hurd, and by uncompromising conservatives.

Though the puritanism of America's early portraitists geometrized the lush curves of the Vandyke style, and though George Caleb Bingham's raftsmen are magnificently Poussinesque, and despite the collage of William Harnett and John Peto, one cannot trace a continuing native structuralism. There was one painter, Albert Pinkham Ryder, who can in retrospect be called an expressionist, and even abstract. Ryder rebelled against detailed realism; he discarded brushes for a knife with which he could work up pigment for its own sake. He drew his content simultaneously from memory, inner visions, and a generalized nature; he lived and meditated in Manhattan during the change in centuries, unmindful of the litter piled up in his rooms on 15th Street. Not only was Ryder more pointedly subjective than any American romantic save John Quidor—who was "discovered" by Surrealism—and Ralph Blakelock, and not only did he manipulate pigment for itself, he was by all odds the most abstract American painter of the late nineteenth century. He shaped and reshaped relational flat areas on a heavily painted and repainted surface. The fundamental elements of Abstract Expressionism are all implicit: picture plane, active and personal use of the medium for itself, unfinish, relational use of flat shapes, and abstract naturalism. It is no wonder that Hans Hofmann and Jackson Pollock find Ryder the only nineteenth-century American artist with whom they feel kinship.[4]

Abstract Expressionism throws new light on James M. Whistler, too. In his Nocturnes, some of which date to the 1860s, Whistler preceded Impressionism in representing an essentialized nature, purified pictorial relations, structure, and mood. But, like Benjamin West and the Synchromists, he was an expatriate. Tobey feels a kinship with Whistler. His singular biography establishes a connection between America's past and present which might have been overlooked. The expansion of his love of the superficial handling of commercial artists, to include the work of Sargent, Sorolla, Hals, and finally—with parallels in both form and spirit —the calligraphic art of the Chinese, calls for another look at the means of Robert Henri, John Sloan, and George Luks. Since the chinoiserie of the eighteenth century, many varieties of Orientalism have appeared in Western painting. The Japanese print stimulated interest in flatness, gesture, and representational freedom for virtually all of the French masters from Manet to Toulouse-Lautrec; the calligraphy of van Gogh, and perhaps even that of Cézanne, shows its influence. There were unfulfilled impulses in this direction during this century in America as well, but not until Tobey's embracing world view of the forties did a painter put forward the full aesthetic significance of America's geographical position:

Our ground today is not so much the national or the regional ground as it is the understanding of this single earth. The earth has been round for some time now, but not in man's relations to man nor in the understanding of the arts of each as a part of that roundness. As usual we have occupied ourselves too much with the outer, the objective, at the expense of the inner world wherein the true roundness lies.

Naturally, there has been some consciousness of this for a very long time, but only now does the challenge to make the earth one place become so necessarily apparent. Ours is a universal time and the significances of such a

time all point to the need for the universalizing of the consciousness and the conscience of man. It is in the awareness of this that our future depends unless we are to sink into a universal dark age.

America more than any other country is placed geographically to lead in this understanding, and if from past methods of behavior she has constantly looked toward Europe, today she must assume her position, Janus-faced, toward Asia, for in not too long a time the waves of the Orient shall wash heavily upon her shores.

All this is deeply related with her growth in the arts, particularly upon the Pacific slopes. Of this I am aware. Naturally my work will reflect such a condition and so it is not surprising to me when an Oriental responds to a painting of mine as well as an American or a European.[5]

Hofmann spent ten years, beginning when he was twenty-four years old, in the Paris of Fauvism and Cubism. He knew Picasso, Braque, Delaunay, and Matisse and became friendly with the American Arthur B. Carles, whose work of the twenties and thirties is so prophetic of that of the next decades. But Hofmann's early works are not nearly so radical as those of Weber, Maurer, Macdonald-Wright, or Russell. With the format compressed by Cubist precedent, they powerfully, but rather conservatively, synthesize the discoveries of Cézanne with the flatness and color of Matisse. But when Hofmann came to America for a summer's teaching at the University of California in 1930, our second wave of abstract art was already under way, and as a well-known teacher of modern style, he did not arrive unannounced. Sheldon Cheney, in *A Primer of Modern Art* (first edition, 1924), summarized some of Hofmann's theories and gave pointed emphasis to German art, arguing that "students can probably learn more at the moment from Hofmann of Munich or from the 'masters' at Dessau than in any art school in Paris."[6] In retrospect, Cheney's taste was singularly "Abstract Expressionist." He believed deeply in contemporary form, and his *Ex-*

pressionism in Art (1934; rev. ed. 1948) includes the first broadly disseminated explanation of Hofmann's theories. But he rejected Dada, dismissed Futurism, "because it ended by being merely *illustration of movement*,"[7] and tended to ignore the representational wing of Surrealism. The names Kasimir Malevich and Piet Mondrian do not appear in either book. As a result, Cheney's first selection of modern painters included all of the European masters who combined structure, naturalism, and brush, the foremost American precursors of Abstract Expressionism, and Thomas Wilfred, whose light-creations call to mind the early works of Kandinsky or the late works of Turner.

Conceiving Abstract Expressionism in terms of the form characteristics, must we necessarily see their expansion into all genres of American painting as proceeding in waves? The most important of the pioneers by this measure is John Marin, who, combining independence and an intuitive understanding of Cézanne and Cubism with his own Yankee brand of Dadaism, demonstrates such qualities before 1915. One has only to compare his watercolors of 1921 and 1951 (Figs. 286, 287) to see a continual development. Adamant in his insularity when threatened by the diversity around him, nevertheless—and despite his resentment of the New York group—he changed with their spirit, as have many other painters who speak of them with contempt or annoyance. What gave him the idea, while he was in the hospital a few years ago, that a hypodermic syringe would leave a "written line"?

Stuart Davis, like John Marin, was included in the Armory Show. With the Philadelphia illustrator's background of The Eight, and a great deal of their defiance, Davis developed a pugnacious modernism that was never dented by his political liberalism. But in his attitude and declared content he is at the farthest remove from Abstract Expressionism. He dogmatically cuts off Objective Art, and the painting as a Real Object, from the aura of

subjectivism which surrounds New York School works. And he bitterly quotes "Learned Proponents for Expressionism" who identify its content as "Psychic Discharge," and a "Belch from the Unconscious."[8] Davis was tough; throughout the thirties he battled for modern form, which he flatly denied was abstract. He pointed out to the New York artists the importance of the picture as a designed object, and he was idolized by Gorky for his understanding of the flat surface. Abstract painting of the thirties, however geometric it might have been, was the core of the development which later resulted in Abstract Expressionism because, though it was often static, it kept alive the idea of structure which the realists, the romantics, the propagandists, and most of the Surrealists forgot.

Like Marin and Davis, the pressures of social realism made not a scratch on the art of Gorky. A brooding Cézannist in 1925, Gorky by 1929 created picture-objects that are flat and hard. But the brush was never frozen, and the biomorphic shapes initiated by Arp's Dadaism and used in the twenties by Miró, Masson, Ernst, and even Picasso and Braque crept into Gorky's vocabulary almost immediately. Yet the fine drawings of the early thirties are not eclectic; whatever their origins, they are an abstract Surrealism that is inimitably Gorky's.

The American Abstract Artists, a society formed by G. L. K. Morris in 1937, was in the main geometric in its emphasis. Yet several of its members, among them George McNeil, Harry Bowden, Hananiah Harari, and Rupert Turnbull, were "organic" abstractionists. At the Art Students League, Vaclav Vytlacil's teaching methods paralleled those Hofmann used in New York and Provincetown, and students of Hofmann spread his influence at other centers. The WPA Design Laboratory, formed in 1935, taught shop techniques based on those of the Bauhaus at Dessau along with semiabstract drawing from the model. Through the Federal Art Projects hundreds of American artists were sus-

tained and given time and freedom to follow out form ideas. In 1935 the Whitney Museum of American Art held an exhibition of Abstract art in America which included, along with first-wave men, Byron Browne, Balcomb Greene, John Graham, Karl Knaths, I. Rice Pereira, Louis Schanker, Theodore Roszak, and Gorky. Roszak (now a leading Abstract Expressionist sculptor), Graham, Gorky, Lee Gatch, and others began to appear in the Whitney annual exhibitions. During the thirties lyrical, organic, Surrealist, or naturalist abstract painting, as well as purism, was growing.

The importance of open sculpture has been pointed out, especially in its relation to structure. David Smith was the key figure. He studied painting with John Sloan and Jan Matulka, a Munich Hofmann student, and made his living as a metalworker. But by 1932 he had seen the freely constructivist work of the Europeans Pablo Gargallo and Julio Gonzalez: here was "painting" in his own medium. Smith's first welded steel constructions were done in 1933, and "line sculpture" followed from 1934 to 1936. His first one-man show, under the sponsorship of Marian Willard, was held at the East River Gallery in 1938. Like Tobey, Smith perceived the relevance of Oriental brush to modern structural form. It is not accidental that the first calligraphic paintings of Tobey, the open sculpture of Smith, and Marian Willard's interest in the East coincided. Radiating largely from this nucleus, the precision of purist structure was reconciled with organicism.

The thirties were years of discovery, teaching, and influence. New York University's Museum of Living Art had been founded in 1927, and The Museum of Modern Art in 1929. Wassily Kandinsky's Abstract Expressionism could be seen, after 1937, in the Museum of Non-Objective Art founded by the Solomon R. Guggenheim Foundation. But the connection of New York to Europe was still provincial. *The Art Index* lists reviews of only five exhibitions of Kandinsky's work before 1938, and six of Paul Klee's, including that at The Museum of Modern Art in 1930. Works of the other painters of Der Blaue Reiter, and of Die Brücke, except for the Modern Museum's exhibition of German painting in 1931, were little known. Joan Miró and André Masson could be seen, however, at the Valentin and Pierre Matisse galleries; and in 1937 the Soutine boom began —fifteen years after the first purchases of Dr. Albert C. Barnes. No Piet Mondrian exhibitions are listed prior to 1939, the year before the master of de Stijl arrived from London.

How can the colossal impact of The Museum of Modern Art on painters be estimated? It was a center, a "cathedral" of art, if ever one existed, within which direct experience of the greatness of Cézanne, Gauguin, van Gogh, Picasso, Seurat, and Braque fired young men, most of them "uncultured" in the academic meaning of the word and defiant of middle-class respectability, to paint with modern forms. In the wake of the depression, with $23.86 to spend each week, money didn't matter; poor clothes served as an emblem of commitment. The masterpieces of modern art were available almost gratis with a special artist's card of membership—as were free movies at four o'clock! What the Museum meant to an out-of-town student can be found in a statement of the Boston expressionist Hyman Bloom, who, with his teacher Harold Zimmermann, visited it just after it had been opened. He saw the work of Rouault and Soutine: "It was a clarifying experience, and I began to imitate Rouault to Zimmermann's chagrin and [Denman] Ross' dismay. Ross couldn't stand Rouault or even Cézanne."[9]

The forties began on another level. First, through the Federal Art Projects, teaching, combined exhibition-publications like Alfred Barr's *Cubism and Abstract Art* and *Fantastic Art, Dada, Surrealism* (both 1936), the studies of Clive Bell, Roger Fry,

Sheldon Cheney, James Johnson Sweeney, James Thrall Soby, and others, and the expanding dissemination of reproductions, the knowledge of American painters had greatly increased. Second, excepting Picasso, Braque, and Matisse, who were already well known, a majority of the leading exponents of abstraction, expressionism, and Surrealism had made America their refuge from totalitarianism and war. During the thirties Joseph Albers, Lyonel Feininger, László Moholy-Nagy, Herbert Bayer, and other established artists had arrived; and between 1939 and 1942 Amédée Ozenfant, Stanley William Hayter, Fernand Léger, André Breton, Matta, Kurt Seligmann, Yves Tanguy, Max Ernst, Salvador Dali, André Masson, and Pavel Tchelitchew followed. New York became the scene of the same fermentation of abstraction and Surrealism which had marked Paris in the twenties and thirties, but with one important difference: in its very provincialism, in its separation from the ancient cultural traditions of Europe, New York was a melting pot. Intangible ingredients, which because of nationalistic jealousies and time-honored cultural prerogatives were excluded in Paris, could mix freely here, and the degrees of divergence could be greater. In loft studios, at openings in the rooms of new dealers in modern art, and in the apartments of patrons and patronesses, a cultural cross-fertilization took place which, if one adds the new Orientalism that is only now coming to its fullest development, is without historical precedent. New York City, multiplied and expanded throughout the United States by groups in California, Washington, and, at some scale, in almost every state of the Union, became the haven of the world's advanced artists, and therefore a confluence of the most vital tendencies of the century. It did not matter how contradictory the individual styles and doctrines were, what the nationality and cultural background of their authors might be, or, in the tension of war,

how extreme, outrageous, or precious they might at first appear.

The foregoing summary is limited to the barest sketch of the formal influences which played on the American scene during the thirties and early forties. To include such an outline of the spiritual conditioning on the same basis is impossible. "Each work of art," it has been said, "is a little incarnation." This is not a vague, quasi-theological aphorism, but a statement of technical fact. Pictorial images manifest a meeting of matter and spirit, and the invisible forces contained within them are so essential, yet so diverse and untouchable, that they cannot be outlined or systematized without impairing truth. Nor do they always follow the same cultural paths as the forms by which they are expressed.

In certain instances, however, form and spirit flow through a common channel. This is true of the influence of German Expressionism. It has been suggested that somehow, in complete contradiction to evident lines of development, the painting of de Kooning, Pollock, Gorky, and Motherwell was the outcome of tendencies initiated perhaps by Ernst Kirchner or Emil Nolde, and spread in America by George Grosz, Max Beckmann, and Karl Zerbe. Such a conclusion can only be the result of an extreme oversimplification of German art from 1904 until Hitler, a reduction of the idea of Expressionism to a caricature, and an abiding faith in terminology divorced from data. The influence of these artists, and Die Brücke, on the new Abstract Expressionism is nonexistent except perhaps for the example of ruthless intensity set by the brilliant Dadaist drawings of Grosz. By this false connection the amazing parallels which actually do exist, because of partially analogous cultural situations, are obliterated. Oversimplification does a disservice to German modern art as well as falsifying the origins of American art. The actual impact of the German

scene came almost solely through the "Abstract Expressionist" paintings of Kandinsky and Klee (and perhaps of Feininger), and from their translated writings. Klee's teaching methods and philosophy of art, as they are recorded in his *Pedagogical Sketchbook*, were first published in English in 1944; they are everything which the Bauhaus idea, as it appears to artists today, was not. Kandinsky's *On the Spiritual in Art* and *Point and Line to Plane* (first American translations 1946 and 1947 respectively) gave support for the attack on materialism, eulogized the spiritual, and provided a grammar of nonobjective forms and principles.[10] Through the work and writing of both artists came the idealism, Pantheism, Orientalism, and religious fervor which has marked the spirit of northern Europe for centuries, and modern German art ever since Kaspar David Friedrich and the Romantic poet-philosophers. In New York the metaphysics of Klee and Kandinsky could meet that of Tobey, Morris Graves, Kenneth Callahan, Clyfford Still, and Rothko. Klee's influence especially is one of spirit; for painters learned early, and sometimes disastrously, that his style defies borrowing. Yet, in miniature, almost every formal solution and technical innovation of modern art can be found in his watercolors and oils, and his aesthetics is at the core of the spirit characteristics listed above.

Earlier the romantic tradition was traced—but as form. Once Delacroix, Chassériau, Monticelli, Turner, Whistler, Redon, and perhaps Gauguin are singled out, great gaps are left, for the path of romanticism separates from that of painting. Beginning with the Gallic interpretations of Kant in the salon of Madame de Staël, it is passed on by sensibilities like those of Théophile Gautier, Charles Baudelaire, Jean Arthur Rimbaud, Stéphane Mallarmé, and Pierre Reverdy. It is at the same time idealistic, self-centered, mystical, and rebellious, uniting with painting in Baudelaire's support of

Delacroix and Courbet, the contact of Mallarmé's Symbolism with Gauguin and his following, and the *surréalisme* of Guillaume Apollinaire. Important to it also is the self-analysis of Kierkegaard and the development of the various psychologies and philosophies which sought to explain the modern crisis of personality. It erupts in the desperate antics of the Dadaists, and comes to a climax in André Breton and Surrealism.

The method of "psychic automatism," when it was defined by Breton in 1924, was first a psychological, and second a literary method. At its inception Surrealism was more a sociological, political, and psychological revolt against complacency, rationalism, and authoritarianism than anything else; and it was more literary than it was painterly or sculptural. Its organicism was a state of mind; its contradictory Marxism and idealism expressed the dilemma of sensitive men in a frightening world. It emphasized content over form, so that its conservative painters were content to illustrate with mannerized styles from the past, and to attack the formalism of the abstract painters. Both Salvador Dali and Joan Miró were comprehensively shown by The Museum of Modern Art in 1941, but Miró had the deeper influence.

After surveying some of the sources of postwar modern art, it is understandable that an isolationist legislator might see it as un-American, however little it has to do with communism. But in its spirit a great deal can be found that is native. At its worst, the American spirit is materialistic, self-satisfied, and overbearing. At its best, these qualities become practicality, confidence, determination, inventiveness, and a hardheaded refusal to accept cultish preciosity. Often they are fused with deep love of man and identification with nature. In the personality and architecture of Frank Lloyd Wright, the poetry of Whitman and Sandburg, and the novels of Faulkner and Hemingway, this spirit has been our

foremost contribution to international art and thought. Coupled with a pioneering romanticism and the dynamism of a machine culture, such traits, if they do not add up to a national personality, have undoubtedly colored our art, whatever its media or formal solutions have been. Looking at American realistic and romantic art from this viewpoint, one could find in Eakins and Homer the historical equivalent of Courbet: a realistic foundation; and in Allston, Cole, Quidor, Church, and Ryder our native love of the unknown.

John Marin's first show at Stieglitz's 291 gallery occurred in 1909, one year after the exhibition of The Eight, which as a group had by then already dissolved. But Marin shared their obstreperous vitality, and even their love of factuality. One only needs to realize the native Dada in his early letters and statements and to review the activities which centered around the father of the Dada spirit, Marcel Duchamp, to realize that New York did not need to inherit Dada from Zurich, Hanover, Cologne, Berlin, or Paris. Call it what you will, the dynamic atmosphere of New York has expressed and bred a nihilism close in many ways to Dadaism and even to Italian Futurism. As my discussion of the city as a subject tried to demonstrate, the tension and vitality of the world's most active metropolis has been a stimulant to the art of many European artists, among them Léger, Mondrian, and Beckmann. Though we do not find it as desirable a quality in our own daily psychic states as we do in art, here are contributory conditions toward the tension so characteristic of modern form.

Aspects of the spirit of Abstract Expressionism can also be found in quite a different phenomenon: that dramatized by André Malraux as the Museum without Walls, but expanded to include not only the artifacts of the world's cultures, civilized and primitive, but the growing record of philosophical interpretations, religions, and world views which offer the artist a multiplicity of ideological sources

without precedent. As Picasso turned to African sculpture for form, Tobey found content in a syncretistic religion of Near Eastern origin. During the forties Rothko found his own need for ubiquitous experience reflected in ancient myth, just as his friend Adolph Gottlieb found a form stimulation (as had Klee and Torres-García) in primitive pictographs. For thoughts of ascent Tobey and Feininger used Gothic forms, and mystically disposed artists now find food in Meister Eckhart and Zen Buddhism.

Thus, as the American painter has become more broadly cultured—and this phenomenon too is characteristic of Abstract Expressionism—his relationship to history has changed. His connection with it is no longer confined to what he can get from one master, school, or tradition. As his view has expanded, it has become less and less a result of temporal succession. History becomes a vast repository of ideas, forms, and feelings to be appropriated, altered, or montaged on the basis of one particular individual's felt reality.

It is difficult to realize just how little a painter needs, once an idea begins churning in his brain, to start a chain reaction. A detail of a piece of drapery in a news photograph is enough for de Kooning, and Gorky could invent a whole cycle of forms from a morphological trait observed in a photograph, in nature, or in the painting of a friend. The same is true of ideas: a word, a phrase, the page of a book read at someone's apartment, or a cue dropped in a conversation can set the tone for years of work.

Unlike scholars, painters do not have the responsibility of factual accuracy. But through the empathy of their responses, the past can be altered; unsuspected values are uncovered through their affinities to modernity. Besides a new emphasis on the Orient, Abstract Expressionism's effect in this regard centers mainly on the modern tradition. In its effort to encompass dualisms, it has called atten-

tion to the problem of opposition and synthesis in Western art, just as Surrealism threw its beam on the history of the fantastic. In its diversity of sources Abstract Expressionism reveals threads of development which went unperceived because they crossed boundaries. The growing importance of the picture plane can be seen as an aspect of both abstraction and Expressionism, and the emphasis on the relativity of elements can be followed from Manet's preoccupation with surface arrangement and the interest in the Japanese print to Cézanne's discovery of what Herbert Read calls the "good Gestalt" and its parallels in psychology. Collage can be seen as the ideal surface-asserting and relational medium. From its beginning in the Cubism of Picasso and Braque, it is continued in the montages of the Dadaists, the impeccable organizations of Schwitters, and, relational in subject more than in form, the pastings of Max Ernst. For Surrealism, with its literary and psychological bias, introduced the counterpart in content of the abstract tradition's equivocal tension of form and structure. The concern for reality, structure, inclusiveness, and centrality isolates more clearly the ascending concept of the real, which begins with Courbet, and perhaps with Homer and Eakins; and it gives us a richer understanding of Cézanne's focus, which was simultaneously in his motif, on his panel, and within himself. The need for organicism calls to mind the inherent similarities of many vitalistic concepts and art forms. The aesthetic of unfinish, already emphasized by Romanticism, offers a new view of the studies of the Renaissance and especially of the drawings of Leonardo, in contrast to the classical concept of perfection. Abstract Expressionism has served to stress constituent facts in the development of modern art.

The refusal to accept the divisional lines drawn during the first forty years of the twentieth century sets a new value on those American artists in whose work structure and subject were identical, or those who instinctively tried to reconcile divergent goals. Hans Hofmann's admiration of Alfred H. Maurer calls attention to the American pioneer's jump from Sargentesque brushing to Fauvism and his attempt to combine Cubism with Expressionism. Marsden Hartley's early paintings can also be seen as precursive: Clement Greenberg wrote in 1950 that "perhaps he anticipated the present mood of American art more clearly than any other American artist of his time by giving his modernism a German and expressionist inflection."[11] Charles Demuth, especially in the fluctuating floral watercolors and mysteriously ambiguous illustrations for Zola's *Nana* and James's *The Turn of the Screw*, which preceded his Precisionist style, also approached Abstract Expressionism. And, though the form derivations of Max Weber have been predominantly structural or Neo-Classic, his career also offers a parallel, not only because of a natural tendency to emotional brushwork and the richness of his Hebraic subject matter, but especially in his move toward Abstract Expressionism in the forties. For the lyrical and naturalistic artist, the development of Arthur G. Dove, Maurer's friend, from a more or less geometric style to a flat, flowing, and calligraphic naturalism provides a link with Ryder. Whether Dove can be regarded as an influence on the development of Abstract Expressionism because of the interest in him shown by such painters as Theodoros Stamos is questionable, but there is no question that his spirit presaged theirs.

One of the least appreciated of our pioneers was Arthur B. Carles. He knew Hofmann well, in both Paris and the United States, and was a close friend of Marin. In *Turkey* (Fig. 281, 1927) Carles spanned the gap from his early realism to an Abstract Expressionism prophetic of the late style of Gorky. There are parallels with Hofmann in the twenties, but their synthesis is far more advanced; one canvas of the thirties resembles a Rothko of a decade later; and his *Composition, III* (Fig. 282,

1931–1932) could have been painted in the fifties. Carles was like Gorky in being able to blend divergent experiences into unity, but he did it purely as an individual, without reassurance from the Surrealist and automatist milieu. Here is a case which demonstrates how, independently, similar attitudes can result in similar forms. The forties and fifties are implicit in Carles's art of the thirties. He was one of the most notable native precursors of Abstract Expressionism.

A final implication of the synthesizing tendency concerns the methods by which modern art is studied. In analyzing the art of Europe during the first four decades of the century, categorization along national and stylistic lines was inevitable. Though they overlapped, the concepts of Russia, Italy, France, and Germany differed demonstrably. And what formal similarities could be found between the Surrealism of Salvador Dali and the purism of de Stijl? But the historical situation of 1930 no longer holds true. Now, as Tobey says, "we must look to the center to find the truth." Categorization was a millstone about the neck of criticism during the forties. Over and over, artists attacked its arbitrariness.

The Years of Concentration

If one begins from de Kooning's conclusion that among modern artists there "is no style of painting now," notice is immediately drawn to those broad underlying presuppositions uniting modern style rather than dividing it into segments. The developments which have taken place during the last decade have made it unnecessary to throw up one's hands in the face of diversity. Differences are more and more those of individuals, not groups, and supranational period similarities have been growing more apparent.

The formation of the School of New York, from its beginnings before 1939 and World War II until

the present spread of Abstract Expressionism, should be documented month by month, and even day by day—preferably by the cooperative effort of those painters who were its leaders. This book aims merely to recollect the astounding diversity of the factors that converged on New York City during these years. The advent of the hydrogen bomb has shown that an explosion can be produced not only by fission but by fusion, a process through which completely new elements are formed. Talk of origins brings to light only the old things which make up the present. Quite apart from its concentration of traditions, the New York School is most often seen as a complete break with the past, as a violent rejection of illustration, commercialism, materialism, formalism, politics, utilitarianism, and even bohemianism for more meaningful values and forms. "A true history of modern art," Motherwell writes,

will take account of its innumerable concrete rejections. True, it is more difficult to think under the aspect of negations, or to contend with what is not stated. But this does not justify the history of an indirect process being written under the category of the direct. I do not see how the works of a Mondrian or Duchamp can be described apart from a description of what they refused to do. Indeed, a painter's most difficult and far-reaching decisions revolve around his rejections.[12]

Ever since the colonies separated from England and Europe, America's viewpoint has been forward, futuristic, identifying itself with the new, rather than nostalgic for the past. The United States has kept its spirit of revolt, its willingness to upset the cultural applecart. In Peggy Guggenheim's gallery, Art of This Century, which opened in 1942, and in those of Julien Levy, Betty Parsons, Mortimer Brandt, Howard Putzel, Samuel Kootz, and Charles Egan the divergent impacts of purist, Surrealist, and expressionist styles converged on men who reacted intensely to their composite premises.

The many sources tapped by Gorky—Cézanne, Picasso, Davis, Miró, Tanguy, and Kandinsky among them—branded him as an eclectic. But, aided by the catalyst of the linear, fluid paintings of Roberto Matta Echaurren during 1941 and 1942, Gorky's work developed into one of the most original and personal styles in American painting history. Pollock's reaction to the vigorous teaching of the regionalist Thomas Benton was to push the idea of automatism derived from Breton, Miró, Masson, and Matta to an extreme far beyond anything postulated in their art or statements, and thus to create an entirely new image of space, structure, and surface. De Kooning, who first showed at the Egan Gallery in 1948, was the last to be seen publicly. Though his abstract canvases were strikingly new, his figures remained more traditional. But by opening the twisted female images of Picasso's post-Guernica style, and spreading the inclusiveness of his own dilemma to include the geometrical abstractions of Mondrian as well as the expressionism of van Gogh and Soutine, a new style was created. Motherwell began painting with a predisposition for feeling and intellection, a taste for romanticism and automatism, a superb sensibility, and an interest in the formal relations of collage, the flat shapes of Matisse, and the content of Picasso, who "deals with love and death."[13] His art, nevertheless, cannot be called derivative. Rothko is the only artist of the group who, as a student of Max Weber, could be said to have begun as an expressionist. But his present manner of painting, as I have emphasized, is the least precedented of the group. Innovation and synthesis are not necessarily contradictory—a truth evidenced again in Tobey's originality which, though it has little to do with the Surrealist influence on the New York School, is nevertheless similar in being a product of fusion.

The confluence of diverse traditions offered the premises for innovation. Dazzling and explosive, the completely original early canvases of Matta provided a white heat to combine opposed styles which, as the title of Sidney Janis' *Abstract and Surrealist Art in America* (1944) indicates, were then the dominant forces.

To the artists involved Abstract Expressionism was "not an aesthetic but," as Motherwell says, "an experience that we lived (largely unwittingly) . . . a real underground whose center shifted and changed year by year."[14] It was a true avant-garde in that it produced deeply felt works and ideas which were received with hostility outside its own circle. This nucleus expanded rapidly, however, as images and statements were communicated in a series of richly illustrated journals: the Surrealist *VVV* (1942–1944), modeled on the Parisian *Minotaure; View* (1940–1947), which ambitiously combined neo-Dadaist typography, Schiaparelli Surrealism, and serious criticism; the more intellectual and analytic *Dyn* (1942–1944), published by Wolfgang Paalen in Mexico and representing French and American viewpoints. *Possibilities* (one 1947–1948 issue), *Tiger's Eye* (1947–1949), and *Trans/formation* (1950–1952) followed, with an increasing trend toward cultural unification and Abstract Expressionism rather than Surrealism or purism, and poetic or intellectual seriousness rather than fashionableness or shock. In one capacity or another the influence of Motherwell, as partisan analyst and spokesman and as editor of the documents published by Wittenborn and Schultz, was everywhere.

The years bridged by these publications saw the dissolution of the repeatedly organized Surrealist movement. It has been asked why American artists did not continue it. In terms of form and spirit an answer becomes evident. The automatist wing of that movement was never, nor is it now, fully repudiated. The work of Miró and Masson, even during the twenties, could have been labeled Abstract Expressionist. They were men who began with Cubism, but, maintaining surface, they softened and

activated their brush gestures and became more and more immersed in surface relationships and a biological idea of process. Miró's statement to James Johnson Sweeney in 1948 is an ideal summary of the automatism which Abstract Expressionism adapted to its own needs.[15] Gorky fused double imagery and formal equivalence. Pavel Tchelitchew's *Hide-and-Seek* (1940–1942, The Museum of Modern Art) demonstrates the breaking point: though its multiple images are representational, its ambiguities are spatial as well as literary, and it maintains the picture plane. What might be called the right wing of Surrealism was rejected for specific reasons:

1. It ignored the formal principles of the structural tradition, breaking the picture plane for illusionistic depth and bulk.

2. Surrealism was a manifesto movement. To the Abstract Expressionists' indeterminism, the positive aspects of Dada offered a more appropriate atmosphere.

3. More and more, Surrealism emphasized pure fantasy, fashionable romanticism, and scatology over "*surréalité.*"

On the basis of these conditions, Tanguy's bulk and recession were too absolute and sculptural. Matta's later style mannerized Renaissance perspective; furthermore it emphasized an eschatological content alien to the more positive and humanistic viewpoint of the American painters.

The intensity of the years from 1940 to 1945 is a primary condition of the new expressionism. With the paintings and ideas of the entire world as a taking-off place, the tension of the New York scene passed into paint. Though he was never a static painter, Hofmann's new violence was not brought from Europe, but was sparked in association with that of the completely American Jackson Pollock. Rothko's brush and line gestures, paralleling those of Matta, Miró, and Gorky during the same years, rose directly from the immediate scene. Although it refers back to van Gogh, de Kooning's expressionistic brush was not brought from Holland, but was built up progressively in New York.

The Spread of Abstract Expressionism

If we would make a distinction between the New York School and a more widely dispersed combination of synthesis and innovation in the United States, it must be in terms of degrees of tension, and content, rather than pictorial means or technical skill. Of all centers it was in New York where the life of art was keenest. If the combined presence of the greatest number of form and spirit characteristics constitutes superiority, it was the painters in closest contact with the confluence of traditions who in the main produced the better works.

The opposite side of this direction of thought—though not, perhaps, its contradiction—can be found in those painters who, though intuitively in key with their period and working in modern means, chose to cut themselves off completely from the disconcerting tempo of New York, or divided their time between isolation and cosmopolitan life. The precursors of abstract and semiabstract naturalists like Morris Graves, Lee Gatch, or John Ferren, are Ryder, Marin, and Dove. Their mood is that of meditation and quiescence, qualities which have their own levels of intensity.

Nevertheless, the story of Abstract Expressionism from 1947 until 1954 is one of dissemination from a source. Each year the number of realists, abstractionists, Surrealists, and figurative expressionists who have modulated or radically changed their styles in the direction of the characteristics listed above has increased. Philip Guston broke utterly with romantic realism; Bradley Walker Tomlin evolved from structural romanticism to a loose geometricism; Balcomb Greene shifted from a precise

nonobjectivism to a light-conscious style in which dissolution and Cubist flatness contradict bulky nude figures; Franz Kline staked everything on single units of black-and-white calligraphy; John Ferren softened and naturalized a geometric style; the figurative Boston expressionists Levine and Bloom introduced fragmenting and flattening devices into their realistic subjects. The list is too lengthy to cite.

Year by year what was once the work of an avant-garde has become the leading modern style of America. The period of the little magazines, unable to survive economically, has been succeeded by a conversion of the editors of virtually all major art periodicals, the patronage (in wall space if not in economic support) of most of the important museums, the opening of dozens of new galleries, and the widest possible dissemination of avant-garde ideas.

Without voluminous lists of exhibitions and prizes, of artists who have been won over to the new form and content on various levels of understanding and mastery, or citations of the hundreds of young painters who turned to it early, it is impossible to convey fully the degree to which Abstract Expressionism has become a universal style. Its proponents win the prizes in exhibitions dotted in every region of the United States. In the large national shows its purest form heavily outweighs all other types of painting, and the other groups—social realism, figurative expressionism, and Surrealism—have been so deeply marked by surface consciousness, brush, and the structure of geometric abstraction (which is becoming rare outside New York City) that little painting remains which is modern and not in some way affected by Abstract Expressionist characteristics.

A valuable service has been performed by Robert D. Kaufmann at his New York Forum Gallery in exhibiting student work from college and univer-

sity art departments of the West, Midwest, South, and East.[16] Approximately 80 percent of the work shown so far, he estimates, is Abstract Expressionist in character. A great deal of it, notably that from the University of California, which sponsored Hofmann's first teaching in this country, has been technically of extremely high quality. The most conservative showing, interestingly, was that of Columbia University.

The changes wrought in Abstract Expressionism as it has been carried by visiting New York painters, internationally minded instructors, artists-in-residence, books, and journals to every part of the United States have not affected its form characteristics, nor has there been a conspicuous decline in technical proficiency. The art teachers who have translated the principles of Cézanne, the Cubists, the Expressionists, and Hofmann, and who have encouraged their students toward inner, imaginative expression rather than Neo-Classical antique drawing or detailed realism have done their jobs well. What was once the property of an avant-garde has in truth become an Abstract Expressionist Academy!

Some see the wide dissemination of what amounts to a synthesis of, and a response to, the constituent elements of modern art as unfortunate. However, it is unquestionable evidence of a surge of talent, intelligence, knowledge, and seriousness which on such a scale has never before existed in the United States. The lack of awareness of spiritual values which Hofmann noted in 1930 has been altered, and it has been mainly the universities and colleges, rather than the private art academies, which, in their rejection of localism, have provided the nuclei for a greater interest in the practice of art on the part of a whole nation than has heretofore (except perhaps for Italy during the Renaissance) ever existed.

The relationship between this expanding Amer-

ican style and the paintings of a Western Europe no longer sharply divided in style along nationalistic lines is a subject outside this book. Michel Tapié de Celeyran, who has been identified with the advent of Abstract Expressionism in France, asserts that "it was during 1946 that certain sincere individuals staked their destinies on 'Lyrical Abstraction' quite independently and in complete isolation from each other, despite their simultaneous compulsion toward the same end."[17] The topic of American influence on European style is a touchy one, and statements concerning it should not be made without careful study. On the basis of the present evidence we do know, however, that the uniting features of the style which can now be found in England, France, Germany, Italy, Spain, and even Japan—whether or not they were invented simultaneously, as Tapié asserts, by Hans Hartung, Wols, and Georges Mathieu—were well established in the United States, as a result of the war situation in Europe, two years earlier.

In speculating on the reasons for the phenomenal interest of young Americans in a life devoted to art, and for the increasingly large group of curators, writers, teachers, and researchers who have made it their study, it should be asked to what degree the spirit characteristics of Abstract Expressionism, divorced from the forms given to them by the European tradition, are relevant to our society at large. To what degree is this modern art an expression of the whole culture?

The growth of Abstract Expressionism is a function of its spirit, which parallels the pattern of a large group of intellectuals who, like Herbert Read and André Malraux, have lost faith in social panaceas. Their increasing idealism and mysticism has in it the desire for faith and for common, but less material, values. It is related to the broader phenomenon which has been called both a "religious revival" and a "failure of nerve." The will to believe is avowed by Tobey, though whether his faith is in God or man is difficult to say. Somewhat pompously, Malraux has spoken of the museum as a cathedral. Can art, which in the past has been the icon of religious belief, reverse its former role? Is it possible for the bond between man and man, and between man and the universe, to be symbolized through art directly? Can religion be submerged in art? One pastor has remarked that artists do not need church services; they have their own means of seeking salvation.

These are speculations which cannot be answered easily, but truth seems to lie somewhere in their direction. Abstract Expressionism—or whatever else one chooses to call this alliance of forms, feelings, and ideas that constitutes what is at once the most universal and the most personal painting style in the history of the world—reveals the functioning of modern personality. As by-product rather than goal, it has produced new images of great beauty. In comparison with many of the principles which govern the modern world, its motivations are astonishingly pure. In its concern for creation over destruction, humanism and naturalism over mechanism, freedom over regimentation, truth and reality over falsehood and sham, inclusiveness over chauvinism, live structure over chaos or dead order, and commitment over pragmatism, it portrays the searcher and idealist among contemporary men, whatever his field of endeavor may be.

Appendix

Notes

Illustrations

Index

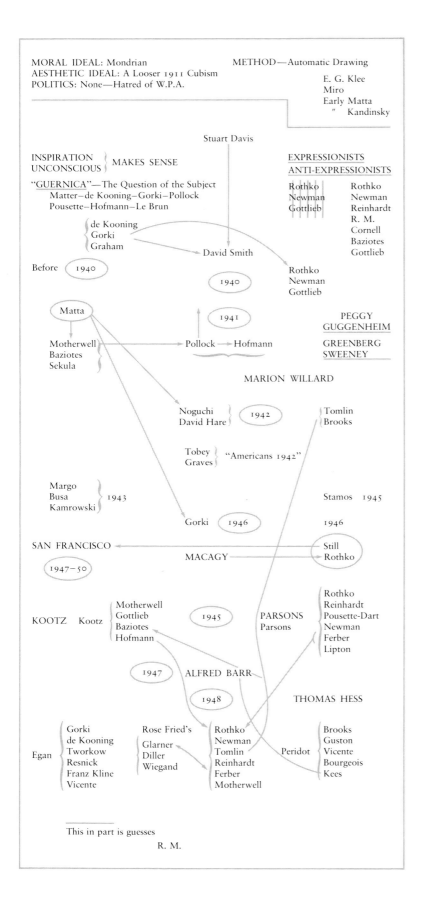

MORAL IDEAL: Mondrian METHOD—Automatic Drawing
AESTHETIC IDEAL: A Looser 1911 Cubism
POLITICS: None—Hatred of W.P.A.
 E. G. Klee
 Miro
 Early Matta
 ″ Kandinsky

 Stuart Davis

INSPIRATION ⎱ MAKES SENSE EXPRESSIONISTS
UNCONSCIOUS ⎰ ANTI-EXPRESSIONISTS

"GUERNICA"—The Question of the Subject Rothko Rothko
 Matter–de Kooning–Gorki–Pollock Newman Newman
 Pousette–Hofmann–Le Brun Gottlieb Reinhardt
 R. M.
 ⎰ de Kooning Cornell
 ⎱ Gorki Baziotes
 ⎱ Graham Gottlieb
 David Smith

Before (1940) Rothko
 Newman
 (1940) Gottlieb

 Matta (1941) PEGGY
 GUGGENHEIM
Motherwell → Pollock → Hofmann GREENBERG
Baziotes SWEENEY
Sekula

 MARION WILLARD

 Noguchi ⎱ (1942) ⎱ Tomlin
 David Hare ⎰ ⎰ Brooks

 Tobey ⎱ "Americans 1942"
 Graves ⎰

Margo ⎱
Busa ⎰ 1943 Stamos 1945
Kamrowski ⎰
 Gorki (1946) 1946

SAN FRANCISCO ← Still
 Rothko
 MACAGY

(1947–50)

 Motherwell
 Gottlieb (1945) PARSONS Rothko
KOOTZ Kootz Baziotes Parsons Reinhardt
 Hofmann Pousette-Dart
 Newman
 Ferber
 (1947) ALFRED BARR Lipton

 (1948) THOMAS HESS

 Gorki Rose Fried's Rothko Brooks
 de Kooning Glarner Newman Guston
 Tworkow Diller Tomlin Peridot Vicente
Egan Resnick Wiegand Reinhardt Bourgeois
 Franz Kline Ferber Kees
 Vicente Motherwell

 ————————
 This in part is guesses
 R. M.

This diagram was an impromptu creation of Robert Motherwell's produced during a conversation between the artist and the author. In Motherwell's words it represents "an impression of the true chronology and of the separate clusters that taken together are sometimes called Abstract Expressionism, sometimes called the New York School."

Notes

The six painters are referred to by initials. Two works repeatedly cited are abbreviated as follows:

MOMA Bull "What Abstract Art Means to Me," *The Museum of Modern Art Bulletin*, 18 (Spring 1951).

MAA Robert Motherwell, Ad Reinhardt, and Bernard Karpel, eds., *Modern Artists in America*. First series. (New York: Wittenborn, Schultz, [1952]). Includes "Artists' Sessions at Studio 35 (1950)," and "The Western Round Table on Modern Art (1949)."

1. The Spread of Abstract Expressionism

1. The term Abstract Expressionism appears to have been used in the United States for the first time by Alfred H. Barr, Jr., in reference to the freely painted early works of Wassily Kandinsky. It occurs in the announcement of a course of Barr's lectures delivered during 1929 at the Department of Art, Wellesley College, Massachusetts, and in the catalogue *First Loan Exhibition: Cézanne, Gauguin, Seurat, van Gogh* (New York: The Museum of Modern Art, 1929), p. 15. An earlier European use of the phrase, called to my attention by Peter Selz, dates back to 1919. During that year an article with the title "Der abstrakte Expressionismus," by Oswald Herzog, appeared in *Der Sturm*, 10 (Berlin, 1919), 29.

2. RM, *Fourteen Americans*, exhibition catalogue (New York: The Museum of Modern Art, 1946), pp. 34–36.

3. RM, *The School of New York*, exhibition catalogue (Beverly Hills, Calif.: Frank Perls Gallery, 1951). WdeK, "The Renaissance and Order," *Trans/formation*, 1 (1951), 86–87.

4. Sigfried Giedion, *Space, Time and Architecture*, 10th ed. (Cambridge, Mass.: Harvard University Press, 1954), pp. 18–19.

5. Richard P. Blackmur, *Religion and the Intellectuals* (New York: Partisan Review, 1950), p. 42.

6. AG, "Stuart Davis," *Creative Art*, 9 (September 1931), 217.

7. Quoted by Adolph Gottlieb, in *Arshile Gorky*, exhibition catalogue (New York: Kootz Gallery, 1950).

8. Thomas B. Hess, *Abstract Painting* (New York: Viking, 1951), p. 100.

9. Quoted by Martha Bourdrez, "De Kooning, Painter of Promise," *The Knickerbocker*, 21 (May 1950), 8.

10. Quoted in "Willem the Walloper," *Time*, 57 (April 30, 1951), 63.

11. James Fitzsimmons, "Robert Motherwell," *Design Quarterly*, 29 (1954), 20.

12. Conversation with me.

13. "18 Painters Boycott Metropolitan; Charge 'Hostility to Advanced Art,'" *New York Times*, May 22, 1950, sec. 1, p. 15; see *MAA*, p. 154, for additional references.

2. Pictorial Elements

1. Quoted by Belle Krasne, "A Tobey Profile," *Art Digest*, 26 (Oct. 15, 1951), 26.

2. Henri Focillon, *The Life of Forms in Art*, trans. Charles B. Hogan and George Kubler, 2nd ed. (New York: George Wittenborn, 1948), 8.

3. Maurice Denis, *Théories: 1890–1910*, 4th ed. (Paris: Rouart and Watelin, 1920), p. 1: "Se rappeler qu'un tableau—avant d'être un cheval de bataille, une femme nue, ou une quelconque anecdote—est essentiellement une surface plane recouverte de couleurs en un certain ordre assemblées."

4. RM, "Painters' Objects," *Partisan Review*, 11 (Winter 1944), 94, 95; italics mine.

5. RM, "Beyond the Aesthetic," *Design*, 47 (April 1946), 15.

6. Statement in a Bahai lecture, New York, Oct. 30, 1951.

7. HH, *Search for the Real* (Andover, Mass.: Addison Gallery of American Art, 1948), p. 46.

8. Conversation with me.

9. The word "purist" is used throughout this book to designate the general philosophical position of the geometrical abstractionists. It does not designate the view of any specific painter or group. No reference to the Purism of Ozenfant and Jeanneret-Le Corbusier is intended.

10. Roger Fry, "Sensibility," *Last Lectures* (New York: Macmillan, 1939), pp. 22–36.

11. The word "transcendental" is used, as it is by the artists, to indicate values which, though subjective, are not merely personal. They are ideal or spiritual, but still immanent in sensory and psychic experience.

12. Stanley William Hayter, "Life and Space of the Imagination," *View*, 4 (December 1944), 127–128.

13. HH, *Search for the Real*, p. 48.

14. Hayter, "Life and Space of the Imagination," p. 140.

15. The words "calligraphy" and "calligraphic" are used exclusively to designate the free brushstroke which varies in width and quality. They are never used to mean "elegant penmanship"—the more common dictionary usage.

16. HH, *Search for the Real*, p. 71.

17. Statement in a Bahai lecture, Oct. 30, 1951.

18. MT, exhibition catalogue (San Francisco: California Palace of the Legion of Honor, 1951).

19. MT, "Reminiscence and Reverie," *Magazine of Art*, 44 (October 1951), 231.

20. Ethel Schwabacher, *Arshile Gorky Memorial Exhibition* (New York: Whitney Museum of American Art, 1951), p. 19.

21. Stuart Davis, "Arshile Gorky in the 1930s: A Personal Recollection," *Magazine of Art*, 44 (February 1951), 56.

22. Schwabacher, *Gorky Memorial*, p. 12.

23. Elaine de Kooning, "Gorky: Painter of His Own Legend," *Art News*, 49 (January 1951), 64.

24. Ibid.

25. A fact confirmed in conversation with de Kooning.

26. Thomas B. Hess, "De Kooning Paints a Picture," *Art News*, 52 (March 1953), 30–33, 64–67.

27. HH, *Search for the Real*, p. 71.

28. Elaine de Kooning, "Hans Hofmann Paints a Picture," *Art News*, 48 (February 1950), 40.

29. See comment on face of diagram in Appendix.

30. RM, exhibition catalogue (New York: Kootz Gallery, 1950). In this catalogue he divides his current work into several categories: Elegies, Wall Paintings, and Capriccios, describing the latter as a "'composition in a more or less free form,' often fantastic. The subjects are the classical ones of 20th Century Parisian abstract painting: figures, interiors, still lifes. The fantasy is brutal and ironical."

31. Thomas B. Hess, *Abstract Painting* (New York: Viking, 1951), p. 153.

32. Knud Merrild, in James Fitzsimmons, "All is Flux," *Art Digest*, 26 (Mar. 15, 1952), 18.

33. Arthur Drexler, "Interiors to Come: Unframed Space; A Museum for Jackson Pollock's Paintings," *Interiors*, 109 (January 1950), 90–91.

34. Focillon, *Life of Forms in Art*, p. 18.

35. *MAA*, p. 18.

36. An achievement attributed to Will Barnet, Steve Wheeler, Peter Busa, and Norman Daly by Gordon Brown, "New Tendencies in American Art," *College Art Journal*, 11 (Winter 1951–52), 105. See also Will Barnet, "Painting without Illusion," *The League Quarterly*, 22 (Spring 1950), 8–9.

37. See Franklin P. Kilpatric, ed., *Human Behavior from the Transactional Point of View* (Hanover, N. H.: Institute for Associated Research, 1952); Earl Kelley, *Education for What Is Real* (New York: Harper, 1947).

38. RM, exhibition catalogue, 1950.

39. MR and Adolph Gottlieb, statement quoted in Edward Alden Jewell, "'Globalism' Pops into View," *New York Times*, June 13, 1943, sec. 2, p. 9. Rothko regards this as a collaborative statement of general agreement rather than as a personal credo.

40. MR, "The Romantics Were Prompted," *Possibilities*, 1 (Winter 1947–48), 84.

41. E. de Kooning, "Gorky: Painter of His Own Legend," p. 65.

42. Hess, "De Kooning Paints a Picture."

43. HH, *Search for the Real*, pp. 52, 50.

44. Ibid., p. 70.

3. Pictorial Relationships

1. HH, *Search for the Real* (Andover, Mass.: Addison Gallery of American Art, 1948), pp. 46, 47; italics mine.

2. See *MAA*, p. 19; italics mine.

3. Oberlin College seminar, Spring 1952.

4. HH, *Search for the Real*, pp. 47, 48, 55.

5. Quoted by Belle Krasne, "A Tobey Profile," *Art Digest*, 26 (Oct. 15, 1951), 5.

6. MT, statement in the file of the Willard Gallery, New York, concerning the painting *Threading Light*.

7. *MAA*, pp. 20, 19.

8. Wdek, *MOMA Bull*, p. 7.

9. David Hare, "The Spaces of the Mind," *Magazine of Art*, 43 (February 1950), 48.

10. *MAA*, p. 17.

11. Quoted by Thomas B. Hess, "De Kooning Paints a Picture," *Art News*, 52 (March 1953), 67.

12. AG, "Stuart Davis," *Creative Art*, 9 (September 1931), 213.

13. HH, *Search for the Real*, p. 70.

14. Ibid., pp. 50, 68.

15. Ibid., pp. 21, 40.

16. Ibid., p. 50.

17. Ibid., pp. 71–72; italics mine.

18. Krasne, "A Tobey Profile," p. 26.

19. A fact established by me in conversation with Tobey.

20. MT, statement in the file of the Willard Gallery.

21. Ibid.

22. MT, "Reminiscence and Reverie," *Magazine of Art*, 44 (October 1951), 228–229; italics mine.

23. MT, exhibition catalogue (San Francisco: California Palace of the Legion of Honor, 1951).

24. WdeK, *MOMA Bull*, p. 7.

25. Thomas B. Hess, *Abstract Painting* (New York: Viking, 1951), p. 103.

26. Cf. discussion of landscape as a subject, infra.

27. Louis Finkelstein, "Marin and De Kooning," *Magazine of Art*, 43 (October 1950), 204.

28. "Willem the Walloper," *Time*, 57 (Apr. 30, 1951), 63.

29. See *MAA*, p. 12.

30. An observation made by Sidney Janis, in conversation with me.

31. RM, "Beyond the Aesthetic," *Design*, 47 (April 1946), 15.

32. RM, "The Modern Painter's World," *Dyn*, 6 (November 1944), 11.

33. Oberlin College seminar (Spring 1952).

34. MR, "The Romantics Were Prompted," *Possibilities*, 1 (Winter 1947–48), 84.

35. RM, "Beyond the Aesthetic," pp. 14, 15.

36. Konrad Z. Lorenz, "The Role of Gestalt Perception in Animal and Human Behaviour," in *Aspects of Form: A Symposium on Form in Nature and Art*, ed. Lancelot Law Whyte (London: Lund Humphries, 1951), p. 157.

37. Alfred North Whitehead, *Science and the Modern World* (New York: Macmillan, 1948), pp. viii–ix.

38. Quoted by Elaine de Kooning, "Diller Paints a Picture," *Art News*, 51 (January 1953), 55.

39. Piet Mondrian, *Plastic Art and Pure Plastic Art* (New York: Wittenborn, 1945), p. 13.

40. Artists Club, New York, Mar. 28, 1952.

41. Ibid., Feb. 20, 1952; italics mine.

42. Conversation with me.

43. Quoted by Krasne, "A Tobey Profile," p. 34.

44. Conversation with me.

45. MR, *Fifteen Americans*, exhibition catalogue (New York: The Museum of Modern Art, 1952), p. 18.

46. Alfred H. Barr, Jr., *What Is Modern Painting*, rev. ed. (New York: The Museum of Modern Art, 1952), p. 43.

47. *Reality*, 1 (Spring 1953), 1; editorial statement signed by 46 painters. Harold Rosenberg, "The American Action Painters," *Art News*, 51 (December 1952), 49.

48. Compare Chapter 4, section on "Color."

49. "The Talk of the Town: Unframed Space," *The New Yorker*, 26 (Aug. 5, 1950), 16.

50. Alexander Dorner, *The Way Beyond "Art"* (New York: Wittenborn, Schultz, 1947), pp. 17, 225, 227.

51. Discussion at Artists Club, Feb. 1, 1952.

52. Hess, *Abstract Painting*, p. 104.

53. See Chapter 4, section on "Movement"; and Chapter 7, section on "Subject Matter and Content."

54. MT, exhibition catalogue, 1951.

55. HH, *Search for the Real*, pp. 53, 60, 50, 48, 73, 71.

56. Ibid., pp. 48, 72, 73, 61.

57. Unpublished letter, used through the courtesy of Ethel Schwabacher.

58. Ethel Schwabacher, *Arshile Gorky Memorial Exhibition* (New York: Whitney Museum of American Art, 1951), p. 30.

59. *MAA*, pp. 11, 12.

60. Rosenberg, "American Action Painters," pp. 22–23, 48–50.

61. WdeK, "The Renaissance and Order," *Trans/formation*, 1 (1951), 86.

62. *MAA*, p. 20.

63. WdeK, "Renaissance and Order," p. 86.

64. RM, "Painters' Objects," *Partisan Review*, 11 (Winter 1944), 97.

65. My characterization is drawn mainly from conversations with the painter.

66. Quoted in *Mark Tobey Retrospective Exhibition* (New York: Whitney Museum of American Art, 1951).

67. MT, "Reminiscence and Reverie," p. 230; italics mine.

68. Statement in a Bahai lecture, New York, Oct. 30, 1951; italics mine.

69. MT, statement in the file of the Willard Gallery.

70. MT, "Reminiscence and Reverie," p. 230.

71. MR, "The Romantics Were Prompted," p. 84.

72. Quoted by Elaine de Kooning, "Albers Paints a Picture," *Art News*, 49 (November 1950), 40.

73. See, for example, Ralph M. Evans, *An Introduction to Color* (New York: John Wiley and Sons, 1948).

74. Aloys Maerz and M. Rea Paul, *A Dictionary of Color* (New York: McGraw-Hill, 1930), pp. 11–12.

75. Hess, "De Kooning Paints a Picture," p. 66.

76. HH, exhibition catalogue (New York: Kootz Gallery, 1951). Hofmann regards this as an important summation of his color theory. Unless otherwise noted, all subsequent quotations in this section regarding color are taken from it.

77. Quoted by E. de Kooning, "Albers Paints a Picture," p. 57.

78. HH, exhibition catalogue, 1951; italics in original.

79. HH, *Search for the Real*, pp. 51, 74, 73.

80. MT, exhibition catalogue, 1951.

81. Quoted by Krasne, "A Tobey Profile," p. 26.

82. HH, *Search for the Real*, p. 74.

83. HH, exhibition catalogue, 1951.

84. MT, exhibition catalogue, 1951.

85. RM, "Beyond the Aesthetic," p. 15.

86. RM, in *Black or White*, exhibition catalogue (New York: Kootz Gallery, 1950).

87. MT, "Reminiscence and Reverie," p. 231.

88. RM, exhibition catalogue (New York: Kootz Gallery, 1950).

89. RM, in *Black or White*.

90. Elaine de Kooning, "Gorky: Painter of His Own Legend," *Art News*, 49 (January 1951), 64.

91. Hess, *Abstract Painting*, p. 110.

92. See Osvald Sirén, *The Chinese on the Art of Painting* (Peiping: Henri Vetch, 1936).

93. George Rowley, *Principles of Chinese Painting* (Princeton: Princeton University Press, 1947), pp. 46, 76.

94. Quoted by Krasne, "A Tobey Profile," p. 26.

95. Artists Club, Jan. 23, 1952.

96. Clement Greenberg, *The Nation*, 166 (Apr. 24, 1948), 448.

97. Thomas B. Hess, "8 Excellent, 20 Good, 133 Others," *Art News*, 48 (January 1950), 34.

98. Hess, "De Kooning Paints a Picture," p. 65.

99. David Katz, *The World of Colour* (London: Kegan Paul, Trench, Trubner, 1935), pp. 9, 8.

100. Ibid., pp. 9, 10.

101. Ibid., p. 21.

102. MT, "Reminiscence and Reverie," pp. 228, 231.

103. Katz, *World of Colour*, p. 10.

104. MR, statement in *Fifteen Americans*, p. 18.

105. Barr, *What Is Modern Painting*, p. 43.

106. Quoted in Hess, *Abstract Painting*, p. 150.

107. Katz, *World of Colour*, p. 27.

108. Hess, "De Kooning Paints a Picture," p. 66.

109. Quoted by Elaine de Kooning, "Hofmann Paints a Picture," *Art News*, 48 (February 1950), 38.

110. WdeK, "Renaissance and Order," p. 87.

111. James Fitzsimmons, "Robert Motherwell," *Design Quarterly*, 29 (1954), 20–21.

112. Hess, "De Kooning Paints a Picture," p. 67.

113. Quoted by E. de Kooning, "Hofmann Paints a Picture," p. 38.

114. Quoted by Dorothy Seckler, "Can Painting Be Taught?" *Art News*, 50 (March 1951), 64.

115. HH, *Search for the Real*, pp. 66, 68.

116. Quoted by E. de Kooning, "Hofmann Paints a Picture," p. 38.

117. Conversation with me.

118. WdeK, *MOMA Bull*, pp. 5, 4.

119. Quoted by Hess, "De Kooning Paints a Picture," p. 32.

120. Quoted by Schwabacher, *Gorky Memorial Exhibition*, p. 30.

121. MT, "Reminiscence and Reverie," p. 229.

4. *The Creative Process*

1. *MAA*, p. 11.

2. Ibid., pp. 17, 15.

3. Ibid., p. 14.

4. Comments during discussions at the Artists Club, New York, January–March 1952.

5. RM, "The Modern Painter's World," *Dyn*, 1 (November 1944), 9; italics in original.

6. *MAA*, p. 11.

7. Ibid., p. 11.

8. Belle Krasne, "A Theodore Roszak Profile," *Art Digest*, 27 (Oct. 15, 1952), 9.

9. Quoted by Belle Krasne, "A David Smith Profile," *Art Digest*, 16 (Apr. 1, 1952), 26.

10. *MAA*, p. 11.

11. RM, exhibition catalogue (New York: Kootz Gallery, 1947).

12. *MAA*, p. 15.

13. Ibid., pp. 17, 18.

14. Quoted in Thomas B. Hess, *Abstract Painting* (New York: Viking, 1951), p. 132.

15. "Jackson Pollock," *Arts and Architecture*, 61 (February 1944), 14.

16. Jackson Pollock, "My Painting," *Possibilities*, 1 (Winter 1947–48), 79.

17. RM, "Modern Painter's World," p. 13.

18. Quoted by Elaine de Kooning, "Hofmann Paints a Picture," *Art News*, 48 (February 1950), 40.

19. *MAA*, pp. 18, 14.

20. RM and Harold Rosenberg, statement in *Possibilities*, 1 (Winter 1947–48), 1.

21. RM, in *The School of New York*, exhibition catalogue (Beverly Hills, Calif.: Frank Perls Gallery, 1951).

22. *MAA*, p. 15.

23. Artists Club, Feb. 20, 1952.

24. RM and Rosenberg, statement in *Possibilities*, 1.

25. *MAA*, p. 18.

26. Ibid., p. 19.

27. John Dewey, *Art as Experience* (New York: Minton, Balch, 1934), pp. 50–51.

28. *MAA*, pp. 11, 18.

29. Statement in symposium "The New Sculpture" (New York: The Museum of Modern Art, Feb. 12, 1952).

30. *MAA*, p. 20.

31. RM, exhibition catalogue (New York: Kootz Gallery, 1950).

32. MR, "The Romantics Were Prompted," *Possibilities*, 1 (Winter 1947–48), 84.

33. RM, "Beyond the Aesthetic," *Design*, 47 (April 1946), 15.

34. HH, *Search for the Real* (Andover, Mass.: Addison Gallery of American Art, 1948), pp. 65, 46; italics mine.

35. Ibid., p. 63.

36. Ibid., p. 70.

37. Harold Rosenberg, "The American Action Painters," *Art News*, 51 (December 1952), 23.

38. E. de Kooning, "Hofmann Paints a Picture," p. 38.

39. WdeK, *MOMA Bull*, p. 7.

40. Noted by James Thrall Soby, in *Magazine of Art*, 40 (March 1947), 102, 104. Matta preferred "experienced" to "theoretical" art, a distinction derived "from a devoted reading of the philosophies of William James and John Dewey."

41. Rosenberg, "American Action Painters," p. 23.

42. MR, "Romantics Were Prompted," p. 84.

43. *MAA*, p. 12.

44. Ibid., pp. 11, 12.

45. Ibid., p. 11.

46. E. de Kooning, "Hofmann Paints a Picture," p. 59.

47. *MAA*, p. 11.

48. Ibid., p. 12.

49. HH, *Search for the Real*, p. 72.

5. *The Problem of Opposites*

1. RM, "Beyond the Aesthetic," *Design*, 47 (April 1946), 15. WdeK, *MOMA Bull*, p. 7; and quoted in "Big City Dames," *Time*, 61 (April 6, 1953), 80, repeating a statement made to the same journal in 1951.

2. May, as of 1953, was chairman of the Joint Council of New York State Psychologists, a practicing psychotherapist, and a member of the William Alanson White Institute of Psychiatry, Psychoanalysis, and Psychology. Rollo May, *Man's Search for Himself* (New York: W. W. Norton, 1953), pp. 34, 50, 70, 53–54.

3. Eric Robertson Dodds, *The Greeks and the Irrational* (Berkeley and Los Angeles: University of California Press, 1951); ch. VII, "The Fear of Freedom," pp. 236–255, compares Hellenistic Greece with modern society in this regard.

4. Friedrich Nietzsche, *The Birth of Tragedy*, trans. William A. Haussmann (London, 1909), vol. I of *The Complete Works of Friedrich Nietzsche*, ed. Oscar Levy (Edinburgh and London: T. N. Foulis, 1909–1913), p. 121.

5. My conclusion, based on Rothko's writings and my conversations with him.

6. Hubert Crehan, "Rothko's Wall of Light," *Art Digest*, 19 (Nov. 1, 1954), 19.

7. Artists Club, New York, Feb. 22, 1952.

8. Artists Club, Mar. 19, 1952.

9. Morse Peckham, "The Triumph of Romanticism," *Magazine of Art*, 45 (November 1952), 291–299. Cyril Connolly, "Surrealism," *Art News Annual*, 21 (1952), 170.

10. Statement in a Bahai lecture, New York, Oct. 30, 1951; MT, in *The Tiger's Eye*, 1 (March 15, 1948), 52.

11. RM, *MOMA Bull*, p. 12.

12. Reginald Howard Wilenski, *The Modern Movement in Art*, rev. ed. (London: Faber and Faber, 1945).

13. RM, *MOMA Bull*, p. 12.

14. RM, "The Modern Painter's World," *Dyn*, 1 (No-

vember 1944), 9; statement in Sidney Janis, *Abstract and Surrealist Art in America* (New York: Reynal and Hitchcock, 1944), p. 65.

15. Adolph Gottlieb, *Arshile Gorky*, exhibition catalogue (New York: Kootz Gallery, 1950).

16. RM, "Painters' Objects," *Partisan Review*, 11 (Winter 1944), pp. 94, 95.

17. Conversation with me. Statement in Bahai lecture, Oct. 30, 1951.

18. HH, *The Search for the Real* (Andover, Mass.: Addison Gallery of American Art, 1948), 69.

19. MR, "The Romantics Were Prompted," *Possibilities*, 1 (Winter 1947–48), 84.

20. WdeK, *MOMA Bull*, pp. 4, 6.

21. Ibid., p. 7.

22. Artists Club, Apr. 11, 1952.

23. Artists Club, Feb. 22, 1952. WdeK, "The Renaissance and Order," *Trans/formation*, 1 (1951), 86; *MOMA Bull*, p. 7.

24. Quoted by Ethel Schwabacher, in *Arshile Gorky Memorial Exhibition* (New York: Whitney Museum of American Art, 1951), p. 34.

25. William Baziotes, *Fifteen Americans*, exhibition catalogue (New York: The Museum of Modern Art, 1952), p. 12.

26. RM, *The School of New York*, exhibition catalogue (Beverly Hills, Calif., 1951).

27. *MAA*, pp. 19–20. All quotations in the paragraphs that follow are from this source.

28. RM, exhibition catalogue (New York: Kootz Gallery, 1947).

29. MR, *Fifteen Americans*, p. 18.

30. RM, "Modern Painter's World," pp. 10, 11–12.

31. *Congressional Record*, 95 (1949), pt. 2, 2317–2318; pt. 3, 3233–3235; pt. 9, 11584–11587, 11750, 12099–12100. For further bibliography, see *MAA*, p. 151.

32. RM, note on diagram; see Appendix.

33. WdeK, *MOMA Bull*, p. 7.

34. HH, *Search for the Real*, p. 53.

35. WdeK, *MOMA Bull*, p. 7.

36. Comment on face of diagram in Appendix. Note also:

"Cubism was a revolution in that the artist broke with

tradition by changing from a line to a plane concept" (HH, *Search for the Real*, p. 52).

"Has there in six centuries been better art than Cubism? No. Centuries will go past—artists of gigantic stature will draw positive elements from Cubism" (AG, "Stuart Davis," *Creative Arts*, 9 [September 1931], 213).

"The great cubist pictures . . . transcend and belie the implications of the cubist program" (MR, "Romantics Were Prompted," p. 84).

MT refers to "multiple space" as his "personal discovery of cubism"; quoted by Belle Krasne, "A Tobey Profile," *Art Digest*, 26 (Oct. 15, 1951), 26. In 1945 he regretted that "the great cubist school of France didn't have more effect on the curriculum of our art schools"; statement in *Paintings by Mark Tobey* (Portland, Ore.: Portland Art Museum, 1945).

37. *MAA*, p. 28.

38. MR, "Romantics Were Prompted," p. 84; quoted by Douglas MacAgy, "Mark Rothko," *Magazine of Art*, 42 (January 1949), 21; MR, statement in *Fifteen Americans*, p. 18.

39. Artists Club, Feb. 1, 1952.

40. WdeK, *MOMA Bull*, p. 7. MT, "Reminiscence and Reverie," *Magazine of Art*, 44 (October 1951), 231.

41. WdeK, *MOMA Bull*, p. 7.

42. Frank O'Hara, "Nature and New Painting," in the third issue of *Folder*, a semi-annual (New York: Tibor Press, 1954–55). The young painters referred to are, in the main, those exhibiting at the Tibor de Nagy Gallery, New York.

43. RM and Harold Rosenberg, in *Possibilities*, 1 (Winter 1947–48), 1.

44. Bahai meeting, Oct. 30, 1951.

45. Quoted by Paul Ellsworth, "Hans Hofmann, Reply to a Questionnaire and Comments on a Recent Exhibition," *Arts and Architecture*, 66 (November 1949), 45.

46. RM, ed., *The Dada Painters and Poets* (New York: Wittenborn, Schultz, 1951), p. xiii.

47. WdeK, *MOMA Bull*, p. 7.

48. For Baziotes' words, see *MAA*, p. 15. McNeil spoke at the Artists Club, Feb. 20, 1952.

49. RM, ed., *Dada Painters and Poets*, p. xxxvii.

50. John Ferren, Artists Club, March 28, 1952.

51. Oberlin College seminar, Spring 1952.

6. *Subject Matter and Content*

1. *MAA*, p. 21.

2. Lionello Venturi, *Art Criticism Now* (Baltimore: The Johns Hopkins Press, 1941), p. 10.

3. WdeK, "The Renaissance and Order," *Trans/formation*, 1 (1951), 86.

4. RM, "The Modern Painter's World," *Dyn*, 1 (November 1944), 12.

5. Pablo Picasso (trans. Myfanwy Evans), in Alfred H. Barr, Jr., *Picasso: Fifty Years of His Art* (New York: The Museum of Modern Art, 1946), p. 274.

6. HH, *Search for the Real* (Andover, Mass.: Addison Gallery of American Art, 1948), p. 66.

7. Elaine de Kooning, "Hofmann Paints a Picture," *Art News*, 48 (February 1950), 38.

8. Paul Brach, at the Artists Club, New York, March 28, 1952.

9. MR, "The Romantics Were Prompted," *Possibilities*, 1 (Winter 1947–48), 84.

10. The use of the terms "humanism" or "humanistic" other than in reference to classical learning and the education founded upon it often occasions misunderstanding. As used by artists, "humanism" denotes a concern for distinctively human interests or aims. A "humanist," therefore, is one with faith in man, involvement with his experience, and dedication to his well-being. This is the sense in which these words are used throughout.

11. RM, "Modern Painter's World," pp. 12, 14; *MOMA Bull*, p. 12; ed., *The Dada Painters and Poets* (New York: Wittenborn, Schultz, 1951), p. xii; "Notes on Mondrian and Chirico," *VVV*, 1 (June 1942), 59; exhibition catalogue (New York: Kootz Gallery, 1947).

12. HH, *Search for the Real*, pp. 61, 67.

13. WdeK, "Renaissance and Order," pp. 86–87.

14. Views stated in conversation with me.

15. Quoted by Belle Krasne, "A Tobey Profile," *Art Digest*, 26 (Oct. 15, 1951), 26.

16. RM, *MOMA Bull*, p. 12.

17. Ethel Schwabacher, *Arshile Gorky Memorial Exhibition* (New York: Whitney Museum of American Art, 1951), 15.

18. Krasne, "A Tobey Profile," p. 34.

19. Alfred H. Barr, Jr., *Matisse: His Art and His Pub-

lic (New York: The Museum of Modern Art, 1951), p. 264.

20. "Realstraction": a word coined (tongue in cheek, one assumes) by Thomas B. Hess; in "Cinemiconology and Realstraction," *Art News*, 51 (December 1952), 24.

21. WdeK, "Renaissance and Order," p. 86.

22. Thomas B. Hess, "De Kooning Paints a Picture," *Art News*, 52 (March 1953), 31.

23. Quoted by Belle Krasne, "A Tobey Profile," p. 26.

24. Statement in a Bahai lecture, New York, Oct. 30, 1951.

25. John Ferren, in "Symposium: The Human Figure," *Art Digest*, 28 (Nov. 15, 1953), 13.

26. MR, "Romantics Were Prompted," p. 84.

27. Edward F. Rothschild, *The Meaning of Unintelligibility in Modern Art* (Chicago: University of Chicago Press, 1934).

28. Alfred Russell, in "Symposium: The Human Figure," p. 13.

29. Ferren, in "Symposium: The Human Figure," pp. 13, 32.

30. WdeK, *MOMA Bull*, p. 4; "Renaissance and Order," p. 87; *MOMA Bull*, p. 6.

31. Conversation with me.

32. MT, statement in files of the Willard Gallery, New York; "Reminiscence and Reverie," *Magazine of Art*, 44 (October 1951), 230.

33. MT, "Reminiscence and Reverie," pp. 230, 231, 229.

34. Henri Focillon, *The Life of Forms in Art*, trans. Charles B. Hogan and George Kubler, 2nd ed. (New York: George Wittenborn, 1948), p. 74.

35. Rudolf Arnheim, in *The Journal of Aesthetics*, 9 (June 1951), 338.

36. Jean Paul Sartre, *What Is Literature*, trans. Bernard Frechtman (New York: Philosophical Library, 1949), pp. 8, 9.

37. HH, *Search for the Real*, pp. 77, 70.

38. Ruth Field, "Modern Poetry: The Flat Landscape," *Trans/formation*, 1, no. 3 (1952), 152.

39. Gordon Brown, "New Tendencies in American Art," *College Art Journal*, 11 (Winter 1951–52), 103–110.

40. MT, "Reminiscence and Reverie," p. 231.

41. Statement from a wall label for the exhibition *Diogenes with a Camera II: A. Adams, Lange, Matsumoto, Man Ray, Siskind, Webb* (New York: The Museum of Modern Art, 1952).

42. Schwabacher, *Gorky Memorial Exhibition*, pp. 22–23.

43. André Breton, *Le surréalisme et la peinture* (New York: Brentano's, 1945), pp. 197, 198.

44. Quoted by Schwabacher in *Gorky Memorial Exhibition*, pp. 28–29.

45. Ibid., pp. 33–34.

46. RM, "Beyond the Aesthetic," *Design*, 47 (April 1946), 15.

47. RM, *14 Americans*, exhibition catalogue (New York: The Museum of Modern Art, 1946), p. 36.

48. Conversation with me.

49. Quoted through the kindness of Ethel Schwabacher.

50. MR and Adolph Gottlieb, in Edward Alden Jewell, "'Globalism' Pops into View," *New York Times* (June 13, 1943), sec. 2, p. 9. See Chapter 2, note 39.

51. RM, "Painters' Objects," *Partisan Review*, 11 (Winter 1944), 94, 95.

52. RM, "Beyond the Aesthetic," p. 15.

53. Meyer Schapiro, "Nature of Abstract Art," *Marxist Quarterly*, 1 (Jan.–March 1937), 95.

54. Rothschild, *Meaning of Unintelligibility in Modern Art*, p. 25.

55. Quoted by MacKinley Helm, *John Marin* (Boston: Pellegrini and Cudahy with the Institute of Contemporary Art, 1948), p. 29; cf. Hofmann's "Push and Pull."

56. RM, "Painters' Objects," pp. 95–96.

57. MT, exhibition catalogue (San Francisco: California Palace of the Legion of Honor, 1951); *Paintings by Mark Tobey*, exhibition catalogue (Portland, Ore.: Portland Art Museum, 1945).

58. MT, "Reminiscence and Reverie," p. 230.

59. Hess, "De Kooning Paints a Picture," p. 30.

60. Conversation with me.

61. Noted in conversation with Ethel Schwabacher.

62. Artists Club, Jan. 8, 1952; *MAA*, p. 16.

63. See *MAA*, p. 18.

64. Ibid., pp. 16, 15, 10, 12.

65. RM, "Modern Painter's World," pp. 10, 13.

66. Oberlin College seminar, Spring 1952.
67. *MAA*, p. 16.
68. MR, "Romantics Were Prompted," p. 84.
69. *MAA*, p. 15.
70. Artists Club, Jan. 22, 1952, Feb. 22, 1952.
71. WdeK, *MOMA Bull*, p. 7.
72. *MAA*, p. 15.
73. AG, "Stuart Davis," *Creative Art*, 9 (September 1931), 217, 213.
74. Quotation from an unpublished letter used through the courtesy of Ethel Schwabacher.
75. HH, *Search for the Real*, p. 67.
76. *MAA*, p. 10.
77. HH, *Search for the Real*, pp. 78, 76.
78. Ibid., pp. 78, 46, 67.
79. Quoted in *Mark Tobey Retrospective Exhibition* (New York: Whitney Museum of American Art, 1951).
80. RM and Harold Rosenberg, *Possibilities*, 1 (Winter, 1947–48), 1.
81. WdeK, *MOMA Bull*, p. 7. Artists Club, Feb. 22, 1952.
82. Quoted by Paul Ellsworth, "Hans Hofmann, Reply to Questionnaire and Comments on a Recent Exhibition," *Arts and Architecture*, 66 (November 1949), 45.
83. HH, *Search for the Real*, p. 66.
84. RM, "Modern Painter's World," pp. 11, 12; "Painters' Objects," p. 94; *MOMA Bull*, p. 12.
85. WdeK, *MOMA Bull*, p. 7.
86. Jack Levine, "Man Is the Center," *Reality*, 1 (Spring 1953), 5.
87. WdeK, *MOMA Bull*, pp. 7, 6.
88. Artists Club, Feb. 20, 1952.
89. Conversation with me.
90. *MAA*, p. 12.
91. *MAA*, pp. 33, 27.
92. Statement in Bahai lecture, Oct. 30, 1951.
93. Artists Club, Jan. 8, 1952.
94. Weldon Kees, *The Nation*, 170 (Feb. 4, 1950), 113.
95. William Baziotes, "I Cannot Evolve Any Concrete Theory," *Possibilities*, 1 (Winter 1947–48), 2.
96. MR, "Romantics Were Prompted," p. 84.
97. MT, *Paintings by Mark Tobey*, exhibition catalogue (Portland, Ore.: Portland Art Museum, 1945).

98. André Malraux, *The Twilight of the Absolute*, vol. III of *The Psychology of Art*, trans. Stuart Gilbert (New York: Pantheon, 1950), p. 128. Quoted by Stephen C. Pepper, in *College Art Journal*, 11 (Fall 1951), 50.
99. MT, statement in *Paintings by Mark Tobey. MAA*, p. 28. MT, comment on *Tundra* (Fig. 255), in files of Willard Gallery.
100. Statement in a lecture at Princeton University, 1951.
101. Artists Club, Apr. 25, 1952. Richard Huelsenbeck, "Dada Manifesto 1949" (New York, 1951). See RM, ed., *The Dada Painters and Poets*, pp. xi–xii, xv, xxx, for a discussion of the reasons why this manifesto was not signed, as planned, by Huelsenbeck, Arp, Duchamp, Ernst, Hausmann, and Richter.
102. Alexander Dorner, *The Way beyond "Art"* (New York: Wittenborn, Schultz, 1947).
103. RM, exhibition catalogue (New York: Kootz Gallery, 1947).
104. Clyfford Still, *Fifteen Americans*, exhibition catalogue (New York: The Museum of Modern Art, 1952), p. 21.
105. See *MAA*, p. 20.
106. Ibid., p. 18.
107. MT, exhibition catalogue, 1951.

7. The Artist and Society

1. RM, "The Modern Painter's World," *Dyn*, 1 (November 1944), 10.
2. A paraphrase of RM, Oberlin College seminar, Spring 1952.
3. WdeK, *MAA*, p. 16.
4. RM, "Modern Painter's World," p. 10.
5. WdeK, *MOMA Bull*, p. 6.
6. MR, "The Romantics Were Prompted," *Possibilities*, 1 (Winter 1947–48), p. 84.
7. *MAA*, pp. 10, 16.
8. RM, "Modern Painter's World," p. 10.
9. *MAA*, p. 30.
10. Quoted by Belle Krasne, "A Tobey Profile," *Art Digest*, 26 (Oct. 15, 1951), 26, 34.

11. HH, *Search for the Real* (Andover, Mass.: Addison Gallery of American Art, 1948), p. 62.

12. HH, "Art in America," *Art Digest,* 4 (August 1930), 27.

13. Quoted in "Hans Hofmann," *Arts and Architecture,* 61 (March 1944), 23.

14. HH, *Search for the Real,* pp. 62, 64.

15. Quoted by Paul Ellsworth, "Hans Hofmann, Reply to a Questionnaire and Comments on a Recent Exhibition," *Arts and Architecture,* 66 (November 1949), 45.

16. *MAA,* p. 15.

17. RM, *MOMA Bull,* p. 12.

18. Edward F. Rothschild, *The Meaning of Unintelligibility in Modern Art* (Chicago: University of Chicago Press, 1934), p. 7.

19. *MAA,* p. 21.

20. "The Purist Idea," Artists Club discussion, New York, March 28, 1952.

21. MR, "Romantics Were Prompted," p. 84.

22. RM, "Modern Painter's World," pp. 14, 11–12.

23. Ibid., p. 10.

24. *MAA,* pp. 16, 15.

25. RM, *The School of New York,* exhibition catalogue (Beverly Hills, Calif.: Frank Perls Gallery, 1951).

26. Quoted by Elaine de Kooning, "Hofmann Paints a Picture," *Art News,* 48 (February 1950), 38.

27. *MAA,* pp. 20, 21.

28. Ibid., pp. 22, 21.

29. Artists Club, Apr. 25, 1952.

30. Quoted by Adolph Gottlieb, in *Arshile Gorky,* exhibition catalogue (New York: Kootz Gallery, 1950).

31. Artists Club, Apr. 25, 1952.

32. "Hans Hofmann Continues Despite the War," *Art Digest,* 16 (May 15, 1942), 29; *Search for the Real,* p. 66.

33. Statement in a Bahai lecture, New York, Oct. 30, 1951.

34. Joseph C. Sloane, "Modern Art and The Criticism of Love," *College Art Journal,* 11 (Spring 1952), 160.

35. HH, *Search for the Real,* p. 61.

36. Statements made in a symposium, "The New Sculpture," New York: The Museum of Modern Art, Feb. 12, 1952.

37. Statement in *Fifteen Americans,* exhibition catalogue (New York: The Museum of Modern Art, 1952), p. 22.

38. *MAA,* p. 33.

39. Quoted in "Seattle Tangler," *Time,* 57 (Apr. 9, 1951), 89. Belle Krasne, "A Tobey Profile," p. 34.

40. Dorothy Seckler, "Can Painting Be Taught?" *Art News,* 50 (March 1951), 40.

41. HH, *Search for the Real,* pp. 62–63.

42. Quoted by Paul Ellsworth, "Hans Hofmann, Reply to a Questionnaire and Comments on a Recent Exhibition," *Arts and Architecture,* 66 (November 1949), 45.

43. RM, "Modern Painter's World," p. 12.

44. *MAA,* pp. 10–11.

45. MT, "Reminiscence and Reverie," *Magazine of Art,* 44 (October 1951), 231.

46. Artists Club, Feb. 22, 1952.

47. Bahai meeting, Oct. 30, 1951.

48. *MAA,* p. 12.

49. Quoted by Seckler, "Can Painting Be Taught?" p. 40.

50. Artists Club, March 19, 1952.

51. WdeK, *MOMA Bull,* p. 4. Artists Club, Feb. 22, 1952.

52. *MAA,* pp. 11, 14, 15.

53. Ibid., pp. 14–16.

54. Ibid., pp. 14, 15.

55. MR and Adolph Gottlieb, quoted in Edward Alden Jewell, "'Globalism' Pops into View," *New York Times,* June 13, 1943, sec. 2, p. 9.

56. *MAA,* p. 14.

57. Artists Club, Apr. 11, 1952, Jan. 8, 1952.

58. Hedda Sterne, in *MAA,* p. 14.

59. *MAA,* pp. 21, 22.

8. The Historical Position of Abstract Expressionism

1. For others, see *Pioneers of Modern Art in America,* exhibition catalogue (New York: Whitney Museum of American Art, 1946), Andrew C. Ritchie, *Abstract Painting and Sculpture in America,* exhibition catalogue (New York: The Museum of Modern Art, 1951).

2. John I. H. Baur, *Revolution and Tradition in Mod-*

ern American Art (Cambridge, Mass.: Harvard University Press, 1951), p. 88.

3. Ritchie, *Abstract Painting and Sculpture in America.*

4. Hofmann: "Maurer, Flannagan, Carles, Gorky, Ryder are the forerunner of a true and great American tradition that is being carried on by the vanguard of advanced modern artists"; in "Homage to A. H. Maurer," *Hartley-Maurer Contemporaneous Paintings,* exhibition catalogue (New York: Bertha Schaefer Gallery, 1950). Pollock: "The only American master who interests me is Ryder"; in "Jackson Pollock," *Arts and Architecture,* 61 (February 1944), 14.

5. MT, in *Fourteen Americans,* exhibition catalogue (New York: The Museum of Modern Art, 1946), p. 70.

6. Sheldon Cheney, *A Primer of Modern Art,* 10th ed. (New York: Tudor, 1939), p. 215.

7. Sheldon Cheney, *Expressionism in Art,* rev. ed. (New York: Tudor, 1948), p. 65.

8. Stuart Davis, *MOMA Bull,* p. 15.

9. Hyman Bloom, exhibition catalogue (Boston: The Institute of Contemporary Art, 1954), p. 6.

10. Though the spirit of these writings may well have been an influence before this time, note the late date of the American translations.

11. Clement Greenberg, in *Hartley-Maurer Contemporaneous Paintings.*

12. RM, "A Tour of the Sublime," *Tiger's Eye,* 1 (Dec. 15, 1948), 47.

13. RM, quoted by Alfred H. Barr, Jr., *Matisse: His Art and His Public* (New York: The Museum of Modern Art, 1951), p. 266.

14. Statement in a letter to me.

15. James Johnson Sweeney, "Joan Miró: Comment and Interview," *Partisan Review,* 15 (February 1948), 206–212.

16. During the period from September 1954 until June 1955, Kaufmann showed work from the following schools: University of Texas, University of Colorado, University of California, University of Oklahoma, Michigan State College, University of Mississippi, University of North Carolina, Columbia University, Hunter College, University of Illinois, and University of Florida.

17. Michel Tapié de Céleyran, "Mathieu Paints a Picture," *Art News,* 53 (February 1955), 50.

Willem de Kooning

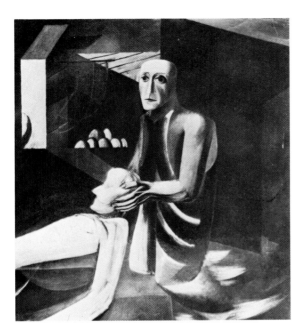

1A DE KOONING

The Death of a Man (detail), ca. 1930
Oil on canvas
(Destroyed)

1B DE KOONING

The Inquest, ca. 1930
Pencil, 8 × 11¼ in.
(Allan Stone Gallery, New York)

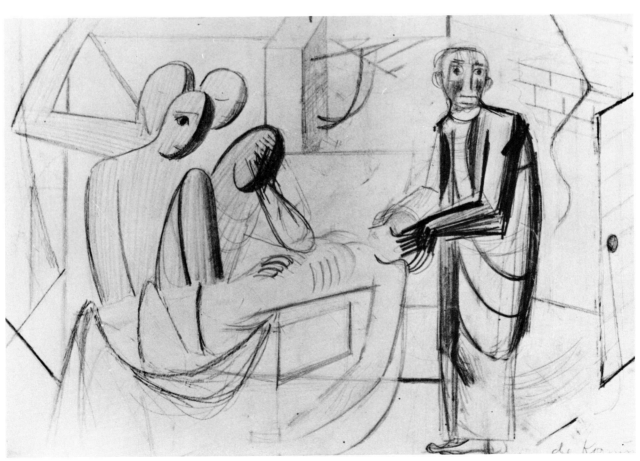

Abstraction, ca. 1938
Oil on canvas, $11^{1}/_{4} \times 8^{1}/_{4}$ in.
(Allan Stone Gallery, New York)

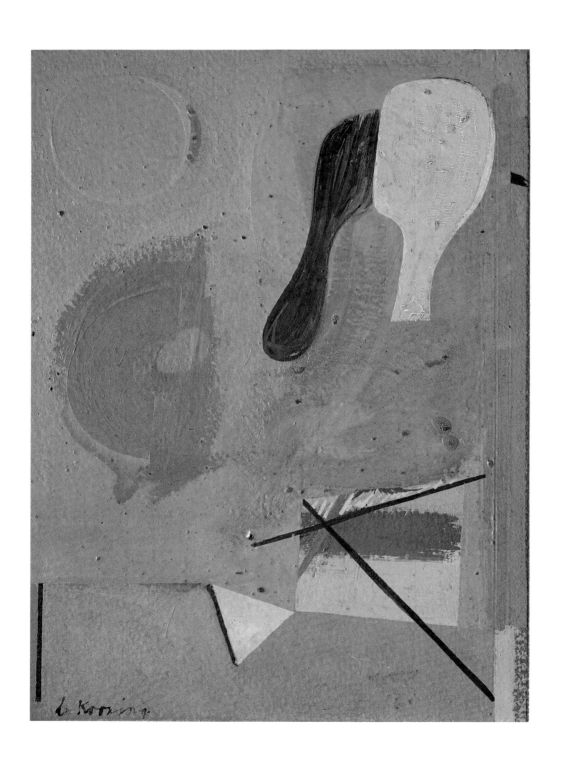

Boy, ca. 1938
Oil on canvas
(Destroyed)

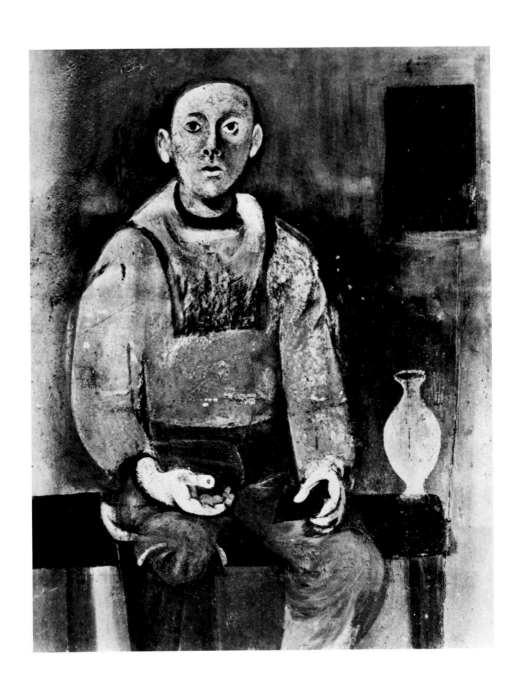

Figure, ca. 1938
Oil on canvas
(Destroyed)

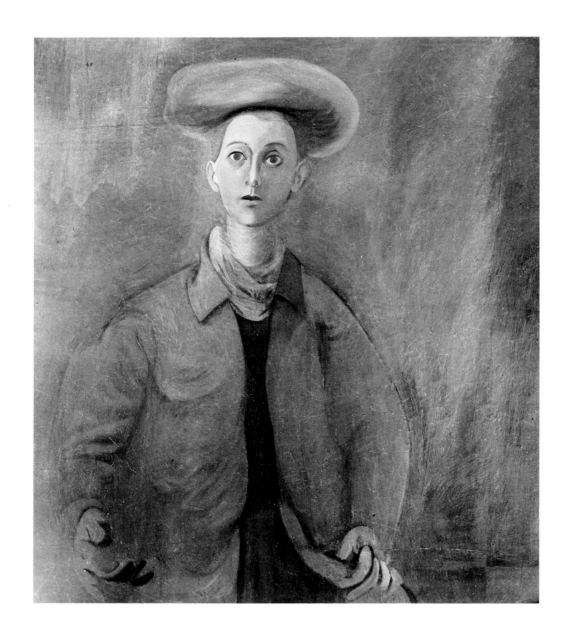

Abstraction, ca. 1938
Oil on canvas, 9$^1/_2$ × 15 in.
(Private Collection)

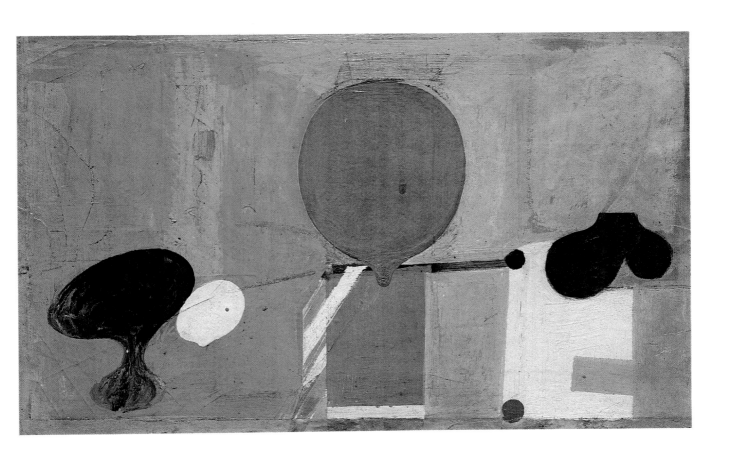

Man, ca. 1939
Oil on paper, mounted on composition board,
11 1/4 × 9 3/4 in.
(Private Collection)

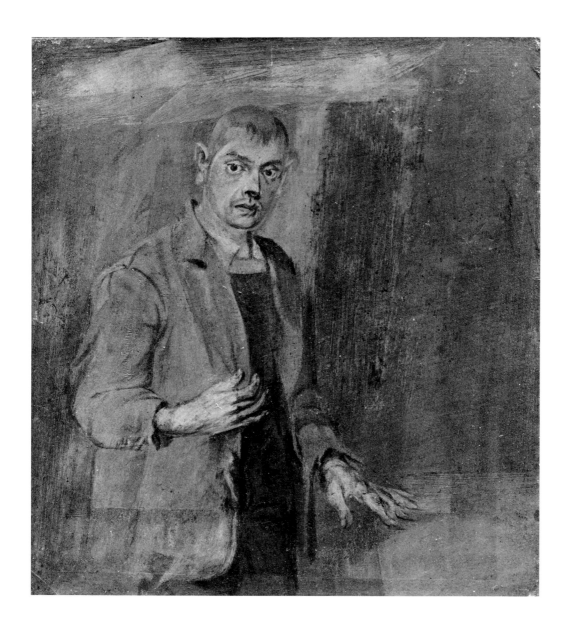

Acrobat, ca. 1940
Oil on canvas, 35 ¹/₂ × 25 ¹/₂ in.
(The Metropolitan Museum of Art, New York, Gift of
Thomas B. Hess, in memory of Audrey Stern Hess, 1977)

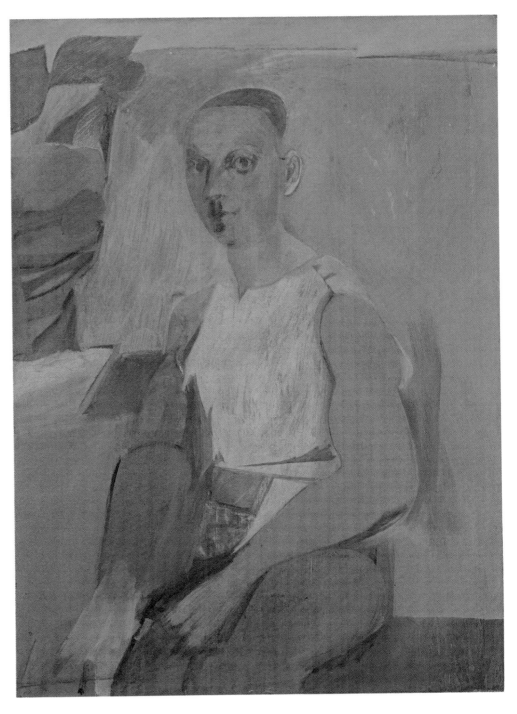

8 DE KOONING
Woman, ca. 1940
Oil on canvas
(Destroyed)

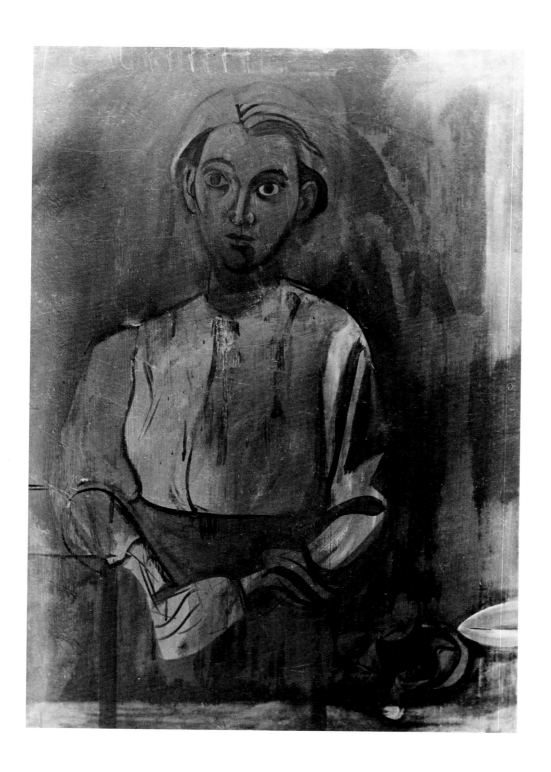

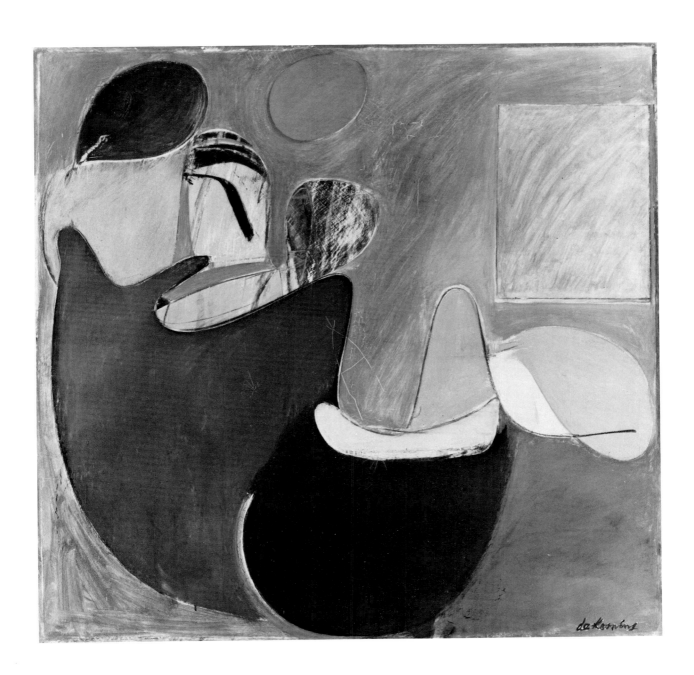

The Wave, 1940–1941
Oil on canvas, 48 × 48 in.
(National Museum of American Art, Smithsonian
Institution, Washington, Gift from the Vincent Melzac
Collection)

Untitled, 1940–1941
Oil on canvas, 46 × 46 in.
(Private Collection)

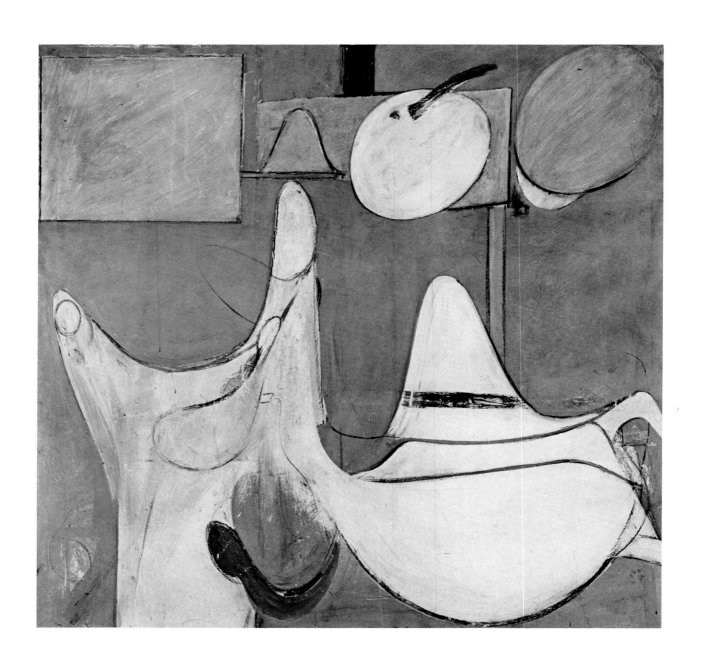

Summer Couch, 1942–1943
Oil on composition board, 31 1/4 × 52 1/2 in.
(Private Collection)

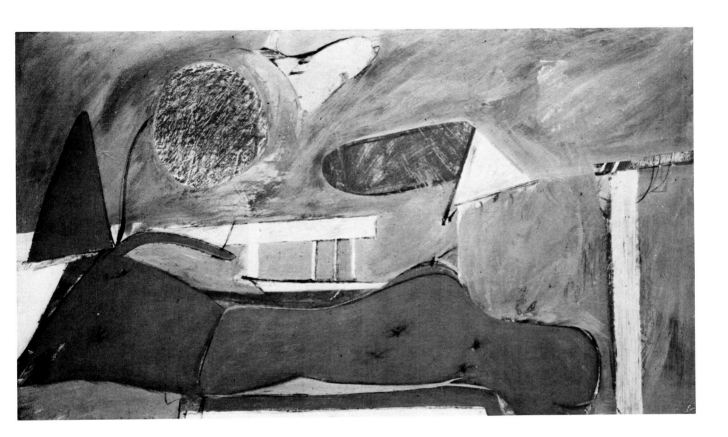

Untitled, ca. 1944
Oil and charcoal on paper,
mounted on composition board, 13 ¹/₂ × 21 ¹/₄ in.
(Mr. and Mrs. Lee V. Eastman)

Head of a Girl, ca. 1942
Oil on paper, 21 × 14 in.
(Allan Stone Gallery, New York)

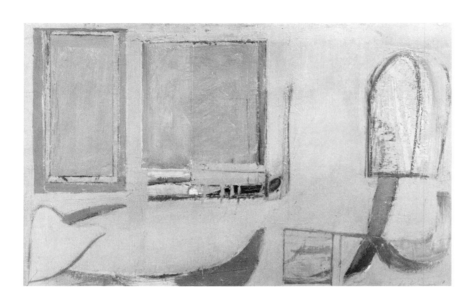

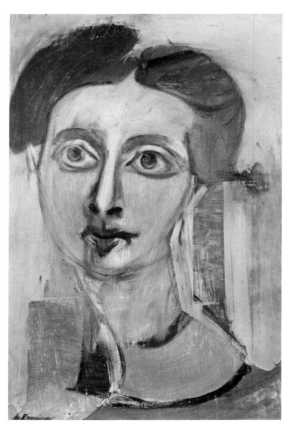

Pink Lady, ca. 1944
Oil and charcoal on composition board, 48³/₈ × 35³/₈ in.
(Betty and Stanley K. Sheinbaum)

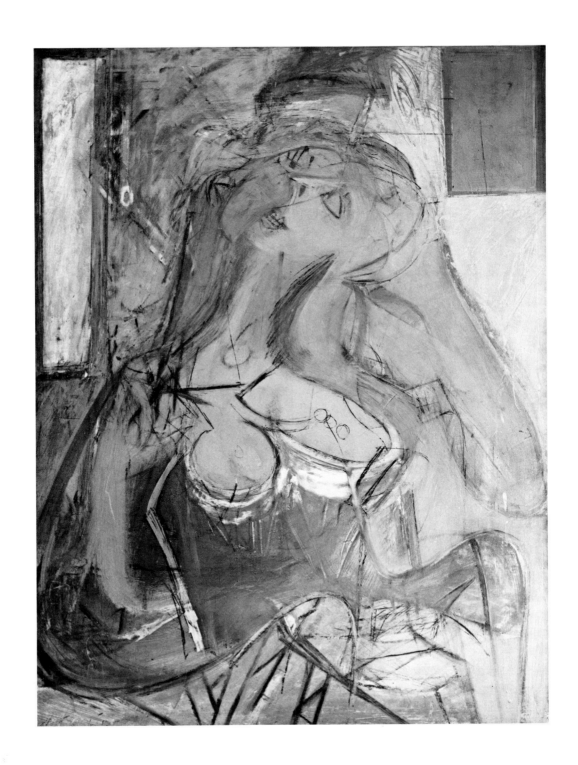

Study for a Backdrop, 1946
Oil and charcoal on paper, 22 1/8 × 28 1/2 in.
(Private Collection)

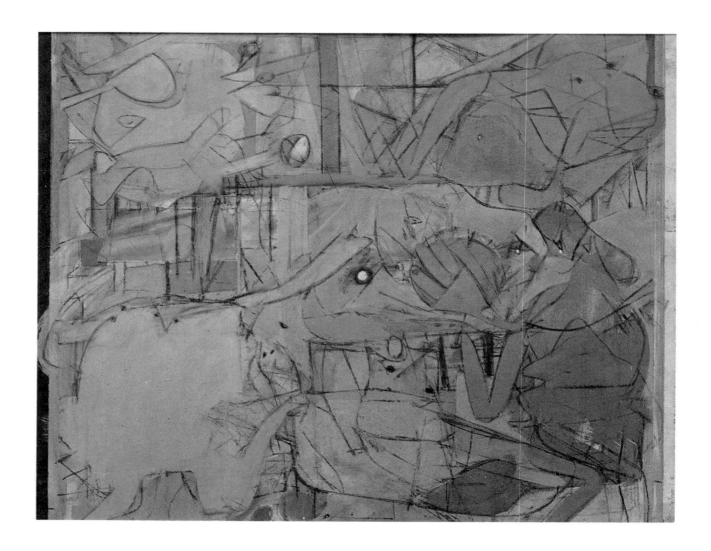

Bill-Lee's Delight, ca. 1946
Oil on paper, mounted on composition board,
27¹/₂ × 34¹/₂ in.
(Mr. and Mrs. Lee V. Eastman)

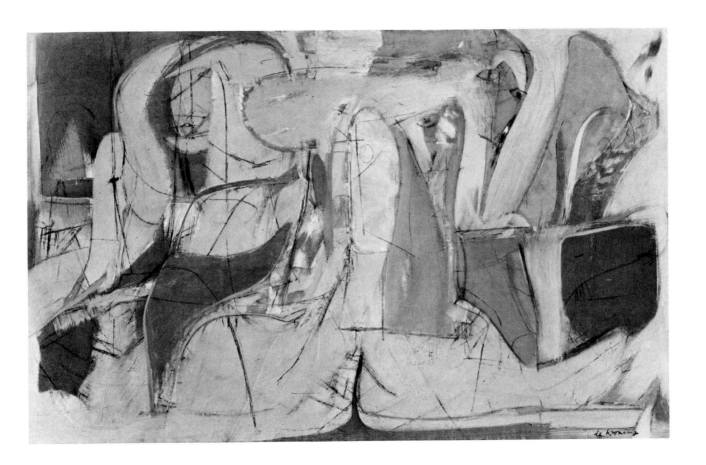

Noon, 1947
Oil on paper, 48 × 33 ½ in.
(Philadelphia Museum of Art, The Albert M. Greenfield
and Elizabeth M. Greenfield Collection)

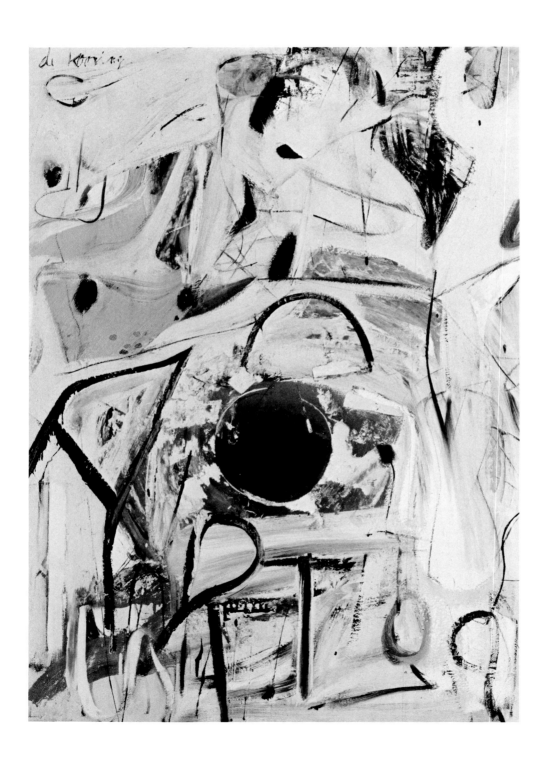

Zurich, 1947
Oil on paper, 36¼ × 24¼ in.
(Estate of Joseph H. Hirshhorn)

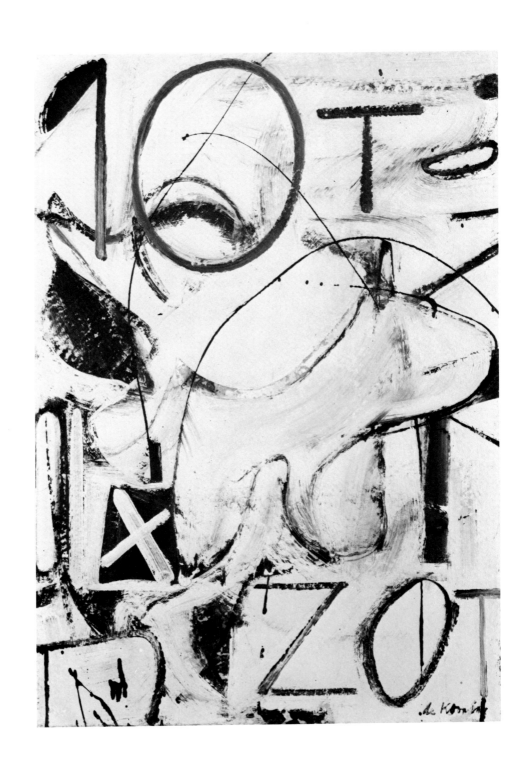

19 DE KOONING

Orestes, 1947
Enamel on paper, mounted on plywood,
24 1/8 × 36 1/8 in.
(Unlocated)

20 DE KOONING

Woman, ca. 1947
Oil on paper, mounted on composition board,
16 × 15 1/2 in.
(American Broadcasting Companies, Inc.)

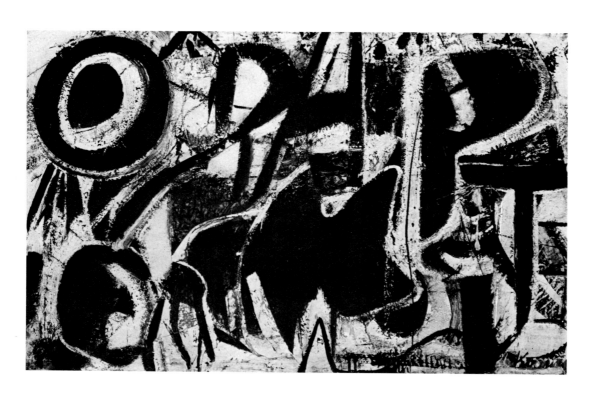

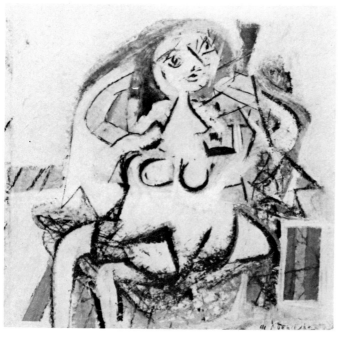

21 DE KOONING

Painting, 1948
Enamel and oil on canvas, $42^{5}/_{8} \times 56^{1}/_{8}$ in.
(The Museum of Modern Art, New York)

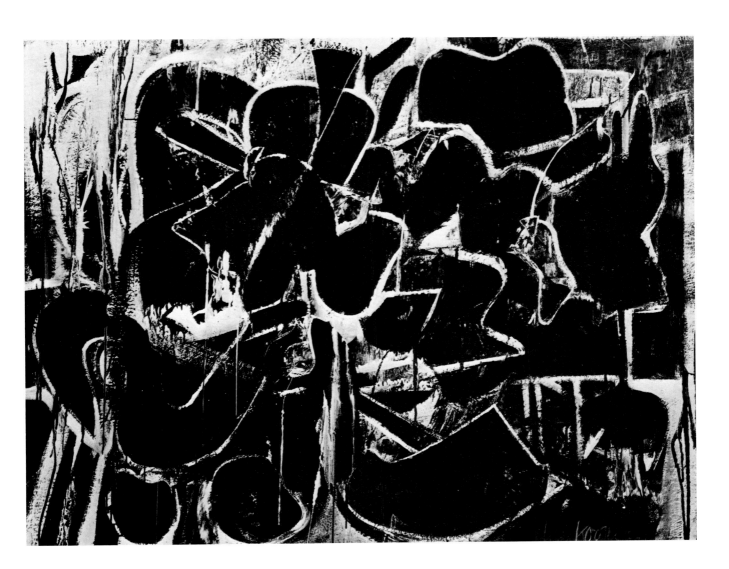

The Mailbox, 1948
Oil, enamel, and charcoal on paper,
mounted on cardboard, 23¼ × 30 in.
(Private Collection)

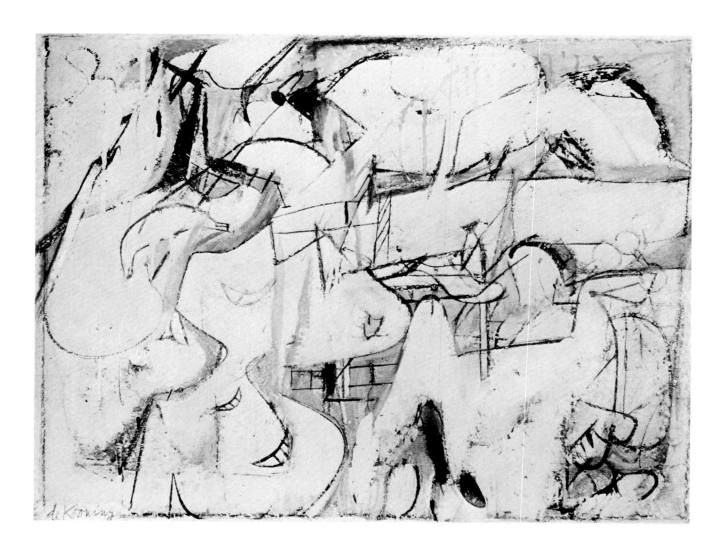

Attic, 1949
Oil, enamel, newspaper transfer on canvas,
61⅞ × 81 in.
(Jointly owned by The Metropolitan Museum of Art,
New York, and Muriel Kallis Newman, in honor of her
son, Glen David Steinberg. The Muriel Kallis Steinberg
Newman Collection, 1982)

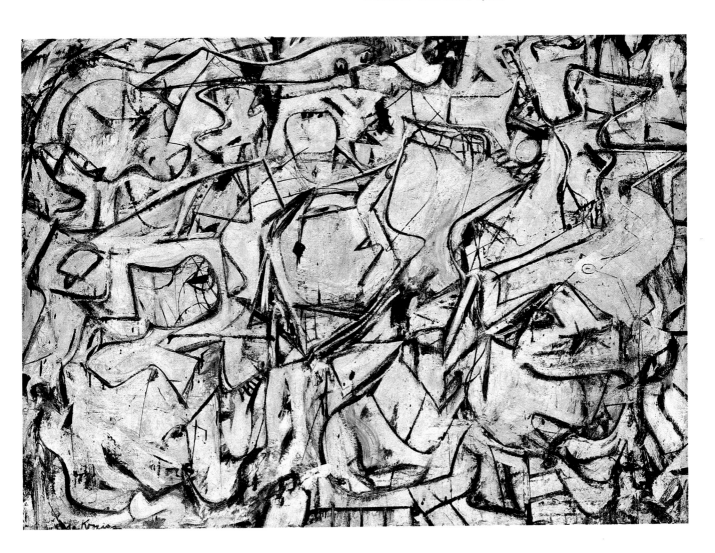

Figure, 1949
Oil on cardboard, 18³/₈ × 14¹/₂ in.
(Contemporary Collection of the Cleveland
Museum of Art)

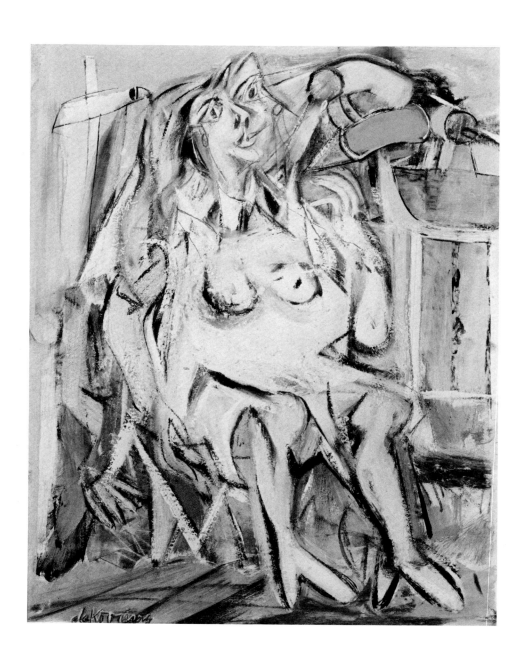

Woman, 1949
Oil, enamel, and charcoal on canvas, 60½ × 47⅞ in.
(Boris and Sophie Leavitt, Hanover, Pennsylvania)

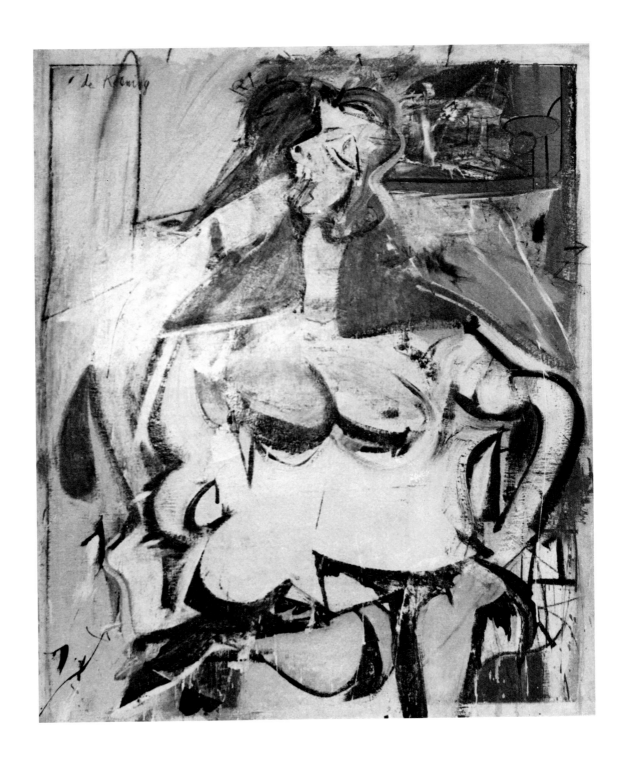

Ashville, 1949
Oil on masonite, $25^5/_8 \times 31^7/_8$ in.
(The Phillips Collection, Washington)

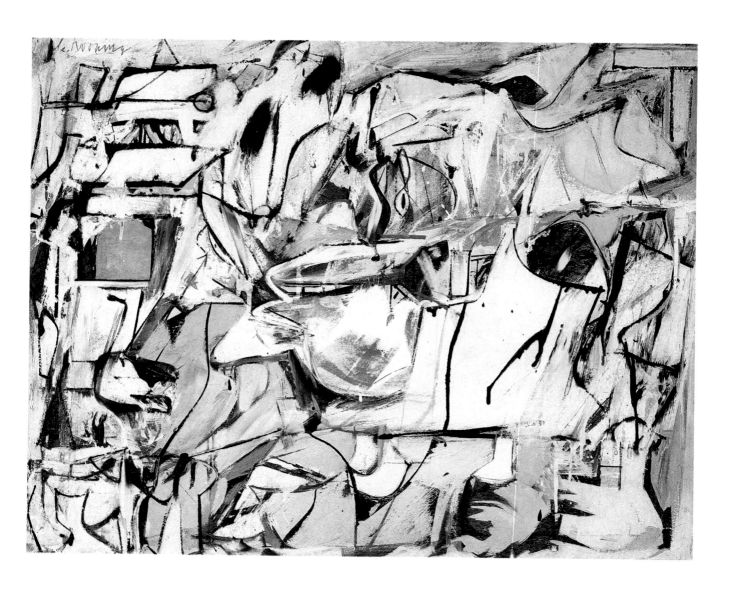

27 DE KOONING

Black and White Abstraction, ca. 1950
Enamel on paper
(Unlocated)

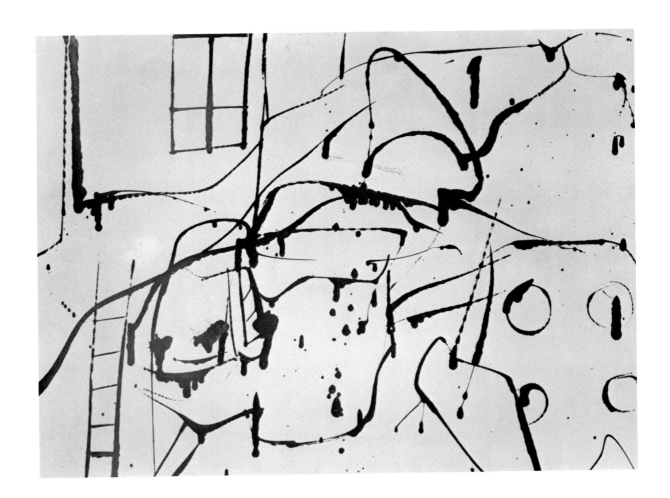

28 DE KOONING

Black and White Abstraction, ca. 1950
Enamel on paper, 21 1/4 × 30 1/4 in.
(Unlocated)

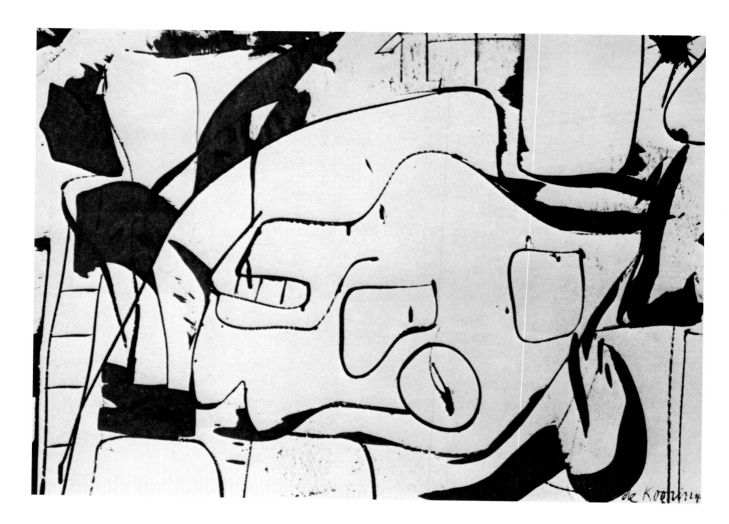

Black and White Abstraction, ca. 1950
Enamel on paper, 10 × 15 in.
(Mr. and Mrs. Ralph I. Goldenberg)

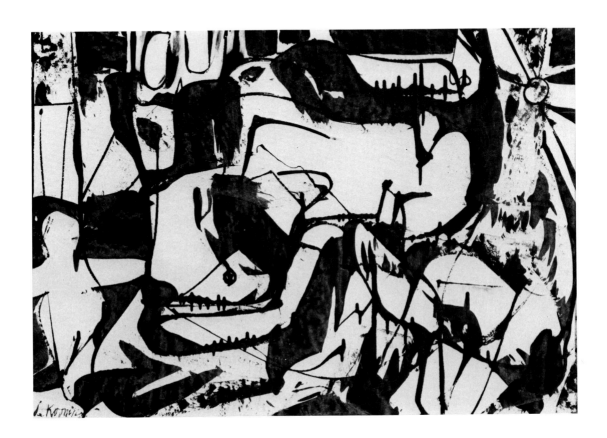

Excavation, 1950
Oil on canvas, 6 ft. 8 ¹/₈ in. × 8 ft. 4 ¹/₈ in.
(The Art Institute of Chicago, Gift of
Mr. and Mrs. F. G. Logan, Mr. Edgar W. Kauffman, Jr.,
and Mr. and Mrs. Noah Goldowsky)

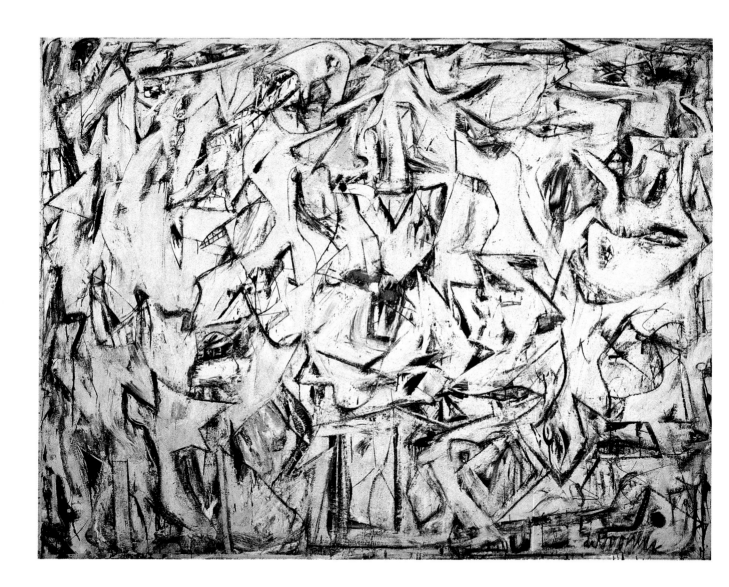

Collage, 1950
Oil, enamel, and thumbtacks on cut papers, 22 × 30 in.
(David M. Solinger)

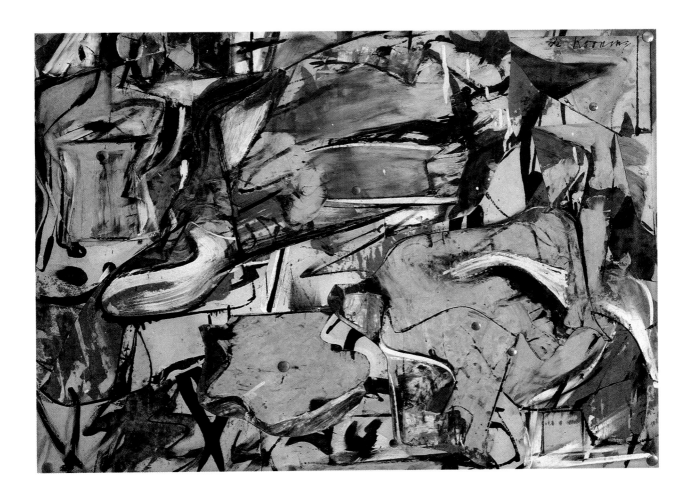

Night Square, ca. 1950
Oil on masonite, 30 × 40 in.
(David Anderson)

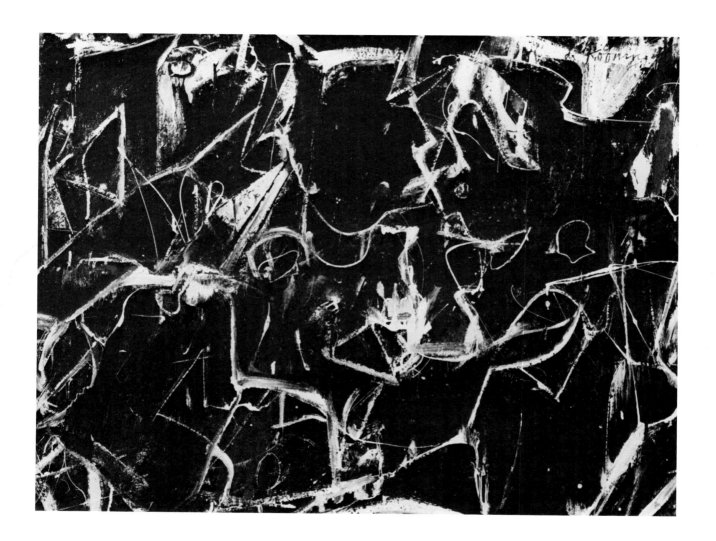

33 DE KOONING

Woman, ca. 1950
Oil on canvas, 64 × 46 in.
(Weatherspoon Art Gallery,
University of North Carolina at Greensboro,
Lena Kernodle McDuffie Memorial Gift, 1954)

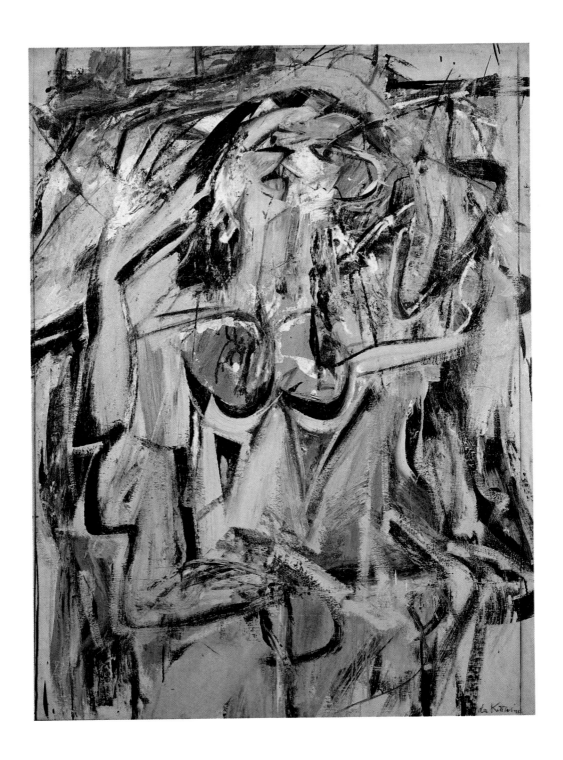

Study for "Woman," 1950
Oil and enamel on paper with collage, $14^5/8 \times 11^5/8$ in.
(Private Collection)

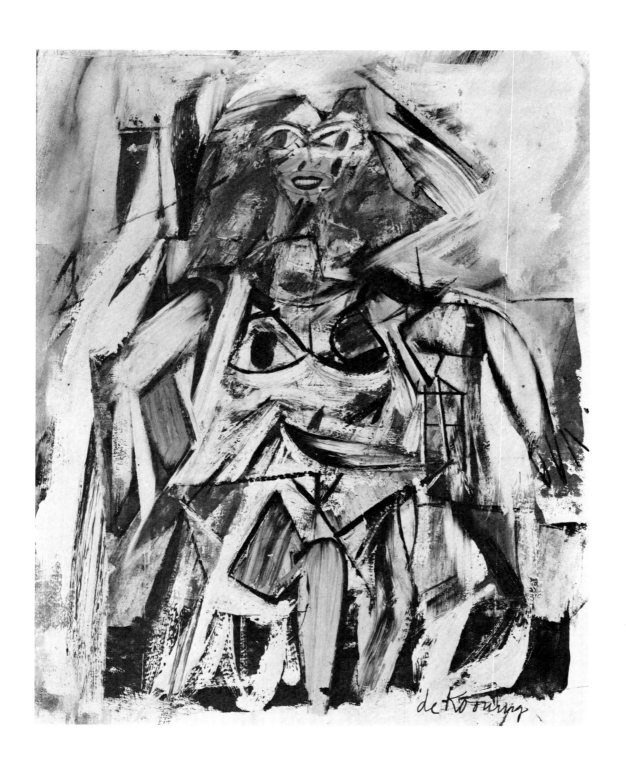

35 DE KOONING

Two Standing Women, 1949
Oil, enamel, and charcoal on paper,
mounted on composition board, 29¹/₂ × 26¹/₄ in.
(Mr. and Mrs. Irwin Green)

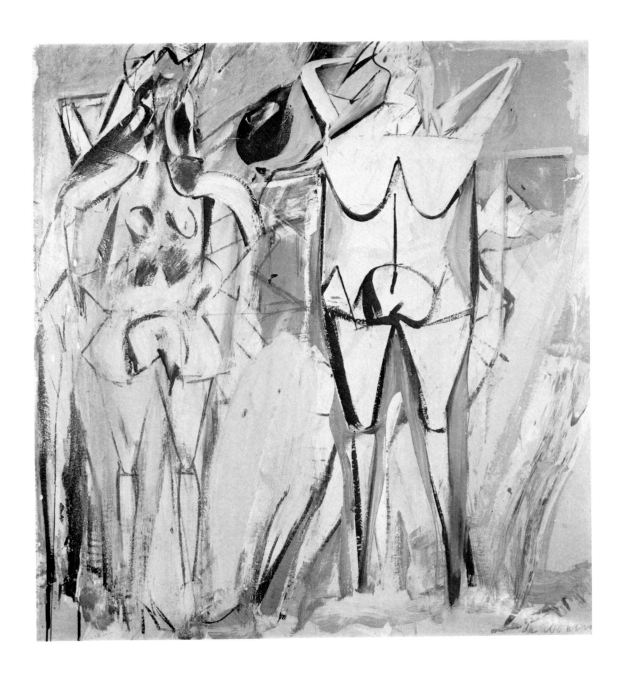

Boudoir, ca. 1950
Oil on composition board, 27¹/₂ × 33¹/₄ in.
(Nelson Gallery—Atkins Museum, Kansas City,
Nelson Fund)

Warehouse Mannequins, 1949
Oil and enamel on paper, mounted on cardboard,
24¹/₄ × 35⁵/₈ in.
(Mr. and Mrs. Bagley Wright)

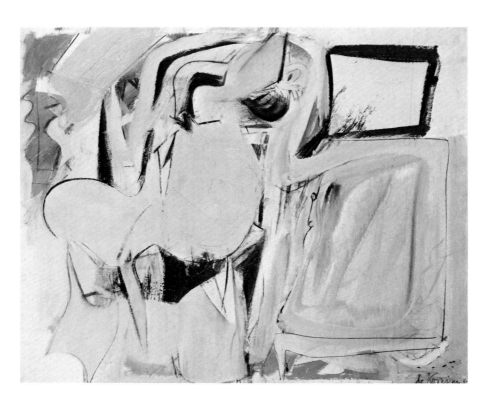

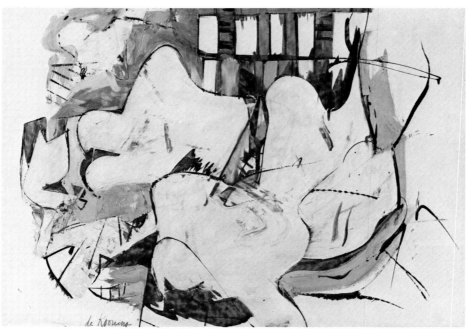

Women, ca. 1950
Oil
(Unlocated)

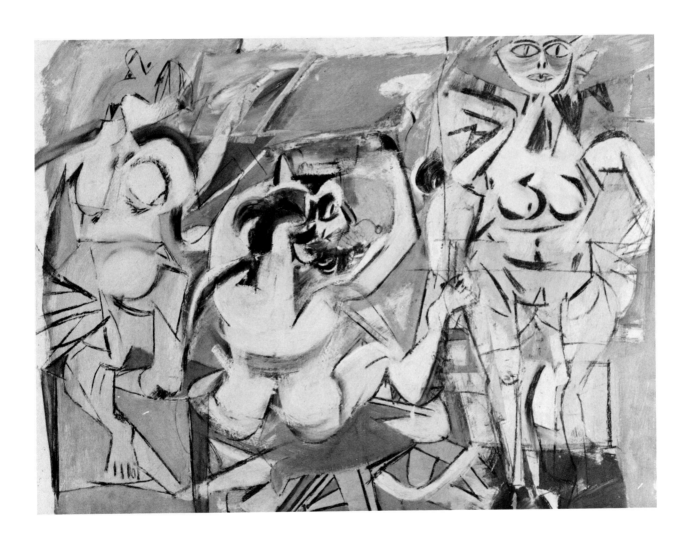

De Kooning at work on drawing preliminary
to *Woman I*, June 1950

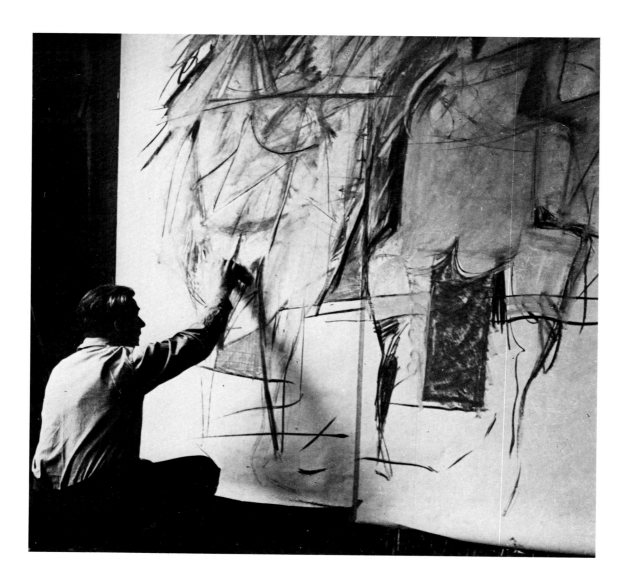

Phases in the development of *Woman I*

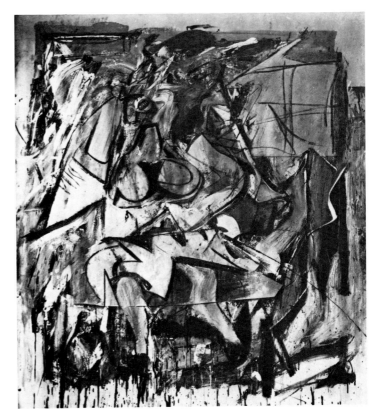

State I, 1950

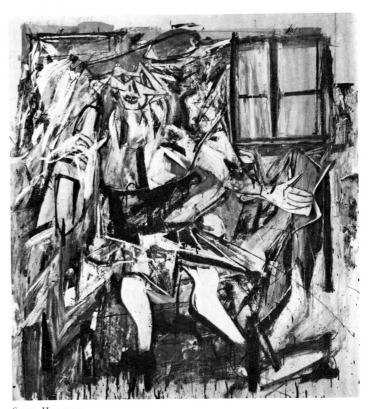

State II, 1950

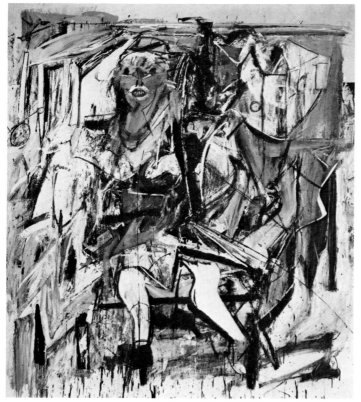

State III, 1951

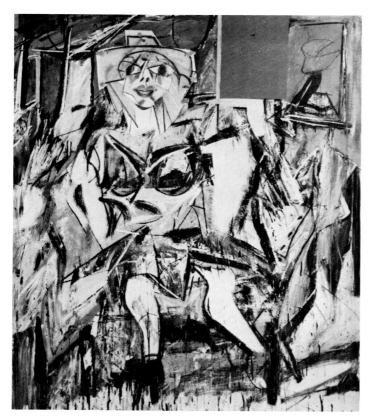

State IV, 1951

Phases in the development of *Woman I*

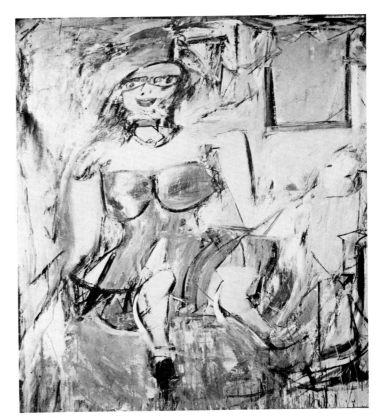

State V, 1951–1952

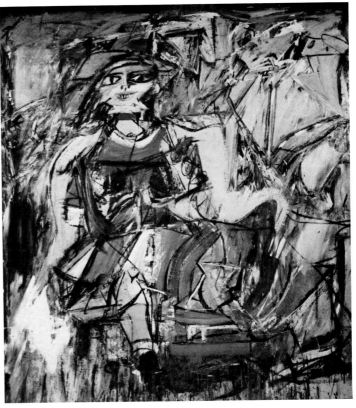

State VI, 1951–1952

41 DE KOONING

Woman I, 1950–1952
Oil on canvas, 75⁷/₈ × 58 in.
(The Museum of Modern Art, New York)

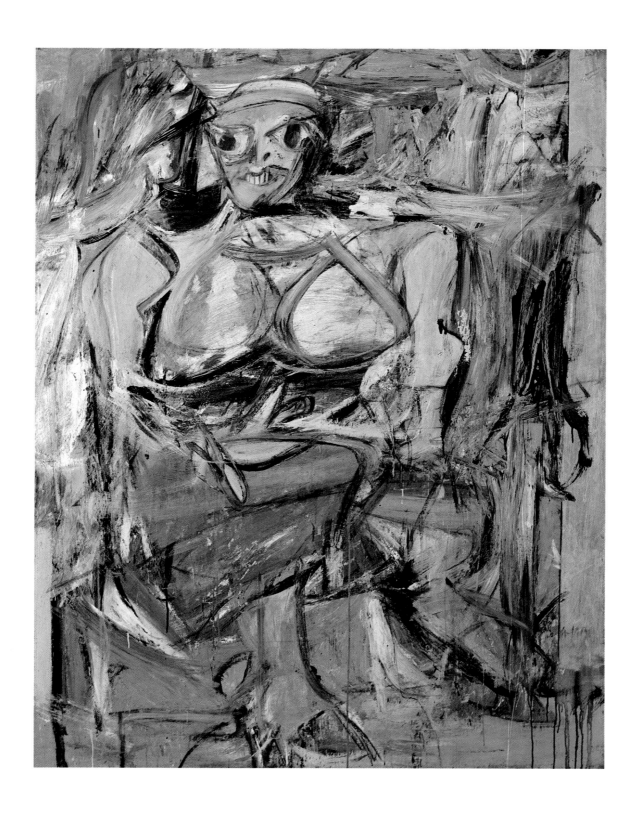

Woman II, 1952
Oil on canvas, 59 × 43 in.
(The Museum of Modern Art, New York,
Gift of Mrs. John D. Rockefeller, 3rd)

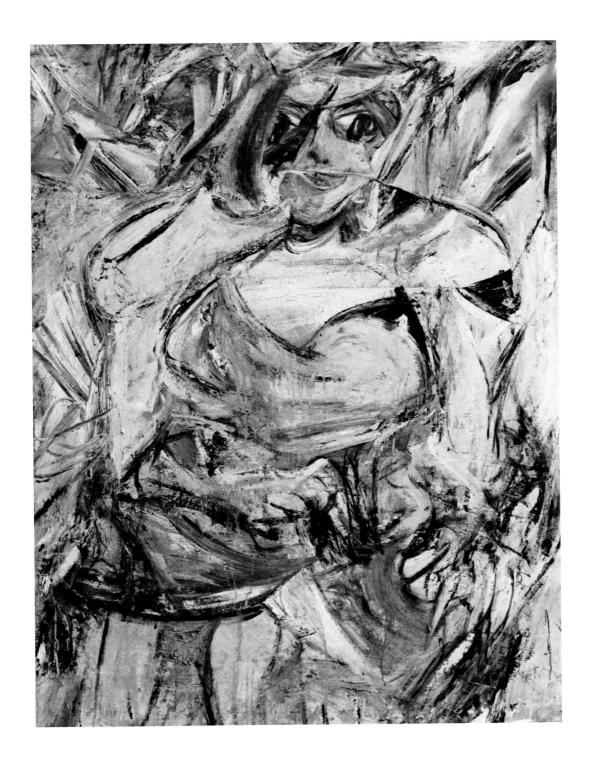

Woman III, 1952–1953
Oil on canvas, 67 × 48 in.
(Tehran Museum of Contemporary Art)

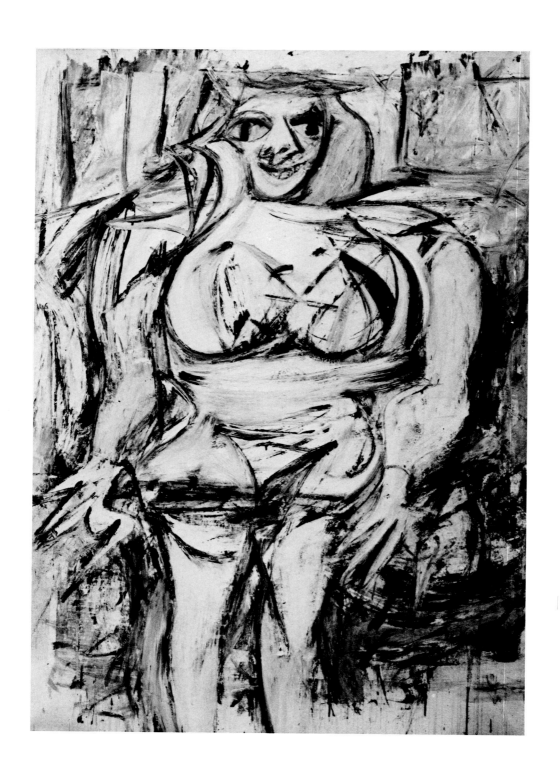

Arshile Gorky

Still Life with Skull, late 1920s
Oil on canvas, 33 × 26 in.
(Private Collection, Courtesy Xavier
Fourcade, Inc., New York)

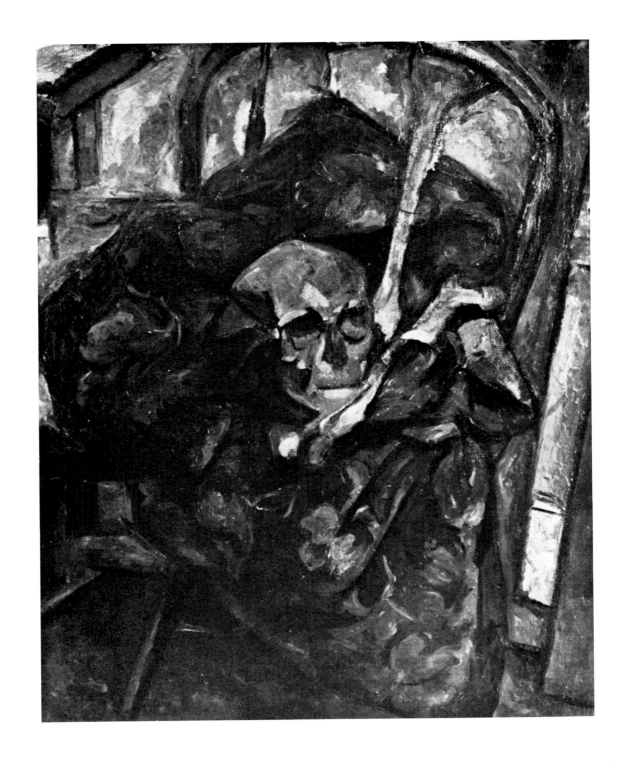

The Antique Cast, 1926
Oil on canvas, 36¹/₈ × 46 in.
(David McCulloch, California)

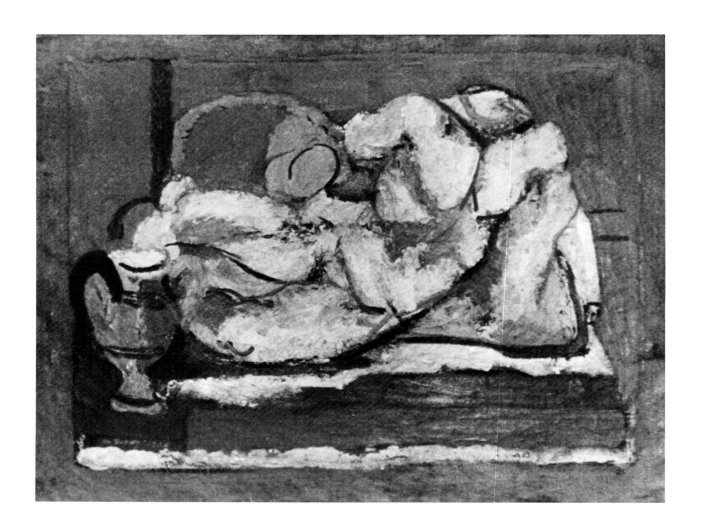

Composition: Horse and Figures, 1928
Oil on canvas, 34¼ × 43⅜ in.
(The Museum of Modern Art, New York,
Gift of Bernard Davis in memory of the artist)

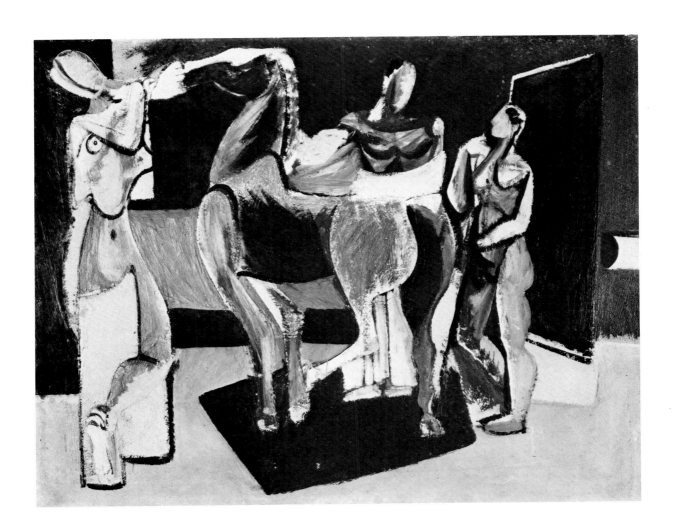

Still Life, 1929–1932
Oil on canvas, 42⁷/₈ × 60¹/₂ in.
(Private Collection, Courtesy Xavier
Fourcade, Inc., New York)

The Artist and His Mother, 1926–1936
Oil on canvas, 60 × 50 in.
(Whitney Museum of American Art, New York,
Gift of Julien Levy for Maro and Natasha Gorky
in memory of their father)

49 GORKY

Still Life with Palette, 1930
Oil on canvas, 28 × 36 in.
(Unlocated)

Abstraction with Palette, ca. 1930
Oil on canvas, 47¹/₂ × 35¹/₂ in.
(Philadelphia Museum of Art, Gift of Bernard Davis)

Study for "Image in Xhorkom," ca. 1932
Pencil, 18¹/₂ × 24³/₈ in.
(Private Collection, Courtesy Xavier
Fourcade, Inc., New York)

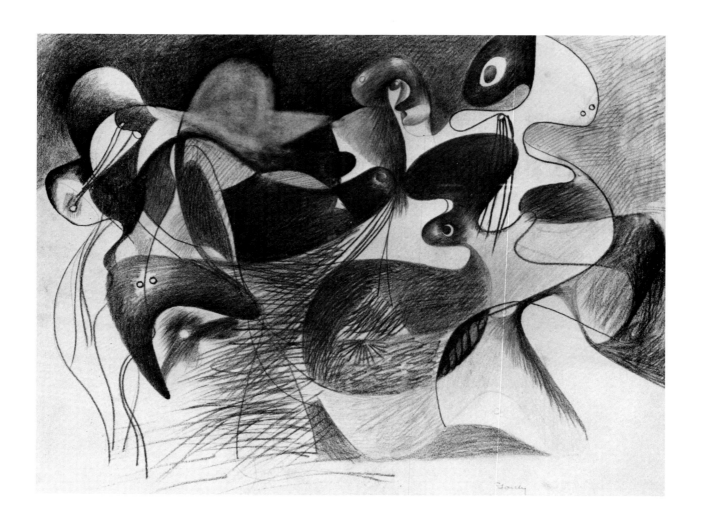

52 GORKY

Study for "Nighttime, Enigma, and Nostalgia,"
ca. 1931–1932
India ink, 12¾ × 21¾ in.
(Mr. and Mrs. Philip Gersh, Beverly Hills, California)

53 GORKY

Untitled, 1932
Pen and ink, 14⅞ × 21¼ in.
(Private Collection, Courtesy Xavier
Fourcade, Inc., New York)

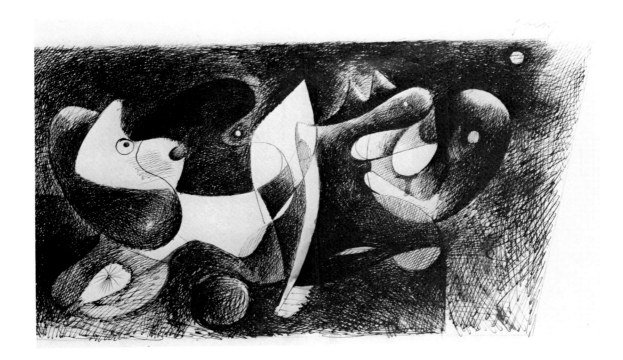

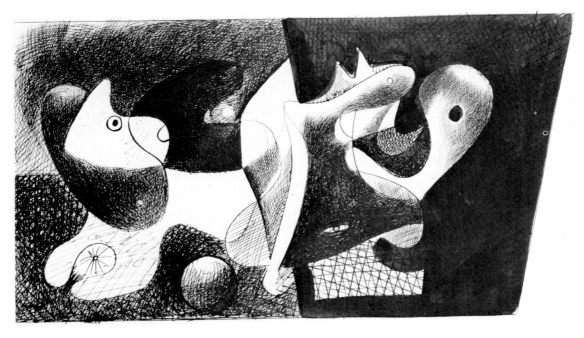

Drawing, ca. 1932
Ink, 21⅝ × 27¼ in.
(Private Collection, Courtesy Xavier
Fourcade, Inc., New York)

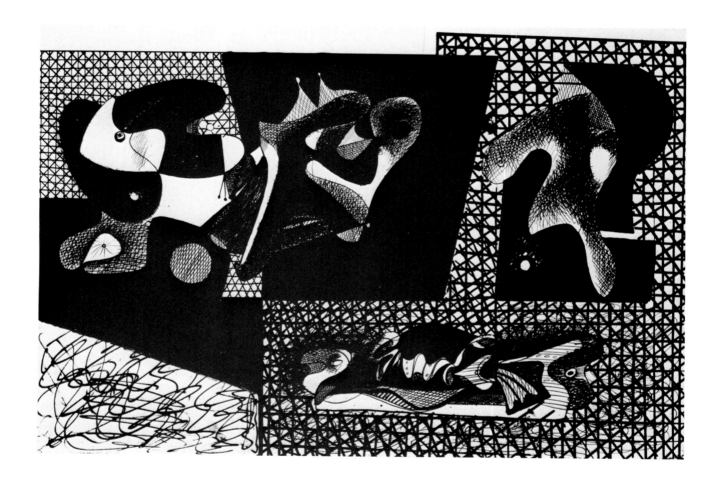

55 GORKY

Study for "Nighttime, Enigma, and Nostalgia," 1932
Pen and ink, 28¹/₂ × 38 in.
(Courtesy Sidney Janis Gallery, New York)

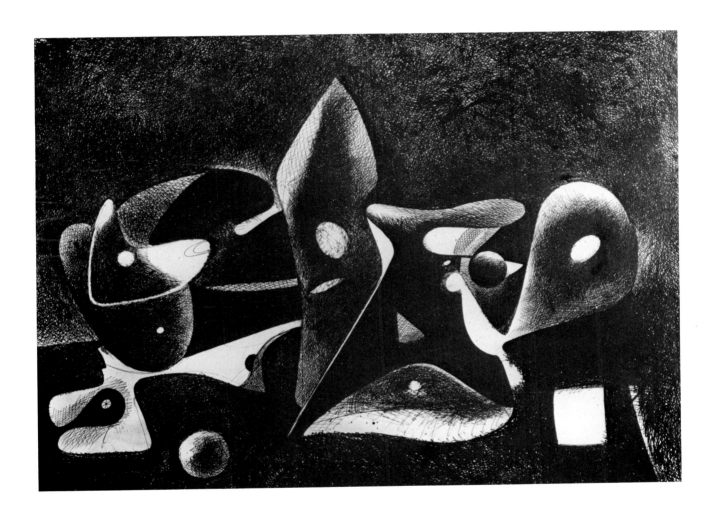

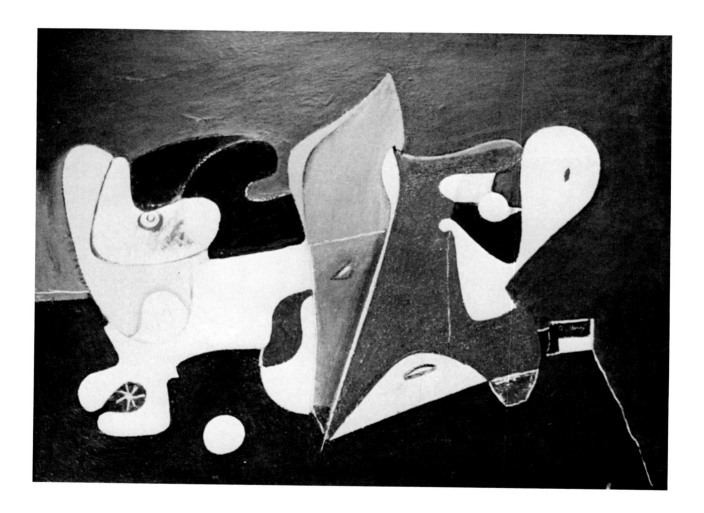

Nighttime, Enigma, and Nostalgia, 1933–1934
Oil on canvas, 36 × 48 in.
(Private Collection, Courtesy Xavier
Fourcade, Inc., New York)

Organization, ca. 1936
Oil on canvas, 50 × 60¹/₂ in.
(National Gallery of Art, Washington,
Ailsa Mellon Bruce Fund, 1979)

Composition with Head, ca. 1934–1936
Oil on canvas, 78 × 62¹/₄ in.
(Private Collection, Courtesy Xavier
Fourcade, Inc., New York)

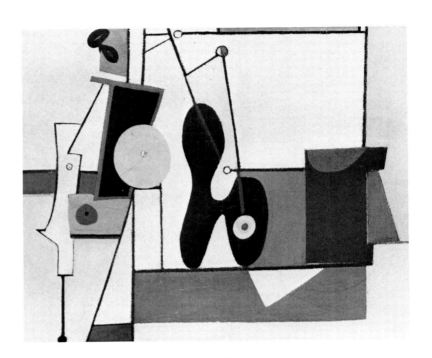

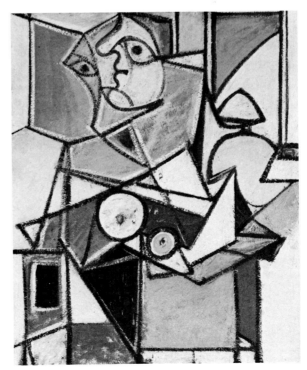

Image in Xhorkom, ca. 1934–1936
Oil on canvas, 33 × 43¹/₈ in.
(Private Collection, Courtesy Xavier
Fourcade, Inc., New York)

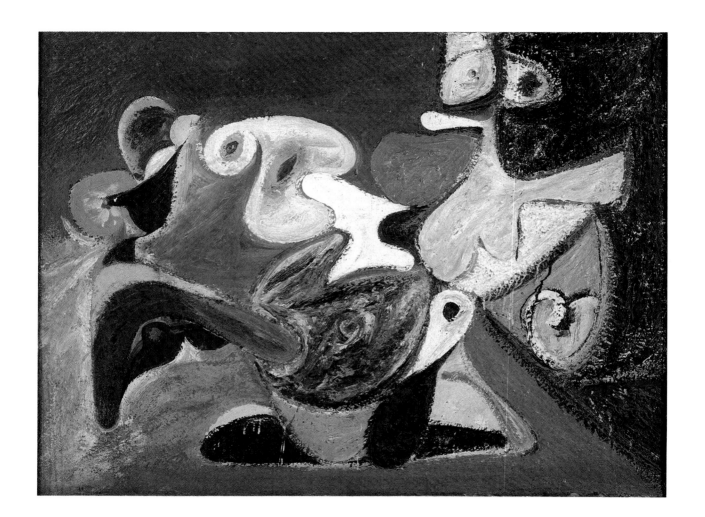

Image in Xhorkom, Summer, 1934–1936
Oil on canvas, 36 × 48 in.
(David Anderson)

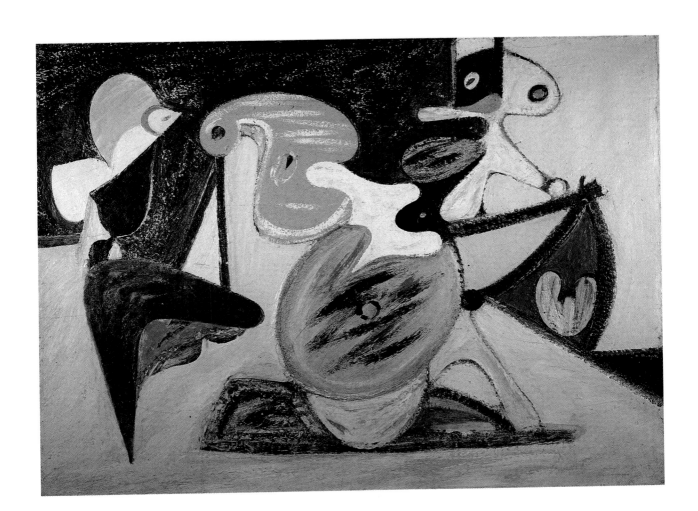

Enigmatic Combat, ca. 1936–1937
Oil on canvas, 35³/₄ × 48 in.
(San Francisco Museum of Modern Art,
Gift of Jeanne Reynal)

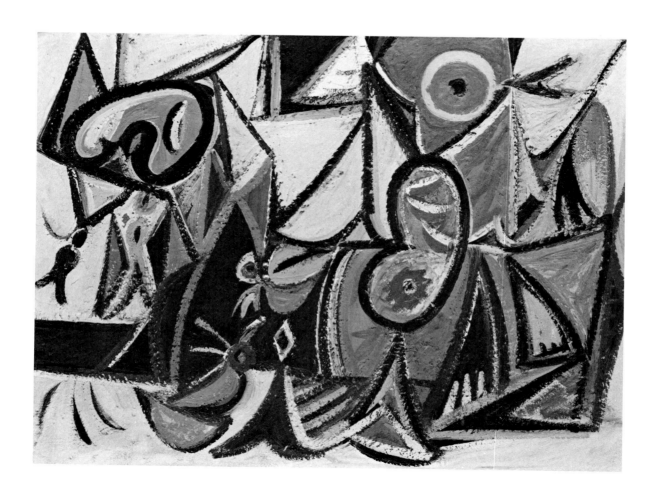

Portrait, ca. 1936–1938
Oil on canvas, 29¹/₂ × 23⁵/₈ in.
(Private Collection, Courtesy Xavier
Fourcade, Inc., New York)

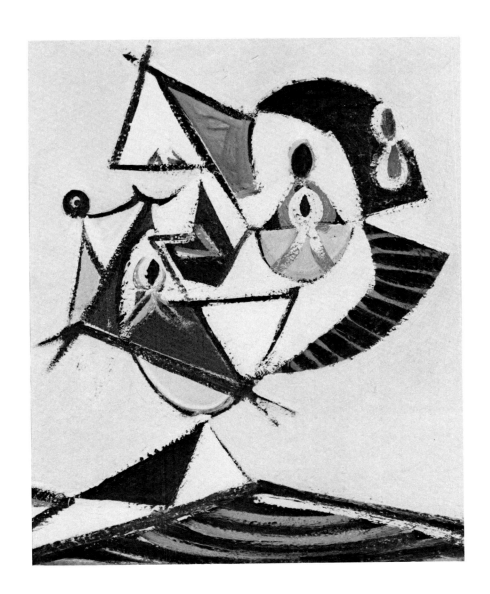

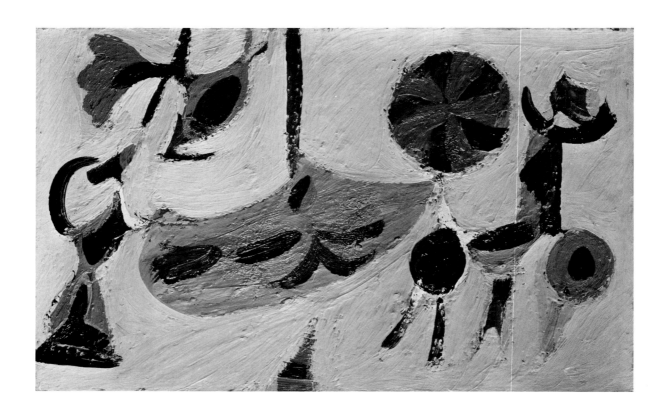

63 GORKY

Argula, 1938
Oil on canvas, 15 × 24 in.
(The Museum of Modern Art, New York,
Gift of Bernard Davis)

Garden in Sochi, 1941
Oil on canvas, 44¼ × 62¼ in.
(The Museum of Modern Art, New York, Purchase Fund
and Gift of Mr. and Mrs. Wolfgang S. Schwabacher)

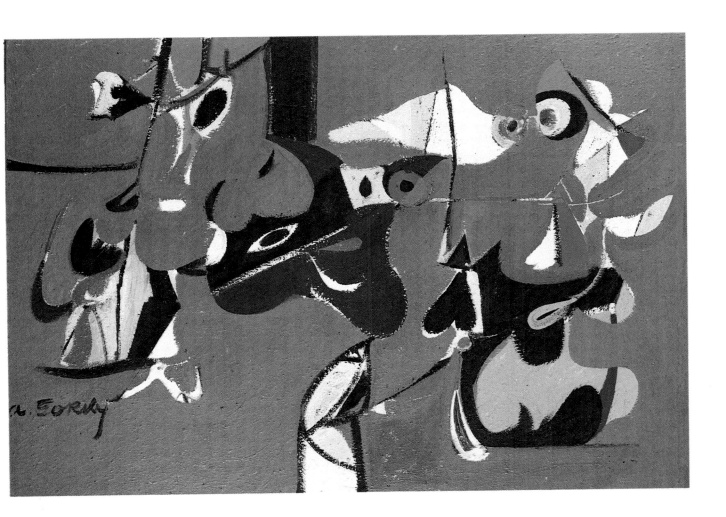

65 GORKY

Sketch for Ben Marden's Riviera Murals, 1941
Gouache on cardboard, 13 × 18¹⁵/₁₆ in.
(Louis Allen Abramson, New York)

66 GORKY

Sketch for Ben Marden's Riviera Murals, 1941
Gouache on cardboard, 13 × 19¹/₁₆ in.
(Louis Allen Abramson, New York)

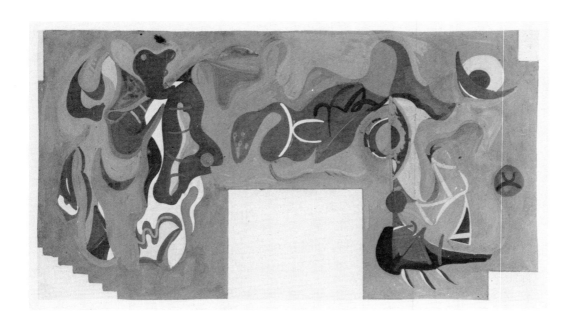

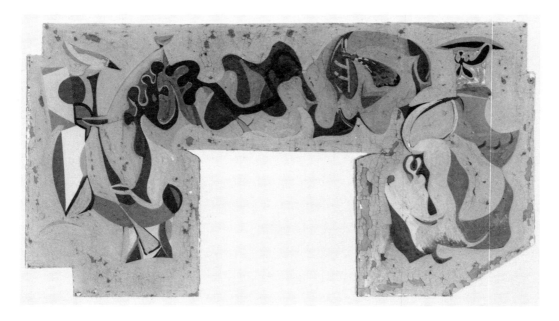

67 GORKY

Waterfall, ca. 1943
Oil on canvas, 60½ × 44½ in.
(The Trustees of the Tate Gallery, London)

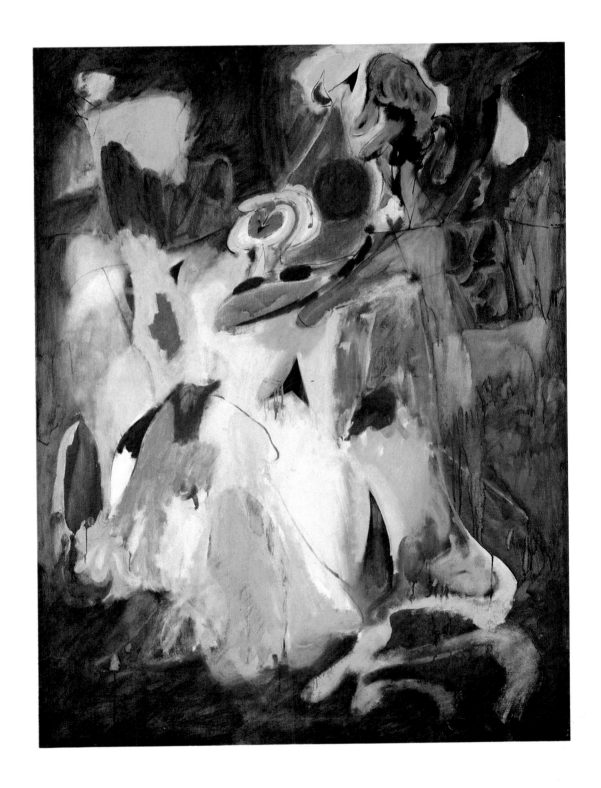

Anatomical Blackboard, 1943
Pencil and wax crayon, 20¼ × 27⅜ in.
(Mr. and Mrs. Walter Bareiss)

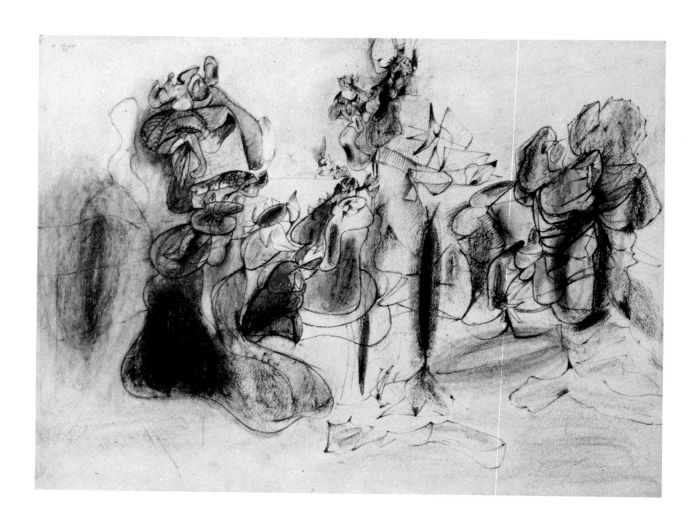

Study for "The Liver is the Cock's Comb," 1943
Pencil, ink, and crayon on paper, 19 × 25¹/₂ in.
(The Weisman Family Collection)

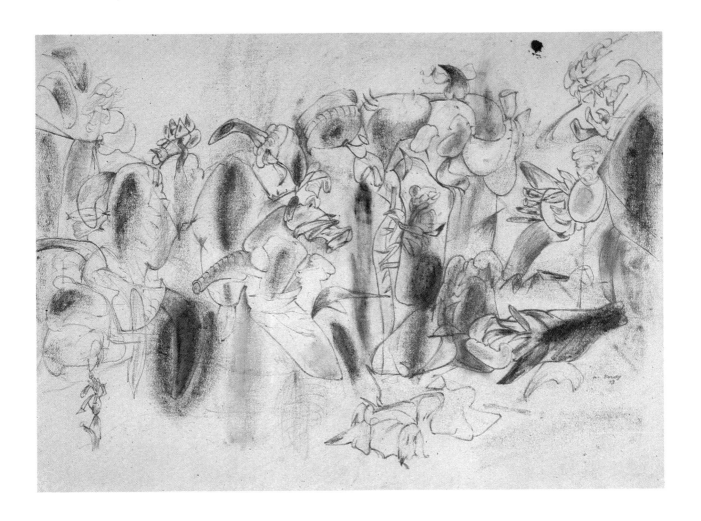

The Liver is the Cock's Comb, 1944
Oil on canvas, 72 × 98 in.
(Albright-Knox Art Gallery, Buffalo, New York,
Gift of Seymour H. Knox)

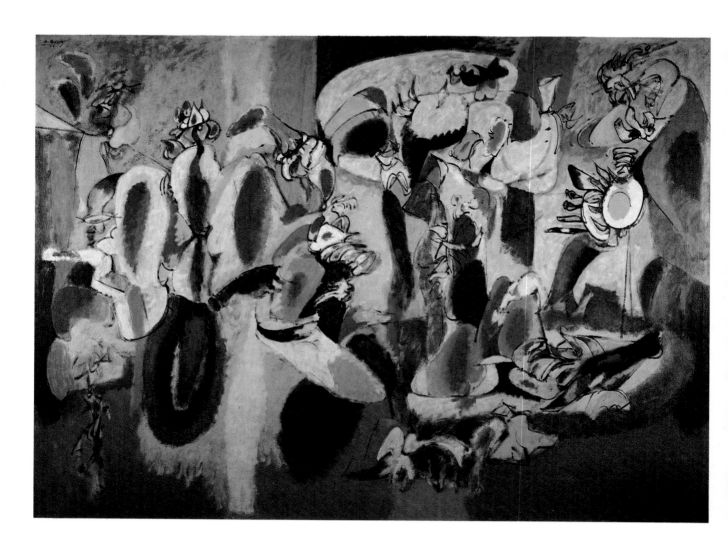

*How My Mother's Embroidered Apron Unfolds
in My Life,* 1944
Oil on canvas, 40 × 45 in.
(Seattle Art Museum,
Gift of Mr. and Mrs. Bagley Wright)

Study for "Good Afternoon, Mrs. Lincoln," 1944
Pencil and crayon on paper, 20 × 26⅛ in.
(Unlocated)

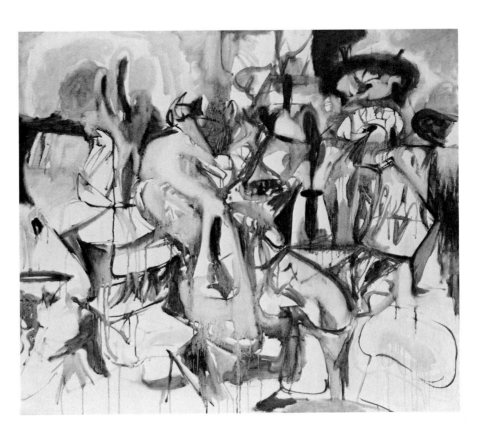

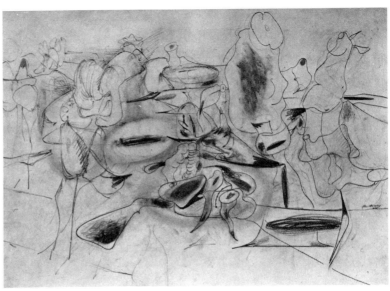

The Leaf of the Artichoke Is an Owl, 1944
Oil on canvas, 28 × 35 7/8 in.
(The Museum of Modern Art, New York,
Fractional Gift of Sidney Janis)

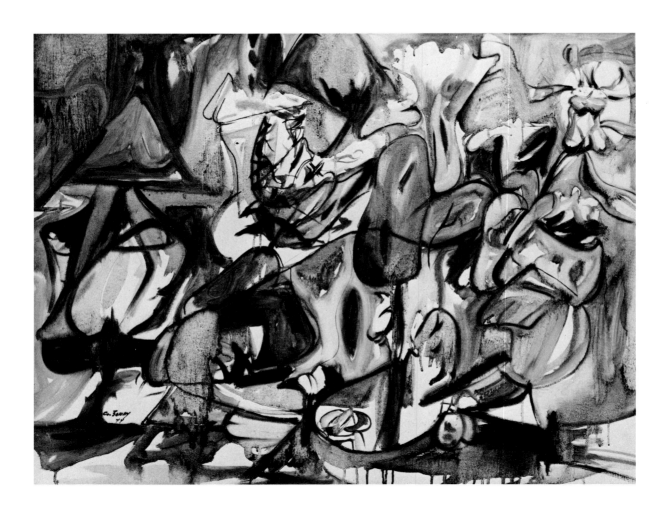

Landscape Table, 1945
Oil on canvas, 36 × 48 in.
(Musée National d'Art Moderne, Centre National
d'Art et de Culture Georges Pompidou, Paris)

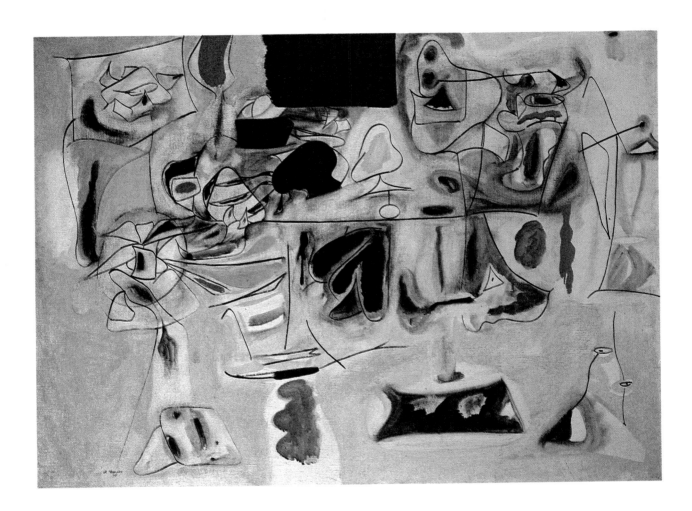

75 GORKY

Diary of a Seducer, 1945
Oil on canvas, 50 × 62 in.
(Mr. and Mrs. William A. M. Burden, New York)

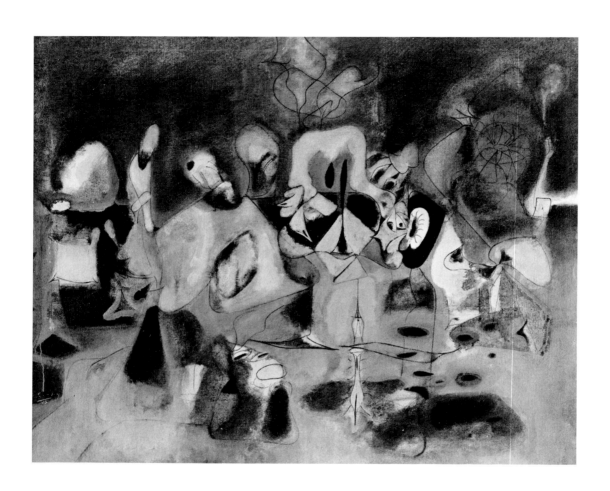

The Unattainable, 1945
Oil on canvas, 41 1/8 × 29 1/4 in.
(The Baltimore Museum of Art)

Untitled, ca. 1946
Pencil, pen and ink, and crayon on paper,
19 1/8 × 24 3/4 in.
(Unlocated)

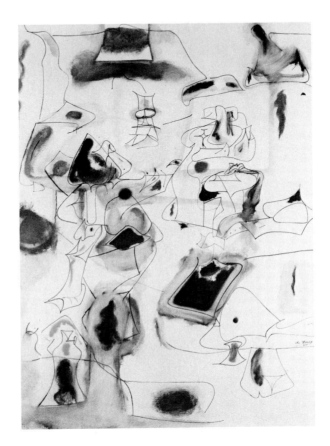

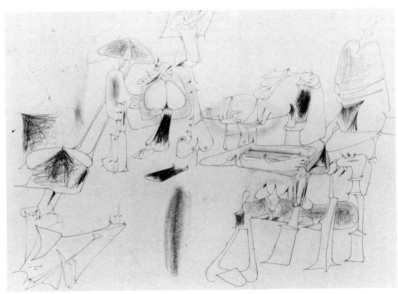

Charred Beloved II, 1946
Oil on canvas, 53 15/16 × 40 in.
(The National Gallery of Canada, Ottawa)

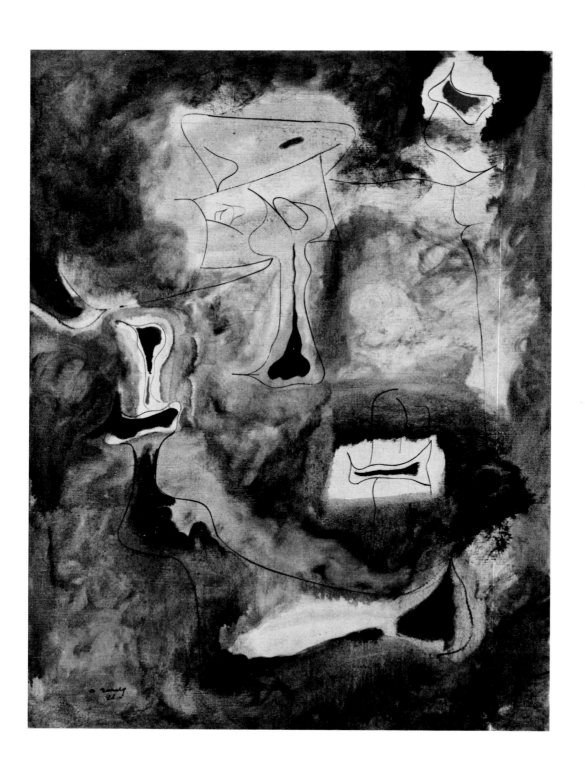

79 GORKY

The Calendars, 1946–1947
Oil on canvas, 50 × 60 in.
(Destroyed)

80 GORKY

The Limit, 1947
Oil on paper over burlap, 50³/₄ × 62¹/₂ in.
(Private Collection, Courtesy Xavier
Fourcade, Inc., New York)

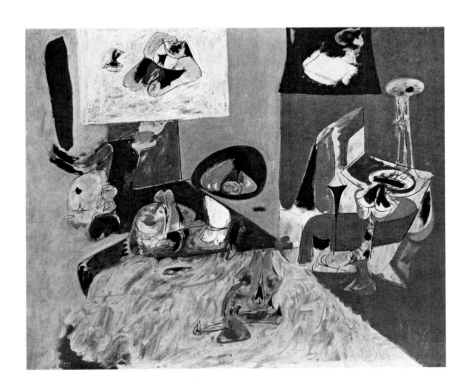

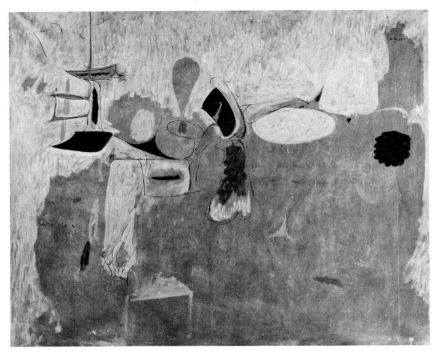

81 GORKY

The Betrothal I, 1947
Oil on canvas, mounted on composition board,
50⁷/₈ × 49⁷/₈ in.
(Mrs. Taft Schreiber)

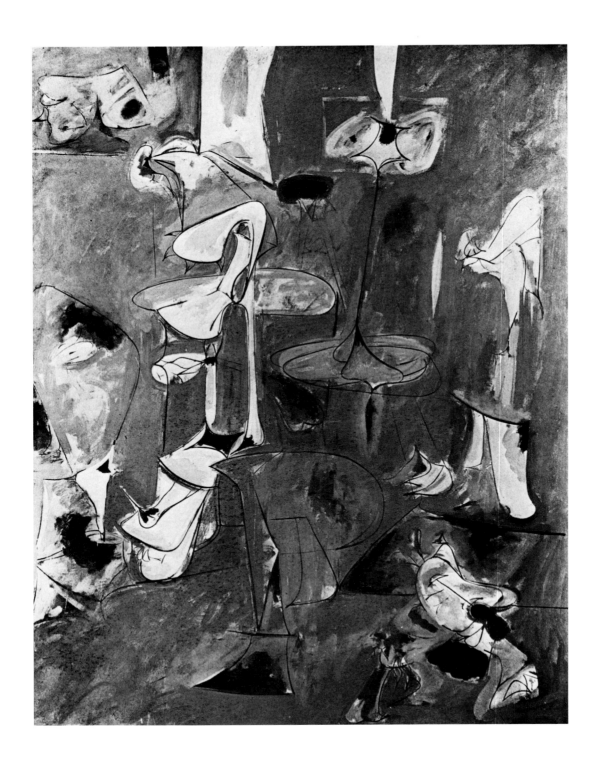

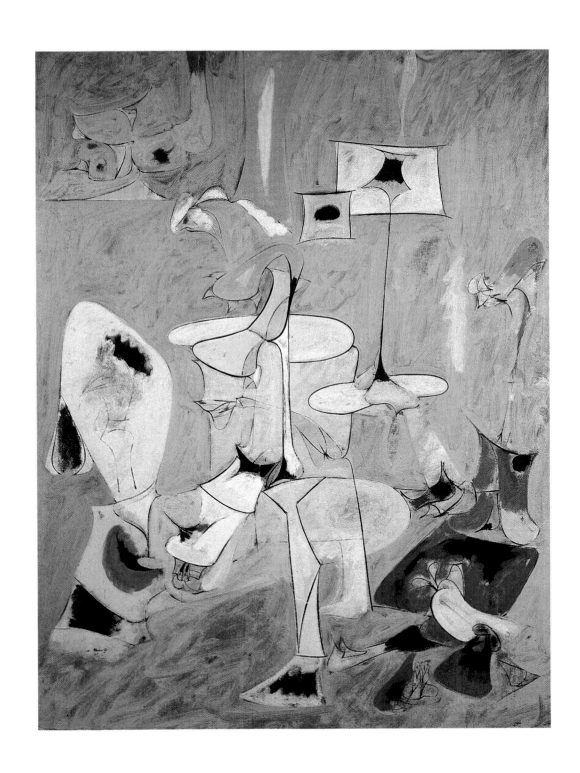

The Betrothal II, 1947
Oil on canvas, 50³/₄ × 38 in.
(Whitney Museum of American Art, New York)

Study for "The Plow and the Song," ca. 1946
Pencil and crayon, 20 × 25 in.
(Fogg Art Museum, Harvard University, Cambridge,
Anonymous Loan)

Study for "The Plow and the Song," 1946
Pencil, charcoal, crayon, pastel, and oil on paper,
47⁷⁄₈ × 59³⁄₈ in.
(National Gallery of Art, Washington, Avalon Fund,
1971)

85 GORKY

The Plow and the Song, 1947
Oil on burlap, 52⅛ × 64⅛ in.
(Milton A. Gordon)

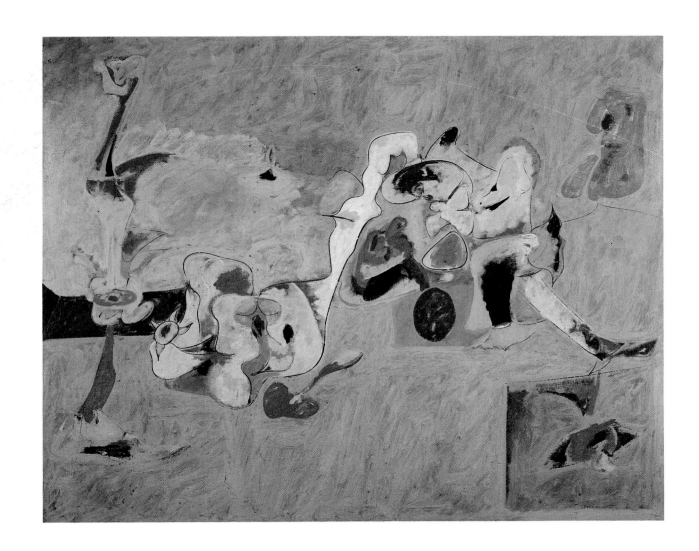

The Plow and the Song II, ca. 1946
Oil on canvas, 51⁷/₈ × 61³/₈ in.
(The Art Institute of Chicago,
Mr. and Mrs. Lewis Larned Coburn Fund)

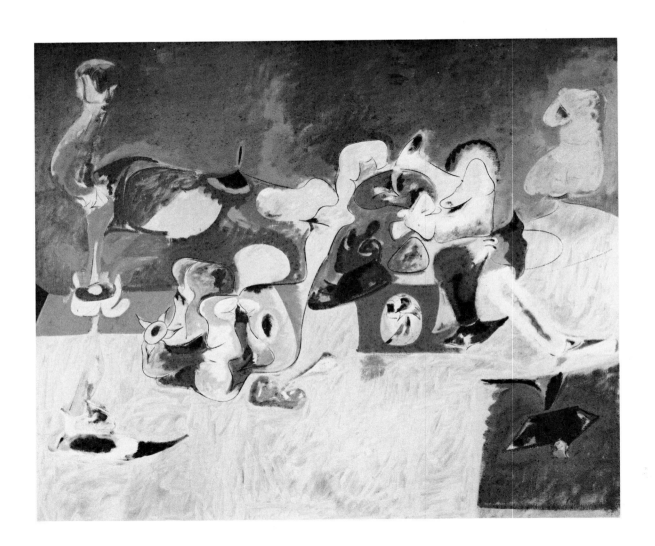

The Plow and the Song, 1947
Oil on canvas, 50¾ × 62¾ in.
(Allen Memorial Art Museum, Oberlin College, Ohio,
R. T. Miller, Jr., Fund)

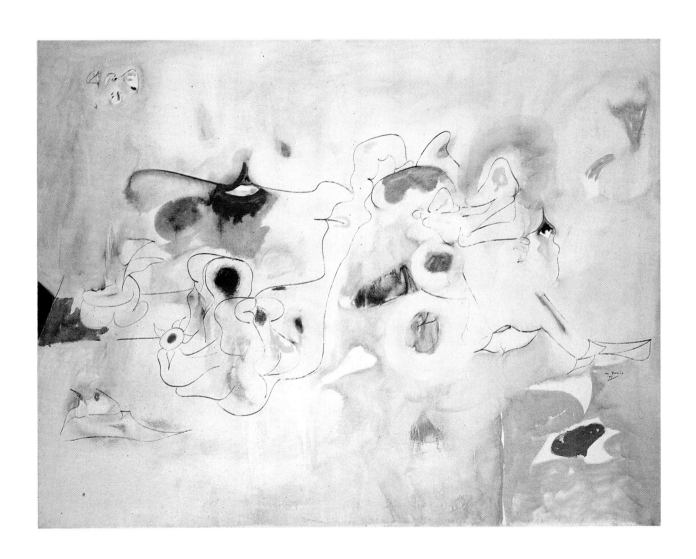

88A GORKY

Agony, 1947
Oil on canvas, 40 × 50¹/₂ in.
(The Museum of Modern Art, New York,
A. Conger Goodyear Fund)

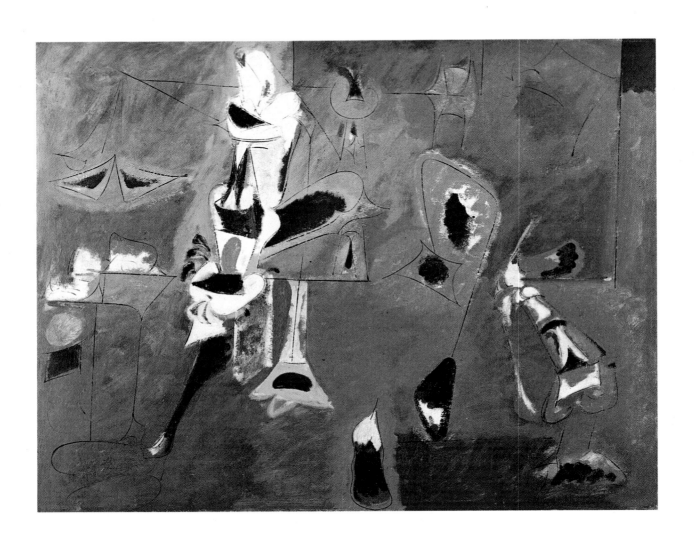

Study for "Agony," 1947
Oil on canvas, 36 × 48 in.
(Private Collection, Courtesy Xavier
Fourcade, Inc., New York)

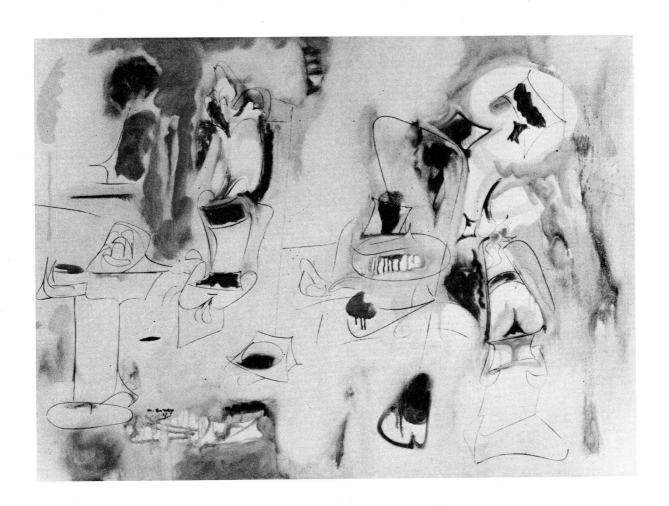

89 GORKY

Soft Night, 1947
Oil on canvas, 37⅞ × 50 in.
(Estate of Joseph H. Hirshhorn)

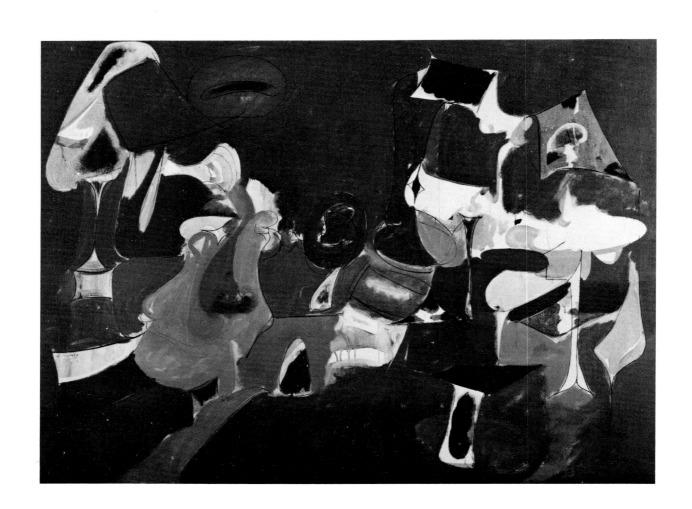

90 GORKY

The Orators, 1947
Oil on canvas, 61 × 73 in.
(Private Collection)

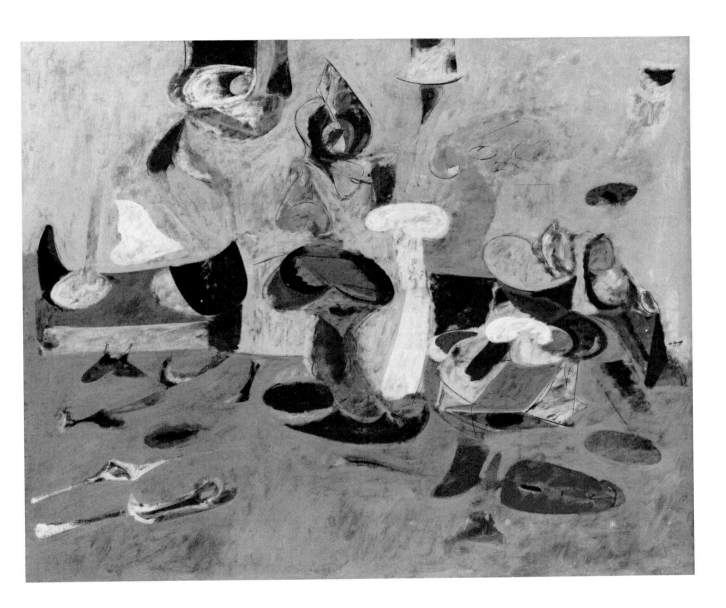

Dark Green Painting, ca. 1948
Oil on canvas, $43^{7}/_{8} \times 55^{7}/_{8}$ in.
(Mr. and Mrs. H. Gates Lloyd)

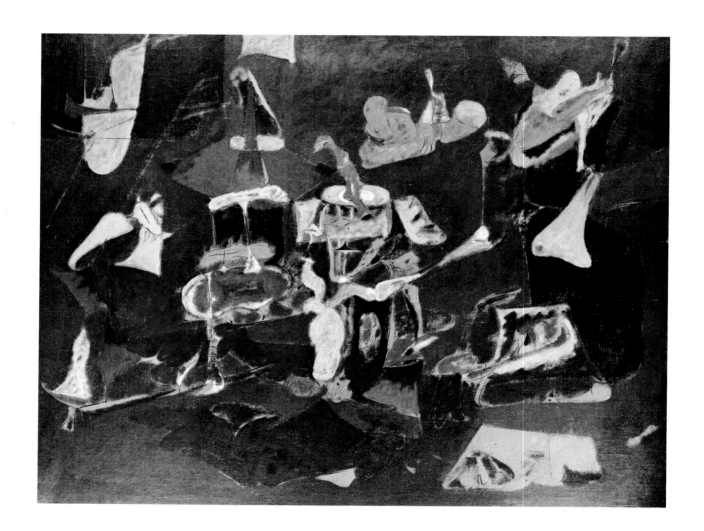

92 GORKY

Last Painting, 1948
Oil on canvas, 31 × 40 in.
(The Thyssen-Bornemisza Collection,
Lugano, Switzerland)

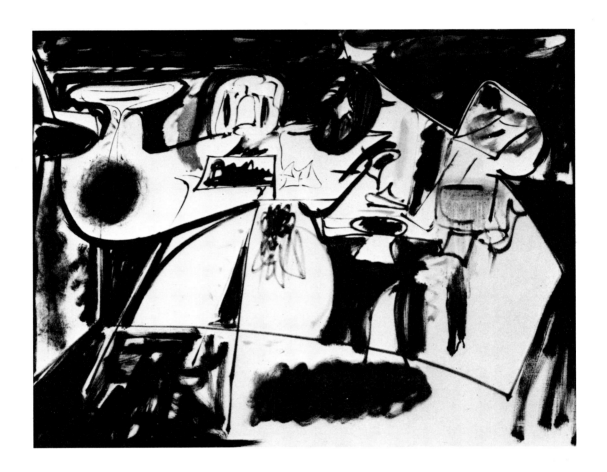

Hans Hofmann

93 HOFMANN

Self Portrait, ca. 1902
Oil on composition board, $16^5/_8 \times 20$ in.
(Courtesy André Emmerich Gallery, New York)

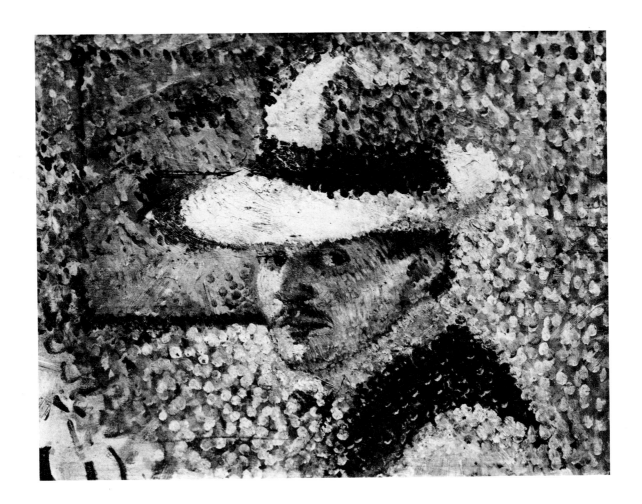

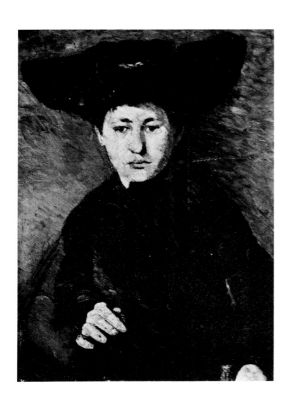

94 HOFMANN

Portrait of Maria (Miz) Hofmann, ca. 1901
Oil, $27^{1}/_{8} \times 19^{1}/_{8}$ in.
(Courtesy André Emmerich Gallery, New York)

95 HOFMANN

Ceiling Design, 1914
Pencil and watercolor on paper,
$8^{5}/_{16} \times 10^{1}/_{2}$ in.
(Hans Hofmann Estate, courtesy
André Emmerich Gallery, New York)

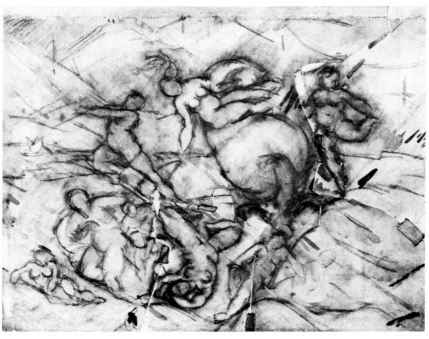

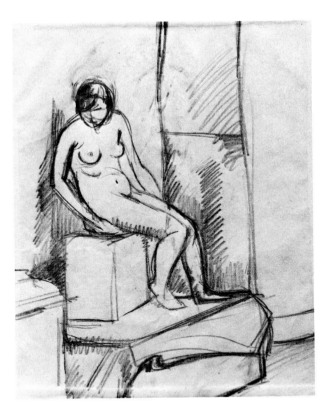

96A HOFMANN

Student Drawing, 1898
Pencil on paper, 10⁵/₈ × 8³/₄ in.
(Hans Hofmann Estate, courtesy
André Emmerich Gallery, New York)

96B HOFMANN

Student Drawing, 1898
Pencil on paper, 11¹/₂ × 8 in.
(Hans Hofmann Estate, courtesy
André Emmerich Gallery, New York)

96C HOFMANN

Student Drawing, 1898
Pencil on paper, 11¹/₂ × 8 in.
(Hans Hofmann Estate, courtesy
André Emmerich Gallery, New York)

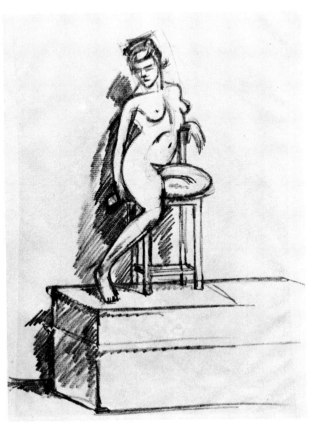

Green Bottle, 1921
Oil, 16⅝ × 22⅞ in.
(William H. Lane Foundation)

Apples, 1931
Oil, 25 × 30 in.
(Mrs. Frederick Kiesler)

Student with Spectacles, 1926
Pen and ink on paper, 13³/₄ × 11¹/₁₆ in.
(Hans Hofmann Estate, courtesy
André Emmerich Gallery, New York)

Still Life, Pink Table, 1936
Oil on plywood, 58 × 44½ in.
(Unlocated)

Green Table, 1937
Casein on board, 60 × 48 in.
(World Headquarters, The Bendix Corporation,
Southfield, Michigan)

Little Blue Interior, 1937–1938
Casein on plywood, 41¾ × 35½ in.
(Unlocated)

Still Life, Magic Mirror, 1939
Casein, 50¼ × 35¼ in.
(Unlocated)

Figure, 1940
Oil on composition board, 36 × 30 in.
(Unlocated)

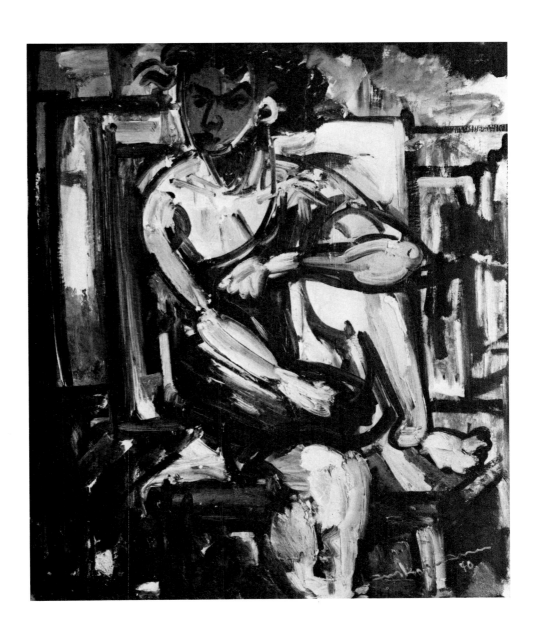

Wharves (*Provincetown*), 1941
Wax crayon and ink on paper, 14 × 17 in.
(Unlocated)

Provincetown Harbor, 1941
Wax crayon and ink on paper, 11 × 14 in.
(Unlocated)

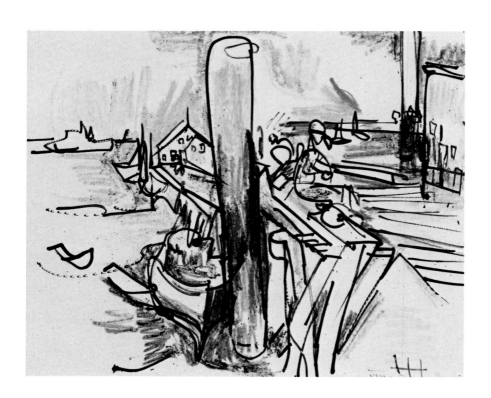

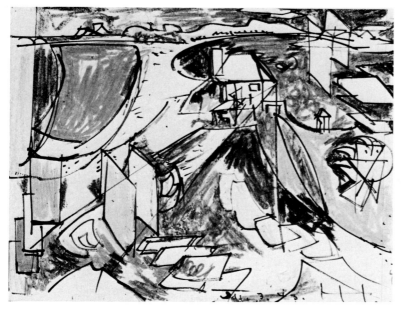

Interior in Blue and Red, 1941
Oil, 44⅝ × 58¾ in.
(Unlocated)

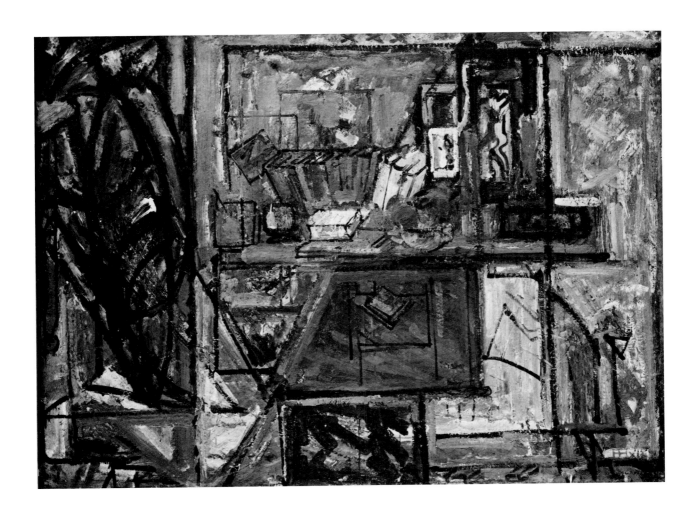

Yellow Sun, 1943
Oil on board, 23½ × 29½ in.
(Private Collection)

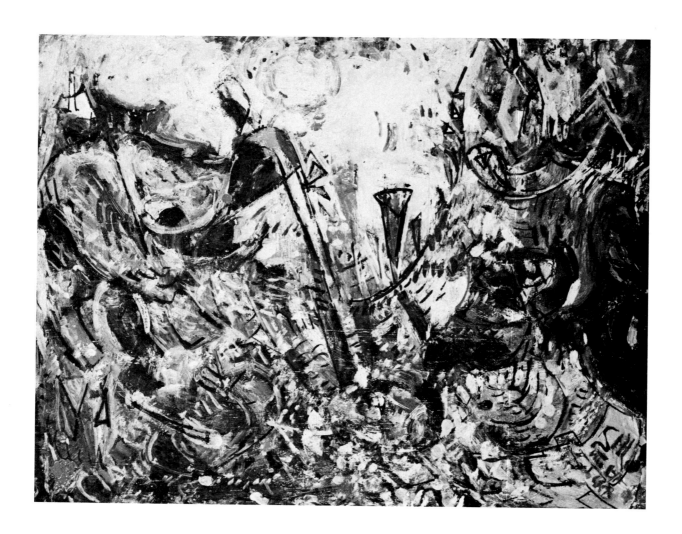

109 HOFMANN

House on a Hill, 1941
Wax crayon and ink on paper, 14 × 17 in.
(Unlocated)

110 HOFMANN

Dunes and Sky, 1943
Watercolor on paper, 17½ × 24 in.
(Unlocated)

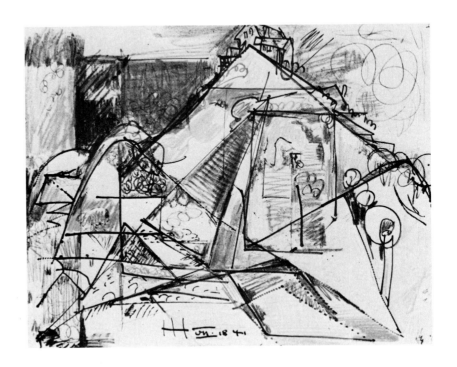

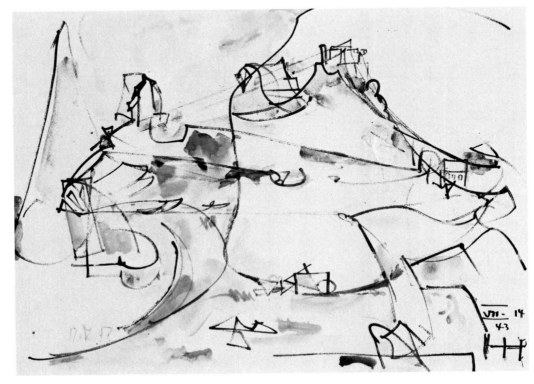

Idolatress I, 1944
Oil and aqueous media on upsom board,
60⅛ × 40⅛ in.
(University Art Museum, University of California,
Berkeley)

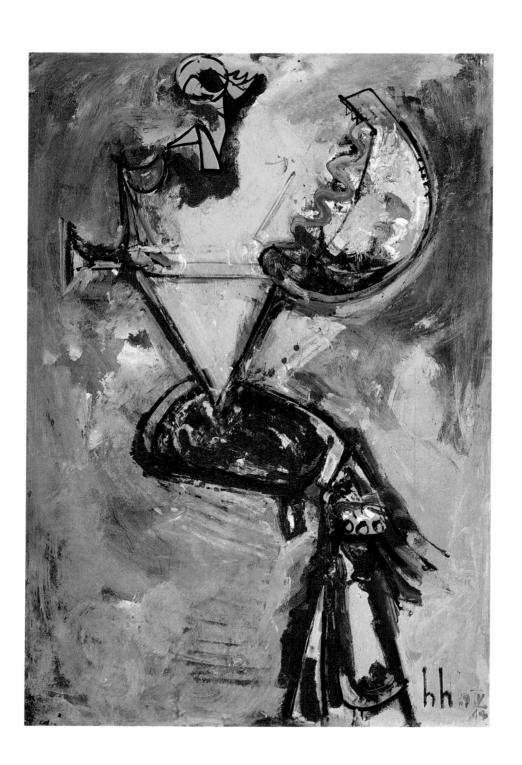

The King, 1944
Oil on composition board, 48 × 43 1/2 in.
(Unlocated)

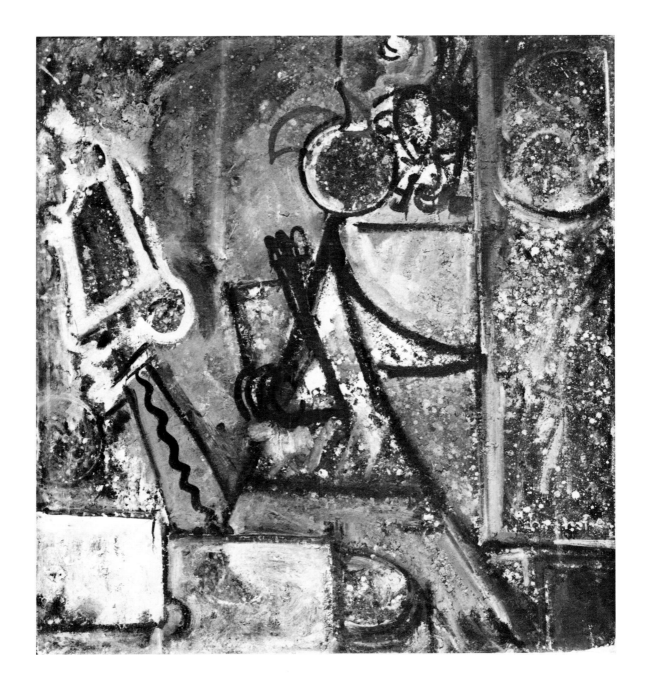

Ambush, 1944
Oil on paper, 24 × 19 in.
(The Museum of Modern Art, New York)

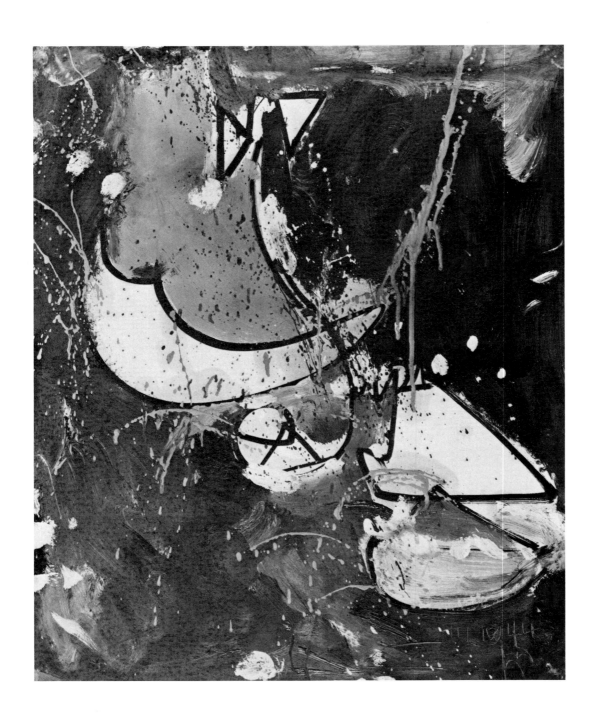

Aggressive, 1944
Oil, 30¾ × 41⅛ in.
(Hans Hofmann Estate, courtesy
André Emmerich Gallery, New York)

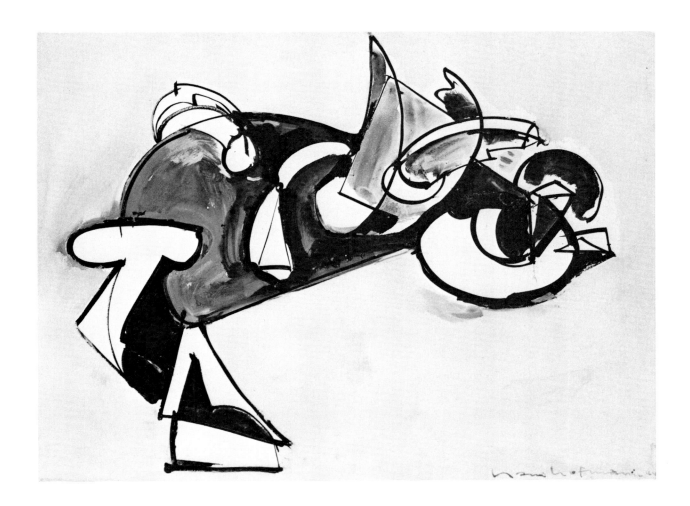

Fairy Tale, 1944
Oil on wood, 60 × 36 in.
(Courtesy André Emmerich Gallery, New York)

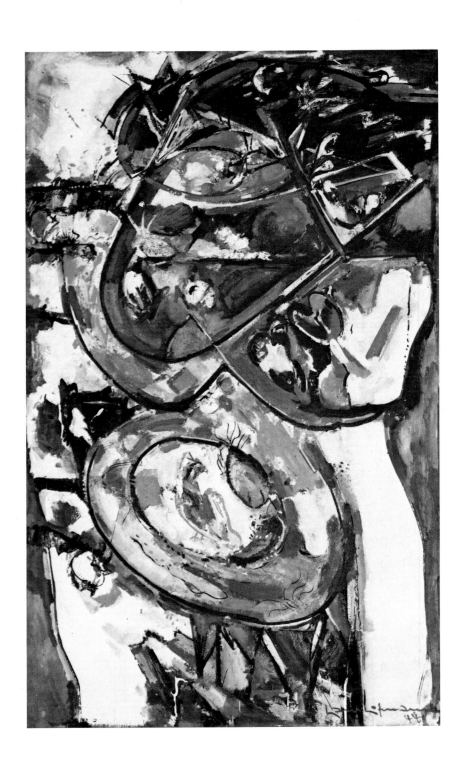

Seated Woman, 1944
Oil on plywood, 61 × 47 in.
(Unlocated)

Drawing, 1945
Ink on paper, 41 × 30½ in.
(Unlocated)

118 HOFMANN

Fantasia, 1943
Oil, duco, and casein on plywood, $51\,^{1}/_{2} \times 36^{5}/_{8}$ in.
(University Art Museum, University of California,
Berkeley, Gift of the artist)

Cataclysm, 1945
Watercolor on gesso on paperboard, 51³/₄ × 48 in.
(Courtesy André Emmerich Gallery, New York)

Bacchanale, 1946
Oil on board, 64 × 48 in.
(Courtesy André Emmerich Gallery, New York)

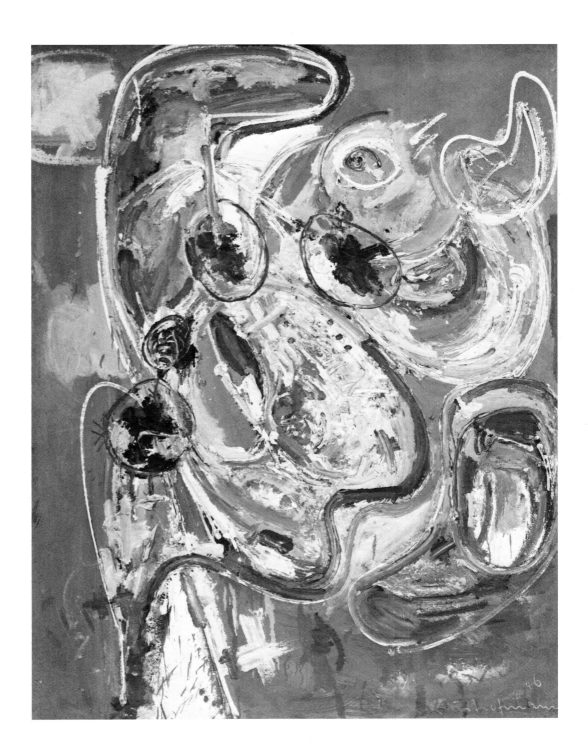

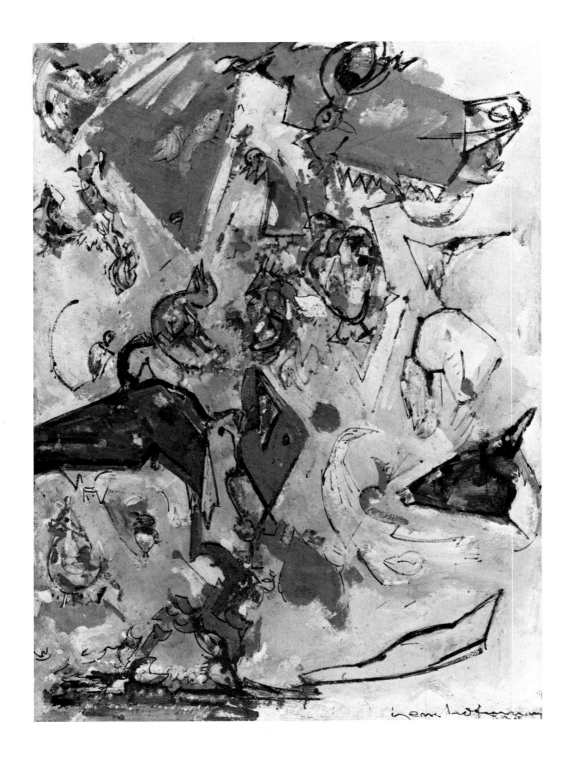

The Circus, 1945
Oil on wood, 55 × 40 in.
(Courtesy André Emmerich Gallery, New York)

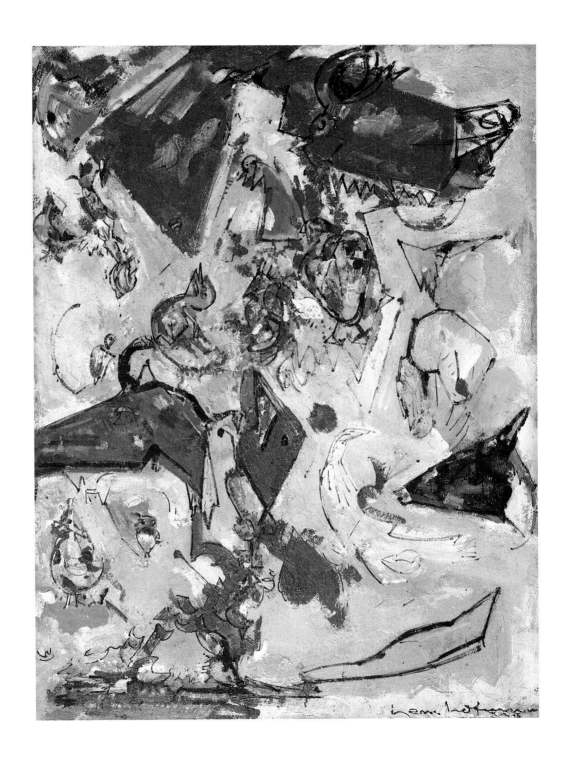

Submerged, 1947
Oil on canvas, 60 × 68 in.
(Sylvia G. Zell, Florida)

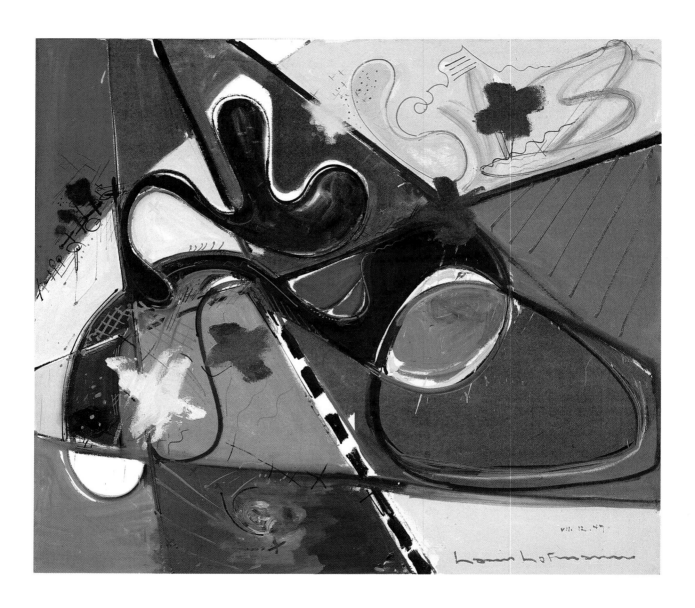

123 HOFMANN

Palimpsest, 1947
Oil on board, 39½ × 59½ in.
(Courtesy André Emmerich Gallery, New York)

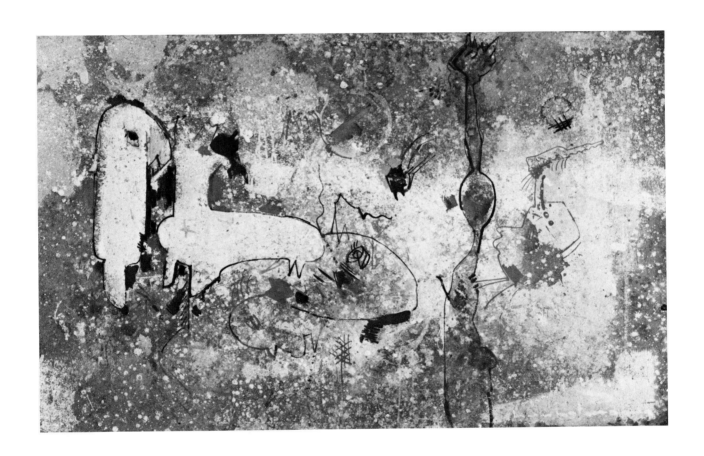

Awakening, 1947
Oil, 60 × 40 in.
(Courtesy André Emmerich Gallery, New York)

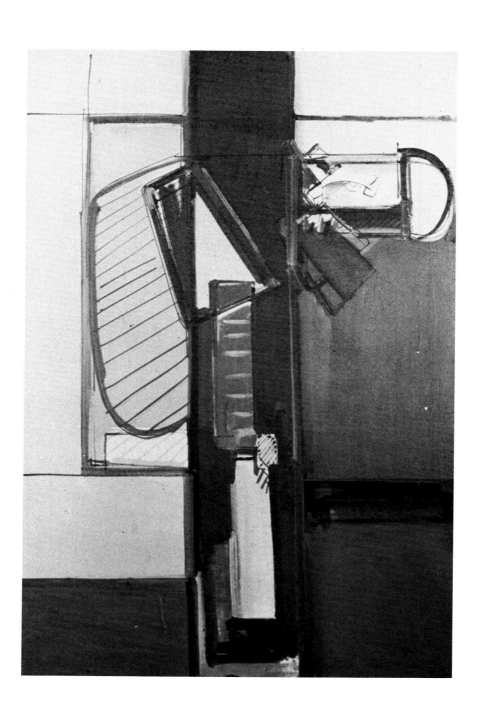

125 HOFMANN

Apparition, 1947
Oil on reinforced panel, 48 × 57⁷/₈ in.
(Krannert Art Museum, University of Illinois,
Champaign)

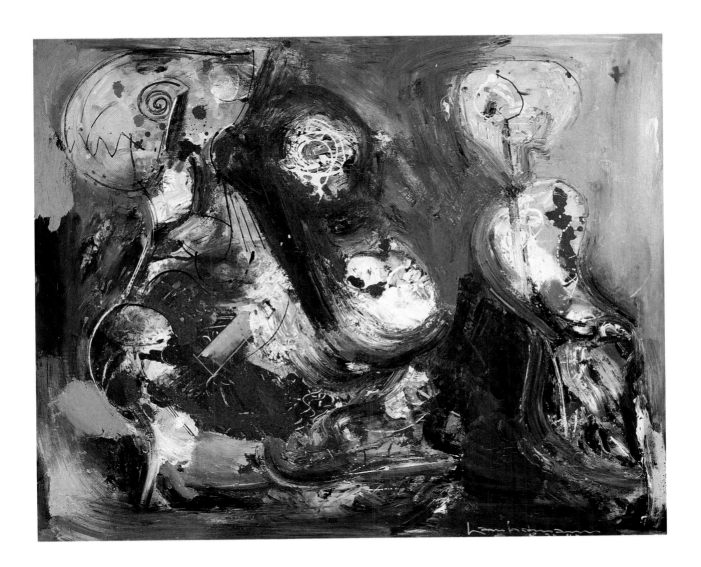

Retained Mood, 1949
Oil, 32 × 35 in.
(Unlocated)

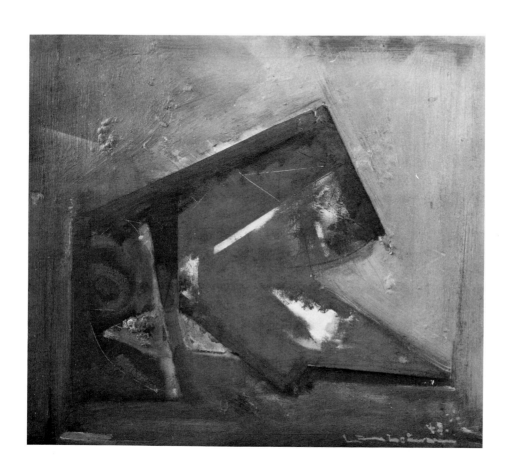

Quartet, 1949
Oil on canvas, 50 × 50 in.
(Courtesy André Emmerich Gallery, New York)

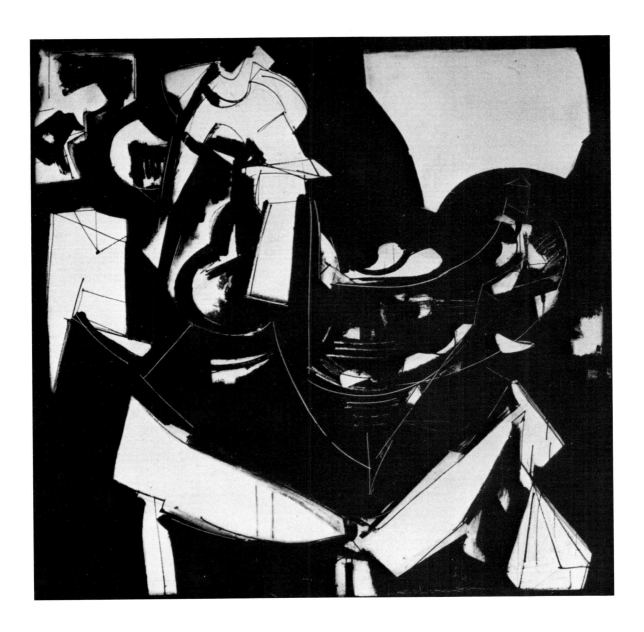

Fruit Bowl, 1950
Oil, 30 × 38 in.
(Henry Geldzahler, New York)

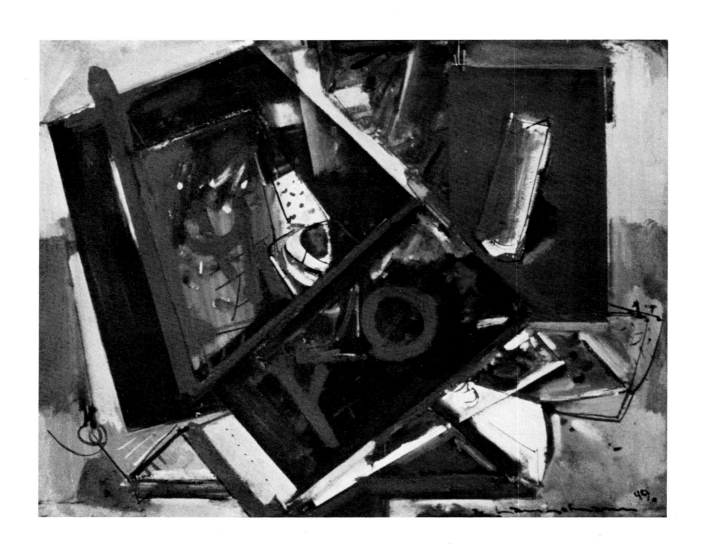

Fruit Bowl

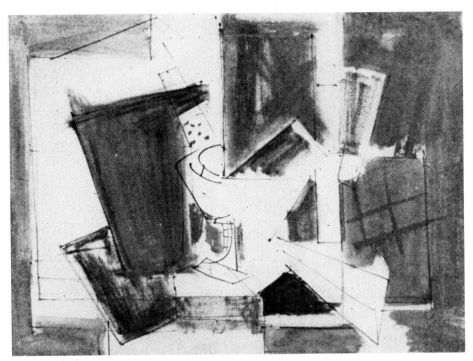

(First state)

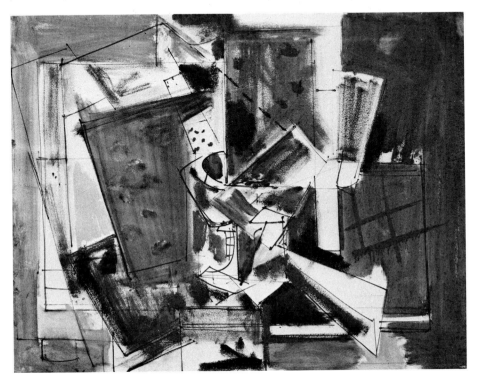

(Second state)

Fruit Bowl, 1950
Oil on canvas, $29^7/_8 \times 38$ in.
(Nebraska Art Association, Sheldon Memorial Art
Gallery, Lincoln)

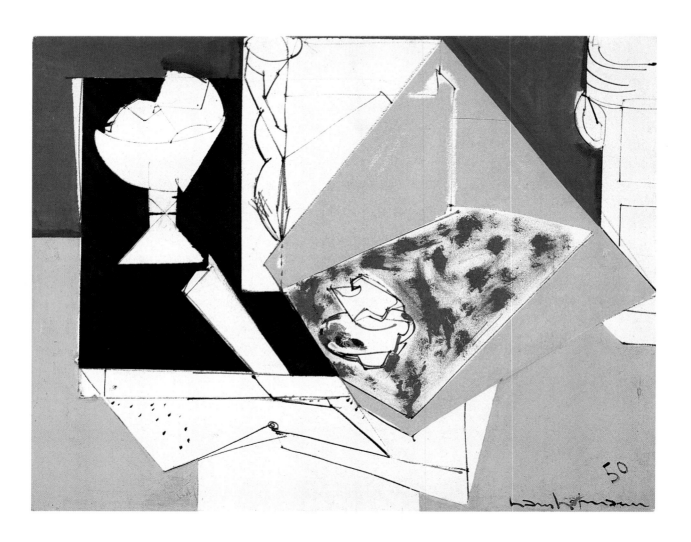

Push and Pull I (Fragment of Chimbotte Mural),
ca. 1950
Oil, 30 × 38 in.
(Hans Hofmann Estate, courtesy
André Emmerich Gallery, New York)

Elegy, 1950
Oil and plaster on composition board, 40 × 59½ in.
(Walker Art Center, Minneapolis, Gift of the
Gilbert M. Walker Fund)

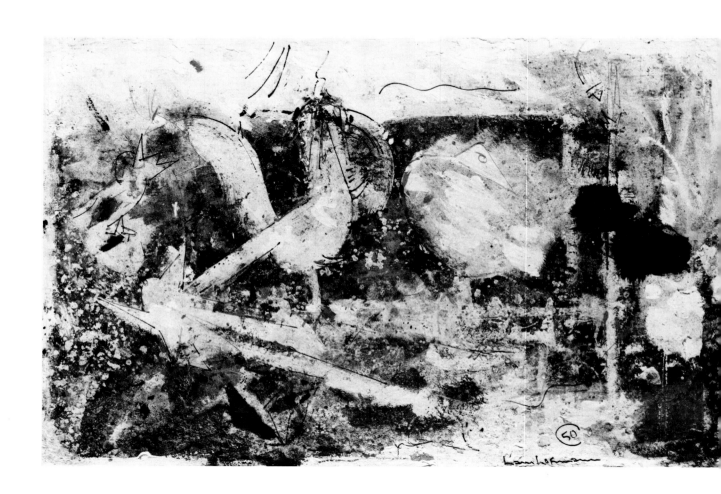

Push and Pull III, 1950
Oil, 36 × 48 in.
(Hans Hofmann Estate, courtesy
André Emmerich Gallery, New York)

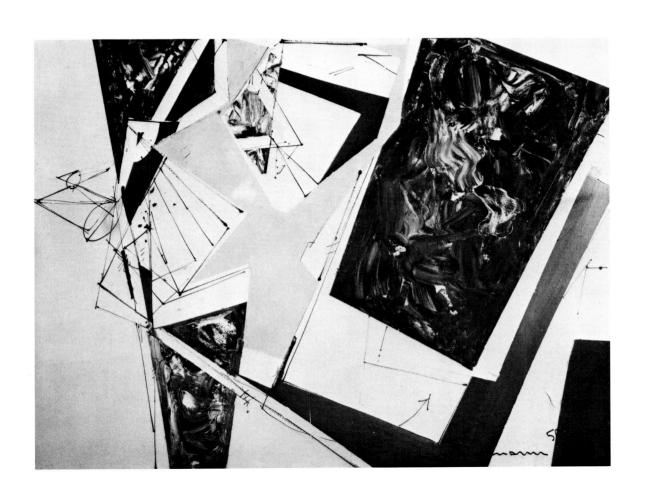

133 HOFMANN
Color Poem, 1950
Oil, 14 × 20 in.
(Unlocated)

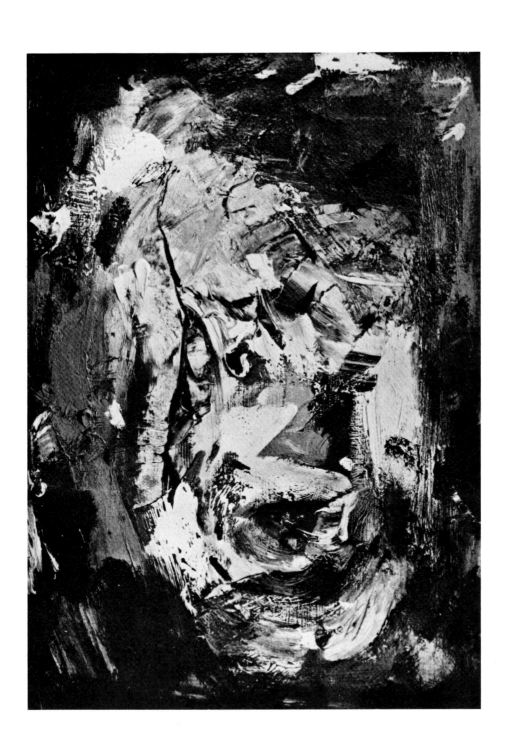

Magenta and Blue, 1950
Oil on canvas, 48 × 58 in.
(Whitney Museum of American Art, New York)

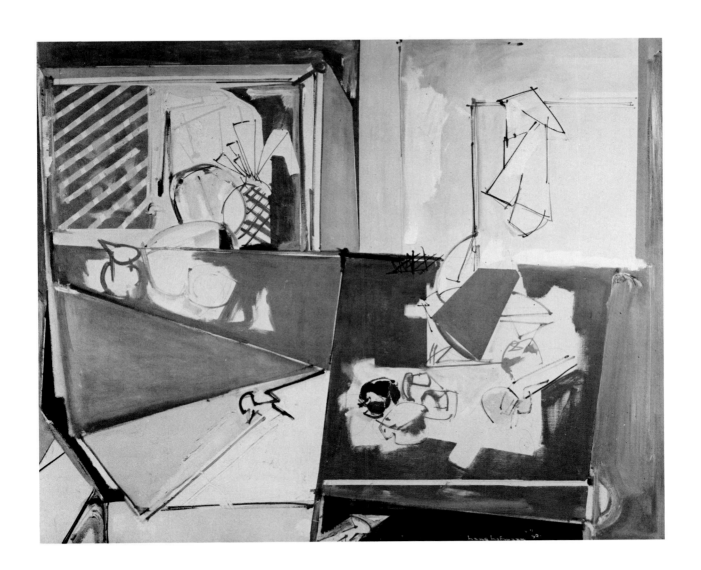

135 HOFMANN

The Window, 1950
Oil on gesso coated canvas, 48 × 36⅛ in.
(The Metropolitan Museum of Art, New York,
Gift of Mr. and Mrs. Roy R. Neuberger, 1951)

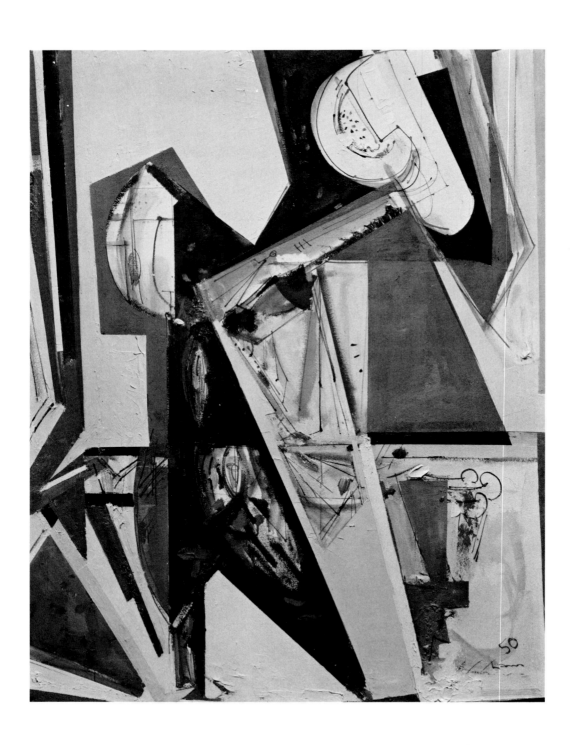

Painting, 1950
Oil on canvas, 36 × 40 in.
(Unlocated)

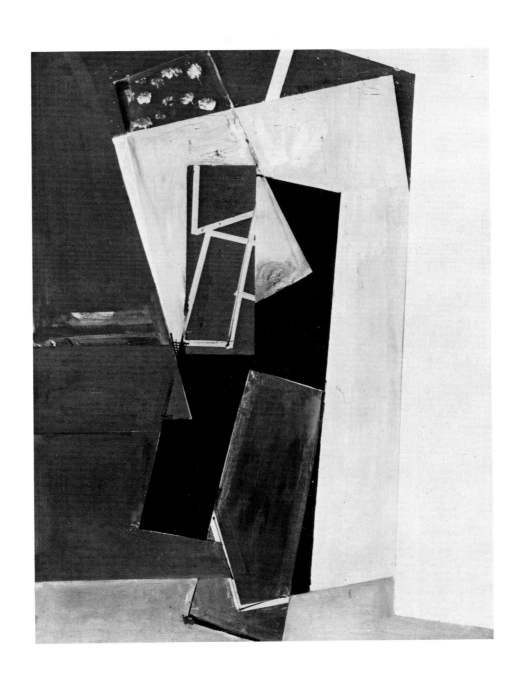

Push and Pull II, 1950
Oil on canvas, 36 × 48 in.
(Hans Hofmann Estate, courtesy
André Emmerich Gallery, New York)

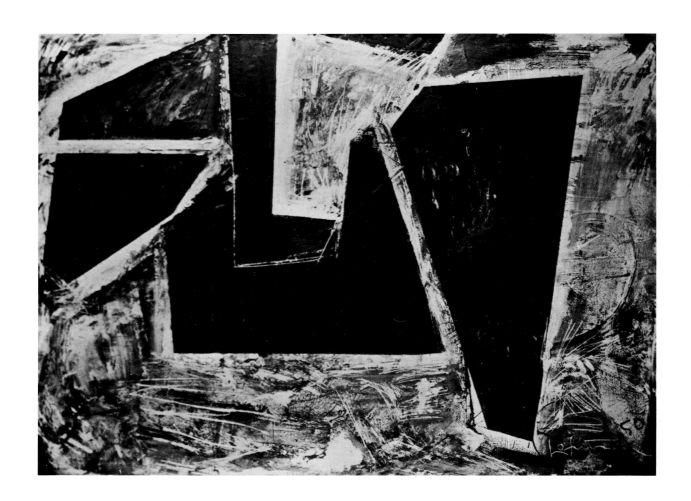

White Space, 1950
Oil, 30 × 38 in.
(Unlocated)

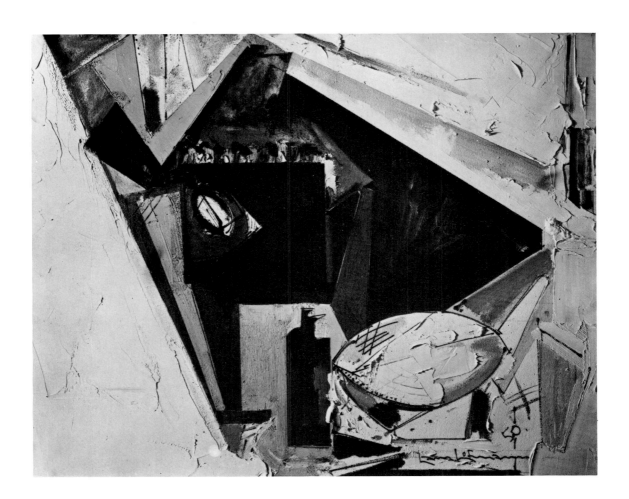

Chimbotte Mural (Middle Section), ca. 1950
Oil on board, 7 × 4 ft.
(Hans Hofmann Estate, courtesy
André Emmerich Galley, New York)

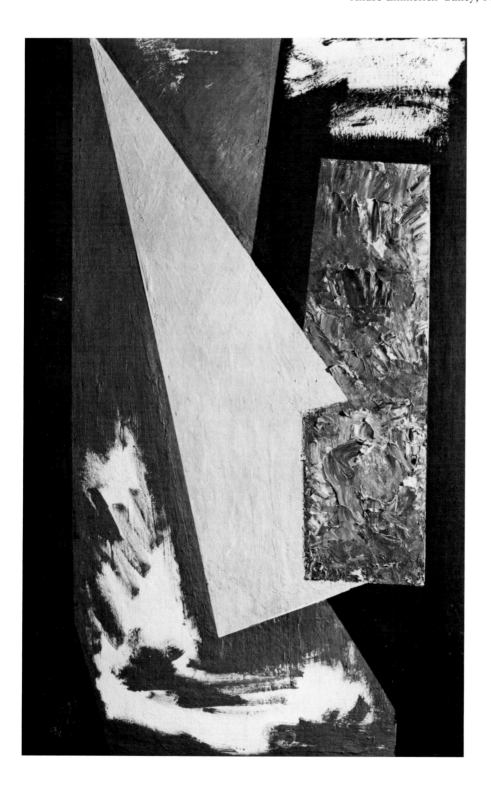

Chimbotte Mural (Left Section), ca. 1950
Oil on board, 7 × 3 ft.
(Hans Hofmann Estate, courtesy
André Emmerich Gallery, New York)

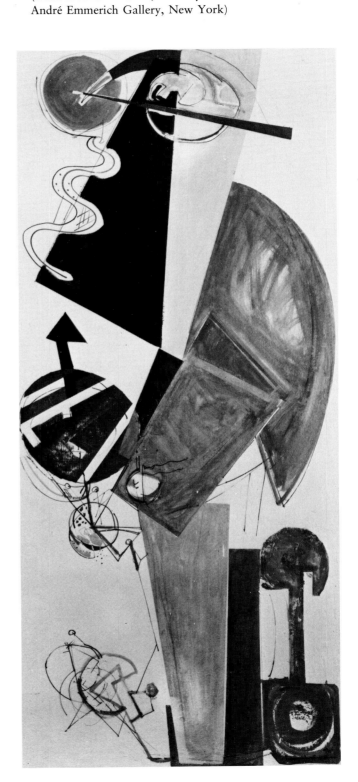

Nirvana, 1951
Oil, 38 × 30 in.
(Blanden Art Gallery, Fort Dodge, Iowa)

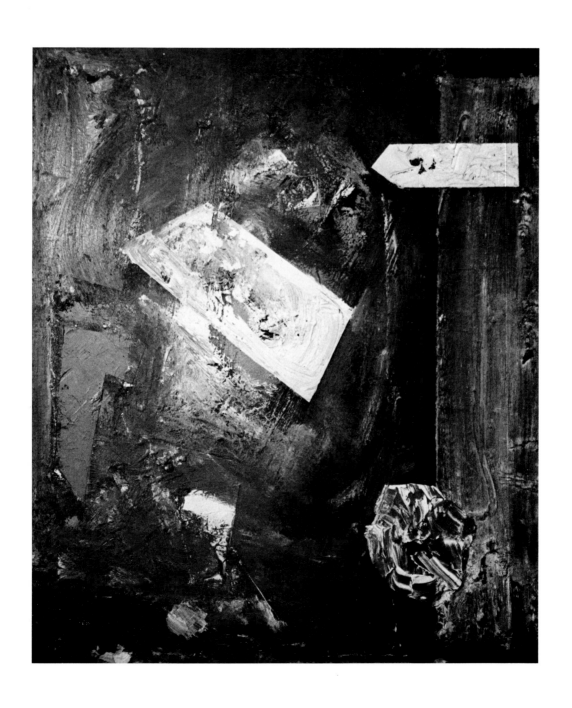

141A HOFMANN

Composition No. 6, 1951
Oil, 48 × 36 in.
(Courtesy André Emmerich Gallery, New York)

141B HOFMANN

Painting, ca. 1951
Oil
(Unlocated)

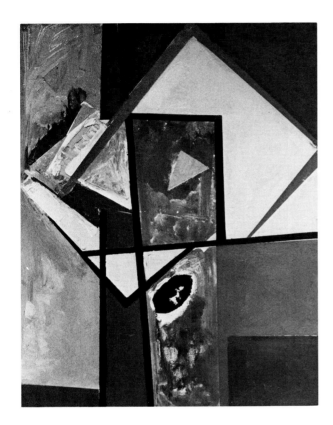

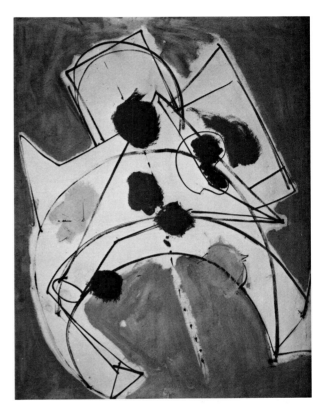

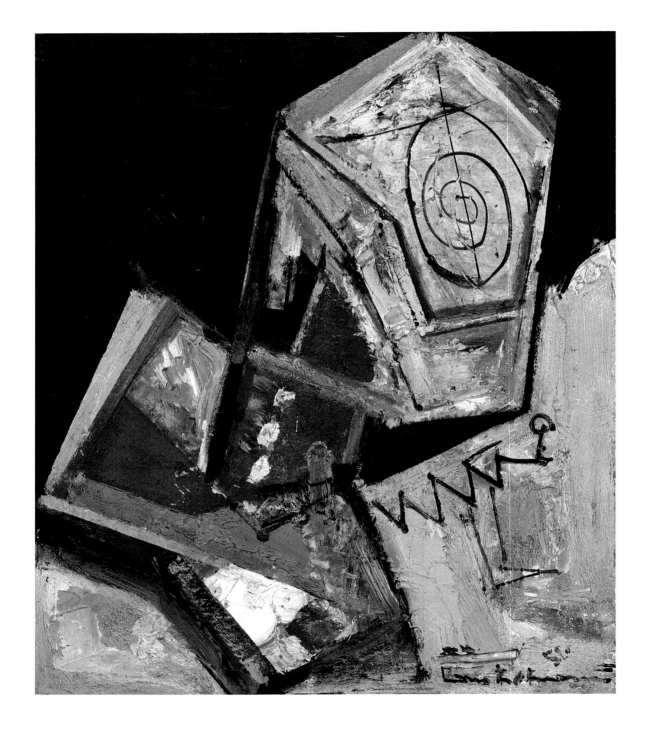

Interpenetration, 1951
Oil, 24 × 20 in.
(Mr. and Mrs. Herman Jervis, New York)

Visione Nobilissima, 1951
Oil, 38 × 30 in.
(Hans Hofmann Estate, courtesy
André Emmerich Gallery, New York)

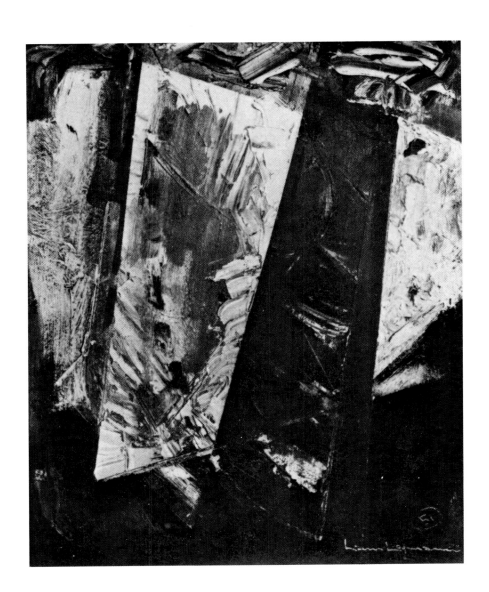

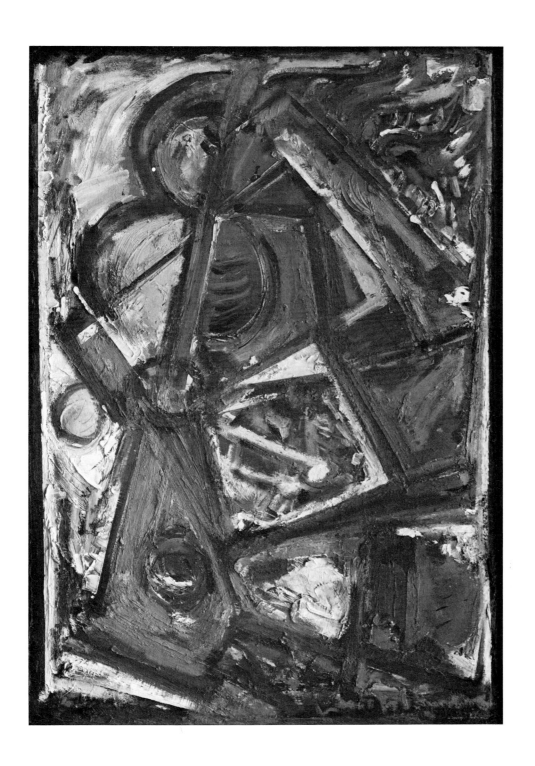

Scotch and Burgundy, 1951
Oil on canvas, 60⅝ × 40½ in.
(Lariviere Collection, Montreal)

145 HOFMANN

Das Lied der Liebe, 1952
Oil, 36 × 48 in.
(Private Collection)

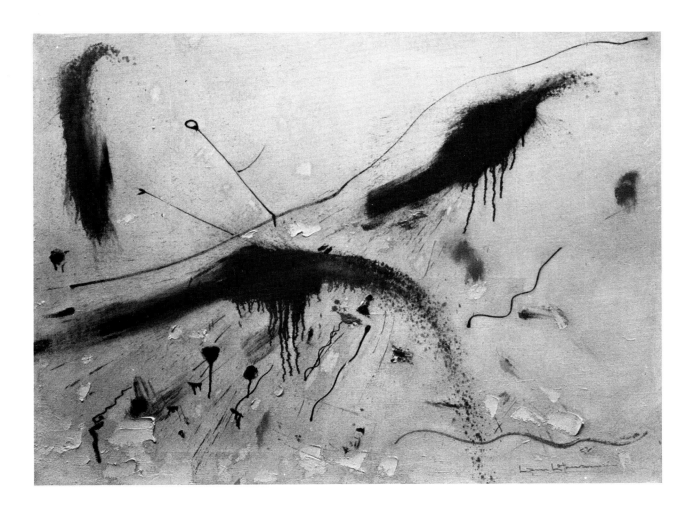

Germania, 1951
Oil on canvas, 30 × 38 in.
(Unlocated)

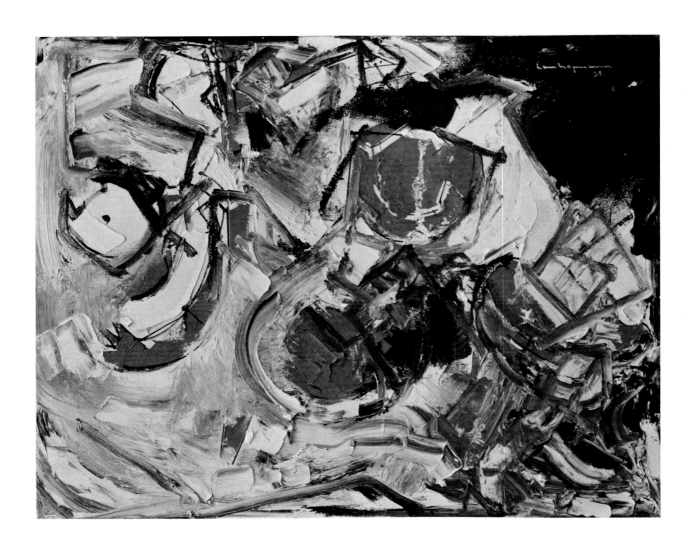

Burst Into Life, 1952
Oil on canvas, 60 × 48¹/₂ in.
(The Art Institute of Chicago, Anonymous Loan)

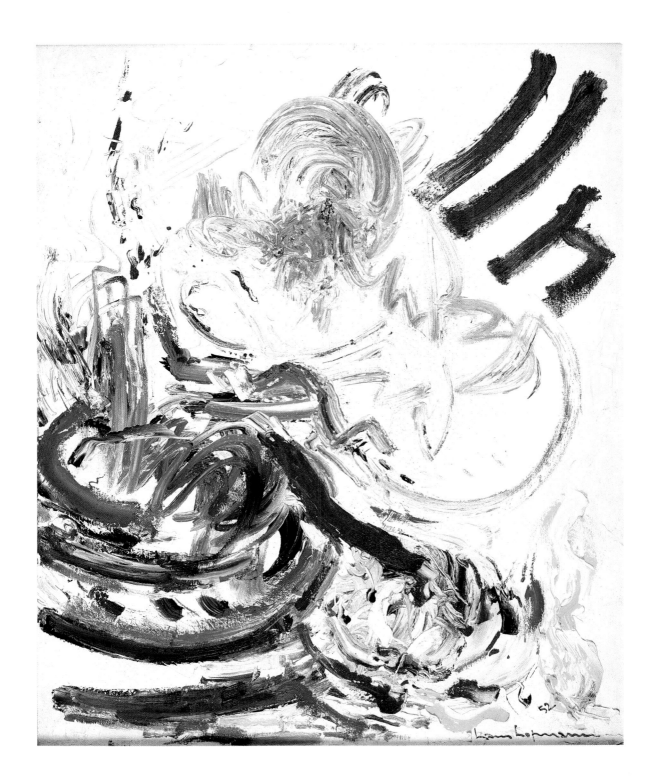

Jubilant, 1952
Oil, 60 × 48 in.
(Courtesy André Emmerich Gallery, New York)

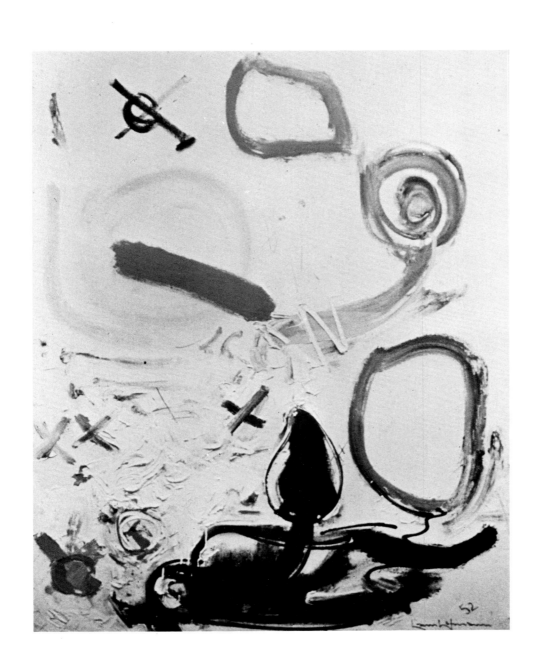

Composition, 1952
Oil on canvas, 48 × 36 in.
(Private Collection)

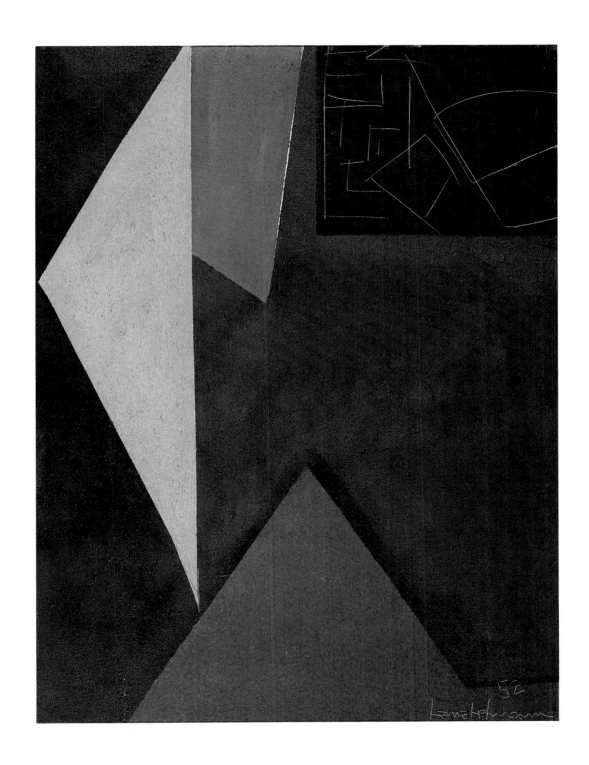

Robert Motherwell

Automatic Drawing No. 1, 1941
Watercolor on paper
(Unlocated)

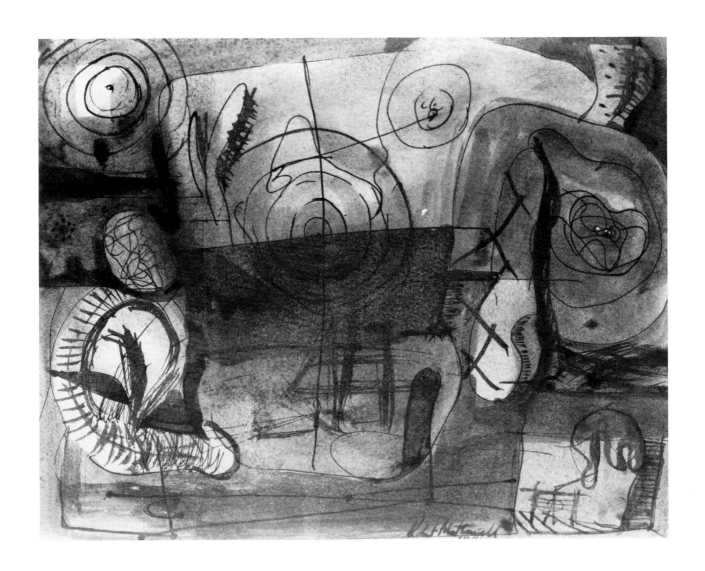

Personage, 1943
Oil on canvas, 48 × 38 in.
(Norton Gallery and School of Art,
West Palm Beach, Florida)

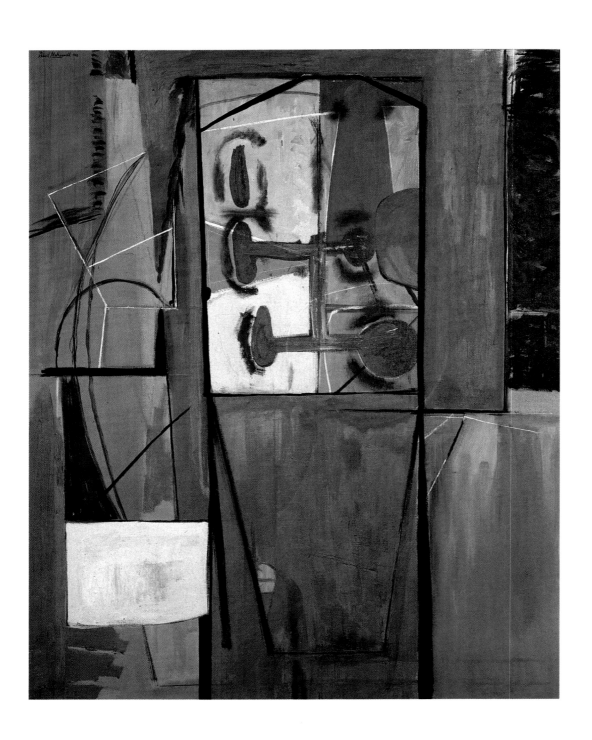

The Flute, 1943
Collage, 35 ½ × 18 in.
(Mr. and Mrs. Samuel Pisar, Paris)

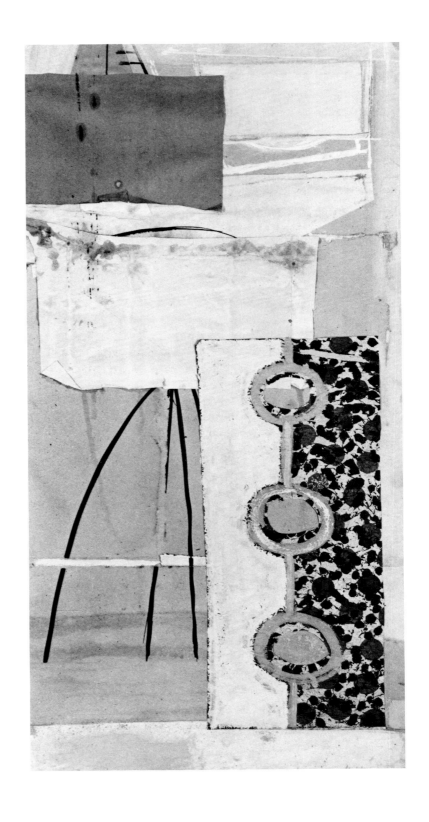

Mallarmé's Swan, 1944–1947
Collage using gouache, crayon,
and paper on cardboard,
43$^{1}/_{2}$ × 35$^{1}/_{2}$ in.
(Contemporary Collection of the Cleveland
Museum of Art)

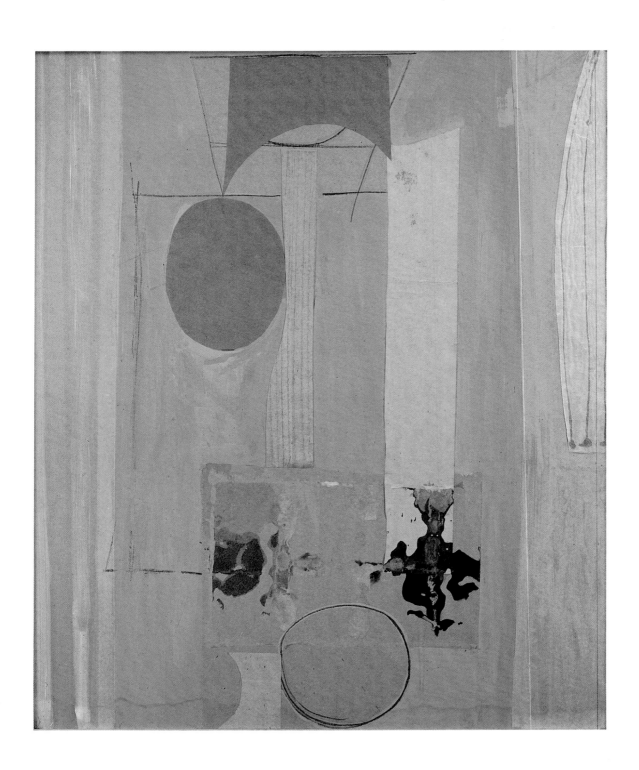

Surprise and Inspiration, 1943
Gouache and oil with collage, 40 1/8 × 25 1/4 in.
(The Peggy Guggenheim Collection, Venice,
The Solomon R. Guggenheim Foundation)

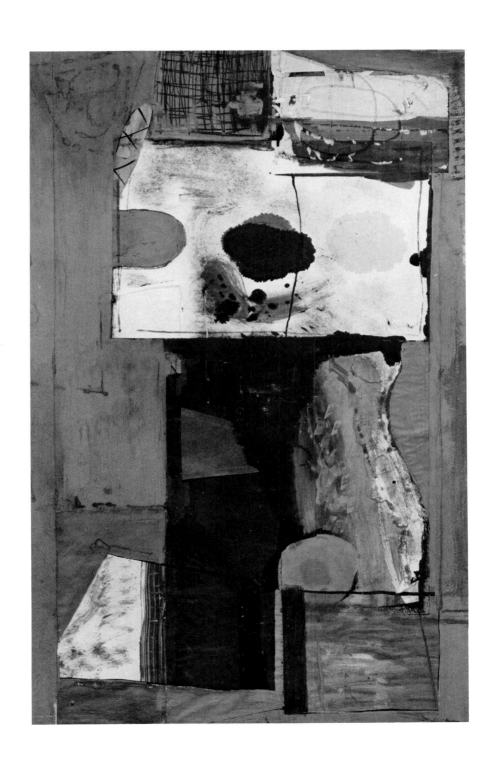

Pancho Villa, Dead and Alive, 1943
Gouache and oil with collage on cardboard,
28 × 35 7/8 in.
(The Museum of Modern Art, New York)

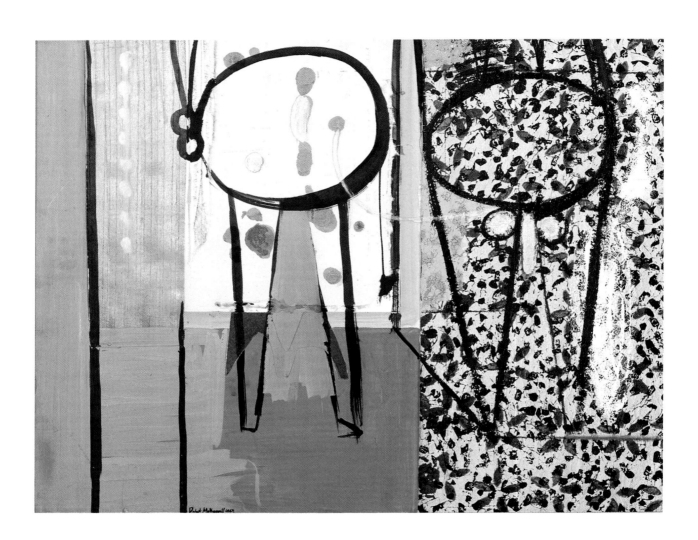

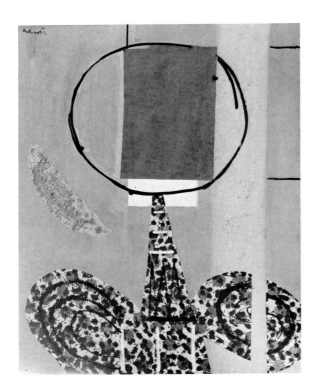

156 MOTHERWELL

Figure, 1945
Collage, 30 × 23¼ in.
(Dr. and Mrs. Leo Wilson)

157 MOTHERWELL

Three Figures Shot, 1944
Colored ink on paper, 11³/₈ × 14½ in.
(Collection of Whitney Museum of American Art
Purchase, with funds from the Burroughs Wellcome
Purchase Fund and the National Endowment
for the Arts)

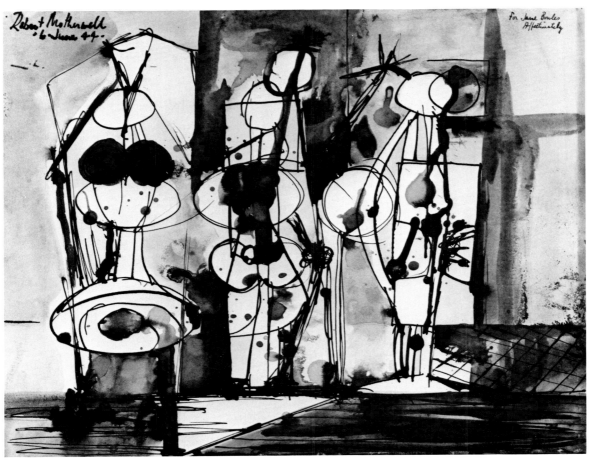

The Room, 1944
Gouache
(Unlocated)

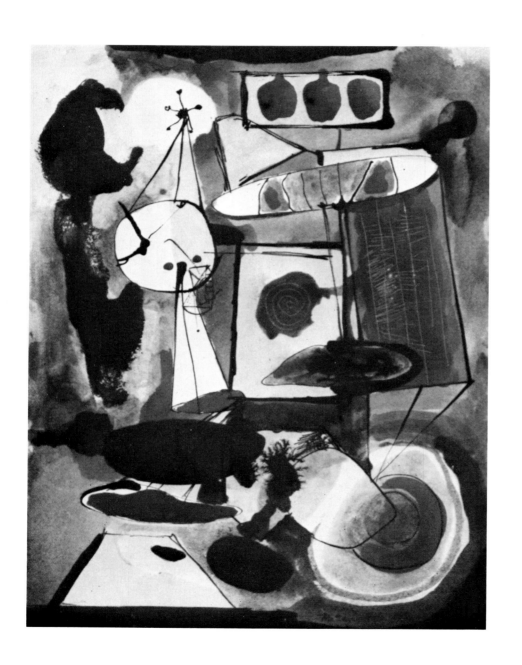

View from a Tower, 1944
Collage
(Unlocated)

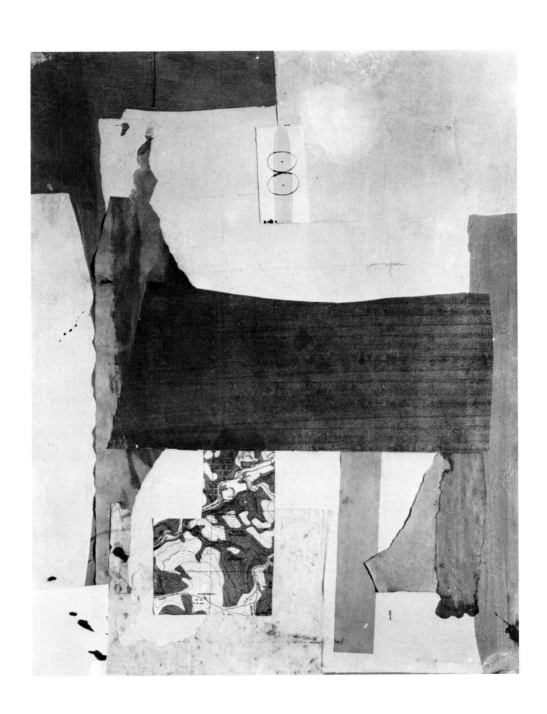

Collage in Beige and Black, 1944
Collage and oil on board, $43^{3/8} \times 29^{1/8}$ in.
(Private Collection, Boston)

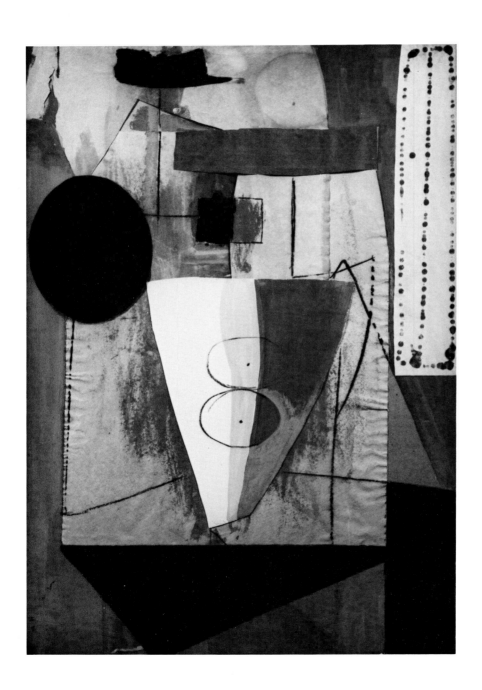

Spanish Prison (Window), 1943–1944
Oil on canvas, 52¼ × 42¼ in.
(Mrs. H. Gates Lloyd, Haverford, Pennsylvania)

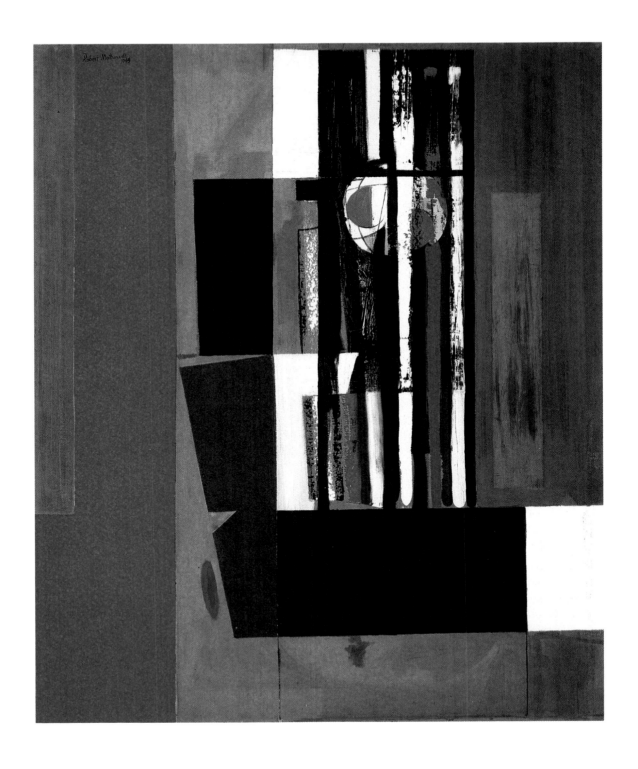

162 MOTHERWELL

Jeune Fille, 1944
Oil and collage
(Unlocated)

163 MOTHERWELL

Motherwell in his studio, 1944

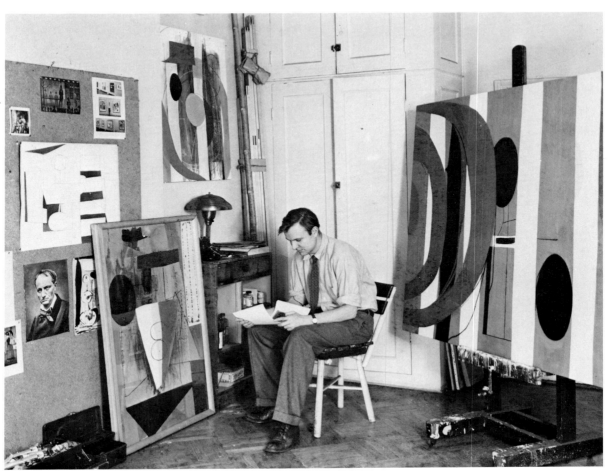

164 MOTHERWELL

Wall Painting with Stripes, 1944
Oil on canvas, 54 × 67⅛ in.
(The Lannan Foundation)

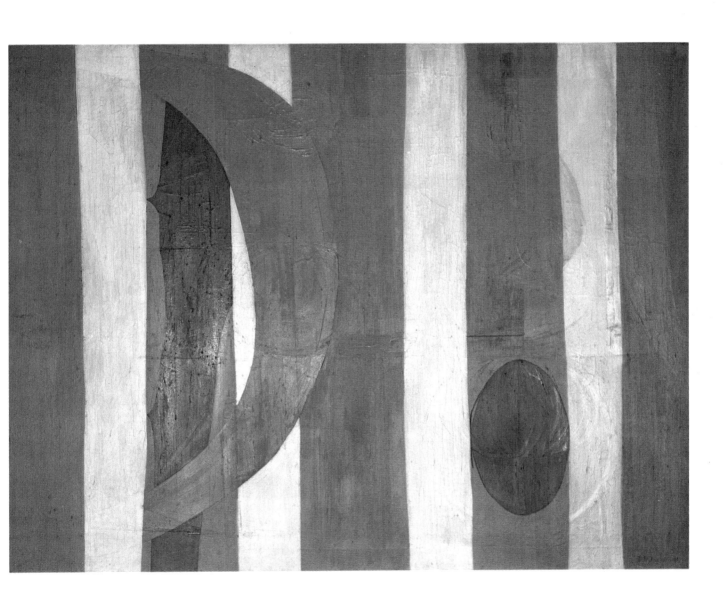

La Résistance, 1945
Collage, 36 × 47³/₄ in.
(Yale University Art Gallery, New Haven,
Gift of Fred Olsen)

166 MOTHERWELL

Maria, 1945
Oil, charcoal, and sand with collage, 30 × 24 in.
(Esmé O'Brien Hammond)

167 MOTHERWELL

Figure in Red, 1945
Oil on masonite, 24 × 18 in.
(Unlocated)

Personage with Yellow Ochre and White, 1947
Oil on canvas, 72 × 54 in.
(The Museum of Modern Art, New York,
Gift of Mr. and Mrs. Samuel M. Kootz)

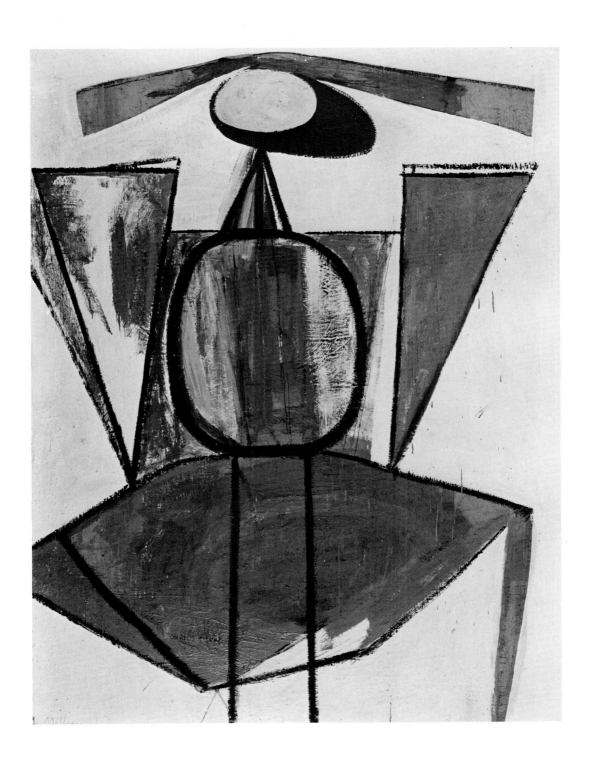

The Red Skirt, 1947
Oil on composition board, 48 × 24 in.
(Whitney Museum of American Art, New York)

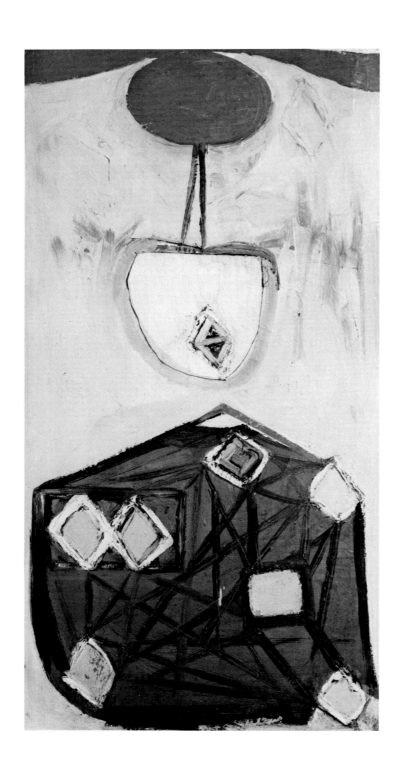

Poet with Orange, 1947
Oil, 54 × 36 in.
(Private Collection)

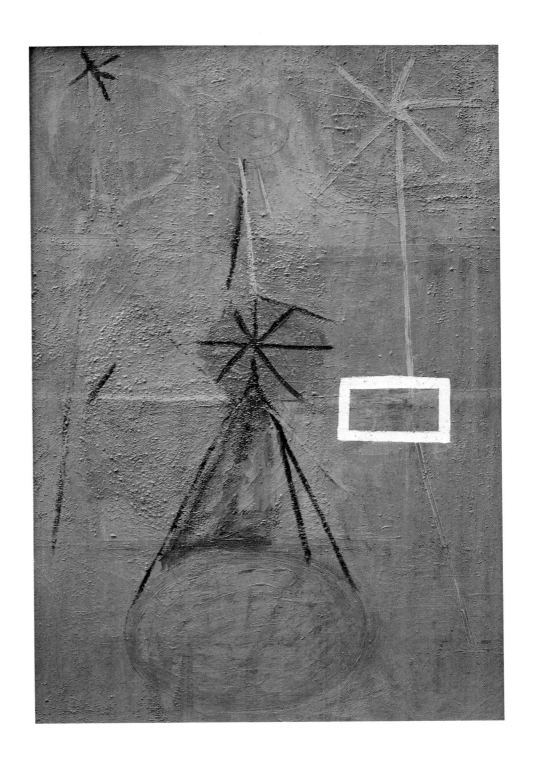

The Poet, 1947
Collage, 55³/₈ × 39¹/₈ in.
(Estate of Mary Alice Rothko)

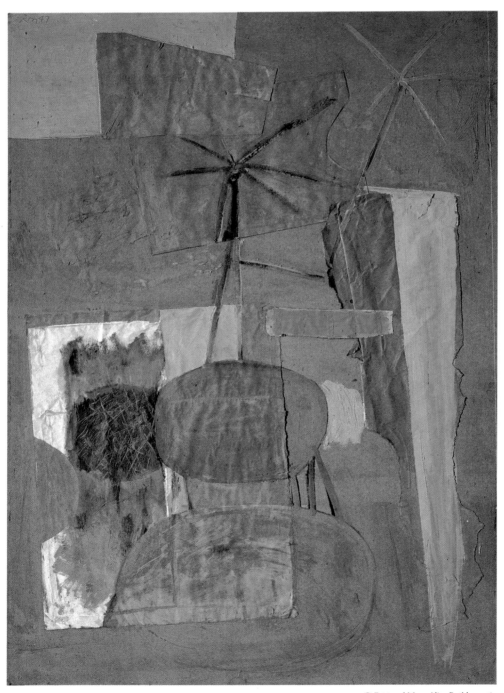

Western Air, 1946–1947
Oil on canvas, 72 × 54 in.
(The Museum of Modern Art, New York)

The Emperor of China, 1947
Oil on canvas, 48 × 36 in.
(Mr. and Mrs. Maxwell Jospey)

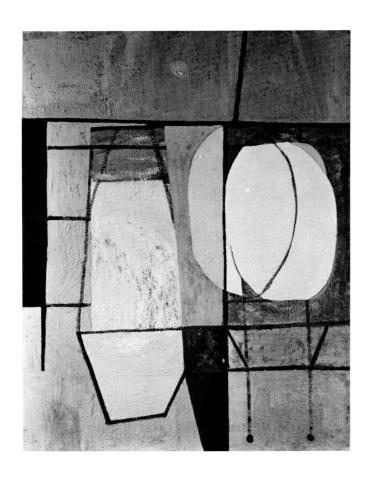

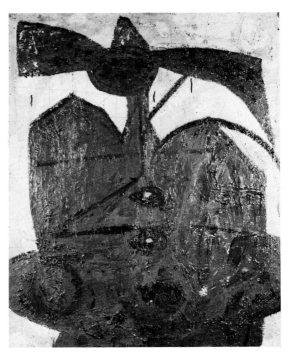

175 MOTHERWELL

The Homely Protestant, 1948
Oil on composition board, 96 × 48 in.
(Collection of the Artist, on extended loan to
The Metropolitan Museum of Art, New York)

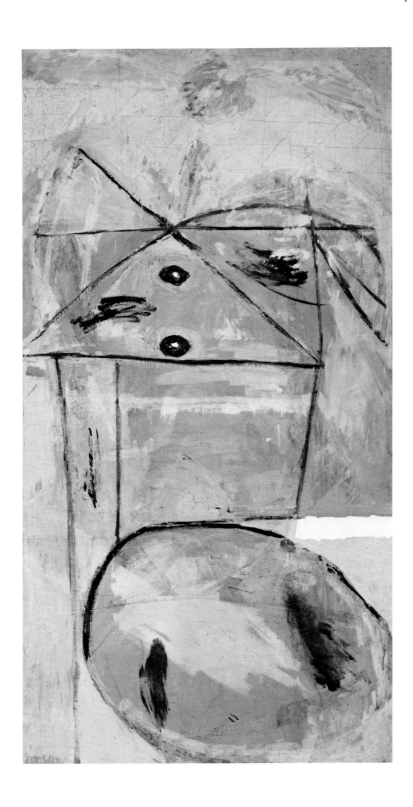

Collage in Yellow and White with Torn Elements, 1949
Collage, 47³/₈ × 35¹/₂ in.
(Mr. and Mrs. Ben Heller)

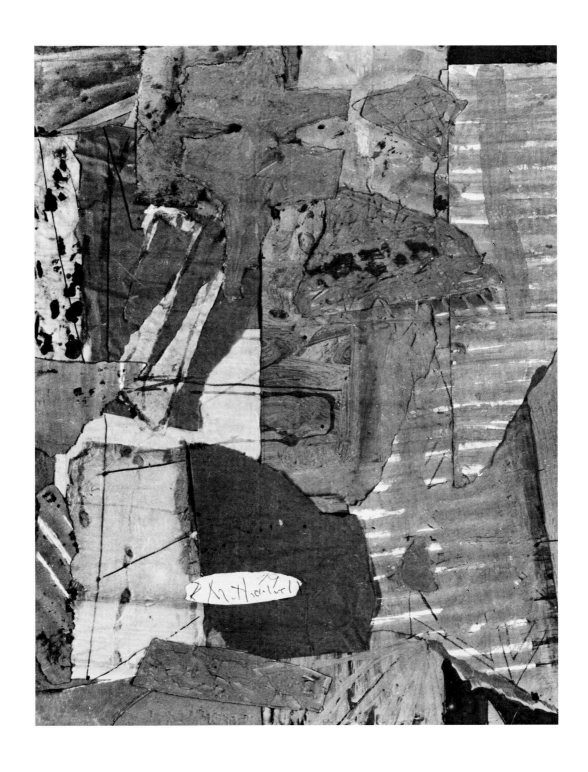

Granada, 1949
Oil on paper over masonite, 47 × 55 ¹/₂ in.
(National Trust for Historic Preservation in the
United States, Bequest of Nelson A. Rockefeller)

178 MOTHERWELL

The Voyage, 1949
Oil and tempera on paper,
mounted on composition board, 48 in. × 7 ft., 10 in.
(The Museum of Modern Art, New York,
Gift of Mrs. John D. Rockefeller 3rd)

At Five in the Afternoon, 1950
Oil on masonite, 36 × 48 in.
(Mrs. Josephine Morris)

Study for "Spanish Elegies," ca. 1952
Ink on paper
(Unlocated)

Black Still Life, 1950
Oil on board, 40 × 48 in.
(Mr. and Mrs. Gifford Phillips)

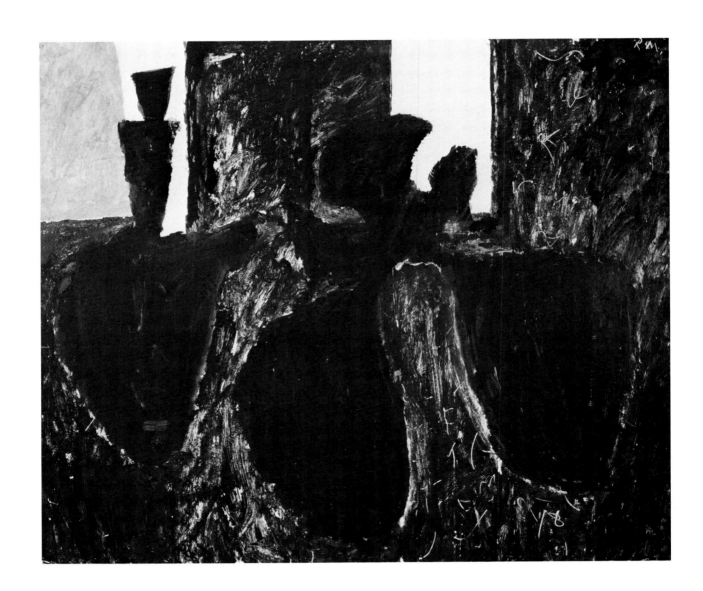

Ile de France, 1952
Oil, 48 × 60 in.
(Walter and Dawn Clark Netsch)

*Mural Design for a Junior High School
in Massachusetts,* 1951
Gouache on paper, 5 × 34 in.
(Collection of the Artist)

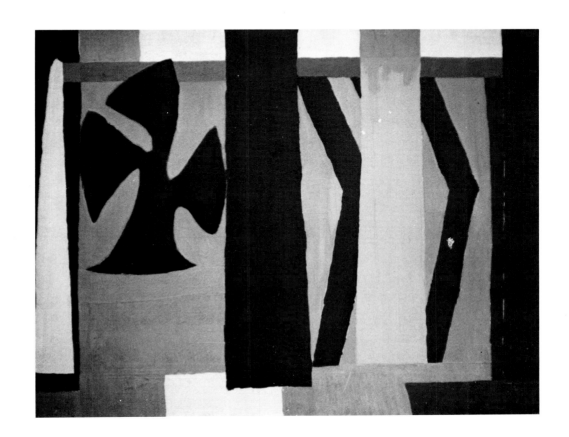

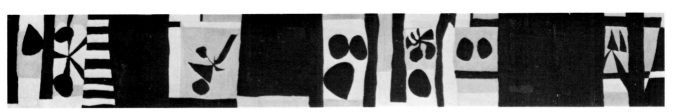

Mural Fragment, 1950
Oil on composition board, 8 × 12 ft.
(three panels 8 × 4 ft.)
(University Gallery, University of Minnesota,
Minneapolis, Gift of Katherine Ordway)

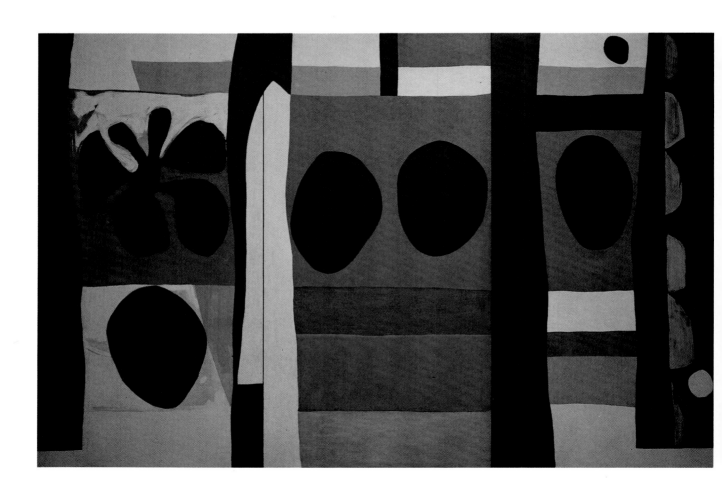

Wall Painting III, ca. 1952
Oil on board, 48 × 72 in.
(Collection of the Artist)

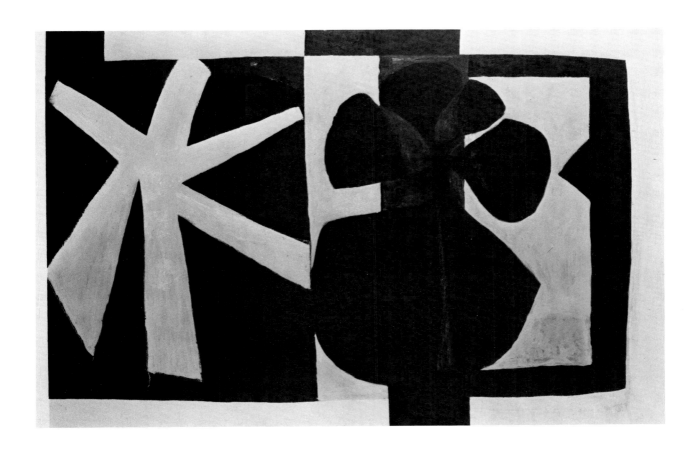

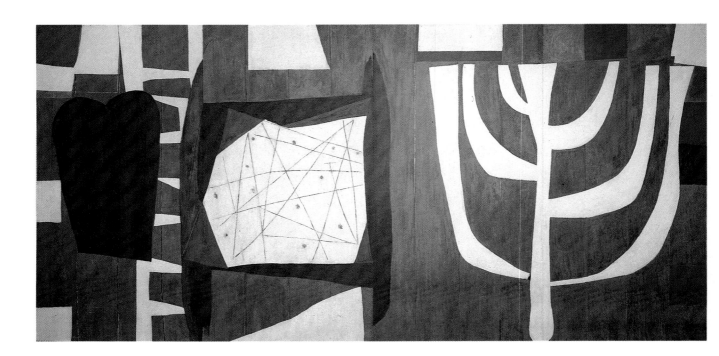

186 MOTHERWELL

Mural, ca. 1951
Oil on wood, 8 × 12 ft.
(Owned by and for exclusive display at
Congregation B'nai Israel, Millburn, New Jersey)

The Easel, ca. 1954
Collage, 29⁷/₈ × 20¹/₈ in.
(Dr. Montague Ullman)

The Easel No. 2, ca. 1953
Ink on paper, 14¹/₂ × 11¹/₂ in.
(Unlocated)

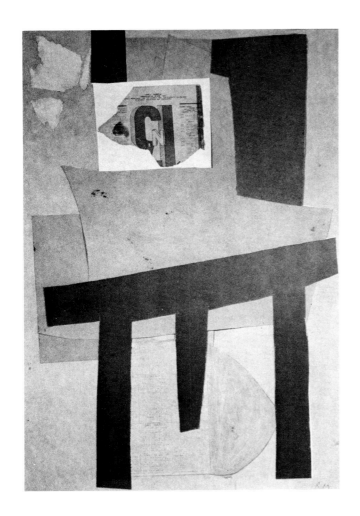

189 MOTHERWELL

Magpie, 1952
Ink on paper, 28 × 22 in.
(Unlocated)

190 MOTHERWELL

Jewish Candelabra, ca. 1951
Ink on paper, 24 × 30 in.
(Collection of the Artist)

191 MOTHERWELL

Nude, 1952
Ink on paper, 21 1/2 × 29 3/8 in. (sight)
(Munson-Williams-Proctor Institute, Utica,
New York, Edward W. Root Bequest)

Dover Beach, 1952
Collage, 40 × 30 in.
(Unlocated)

Pregnant Woman Holding Child, 1953
Casein and ink on paper, 10 × 8³/4 in.
(Collection of the Artist)

La Danse II, 1952
Oil on canvas, 60 × 76 in.
(The Metropolitan Museum of Art, New York,
George A. Hearn Fund, 1953)

195 MOTHERWELL

Wall Painting IV, 1954
Oil on canvas, $54\frac{1}{8} \times 72\frac{1}{8}$ in.
(Mr. and Mrs. Ben Heller)

Mark Rothko

196 ROTHKO

Subway (Subterranean Fantasy), ca. 1936
Oil on canvas, 33³/₄ × 46 in.
(The Mark Rothko Foundation, New York)

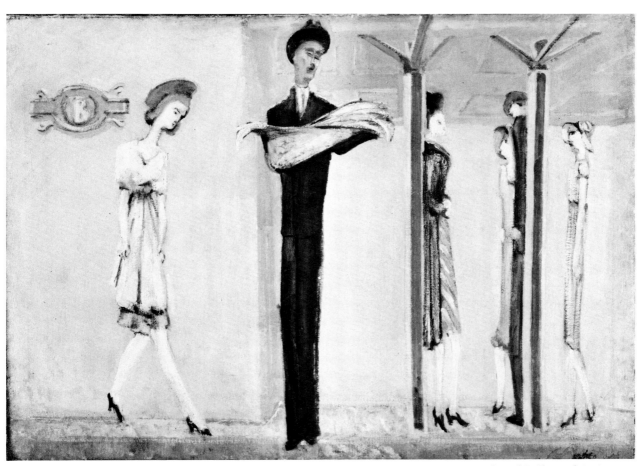

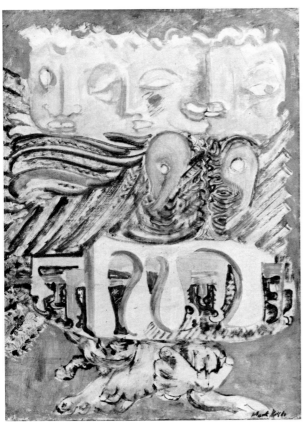

197 ROTHKO

The Omen of the Eagle, 1942
Oil on canvas, 25 1/2 × 17 3/4 in.
(The Mark Rothko Foundation, New York)

198 ROTHKO

Untitled, 1943
Oil on canvas, 28 × 36 in.
(The Mark Rothko Foundation, New York)

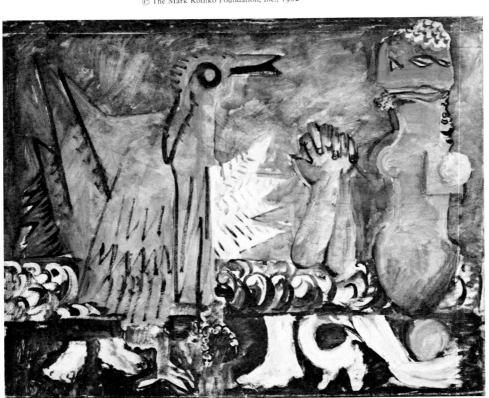

Processional, 1943–1944
Oil on canvas, 19¹/₂ × 13¹/₄ in.
(Estate of Mary Alice Rothko)

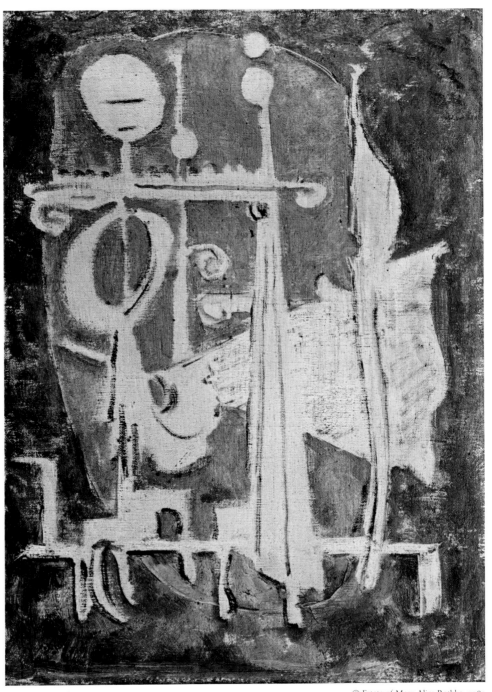

Birth of Cephalopods, 1944
Oil on canvas, 39⁵/₈ × 53¹¹/₁₆ in.
(The Mark Rothko Foundation, New York)

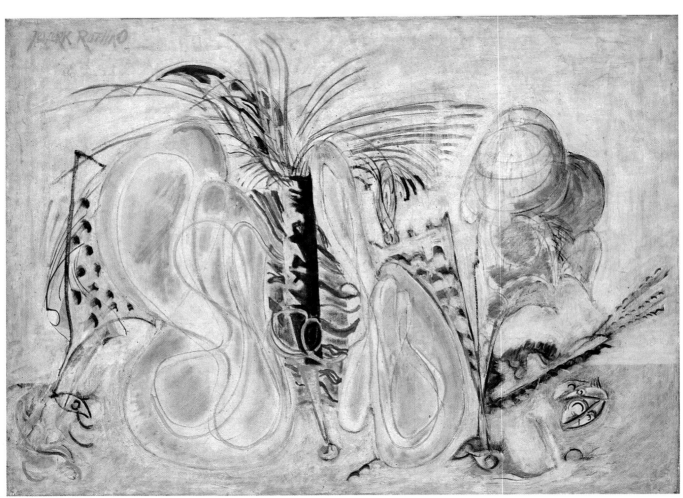

Slow Swirl by the Edge of the Sea, 1944
Oil on canvas, 75³/₈ × 84³/₄ in.
(The Museum of Modern Art, New York,
Bequest of Mrs. Mark Rothko)

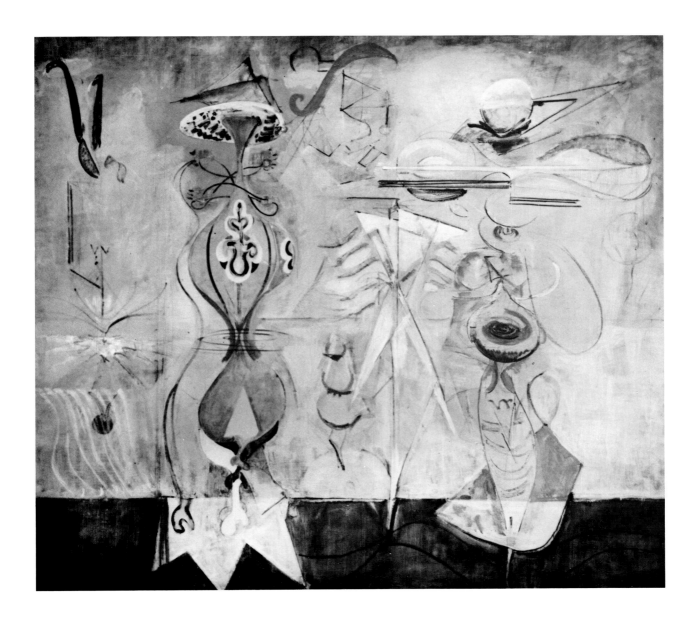

Archaic Idol, 1945
Gouache, wash, brush, pen, and ink, 21⁷/₈ × 30 in.
(The Museum of Modern Art, New York, The Joan and
Lester Avnet Collection)

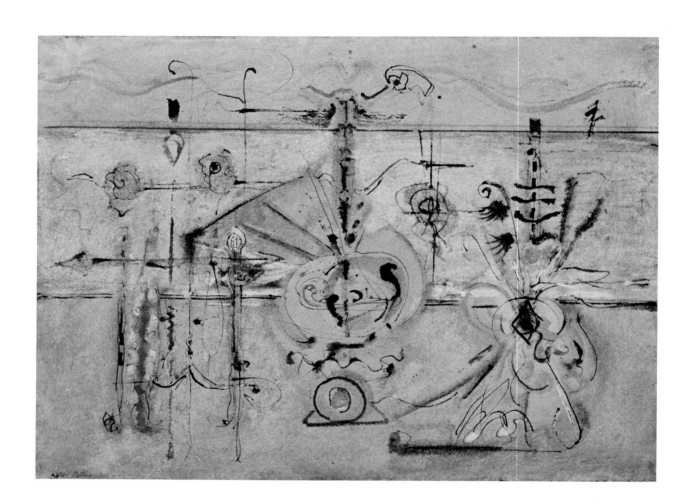

Baptismal Scene, 1945
Watercolor on paper, 19⁷/8 × 14 in.
(Whitney Museum of American Art, New York)

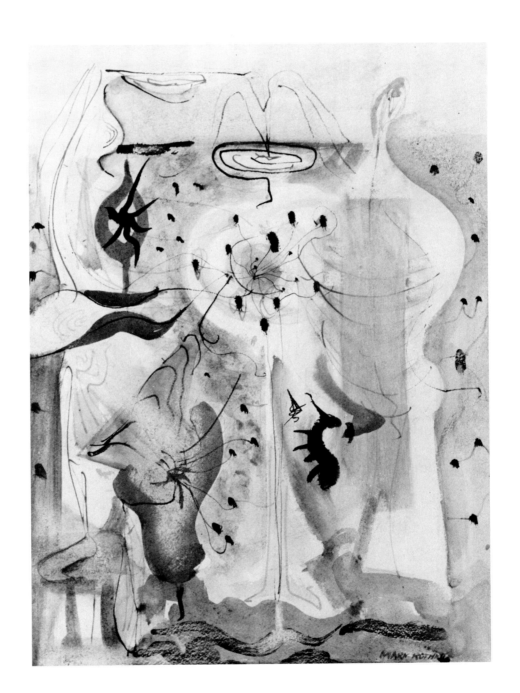

Gethsemane, 1945
Oil on canvas, 54³/₈ × 35³/₈ in.
(Christopher and Kate Rothko)

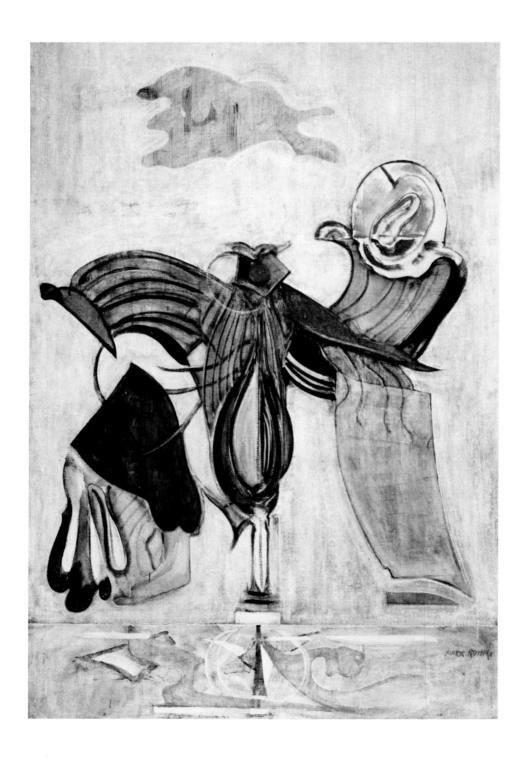

205 ROTHKO

Primeval Landscape, 1945
Oil on canvas, 54³/₈ × 35 in.
(Kate and Christopher Rothko)

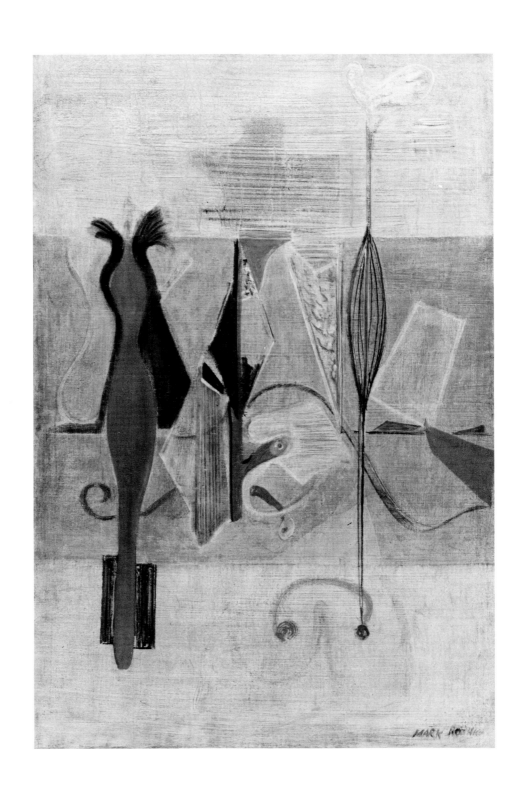

Poised Elements, 1944
Oil on canvas, 37 × 49 in.
(Christopher and Kate Rothko)

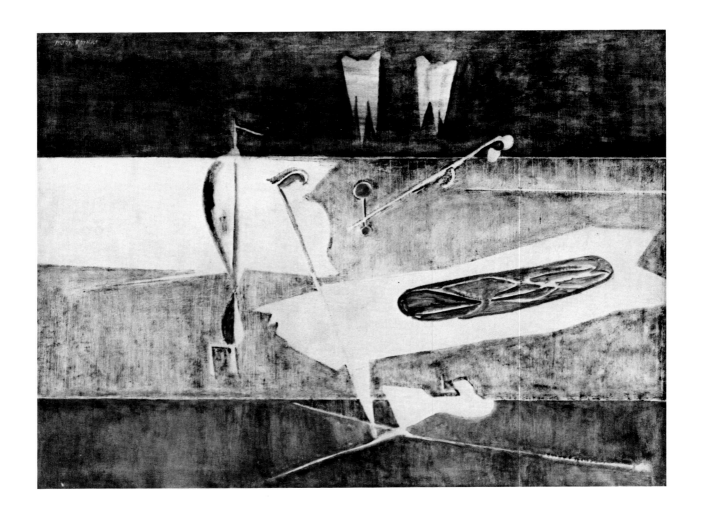

207 ROTHKO

Personages, ca. 1946
Gouache on paper, 22 × 30 in.
(Mr. and Mrs. Jacob Kainen)

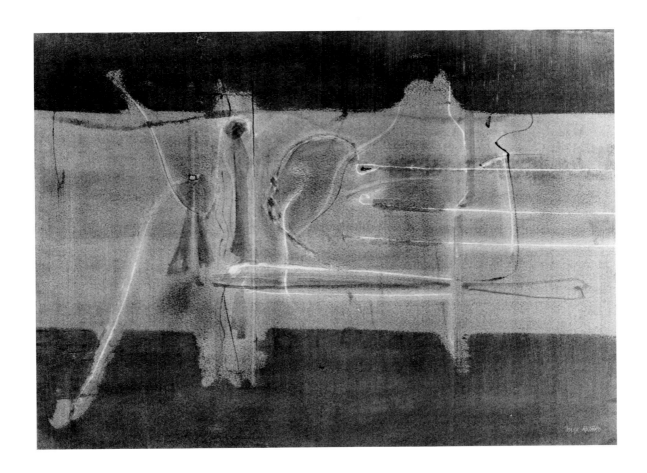

The Source, 1945–1946
Oil on canvas, 39¼ × 27¾ in.
(The Mark Rothko Foundation, New York)

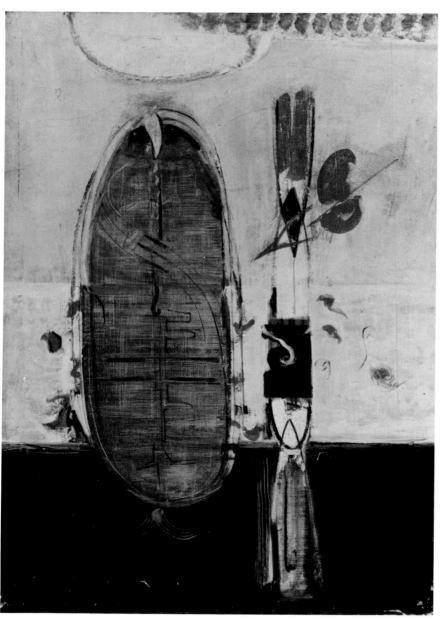

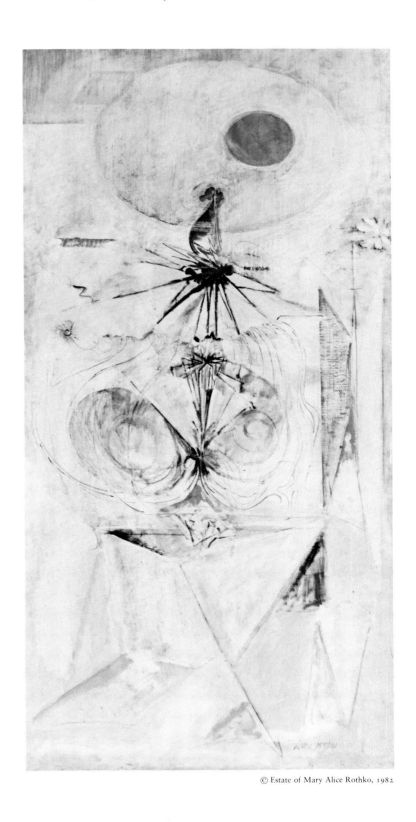

209 ROTHKO

Tiresias, 1944
Oil on canvas, 79³/₄ × 40 in.
(Estate of Mary Alice Rothko)

Astral Image, ca. 1946
Oil on canvas, 44⅛ × 34 in.
(Menil Foundation Collection, Houston)

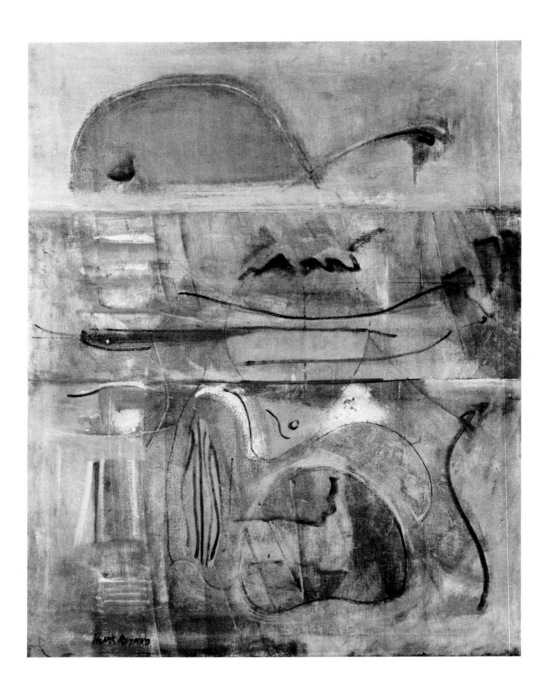

Phalanx of the Mind, 1944
Oil on canvas, 54⁵/₁₆ × 35³/₄ in.
(The Mark Rothko Foundation, New York)

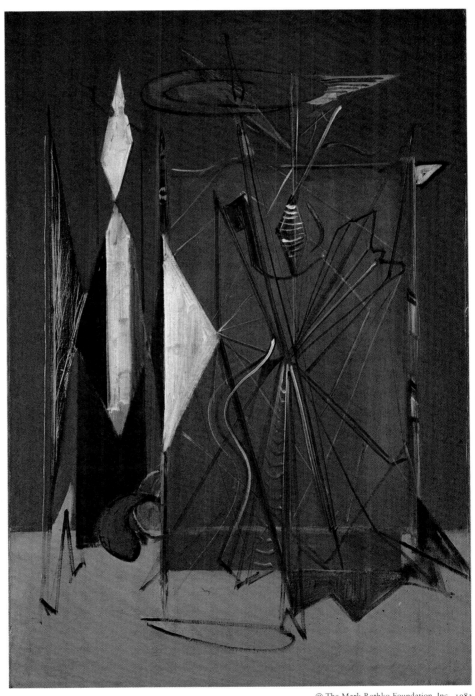

Figure in Archaic Sea, 1946
Oil on canvas, 54¼ × 38⅝ in.
(Christopher and Kate Rothko)

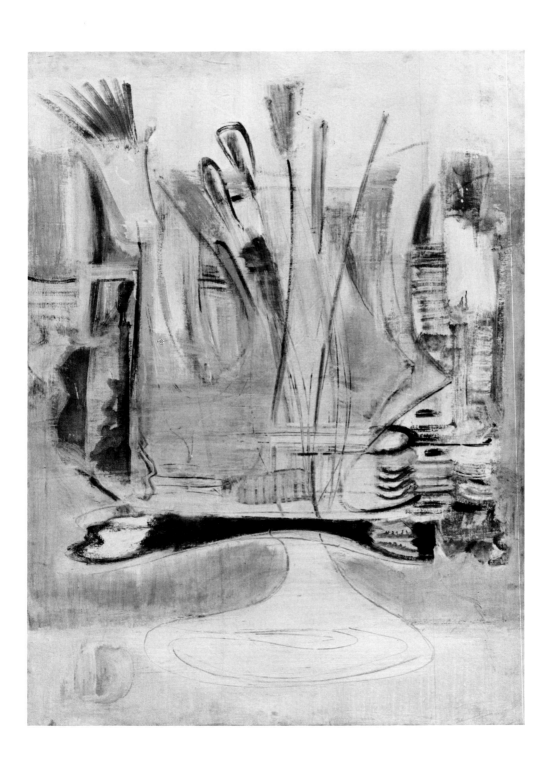

Sacrificial Moment, 1945
Oil on canvas, 38¹/₂ × 27¹¹/₁₆ in.
(The Mark Rothko Foundation, New York)

Ancestral Imprint, 1946
Watercolor on paper, 30 × 22 in.
(Unlocated)

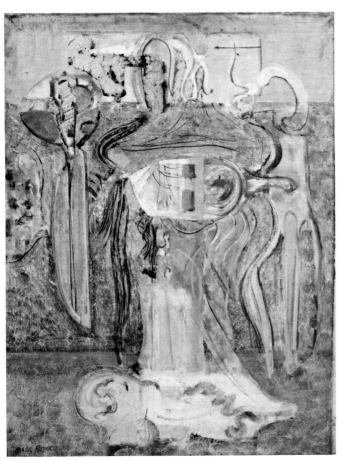

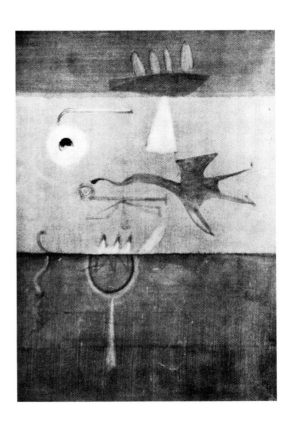

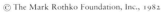

Rites of Lilith, 1945
Oil on canvas, 81⅝ × 100⅝ in.
(Kate and Christopher Rothko)

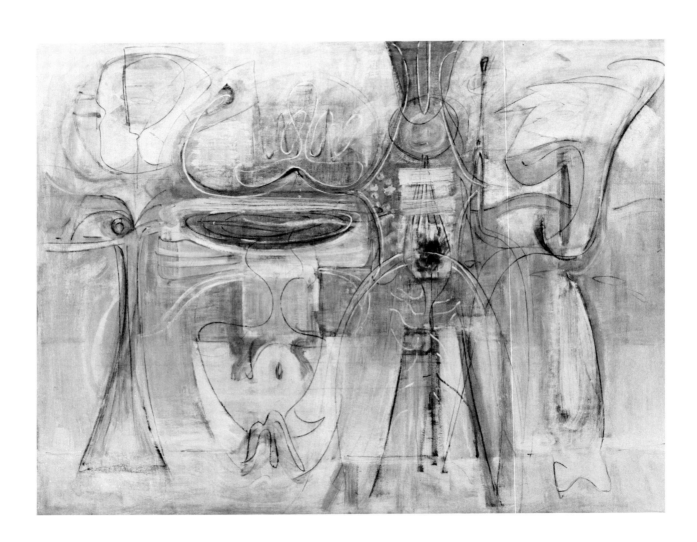

Untitled Painting, 1945–1946
Oil on canvas, 31³/₄ × 39³/₄ in.
(The Mark Rothko Foundation, New York)

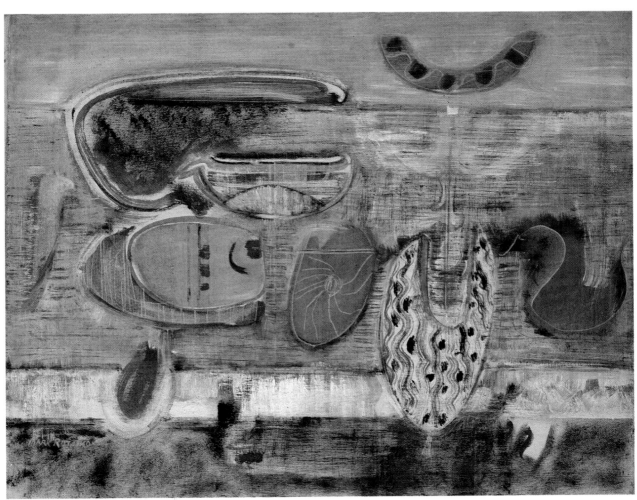

Untitled Painting, 1947
Oil on canvas, 61 × 43 in.
(The Mark Rothko Foundation, New York)

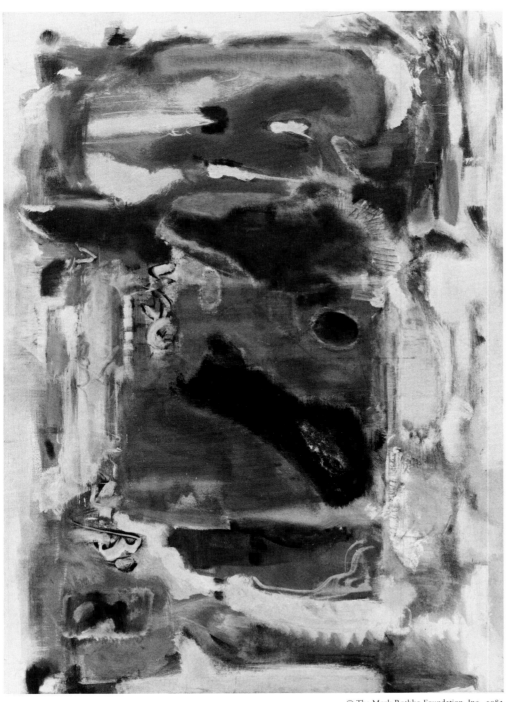

Number 4, 1948
Oil on canvas, 46½ × 51 in.
(Unlocated)

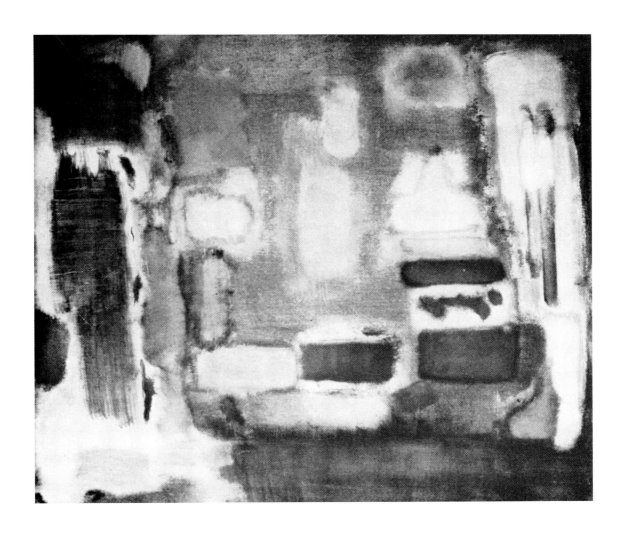

219 ROTHKO

Number 18, 1948, 1949
Oil on canvas, 67⅛ × 56 in.
(Vassar College Art Gallery, Poughkeepsie, New York,
Gift of Blanchette Hooken Rockefeller '31)

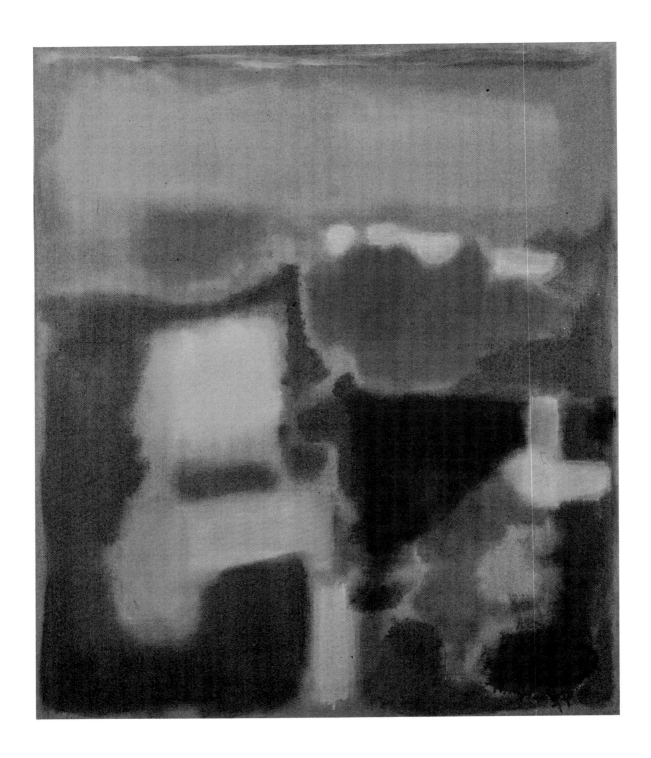

Multiform, 1948
Oil on canvas, 53 1/8 × 46 5/8 in.
(The Mark Rothko Foundation, New York)

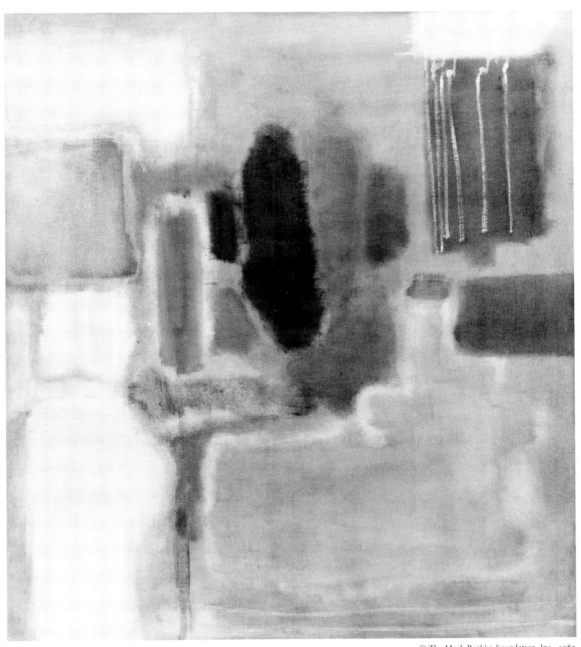

221 ROTHKO

Number 14, 1949
Oil, 60 × 41 ¼ in.
(Unlocated)

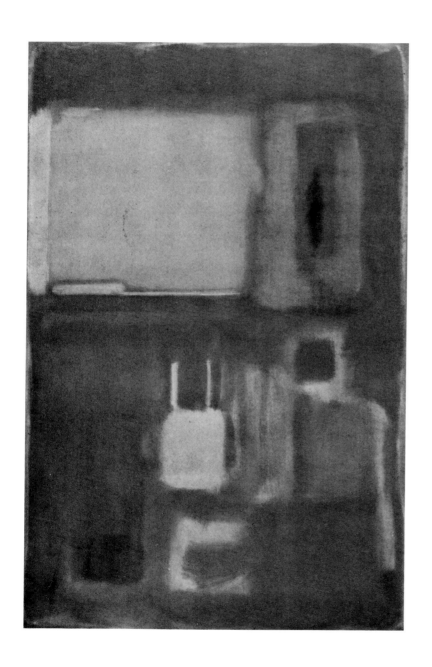

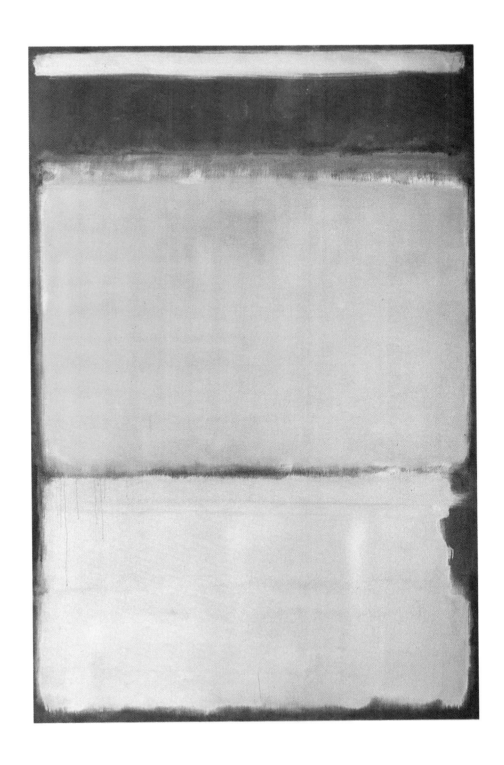

Number 10, 1950
Oil on canvas, 90³/₈ × 57¹/₈ in.
(The Museum of Modern Art, New York,
Gift of Philip Johnson)

Number 18, 1951
Oil on canvas, 81 ¾ × 67 in.
(Munson-Williams-Proctor Institute,
Utica, New York)

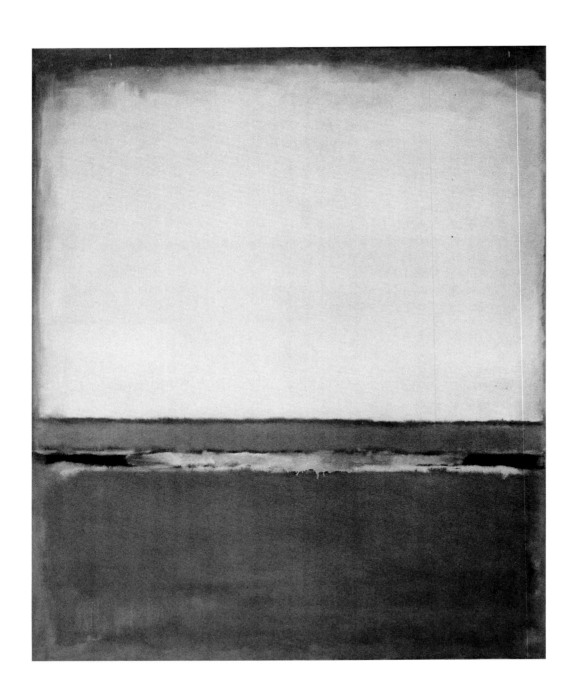

Number 21, 1951
Oil on canvas, 95 × 64 in.
(Mr. and Mrs. Pierre Schlumberger)

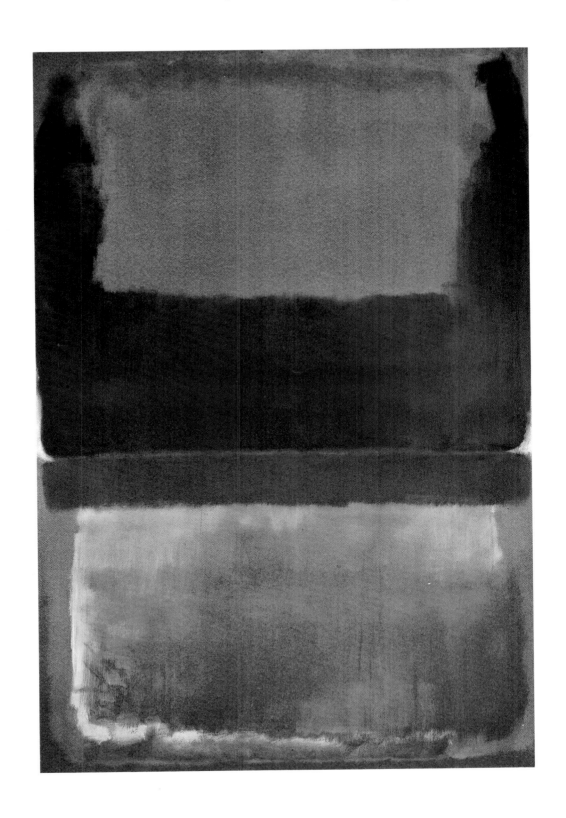

White and Black on Red, 1954
Oil on canvas, 92 × 60 in.
(Alessandro Panza)

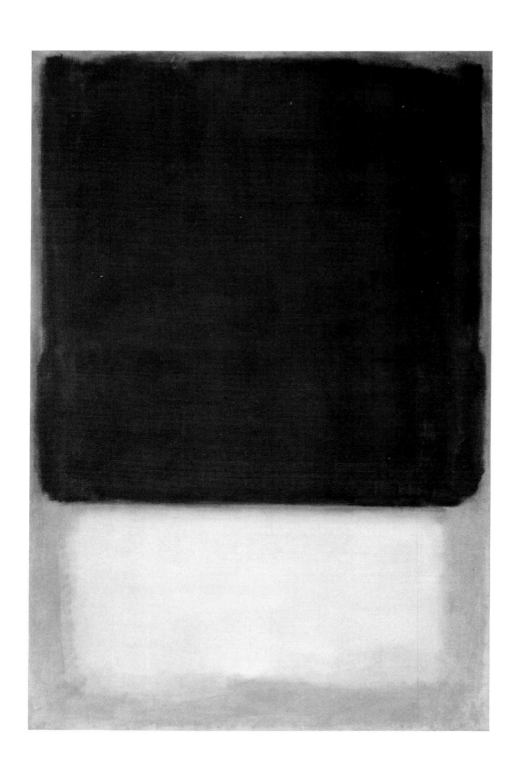

226 ROTHKO

Red, Dark Green, Green, ca. 1952
Oil on canvas, 95 × 81 in.
(Mr. and Mrs. S. I. Newhouse, Jr.)

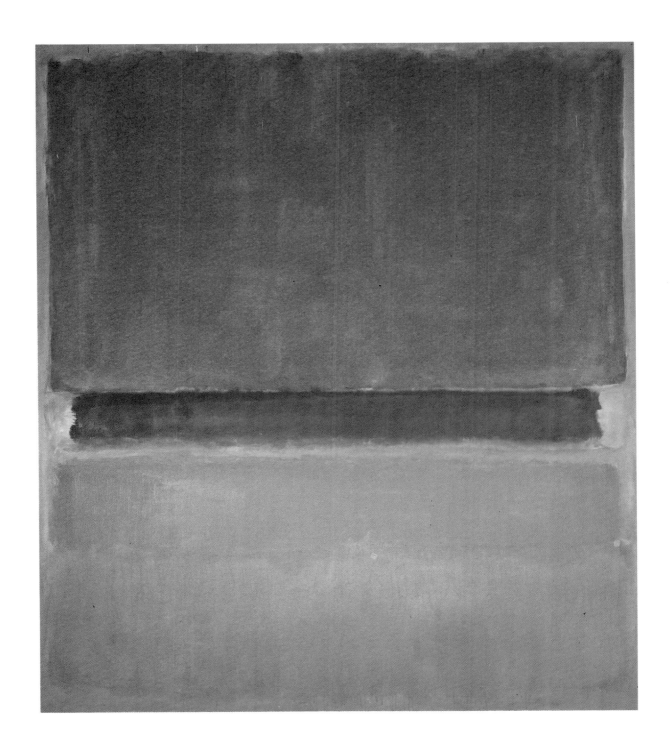

Number 18, 1952
Oil on canvas, $116 \times 91^{1/2}$ in.
(Allgemeine Europaeische Kunstanstalt)

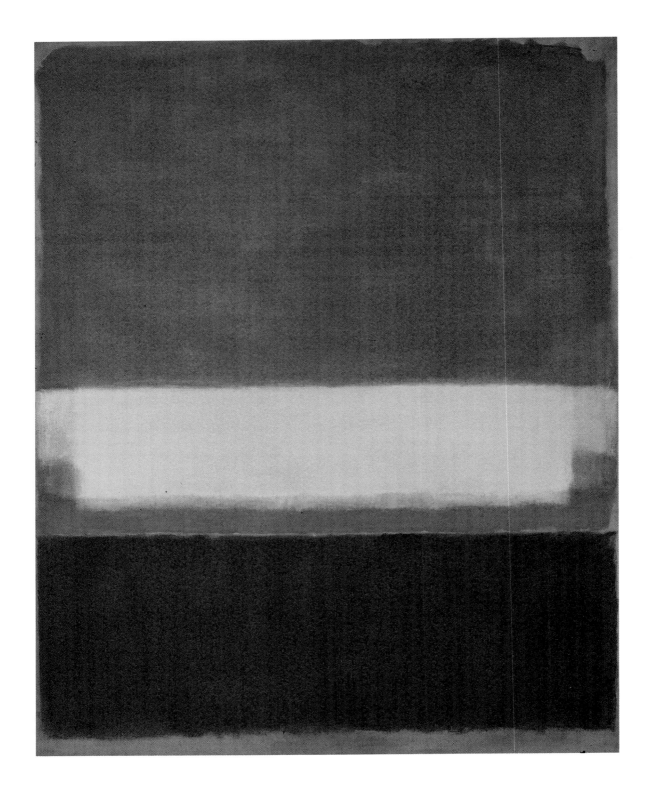

228 ROTHKO

Red, Gray, White on Yellow, 1954
Oil on canvas, 116³/₄ × 92¹/₄ in.
(Unlocated)

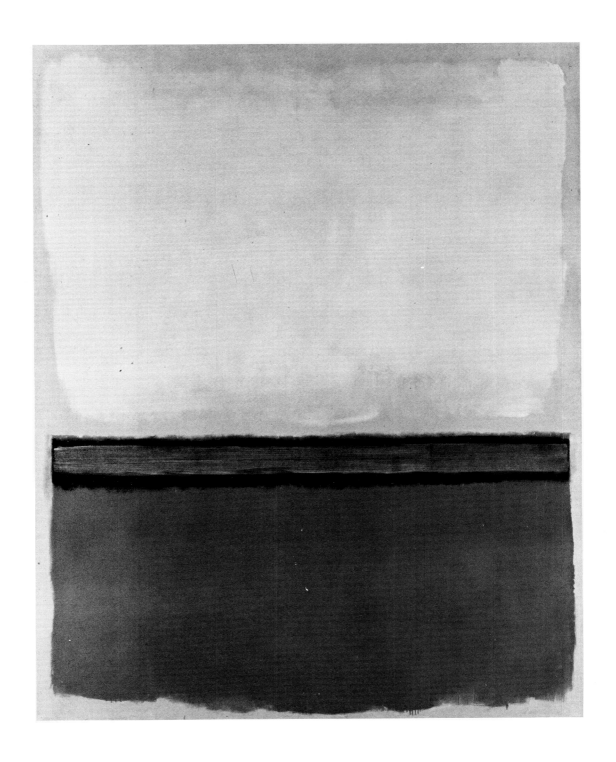

229 ROTHKO
Blue, Green, and Brown, 1951
Oil on canvas, 103 × 83 in.
(Mr. and Mrs. Paul Mellon, Upperville, Virginia)

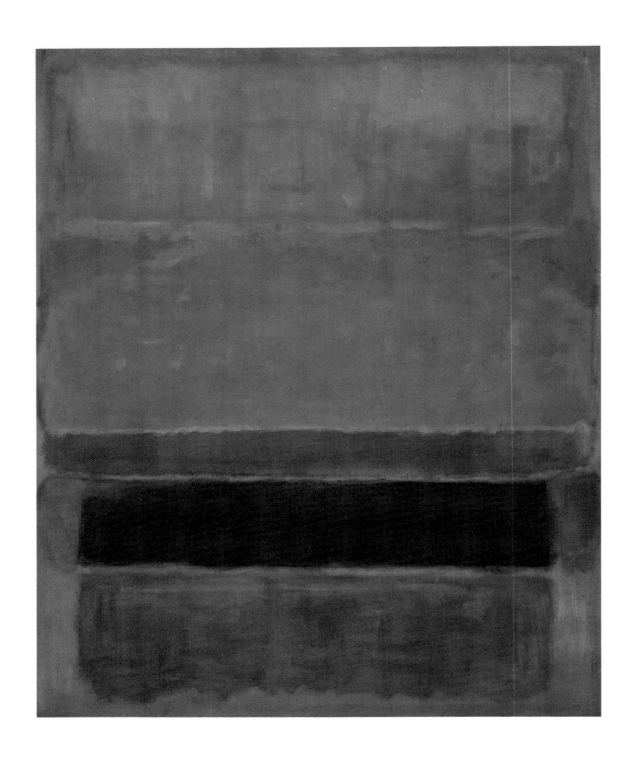

Untitled, ca. 1952
Oil on canvas, 97$^{1}/_{2}$ × 67$^{1}/_{2}$ in.
(The Dallas Museum of Fine Arts,
Gift of the Meadows Foundation Incorporated)

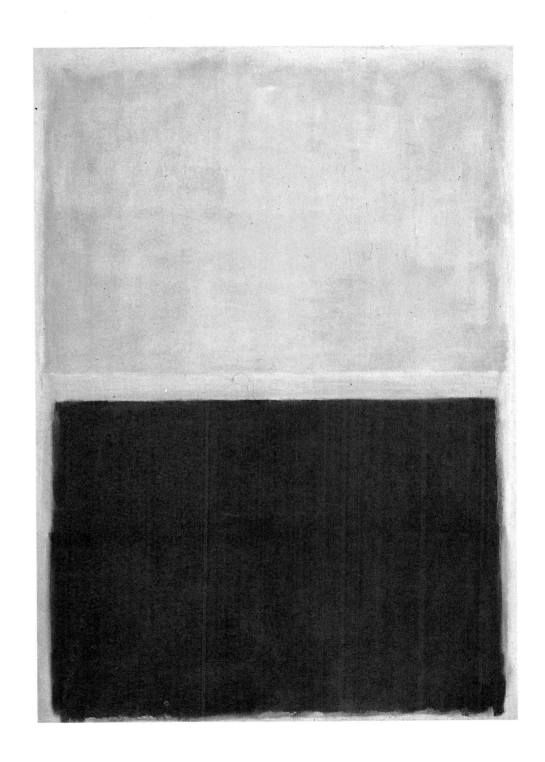

Red, Black, Orange, Yellow on Yellow, 1953
Oil on canvas, 94⅛ × 47¹⁵/₁₆ in.
(The Mark Rothko Foundation, New York)

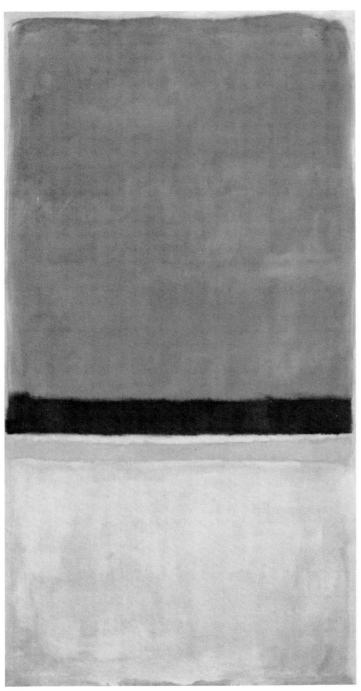

Mark Tobey

Green Apples on a Purple Cloth, ca. 1917
Pastel, 16⁷/₈ × 22⁷/₈ in. (sight)
(Cliffa E. Corson)

The Middle West, 1929
Oil on canvas, 37³/₄ × 59³/₄ in.
(The Seattle Art Museum, Gift of
Mrs. Thomas D. Stimson)

Dancing Miners, 1927 or earlier
Oil on canvas, 67 × 39¹/₄ in.
(The Seattle Art Museum, Eugene Fuller
Memorial Collection)

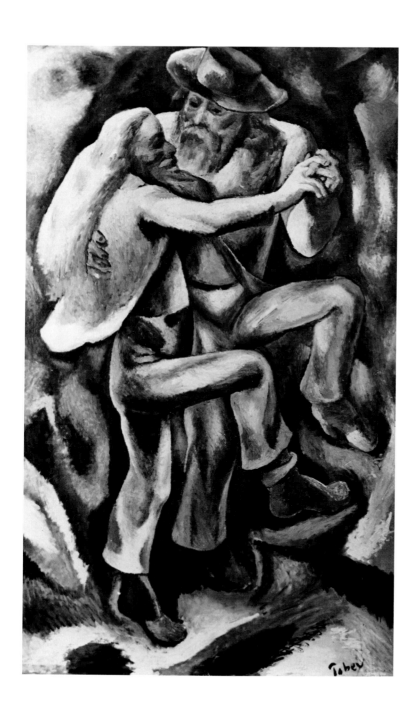

Cirque d'Hiver, 1933
Pastel, $16^7/_8 \times 21^1/_2$ in.
(Mr. and Mrs. Windsor Utley)

236 TOBEY

Shanghai, 1934
Watercolor, 20³/4 × 10¹/4 in.
(Private Collection)

237 TOBEY

Landscape in the Snow, 1935
Tempera, 11 × 15 in.
(Mr. and Mrs. John M. Cooper)

Broadway Norm, 1935 (?)
Tempera, 13 1/8 × 9 1/4 in.
(Carolyn Ely Harper)

Broadway, 1935 (?)
Tempera on composition board, 26 × 19³/₁₆ in.
(The Metropolitan Museum of Art, New York,
Arthur Hoppock Hearn Fund, 1942)

Interior of the Studio, 1937
Gouache on paper on cardboard, 17½ × 22½ in.
(National Gallery of Art, Washington,
Gift of Viola Patterson, 1979)

Still Life with White Plane, 1941
Gouache on panel, 17⅝ × 21¾ in.
(The Seattle Art Museum, Eugene Fuller
Memorial Collection)

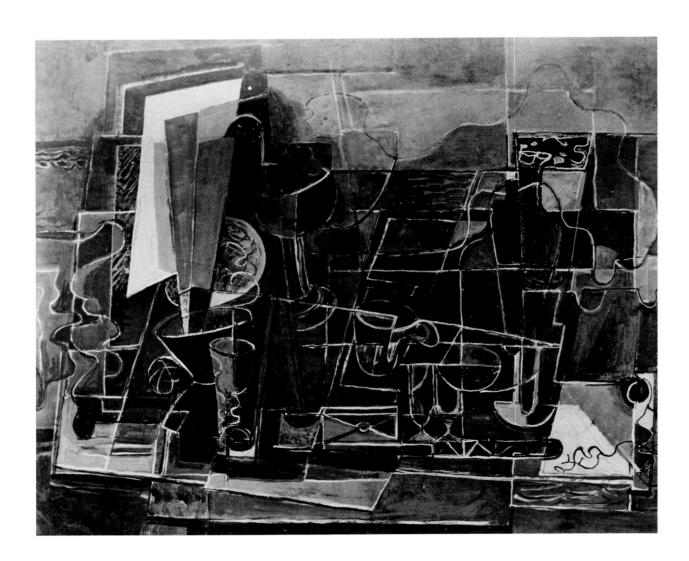

Forms Follow Man, 1941
Gouache on cardboard, 13⅝ × 19⅝ in.
(The Seattle Art Museum, Eugene Fuller
Memorial Collection)

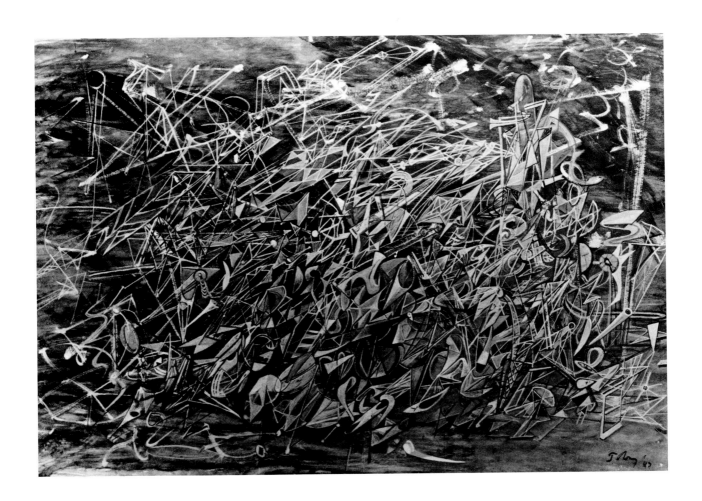

Rummage, 1941
Watercolor, gouache on masonite, $38^{3}/_{8} \times 25^{7}/_{8}$ in.
(The Seattle Art Museum, Eugene Fuller
Memorial Collection)

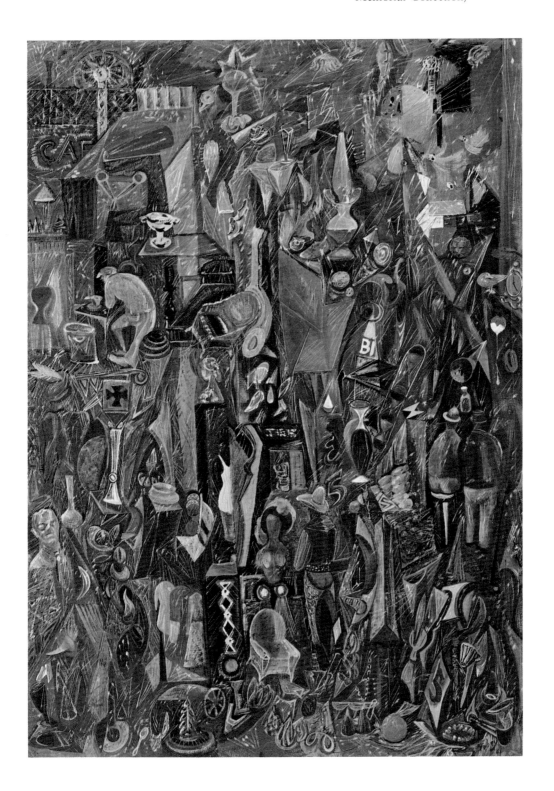

Threading Light, 1942
Tempera on cardboard, 29³/₈ × 19¹/₂ in.
(The Museum of Modern Art, New York)

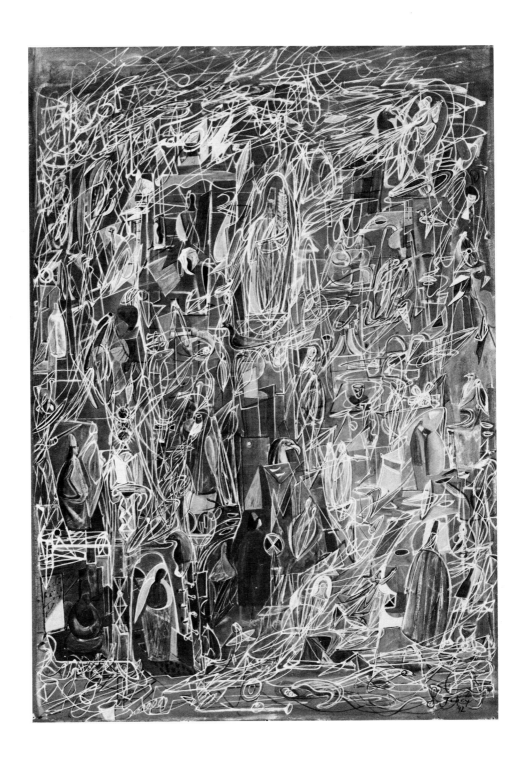

245 TOBEY

Drift of Summer, 1942
Tempera, 28 × 22 in.
(Unlocated)

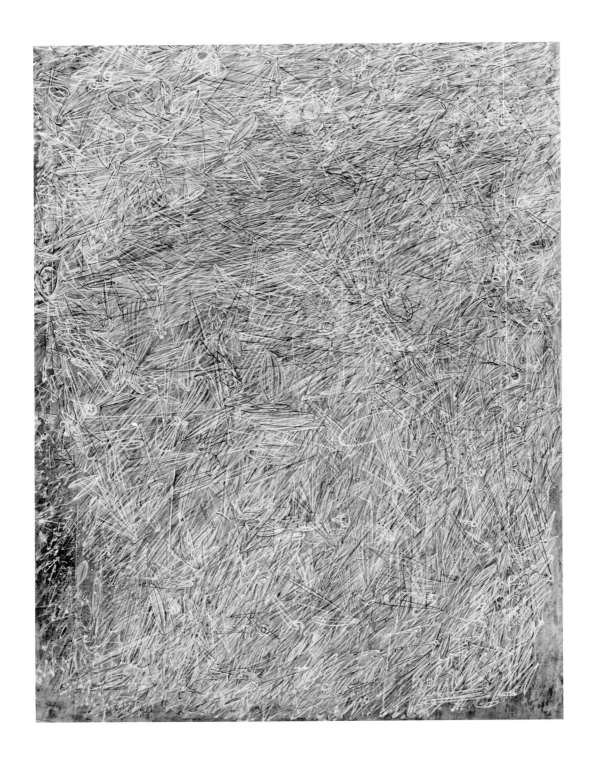

Broadway Boogie, 1942
Tempera on composition board, 31³/8 × 24³/8 in.
(Mr. and Mrs. Max Weinstein)

Cubist Vertical, 1943
Tempera, 17 × 6 in.
(Unlocated)

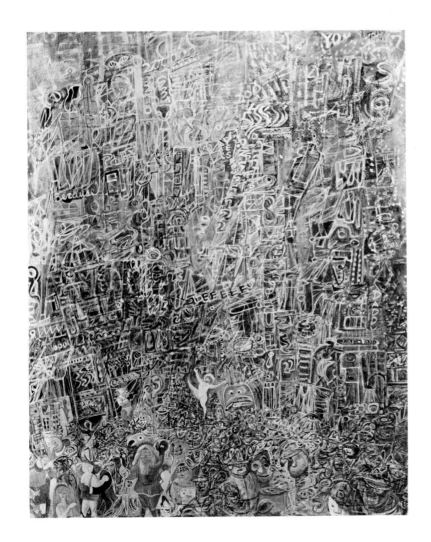

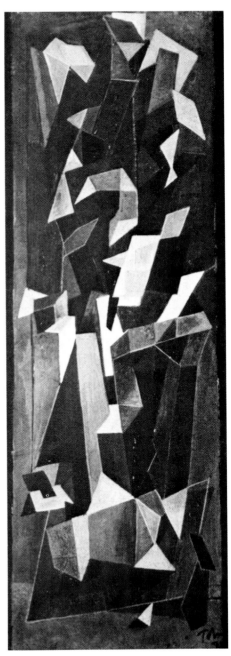

Gothic, 1943
Tempera on board, 27³/₄ × 21⁵/₈ in.
(The Seattle Art Museum, Bequest of
Berthe Poncy Jacobson)

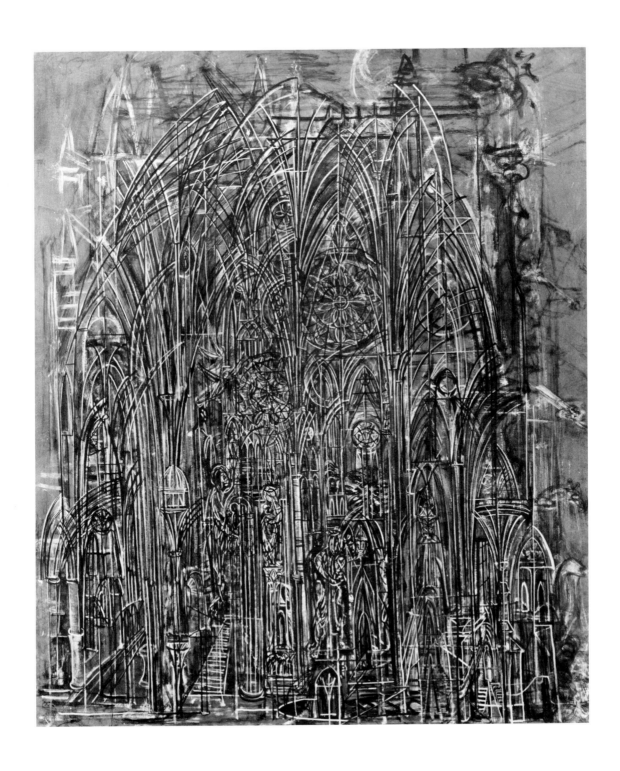

249 TOBEY

Space Architecture, 1943
Tempera on paper, 10 × 16¼ in.
(Rainier National Bank, Seattle)

E Pluribus Unum, 1942 (?)
Tempera on paper, mounted on panel,
19³/₄ × 27¹/₄ in.
(The Seattle Art Museum,
Gift of Mrs. Thomas D. Stimson)

Pacific Transition, 1943
Gouache on paper, 23 ¼ × 31 ¼ in.
(The St. Louis Art Museum, Gift of Joseph Pulitzer, Jr.)

252 TOBEY

The World Egg, 1944
Tempera, 19 × 24 in.
(Carolyn Kizer Woodbridge)

Drums, Indians and the Word of God, 1944
Tempera on wood, 18½ × 13⅞ in.
(Herman Shulman)

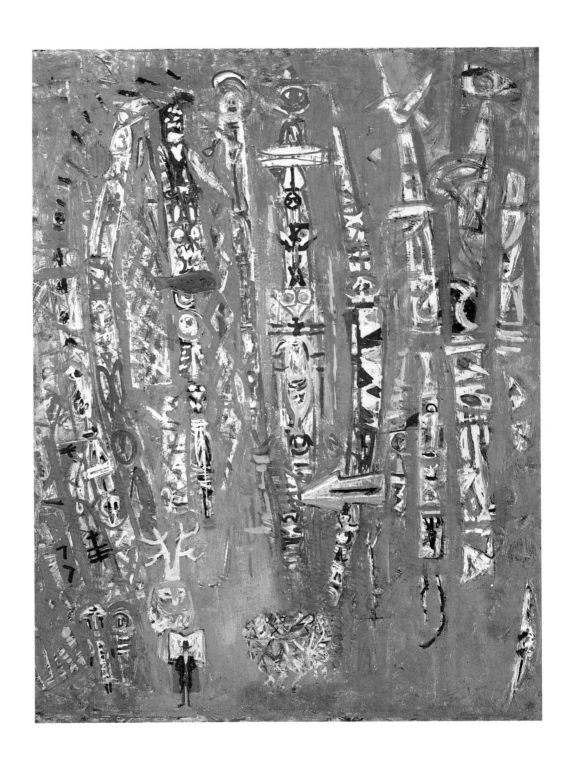

City Radiance, 1944
Tempera on paper, 19³/₈ × 14¹/₄ in.
(Private Collection, Switzerland)

255 TOBEY

Tundra, 1944
Tempera on board, 24 × 16¹/₂ in.
(Neuberger Museum, State University of New York,
College at Purchase, Gift of Roy R. Neuberger)

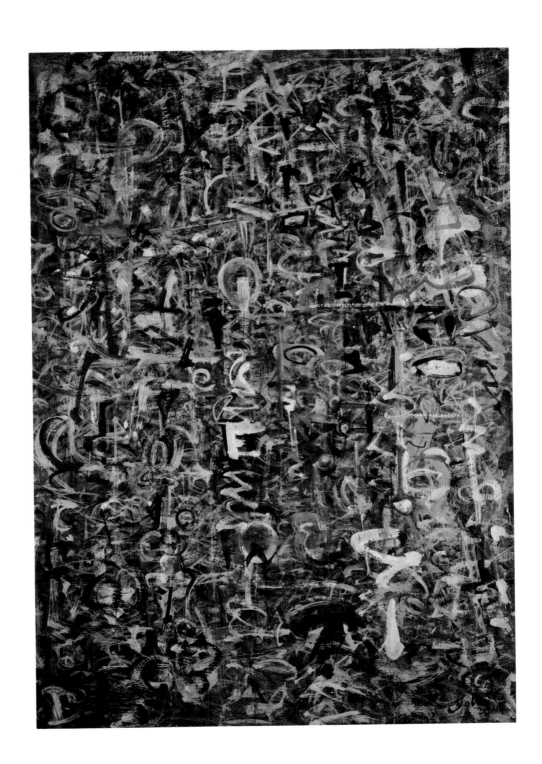

New York, 1944
Tempera on paperboard, 33 × 21 in.
(National Gallery of Art, Washington,
Avalon Fund, 1976)

Mockers Number 2, 1945
Tempera, 20 × 8 in.
(Unlocated)

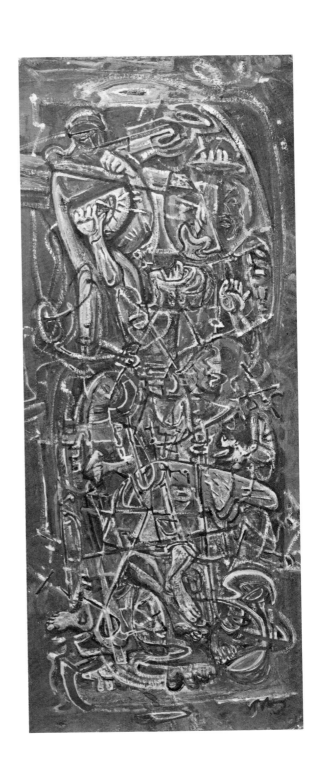

The Dormition of the Virgin, 1945
Tempera, 16³/₄ × 13 in.
(Josiah R. and Laile E. Bartlett)

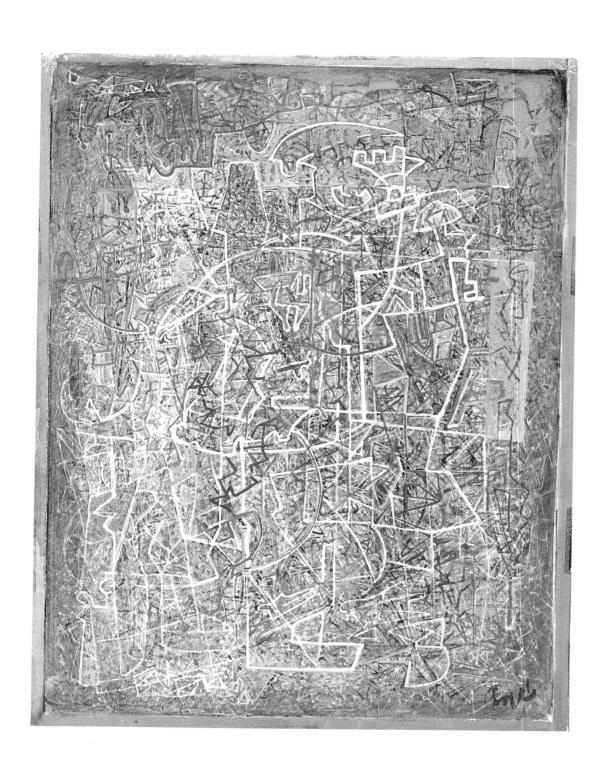

Agate World, 1945
Watercolor, gouache on panel, 14⁷/₈ × 11 in.
(The Seattle Art Museum, Gift of the
Eunice P. Clise Fund, Seattle Foundation)

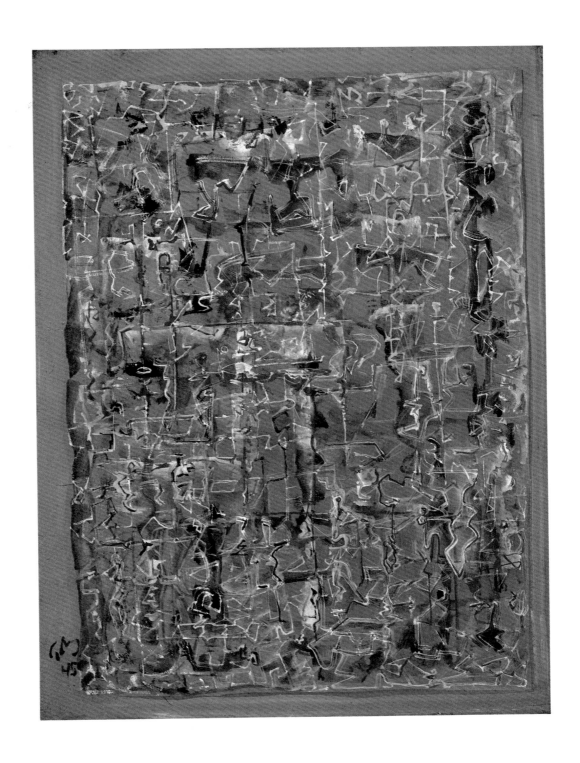

Lines of the City, 1945
Tempera on paper, 17½ × 21¾ in.
(Addison Gallery of American Art, Phillips Academy,
Andover, Massachusetts)

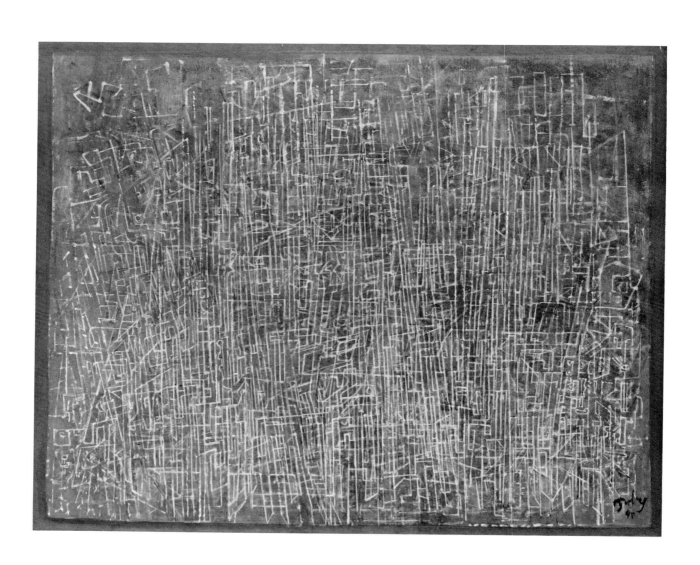

New York Tablet, 1946
Tempera on watercolor paper, 24⁷/₈ × 19 in.
(Munson-Williams-Proctor Institute, Utica, New York,
Edward W. Root Bequest)

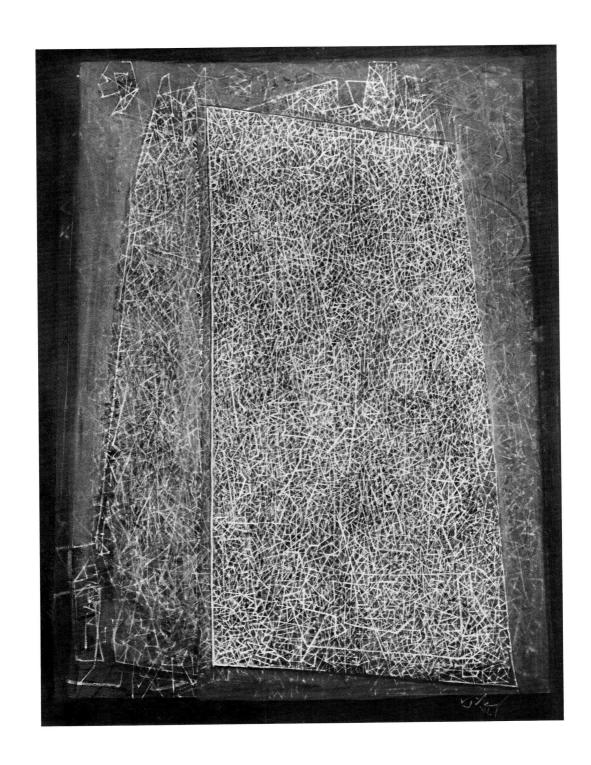

262 TOBEY

Ancestral Island, 1947
Tempera, 24¹/₄ × 19 in.
(Unlocated)

Prophetic Plane, 1947
Tempera on paper, 25¹/₄ × 19¹/₈ in.
(Grand Rapids Art Museum, Michigan)

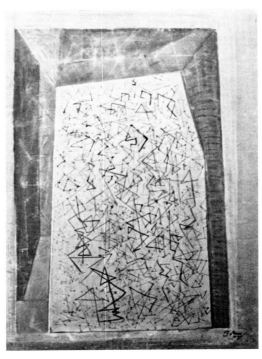

Multiple Margins of Space, 1948
Tempera, 18$^{1}/_{4}$ × 24$^{1}/_{2}$ in.
(Unlocated)

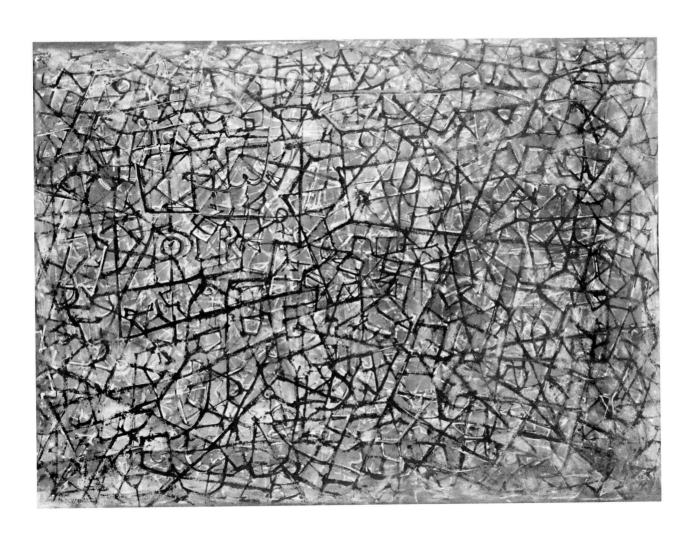

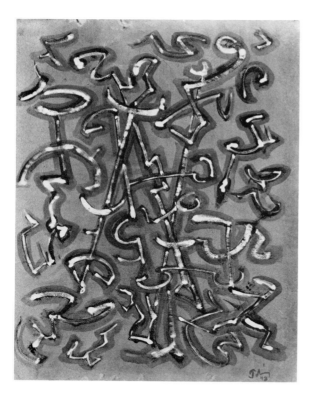

265 TOBEY

Transit, 1948
Tempera on board, 24½ × 18½ in.
(The Metropolitan Museum of Art, New York,
George A. Hearn Fund, 1949)

266 TOBEY

Geography of Fantasy, 1948
Tempera on paper, 20 × 26 in.
(Mr. and Mrs. Olin J. Stephens II)

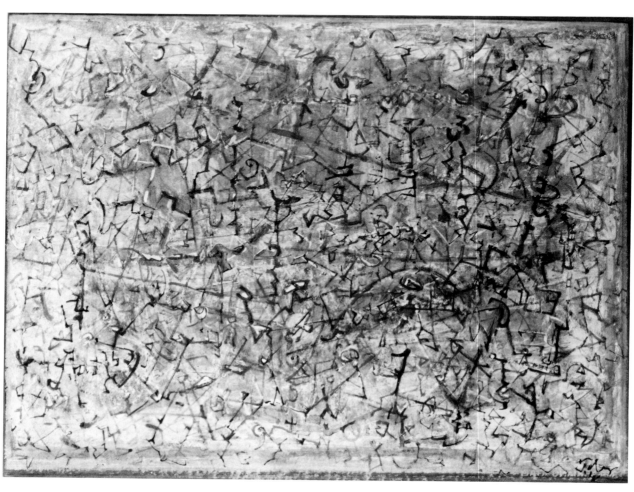

Icon, 1949
Tempera on cardboard, 12 × 15⁷/₈ in.
(University of Nebraska Art Galleries, Lincoln,
F. M. Hall Collection)

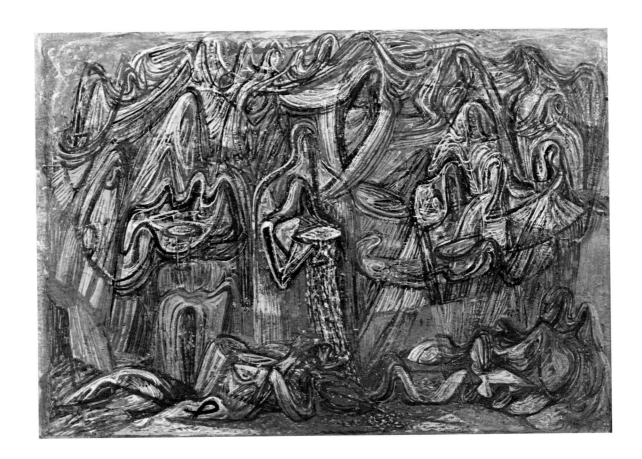

Universal Field, 1949
Pastel and tempera on cardboard, 27¹/₄ × 43¹/₂ in.
(Whitney Museum of American Art, New York)

269 TOBEY

Deposition, ca. 1949
Tempera, 12 × 7³/₄ in.
(Private Collection)

270 TOBEY

Awakening Night, 1949
Opaque watercolor on masonite, 20 × 27¹/₈ in.
(Munson-Williams-Proctor Institute, Utica, New York,
Edward W. Root Bequest)

271 TOBEY

Space Intangibles, 1949
Tempera on academy board, 28 × 44 in.
(Museum of Art of Ogunquit, Maine)

Family, 1949
Tempera, 12 × 7¹/₂ in.
(Marian Willard Johnson)

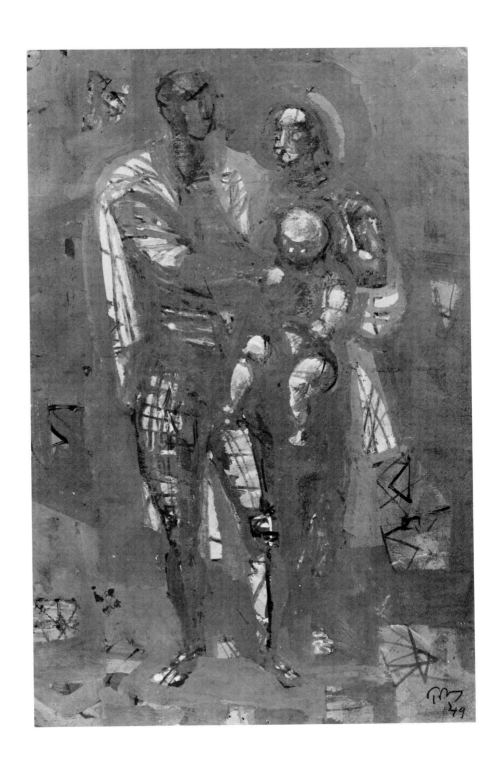

273 TOBEY

Beach Space, 1950
Tempera, 25 1/4 × 18 5/8 in.
(Henry Art Gallery, University of Washington, Seattle)

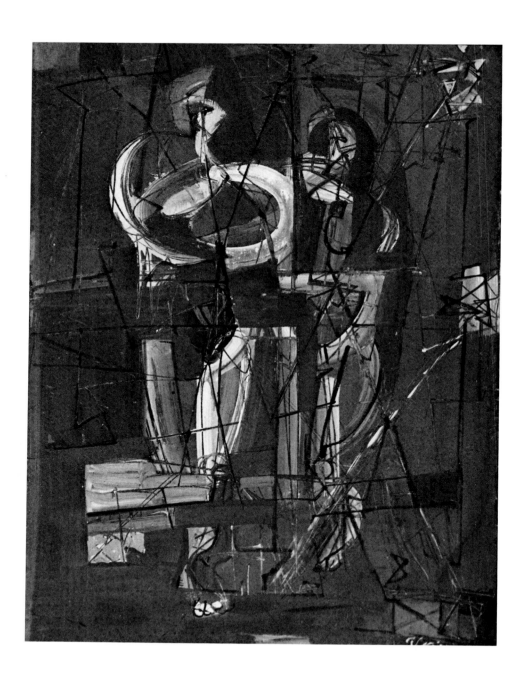

Written Over the Plains, 1950
Oil and tempera on masonite, 30¹/₈ × 40 in.
(San Francisco Museum of Modern Art,
Gift of Mr. and Mrs. Ferdinand C. Smith)

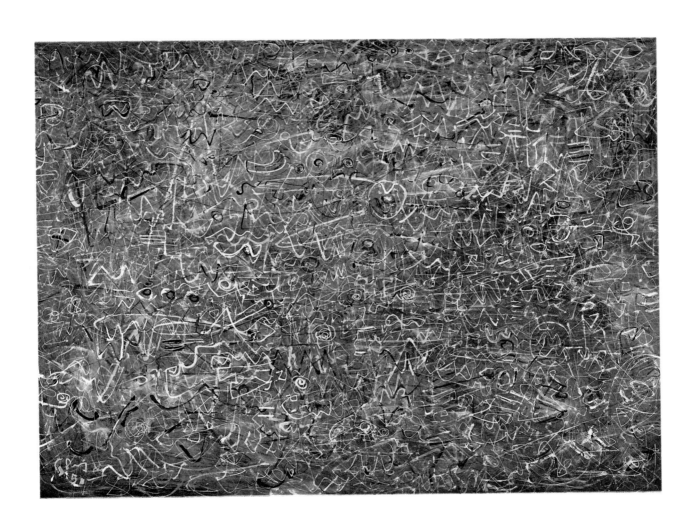

Canal of Cultures, 1951
Tempera, 19 1/2 × 25 3/4 in.
(Carolyn Kizer Woodbridge)

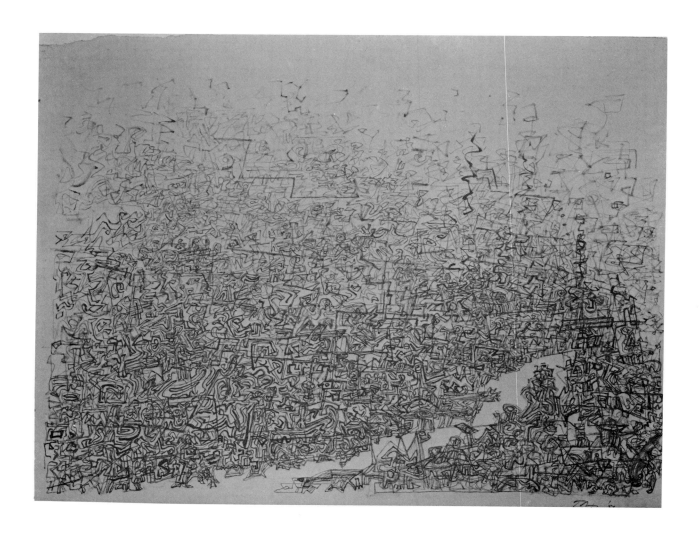

276 TOBEY

Pinnacles, 1950
Tempera, 25³/₄ × 19¹/₄ in.
(Otis D. Hyde)

Distillation of Myth, 1950
Tempera, 17 × 23¼ in.
(Willard Gallery, New York)

Universal City, 1951
Watercolor, gouache on paper, $37^{1/2} \times 25$ in.
(The Seattle Art Museum,
Gift of Mr. and Mrs. Dan Johnson, New York)

279 TOBEY

The Street, 1952
Tempera on paper, 41 1/2 × 32 5/8 in.
(Mrs. T. V. Barber)

Above the Earth, 1953
Gouache, 39¹/₂ × 29³/₄ in.
(The Art Institute of Chicago,
Gift of Mr. and Mrs. Sigmund Kunstadter)

Supporting Artists

Turkey, 1927
Oil on canvas, 56½ × 44½ in.
(Philadelphia Museum of Art,
Gift of Mr. and Mrs. R. Sturgis Ingersoll)

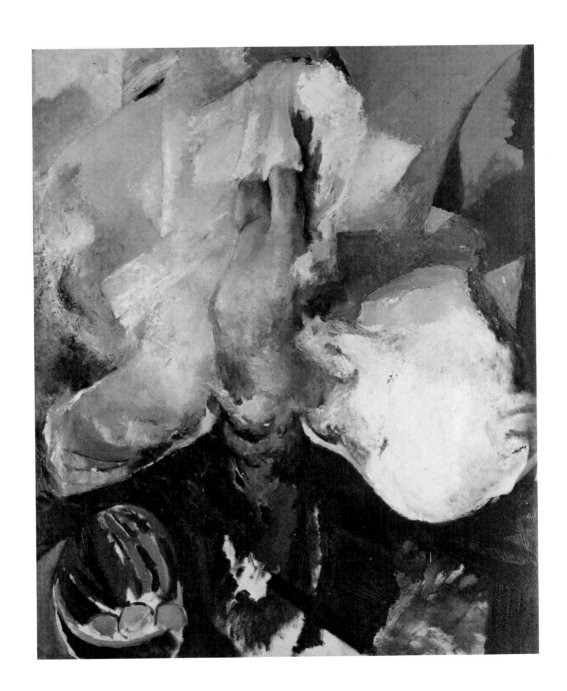

282 ARTHUR B. CARLES

Composition, III, 1931–1932
Oil on canvas, 51³/₈ × 38³/₄ in.
(The Museum of Modern Art, New York,
Gift of Leopold Stokowski)

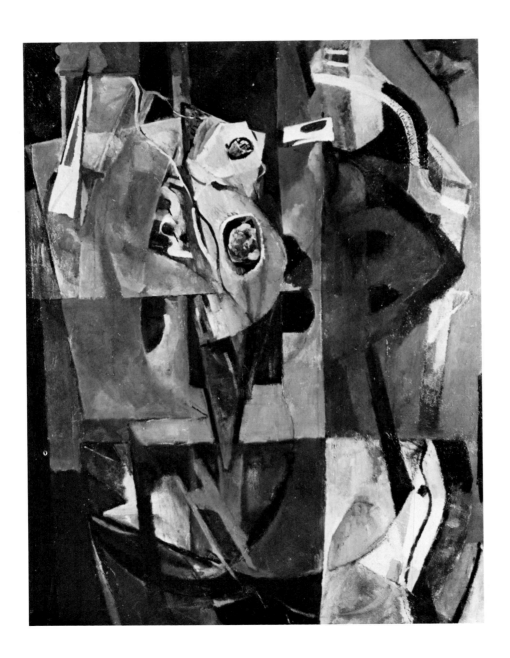

Mars Disarmed by Venus, 1824
Oil on canvas, 121¼ × 104⅜ in.
(Musées Royaux des Beaux-Arts de Belgique, Brussels,
Bequest of David Chassagnol)

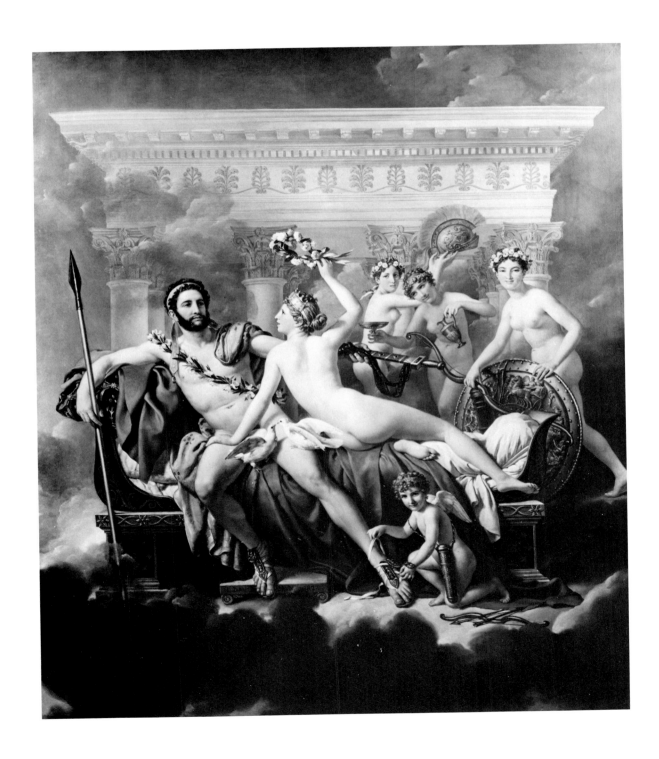

Odalisque in Grisaille, 1813–1814
Oil on canvas, 32³/₄ × 43 in.
(The Metropolitan Museum of Art, New York,
Wolfe Fund, 1938)

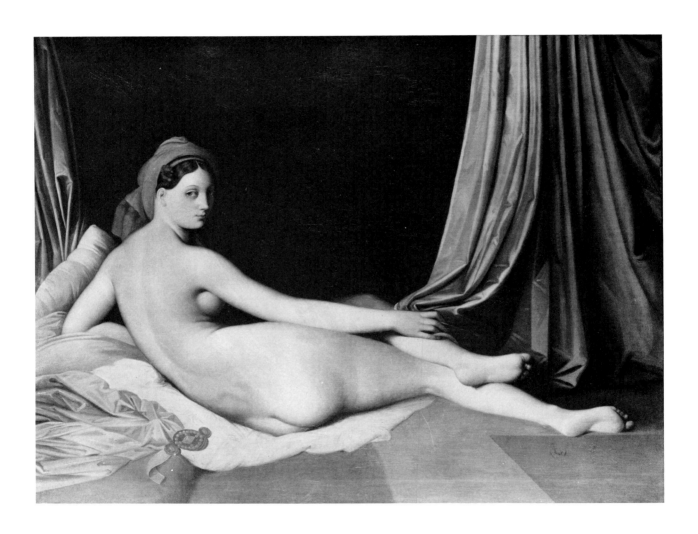

285 FRANZ KLINE

Diagonal, 1952
Oil, 43 1/2 × 32 1/2 in.
(Mr. and Mrs. I. David Orr)

286 JOHN MARIN

Sun, Isles and Sea, 1921
Watercolor on paper, 16½ × 19 in.
(The Baltimore Museum of Art, Edward Joseph
Gallagher III Memorial Collection)

287 JOHN MARIN

Sea Piece, Maine, 1951
Watercolor on paper, 14 × 20 in.
(Private Collection)

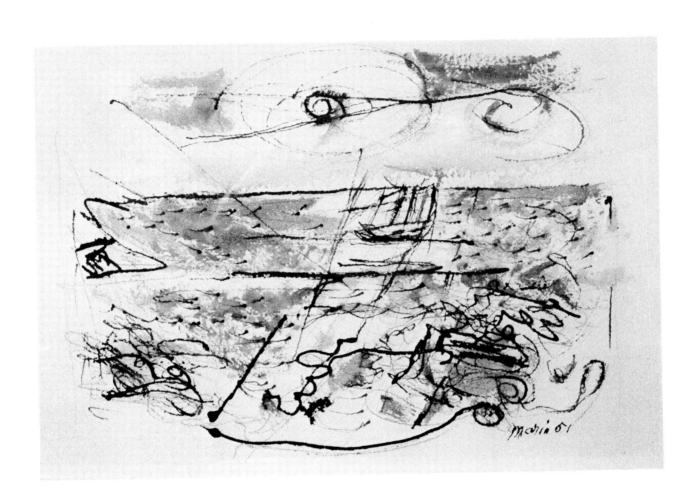

Broadway Boogie Woogie, 1942–1943
Oil on canvas, 50 × 50 in.
(The Museum of Modern Art, New York)

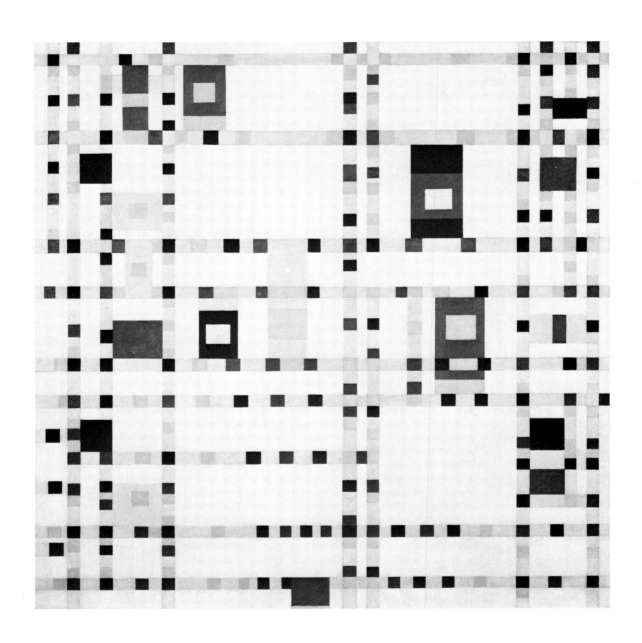

289 CLAUDE MONET

The Houses of Parliament, Sunset, 1903
Oil on canvas, 32 × 36³⁄₈ in.
(National Gallery of Art, Washington,
Chester Dale Collection, 1962)

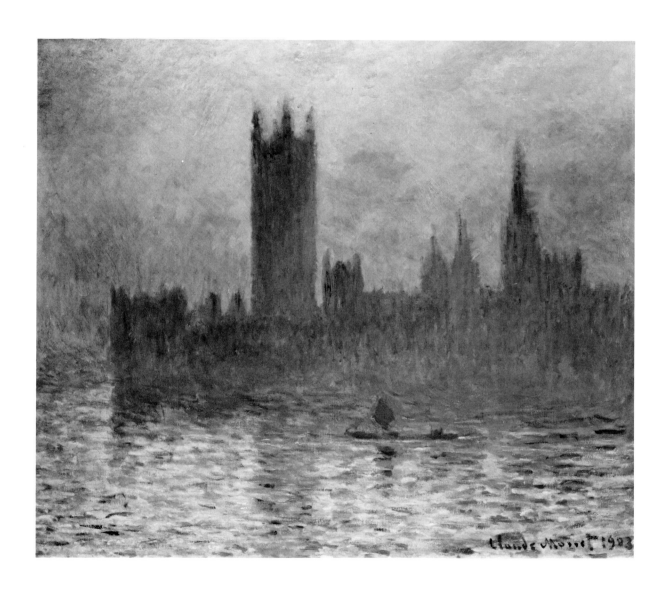

Harlequin (*Project for a Monument*), 1935
Oil on canvas, 24½ × 20 in.
(Albright-Knox Art Gallery, Buffalo,
Room of Contemporary Art Fund)

Guernica, 1937
Oil on canvas, 137½ × 305¾ in.
(Museo del Prado, Madrid)

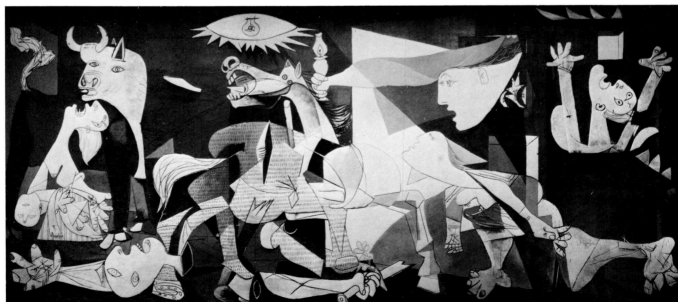

Number 1, 1949
Duco and aluminum paint on canvas,
63 1/8 × 102 1/8 in.
(Mrs. Taft Schreiber)

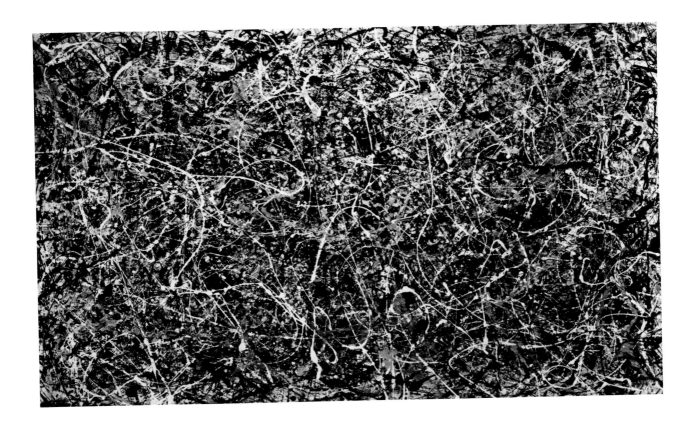

Toilers of the Sea, early 1880s
Oil on wood, 11 1/2 × 12 in.
(The Metropolitan Museum of Art, New York,
George A. Hearn Fund, 1915)

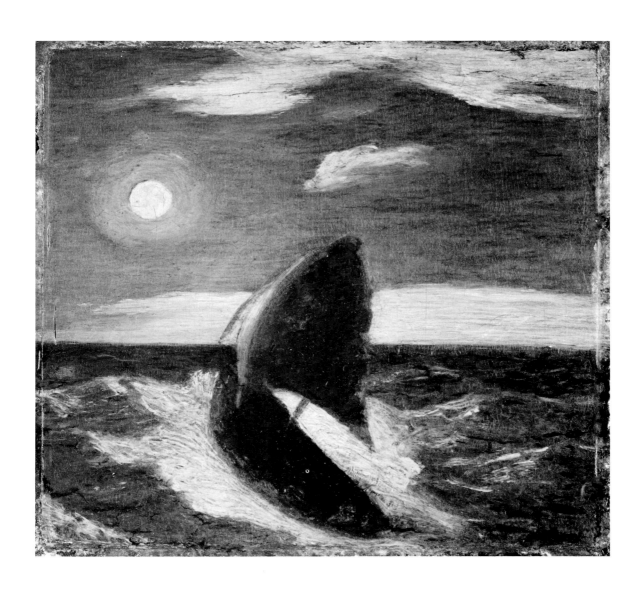

Nocturne in Blue and Gold: Old Battersea Bridge,
ca. 1872–1875
Oil on canvas, 26³/₄ × 20 in.
(The Trustees of the Tate Gallery, London)

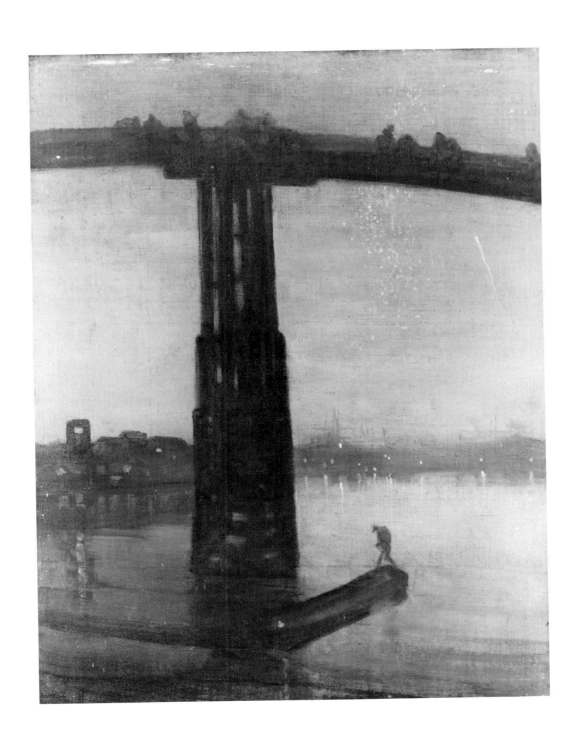

Nocturne in Black and Gold:
Entrance to Southampton Waters, 1876–1877
Oil on canvas, 20 × 30 in.
(The Art Institute of Chicago, The Stickney Collection)

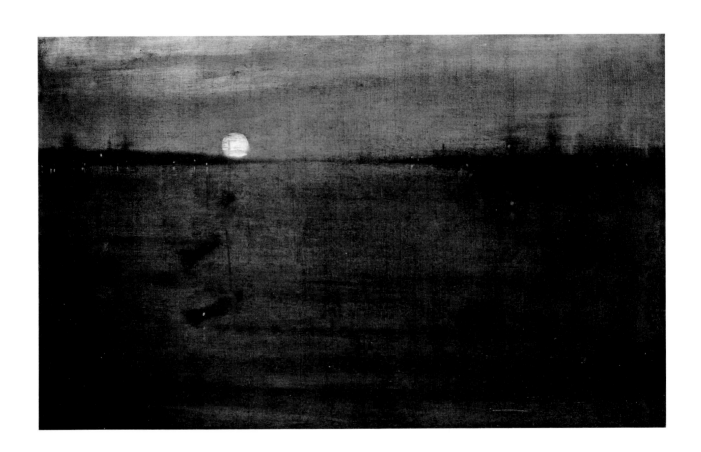

Index of Illustrations

Index

Index of Illustrations

Index

book design by Marianne Perlak
composed in VIP Sabon by Progressive Typographers
printed by Federated Lithographers on
80 pound Cameo manufactured by S. D. Warren Co.
bound by The Book Press